Pissarro

Camille Pissarro 1830-1903

Hayward Gallery, London 30 October 1980-11 January 1981
Grand Palais, Paris 30 January-27 April 1981
Museum of Fine Arts, Boston 19 May-9 August 1981

Working Committee

Françoise Cachin Musée d'Orsay
Anne Distel Musée d'Orsay
Christopher Lloyd Ashmolean Museum
Barbara Stern Shapiro Museum of Fine Arts, Boston
John Walsh Jnr. Museum of Fine Arts, Boston

Hardback ISBN 0 7287 0261 4 Softback ISBN 0 7287 0253 3
© Copyright 1980 Arts Council of Great Britain and the
Museum of Fine Arts, Boston

Sub-Editor: Irena Hoare
Translator: PS Falla
Catalogue designed by Roger Huggett/Sinc
Printed in England by Balding and Mansell
Exhibition Officer: Janet Holt
Exhibition Assistant: Jaqueline Eland until May 1980; Julia Baxter

PHOTOGRAPHIC CREDITS

Lending Institutions
Prudence Cuming, London
John Freeman Group, London
Courtauld Institute of Art, London
Annan, Glasgow
Lauros Giraudon, Paris
Réunion des musées nationaux, Paris
Atelier 80, Paris
Olivier Pascal, Paris
Photorama, Le Havre
Robert Chanoine, St. Ouen L'Aumone
I. Zafrir, Tel Aviv

Cover: *La jeune fille à la baguette* (cat. no. 53)

Foreword

This exhibition celebrates the 150th anniversary of the birth of Camille Pissarro. It was proposed by Christopher Lloyd of the Ashmolean Museum, prompted in part by the considerable collection of paintings, drawings and archival material, which forms the Pissarro Gift to that museum. The idea was welcomed by the Arts Council who were encouraged by Michel Laclotte and Hélène Adhémar, and adopted as a joint exhibition project by the Arts Council, the Réunion des musées nationaux and the Museum of Fine Arts, in Boston. We have also been encouraged by the support of John Rewald whose seminal work on the history of Impressionism and in particular Camille Pissarro has provided the impetus for much research. The working committee has also benefited from the advice of Richard Brettell of the Art Institute of Chicago.

The Arts Council gladly accepted the responsibility of administering the exhibition and both the Réunion des musées nationaux and the Museum of Fine Arts have worked untiringly to secure important loans on both sides of the Atlantic. The efforts of the three institutions would amount to little, but for the generous support of lenders, and we owe a deep debt of gratitude to both public institutions and private collectors who are listed on pages 4 and 5.

Particular thanks are due to David Piper, Director of the Ashmolean Museum and the Visitors for the whole-hearted support they have given Christopher Lloyd during the preparation of the exhibition. We would also like to thank the numerous people on both sides of the Atlantic, who have given advice and information in the formation of the exhibition and the catalogue. They are listed on page 6.

We are pleased to have had the opportunity of collaborating in organizing this major international retrospective exhibition of Camille Pissarro's work.

Joanna Drew
Director of Art, Arts Council of Great Britain

Hubert Landais
Directeur des Musées de France

Jan Fontein
Director, Museum of Fine Arts, Boston

Lenders

UNITED KINGDOM	CAMBRIDGE	Fitzwilliam Museum 2, 59
	CARDIFF	National Museum of Wales 83
	EDINBURGH	National Galleries of Scotland 4
	GLASGOW	Art Gallery and Museum, Kelvingrove 3, 85
	JERSEY	The Earl of Jersey 28
	LONDON	The Trustees of the British Museum 116, 148, 192, 193
		Estate of the Late Sir Charles Clore 72
		Courtauld Institute Galleries 16
		Princess Fevsi 200
		J. P. L. Fine Arts, Mme. Katia Pissarro and Mr. Christian Neffe 213
		National Gallery 46
		The Tate Gallery 55, 58, 60, 93
		Sir Isaac and Lady Wolfson 91
	MANCHESTER	Whitworth Art Gallery 128
	OXFORD	The Visitors of the Ashmolean Museum 34, 49, 65, 89, 102, 103, 104, 108, 109, 110, 115, 118, 120, 122, 123, 124, 125, 126, 127, 133, 134, 135, 138, 139, 145, 149, 150, 153, 164, 169, 173, 182, 188, 196, 197, 212, 225, 226, 227, 228
		Mr. Tim Rice 5
	YORK	City Art Gallery 106
		Private Collections 38, 82, 116, 117, 129, 146, 147, 148, 177, 192, 193, 203, 204, 205, 206, 207, 208
CANADA	TORONTO	Art Gallery of Ontario 75, 140
	OTTAWA	National Gallery of Canada 167
FRANCE	DOUAI	Musée de la Chartreuse 48
	LE HAVRE	Musée de la Ville du Havre 92
	LIMOGES	Musée Municipal de Limoges 220
	MENTON	Collection of M. and Mme. Felix Pissarro 215, 223, 224
	PARIS	Bibliothèque Nationale 166, 208a
		M. Claude Bonin 219
		M. Henri M. Cachin 218
		Durand-Ruel Collection 27, 31, 32, 62, 84, 87
		Musée du Jeu de Paume 24, 26, 45, 47, 53
		Musée du Louvre, Cabinet des Dessins, 111, 112, 119, 121, 130, 131, 187, 217
		Musée du Louvre, Cabinet des Dessins and the heirs of Antonin Personnas 113
		Musée Marmottan 50
		Musée d'Orsay 26, 45
		Musée Petit Palais 90
		Paul Prouté S.A. 201
		Collection of the Late Mme. Ginette Signac 229
	PONTOISE	Musée de Pontoise 230
	REIMS	Musée Saint-Denis 79
		Private Collections 67, 222
GERMANY	BERLIN	Nationalgalerie 7
	BREMEN	Kunsthalle 56
	COLOGNE	Wallraf-Richartz Museum 10

Acknowledgements

Kathleen Adler, John Bensusan-Butt, M. and Mme. Bidon, André Bonin, Alfredo Boulton, Oswald Burchart, Anthea Callen, L. Couvée, Charles Durand-Ruel, Eva Ganneskov, Marc Gerstein, Jendreau Gruet, Lullie Huda, Edda Maillet, Kenneth Malcolm, Michel Melot, Christian Neffe, Katia and Hugues Pissarro, Eleanor Sayre, R. Schmidt, Ralph Shikes, Rosa Bianca Skira, Richard Thomson, Anne Thorold, Lauro Venturi.

The Museum of Fine Arts would like to thank John Walsh and Barbara Stern Shapiro who were responsible for the exhibition in Boston. They were greatly aided by many members of the Museum staff. Scott Schaefer, Alexandra Murphy, and Helen Hall shared various curatorial labours with Mr. Walsh; Linda Thomas dealt with countless details of transport, insurance and other practical matters; Eleanor Sayre and her staff were extremely helpful to Mrs. Shapiro while she wrote the section on prints, and Margaret Jupe made editorial suggestions; Tom Wong and Judith Downes designed the installation; Vishakha Desai and Mary Robinson devised an ambitious educational programme; the conservators Alain Goldrach and Roy Perkinson were responsible for the inspection and care of the pictures; Clementine Brown and Charles Thomas helped to assure a large audience and G. Peabody Gardner III guided the Museum's solicitation of funds for the exhibition.

The exhibition in Boston is made possible by a grant from the National Endowment for the Arts, a federal agency, and by indemnification of loans under the Arts and Artifacts Indemnity Act, administered by the Federal Council on the Arts and Humanities.

Contents

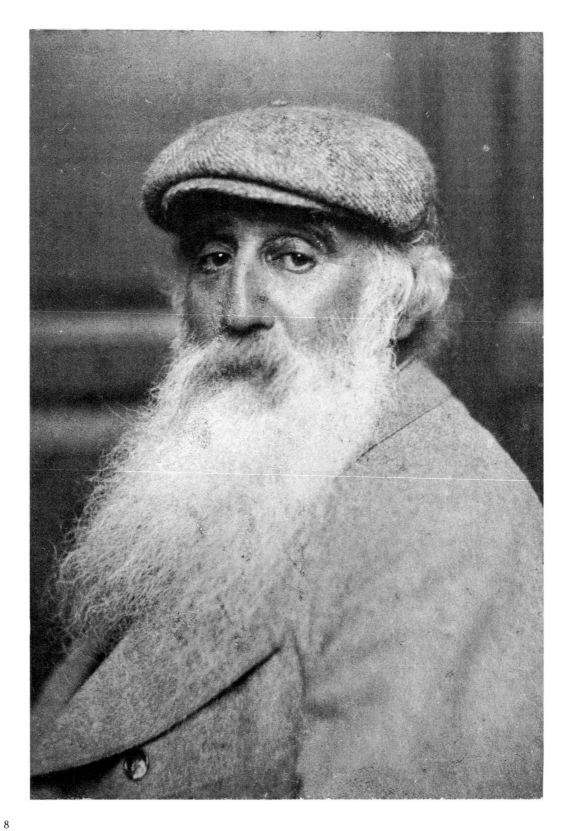

John Rewald

Foreword

'I recall that at the Académie Suisse there were students who were remarkably skilful and could draw with surprising sureness. Later on, I saw these same artists at work; they were still skilful, but no more than that. Just think of Bastien-Lepage! and Carolus Duran!!! No, no, no, that is not art!'

Camille Pissarro to his son Lucien, 1884

The chronicling of events is a matter of selection and evaluation. Volumes of newspapers do not constitute a history book, though they contain much of the data for one. Only time provides the perspective that endows past happenings with their true meaning, disclosing their importance or triviality. It is from a distance that minor occurrences may reveal themselves pregnant with the most decisive elements; it is from a distance also that many who were major figures in their day shrink to nothingness. But unless we perceive this clearly and let those who fall by the wayside sink into oblivion, we are abusing the advantages of hindsight.

This is exactly the danger we are facing at present when some historians, with the admirable aim of presenting a total picture of the artistic achievements offered by nineteenth-century France, engage in the resurrection of the ghosts of Academism. By doing so, they bestow upon the very men who were merciless enemies of every new tendency, an equality of rank which places them among the significant forces of the past. This is neither 'justice' nor 'clarification'; it is instead a dangerous manipulation that diverts the powerful flow of the mainstream of history.

Shortly before the outbreak of the First World War, Louis Dimier, a French critic whose reactionary attitude entitles him to a special niche in the literature of art, published a learned volume, *Histoire de la peinture française au XIXe siècle (1793–1903)*. He chose 1903 as his cut-off date because that was the year in which Léon Gérôme had died and with that artist there 'disappeared the successor of David and Ingres, heir to the authority established by them'. As the impartial historian he pretended to be, Dimier dutifully recorded that Gérôme had been the only one who 'brilliantly resisted' Impressionism, 'designating Manet's paintings as *cochonneries*'.

The year 1903 also saw the death of Camille Pissarro, whose name appears exactly once in Dimier's 319 pages, when the author explains that divisionism and the application of scientific data to art were a tendency prompted, above all, by the need 'to justify the technique of Monet, born of the hallucinations of an exasperated eye . . . The system was called *pointillé*. Pissaro [*sic*], friend of Monet and disciple of Impressionism, followed it'.

One may consider 1903 as a significant date because of Gérôme or Pissarro, but to select it because *both* men died that year simply won't do. Such are the pitfalls of a supposedly equitable perception of history, that the perfectly correct statement, 'In 1903 Pissarro and Gérôme died', implicitly puts the two men on the same level. One of the great Impressionists and an essential figure in the evolution of modern

art is equated with the benighted Academician who considered Impressionism to be *le déshonneur de la France*. Even more, it establishes a parallel between a man whose perceptions and creative powers remained fresh and vivid until the last, and a dried-out practitioner whose main concerns were with Oriental picture postcards and slick nudes, some of them in marble with bronze adjuncts.

Those who think that Dimier honestly believed in the historic role played by Gérôme, should perhaps consider that what is at stake here is not Dimier's sincerity, but the stand he took. At the time Dimier deemed it relevant to slander Impressionism (with Monet, Renoir, and Degas still alive), to completely overlook Pissarro, and to glorify Gérôme, the cause of the latter was already irremediably lost; new generations had appeared, on whom Gérôme's 'authority' did not have the slightest hold. And well before Dimier attempted his peculiar classification of the vital currents of the nineteenth century, there had been men who had spoken up for Manet and Cézanne, Monet and Pissarro, recognizing them as the true masters of the period. Among them were Emile Zola and Mallarmé, Théodore Duret, Gustave Geffroy, Octave Mirbeau, and Georges Clemenceau. To go back today and absolve Dimier is to race through history in reverse gear.

Gérôme, admittedly, does not even deserve to be attacked and could remain a footnote were it not for recent endeavours to re-establish him and his brethren – the Lhermittes, Besnards, Chabas', Le Sidaners, Henri Martins, and Bérauds – in the overview of French nineteenth-century art. This is done under the illusion that they represent the other side of the coin. But this concept is based on a fallacy. When two real forces confront each other, such as Ingres and Delacroix, their opposition yields positive results and adds vitality to the period. It is possible, and indeed necessary, to appreciate both Delacroix and Ingres as, incidentally, Camille Pissarro did. Yet the struggle between Academic art and Impressionism which dominated the second half of the last century – that is Pissarro's entire lifespan – was not a competition between equal forces. Those who, in the wake of Gérôme, endeavoured to stem the tide of Impressionism had nothing to offer but still-born concepts, antiquated ideals, empty skills, and a contemptible willingness to accommodate the conquests of *plein-air* painting to the debased taste of the Salon jury.

How are we to evaluate the contribution of a man like Besnard, who has recently been credited with 'making the richness of the Impressionists' atmospheric colour acceptable' in the context of Salon painting. Was that a purpose of historic import? Was the watering-down of the impressionist approach to nature an achievement that deserves recognition? 'They shoot us but they go through our pockets', Degas quipped.

Souvenir hunters who are presently 'rediscovering', or even 'rehabilitating', various producers of anaemic Salon wares seem completely unconcerned with the fact that what those people manufactured were *unnecessary* pictures. Nor do they appear to recognize that the authors of those commercial artefacts were by no means modest and inoffensive wielders of outmoded and syrupy brushes, but that they were active reactionaries in positions of power.

Though this is sad, it is not new. By a strange coincidence, Friedrich Nietzsche wrote his study *The use and abuse of history* in 1873, at the very time when Pissarro and his friends were beginning to plan their first group exhibition, the historic show that was to gain them unprecedented abuse and the derisive designation of

'Impressionists'. Nietzsche was fascinated with the observation that 'the great moments in the battle of individuals form a chain of crests that links humanity through the ages, and the highest points of those vanished moments are yet great, luminous, and alive'.

Concerning himself with the artists' perennial struggle for acceptance, Nietzsche wrote:

'Consider the simplest and commonest example, the inartistic or half artistic natures whom a monumental history provides with sword and buckler. They will use these weapons against their hereditary enemies, the strong artistic spirits who alone can learn from that history the one true lesson, how to live and embody what they have learned in noble action. Their way is obstructed, their air darkened by the idolatrous and eager dance round the half understood monument of a great past . . . Apparently the dancing crowd even has the monopoly of "good taste": for the creator is always at a disadvantage compared to mere onlookers . . . But if the custom of democratic suffrage and numerical majorities be transferred to the realm of art, and the artist put on his defence before the court of aesthetic dilettanti, you may take your oath on his condemnation, although – or rather because – his judges had proclaimed solemnly the canon of "monumental art" the art that has "had an effect on all ages", according to the official definition. In the eyes of these judges no need nor inclination nor historical authority exists for the art which, being contemporary, is not yet "monumental". Their instinct tells them that art can be slain by art: the monumental must never reappear, and to that end its authority is invoked from the past. They are connoisseurs of art, primarily because they wish to kill art . . . They develop their tastes to a point of perversion that they may be able to show a reason for continually rejecting all the nourishing artistic fare that is offered them. For they do not want greatness to arise; their method is to say, "See, greatness is already here!" In reality, they care as little about the greatness that is already here as that which is about to be born . . . Monumental history is the cloak under which their hatred of present might and greatness masquerades as an extreme admiration for the mighty and great of the past . . . Whether they really know it or not, they are actually behaving as though their motto were: "Let the dead bury the living."'

And in truth, these barren Academicians who are now being rescued from well-deserved neglect did try to bury the living. Yet Nietzsche overlooked that their historian-servants would also pervert our vocabulary. For if perpetrators of moist nudities *à la* Chabas, of adorable peasant girls *à la* Bastien-Lepage, of draped silks on lifeless dummies *à la* Besnard, of sentimental calendar landscapes painted in dots *à la* Le Sidaner, if these are given credit for 'bold and sparkling representation', for their 'richness of colour and texture', for their 'luminous and blond tonalities', or the virtuosity of their brushwork, then no words are left to describe the accomplishments of Manet, Monet, Renoir, Pissarro, and their friends. Shall we have to forge a new language for doing justice to the men who added so many fresh perceptions to our vision? Or would it not be simpler to sweep away once and for all the anecdotal productions of anti-monumental practitioners, and turn our attention to those who contributed to the chain of crests whose peaks are still great, luminous, and alive?

Not all of them have yet received their full due. In spite of his stoic and brave, stubborn and even cheerful struggle, Camille Pissarro's name is seldom mentioned

among those who played a pivotal role in the evolution of nineteenth-century painting. Yet it was he who, more than any other, built the bridge that led from Barbizon to Louveciennes and eventually to Asnières and the Grande Jatte. He did so quietly, guided by a generous nature and by deep convictions that often conflicted with his own material interests. He never sought the limelight and yet managed somehow to *cultiver son jardin* at Eragny, and simultaneously keep in touch with all that was new and original. His hand, which early on had reverently clasped that of Corot and later offered guidance to Cézanne, Gauguin, Signac, and Van Gogh, was eventually extended to Matisse and even the young Picabia.

While Manet, the pure-bred traditionalist, carried the torch of anti-Academism and hoisted the banner of an artistic revolution, Pissarro, the anarchist sympathizer, remained in the background, continuing a painterly tradition transmitted not only by Corot, but also by Courbet and Millet. Equally important, however, was his incredible gift for discerning promise in others and helping them develop their potential. His constant function as teacher, collaborator and friend added an extra dimension to his stature as an artist, since he became involved in all the movements of the second half of the last century which have shaped the art of our own. In addition, surrounded by often antagonistic colleagues, he was the only one to whom the others listened, because his conciliatory attitude was always above suspicion. Thus, as an artist *and* as a human being, Pissarro fulfilled a mission matched by no other of his associates or contemporaries.

It is almost a miracle that he managed to achieve a complete balance among the different roles life thrust upon him: he was a painter undaunted by the difficulties of an existence strewn with constant hurdles; he was a father devoted to his children whose artistic inclinations he tirelessly fostered, as though good advice could turn them into masters; he intensely observed the political scene – a very lively one at that – and carried the burden that the Dreyfus affair imposed on all French Jews; he was always ready to be counted when positions had to be taken on social issues, and he was always willing to dispense benevolent and wise counsel. While these qualities endeared Pissarro to all who came in touch with him, it is of course his work that ensures his place and constitutes his great legacy.

There have not been many exhibitions of Pissarro's diverse and multi-faceted production. The present show, celebrating the artist's one-hundred-and-fiftieth birthday (a startling number of years in view of the fact that he still appears so near, his action so close to us), demonstrates the breadth and originality, the warmth and modesty and purity of his artistic nature: in one word, his genius. It illustrates his lifelong quest for expression, a quest in the course of which his style underwent several changes, for he would always reach for new goals rather than sink into facile routine. And – if such a demonstration were needed – this retrospective shows once more that obstacles can hamper but never silence the creative forces opposed by anti-artistic natures. For, to quote again from Nietzsche:

'One thing will live . . . a work, a deed, a rare illumination, a creation; it will live because no posterity can do without it.'

Richard Brettell

Camille Pissarro: A revision

Introduction

In many ways Camille Pissarro was the most complex of the Impressionists, and a careful examination of his work reveals a perplexing diversity of styles and subject-matter. There can be little doubt that this diversity was deliberately sought by Pissarro and that it was not the result of indecision or confusion. Rather, it stemmed from the wide range of his interests – he was concerned with both rural and urban subjects – and it is also reflected in the variety of his artistic sources. One factor, however, did act as a unifying force, for Pissarro more than any other great artist of the late nineteenth century was swayed by politics. The writings of the anarchist philosophers and political theorists, from Saint-Simon to Elisée Reclus and Prince Kropotkin, anchored his thinking about the modern world and formed a conceptual framework for his art. Pissarro's political awareness helps to explain Pissarro the artist. He himself thought that his decision to become an artist stemmed from his profound dislike of what he considered the bourgeois values of his family, and his desire to associate himself with the French landscape tradition resulted as much from the philosophical basis of that tradition as from its importance within the history of French painting.

The major part of this catalogue is devoted to detailed discussion of individual works of art, but this essay aims to introduce the reader to certain larger issues involved in the interpretation of Pissarro's work. It is based on the assumption that Pissarro's art has been misunderstood and that this misunderstanding has been aided by the persistent clichés used to characterize the impressionist movement as a whole. There is little doubt that Pissarro *was* an Impressionist. He was the only artist who participated in each of the Impressionist exhibitions, and he was almost solely responsible for the membership of that loosely defined group of artists. He even drew up a provisional charter for the Impressionists at the outset, and in the final analysis it is mainly his correspondence that forms the basis for our modern understanding of the movement.

Yet his work has often been considered to be somewhat timid and conservative when compared with that of Monet, Renoir, and Degas. He never fully shared Monet's interest in light, atmosphere, and the ephemeral nature of reality. He did not paint as loosely or as fluidly as Renoir. He failed to pay as much attention to modern urban life as Degas. Furthermore, Pissarro's sympathy with the Neo-Impressionists during the second half of the 1880s has often been used as proof of the essentially derivative character of his art. The greatest critics and early historians of Impressionism gave the laurels to other artists; Duret preferred Manet, Laforque and Geffroy Monet, Duranty Degas. In addition, dealers had difficulty in selling Pissarro's paintings, so that the artist himself occasionally gave way to despair: 'Like Sisley, I remain in the rear of Impressionism.'

The Early Years, 1852–1869

Although fewer than 50 paintings survive from the first fifteen years of Pissarro's career, a considerable body of drawings makes it possible to discuss the character of his training in some detail. The very preponderance of drawings from this period makes it clear that Pissarro began his career as a graphic artist and that, in

spite of the fact that he struggled towards painting as early as 1852, his achievements in that medium came rather late in his development. Pissarro painted his first masterpiece only in the mid 1860s, and it is crucial to stress the difficulties which he experienced as a student painter. Unlike Monet and Renoir, who painted easily, even effortlessly, early in their careers, Pissarro worked toward painting slowly and conceived of the medium in an intellectual rather than a purely sensual manner.

I. PISSARRO AND THE POPULAR LANDSCAPE TRADITION, 1852–1855

One of the most appealing, but misleading, ideas associated with Pissarro is that he was a self-taught artist. This view divorces Pissarro from an official academic training and suggests that his art issued directly from nature, it almost leads one to believe that Pissarro was born into a state of 'impressionism'. Yet, while Pissarro's art did develop far from Paris it was not initiated in an aesthetic vacuum. First of all there was the brief early training in drawing and landscape which he received while attending a school at Passy near Paris. All biographies of Pissarro stress the precocity of his art. His teachers at Passy in the late 1840s introduced the young Pissarro to a well-established tradition of amateur art, based for the most part on landscape and life drawing. He was encouraged to visit museums and to discipline what seems to have been a well-established habit of drawing. It is therefore fair to say that, when he was 'discovered' by the itinerant Danish artist Fritz Melbye in St. Thomas (Virgin Islands) in 1851, Pissarro was already a proficient draughtsman. We know a great deal about Pissarro's early work with Melbye and so can judge the importance of his professional *début* as an artist. It has often been assumed that Pissarro served as an apprentice to Melbye, but the visual evidence suggests that he was capable of producing works of a higher quality than those of Melbye. It is more sensible to regard Pissarro and Melbye as applying themselves jointly to the European topographical tradition. This tradition stressed the direct, even systematic recording of landscapes, cities and ports, together with the portrayal of people in every-day situations. It was a tradition widely disseminated throughout the world in illustrated periodicals, painting and drawing manuals written for amateurs, and illustrated travel literature.

Several aspects of Pissarro's early work done in South America should be mentioned because they remained important elements in his mature style. Perhaps the most obvious is the subject-matter. The rural landscapes, suburban areas, market scenes, and ports, are all subjects that recur later in Pissarro's work. Indeed, in several instances it seems that he might have reviewed his early sketching tablets in search of pictorial ideas for later works. Stylistically, the most important characteristic of these early years is the use of diagonal hatching in the drawings. The technique is common to engravings and lithographs, but what is interesting is the extent to which Pissarro exaggerated it. The hatching is often detached from the contours and, hence, from the forms themselves, thereby possessing an independent graphic quality (Cat. 94, 95). This mode of drawing forms the graphic origins of Pissarro's, and possibly Cézanne's, style of painting during the late 1870s and early 1880s (Cat. 46–8, 52, 53–4).

Melbye's paintings of this period were no doubt instructive for Pissarro, and virtually all of the surviving landscapes painted by Melbye in Venezuela are brilliant in hue. Perhaps because of the exotic jungle landscape in which he worked, Melbye chose to use a limited palette of full-intensity colours, and, in

many pictures, he constructed the foreground plane with adjacent patches of bright, often unmixed colour used in warm-cool juxtaposition. When compared with the landscape paintings shown at public exhibitions in France, which Pissarro must have seen as a young artist, Melbye's landscapes have an optical brilliance which looks forward to Impressionism, and occasionally to the landscapes of the late 1880s painted by Gauguin and his followers.

II. PISSARRO AND THE FRENCH LANDSCAPE TRADITION, 1855–1866

When Pissarro arrived in France in 1855, he had already nurtured many of the standard features of his mature art. While it is often argued that Pissarro's formal training began with Corot, this view, although not wholly inaccurate, is certainly much exaggerated. In fact, Pissarro's first master in Paris was Anton Melbye, the brother of Fritz Melbye, and a relatively successful painter of marine pictures for the bourgeois art market in Paris. Pissarro also tried academic training in the *ateliers* of Lehmann, Picot, and Dagnin, official teachers at the Ecole des Beaux-Arts. If anything, he suffered from a surplus of instruction in those years, and this may have led to what is best described as a crisis of confidence. His drawings and paintings from 1855–1866 are comparatively rare, and those that have survived suggest a rather confused young artist. The confidence which was so apparent in South America is less evident here. Pissarro's confusion was probably caused by the relative strength of the artists around him. Anton Melbye had provided Pissarro with access to Corot, and he went on to meet Chintreuil, Daubigny, and eventually Courbet. Far from being a young master in his own right, he was now a pupil of many masters and, although this did not result in a total loss of direction, it did cause uncertainty.

Pissarro's surviving oil sketches from the early 1860s prepare us only slightly for his *début* as an important and independent painter in the Salons of 1865 and 1866. They are modest, carefully painted, and tightly structured landscapes and relate most closely to the early oil sketches of Corot. Yet, it was not merely Corot, but Daubigny, Chintreuil, and Courbet to whom Pissarro turned for aesthetic inspiration in painting *The banks of the Marne at Chennevières* (Cat. 4) and *The banks of the Marne in winter* (Cat. 6). These pictures, although eclectic in both their composition and facture, represent more than a hybrid response to the French landscape tradition in which Pissarro worked. Indeed, they are a synthesis of the principal strands of that tradition. Their thickly painted surfaces owe a great deal to those of Courbet. Their composition and pictorial space stem both from Chintreuil's desolate landscapes and from the river landscapes of Daubigny. Their palette is a marriage of those of Courbet and Corot, with the occasional addition of primary colours which add an optical brilliance to the predominant greens, greys, and browns. The quality of these pictures prompted the critic Castagnary to give Pissarro a very high rank in what he called the 'grande armée des paysagistes', an army he invented in response to the Salon of 1866.

III. PISSARRO'S L'HERMITAGE PICTURES AND THE SALON, 1866–1869

When Pissarro moved to Pontoise in 1866, he began a series of large landscape paintings intended for exhibition at the Salon. These pictures depict the rural landscape around Pontoise, principally the landscape of L'Hermitage where Pissarro lived. The pictures were admired by Castagnary, Zola, and Redon and have come to be considered amongst his masterpieces. Again they are clearly related to Salon landscapes by Courbet and Daubigny. Yet while these stylistic

affinities are undeniable, they do not explain the extraordinary strength and quality of the pictures, nor do they allow us to recognize their importance for Cézanne. Both Redon and Zola found Pissarro's L'Hermitage landscapes to be 'sincere', 'truthful', and 'difficult'. They possessed what Zola termed, with a kind of irony common in realist criticism, a heroic frankness and simplicity. It is perhaps easiest to see what Zola meant in *L'Hermitage at Pontoise* of 1867 (Cat. 10). The simplicity of which the novelist spoke is to be found in the subject, a group of late eighteenth- and early nineteenth-century rural dwellings along the Rue de L'Hermitage which is imbued with an almost heroic grandeur by the simple directness of Pissarro's composition. It is important to stress that his approach was not new. One can easily find precedents in Corot, particularly in the Italian oil-sketches of the late 1820s and the early 1830s. These, in turn, relate to eighteenth- and early nineteenth-century oil-sketches of humble rural buildings found in the art of Valenciennes, Bertin, and others. Yet Pissarro chose to enlarge what had been appropriate forms for *plein-air* oil-sketches to the scale of a Salon landscape. His realism was therefore hardly new in itself, but the context in which it was presented was certainly new.

The Salon landscapes executed by Pissarro in Pontoise are also interesting because they were painted directly onto the canvas. The impetus for such a manner of working comes purely from Daubigny and more immediately from Monet, who executed his painting *Women in the garden* out of doors using live models. However, there are certain differences in the kind of oil-sketch which Pissarro chose to ennoble and those preferred by Monet. While Monet turned increasingly to the landscape sketches of Boudin and Jongkind for his models, Pissarro again sought out Corot, who provided him with such vital compositional principles as the division of the picture surface into horizontal bands, the geometric ordering of whole landscapes based on architectural features, and the careful positioning of figures. These principles are much less evident in the oil-sketches of Boudin or of Jongkind, who devoted most of their attention to light, colour, and movement, emphasizing those particular qualities by adopting a looser technique. It is therefore no exaggeration to say that Pissarro's Salon paintings of 1866–1868 form a crucial link in the history of classical landscape painting in France, extending from Valenciennes to Seurat and Cézanne.

The Impressionist Decade, 1869–1880

The 1870s are at the very core of Pissarro's career. In that decade he became an Impressionist, severing, at least partially, his strong links with French artists of the mid-nineteenth century and working more fervently with the young rebels whom he had met at the Académie Suisse and the Café Guerbois in the early 1860s. By 1869, Monet had supplanted Corot as the touchstone against which to measure his achievement, and he began in the next decade to engage in a pictorial dialogue with the younger master which lasted until Pissarro's death in 1903. Students of Monet have observed the important shifts in his style during the period between 1868 and 1880, and many of the same shifts can be found in the contemporary paintings of Pissarro. The two artists painted together in 1869 and 1870, kept in close touch during the early 1870s, and saw each other's work at the Impressionist exhibitions in 1874, 1876, 1877, 1878, and 1879. Yet, Pissarro can never be described as a follower of Monet, and it is therefore important to discuss his own

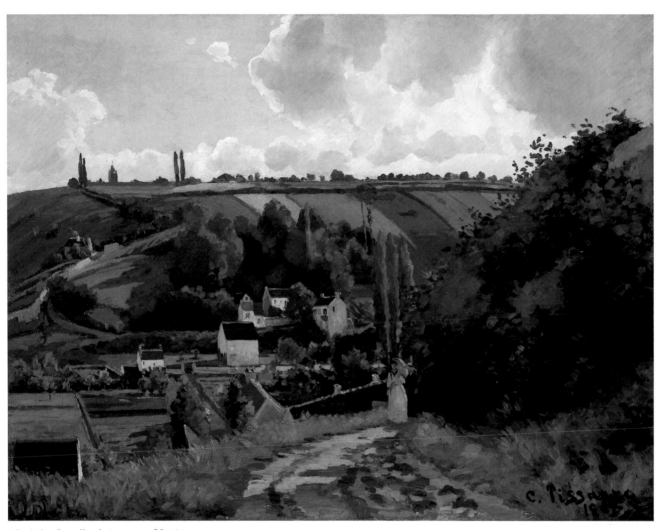

The 'Côte du Jallais', Pontoise 1867 Cat. 9

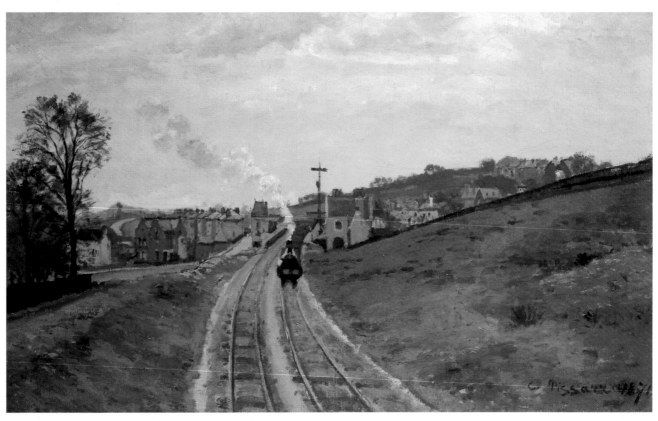

Lordship Lane Station, Upper Norwood, London 1871 Cat. 16

development separately so that a clear idea of his independent contribution to Impressionism can be assessed. Three observations can be made at the outset of this discussion. First, Pissarro's imagery differed markedly from that of Monet, and, as a corollary to that, his stylistic development must be considered in the light of his own iconography rather than of 'impressionist' iconography in general. Second, drawings and prints played a more important role in Pissarro's *oeuvre* than they played in that of Monet. Indeed, Pissarro's continued reliance on the graphic media must be understood before any adequate analysis of his Impressionism is possible. Third, Pissarro spent most of the 1870s in Pontoise, detached from the centres of Impressionism, Argenteuil and Paris, and worked in relative isolation from Monet in the company of such artists as Cézanne, Guillaumin, Vignon, and, later, Gauguin, artists who formed the 'school of Pontoise'.

I. PISSARRO IN 1869

In 1869, Pissarro moved from Pontoise to Louveciennes, a village associated with arcadian imagery ever since the Goncourts had seen François Français painting near there in the 1850s. There is no surviving document to explain why Pissarro left the prosperous market town of Pontoise for the suburban village of Louveciennes, but his reasons were surely artistic. He moved to paint with Monet, Sisley, and Renoir, all of whom were in the area, and in so doing to mingle with the new generation of landscape painters. Within one year Pissarro's pictures became smaller in size, more varied in palette, and looser in facture. More important was the fact that they displayed a growing interest in light, colour, and atmosphere, all of which are closely related to changes of season and time of day.

Perhaps the greatest problem for the historian of Impressionism is that there are no surviving pictures by Pissarro actually dated 1869, making it difficult to compare his painting in that crucial year with that of Monet or of Renoir. It is customary to blame this situation on the Prussian troops who lived in Pissarro's house on the Route de Versailles in Louveciennes during the Franco-Prussian war of 1870, and who reportedly destroyed much of the early work that was stored there. This view is possibly both exaggerated and inaccurate. There are thirty-four pictures in the official *catalogue raisonné* which bear a date of 1870 and which in addition represent Louveciennes. These pictures would have been left by Pissarro in Louveciennes before the flight to Brittany, and eventually to England, in July 1870. Clearly, the chance survival of thirty-four pictures dating from 1870 and none from 1869 is unlikely, and the historian must search for other explanations. It is perhaps more convincing to suppose that many, or most, of the undated pictures representing Louveciennes currently dated *c.* 1870, *c.* 1871, or even *c.* 1872, were in fact painted in 1869. There are eighteen such pictures in the *catalogue raisonné* which, when considered as a unit, might form an *oeuvre* for 1869.

If this is acceptable then we do, in fact, have a better idea of Pissarro's work in that year than we do in the cases of Sisley, Renoir, or Monet. Significantly, Pissarro's view of the Seine near La Grenouillère (Fig. 1), is one of the pictures in this provisional grouping, and it is not unreasonable to suppose that it was painted during the summer months of 1869 either in response to, or at the same time as, the famous picture of that subject painted by Monet and Renoir, which have rightly become icons of Impressionism. Pissarro's painting can be contrasted with them in virtually every detail. Monet and Renoir accept, indeed revel in, the glories of

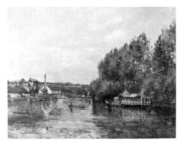

Fig. 1. *Seine near La Grenouillère*, formerly entitled *The Oise at Pontoise* P&V 174 Earl of Jersey collection, Jersey

bourgeois leisure pursued in the summer sun, while Pissarro, using a composition derived from Daubigny, keeps his distance and created an industrial landscape. Whereas Monet and Renoir defined their transitory figures with large heavily loaded brushstrokes, Pissarro constructed a stable landscape with small touches of colour applied carefully to the surface. It is clear that we are dealing in this instance with two rather different types of Impressionism.

Pissarro and Monet, however, approached one another more closely in the landscapes they painted along the Route de Versailles, Louveciennes, in 1869–1870. Pissarro had never before painted a winter landscape with snow and was perhaps prompted to do so by Monet, who had executed a distinguished series of snow scenes in 1867. Monet's compositions are less intricate than those of Pissarro, but a careful comparison reveals the extent to which Pissarro approached Monet's style. When Monet parted from Pissarro in 1870 for his trip to the north of France, Pissarro was involved in a series of pictures representing the street on which he lived, seen at different times of day and in all seasons (Cat. 13, 14), a series in which the probity and completeness of his vision transcended the brilliant, but fleeting pair of pictures executed by Monet on the same road.

II. CAMILLE PISSARRO AND THE IDEA OF IMPRESSIONISM

One of the main tenets of our idea of Impressionism is the central importance of *plein-air* painting. This view stresses the extent to which Impressionism was a disavowal of academic methods, and presents us with the image of the impressionist artist standing in front of his easel transcribing his sensations directly on to the canvas. There is some truth in these ideas and it is not the intention of this essay to deny them unequivocally, but there is more to Pissarro's impressionist painting than this view allows. The critic and novelist Georges Lecomte, writing in the 1890s, was the first to realize the extent to which Pissarro prepared his 'impressionism' in advance, retiring from the motif in order to achieve unified works of art. It is, of course, understandable that a 'post-impressionist' critic should stress the premeditated quality of his hero's art in a generation averse to the spontaneous. Yet Lecomte, in his various discussions of Pissarro's working methods, was not speaking only of the master's current work, much of which was carefully prepared in drawings, but of his earlier work as well. It is clear today that Lecomte was correct. The number and variety of Pissarro's sketchbooks (now mostly dismembered) indicate that at no time did he abandon drawing from nature. Indeed, he found it appropriate throughout his life to transcribe his initial reactions to a landscape or a figure in the form of drawings.

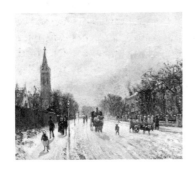

Fig. 2. *Upper Norwood with All Saints Church,* formerly entitled *Church, Weston Hill* P&V 108. Robert Schmidt, Paris

Fortunately, there is one picture, *Upper Norwood with All Saints Church* (P&V 108), dating from 1870, for which a virtually complete sequence of preparatory drawing exists (Fig. 2). The first drawings form part of a sketchbook used in England and record Pissarro's attempt to select an appropriate format for the painting. After establishing this, Pissarro began to work on the exact relationship between the building and the figures. At this point he changed from pencil, which is the customary medium for the impressionist sketch, to ink and, finally, introduced watercolour washes as well. This preparatory process is reminiscent of that previously adopted in Venezuela, where the watercolour served as the oil-sketch. In France it was Jongkind who chiefly used watercolour in this way.

It is important to realize that, even at this date, Pissarro's preparatory processes

were never specifically predetermined. There are seldom exact connections between preparatory material and finished work, and, like Monet and Degas, he adjusted his composition at every stage. Similarly, the series of drawings relating to *Upper Norwood with All Saints Church* does not mean that the oil painting was executed entirely in the studio from the drawings. In fact, the number of differences between the drawings and the final picture suggests that the painting was made outdoors, at least in part. Yet, the fact that Pissarro worked out a composition so carefully before the execution of an oil painting serves to underline the intellectual rigour of his Impressionism.

It would be wrong to assert that because Pissarro drew so persistently he was a conservative artist. In fact, he gave careful consideration to the 'optical' theories of the Impressionists. A phrase inscribed on a slight pencil drawing made in 1869 or 1870 refers to a landscape *vue attravers une vapeur complètement transparent et les couleurs fondues d'une dans l'autre et tromblotants*. This is perhaps the only statement devoted to light and colour made by an impressionist artist in the formative years of the movement. Pissarro's reference to a world seen through a vapour, a world not of tangible and three-dimensional forms, but rather of light and colour materialized in vapour, is tantalizing, and it is a pity that neither he nor any of the other painters chose to write more about such theories at that time. Yet, this one phrase helps us to understand why the Impressionists were so fascinated with fog, steam, and mist; namely because these atmospheric conditions come between objects and the eye, with the effect of dematerializing form. Pissarro in the phrase quoted above extended the metaphor further, and began to conceive of a world seen through vapour, but a vapour which was *completely* transparent, and hence, invisible.

III. PISSARRO AND INDUSTRIAL MODERNISM

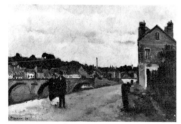

Fig. 3. *View of Pontoise 'Quai du Pothuis'* Tel Aviv Museum

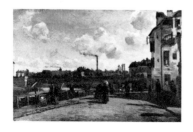

Fig. 4. *View of Pontoise, 'Quai du Pothuis'* P&V 60. Kunsthalle, Manheim

It is customary to consider Pissarro as a painter of 'la vie agreste' and to discuss his work apart from that of Monet and the other Impressionists. Yet, like Guillaumin in his own generation and the Neo-Impressionists in the next, Pissarro devoted considerable attention to industrial forms, creating one very important series of pictures of a single factory in St. Ouen-l'Aumône, across the river Oise from Pontoise. These pictures, together with similar images painted or drawn at different dates, form a small but important group, which, given Pissarro's active political interests, are worthy of comment. When considered in the context of Pissarro's peasant landscapes and market scenes, they reflect a preoccupation with labour which is opposed to that absorption in a more leisurely world which is characteristic of the other impressionist landscape painters. Pissarro's views of the city of Pontoise, painted in 1867 and 1868, make it clear that he embraced rather than ignored the industrial character of Pontoise. *Quay and bridge at Pontoise* (Fig. 3) of 1867 is virtually centred on the small factory near the Boulevard des Fossés in Pontoise, and represents an attempt to integrate a pair of frankly bourgeois figures into a view in which industry and urban architecture predominate over rural nature. Pissarro's next townscape, painted in 1868 and now in the Kunsthalle, Mannheim (Fig. 4), states the theme more emphatically. The smokestack of the gas-works which was then only recently opened, marks the centre of the composition and is placed on a line with a bourgeois family, the only such figures in the picture. It must be remembered that these strictly ordered compositions were painted in the same years in which Monet and Renoir painted bourgeois figures moving along

the banks of the Seine in Paris. Pissarro's smaller and tighter compositions owe little to the Baudelairian understanding of 'la vie bourgeoise' with its emphasis on movement and costume, but they are surely as 'modern' in their acceptance of industrial forms.

Pissarro's most probing series of industrial images was painted in 1873. Like the Mannheim picture of 1868, the four pictures in the 1873 series represent a factory which was a recent intrusion into the landscape in which Pissarro lived. The factory was built for the distillation of alcohol from beets and was constructed in 1872–1873, next to a smaller and older factory owned by the same firm, Chalon et Cie. Its scale was vast when compared with the *fabriques* of the gas company, the paint factory, and the other distillery already in Pontoise, and it was constructed to take advantage of the much increased barge traffic along the Oise. Pissarro tackled the new factory with considerable energy and painted his first and last series of views of a single building (Cat. 28–30). In three of the four pictures (see Cat, 28, 29) the factory totally dominates the river landscape. The fourth view (Cat. 30) places the new factory in a larger and better defined landscape adjoining the older factory. All the pictures are unusual in Pissarro's work because they are virtually unpopulated. The Williamstown landscape (Cat. 30), surely the most bucolic of the four, is the one which conforms least to the actual appearance of the factory. In the other three pictures, Pissarro studied the precise relationships between the smokestacks, roofs, windows, and walls and placed the factory in a landscape which accords well with the actual topography of the region. The Williamstown picture is wholly integrated as a picture, but bears no clear relationship to real topography and, in addition, distorts the relative scale and position of the old and the new factory buildings. What Pissarro did was to enlarge the smaller white *fabrique*, which had stood on the Oise at least since the early 1860s, and to diminish radically the scale of the new factory.

These pictures reveal an artist who does not conform easily to our notion of the Impressionist as a direct transcriber of pictorial information onto canvas. Pissarro's factories of 1873 never dissolve into impressionist realms of colour and light. Rather, they anchor a strictly modern landscape, much as the ruins of classical buildings had anchored the landscapes of the French classical tradition.

One is tempted to suggest that Pissarro is here concerned with deeper issues such as the role of industry in the landscape. There is, unfortunately, no positive evidence for this. Yet, it is surely no accident that Pissarro painted so many industrial views in 1873 and virtually none in the succeeding two years. It is even more interesting that, on returning to modern industrial images in 1876, he should depict the same factory again in another series. This second series may be considered as much an avoidance of the factory as the first series was a frank acceptance of it. Using the foliage of the Ile de Pothuis, which he expanded considerably, Pissarro screened the factory from view in two landscapes (P&V 355–6, Fig. 5) and in a group of three very similar paintings (P&V 353–4, 357), he eliminated the building totally (Fig. 6), showing only the chimney. These later images make even greater alterations in the actual character of the landscape than do those of 1873. Clearly, the world of Pissarro's landscapes was altered, pruned, and edited in keeping with his social vision. His attitude towards the factory, problematic though it was, is mirrored in his attitudes towards other modern forms, including steamboats and trains. Although these modern forms do appear

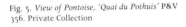

Fig. 5. *View of Pontoise, 'Quai du Pothuis'* P&V 356. Private Collection

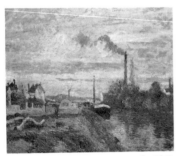

Fig. 6. *The Oise at Pontoise, grey weather* P&V 353. Boymans van Beumingen Museum, Rotterdam

The Crossroads, Pontoise (Place de Vieux Cimitière) 1872 Cat. 20

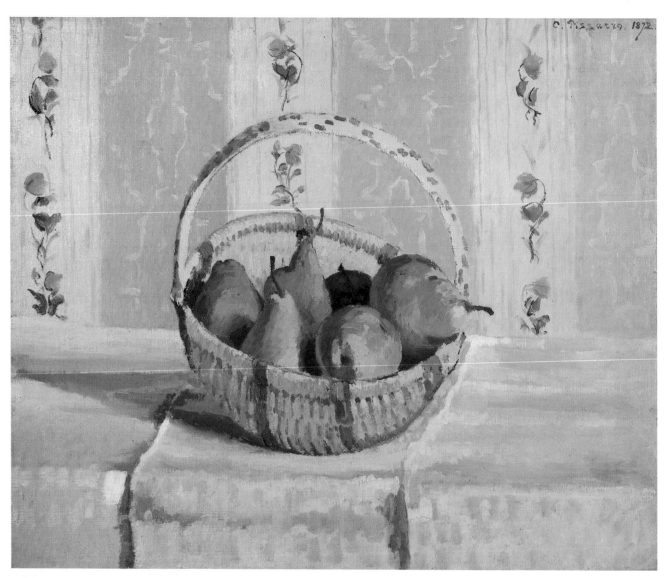

Still life, pears in a round basket 1872 Cat. 21

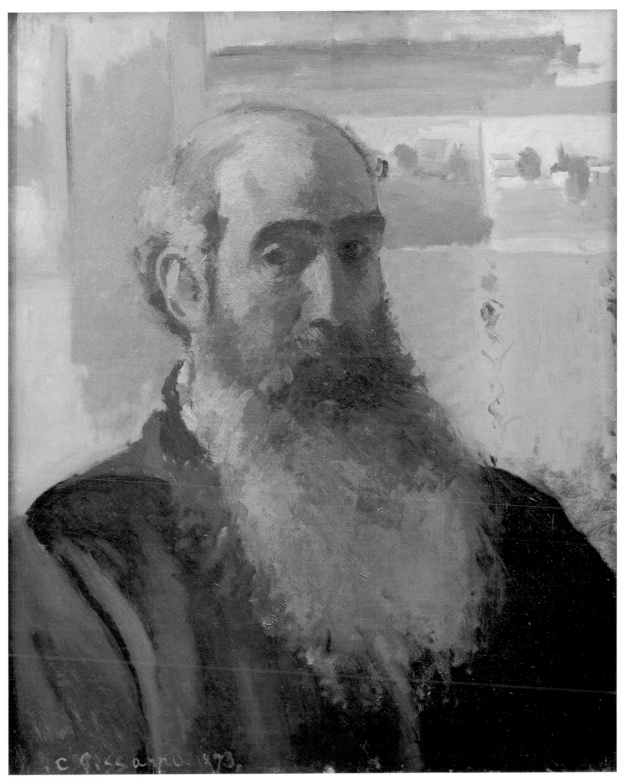

Self-portrait 1873 Cat. 24

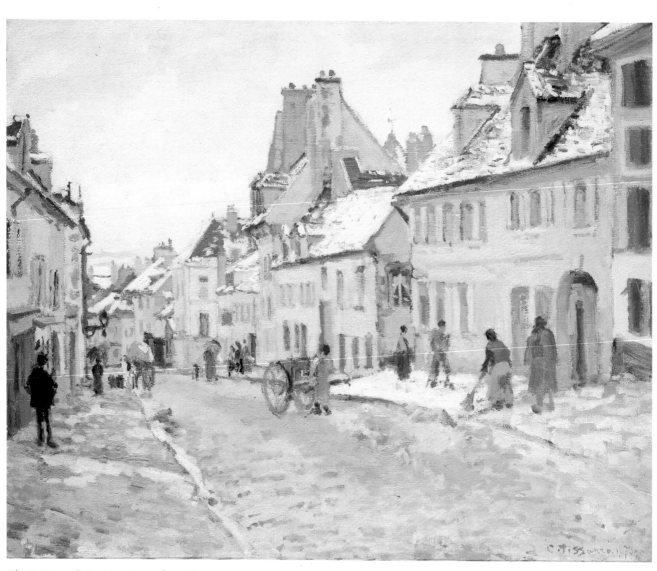

The Gisors road, Pontoise. Snow 1873 Cat. 25

in his paintings, they are always viewed from the slower and older networks of paths and roads running alongside the river Oise or the railway line.

IV. PISSARRO, MILLET, AND THE PEASANTRY, 1875–1876

Pissarro has often been considered the heir to Millet, and the precursor of Gauguin as a painter of the peasantry. All nineteenth-century writers about Pissarro have assumed his intimate knowledge of this social class and his complete immersion in the rural milieu. Their phrases have that hint of moralism so common in nineteenth-century descriptions of landscape art. Lecomte described Pissarro in 1890 as a 'possesseur profond des essences intimes de la vie agreste, familier avec des aspects exacts des choses et des êtres de campagne', and Alexandre called Pissarro simply 'un historien des champs'.

Considering these comments by contemporaries, it is surprising that Pissarro himself said little about peasants. There is no evidence that he had friends among the neighbouring peasant families in Pontoise or Eragny-sur-Epte, and it is easier to consider the Pissarro household as bourgeois rather than peasant. His own up-bringing in a distinctly bourgeois Jewish family did little to equip him to understand or sympathize automatically with the peasantry, and there is some evidence to suggest that his wife, although from a family of peasant landowners and farmers, was anxious to forget her origins. Pissarro is in no way similar to Millet in social background, and hence his view of the peasantry has none of the depth and sense of detail which characterized the peasant imagery of the earlier artist. There are as many bourgeois figures as peasants in Pissarro's early landscapes, and it was only in 1874, in the summer and winter following the Impressionist exhibition of that year, that Pissarro turned away from landscape to paint peasant subjects.

For three successive autumn and winter 'seasons' in 1874, 1875, and 1876 Pissarro drew and painted the peasant population of the Mayenne region of southern Brittany, in his first major attempt to create figure paintings since Venezuela. It seems that his choice of these figures was not made purely for ideological or political reasons. Indeed, his correspondence with Duret from the later months of 1873 and early 1874 makes it clear that Duret pushed Pissarro to abandon the idea of exhibiting with the Impressionists and to turn away from modern subject-matter to what Duret called 'la vie agreste'. Duret even mentioned Millet in his letters, and the death of that great artist in 1875 brought his memory more forcibly to Pissarro's attention.

As if in memoriam to Millet, Pissarro's peasants of the mid 1870s are painted in the tradition of the earlier master, solidly constructed, stable in their poses, and occupied in similar tasks. The women in the farm interiors, sewing in silence or spinning by the fire, are readily found in Millet's *oeuvre*, as are the peasant figures tending animals or bringing in the harvest. While it is clear that when Pissarro thought about the peasantry that he was to depict he had Millet very much in mind, and that he rarely painted subjects or poses unexplored by earlier painters of peasant life, his images are nonetheless different. Nowhere is this more apparent than in Pissarro's drawings of peasants executed in the 1870s. *Study of a female peasant carrying a load of hay* (Cat. 110) in the exhibition can be contrasted with virtually any pastel or charcoal drawing by Millet. Pissarro, it will be seen, was almost geometric in his conception of the figure. His drawing defines both figure and landscape as a set of interlocking polygonal shapes, each accepting the shapes

around it so that there is neither pictorial recession nor a clear sense of volume. Millet's drawings, on the other hand, intensify the volume of the figures, which are placed in stage-like settings. By denying volume and monumentality to his figures, Pissarro also surrendered the peasant's individuality, and in this way Millet's tendency to isolate and aggrandize the peasant is reversed.

V. DISJUNCTIONS AND CONJUNCTIONS: PROBLEMS OF STYLE AND SUBJECT IN PISSARRO'S PAINTING

Turning now to the matter of style, one can create at least four relatively distinct groups of pictures painted during the 1870s and early 1880s. First there is Pissarro's impressionist style, prevalent between 1869 and 1873, when small and irregularly shaped patches of colour were applied to the surface. This style coincides with the modern urban subjects attempted by Pissarro. During the second phase from 1874 to 1876, the paint was applied more thickly, often with larger brushes and occasionally with a palette knife. The facture is more regular and the colour is more intense. The immediacy of physical sensation is retained in the tactile quality of the paint. The landscapes are much less spacious and the forms are closer to the surface of the picture. The number of 'modern' subjects painted during the mid 1870s is significantly smaller, and it is clear that Pissarro chose to paint rural life in what he considered to be a rural style.

The last years of the 1870s are characterized by Pissarro's adoption of two other styles which are more or less interchangeable. One of these uses many short, curving brushstrokes which intertwine around the form and enliven the surface of the picture. While Pissarro was not absolutely consistent in his use of this style, he applied it most often to 'modern' subjects involving either industrial forms or bourgeois figures in the landscape (Cat. 44). The other style of the late 1870s may be called the granular style and was rarely used. Pissarro seems to have derived it both from his own heavily painted pictures of the mid 1870s and from Monet's pictures of 1877. It is characterized by irregular patches of colour, which are overlaid so as to build up a heavily textured and more evenly distributed surface. This seems to have been adopted for pictures of rural subjects containing few 'modern' forms (Cat. 46–7).

It is possible to argue on this basis that Pissarro's style is related to subject. Both the rural and the industrial pictures convey his anxiety to create a unified visual reality by reducing the relevance of certain forms which were, for other artists, highly significant. Pissarro deliberately chose to explore the inter-relationship between the dominant motif of the picture, whether a peasant or a factory, and the background which provided the setting. In this way, it is clear that Pissarro's style during the 1870s was derived both from impressionist ideas of reality as a visual realm without clearly developed hierarchies, and from the traditional theory of 'landscape' as the harmonious interplay among diverse forms.

The Paradox of Unity, 1880–1890

Pissarro's career underwent many significant changes after the fourth Impressionist exhibition of 1879. Such changes justify our acceptance of the date 1880 as a turning point in his *oeuvre*. In that year, he began to turn increasingly from landscape painting to genre, he concentrated on the graphic arts, and he shifted his attention gradually from the original Impressionists to the many younger artists who were to dominate the next generation of French art. Indeed, Pissarro's role in the formulation of the styles of Cézanne, Gauguin, and many

members of the neo-impressionist circle has often been remarked upon, but, curiously enough, it has yet to be examined in detail.

I. PISSARRO, DEGAS, AND THE NEW PEASANT IMAGE, 1879–1883

Pissarro painted virtually no peasant figure compositions between 1876 and 1879. Yet, in 1879 he inaugurated the most important series of peasant images in his career. The importance of these pictures in Pissarro's *oeuvre* is undeniable, amounting to the rejection of the landscape art that had preoccupied him for the first twenty-five years of his career. The artist who stood behind Pissarro in the early 1880s was Edgar Degas, with whom he had begun to collaborate on prints in 1879, and who provided the impetus for this entire phase in Pissarro's career. It can be argued that he borrowed more from Degas than he did from any other artist of his own generation, and that it is Degas' treatment of the figure, as translated by Pissarro, that provided the basis for the synthetist style of Paul Gauguin in the later 1880s. Degas' drawings, prints, and paintings of the working women of Paris provided a new repertoire of poses, gestures, and viewpoints for Pissarro. His peasant women are now viewed from close range, and they are arranged against backgrounds with high horizon lines, which seem to tip towards the picture plane, lending an additional instability and immediacy to the images. However, Pissarro was not unqualified in his acceptance of Degas' example, and even a cursory examination of the figure drawings and paintings executed by the two artists in the early years of the 1880s reveals their basic differences. Pissarro was less interested in describing the precise tasks of his figures than Degas. Pissarro's women chat on a path, sit on grassy knolls, or stand. They are, for the most part, idle, or performing repetitive domestic chores. If they are shown with implements of labour, these are either discarded or held without conviction. There is little of the strain or tension of labour, which is such an important part of Degas's working women.

There is one new aspect of peasant life which Pissarro introduced in the early 1880s, an aspect which helps us to understand the 'modernity' of his peasant imagery – the peasant at the market place. These pictures suggest that it was the economic inter-relationship between the fields and the town which fascinated Pissarro, and that for him the life of the peasant was not a seasonal cycle of sowing and harvesting, but rather one of events that ended with the market. Pissarro's earliest market scenes of the 1880s are his rural equivalent to the crowded cafés and urban gatherings painted by the other Impressionists. These images form the necessary bridge between 'la vie agreste' and 'la vie bourgeoise', and complement Pissarro's landscapes with factories. While the factories symbolize the extension of industry into the countryside, the markets represent the penetration of rural peasants into the towns. Indeed, Pissarro was the first major French painter to turn his attention from the peasant as a rural labourer producing his own food to the peasant as a '*petit commerçant*'.

II. CARICATURE AND TOPOGRAPHY: PISSARRO AND POPULAR ART, 1883–1890

Pissarro's trip to Rouen in 1883 was arguably the most important of his life. The precise reasons for his undertaking it are not known, but, nonetheless, the results in painting, drawing, and print-making were astonishing. In a scant two months there he painted thirteen canvases and made numerous drawings of urban figures, street views, and dock scenes, many of which formed the basis for prints. His letters indicate the extent of his activity, which rekindled his interest in

topography and caricature in which his career had been nurtured.

It is perhaps best to consider first the more accessible of these traditions, namely the topographical, because it revolutionized Pissarro's attitude towards landscape. Rouen was a place with a strong topographical tradition of its own, and Pissarro was able to compare his personal reactions to the city with those recorded by Bonington and Turner. This situation prompted, even challenged, Pissarro to produce a number of paintings and prints, and those are concrete evidence of his shift in allegiance away from the classical landscape tradition of Corot. In these views Rouen is observed dispassionately, usually from a distance or from above. There are none of the anxious interconnections of foreground and background that characterize the earlier landscapes. Rather, forms are placed in separate horizontal bands and figures are seen from far away. Pissarro returned to Rouen to work in the 1890s and many of the drawings he made in 1883 were used later as the basis for prints (Cat. 122).

While he was in Rouen Pissarro also purchased Champfleury's *Histoire de la caricature* (1863–5), a comprehensive survey in several volumes, extending from the popular wood-engravings of the later middle ages through Leonardo da Vinci to Daumier. The book was extremely well illustrated and it served as a compendium of caricatural form for Pissarro throughout the remainder of his life. He had long been fascinated by urban figures, but his interest seems to have increased tremendously as a result of Champfleury's book. The concentration on figures in the paintings and prints dating from after 1883 increases, and they are energetically drawn, as though the rapidity of movement seen in an urban context had enlivened the artist's hand.

III. PISSARRO AND THE NEO-IMPRESSIONISTS

Pissarro's neo-impressionist phase from 1885–1890 is possibly the most studied period of his career. It is often stated that Pissarro was a rather untheoretical member of a highly theoretical movement and that, when asked to clarify his own theories of colour to the public, he relied heavily on Lucien Pissarro and Maximilien Luce. There is a startling decline in the number of completed pictures in the years 1885 to 1890. This decline cannot simply be explained by the relative laboriousness of the neo-impressionist technique, since many of his canvases dating from the late 1870s are just as elaborately executed. The decrease in the number of pictures may perhaps reflect a crisis in Pissarro's career, a crisis which initially prompted his interest in Neo-Impressionism.

Any careful examination of Pissarro's work will reveal that many, if not all, the major stylistic traits of the neo-impressionist movement were already present by 1883. The most obvious connection is in the facture, for Pissarro, like the Neo-Impressionists, sought pictorial unity by the standardization of the surface of his paintings as early as 1880. The fascination with colour and colour theory is another connection with the Neo-Impressionists. It seems that Pissarro was familiar with optical theories of colour well before his discussions with Seurat in 1885. Several pictures painted during the 1870s are constructed with complementary colours and suggest that treatises on colour were used by painters throughout the nineteenth-century. In Pissarro's *oeuvre* the *Seine at Marly* of 1871 (P&V 122) and the important *Potato harvest* of 1874 (P&V 295) are constructed with adjacent patches of complementary colours, whilst in the *The garden of the Mathurins* of 1876 (Cat. 44) the artist has used small daubs of contrasting colour to

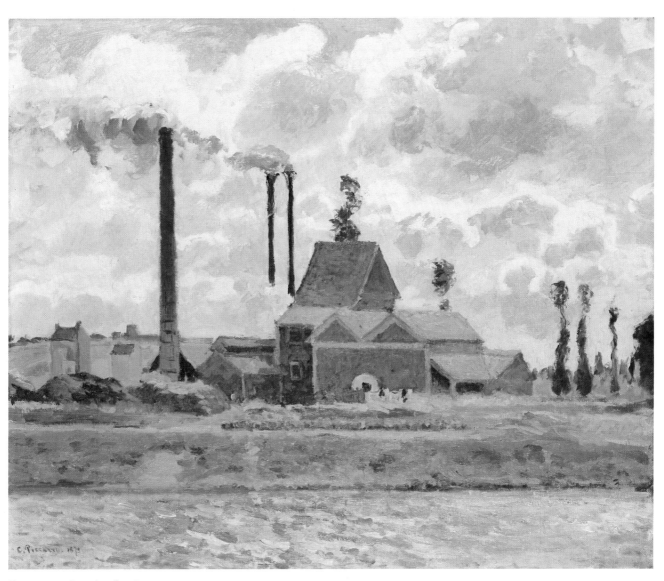

Factory near Pontoise 1873 Cat. 29

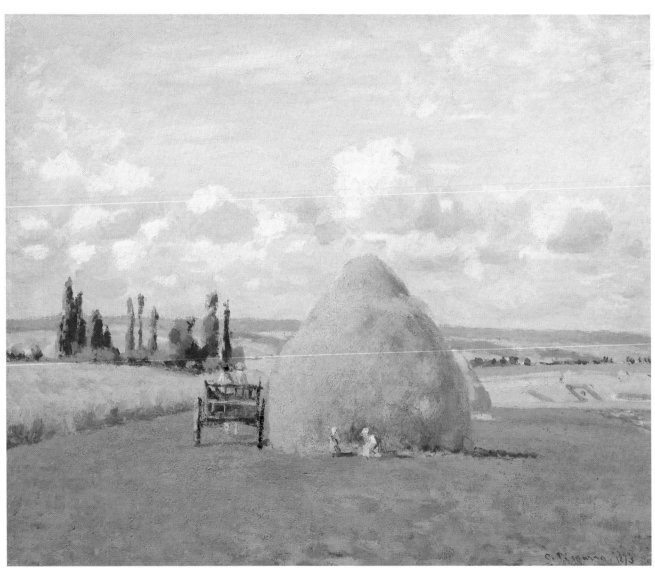

The haystack, Pontoise 1873 Cat. 32

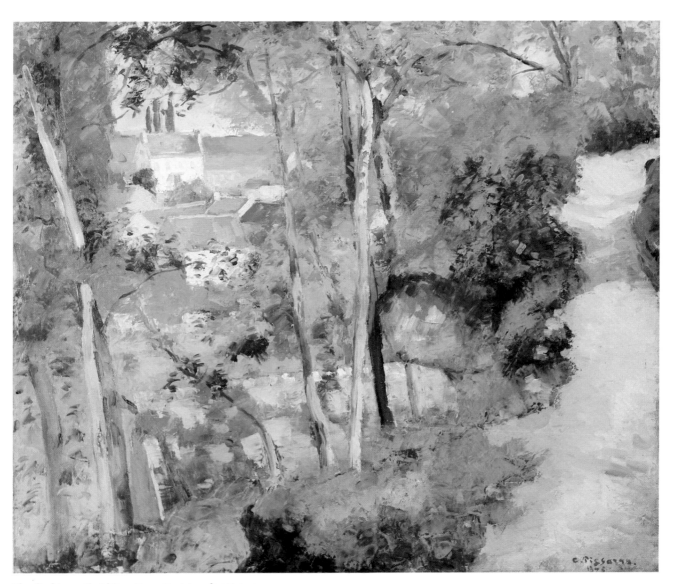

The climbing path, L'Hermitage, Pontoise 1875 Cat. 41

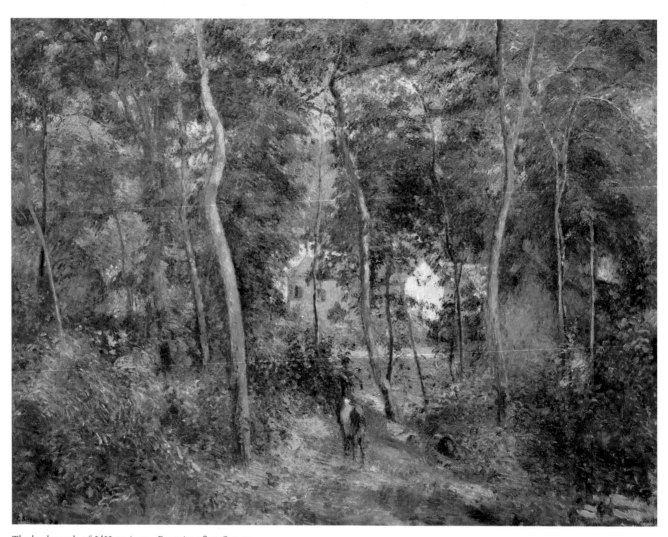

The backwoods of L'Hermitage, Pontoise 1879 Cat. 52

Fig. 7. *Vegetable garden, Pontoise, peasant digging* P&V 534. Private Collection, USA

create shimmering passages foreshadowing those in his neo-impressionist pictures of the late 1880s (Cat. 62–71).

Perhaps the most persistent stylistic feature of the neo-impressionist pictures is their compositional rigidity. Again, the careful ordering of compositional elements is omnipresent in Pissarro's work; for example, *Kitchen garden at Pontoise, female peasant digging* (Fig. 7), of 1881 (P&V 534), is a highly schematic work, created mainly in the studio on the basis of an earlier picture (P&V 345). So rigidly constructed is this painting that it might easily have been conceived as a mathematical exercise, and it is canvases such as this that anticipate Seurat. If Pissarro virtually ceased to paint in the last two years of the 1880s his production in the graphic media did not slacken at all. Indeed, he made a considerable number of watercolours, mostly of landscape subjects, many of which have a freedom and spontaneity that is lacking in the paintings of this time.

It is perhaps the feeling of collectivity and the unanimity of style in Neo-Impressionism that disturbed Pissarro. His own anarchist sensibilities were inclined towards a less theoretical group of artists, more like the original Impressionists. It is no accident that Pissarro fought to have Seurat and the younger painters included at the Impressionist exhibitions, and that he never really favoured the creation of a separate group of neo-impressionist artists. Pissarro was loath to accept the idea of a uniform art and, in fact, complained of the total submission of his own style during the neo-impressionist phase. Although he painted some of his greatest pictures between 1885 and 1890, the difficulty he had in making those pictures must not be forgotten.

The Final Years, 1890–1903

Pissarro's work of the period 1890–1903 has not been as widely admired as his paintings from the 1860s and 1870s. Although they are often reproduced in monographs about Pissarro and included in exhibitions, they might seem to lack the conviction of his earlier paintings. Pissarro's place in the French *avant-garde* was not so vital in the last decade of his life as it had been in the previous three, and while Monet and Cézanne were pushing the tenets of Impressionism into new pictorial realms, Pissarro codified and refined the impressionist ideal. His images oscillate between two iconographical realms – one completely urban and the other totally rural – and the pictures form a kind of *summa* of Impressionism as it was defined in the 1870s.

I. 'LES APPARITIONS DE LA VIE DE CAMPAGNE'; PISSARRO'S LATE RURAL PICTURES

Pissarro's late rural pictures were painted from a window in his studio at Eragny-sur-Epte. They tend to be thickly painted and have a kind of pictorial detachment from the motif which caused Gustave Geffroy to term them 'les apparitions de la vie de campagne'.

In the late rural landscapes, Pissarro investigated effects of season, weather, and time of day much more closely than he had ever done before. The countryside is bathed in sunlight, wrapped in fog, covered with ice or snow. They are very different in their treatment of the peasantry from the pamphlets and books about that class written throughout the same period. The powerful prose of Henri Baudrillart describes the state of the Norman peasantry in 1885 in terms of alcoholism, unemployment, depopulation, and other ills. Baudrillart probably overstated his case, but Pissarro was no less prone to exaggeration in his late rural

pictures, in which figures seem almost to dance as they pick apples (Cat. 68), spade the earth (Cat. 71), or push bean poles into the ground (Cat. 212). These are depictions of a rural paradise not far from the kind of arcadia which was to become the standard subject of the Fauves in the first decade of the twentieth century.

There is, however, one basic difference between Pissarro's rural paradise and the arcadian images of Gauguin, Derain, or Matisse: the artist's concept of work. For Pissarro one works in a paradise, and it is through work that one attains a state of harmony or grace. His peasants never toil, but they work together, performing tasks in the fields of a benevolent earth. One must turn to social philosophy for the origins of Pissarro's later attitudes towards rural life. A devoted reader of such anarchist philosophers as Prince Kropotkin, Pissarro believed that one day all human beings would participate in agricultural work, moving to the country to share for brief periods of the year the joys of agricultural labour. His late rural pictures are evocations of that ideal, and hence they stray rather far from the realities of rural life in Normandy during the 1890s. For Pissarro, work in a harmonious and collective society was never truly hard, and it is salutary to remember his own conception of work:

> 'Le travail est un merveilleux régulateur de santé morale et physique. Toutes les tristesses, toutes les douleurs, toutes les amertumes, je les oublie, et même je les ignore, dans la joie de travailler'.

'Work is a wonderful regulator of mind and body. I forget all sorrow, grief, bitterness and I even ignore them altogether in the joy of working.' From Octave Mirbeau, preface to *Catalogue de l'exposition de l'oeuvre de Camille Pissarro*, Paris, Galeries Durand-Ruel, 1904, p. 3.

II. LES SPECTACLES DE L'EXISTENCE DES VILLES: PISSARRO'S URBAN PICTURES, 1893–1903

Pissarro's urban views were painted from various hotel windows in Rouen, Dieppe, Le Havre, and Paris and were intended to be viewed in series. This was partly due to a recurrent eye problem that forced him to work indoors, and partly to the example of Monet.

Pissarro, in fact, painted two distinctly different types of cities. The most notable was the 'dock city', either Rouen, Le Havre, or Dieppe. These pictures describe scenes alive with urban labour, with the unloading of barges, and with movement on the dockside. The second group of cityscapes describes the life of the *boulevards* in the centre of Baron Haussmann's Paris, especially the greatest avenue of the Second Empire, the Avenue de l'Opéra, which Pissarro began to paint in 1898. The dock cityscapes have a clear precedence in the iconography not so much of Impressionism as of the paintings of the Neo-Impressionists. Yet, unlike the neo-impressionist painters, Pissarro populated the dockside with individual workers and watchers, who move about, animating the pictures. These paintings are concerned with labour, but they do not stress the physical aspects of that labour. Pissarro was interested in the spectacle of urban commerce, in the movement of goods along the rivers of France and on the seas beyond her shores. Similarly Pissarro's images of the *boulevards* and bridges are alive with the bustle of urban life, a bustle which persists along stone city streets, through rain and snow, day and night. It is the very continuity of that urban energy which separates these pictures by Pissarro from those of Monet and Caillebotte painted in the 1870s.

Gustave Geffroy also admired the urban pictures intensely, seeing them as improvements upon the earlier Rouen pictures from which they grew. The passage devoted to the urban pictures in his review of Pissarro's 1898 exhibition at Durand-Ruel is worth quoting. (G. Geffroy, *La vie artistique*, vi, Paris, 1900, pp. 183–5.)

'Cities have special characteristics that readily appeal to the painter. There is constant movement; they are anonymous, busy and mysterious . . . The air that one breathes is enclosed by the very buildings; one experiences the feeling of the muddy streets, the rain, and the *avenues* that disappear into a perspective of mist. In this inharmonious setting the *mêlée* of carriages and traffic changes direction, criss-crosses and intermingles with that remarkable sense of rhythmic pattern that is often induced by crowds. Again and again the social conflict visible in the restless comings and goings in the streets is caught and abstracted by Pissarro, and one of the chief beauties of this series of canvases, is the depiction of the senseless agitation of human beings living out their lives against their ever changing backgrounds'.

'Les villes ont une physionomie particulière, passante, anonyme, affairée, mystérieuse qui doit tenter le peintre . . . L'air que nous respirons est enfermé par ces cadres, à nous donner l'émotion de nos rue boueuses, de nos pluies, de nos avenues qui vont se perdant en une perspective de brume. Dans cette atmosphère véridique, la mêlée des voitures et des passants tournoie, se croise, se mêle, avec un prodigieux sens du mouvement rythmé des foules. A plusieurs reprises, ce combat social visible dans les allées et venues inquiètes de la rue, est aperçu et résumé par Pissarro, et c'est une des beautés de cette série de toiles que la représentation de l'agitation fatale des vivants parmi ces décors d'un jour.'

The ideas of movement, social combat, and urban agitation can indeed be found expressed in the images if they are seen in contrast , not so much with other urban images of the 1890s, but with Pissarro's own rural paradise. In the city, figures move, lurch, and labour in the vast architectural spaces in which they are set. In the country, the figures luxuriate in the larger spaces of the Norman fields.

Pissarro's urban realm, filled with vehicles, boats, *promeneurs,* workers, parades and passers-by is the first complete artistic manifestation in the history of modern art of what Geffroy called the spectacle of urban existence. The boulevard pictures gained strength in numbers, and like Monet Pissarro worked on them simultaneously in order to bring all the individual pictures into a collective harmony. It is interesting, however, to contrast the urban realm depicted by Pissarro in the last decade of his life with the urban images produced by the Nabis, and with the contemporary paintings of the other surviving Impressionists. The world of Paris painted by Toulouse-Lautrec, Bonnard, and Vuillard in the 1890s is a much more restricted world, limited to the interiors of apartments and cafés, to crowded *quartiers*, or to the relative safety of the urban park. The Impressionists themselves had all but totally fled the city by 1890, paradoxically abandoning their radical urban art to a painter who was, until his last decade, a painter primarily of rural life.

Françoise Cachin

Looking at Pissarro

'A fine picture by this artist is the act of an honest man'

Emile Zola

'Pissarro . . . remains the painter for those who look at, rather than for those who read about, painting.'[1] These words by Sickert are no doubt the most illuminating that have ever been written about Pissarro, and may explain why his place in the history of artistic taste is still uncertain.[2] Who has not had the experience of 'discovering' him in the course of walking round an exhibition or a museum, and saying to oneself with astonishment: 'Why, he was a great painter!'

Pissarro is in fact a painter's painter, despite the admiration of literary men such as Zola, Huysmans and Octave Mirbeau. His greatness, in art as in life, lay in his modesty and intransigence, his unswerving attachment to truth without ostentation It was these qualities which, more than those of his contemporaries Monet, Manet or Renoir, set an aesthetic and moral example to such varied artists as Cézanne, Van Gogh and Gauguin, and it was these qualities which prevented him from figuring as a 'strong personality' or a star of the artistic firmament. His own individuality always took second place to his passion for painting and objective reality, which to his mind were one and the same thing: all his devotion was to artistic truth and to his fellow-men.

All witnesses agree in seeing him as a mild-mannered patriarch. A. Tabarant says: 'Pissarro was a delightful man, and so profoundly human that any wrong done to another angered him like a personal offence. You could not set eyes on him without being impressed by the simple majesty of his countenance, in which there was never a hint of hardness or disdain.'[3] Duret: 'He was a kindly, peaceable man.'[4] Natanson: 'Whether it was because he was infallible, infinitely kind and just – or was it merely his prominent, beaky nose and long white beard? – in any case, everyone who knew him in the nineties thought of him as something like God the Father.'[5] Vollard: 'The first thing that struck one in Pissarro was his air of kindness, of delicacy (*finesse*) and at the same time of serenity.'[6] Finally Matisse: 'One could not help liking him, he reminded you of one of the prophets on Moses's well at Dijon.'[7]

Pissarro was no more than forty years old when he attained the moral status of 'le père Pissarro', a righteous man of apostolic dignity; but we must first turn our attention to his earlier career.

Pissarro and the Critics

Camille Pissarro's first beginnings were neither especially brilliant nor the reverse. His pictures were admitted to the Salon from 1859, when Manet and Whistler were rejected, and appeared there fairly regularly until 1870. They at once attracted attention.[8] In 1863 Castagnary mentioned him in his review of the Salon des Refusés, where Manet was the central figure, observing briefly that Pissarro seemed to be attracted by Corot's style: 'an excellent master, my good sir, but you must be careful not to imitate him.'[9] The champion of realism in fact never greatly liked Pissarro's painting and thought it 'vulgar', but his remark about Corot's influence is perfectly justified in this case.

In the late sixties, as we shall see, Pissarro's chief admirer was not a professional

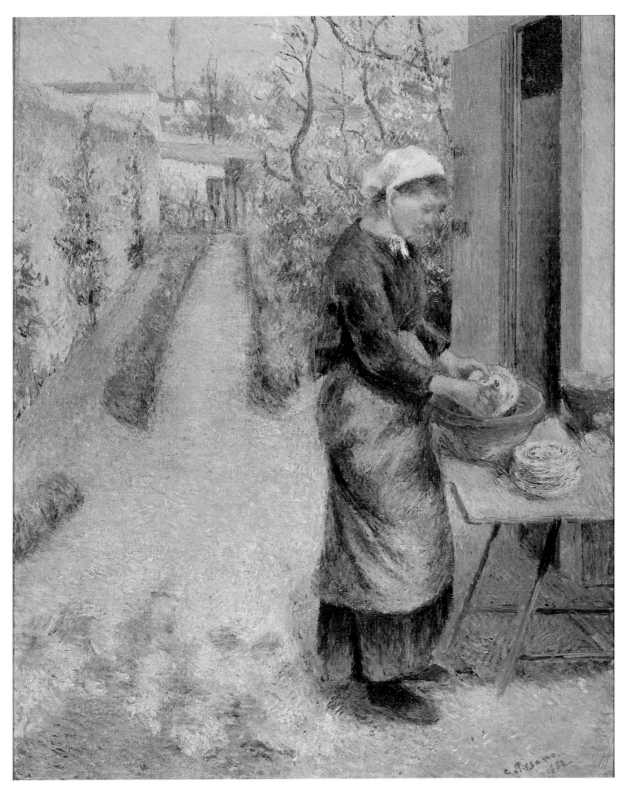

Young woman washing dishes 1882 Cat. 59

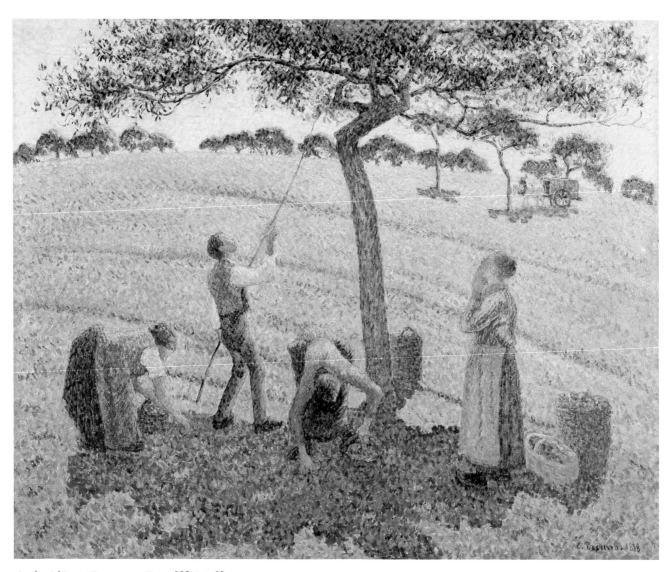

Apple picking at Eragny-sur-Epte 1888 Cat. 68

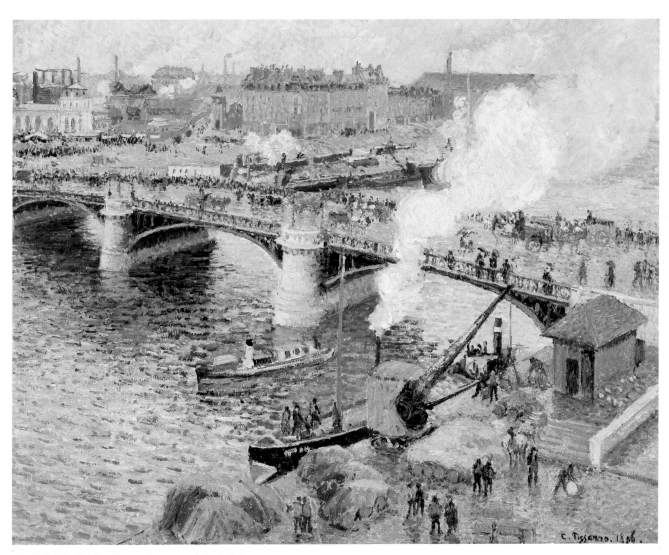

The Boïeldieu Bridge, Rouen, damp weather 1896 Cat. 75

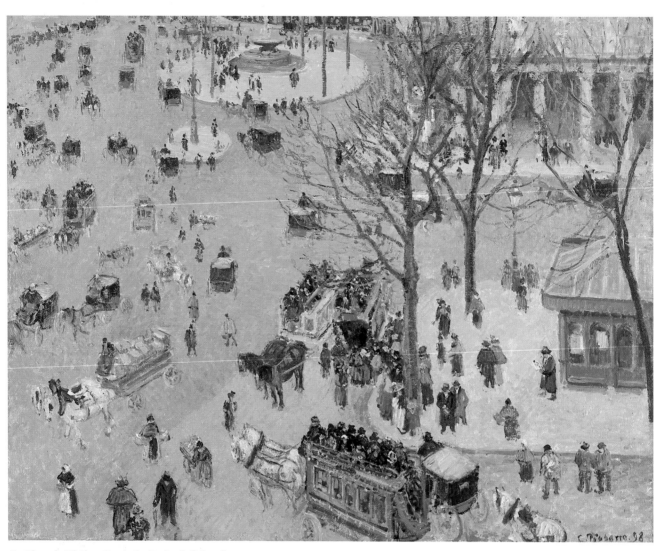

La Place du Théâtre Français, Paris 1898 Cat. 80

art critic but a man of letters. Writing in the journal *l'Événement*, the young Émile Zola provided Pissarro for two years with a *succès de scandale*, a double-edged weapon for an unknown artist. Then came the impressionist battles of the seventies, in which Pissarro's role was even more militant than that of his friends. He was the only member of the group to take part in all its exhibitions from 1874 onwards and to hold out against the temptation to submit works for the Salon. The critic Théodore Duret, who did most to help Pissarro in the seventies by his articles and by buying pictures from him, tried to persuade him to exhibit at the Salon in 1874: 'I urge you to select pictures that have a subject, something resembling a composition, pictures that are not too freshly painted, that are already a bit staid ... I urge you to exhibit; you must succeed in making a noise, in defying and attracting criticism, coming face to face with the big public. You won't achieve all that except at the Salon.'[10] But Pissarro would not submit to the Salon jury and abandon his friends, with whom he was then organizing the first Impressionist exhibition. As always, he refused to compromise, a fact which did much for his prestige in the future. As Caillebotte wrote to him in 1882 apropos of the group's later dissensions: 'If there is anyone in the world who has the right not to forgive Renoir, Monet, Sisley and Cézanne it is you, because you have experienced the same practical necessities as they and you haven't weakened.'[11]

During the heroic period of Impressionism critics appraised the movement with particular reference to the trio of 'pure' Impressionists Pissarro, Monet and Sisley. Pissarro was some ten years older than his friends, and as a rule the critics cast him in the part of the rustic, with forthright homespun qualities. According to Armand Sylvestre: 'At first glance one has difficulty in distinguishing what differentiates the painting of M. Monet from that of M. Sisley and the latter's manner from M. Pissarro's. A little study will soon teach you that M. Monet is the most adept and daring, M. Sisley the most harmonious and hesitant, M. Pissarro the most genuine and naive.'[12] The Italian critic Diego Martelli, a friend of Degas, wrote: 'Pissarro is somewhat more of a dreamer ... Crude and monotonous in style, all his pictures give the impression that his honest fury has spilled over into them ... Monet is still young, so that his painting too is young and gay. One might compare Monet to spring and Pissarro to autumn.'[13] While Castagnary in his important review of the first Impressionist exhibition spoke of Monet's 'marvellous impasto effects', Sisley's 'distinction' and Renoir's 'boldness', he devoted his longest paragraph and also his most doubtful compliments to Pissarro. 'M. Pissarro, for his part, is powerful and restrained. His synthetic vision perceives the scene as a whole ... [but] he has a deplorable predilection for market gardens, losing no opportunity to paint cabbages and other useful vegetables. However, these inconsistencies and vulgarities do not detract from his fine craftsmanship.'[14]

Among contemporary critics who took a kindly view of the Impressionists, Duret was perhaps the only one who preferred Pissarro to Monet. Reassuring his friend, who was no doubt going through one of his many phases of discouragement, Duret wrote: 'You have not got Sisley's decorative sense or Monet's amazing eye, but you have something they do not – a profound, intimate sense of nature and a gift of forceful brushwork, so that every picture of yours rests on absolutely firm foundations ... Go your own way, go on painting rural nature.'[15] Duret also made further suggestions: 'Have you ever painted animals, either with two legs or four? So many people are engaged in pure landscape that

there is a place to be occupied along the lines of Paul Potter, Cuyp, Troyon or Millet, though of course you must be modern and different.'[16]

Those critics who did not give Pissarro advice took him to task. Armand Sylvestre wrote: 'M. Pissarro has several interesting canvases; this artist has charmingly delicate shades of blue, but he tends to blur his painting too much. M. Sisley is more varied.'[17] Philippe Burty declared that: 'What is needed is more clarity in the outline of branches and the trunks of trees.'[18]

In 1879 Edmond Duranty, no doubt the most respected *avant-garde* critic of the time, whose *Nouvelle peinture* was a defence of Degas rather than Impressionism, summed up the development of the movement which had begun ten years earlier: 'Finally the amazingly bold effects of light that were M. Monet's special accomplishment gave the last decisive impulse to a group of painters including M. Pissarro, who eagerly felt his way along many different paths . . . Today the calmness of M. Monet's exhibition shows that they have pruned away what was not needed . . . M. Pissarro undoubtedly possesses great sensibility and delicacy.'[19] These lukewarm compliments are historically unjust, since they tend to minimize Pissarro's essential role at the beginning of the 1870s; but they were favourable compared with the sarcastic and derisive comments on Impressionism in the pages of *Charivari* or the peevish indignation of Albert Wolf, the art critic most popular with the great Parisian public. Duranty's views are well known[20] and are part of the golden legend of Impressionism as chronicled by Tabarant, for instance, as far back as the turn of the century. Pissarro attracted special attention because the deliberate simplicity of his subjects was considered provocative to an extent that can no longer be imagined at the present time, and also because of his workmanship, which, at first summary and sketch-like, tended increasingly towards fragmentation and 'division'. Both styles encountered criticism as time went on, but Pissarro was entitled not to take this too much to heart. True, it alienated wealthy clients and precluded official honours – but, in the words of Flaubert, whom Pissarro always greatly admired, 'honours are dishonourable', and such criticism could only increase the confidence and combative spirit of an artist who regarded creation and revolt as interchangeable ideas. As for the favourable criticism which emanated from Charpentier the publisher (for instance G. Rivière in *l'Impressionniste*,[21] edited by Renoir's brother) and, later, from Durand-Ruel's review, this was addressed to circles which had no need of conversion.

It must also be recognized that the critics were often lacking in talent and conviction. As Pissarro afterwards wrote very justly to his son: 'If we were to listen to the ideas of all those gentlemen who express their feelings about us, we would have our hands full. I stoically ignore all that. I well remember that around 1874 Duret, who is above reproach, said to me with all sorts of tactful circumlocutions that I was on the wrong track, that everyone thought so . . . '[22] The measured but caustic criticism of the *Gazette des Beaux-Arts* was certainly not calculated to restore peace of mind. 'M. Pissarro works painfully in bright colours: the air becomes heavy at his touch, spring and the flowers are saddened. His execution is viscous, woolly, tormented; his melancholy figures are treated in the same way as trees, plants, walls and houses.'[23] The author of these remarks, Charles Ephrussi, was certainly not a hothead of the *avant-garde*, but he was an enlightened, open-minded critic who admired Renoir. He represents well enough

the attitude of the general public towards Pissarro in the 1880s, which was one of esteem, indifference or slight reserve. Pissarro was felt to be lacking in charm. He never enjoyed the flattering glow of scandal as a member of the *avant-garde*, nor on the other hand did the Salon confer medals that would have boosted his confidence and assured him of official support.

The attitude of the general public and the authorities towards Pissarro, from the 1870s to his death in 1903, in fact requires careful analysis, and the portrait of a helpless victim, as depicted for instance by Tabarant, does not do full justice to the situation, at any rate during the painter's last few years. Certainly he had to wait longer than Renoir or Monet before his works were sold and appreciated outside a fairly small circle of connoisseurs; and even in the nineties, in the seventh decade of his life, his paintings fetched lower prices than those of his friends. The State never bought anything from him either in his youth or in his last years, despite Mirbeau's efforts with Roujon, Directeur des Beaux-Arts.[24] Not until 1897, at a very late stage in the history of Impressionism, did the Museé du Luxembourg first acquire some of Pissarro's works under the terms of the famous Caillebotte bequest, after three years of negotiation between the State and the artists concerned. But the authorities were not simply the villains of the piece, as has been too often suggested. The correspondence of Léonce Bénédite, the curator in charge at the Luxembourg, indicates that each artist was consulted at length, and Pissarro's letters to him show that Pissarro fully approved of Bénédite's selection:[25] When Pissarro, in youthful conversations reported by Cézanne, said that the Louvre and other museums ought to be burnt,[26] he had in mind the dead weight of the past and of official schools; but besides his real personal modesty he took a sober view of the historical importance of Impressionism, and his sincere partisanship never turned the gentle Pissarro into a raging iconoclast. With pride yet with moderation he placed himself in a long line of artists and craftsmen who were not theoreticians, and those who label him a revolutionary anarchist and champion of the *avant-garde* would be surprised to read his reply to an enquiry about modern art: 'I do not believe that art is a matter of progress: it is simply that at the present time we are interested in certain effects that our ancestors were not concerned about. As to your other questions, they are more for art critics and philosophers to answer.'[27] In other words they were the business of literary men, talkers and theorists – people of whose support Pissarro had often been glad, but whom he privately considered ignoramuses as far as painting was concerned. On the other hand his intransigence towards the academic world of the fine arts with its Salon, official shows and world exhibitions was greater even that that of his impressionist contemporaries except Monet and Cézanne, the latter especially being his disciple in this respect. Even so, there was some modification as time went on: while the general public was unable to see Pissarro's paintings after 874 except at the Impressionist exhibitions or at Durand-Ruel's gallery, things were different by the time of the World Exhibition of 1900. The decennial retrospective shown at the Exhibition and organized by professors of the École des Beaux-Arts, ignored the ten years of impressionist painting that had just elapsed, but at the centennial retrospective also shown at the Exhibition, Roger Marx, an official of the fine arts department, was given a free hand and did ample justice to the Impressionists: eight of Pissarro's pictures were selected, as were eight works by Courbet.[28] Thus, paradoxically, to the huge crowd of visitors to the World

Exhibition the Impressionists were 'history' and the Salon represented 'modern art'. But there was no real confusion, as a watered-down form of Impressionism had spread to academic painting, so that the work of Pissarro, which was already part of history, was by now more accessible and comprehensible to the general public.

The 'battles' fought for Impressionism by critics of this period, such as Mellerio and Gustave Geffroy, might be called those of an advanced rearguard (or vice versa) and were in any case fairly tame.[29] Indeed, between 1880 and 1900 the work of professional art critics, whether official or not, was for the most part mediocre and unexciting, except for Félix Fénéon's writing over a period of years.

Writers and 'Literary Men'

'Literary' art criticism, in which men of letters showed far greater brilliance than the Salon fraternity, gave the Impressionists a helping hand but, as we shall see, also lent itself to misconceptions.

The first, most convincing and warmest expression of support that Pissarro ever received (and this was also true for Manet) came from Émile Zola. Zola noticed Pissarro's work at the 1866 Salon, and defended it for the qualities which, in later criticism, have caused the artist to be consistently regarded as a highly deserving poor relation of the great impressionist family. 'I know that you were admitted [to the Salon] with great difficulty, and I offer my sincere congratulations. You should realize that you will please no one and that your picture will be found too bare, too black . . . You choose a wintry scene with nothing but an avenue, a hill at the far end, and empty fields stretching to the horizon. Nothing whatever to delight the eye. An austere and serious kind of painting, an extreme concern for truth and accuracy, a rugged and strong will. You are a great blunderer, Sir – you are an artist that I like.'[30] Here we have Pissarro's role defined once and for all. In 1868 Zola filled in some details of the portrait. This, as far as I know, is the only occasion on which a critic chose Pissarro as the main example wherewith to illustrate his praise of the 'new naturalists' who took the name of Impressionists after the 1874 exhibition. 'None of them [the Salon critics] seem as yet to have noticed that we have here one of the profoundest and most serious talents of our time . . . If Pissarro fails to appeal to the crowd and is a source of perplexity to the jury, who accept or refuse his work as the fancy takes them,[31] this is because he has none of the petty skills of his fellow-painters. He is a pursuer of excellence, a strenuous seeker after truth, unconcerned with little "tricks of the trade" . . . He paints with supreme accuracy and energy, in such a way that the result is almost gloomy – how on earth can one expect such a man and such pictures to be popular?'[32] Gradually, in his eloquent defence of Pissarro, we find Zola identifying the artist's creative process with his own. 'He is neither a poet nor a philosopher but simply a naturalist. He paints the earth and the sky – this is what he has seen, and you may dream dreams about it if you like. The originality here is deeply human . . . it forms part of the painter's inmost temperament, which is one of seriousness and accuracy . . . Such realities are more important than dreams . . . A quick glance at such a work is sufficient to make one understand that the man who created this was a straight and strong person, incapable of dishonesty, and a man who turns his art into a pure and eternal truth . . . A fine picture by this artist is the act of an honest man.'[33] In 1876, reviewing the second Impressionist exhibition, Zola observed that

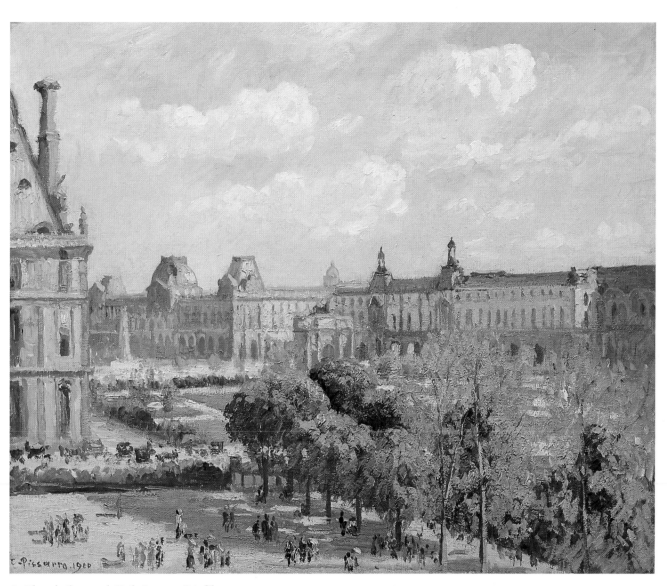

La Place du Carrousel, Tuileries 1900 Cat. 86

Twilight with haystacks 1879 (D23 second state) Cat. 164

Twilight with haystacks 1879 (D23 third state) Cat. 165

'Pissarro is a fiercer revolutionary than Monet,' the latter being 'unquestionably the chief member of the group' and a painter of 'inexpressible charm', while Pissarro's style 'is even more simple and naive. His sensitive, variegated landscapes may at first sight puzzle the uninitiated, those who do not fully understand the artist's ambitions and the conventions against which he is striving to react.'[34] As time went on, Zola's enthusiasm cooled somewhat. In 1877 he declared that the painter 'affords strikingly accurate glimpses of nature',[35] while in 1880 Pissarro is simply ranked with Sisley and Guillaumin among artists who 'followed the lead of M. Claude Monet'.[36] As is well known, the Impressionists were disappointed by Zola's gradual abandonment of art criticism and failure to stand up for his friends, especially the closest of them, Paul Cézanne, whom he had known from boyhood but in whose genius (unlike Pissarro, a better judge) he never believed. Pissarro fell out with Zola in 1886 when the latter published *L'Oeuvre*, the portrait of an unsuccessful artist which every member of the group, including Pissarro and, most of all, Cézanne, believed to be intended for himself. Pissarro continued to read and admire Zola's work, but the two men did not become friends again until much later, at the time of the Dreyfus case.[37]

Zola, a novelist of the naturalist school, was the stoutest champion of the young Pissarro, and in the 1880s, when the artist had become a veteran of Impressionism, he was again publicly defended by naturalists or neo-naturalists. Joris-Karl Huysmans began on a reserved note: 'M. Pissarro unquestionably has a true artistic temperament, and, when it casts off its swaddling-clothes, his work will be modern landscape painting in the truest sense'[38] – a somewhat backhanded compliment for a seasoned artist of 50! 'He is another of those who have bedaubed motley canvases which they call "impressions": an uneven artist who oscillates between good paintings and very bad ones, like Claude Monet.'[39] But in 1881 Huysmans changed his tone: 'This artist's exhibition is a revelation. After groping for so long, M. Pissarro has suddenly shaken off his errors . . . The real countryside has at last emerged from the medley of chemical colours.' After describing several canvases the critic launches into a passage which, like his novels, is more convincing in the expression of curiosity and distaste than when it attempts ecstasies of praise. 'Seen at close quarters, *The pathway at Le Chou* [Cat. 48] is a heap of masonry, a strange, rugged, noisy affair, a canvas plastered with a hotchpotch of tones – lilac, Naples yellow, madder and green of every sort. At a distance, what you see in it is boundless sky, the air in motion, nature vibrant with life, radiant sunshine, water evaporating, the earth reeking and fermenting.' Further on, Huysmans appears to lose interest and drops into an unoriginal style as he speaks of 'magnificent landscapes' and 'countryfolk eating their lunch or haymaking – these are real little masterpieces'.[40]

Huysmans had far harsher things to say of Monet and Cézanne, and was only really pleased with Degas, Raffaelli and Caillebotte. When his remarks appeared in book form Pissarro sprang to the defence of Cézanne and Monet.[41] Huysmans' rejoinder is interesting, as it confirms that the general attitude of the press towards the Impressionists had not changed during the ten years since their first exhibition. 'Remember only this: amongst the crowd of Salon critics who go into ecstasies over Gervex and Bastien-Lepage and haven't a good word to say for you, there is one individual who may of course be mistaken but who has at least spoken out against the popular craze and against false modernity, by defending

Caillebotte against Gervex.'[42] Writing to his son, Pissarro commented: 'You will see, alas, that like all the critics, under the pretext of naturalism he makes literary judgements and most of the time sees only the subject of the picture. He puts Caillebotte above Monet.'[43] Before long, as Huysmans gradually abandoned naturalism and became a symbolist and decadent, his pictorial tastes shifted to a very different universe, that of Redon and Gustave Moreau, and Pissarro's humble orchards then seemed to him very dull affairs. Having enjoyed the ambiguous praise of naturalist writers who admired his frank, uncomplicated acceptance of reality, however trivial, Pissarro found himself blamed by the symbolist generation for the very thing that Zola had commended: the fact that, even more than the other Impressionists, he chose almost wilfully to limit his artistic universe to a small, confined space, to country scenes and kitchen-gardens, in short to a down-to-earth, familiar world with nothing cosmic about it.

Camille Mauclair, a young art critic on the *Mercure de France*, who was to give Pissarro such a glorious obituary some twenty years later, at this time made jokes about his everlasting cabbages; so did the author of an entry in the *Petit Bottin des Lettres et des Arts* (1886)[44] – probably the symbolist poet Jean Moréas – which reads: 'Pissarro, Camille, an impressionist market-gardener specializing in cabbages.' Pissarro, with the asperity that from time to time forms a welcome relief from his usual mildness, wrote of this: 'What would the Gothic artists say, who so loved cabbages and artichokes and knew how to make of them such natural and symbolic ornaments?'[45] Having been the champion of 'truth to life' as opposed to 'professionalism' and of the 'natural taste of things' instead of tricks and cleverness, and having taken his stand against 'pictures that tell a story', at the height of the symbolist period Pissarro showed increasingly firm opposition to 'pictures that express ideas' – though in this, to his regret, he was not followed by Gauguin.

The poet Albert Aurier, who at this period was to Gauguin and Van Gogh what Fénéon was to Seurat, made a serious and severe analysis of Impressionism with the object of bringing out the specific quality of these two artists some twenty years before they were classified as 'Post-Impressionists'. 'It can only be a variety of realism . . . Certainly MM. Pissarro and Monet express forms and colours differently from Courbet, but fundamentally, like Courbet and indeed more than he, they are interested in nothing but forms and colours, the sub-stratum, and the ultimate object of their art is material reality.' Aurier admits that Pissarro has elements of greatness, but only in so far as he depicts, almost involuntarily, the 'soul' of nature. 'That majestic tranquility, that solemn melancholy which broods over the figures and objects of the countryside . . . We actually hear the throb of vegetative life, we sense the silent ebullition of saps and juices, the exultation of cells, the intoxication of gradual burgeoning in that serene and torrid atmosphere, where there is almost more oxygen than life requires.' This unsolicited piece of fine writing was well calculated to annoy the materialist Pissarro, especially when Aurier, the champion of idealistic painting, went on to complain that he had placed a cowgirl and some cows in the landscape instead of leaving it as a 'poem of motionless life, a great epic of vegetation.'[46] Another poet, Émile Verhaeren, was still less indulgent towards Pissarro, who served as a foil to his admiration for Monet. In the latter's work 'one has a sense of firmness, security and masterfulness. He makes a strong, irresistible impression . . . To appreciate his

merit we have only to look at Pissarro, whose paintings at every turn give us a feeling of hesitation and indecision: he is forever groping, altering, amending and starting over again.'[47]

Given this lack of appreciation on the part of literary men, it is not surprising that Pissarro showed caution when Durand-Ruel first invited him to receive a writer who was to be the acknowledged defender of his cause from the late eighties to the turn of the century. 'The more I try to imagine what information M. Mirbeau wants, the less I can form any practical idea of it: it is very difficult for a painter to give information about himself. The writer has to assimilate the artist, or rather his ideas and manner of understanding things, he must frequent the artist's *milieu*, and then after a time, with the help of his own observations, he may produce something useful; but in this way, point-blank, it is bound to be very imperfect. Zola in his time studied Manet in that way, and he did succeed in giving a strong, lively idea of him.'[48] Perhaps because of this reluctance on Pissarro's part, Mirbeau did not write about him until 1886–7, when the patriarch of Impressionism joined the ranks of the Neo-Impressionists and began to 'divide' colours into little dots, like Seurat and Signac who belonged to the generation of his son Lucien. This was something of a difficulty for the fervent Mirbeau, who never greatly admired Seurat. However, 'the choice of technique is of small importance if the work is well carried out . . . The object of art is to produce a moving effect, whether by round brush-marks or square ones . . . If Pissarro has a technique of his own he also has a very individual vision – delicate, subtle and charming . . . Fields and more fields, with little hedges between, and you can have no idea of the peace of those fields and all that sunny greenery . . . The painter makes you sense the powerful yet restful smell of the earth. What a long way it is from the finicky, dolled-up countryside of M. Jules Breton!'[49] The same rather conventional lyricism can be found in the Anglo-Parisian George Moore's description of a painting at the last Impressionist exhibition of 1886, at which Seurat's *Sunday afternoon at La Grande Jatte* was shown at Pissarro's insistence. 'Pissarro exhibited a group of girls gathering apples in a garden (Cat. 64) – sad greys and violets harmonized. The figures seem to move as in a dream: we are on the thither side of life, in a world of quiet colour and happy aspiration. Those apples will never fall from the branches, those baskets that the stooping girls are filling will never be filled . . .'[50]

In 1886–8 the most talented if not the most convinced defender of Pissarro was Félix Fénéon, who was only too happy to be joined in his championship of Seurat by such a venerable impressionist ally. As far as Pissarro was concerned the new technique, until it began to cramp his sensibility, was an intellectual stimulus and a source of rejuvenation, giving him a sense of unity with a *milieu* that shared his ideological and aesthetic preoccupations. This, for the time being, allayed some of his anxieties in the artistic sphere, but it led to the estrangement of critics and admirers whose support had been dearly bought. After his death, critics were to cite his brief sojourn among the Neo-Impressionists either as a sign of insecurity or, contrariwise, as proof of his freshness of mind and constant aptitude for self-renewal. Meanwhile, from 1886 to about 1889 his somewhat artificial relationship with the post-impressionist generation was based on his adoption of the radical-scientific theories of the young Seurat, and on the novel association of symbolist writers and neo-impressionist painters, in an effervescent *milieu* of which Félix Fénéon was the moving spirit. The latter's famous *Les Impressionnistes en 1886*,

which is in fact a manifesto on behalf of Seurat, referred respectfully to Pissarro's past exhibitions of 'superb landscapes, painted with austerity and assurance,' but took care to add that he subsequently 'transformed his style and brought to Neo-Impressionism, together with the authority of his name, a technique of mathematically strict analysis.'[51] In 1888, reviewing an exhibition at Durand-Ruel's gallery of pictures dating from 1881–5, Fénéon once more stressed Pissarro's adherence to the new technique. 'In all these works we find the same youthful charm, serenity and a sense of space. Interest in the analysis of light, together with a quest for harmonization, were to lead M. Camille Pissarro to the neo-impressionist technique which he adopted in about 1885.'[52] However, Fénéon showed a serener mood in February 1892 apropos of Durand-Ruel's first great retrospective exhibition of a hundred paintings which at last canonized Pissarro, then aged over sixty. In a 'decadent' style which seems strangely inappropriate to the painter of 'things as he saw them', Fénéon says that in a painting like *The girl tending cows* Pissarro 'recreates a virginal universe and, for a moment, imputes a primitive soul to contemporaries of *la môme cataplasme*. It is this Pissarro, the most recent of all, that we must celebrate: having at last achieved mastery over forms, he envelops them in a perpetually translucent atmosphere, eternizing their exalted interconnection in the blithe and flexible hierarchical order which he inaugurates.'[53] Thus our painter, having been put through the naturalist mill by Zola and Mirbeau, was now subjected to an effusion in the style of Mallarmé. Not for nothing, it may be thought, was Pissarro mistrustful of literary admirers!

It was Mirbeau, however, who made the longest and warmest defence of Pissarro since Zola, in the context of the 1892 exhibition. Evoking a broad historical perspective, he wrote: 'M. Camille Pissarro has shown himself a revolutionary by renewing the art of painting in a purely working sense; at the same time he has remained a purely classical artist in his love of exalted generalizations, his passion for nature and his respect for worth-while traditions.' At a time when symbolist tastes and ideology reigned supreme, Mirbeau sought to vindicate Pissarro in terms of the current fashion. 'No one has ever analysed with more intelligence and penetration the character of things and all that lies hidden under the living appearance of figures. A hill without a silhouette, under a sky with a single roving cloud – that is all he needs. An orchard with its rows of apple-trees, with a brick farmhouse in the background and women under the trees picking up the fruit . . . All this comes to life, one's imagination soars and hovers, and the simple, familiar scene turns into an ideal vision, taking on depth and resonance after the fashion of high descriptive poetry.'[54]

As regards the effect on Pissarro of the various writings about him, those which appeared hostile were sometimes welcome as a stimulus, for instance if, like those of Albert Wolf, they reassured him that his *avant-garde* campaign was well justified; while, on the other hand, he reacted with scepticism and dissatisfaction to literary compliments which had more to do with their authors' theories than with his own modest, specific aims. In any case painters always regarded him with sympathy and understanding, and unquestionably this mattered far more to him than anything else. As he wrote to his son Lucien, his closest companion and real sharer of his thoughts: 'Painting, art in general is what enchants me – it is my life. What else matters? When you put all your soul into a work, all that is noble in you,

you cannot fail to find a kindred soul who understands you, and you do not need a host of such spirits.'[55]

The Painter's Painter

Curiously, one of the first critics to notice Pissarro's particular greatness afterwards became one of his artistic adversaries, judging his conceptions and ambitions to be too limited: this was the young Odilon Redon. Reviewing two of Pissarro's landscapes at the Salon of 1868 he wrote: 'The colour is a little dull, but it is straightforward and well observed. This painter has a singular talent which seems to bully nature. His technique appears rough-and-ready, but this is above all a mark of sincerity. M. Pissarro's vision is simple: the sacrifices he makes in regard to colour serve to emphasize the general impression, which is simple and therefore always strong.'[56] Towards the end of Pissarro's life he received discerning and eloquent praise from quite young painters who were incidentally critics, such as Sickert, Maurice Denis or even Félix Vallotton.

Pissarro in fact played the same role vis-à-vis two or three generations as Corot had played in his own career – Corot, whom he resembled by his modesty and love of nature 'as he himself perceived it'. This implied a twofold respect for nature, internal and external; faith in his own sensations gave him an optimistic, reassuring conception of nature in general and human nature in particular. This was a very different vision from, for instance, the sometimes savage lucidity of Degas, who stood at a distance from Pissarro in politics[57] and other respects, but admired him as a man, a painter and especially an engraver. Pissarro understood this well enough: 'We are on excellent terms. He is a terrible man, but he is sincere and trustworthy . . . He would be ready to give me a helping hand, as he has in fact done on many occasions.'[58] Degas showed his awareness of Pissarro's evangelical strain when he wrote that the painter's peasant women were 'like angels going to market'. We need not enlarge on Pissarro's friendly relations with Sisley and especially with Monet, despite the former's isolation and the latter's more rapid rise to fame; despite, also, the neo-impressionist interlude which for a time separated him from those whom he dubbed 'romantic Impressionists'. His relations with Cézanne are also well known, as is the latter's admiration for him in the sixties and seventies in particular: 'If he had gone on painting as he was doing in 1870, he would have outclassed us all.'[59] After 1900, when Cézanne had become the absolute model for the whole *avant-garde*, from Matisse to the Cubists, he lost no opportunity of recalling Pissarro's importance: the latter, after his death, was already somewhat neglected, while Renoir, Degas and Monet lived on, painting actively and enjoying a high reputation. 'Pissarro,' said Cézanne, 'was like a father to me: he was a man you turned to for advice, and he was something like *le bon Dieu*.'[60] This phrase was repeated by all the young painters who came to imbibe the wisdom of the hermit of Aix and pass it on to others; among them were Émile Bernard, Charles Camoin and Maurice Denis. Cézanne never ceased to pay homage to 'that humble and colossal Pissarro',[61] whom he regarded as the originator of Impressionism and its most faithful representative, and towards whom he felt such a debt that he referred to himself as 'Cézanne, pupil of Pissarro' in the catalogue of an exhibition at Aix in 1906, three years after the patriarch's death.[62]

Pissarro in fact had a true pedagogical vocation, as can be seen in his letters to Lucien, and it is no accident that all his sons became painters. As Mary Cassatt well

said: ' He was such a teacher that he could have taught stones to draw correctly.'[63] Berthe Morisot testified that the least compliment from Pissarro reassured and delighted her.[64] But for several years his pupil in the fullest sense was Paul Gauguin. The debt which Gauguin owed to his impressionist master in the early 1880s is well known, but Pissarro's influence was not only artistic: he imprinted on Gauguin a moral sense and an attitude which affected his whole personality. When Gauguin called himself 'an impressionist artist, that is to say a rebel,'[65] we sense Pissarro's anarchism in the background, and Gauguin's cultivation of the idea of himself as a 'savage' is likewise an echo of Pissarro's self-judgement: 'I have the temperament of a peasant, I am melancholy, coarse and savage in my work.'[67]

Another fruit of Gauguin's conversations with Pissarro was a certain detachment with regard to the direct observation of nature. At the time when Gauguin, at the beginning of his career, was seeing much of the elder painter, Pissarro advised his son Lucien: 'Your observations from memory will be much more powerful and original than those made directly from nature.'[68] We find an echo of this advice in Gauguin's injunction to Schuffenecker a few years later: 'Don't paint too much direct from nature. Art is an abstraction – study nature, then brood on it.'[69] When, around 1886, Pissarro took up with Seurat and the 'enemy' camp, Gauguin was cruelly sarcastic about 'the ancestral Pissarro, producing works of art in spite of himself: his peasant women are uncertain figures, twice widowed of Millet and Seurat, though quite skilfully put together.'[70] But these remarks were really aimed at Seurat and not Pissarro. With the advantage of time and distance Gauguin, detached from the artistic rivalries of Paris, was to sum up the position more fairly: 'Examining Pissarro's work as a whole, despite its flucuations, we find in it not only an overwhelming sense of purpose that never fails, but an essentially intuitive and highly distinguished artistic sense . . . He paid attention to everyone, you may say – well, why not? Everyone paid attention to him too; they deny him now, but I shall not. He was one of my masters.' Reverting to his own sarcastic judgement quoted above, Gauguin turned it to Pissarro's advantage apropos of a fan painted by the latter. 'Through a simple half-open gate between two very green (Pissarro green) meadows, a flock of geese advances warily as if saying to one another: "Do we belong to Seurat or Millet?" But in the end they all belong to Pissarro.'[71] As for Gauguin's anarchistic ideas about the artist as a victim of society, these too were the direct result of his conversations with Pissarro, who was an avid reader of Kropotkin.

Gauguin, in short, not only looked hard at Pissarro's pictures but listened to him as well, as did Gauguin's friend Van Gogh. Pissarro clearly felt affection for Van Gogh as a lame duck (or 'five-footed sheep', in his own phrase), and never ceased commending him to critics and dealers, from Cézanne to Medardo Rosso; perhaps his protective attitude was stronger than his admiration for the Dutch painter's works.[72] Van Gogh for his part liked Pissarro's painting[73] and attached importance to his advice. Writing to his brother in 1889 about the difficulty of catching the 'true intimate note' of nature, he remarked that 'Pissarro used to talk very well about it in the old days, and I am still a long way from being able to do what he said ought to be done.'[74] Again, writing to Théo about a self-portrait, he significantly attributes to Pissarro his own desire for simplicity: 'I have tried to make it simple. Show it to old Pissarro if you see him.'[75]

'Old Pissarro' – that was how artists saw and loved the veteran Impressionist. There was a time, as we have seen, when he humbly divested himself of the fatherly role and, with his son Lucien, enlisted under the banner of Seurat and *pointillisme*. 'I should like it to be well understood everywhere that M. Seurat, an artist of great talent, was the first to hit on and apply the scientific theory.'[76] After this enthusiasm had cooled he continued to see in Seurat 'a man of the École des Beaux-Arts',[77] and his collection of Seurat's drawings showed a significant preference for the softer and less geometric ones and for subjects such as workers and peasants at their daily task.[78] We do not know what Seurat thought of Pissarro's work, but we have a better idea of the opinion of the other Neo-Impressionists – Luce, Signac, Van Rysselberghe or Van de Velde – to whom he remained close for the rest of his life, partly for ideological reasons.[79] Despite the militant 'divisionism' which caused Signac, in 1899, to place Pissarro somewhere in the line between Delacroix and Neo-Impressionism,[80] a few years earlier the younger painter confided to his diary the attraction and admiration he felt for 'an old Pissarro, of 1880 . . . which is a marvel of unity. From top to bottom the picture is in the same blue or green tone, almost with the same value, and yet you have the impression of the air circulating: the planes are distinct, everything remains smoothly in place without disturbing the general harmony. The man who painted this could never have been happy with our technique, which is one of opposition and contrasts. He was pursuing unity in variety, while we seek after variety in unity.'[81]

Signac was not the only one of his generation to be interested in this unitary, strictly pictorial aspect of Pissarro's work. All the young painters who, at the turn of the century, looked back on the impressionist movement which was already part of history – Pissarro being virtually its only surviving exponent since Sisley's death – were struck by his vision of nature. This was not so immediate as it appeared, but was rather a pretext for pure painting, expressing delight not simply in the landscape and the undifferentiated impression made by it, but in the *motif* to be drawn therefrom – this term denoting a chosen glimpse of countryside but also a repeated structure, a rhythm or pattern. Thus Bonnard well perceived what does not appear at first sight in a canvas by Pissarro: 'The Impressionists painted *sur le motif*, but their procedures and methods were especially calculated to protect them against the object itself. This is most evident in Pissarro and the way he arranged things – there is a great deal of system in his painting.'[82] Similarly Maurice Denis was particularly interested in the pictorial and unifying aspects of Pissarro's art, if only because they struck him as somewhat simplistic. 'Their free technique enabled the Impressionists to emphasize fine, pure colours . . . Pissarro, however, pursued shades of grey, which he obtained by the most skilful combinations of tints. He 'divided' in order to neutralize: his Vexin landscapes make one think of faded tapestries . . . he turned our most radiant sunlit scenes into *verdures*.' But Denis was fully and admiringly conscious of the profound harmony between the painter and his work, both of which possessed the same qualities of peaceful serenity, kindness with a tinge of melancholy, sobriety and unassuming greatness. 'Neither lyrical nor vulgar, he applied himself to building up solidly, in masses and values, the figures and country scenes which, with their deep yet varied greenery, bring before us the gracious, friendly landscape of the Seine valley.'[83]

In the generation of the Nabis, Félix Vallotton, an occasional art critic, admired the fact that Pissarro's work was 'purely pictorial, and therefore impossible to

describe. There is no literature in his paintings, no title addressed to the mind or the feelings, nor even any "subject" in the narrow sense.' Vallotton, like many others, was struck by the melancholy quality of Pissarro's landscapes, recognizing in them an implacable streak that appeared later in his own canvases. Apropos of *Snow effect at Éragny* he noted: 'A stretch of muddy road across the white plain, a house and some silhouetted trees; people are moving about, but they seem naked and crushed by the weight of a huge, dead sky. This small canvas has an extraordinary intensity, giving almost a sense of pain: it is harsh and hard like winter itself.' Vallotton expresses surprise that Pissarro 'is still not unreservedly accepted – I mean, of course, by the great public: artists made up their mind long ago.'[84]

There were indeed few young artists at the turn of the century who had not been in prolonged contact with the most approachable yet most demanding of the survivors of Impressionism. Even the very young Picabia found it profitable for some years to work in Pissarro's latest manner, which he attenuated and thus commercialized. Pissarro, an inveterate proselytizer, had initiated Picabia, a pupil of Cormon's studio, into the technique of light colours, impressionist brushwork, open-air painting and revolt against the École des Beaux Arts, and also no doubt into anarchist ideas.[85] But we must not turn Pissarro into a distant progenitor of Dadaism, the ostentation of which was at the opposite pole from his gentle, respectful temperament. Picabia may have considered him a firebrand, but another young painter, Henri Matisse, who was close to Pissarro at the turn of the century, saw in him a man of culture and reflection, the mouthpiece of a recent, heroic past. Matisse, who later remarked 'A Cézanne is a moment of the artist while a Sisley is a moment of nature'[86] would have regarded Pissarro in the late nineties as embodying a just balance between Sisley's somewhat superficial impressionist vision and Cézanne's self-expression. It was, we may note, Pissarro who taught Matisse, the pupil of Gustave Moreau, to appreciate Cézanne's classical greatness.

It may well be that Pissarro owed his moral image, his role as a 'saint' of the art world, not only to his generous nature but also to the fact that, while immensely talented, he always held aloof, deliberately or otherwise, from the mystery and fruitful egoism that accompanies genius. But let there be no mistake: right thinking and feeling can also produce good painting, and the critics' charge that Pissarro was not 'poetic' enough was answered by Venturi nearly half a century ago: 'It is true to say that Monet aimed at the exceptional and extraordinary, while Pissarro aimed at what was customary and everyday. But . . . one of the great miracles of poetry in all ages is that it reveals itself where it is least expected, in subjects which till then were looked at with a prosaic eye.'[87]

However this may be, painters of the first rank, from Cézanne to Matisse, who came into contact with Pissarro's work and personality regarded him as a gentle, tutelary figure who embodied in artistic terms the task of imparting truth and knowledge, both spiritual and technical, which in a unique way combined libertarianism with the traditions of the rabbinate and the trade-guild. He was no less an intercessor than a modernist. 'A man who does not know Corot and Courbet can certainly not understand Pissarro,[88] wrote Sickert, his principal champion in the English-speaking world, rightly emphasizing the fact that Pissarro, with modesty but with more dignity and authority than has been thought, succeeded in bringing about the smooth transmission of a certain idea of artistry and painting from Barbizon to the modern school.

Notes

1 W. Sickert, 'French painters of the nineteenth century at the Lefèvre Galleries', *The Nation and Athenaeum*, 19 May 1923, repr. in *A Free House*, London 1947, p. 132.

2 This remains true in spite of the fundamental works by L. Venturi and J. Rewald (see Bibliography) and particularly Venturi's admirably discerning and informative text, serving as the introduction to P&V (see Abbreviations).

3 A. Tabarant, *Pissarro*, Paris, 1924, p. 57; English translation, London, 1925, pp.60–1.

4 T. Duret, *Gazette des Beaux-Arts*, May 1904, p. 405.

5 T. Natanson, *Peints à leur tour*, Paris, 1948, p. 59.

6 A. Vollard, *Recollections of a picture dealer*, London, 1936, p. 169.

7 Conversation with a friend: information kindly furnished by M. Pierre Schneider.

8 Z. Astruc, *Les quatorze stations du Salon*, Paris, 1859, 'Dialogue entre un âne, une porte verte et un pommier'.

9 *L'artiste*, 1 September 1863, repr. in J. Lethève's excellent anthology with comments, *Impressionnistes et symbolistes devant la presse*, Paris, 1959, p. 23.

10 Letter to Camille Pissarro, Feb. 1874, repr. in P&V, p. 34; cf. J. Rewald, *The History of Impressionism*, (4th rev. edn.), New York, 1973, p. 310.

11 Letter from G. Caillebotte to Camille Pissarro, lot 8 in sale of Pissarro archives, Paris, Hôtel Drouot 21 Nov. 1975; quoted on p. 448 of J. Rewald's invaluable *The History of Impressionism*, (4th rev. edn.), New York, 1973.

12 Armand Sylvestre, preface to *Recueil d'estampes*, Durand-Ruel, 1883; cf. Rewald, op. cit., p. 302.

13 Review of fourth Impressionist exhibition, 27 June 1878, repr. in D. Martelli, *Les impressionnistes et l'art moderne*, Paris, 1979, p. 30.

14 *Le Siècle*, 29 April 1874, repr. in exhibition cat. *Centenaire de l'Impressionnisme*, Paris, 1974, p. 264.

15 Duret to Pissarro, 6 Dec. 1873, pub. in L. Venturi, *Les Archives de l'Impressionnisme*, Vol. 1, Paris, 1939, p. 36.

16 Duret to Pissarro, 11 Dec. 1874 (Fondation Custodia, Netherlands Institute, Paris).

17 A. Silvestre in *L'Opinion*, 2 Apr. 1876, repr. in *Archives de l'Impressionnisme*, Vol. 2, p. 284.

18 Philippe Burty in *La République Française*, 25 Apr. 1874; repr. in *Archives de l'Impressionnisme* Vol. 2, p. 292.

19 *Chronique des Arts et de la Curiosité* (supplement to *Gazette des Beaux-Arts*) on the fourth Impressionist exhibition, 1819, No. 16, pp. 126–7.

20 Thanks especially to J. Rewald, op. cit., and J. Lethève, op. cit.

21 Series of articles by G. Riviére in *L'Impressionniste*, a journal created in support of the movement; particularly the number of 21 April 1877, with a long defence of Pissarro.

22 Letter of 9 May 1883 in C. Pissarro, *Lettres à son fils Lucien*, ed. J. Rewald, Paris, 1951; English version, *Letters to his son Lucien*, New York, 1943, p. 30. This no doubt refers to Pissarro's decision not to exhibit at the Salon, despite the advice of most of his fellow-Impressionists.

23 C. Ephrussi, *La Chronique des Arts et de la Curiosité*, supplement to *Gazette des Beaux-Arts*, 16 April 1881.

24 See several letters on this subject in correspondence with Mirbeau, Archives du Louvre, Cabinet des Dessins, and Pissarro's letter to Lucien of 18 Nov. 1891, op. cit., English edn. p. 186.

25 Caillebotte file, Louvre.

26 Cézanne, *Correspondance*, Paris, 1937, p. 275; *Letters*, ed. J. Rewald, London, 1941, p. 268; letter to his son dated 26 Sept. 1906, describing a conversation with Charles Camoin about Émile Bernard, 'an intellectual suffocated by memories of the museums, but who does not look at nature enough, and that is the great point, to make oneself free of the École des Beaux-Arts and indeed of all such schools. So that Pissarro was quite right, though he went a bit far when he said that all the necropolises of art should be burned.'

27 Letter of 5 Jan. 1900 in reply to an enquiry about modern art, Louvre archives (fonds Henraux).

28 According to A. Michel (*Gazette des Beaux-Arts*, 1900, December, p. 528), the Impressionists refused to show their work at the decennial exhibition, while at the centennial, Monet and Pissarro at first refused to do so (cf. letter of 23 Jan. 1900 in *Archives de l'Impressionnisme*, Vol. 1, p. 374). On all these problems see P. Vaisse, *La IIIème République et les peintres – Recherches sur les rapports des pouvoirs publics et de la peinture en France en 1870 jusqu'à 1914* (thesis), to be published in 1980.

29 A. Mellerio, *L'exposition de 1900 et l'impressionnisme*, Paris, 1900; G. Geffroy, *La vie artistique*, series of volumes describing current events, approx. annually from 1892. On Pissarro see esp. Series 1 (1892), 3 (1894) and 6 (1900).

30 *L'Événement*, 20 May 1866; p. 74 of the excellent annotated edition by J. P. Bouillon of Zola's writings on art: E. Zola, *Le bon combat* Paris, 1974.

31 Works by Pissarro were accepted for the Salon in 1859, 1864, 1865, 1866 and 1868; rejected in 1861, 1863, 1867.

32 *Les Naturalistes*, 19 May 1868, repr. in Zola, op. cit., p.107.

33 Ibid., p. 109.

34 Review of second Impressionist exhibition in *Le messager de l'Europe*, June 1876, repr. in Zola, op. cit., p. 185.

35 *Le sémaphore de Marseille*, 19 Apr. 1877, repr. in Zola, op. cit., p. 189.

36 *Le Voltaire*, 18–22 June 1880, repr. in Zola, op. cit., p. 214.

37 See J. Rewald, *Cézanne, sa vie, son oeuvre, son amitié pour Zola*, Paris, 1939.

38 'L'exposition des Indépendants', 1880, repr. in Huysmans, *L'art moderne*, Paris, 1883, p. 105.

39 Ibid., p.236.

40 Ibid., p. 265.

41 Letter of 11 May 1883 from Camille Pissarro to J.-K. Huysmans, Fondation Custodia, Netherlands Institute, Paris.

42 Letter from Huysmans to Camille Pissarro, published by J. Lethève in *Bulletin de la Bibliothèque Nationale*, June 1979.

43 Letter of 13 May 1883, op. cit., p. 44, English edn. p. 32.

44 Anon. (authors: Félix Fénéon, J. Moréas, Paul Adam, Oscar Méténier), 1886, p. 109.

45 Letter of 29 May 1894 to Lucien, op. cit., English edn. p. 241.

46 Albert Aurier, 'Le symbolisme en peinture', *Mercure de France*, 9 Feb. 1891, repr. in *Oeuvres posthumes*, Paris, 1893, pp. 208 and 11.

47 *Journal de Bruxelles*, 15 June 1885, repr. in *Sensations*, Brussels, 1927, p. 180.

48 Camille Pissarro to Durand-Ruel, Dec. 1892, repr. in *Archives de l'Impressionnisme*, Vol. 1, p. 11.

49 *Le Gil Blas*, 14 May 1887 (not repr. in *Des Artistes*, Paris, 1922).

50 George Moore, *Confessions of a young man*, London, 1888, repr. 1928, p. 38.

51 Review of eighth Impressionist exhibition, *La Vogue*, 13/20 June 1886, repr. as a booklet and in Fénéon, *Au delà de l'impressionnisme*, Paris, 1966, p. 58 ff., also in Fénéon, *Oeuvres plus que complètes*, ed. Joan U. Halperin, Vol. I, Geneva and Paris, 1970, p. 37. Even before Pissarro's 'conversion', the critic Roger Marx pointed out that he was the impressionist painter whose technique most closely resembled that of Seurat. 'These artists apply with skill, and even with considerable severity, the system of multicoloured touches so dear to M. Pissarro' (*Le Voltaire*, 10 Dec. 1884).

52 *La Cravache*, 2 June 1888; repr. in Fénéon, op. cit., 1970, Vol. I, p. 127.

53 *L'art moderne de Bruxelles*, 14 Feb. 1892; repr. in Fénéon, op. cit., Vol. I, p. 209, 'La môme Cataplasme': *môme* is slang for 'girl', *cataplasme* means a poultice or plaster. Presumably the allusion is to a café-concert singer or courtesan of the period (cf. Lautrec's *'la Goulue'* or *'la môme fromage'*), or possibly the heroine of a risqué song. In any case the name suggests an ardent, enveloping kind of female, the antithesis to Pissarro's placid, virtuous peasant women.

54 *Le Figaro*, 1 Feb. 1892, repr. in *Des Artistes*, 1st series, Paris, 1922 p. 145 f.

55 20 Nov. 1883 op. cit., p. 68, English edn. p. 47.

56 *La Gironde*, 19 May, 1 Jun. 1868.

57 As is well known, Degas's anti-Semitism led him into irrational abuse of Pissarro at the time of the Dreyfus case, but this should not invalidate the previous record of a lifelong friendship.

58 Letter of 10 Oct. 1891 from Camille Pissarro to O. Mirbeau, Archives du Louvre, Cabinet des Dessins.

59 Conversation with Le Bail recorded by J. Rewald in *Cézanne et Zola*, op. cit., p. 283.

60 Quoted by Jules Borély (1902), published in *L' Art Vivant*, No 2, 1926, p. 493, and in *Conversations avec Cézanne*, présentées par P. M. Doran, Paris, 1978, p. 21.

61 Letter to Émile Bernard, 1905, in Cézanne, *Correspondance*, 1937, p. 276; *Letters*, 1941, p. 251.

62 First recalled by J. Rewald in *Cézanne et Zola*, op. cit., and frequently since.

63 A. Segard, *Mary Cassatt*, Paris, 1913, p. 45.

64 Letter of winter 1890/1 in Berthe Morisot, *Correspondance*, ed. D. Rouart, Paris, 1950 p. 157.

65 Letter to Émile Bernard in *Lettres de Gauguin à sa femme et à ses amis*, ed. M. Malingue, Paris, 1946, p. 172 (English translation, London, 1948, p. 128).

66 See, e.g., *Lettres*, op. cit., p. 133 (to Schuffenecker), p. 180 (to Madeleine Bernard).

67 Letter to his son, 20 Nov. 1883, op. cit., p. 68, English edn. p. 47.

68 Letter to his son, 13 Jun. 1883, op. cit., p. 35, English edn. p. 50.

69 Letter of 14 Aug. 1888, op. cit., p. 134 (English edn. p. 100).

70 P. Gauguin, review of *Exposition de la libre esthétique*, Brussels, in *Essais d'art libre*, Feb.–Apr. 1894, not republished.

71 Gauguin, *Racontars de rapin* (1902), pub. by Mme. Joly-Segalen, Paris, 1951.

72 He owned some of them, however, and lent one to the retrospective exhibition of 1892, after Van Gogh's death.

73 For example he wrote to his brother Théo on 21 May 1890 expressing admiration for a picture by Pissarro in the possession of Dr. Gachet: *Further letters of Vincent*

Van Gogh to his brother, 1886–1889, London and New York, 1929, p. 455.

74 Letter of 25 June 1889, op. cit., p. 350.

75 Letter of Sept. 1889, op. cit., p. 391.

76 Letter of Camille Pissarro to Durand-Ruel, repr. in *Archives de l'Impressionnisme*, Vol. 2, p. 24.

77 Conversation with Matisse recorded in G. Duthuit, *Les Fauves*, Geneva, 1949.

78 This can be seen from the seven drawings by Seurat bequeathed to the Louvre by Pissarro (Cabinet des Dessins).

79 See the valuable work by E. W. Herbert, *The artist and social reform, France and Belgium, 1885–1898*, Yale University Press, 1961.

80 P. Signac, *D'Eugène Delacroix au Neo-Impressionnisme*, Paris, 1899, repr. 1978, Chap. III, p. 87 ff.

81 *Extraits du journal inédit de P. Signac*, 14 Dec. 1894, pub. by J. Rewald in *Gazette des Beaux-Arts*, July–Sept. 1949, p. 112. In praising Pissarro's more naive and more spontaneous work prior to his acceptance of the *pointilliste* discipline, Signac expressed his own natural inclination towards impressionism and even proto-impressionism, since it was Jongkind – whom he had come to know through Pissarro – that he himself soon took as his model for water-colour painting.

82 Bonnard's remark recorded by Angèle Lamotte, 1943, republished in *Verve*, special number on Bonnard, 1947.

83 Maurice Denis, 'C. Pissarro', *L'Occident*, Dec. 1903, repr. in *Théories* ed. Hermann, Paris, 1964, p. 149ff.

84 Félix Vallotton, 'L'exposition Pissarro', *Gazette de Lausanne*, 24 Feb. 1892.

85 From 1898 onwards Francis Picabia was a friend of Pissarro's two younger sons, Rodolphe and Georges Manzana.

86 'Cézanne, un moment de l'artiste . . . Sisley, un moment de la nature': quoted in Alfred H. Barr, *Matisse his art and his public*, New York, 1951, p. 38; cf. H. Matisse, *Écrits et propos sur l'art*, ed. D. Fourcade, Paris, 1972.

87 Preface to P&V, p. 71.

88 Sickert in *The New Age*, 28 July 1920, repr. in *A Free House*, London, 1947, p. 91.

Camille Pissarro in gaucho costume

Chronology

Janine Bailly-Herzberg

1830 10 July: birth of Jacob Abraham Camille 'Pizarro' at Charlotte Amalie, capital of St. Thomas, Virgin Islands. His father, Frédéric Pissarro, was a businessman who migrated from Bordeaux in 1824; his mother, Rachel Pomié-Manzana, was the widow of Isaac Petit. Both were practising Jews. Camille had two half-sisters, Delphine and Emma (who married Phineas Isaacson), and three brothers.

1842 Camille is sent to boarding-school at Passy in the suburbs of Paris. The headmaster, M. Savary, discovers and encourages his gifts as a painter. He probably spends school holidays with his paternal grandfather and uncle, then living in Paris.

1847 He returns to Charlotte Amalie, where his father takes him into the family business.

1852 In or before April he decides to go to Venezuela with Fritz Melbye, a Danish painter living in St. Thomas. They arrive at Caracas on 12 November. For the next two years Camille mixes with the local intelligentsia.

1853 August: death of Camille's brother Gustave.

1855 Camille definitely decides to give up a business career and return to France. He arrives at Passy, where his relatives are, on about 15 October. He visits the World Exhibition and, no doubt, the Courbet pavilion, and is impressed by Corot and Delacroix. His half-sister Delphine dies on 24 October.

1856 Pissarro works at 49, rue Notre Dame de Lorette, Paris and later at the studio of Fritz Melbye's brother, Anton at 18, rue de la Ferme des Mathurins, Paris. Towards September he has a studio at 16, rue Notre Dame de Lorette, and lives with his family at La Muette.
 Fritz Melbye arrives in Paris, where he stays till July 1857. Pissarro probably visits Montmorency.

1857 Pissarro spends the summer at Montmorency with his family, and paints from nature, following Corot's advice. He is joined by the Danish painter David Jacobsen, and at the end of August they visit La Roche-Guyon (Val d'Oise) and Fourges (Eure).

1858 Lives at 12, rue de la Pompe, Paris with his family, and later at 54, rue Lamartine, Paris. In August, at La Roche-Guyon. His parents make him a monthly allowance.

1859 At 38 bis, rue Fontaine Saint-Georges, Paris. Submits his first painting for the Salon. During the summer, stays at Montmorency with his family and at La Roche-Guyon with Jacobsen and Oller, a painter from Puerto Rico. Occasionally visits a 'free studio' in the rue Cadet and the Académie Suisse, on the quai des Orfèvres, where he becomes a friend of Monet.

1860 At 39, rue de Douai, Paris. Meets Chintreuil and Jean Desbrosses, perhaps through Corot. In July, stays at Lille and Bérelles with the painter P. Lecreux, a fellow-user of the Académie Suisse.
 About this time Julie Vellay, a vine-grower's daughter from Burgundy, enters the service of Mme. Pissarro and she and Camille form a liaison.

1861 Ludovic Piette from Montfoucault (Mayenne) uses Pissarro's studio. He becomes Pissarro's closest friend, and the latter's portrait of him no doubt dates from this time. Pissarro registers as a copyist at the Louvre in April and, at the Académie Suisse, makes the acquaintance of Guillaumin and Cézanne.

1862 Camille works at 23, rue Neuve Bréda, Paris with Jacobsen. Julie works as assistant in a flower-shop.

1863 Pissarro's son Lucien born in Paris. Spends the summer with his family at La Varenne-sur-Maur. Cézanne and Zola visit his studio. He becomes a member of the *Société des Aquafortistes* (but significantly did not exhibit with the *Société*), founded by Cadart, and makes his first prints.

1864 At 57, rue de Vanves, Paris, and La Varenne-sur-Maur. Also stays with Piette at Montfoucault.

1865 Camille's father dies. His daughter Jeanne-Rachel is born at La Varenne, Antoine Guillemet being her godfather.
 Pissarro sells very few paintings and has to pawn property, despite an allowance from his mother. At the end of the year he takes a job as a lawyer's messenger. In October he is probably at La Roche-Guyon with Guillemet. Sees much of Cézanne and Oller.

1866 January at 1, rue du Fond de L'Hermitage, Pontoise. September: at 108, boulevard Rochechouart, Paris. Is introduced to Manet: and attends Zola's 'Thursdays'. Regular meetings at the Café Guerbois, Batignolles, and Bazille's studio, with Monet, Renoir, Sisley and others. Guillemet at Pontoise in September.

1867 At rue du Fond de L'Hermitage, Pontoise, and rue Foyatier, Paris. Monet and his friends plan a rival exhibition to the Salon, following Courbet's example, but the project fails.

1868 At 108, boulevard Rochechouart, Paris; April–October, at Pontoise; November, at 23, rue Chappe, Paris.
 On 20/29 January his half-sister Emma dies in London. In April Julie is godmother to Monet's son Jean. Père Martin, the art dealer, takes an interest in his work. His economic situation is very difficult; he paints blinds and shop signs with Guillaumin.

1869 From 3 May or earlier at Louveciennes: Maison Retrou, 22, route de Versailles, close to the Marly aqueduct. Probably stays with the painter Vuillefroy at Chailly, where he decorates Père Barbey's hostelry.

1870 19 July: outbreak of the Franco-Prussian war. At the end of September, as the Prussians continue to advance, Pissarro and his family flee from Louveciennes, leaving paintings and furniture behind, and take refuge with Piette at Montfoucault, where they arrive on 27 July. Pissarro, to his regret, is unable to fight for France because of his Danish nationality and family ties. His second daughter, Adèle-Emma, is born at Montfoucault on 21 October and dies on 5 November. At the beginning of December he and his family reach London.

1871 At Canham's Dairy, Westow Hill, and afterwards at 2 Chatham Terrace, Upper Norwood, Surrey. Through Daubigny he meets in January the dealer Paul Durand-Ruel.

In the London collections he takes a particular interest in Turner, Constable and Old Crome.

He marries Julie at Croydon on 14 June, and at the end of the month they return to Louveciennes, where they find their house has been requisitioned and pillaged. M. Ollivon, a municipal councillor, has saved some items of furniture and about forty out of 1,500 paintings representing 'twenty years' work'. Pissarro applies for war compensation of 51,156 frs. but receives only 835 frs. His second son, Georges, is born on 22 November.

1872 Besides Martin, Pissarro deals with père Tanguy, who had apparently sold only three of his canvases by 1880. Béliard and Guillaumin rejoin Pissarro at Pontoise, and Cézanne subsequently establishes himself at Auvers-sur-Oise. Pissarro recommends Cézanne to Tanguy, and Sisley and Monet to his (Pissarro's) cousin Alfred Nunès.

1873 At 10 (afterwards 26) rue de L'Hermitage, Pontoise; in July at 21, rue Berthe, Montmartre. Pissarro's interest in Japanese art is strengthened by Théodore Duret, who returns from Asia in January and buys Pissarro's works.

Others who take an interest in his work are the merchants and bankers Albert and Henri Hecht, Achille Arosa, the singer Faure, Étienne Baudry.

He recommends Monet and Cézanne to Duret. Pissarro and Monet plan to form a permanent cooperative society of painters of their group, after the fashion of a trade guild, so as not to be subject to the partial decisions of the Salon jury, which, as Daubigny remarks, are 'absurd'.

Cézanne, who is still at Auvers, copies a work by Pissarro; mutual influence. Pissarro, Guillaumin and Cézanne practise etching at the suggestion of Dr. Gachet, himself a printmaker, who has a studio for the purpose in his house at Auvers. Each of them marks his work with a distinctive sign, Pissarro using a floret.

1874 At 26 (from April, 18 bis) rue de L'Hermitage, Pontoise. 13 January: Hoschedé sale at the Hôtel Drouot, a

success for the Impressionists; out of six works by Pissarro, the dealer Hagerman buys five for 1,850 frs. Durand-Ruel suspends purchases owing to the economic crisis in France.

6 April: death of Pissarro's daughter Jeanne (Minette).

April–May: first Impressionist exhibition, including five landscapes by Pissarro, who has Cézanne invited to join the group known as the *Société anonyme des artistes, peintres, sculpteurs, graveurs etc.* (which is dissolved in December). One of them, A. de Molins, recommends Pissarro to the banker Gustave Arosa, Gauguin's guardian.

May–June: Oller, destitute in Paris, sells paintings by Pissarro which he had purchased before 1870.

24 July: his third son, Félix (Titi), born at Pontoise.

About 15 August Pissarro and his family go to stay with Piette at Montfoucault. Greatly discouraged and missing the help of Durand-Ruel, he entrusts his 'little business matters' to Guillaumin.

He returns to Pontoise at the end of summer, but goes back to Montfoucault about 20 October. Executes a group of twelve lithographs.

1875 Spends the beginning of the year at Montfoucault, where he makes a will for no evident reason. Returns to Pontoise at the beginning of February.

On 24 March the Impressionists organize a sale at the Hôtel Drouot, with poor results. Pissarro does not take part. On Duret's advice he paints scenes with figures and animals.

1876 February–March: Piette at Pontoise.

His chief collectors are A. Personnaz, V. Chocquet, de Bellio, Caillebotte, Dubourg and Latouche.

'Wednesday' dinners with the group at the house of Eugène Murer, pastrycook and art collector.

In the autumn Pissarro takes his family to Montfoucault. He has ideas of painting ceramics, which are easier to sell.

1877 Mary Cassatt tries to help him.

28 May: Impressionist sale at Hôtel Drouot, with five works by Pissarro; mediocre result.

8 November: Murer organizes a lottery with works by Pissarro.

1878 End of October: takes a *pied-à-terre* at 18, rue des Trois Frères, Montmartre.

15 April: Ludovic Piette dies at Montfoucault; Pissarro looks after his affairs.

First fan known to be painted by him.

5–6 June: Hoschedé sale; three works by Pissarro fetch good prices. Financial relations with A. Legrand and Portier, but Martin abandons him.

Through Desboutin, meets the Florentine critic Diego Martelli.

Through Legrand, experiments in painting on English cement.

21 November: his fourth son, Ludovic-Rodolphe, born in Paris.

1879 To pay his debts, he invites Murer and Caillebotte to buy five paintings each at 100 frs.

Gauguin, a collector of Pissarro's work for some

The artist's studio at Eragny-sur-Epte

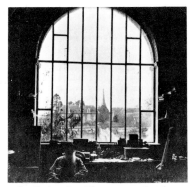

Studio interior: Pissarro seated at the window with the village beyond

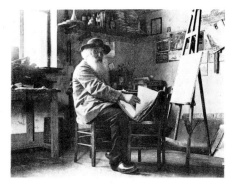

The artist examining a portfolio in his studio at Eragny-sur-Epte

The artist's mother, Rachel, seated in her armchair

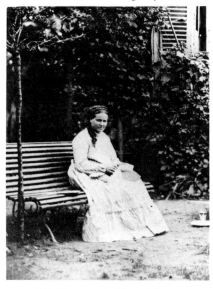

Julie Pissarro seated in a garden

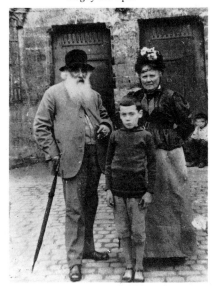

Camille and Julie Pissarro with Paul-Emile

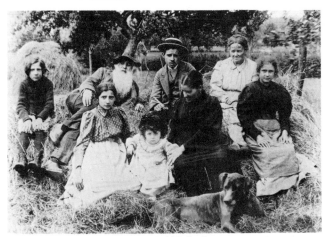

Pissarro and his family

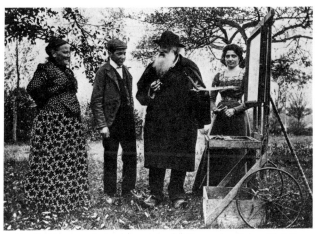

Camille Pissarro painting in an orchard at Eragny-sur-Epte with Julie, Paul-Emile and Jeanne (Cocotte)

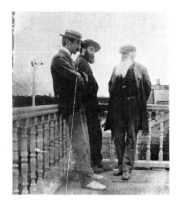

Camille Pissarro with Lucien and
Félix Pissarro in London, 1897

The Pissarro family in a field overlooking Eragny-sur-Epte

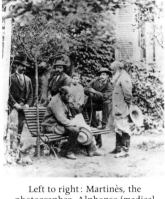

Left to right: Martinès, the
photographer, Alphonso (medical
student and amateur painter),
Cézanne, Lucien, Aguiard (from
Cuba), and Camille

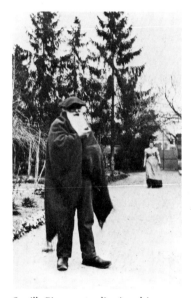

Camille Pissarro standing in a driveway
wrapped in a rug

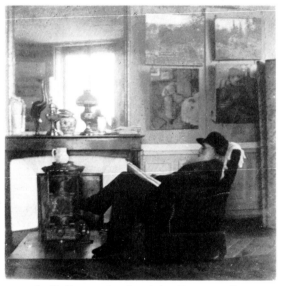

Camille Pissarro asleep in a chair at Eragny-sur-Epte

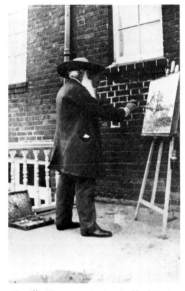

Camille Pissarro painting *Bedford Park,
Jubilee Fête* (P&V 1005, 1007 or 1008)

Paul Cézanne

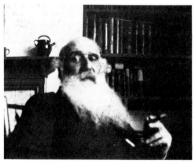

Camille Pissarro seated smoking a cigar

Camille Pissarro with Paul
Cézanne

Contemporary photographs kindly supplied by Claude Bonin and John Bensusan-Butt

years past, comes to paint at Pontoise in the summer.
Evenings at the Nouvelle Athènes café. Pissarro produces eleven etchings, mostly printed at Degas's studio.

1880 Failure of Degas's journal *Le Jour et la Nuit*, which had been designed to publish original prints and on which Pissarro should have collaborated.

1881 About July: at 85, quai de Pothuis, Pontoise.
February: Durand-Ruel starts buying from the Impressionists again, thanks to Feder, director of the Banque de l'Union Générale.
In summer he is visited at Pontoise by Cézanne, Gauguin and Guillaumin. 27 August: birth of his daughter Jeanne (Cocotte).

1882 1 December: at Osny near Pontoise.
January: the Union Générale fails, putting Durand-Ruel in difficulties.
On Gauguin's advice Pissarro takes to sculpting (cows).

1883 On 13 July Pissarro leaves the rue des Trois Frères.
Manet dies on 30 April.
May: Durand-Ruel's first exhibition devoted to Pissarro's work, at 9, boulevard de la Madeleine.
15 June–5 July: Gauguin, at Osny, suggests to Pissarro that they make impressionist tapestries together, but the project fails.
October–November: at Murer's hotel at Rouen.

1884 4 April: Pissarro leaves Osny for Eragny-sur-Epte, near Gisors, where he resides henceforth.
Durand-Ruel is still financially embarrassed; Pissarro, forced to sell his canvases 'for a song', does many watercolours for Heymann, Portier, Latouche and Cluzel.
Foundation of the first *Société des Artistes Indépendants*. Pissarro does not join it, as he is still linked with the Impressionists.
8 August: birth of Pissarro's youngest child, Paul-Émile.
For the past year Pissarro has been reading *Le Prolétaire*, a *socialiste possibiliste* newspaper, and the works of Proudhon, Zola and Flaubert. He is an admirer of Keene and Daumier.

1885 January: he refuses to attend a memorial banquet for Manet, considering it too 'official'. Impressionist dinners are instituted.
Autumn: meets Signac at Guillaumin's studio and Seurat with Durand-Ruel.
Adopts libertarian anarchist ideas and reads Jean Grave's *Le Révolté* (subsequently entitled *La Révolte* and *Les Temps Nouveaux*).

1886 Attends banquet of the *Indépendants*.
Durand-Ruel's money troubles continue, and Pissarro falls more and more into debt. He contacts other dealers and collectors, including Kahn, painting many fans in gouache.

March: Durand-Ruel visits America, sending ahead of him 300 pictures including forty by Pissarro, with reasonable success, and the horizon clears somewhat.
Impressionist dinner with George Moore, Mallarmé, Huysmans and others. Strong attack on Zola's *L'Oeuvre*.
Pissarro is enthusiastic about *pointillisme*, 'A new phase in the logical progress of Impressionism'.
May–June: eighth and last Impressionist exhibition. In a room devoted to Neo-Impressionism are works by Pissarro and others by Seurat, Signac, and Lucien Pissarro.
He makes the acquaintance of Vincent van Gogh and Octave Mirbeau.
July: receives Celen Sabbrin's pamphlet *Science and philosophy in art*, which he admires and translates for Lucien.
September: Fénéon's article on the Neo-Impressionists published in *L'Art Moderne*.
November: Pissarro sends Durand-Ruel a biographical note on 'his new artistic doctrines' and asks not to be separated from Seurat, Signac, Dubois-Pillet and Lucien Pissarro.

1887 January: meeting at Asnières with Seurat, Fénéon and Signac; sells a picture to Seurat's mother.
Suggests unsuccessfully to Durand-Ruel, Dubois-Pillet (perhaps at Rouen) and Murer that they should buy the whole of his studio-full of paintings 'in the old manner'.
Long stays in Paris, attempting to sell watercolours and *au point* drawings at 10 and 20 francs each. Sells from his collection a pastel by Degas and a bronze by Barye.
Increasing dissension between the followers of Gauguin and Seurat, Pissarro belonging to the latter group.
He visits the exhibition organized by Vincent van Gogh at the Café Tambourin near the Place Clichy.
March–May: notices a painting by Luce at the exhibition of the *Indépendants*; they become friends.
Evenings at La Taverne Anglaise with writers for *La Revue Indépendante* and *La Vogue*; offers a pastel to Fénéon; first contact with Emile Verhaeren.
Dr. de Bellio gives homoeopathic treatment to the Pissarro family.
September: contact with Théo van Gogh, manager of the Boussod-Valadon gallery of modern art, to whom Pissarro entrusts works for sale.

1888 Many of Pissarro's works for sale with Théo van Gogh and Durand-Ruel: average price 500 frs., as compared with 30,000 frs. for a painting by Luigi Loir.
July: Luce and Gausson at Eragny.
August: Pissarro and Luce visit Gausson at Lagny, where they meet Cavallo-Peduzzi.
September: Pissarro contracts the eye infection from which he suffers for the rest of his life.

1889 30 May: his mother dies. Difficulties over her estate.
September: he recommends Vincent van Gogh to Dr. Gachet. Tabarant founds the *Club de l'Art Social*, where Pissarro meets him.

1890 January: he sends his London nieces an album of anarchist drawings, *Les turpitudes sociales*. Meets

G. Lecomte through Fénéon.

March: two etchings are bought for 80 frs. by the Administration des Beaux-Arts.

5 May: death of his brother Alfred.

May–June: stays in London with Lucien and Luce.

28 July: death of Vincent van Gogh.

1891 29 March: death of Seurat.

Much trouble throughout the year with his eye infection; operation in July, after which he does not paint out of doors for some time.

October: Mirbeau endeavours to persuade Chéramy, Gallimard and the Administration des Beaux-Arts (Roujon) to buy works by Pissarro. In November he sells a canvas to Rodin for 500 frs. thanks to Mirbeau's efforts.

December: with Mirbeau at Les Damps near Pont-de-l'Arche (Eure). On 12 December Camille, Julie and Mirbeau see the first performance of Maeterlinck's *Les Aveugles*.

1892 Leaves the rue de l'Abreuvoir at the beginning of October.

Anarchistic atrocities by Ravachol and others. Pissarro disapproves of them but provides financial help for families of arrested and exiled anarchists.

May–August: visits London, accompanied by Luce. Buys the house at Eragny. Monet lends him 15,000 frs.

September: stays with Mirbeau at Les Damps. Reads Claudel, Ibsen, Kropotkine.

1893 Stays at Hôtel Garnier, 111, rue St.-Lazare, Paris.

May: special number of *La Plume* on the subject of anarchy, with a drawing by Pissarro.

April–July: renewed inflammation of the eye, and operation. Durand-Ruel again asks for paintings of figures, and he works at the theme of peasant women bathing.

Publication of the album *Les travaux des champs*.

August: forgeries make their appearance, signed 'Pissarro' without the initial 'C'.

5 December: Durand-Ruel relieves him of money troubles by purchasing works to the value of 23,600 frs.

1894 January: buys his first press for print-making from Auguste Delâtre. Series of bathing women, etchings and lithographs; in May, works on coloured etchings. Tentatively plans to exhibit prints with Mary Cassatt.

First commercial contact with Vollard: gives him a painting of his own in exchange for a Manet, and persuades him to organize a Cézanne exhibition.

Although Pissarro was at Eragny at the time of the anarchist outrages, he fears trouble on account of his political sympathies.

Beginning of June to end of September: visits Belgium with Julie and their son Félix. At Brussels, Bruges and Knocke-sur-Mer with Théo van Rysselberghe, at whose home he stays. Meets Henry van de Velde. Trip to Zeeland with van Rysselberghe and Elisée Reclus.

August: his friends Jean Grave, Luce, Fénéon and S. Faure are involved in the trial of anarchists known as 'trial of the thirty'.

This year sees the death of de Bellio, Caillebotte, Tanguy, Contet and Cluzel. Thanks to Caillebotte's will the Musée du Luxembourg acquires its first impressionist works, including some by Pissarro.

1895 January: van Rysselberghe and his wife at Eragny. Pissarro continues to work at lithography on stone and zinc.

February: Durand-Ruel lowers his selling prices; nevertheless Pissarro leaves with him thirteen canvases which fetch the derisory sum of 10,000 frs.

April: short stay at Rouen with Dario de Regoyos. At Lilla Cabot Perry's in Paris he meets several Americans including John La Farge.

May: promises that he and his son will work for Grave's new anarchist paper, *Les Temps Nouveaux*. Admires Monet's *Cathedrals* exhibition (where he meets Cézanne). Van Rysselberghe visits Eragny.

September: Luce spends a fortnight at Eragny.

October: Pissarro decides to sell ten canvases for 9,000 frs. Another case of forgery: gouaches by Piette, signed 'Pissaro' (*sic*).

1896 January–March: stays at Hôtel de Paris, Rouen, in a room with a harbour view.

Links with the *Revue Blanche* critics Fénéon, Dujardin, Lecomte and Edmond Cousturier; these become less close when the critics support Symbolism.

27 March: letter to H. van de Velde explaining why he adopted and then abandoned 'systematic division'. Repays Monet's loan.

June: short trip to Canteleu and Rouen. Arnold of Dresden sells some of his prints and two paintings.

September–November: stays at Hôtel d'Angleterre, cours Boieldieu, Rouen, in a third-floor room with harbour view. Sees Joseph Delattre, Charles Angrand, and the collectors Décap and Depeaux.

Congratulates Bernard Lazare on his pamphlet about anti-Semitism.

October: approves Mirbeau's articles against the 'Symbolos'.

1897 January: Durand-Ruel refuses nine gouaches on peasant subjects, commissioned in November 1896. Stays at Hôtel Garnier, Paris.

February: at Hôtel de Russie, 1 rue Drouot.

May–July: in London, where Lucien is ill.

October: Durand accepts canvases painted in England.

November: a collector presents a Pissarro to the Berlin Museum.

27 November: death of his son Félix, in London.

1898 January–April: at Hôtel du Louvre, Paris.

13 January: congratulates Zola on his pro-Dreyfus article 'J'accuse' in *L'Aurore*.

February: Matisse offers him a studio.

June–July: visits Troyes, Châtillon-sur-Seine, Grancey-sur-Ource, Dijon, Macon, Lyons and Cluny.

July–October: Hôtel d'Angleterre, Rouen.

October: at Amsterdam. Admires the Rembrandt exhibition, and meets Zandomeneghi.

1899 January: rents an apartment at 204, rue de Rivoli, Paris.

29 January: death of Sisley.

June: several public sales; good response.

September–October: at Varengeville-sur-Mer.

November: short stay with Georges at Moret-sur-Loing.

1900 November: 28, Place Dauphine, Paris.

July–September: at Dieppe and Berneval.

1901 Plays off Durand-Ruel against his other principal dealer, Bernheim Jeune.

March: Van Gogh exhibition held by Bernheim. Pissarro lends *Les Murier (sic)*.

April–May: with Georges at Moret-sur-Loing.

May: makes over nine canvases to Durand-Ruel for 24,000 frs. Portier sells a painting to an American for the exceptional price of 15,000 frs.

June: travels to find a suitable place for his summer 'campaign': Dieppe, Lisieux, Trouville, Villers-sur-mer, Caen.

July–September: Hôtel du Commerce, place Duquesne, Dieppe, with a view of the market and the west front of St. Jacques. Rents a chalet for his family at Berneval.

End of September: short visit to Moret-sur-Loing; then back to Eragny and Paris.

1902 May–June: with Georges at Moret.

July to end of September: Arcades de la Poissonnerie, Dieppe.

August: the Berlin art critic J. Elias buys a picture from him.

December: keeps all the canvases painted at Dieppe, as Durand-Ruel and Bernheim combine to lower prices. Advises Picabia, who is staying at Moret.

1903 Beginning of November: at 1, boulevard Morland.

January: the Dieppe series bought by F. Gérard and Son and other dealers.

March–May: Hôtel du Quai Voltaire, Paris.

July–September: stays at Hôtel Continental, Le Havre (overlooking the harbour). Sells five canvases in Le Havre: two to the Museum, the others to collectors including Pieter van de Velde. Paulin, a dentist and sculptor, does a bust of Pissarro.

29 September: takes part in pilgrimage to Médan on the first anniversary of Zola's death.

13 November: Pissarro dies at 1, boulevard Morland, Paris, and is buried in Père Lachaise cemetery. Julie Pissarro dies in 1926.

Simplified Genealogical Tree of
the Pissarro family based on the researches of
Janine Bailly-Herzberg and Kathleen Adler

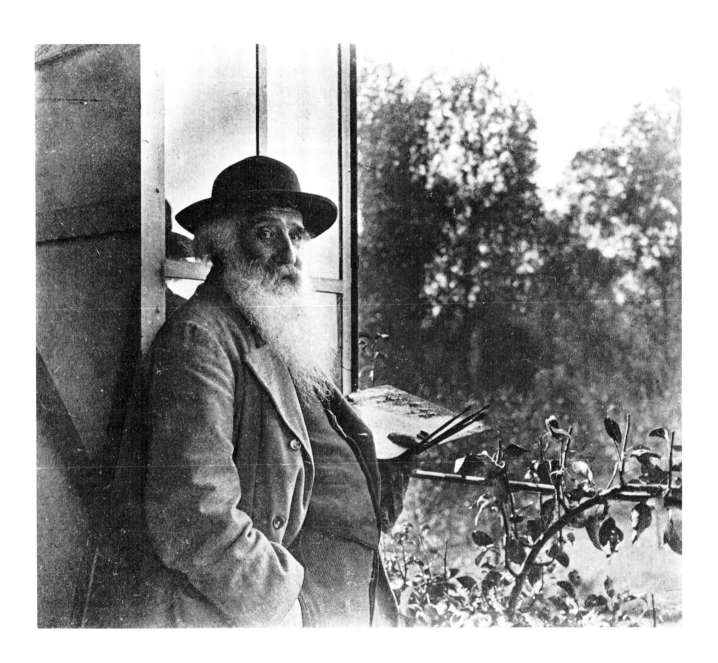

Catalogue of Paintings

Abbreviations

The standard work of reference for Camille Pissarro's paintings, temperas, gouaches and pastels is L.-R. Pissarro and L. Venturi, *Camille Pissarro, son art - son oeuvre* 2 vols., Paris, 1939 (P&V). With one or two exceptions everything cited in the *catalogue raisonné* is reproduced.

For the drawings see R. Brettell and C. Lloyd, *A Catalogue of the Drawings by Camille Pissarro in The Ashmolean Museum, Oxford*. Oxford University Press, 1980 (Brettell and Lloyd).

For prints see L. Delteil, *Le Peintre- Graveur illustré. Pissarro, Sisley, Renoir*, Vol. xvii, Paris, 1923: (D)

For a selection of the artist's letters there is J. Rewald (ed.), *Camille Pissarro. Lettres à son fils Lucien*, Paris, 1950 (*Lettres*).

Other standard works of reference used in this exhibition catalogue are as follows:

Archives	*Archives de Camillle Pissarro*, Paris, Hôtel Drouot, 21 November 1975.
Daulte	F. Daulte, *Alfred Sisley. Catalogue raisonné de l'oeuvre peint*, Lausanne, 1959.
Daulte/Renoir	F. Daulte, *Auguste Renoir. Catalogue raisonné de l'oeuvre peint 1. Figures 1860–1890*, Lausanne, 1971.
Fernier	R. Fernier, *La vie et l'oeuvre de Gustave Courbet. Catalogue raisonné*, 2 vols., Lausanne-Paris, 1977 (Vol. 1), 1978 (Vol. 2).
Hellebranth	R. Hellebranth, *Charles-Francois Daubigny 1817–1878*, Morges, 1976.
Lemoisne	P.A. Lemoisne, *Degas et son oeuvre*, 4 vols., Paris, 1946–8.
Paris, 1975	Robert Herbert, *Jean-François Millet*. Catalogue of exhibition at the Grand Palais, Paris, 17 October 1975–2 January 1976.
Lugt	F. Lugt, *Les Marques de Collections de dessin et d'estampes, Amsterdam*, 1921. Supplement, The Hague, 1956.
Robaut	A. Robaut, *L'Oeuvre de Corot. Catalogue raisonné et illustré précédé de l'histoire de Corot et de ses oeuvres par Etienne Moreau-Nélaton*, 3 vols., Paris, 1905. Supplements by A. Schoeller and J. Dieterle, Paris, 1948 (Vol. 1), 1956 (Vol. 2), 1974 (Vol. 3).
Rouart and Wildenstein	D. Rouart and D. Wildenstein, *Edouard Manet. Catalogue raisonné*, 2 vols., Lausanne-Paris, 1975.
Wildenstein/Gauguin	G. Wildenstein, *Gauguin*, Vol. 1, Paris, 1964.
W	D. Wildenstein, *Claude Monet. Biographie et catalogue raisonné*, 3 vols. continuing, Lausanne-Paris, 1974 (Vol. 1), 1979 (Vols. 2 and 3).
V	L. Venturi, *Cézanne, son art-son oeuvre*, 2 vols., Paris, 1936.

1851–1855

Although born on the island of St. Thomas in the Antilles, at that time a Danish colony, Camille Pissarro attended a school for a short period in France at Passy (1842–47), where he learnt the rudiments of drawing. The significance of this initiation is difficult to assess. On returning to St. Thomas a chance meeting with the Danish artist Fritz Melbye (1826–1896) sometime in 1851–52 was to prove more significant. Pissarro's official *oeuvre* may be said to date from this meeting, and a visit with Melbye to Caracas (November 1852–August 1854) marks Pissarro's first disciplined application as a painter.

Only a dozen or so paintings from this early period have survived, that is, if those like *Coconut palms by the sea, St. Thomas, (Antilles)* (Cat. 1), which was painted shortly after 1855 when Pissarro moved permanently to France, are included. On the other hand, many drawings from this early period are known and several such sheets are included in the present exhibition (Cat. 94–101). Compared with the diversity of subject-matter and the multiplicity of techniques found in these drawings, the paintings are far more restrained in manner and more orthodox in style. Academic tradition, acquired indirectly through Fritz Melbye, forms the basis of these early compositions. Melbye's style is derived ultimately from the Copenhagen Academy of Fine Arts. He had been trained by his brother Anton (1818–1875), who had, in turn, been a pupil of Christoff-Wilhelm Ekersberg (1783–1853) at Copenhagen. It is therefore possible to assert that Pissarro's earliest influences were totally divorced from French art. Artistic developments in France, however, were no doubt recorded in journals and manuals that Pissarro may have been able to obtain on St. Thomas or in Venezuela, but the extent of his use of these sources for his painting has yet to be determined. It would be particularly interesting to discover, for example, if Pissarro knew of Corot's work before he returned to France for good in 1855.

The importance of these early works by Pissarro lies in their subject-matter and confident technique. The depiction of local peasantry in a rural or semi-rural environment was to be one of Pissarro's principal themes, just as urban and marine subjects were also to recur.

I

Coconut palms by the sea, St. Thomas (Antilles) 1856

Cocotiers au bord de la mer, St. Thomas (Antilles)

P&V 8

Canvas. 26.7 × 34.9 cm./10½ × 13¼ in. Signed and dated, lower left: *Camille Pizarro. Paris 1856*

Collection of Mrs. Paul Mellon, Upperville, Virginia

This is one of Pissarro's earliest works. The inscription is now barely legible, but it was customary for Pissarro to use the Spanish spelling of his name on his pictures at this time even in France. Indeed, he appears to have continued doing so until 1858. Only two paintings listed in the *catalogue raisonné* are specifically dated 1854 (P&V 3–4) and must therefore have been completed before the artist's departure for France. The present example, however, together with four other paintings (P&V 5–7 and a previously unrecorded landscape sold Sotheby's 26 April 1967, lot 2 repr.), was executed in Paris, where Pissarro continued for a short time to paint subjects based upon the Antilles or South America.

The present picture, like P&V 6–7, once belonged to Pissarro's friend Anton Melbye, the brother of his former companion Fritz. When Pissarro exhibited at the Salon in 1859 for the first time, he described himself as the pupil of Anton Melbye.

PROVENANCE: Paris, Anton Melbye collection; Mme. Vve. Melbye collection; Le Pecq, Emmanuel Pichon collection (on the basis of an inscription, presumably written by Mme. Melbye, occurring on the back *A mon cher neveu Emmanuel Pichon, Souvenir du 25 mars 1906/Anton Melbye*).

LITERATURE: Rewald, 1936, pp. 141, 143 repr.; Rewald, 1963, repr. p. 11; Pool, 1967, pp. 38–9 repr.; Rewald, 1973, repr. p. 18; Champa, 1973, p. 67 repr.

EXHIBITED: Paris, Durand-Ruel, 1956 (3 repr.).

1855–1869

These are the years when Camille Pissarro fashioned his own individual style of painting, and they represent a considerable expansion in the artist's powers. Indeed, towards the end of the 1860s Pissarro had created some of his most memorable compositions (Cat. 9–12). This rapid development was the direct result of fresh stimuli experienced after reaching France in 1855.

At first Pissarro worked temporarily as an assistant to Anton Melbye (1818–1875), the elder brother of his former companion in South America and a specialist in marine painting, and at the beginning of the 1860s he shared a studio with another Danish painter, David Jacobsen (1821–1871). Already by the end of the 1850s, however, Pissarro had begun to work with Jean-Baptiste-Camille Corot (1796–1875), and through him was led to explore thoroughly many of the motifs painted by members of the Barbizon school. For a time he enrolled in private classes given by official teachers at the Ecole des Beaux-Arts, and it is notable that Pissarro was at this point strictly orthodox in his approach to painting, preparing an oil-sketch before working on a large canvas of impressive proportions suitable for submission to the Salon committee. Eleven of Pissarro's works in all were in fact accepted for exhibition in the official Salon (one in 1859, two in 1864, two in 1865, one in 1866, two in 1868, one in 1869, and two in 1870). Significantly, in the Salon catalogues of 1859 and 1866 Pissarro described himself as the pupil of Anton Melbye, and in those of 1864 and 1865 as the pupil jointly of Anton Melbye and Corot. In the catalogues of the Salons of 1868, 1869, and 1870 Pissarro admits no specific allegiance. Presumably, his submissions to the intervening Salons of the 1860s were refused and in 1863, along with Manet, he exhibited three works in the Salon des Refusés. He was also a signatory of an unsuccessful petition in 1867 to organize a second Salon des Refusés.

Those pictures by Pissarro that were accepted for the official Salons received some critical acclaim, particularly from Zola, Castagnary, and Astruc. Zola, the supporter of Manet and the friend of Cézanne, was especially enthusiastic. The pattern of Pissarro's development, however, kept the painter for the most part out of Paris. Although he retained the use of a studio in the city, he chose to paint and to live in the outlying areas of the Ile de France, such as Montmorency, La Roche-Guyon, La Varenne-Saint-Hilaire, Louveciennes, and Pontoise, depicting those subjects favoured by Corot and his other pupils Antoine Chintreuil, Antoine Guillemet, and Jean Alfred Desbrosses. During this period, too, Pissarro first met the minor painter Ludovic Piette (1826–1878), with whom he became particularly friendly during the following decade. Propinquity to Paris ensured that Pissarro retained his

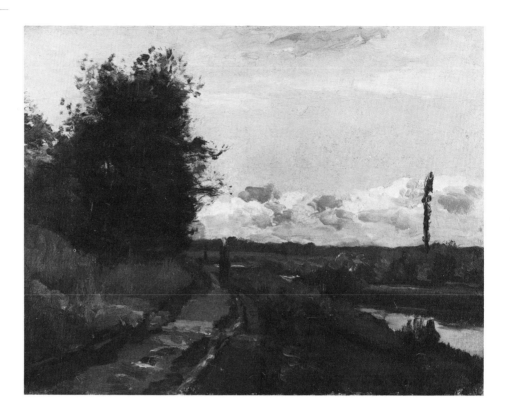

contacts with other artists and with dealers who might be interested in selling his work. It is known, for example, that in the early 1860s at the Académie Suisse, a free drawing school, Pissarro met Monet, Armand Guillaumin, and Cézanne. At the same time (16 April 1861) Pissarro registered as a copyist in the Louvre, although none of his work there has survived.

Undoubtedly those canvases painted in L'Hermitage, an older part of Pontoise, mark the climax of this phase of Pissarro's career. These paintings reveal knowledge of Corot, Daubigny (1817–1878), and Courbet (1819–1877), but Pissarro's own style is not totally dependent upon that of any one of these artists. The canvases of L'Hermitage (Cat. 9–11) possess an acuity of eye, sureness of touch, and undeniable compositional powers. Each painting explores to the full the dramatic potential of an underlying geometric structure. Offsetting this highly disciplined method of working is the light palette and the varied application of paint, often combining brushstrokes with the palette knife. It is, as Zola remarked, a strong and deliberate style as individual as that characterizing the works of Manet or Monet at this date.

2
The towpath 1864

Les bords de la Seine à Bougival
Canvas. 24.4 × 32.4 cm./$9\frac{5}{8}$ × $12\frac{3}{4}$ in. Signed, lower right:
C. Pissarro.
Fitzwilliam Museum, Cambridge (inv. PD 23. 1964)

This is an oil-sketch painted in preparation for the large composition now in the Glasgow Art Gallery and Museum (Cat. 3). On previous occasions the oil-sketch has been entitled *The banks of the Seine at Bougival*, but the exact identification of the stretch of river shown in the finished painting in Glasgow is uncertain.

The picture was not published in the *catalogue raisonné*.

PROVENANCE: H. T. Dunsmuir collection; London, Tooth; London, Sir Edward Cripps (Christie's, 15 July 1955, lot 65), bt. Reid and Lefevre; London, Agnew, from whom purchased by the Fitzwilliam Museum, Cambridge (C. C. Mason Fund), 1964.
LITERATURE: London, Royal Academy, *Impressionism. Its masters, its precursors, and its influence in Britain*, 1974, Introduction to the catalogue, p. 9; Champa, 1973, pp. 70–1 repr.
EXHIBITED: London, Tooth, *Recent acquisitions*, 22 Oct.–16 Nov. 1946 (6); London, Hazlitt, Gooden and Fox, *Landscapes from the Fitzwilliam Museum, Cambridge*, 20 Jun.–12 Jul. 1974 (42 repr.).

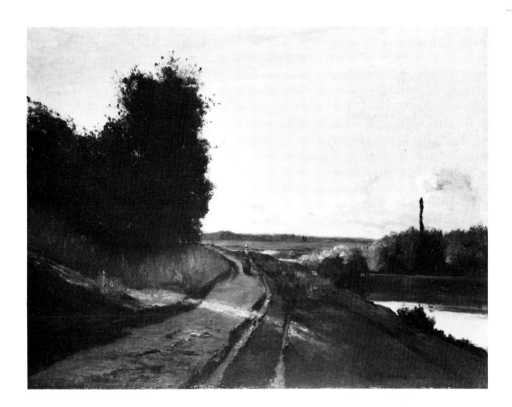

3 EXHIBITED IN LONDON ONLY
The towpath 1864

Le chemin de halage
Canvas. 81.9 × 107.9 cm./32¼ × 42½ in. Signed and dated, lower
right: *C. Pissarro. 1864.*
Glasgow Art Gallery and Museum, Glasgow (inv. 2934)

The painting, which is not recorded in the *catalogue raisonné*, can
almost certainly be identified with one of those exhibited in the
Salon of 1864, but it is by no means certain whether it is *'Bords de la
Marne'* or *'La route de Cachalas à la Roche-Guyon'*. It is unlikely to
be the latter, as is sometimes suggested, because the terrain shown
in the painting does not match that of the area of La Roche-Guyon.
The small village on the right bank of the Seine a short distance to
the west of La Roche-Guyon is in fact called Clachaloze and not
Cachalas. A statement made in the 1953 catalogue of the Glasgow
Art Gallery and Museum to the effect that the signature was added
later cannot now be substantiated. The picture was cleaned on
accession in 1951.

This is one of the few instances where both the oil-sketch (Cat. 2)
and the finished painting have survived, the basic difference
between them being tonal, as though the artist cautiously felt the
need to stabilize the composition by working with a more subdued
and unified palette. Pissarro has also retreated slightly from the
scene in the finished painting, thereby diminishing the stature of
the figure, who, none the less, still serves as the pivot for the whole
picture.

The procedure of working from an oil-sketch to a finished
composition is wholly conventional. Here, however, the
progression is not an additive process completing the composition
with an accumulation of detail, but more of a reflective one, which
was ultimately for Impressionism to result in the gradual
elimination of the division between these two types of painting.

PROVENANCE: Berlin, Goldschmidt collection; London, Herbert Einstein; London,
Reid and Lefevre, by whom sold to the Trustees of the Hamilton Bequest for
presentation to Glasgow Art Gallery and Museum, 1951.
LITERATURE: Tabarant, 1924, p. 17; T. J. Honeyman, *A catalogue of French paintings.
Glasgow Art Gallery and Museum*, Glasgow, 1953, p. 43 repr.; *Glasgow Art Gallery
and Museum. French school. ii. Illustrations*, Glasgow, 1967, repr. p. 91; Rewald,
1973, p. 136 n. 22; Champa, 1973, pp. 70–1 repr.; Brettell, 1977, pp. 245 and 247;
Lloyd, 1979, p. 4 repr. col.
EXHIBITED: Paris, Salon, 1864 (1558, *Bords de la Marne* or 1559, *La route de Cachalas
à la Roche-Guyon*); Belfast, Museum and Art Gallery, *Nineteenth and twentieth
century French paintings*, 2 Dec.–31 Jan. 1958–9 (14); Sheffield, Graves Art Gallery,
Picture of the month, Feb. 1960; Cardiff, National Museum of Wales, *How
Impressionism began*, 16 Jul.–21 Aug. 1960 (29); London, Royal Academy, *Primitives
to Picasso*, Winter Exhibition 1962 (247); Glasgow, Art Gallery and Museum, *The
Hamilton Bequest*, 9 Aug.–1 Oct. 1967 (52 repr.); Glasgow, Art Gallery and Museum,
The Hamilton Bequest – 1927–1977, 14 Sept.–30 Oct. 1977 (54 repr.).

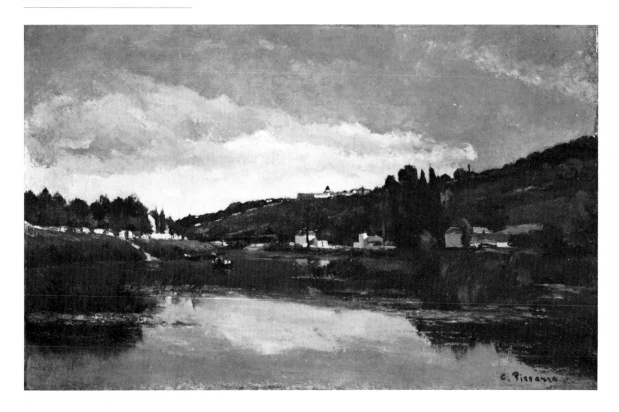

4 EXHIBITED IN PARIS ONLY
The banks of the Marne at Chennevières
1864–5

Bords de la Marne à Chennevières
P&V 46
Canvas. 91.5 × 145.5 cm./36 × 57¼ in. Signed, lower right:
C. Pissarro.
National Gallery of Scotland, Edinburgh (inv. 2098)

There can be little doubt that *The banks of the Marne at Chennevières* was one of two landscapes exhibited in the Salon of 1865, the other being *Le bord de l'eau* (1724). During the 1930s the picture was consistently and misleadingly referred to as *The banks of the Seine*.

The composition owes a great deal to the panoramic views of the rivers Oise and Seine undertaken by Daubigny during the 1850s and 1860s, such as *The banks of the Seine at Bonnières* of 1857 (Hellenbranth 76). The broad technique, however, resulting from the use of the palette knife, resembles that of Courbet. The treatment of the architectural features is particularly striking. As in *The banks of the Marne in winter* (Cat. 6), Pissarro displays highly developed powers of visual analysis in reducing the landscape motif to its basic elements. Certain passages, notably the buildings and the reflections in the water, assume abstract forms when seen in isolation.

A drawing possibly made in connection with this painting is in Oxford (Brettell and Lloyd 64 recto).

Chennevières lies to the south-east of Paris on the banks of the river Marne. It is opposite La Varenne-Saint-Hilaire where Pissarro lived between 1863–5.

PROVENANCE: Paris, Ambroise Vollard; London, Reid and Lefevre, (1937); Canada, private collection; London, Reid and Lefevre (1939); Glasgow, T. J. Honeyman collection, from whom bought by the National Gallery of Scotland, 1947.
LITERATURE: Ravenel [Sensier], 1865; Tabarant, 1924, p. 17; P&V, p. 20; R.I., 'Milestones in French Painting', Shorter Notice, *Burlington Magazine*, lxxv (1939), p. 38 repr.; T. J. Honeyman, *Art and audacity*, London, 1971, p. 123 repr.; Rewald, 1973, repr. p. 106; Champa, 1973, pp. 71–2 repr.; Kunstler, 1974, p. 25; C. Thompson and H. Brigstocke, *National Gallery of Scotland. Shorter catalogue*, Edinburgh, 1978, pp. 74–5; Lloyd, 1979, p. 4 repr. col.; Shikes and Harper, 1980, p. 63.
EXHIBITED: Paris, Salon, 1865 (1723, *Chennevières au bord de la Marne*); Paris, Durand-Ruel, 1904 (1 lent Vollard, *Paysage à la Varenne-Saint-Hilaire*); Paris, Orangerie, 1930 (7 lent Vollard); Paris, Marcel Bernheim, 1936 (8); London, Reid and Lefevre, *Pissarro and Sisley*, Jan. 1937 (1 repr.); Glasgow, McLellan Gallery (Reid and Lefevre), *French art of the 19th and 20th centuries*, Apr. 1937 (40 repr.); London, Reid and Lefevre, *The 19th century French masters*, Jul.–Aug. 1937 (26 repr.); Montreal, *French masters of the 19th and 20th centuries*, Oct. 1937 (35 repr.); New York, Bignou, *Masterpieces by nineteenth century French painters*, 11–30 Apr. 1938 (10); London, Reid and Lefevre, *Milestones in French painting*, Jun. 1939 (21 repr.); Glasgow, Art Gallery and Museum, *The spirit of France*, Jun. 1943 (38); London, Royal Academy, *Landscape in French art 1550–1900*, 10 Dec.–5 Mar. 1949–50 (223 repr. in separate volume of illustrations); London, Royal Academy, *Impressionism. Its masters, its precursors, and its influence in Britain*, 9 Feb.–28 Apr. 1974 (83 repr. and p. 9).

5
The donkey ride at La Roche-Guyon *c.* 1865

La promenade à âne, à La Roche-Guyon
P&V 45
Canvas. 35 × 51.7 cm./13¾ × 20⅜ in. Signed, lower left:
C. Pissarro.
Mr. Tim Rice

5

The composition evokes comparison with Gustave Courbet's painting *Young ladies of the village giving alms to a cow girl in a valley near Ornans* (Fernier 127), which was exhibited at the Universal Exhibition of 1855. The oil-sketch (Fernier 126) for Courbet's picture, which was exhibited elsewhere in Paris in 1855, is now in Leeds City Art Gallery.

The social context, the composition, and the relationship of the figures to the landscape are all features in Pissarro's painting that demonstrate his knowledge of Courbet's work. The flat, even quality of the paint, however, owes little to Courbet and the unified light tones of the palette reveal Pissarro's continuing allegiance to Corot, although it is perhaps Corot as seen through the eyes of the young Monet. Nevertheless, the connection with Courbet emphasizes the political motivation in Pissarro's picture, possibly hinted at in the original title. It is known that Pissarro was reading Proudhon in 1865 (*Archives*, No. 79), which was also the year in which Courbet completed and exhibited his famous portrait of Proudhon (Fernier 443).

In the *catalogue raisonné The donkey ride at La Roche-Guyon* is dated *c.* 1864–5, whereas Champa suggests 1865–6. There is documentary evidence that Pissarro painted in La Roche-Guyon in 1865 (*Archives*, No. 79). La Roche-Guyon is a small town on the right bank of the Seine about half-way between Paris and Rouen. Pissarro first painted there in 1859 (P&V 13) and returned several times during the 1860s.

PROVENANCE: probably to be identified with a picture sold in Paris, Hôtel Drouot, 25 November 1872, lot 36, *Première leçon d'équitation*; Paris, Jean-Baptiste Faure collection; Paris, Durand-Ruel (placed *en dépôt* by Faure *c.* 1910–14 and purchased jointly by Durand-Ruel, New York, and Georges Petit from Mme. Maurice Faure, 1 February 1919); Berlin, Matthiesen; Basle, Robert von Hirsch collection (Sotheby Parke Bernet, London, 26 June 1978, lot 716 repr. col.).
LITERATURE: J.-B. Faure, *Notice sur la collection J.-B. Faure suivie du catalogue des tableaux formant cette collection*, Paris, 1902, No. 77, p. 40, *Cavalcade à dos d'âne* [A. Callen, *Jean-Baptiste Faure, 1830–1914*, Leicester University MA Thesis, 1971, p. 582 No. 77 and p. 378 No. 503]; C. Morice, 'Exposition Pissarro', *Mercure de France*, (May 1904), p. 529; Meier-Graefe, 1907, p. 158; Tabarant, 1924, repr. pl. 4; Rewald, 1963, repr. p. 14; Champa, 1973, p. 74 repr.; Lloyd, 1979, pp. 4–5 repr. col.; Shikes and Harper, 1980, pp. 64–7 repr.; A. Boime, *Thomas Couture and the eclectic vision*, New Haven and London, 1980, p. 476.
EXHIBITED: Paris, Durand-Ruel, 1904 (2); New York, Durand-Ruel, 1919 (3); Paris, Durand-Ruel, 1928 (6); Frankfurt-am-Main, Städelsches Kunstinstitut, *Vom Abbild zum Sinnbild*, 3 Jun.–3 Jul. 1931 (196); Basle, Kunsthalle, *Kunstwerke aus Basler Privatbesitz 19. Jahrhundert Kunst*, 1943 (240); Basle, Kunsthalle, *Impressionisten. Monet, Pissarro, Sisley, Vorläufer und Zeitgenossen*, 3 Sept.–20 Nov. 1949 (16); Schaffhausen, Museum zur Allerheiligen, *Ausstellung die Welt der Impressionismus*, 1963 (86).

6
The banks of the Marne in winter 1866

Bords de la Marne en hiver
P&V 47
Canvas. 91.8 × 150.2 cm./36⅛ × 59⅛ in. Signed and dated, lower right: *C. Pissarro. 1866.*
Art Institute of Chicago, Chicago, gift of Mr. and Mrs. Lewis L. Coburn Fund (inv. 1957.306)

The painting was exhibited in the Salon of 1866 and was highly praised by Emile Zola. Another contemporary critic, Jean Rousseau, also acclaimed Pissarro for the uncompromising features of his style. Like *The banks of the Marne at Chennevières* (Cat. 4), the present painting again illustrates Pissarro's powers of spatial organization. Here, though, with the barrenness of the winter scene, the interaction of diagonals, verticals, and horizontals is more apparent, and it enables Pissarro to make a forceful, yet eloquent, use of the wide open space in the right foreground. The firmly constructed composition is in turn reinforced by the solidly painted architectural elements on the right, which shackle together the upper and lower halves of the painting. These features were to be further developed in paintings undertaken at L'Hermitage in

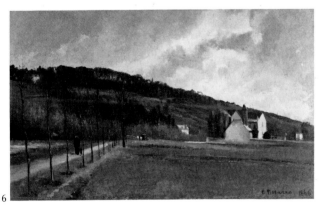

6

Pontoise in 1867 (Cat. 9–11).

Occasionally in the earlier literature the painting is confusingly referred to as *Landscape at La Varenne-Saint-Hilaire*.

PROVENANCE: Camille Pissarro collection; Mme. Vve. Pissarro collection (Paris, Georges Petit, 3 December 1928, lot 27 repr.); Paris, Jacques Dubourg; S. G. Archibald collection; London, Reid and Lefevre (1952). Purchased by The Art Institute of Chicago, 1957.
LITERATURE: Zola, 1866 [Hemmings and Neiss, p. 78]; Castagnary, 1866; Rousseau, 1866, p. 447; Tabarant, 1924, pp. 18–19; Kunstler, 1928, p. 503 repr.; P&V, p. 20; *Paintings in The Art Institute of Chicago*, Chicago, 1961, p. 358 repr.; Lanes, 1965 p. 275; Nochlin, 1965, p. 60 repr.; Pool, 1967, p. 41 repr.; Champa, 1973, pp. 72–3 repr. col. (incorrect caption); Kunstler, 1974, p. 26; Cogniat, 1974, repr. col. p. 12; Shikes and Harper, 1980, p. 70 repr. col.
EXHIBITED: Paris, Salon, 1866 (1564, *Bords de la Marne en hiver*); Paris, 1930 (3 lent Archibald); New York, Wildenstein, 1965 (2 repr.); Philadelphia/Detroit/Paris, *The Second Empire 1852–1870*, 1 Oct.–26 Nov., 15 Jan.–18 Mar., 24 Apr.–2 Jul. 1978–9 (VI-96 repr., in Paris only 264 repr.).

7 EXHIBITED IN LONDON AND PARIS ONLY
A square at La Roche-Guyon *c.* 1867
Une place à La Roche-Guyon
P&V 49
Canvas. 50×61 cm./$19\frac{3}{4} \times 24$ in. Signed with the artist's initials lower right.
Nationalgalerie, Berlin-Dahlem (inv. 75/61)

A square at La Roche-Guyon is directly comparable with *Still-life* (Cat. 8), which is dated 1867. Although it is customary to describe Pissarro's early work with the palette knife as being in the manner of Courbet, the present painting and Cat. 8 are in fact exceptions being far closer to Cézanne's paintings of this period (V 49). The rich warm palette and the close analysis of the irregular shapes and forms of the buildings in *A square at La Roche-Guyon* are also redolent of Cézanne. Significantly, both painters returned to La Roche-Guyon at the beginning of the 1880s (V 441 and D 27 respectively), as did Renoir (A. Callen, *Renoir*, London, 1978, p. 94 repr. pl. VIII col.).

For a modern photograph of the square at La Roche-Guyon see Reidemeister, 1963, p. 42.

PROVENANCE: Camille Pissarro collection; Mme. Vve. Pissarro collection (Paris, Georges Petit, 3 December 1928, lot 47 repr.); Paris, Armand Dorville collection; London, Tooth, from whom bought by the Nationalgalerie, Berlin, 1961.
LITERATURE: Kunstler, 1928, pp. 503–4 repr.; Rewald, 1938, p. 285; P&V, p. 20; Reidemeister, 1963, p. 42 repr.; L. Reidemeister, 'The National Galerie Berlin', *Apollo* lxxx (1964), p. 91 repr.; P. Krieger, *Maler des Impressionismus aus der Nationalgalerie Berlin. Bilderhefte der Staatliche Museen Berlin*, Berlin, 1967, p. 12 repr.; Pool, 1967, p. 42 repr.; Champa, 1973, p. 74 repr.; *Nationalgalerie Berlin. Bestandskatalog. 19 Jahrhundert*, Berlin, 1977, pp. 302–4 repr.; Lloyd, 1979, p. 4 repr. col.
EXHIBITED: Paris, Orangerie, 1930 (5 lent Dorville); Paris, Marcel Bernheim, 1936 (4 lent Dorville); London, Tooth, *Recent acquisitions*, 22 Oct.–16 Nov. 1946 (2); Berlin, Orangeries Schlosses Charlottenburg, *Die Ile de France und ihre Maler*, 29 Sept.–24 Nov. 1963 (10).

7

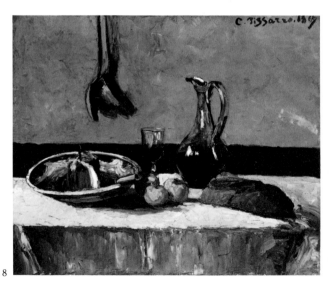

8

8 EXHIBITED IN BOSTON ONLY
Still-life, 1867

Nature morte
P&V 50
Canvas. 81.2 × 100.3 cm./32 × 39½ in. Signed and dated, upper
right: *C. Pissarro. 1867.*
The Toledo Museum of Art, Toledo, gift of Edward Drummond
Libbey (inv. 49.6)

The painting has been executed throughout with the palette knife.
Here, as in *A square at La Roche-Guyon* (Cat. 7), there is an affinity
with Cézanne some of whose still-lives of this period are not
dissimilar (V 61, 65). The horizontal emphasis created by the wall,
the strip of wood panelling, the table, and the cloth in the
foreground is counteracted by the vertical axis derived from the
suspended culinary implements, the objects on the table, and by
the vertical accents made with the palette knife. The edges and
corners of the table, the obliquely placed loaf of bread, the knife
resting in the dish – all suggest a sense of depth within the
composition.

Manet, Renoir, Monet, and Sisley all painted distinguished still-
lives during the 1870s exploring the same spatial tensions, but their
pictures are more closely allied to the European tradition that
was given greater vitality with the revival of interest in Chardin
(J. McCoubrey, 'The revival of Chardin in French still-life painting
1850–1870', *Art Bulletin* xlvi (1964), pp. 39–53).

For the collector Georges Viau see Rewald, 1973 *GBA*, p. 108.

PROVENANCE: Camille Pissarro collection; Mme. Vve. Pissarro collection (Paris,
Georges Petit, 3 December 1928, lot 33 repr.); Paris, Georges Viau collection (first
sale Paris, Hôtel Drouot, 11 December 1942, lot 108 repr. but not sold as painting
was in New York; second sale Paris, Charpentier, 22 June 1948, lot 5); New York,
Wildenstein, from whom acquired by The Toledo Museum of Art, 1949.
LITERATURE: Kunstler, 1928, p. 504 repr.; P&V, p. 20; H.L.F. [H. la Fage], 'Ruisdael
to Pissarro to Noguchi', *Art News* xlix (1950), p. 32 repr. col.; Rewald, 1973,
pp. 157–8 repr.; Champa, 1973, pp. 74–5 repr. col.; J. Rewald, 'The impressionist
brush', *Metropolitan Museum of Art Bulletin* xxxii (1973–4), [p. 16] repr. col. det.;
Kunstler, 1974, pp. 14 and 26 repr. col.; *The Toledo Museum of Art. European
paintings*, Toledo, 1976, pp. 127–8 repr.; F. Schulze, 'A consistently discriminating
connoisseurship', *Art News* lxxvi (1977), p. 64; Iwasaki, 1978, repr. col. pl. 2;
L. Gowing 'The logic of organized sensations', in *The late Cézanne*, London, 1978,
p. 56; Lloyd, 1979, p. 4 repr. col.; Shikes and Harper, 1980, p. 73 repr.
EXHIBITED: Brussels, Palais des Beaux-Arts, *Exposition d'art français*, 13 Apr.–
12 May 1929; Paris, Orangerie, 1930 (6 lent Viau); Paris, Galerie de la Gazette des
Beaux Arts, *Naissance de l'Impressionnisme*, May 1937 (73); Amsterdam, Stedelijk
Museum, *Honderd Jaar fransche Kunst*, Jul.–Sept. 1938 (186 repr.); New York,
World's Fair, Pavillon de France, *Five centuries of French history mirrored in five
centuries of French art*, 1939; New York, Wildenstein, 1945 (1); Detroit, Institute of
Art, *The two sides of the medal: French painting from Gérôme to Gauguin*, 28 Sept.–
31 Oct. 1954 (50 repr.); Paris, Orangerie, *De David à Toulouse-Lautrec: chefs d'oeuvre
des collections américaines*, 1955 (44 repr.); New York, Wildenstein, 1965 (3 repr. col.).

9 ILLUSTRATED IN COLOUR
The 'Côte du Jallais', Pontoise 1867

La côte du Jallais, Pontoise
P&V 55
Canvas. 87 × 114.9 cm./34¼ × 45¼ in. Signed and dated, lower
right: *C. Pissarro/1867.*
The Metropolitan Museum of Art, New York, bequest of William
Church Osborn (inv. 51.30.2)

The 'Côte du Jallais', Pontoise was one of two pictures by Pissarro
exhibited in the Salon of 1868 apparently at the instigation of
Daubigny (Rewald, 1973, pp. 185–6).

The picture is one of an important group of early paintings of
Pontoise where Pissarro lived between 1866–8. Cat. 10–12 also
belong to this same group. The paintings all explore the full
compositional possibilities of a type of landscape essayed by Corot
in the *Ville d'Avray, the pond and the Cabassud House* (Robaut 284)
of 1825–30, by Courbet in *The Valley of Ornans* (Fernier 240) of
1858, and by Daubigny in the *View of Butry near Valmondois*
(Hellenbranth 185) of 1866. Particularly relevant in the present
instance is the painting by Courbet with the curving roadway in
the centre. Pissarro, like his mentors, concentrates on the re-
lationship between the foreground and the rising hillside in the
background. It is significant that the strongest passages in the
painting are to be found in the middle distance, where archi-
tectural elements and foliage are used to weld together the various
parts of the composition.

Pissarro remade the composition in 1875 (P&V 311) during a
period when he was re-examining these same landscape motifs
with Cézanne (V 319).

PROVENANCE: Paris, Durand-Ruel; New York, Heinemann Gallery (1927); New York,
William H. Holston (1929); New York, William Church Osborn collection, by whom
bequeathed to the Metropolitan Museum of Art, 1951.
LITERATURE: Castagnary, 1868; Zola, 1868 [Hemmings and Neiss, pp. 126–9 and
135]; Redon, 1868; Hamel, 1914, p. 26; Duret, 1909, repr. p. 70; Tabarant, 1924,

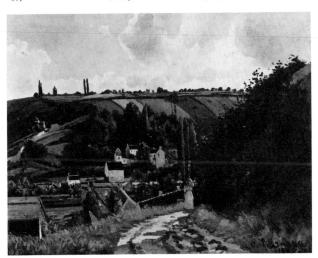

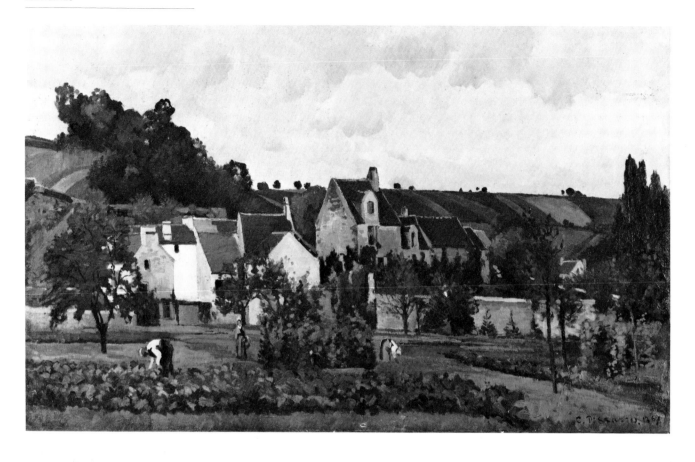

p. 19; *Art News* 22 October (1927), repr. (unpaginated); *Art News* 9 March (1929), p. 26 repr.; Kunstler, 1930, repr. pl. 1; P&V, pp. 20–1; Leymarie, 1955, i. pp. 68, 71 and 73 repr. col.; Rewald, 1963, p. 70 repr. col.; C. Sterling and M. Salinger, *The Metropolitan Museum of Art. A catalogue of the collection of French paintings*, New York, 1967, iii, pp. 15–16 repr.; M. Salinger, 'Windows open to nature', *Metropolitan Museum of Art Bulletin* xxvii (1968), [p. 33] repr.; L. R. Furst, 'Zola's art criticism', in *French nineteenth century painting and literature*, ed. U. Finke, Manchester, 1972, pp. 176–8 repr.; Rewald, 1973, pp. 185–6 repr.; Champa, 1973, pp. 75–7 repr.; Cogniat, 1974, repr. col. p. 11; Bellony-Rewald and Gordon, 1976, p. 137; L. Venturi, *Cézanne*, edn. Geneva, 1978, p. 84, repr.; Shikes and Harper, 1980, pp. 73–5 and 78 repr. col.
EXHIBITED: Paris, Salon, 1868 (2015 '*La Côte de Jallais*'); Paris, Manzi et Joyant, 1914 (5); Chicago, The Art Institute, *A century of progress*, 1 Jun.–1 Nov. 1934 (260 repr. lent Osborn); New York, Metropolitan Museum, *French painting from David to Toulouse-Lautrec*, 6 Feb.–26 Mar. 1941 (96 repr. lent Osborn); New York, Wildenstein, 1945 (2 repr. lent Osborn); Toledo, Museum of Art and Toronto, Art Gallery, *The spirit of modern France*, Nov.–Dec. and Jan.–Feb. 1946–7, (46 lent Osborn); New York, Metropolitan Museum, *Masterpieces of fifty centuries*, 1970 (37 repr.); Paris, Grand Palais and New York, Metropolitan Museum, *Impressionism, a centenary exhibition*, 21 Sept.–24 Nov. and 12 Dec.–10 Feb. 1974–5 (33 repr. col. and det.).

FOOTNOTE
[1]Stated in the catalogue of the Metropolitan Museum (1967) to have been included in the sixth Impressionist exhibition (Venturi, 1939, ii, p. 9 No. 1, *La Côte de Jallais, pris sur le vieux chemin d.Ennery*, and p. 266 No. 72, *Paysage pris sur le vieux chemin d'Ennery (près Pontoise)* but this is unlikely and a more probable identification is with P&V 488, of 1879).

10 EXHIBITED IN LONDON ONLY
L'Hermitage at Pontoise 1867
L'Hermitage à Pontoise
P&V 56
Canvas. 91 × 150.5 cm./$35\frac{7}{8}$ × $59\frac{1}{4}$ in. Signed and dated, lower right: *C. Pissarro. 1867.*
Wallraf-Richartz Museum, Cologne (inv. WRM 3119)

Like the previous painting (Cat. 9), *L'Hermitage at Pontoise* is one of a group of large landscapes painted by Pissarro in Pontoise, in the area on the north-east side of the town known as L'Hermitage where the artist lived between 1866–8. The present painting, and also P&V 52, 57 and Cat. 11, are all interrelated views of L'Hermitage. Like P&V 52 and 62, *L'Hermitage at Pontoise* comprises a level foreground relieved by a sharply rising hillside in the background. This is a type of composition that Cézanne developed further (V 150 and 315) and Pissarro himself often returned to this very same motif (P&V 242, 297, 337, and 495) during the 1870s.

In *L'Hermitage at Pontoise* the artist has concentrated on structure, notably in the depiction of the rooftops, which are painted with broad regular brushstrokes and invested with an

almost geometric quality. Another important feature is the treatment of light, which is of an even intensity throughout, so that surfaces are defined by their own forms rather than by cast shadows.

It is possible that this painting is to be identified with one of those included in the Salons of 1868 (2016) and 1869 (1950) when Pissarro on both occasions exhibited a work entitled simply *L'Hermitage*, although both Cat. 11 and P&V 57 should also be considered in this context.

PROVENANCE: Paris, Ambroise Vollard; London, Chester Beatty collection; Zurich, Fritz and Peter Nathan, from whom bought by the Wallraf-Richartz Museum, 1961.
LITERATURE: *Art News*, xxxiv (1935) repr.; H. Comstock, 'An early Pissarro' *Connoisseur*, xcvii (1936), pp. 43–4 repr.; H.R., 'Corot to Cézanne', Shorter Notice, *Burlington Magazine*, lxix (1936), pp. 36–7 repr.; P&V, p. 20; Rewald, 1963, p. 17 repr.; R. Andree, *Katalog der Gemälde des 19. Jahrhunderts im Wallraf-Richartz-Museum*, Cologne, 1964, p. 98 repr.; *Dr. Fritz und Dr. Peter Nathan 1922–1972*, Zurich, 1972, No. 67 repr.; Champa, 1973, p. 76 repr.; Cogniat, 1974, repr. col. p. 13; Lloyd, 1979, p. 5 repr. col.
EXHIBITED: Paris, Orangerie, 1930 (6 bis lent Vollard); Amsterdam, *Tentoenstelling Vincent Van Gogh en zijn tijdgenoeten*, Sept.–Nov. 1930 (242); New York, Bignou, *Cézanne and the impressionists*, 1935 (8); London, Reid and Lefevre, *Corot to Cézanne*, Jun. 1936 (32 repr.).

11 EXHIBITED IN BOSTON ONLY
The hillsides of L'Hermitage, Pontoise
c. 1867–8

Les coteaux de L'Hermitage, Pontoise
P&V 58
Canvas. 151.4 × 200.6 cm./59⅝ × 79 in. Signed, lower left:
C. Pissarro.
The Solomon R. Guggenheim Museum, New York, Justin K. Thannhauser collection

The hillsides of L'Hermitage, Pontoise is the largest of the paintings of this area of Pontoise dating from 1866–8 and it might therefore be regarded as the climax of the group. It is highly probable that the painting was shown in the Salon, but in which year cannot yet be determined, since Pissarro exhibited a picture entitled *L'Hermitage* in the Salon of 1868 (2016) and in the Salon of 1869 (1950). A reference in a letter from Cézanne to Pissarro dated 2 July 1876 establishes that the painting had been sold to Faure by that year (*Paul Cézanne. Letters*, ed. J. Rewald, Oxford, 1976, pp. 145–8).

Compositionally, *The hillsides of L'Hermitage, Pontoise* is more closely related to Cat. 9 than to Cat. 10 and P&V 57 in that they have in common a pathway along which figures are walking, a valley in the middle distance, and a hillside in the background. As regards the emphasis placed on the houses in the middle distance, however, the present painting resembles P&V 57. A case could therefore be made for *The hillsides of L'Hermitage, Pontoise* being an amalgam of the compositional motifs explored in these important canvases – a group of works that was surely of the utmost significance for Cézanne.

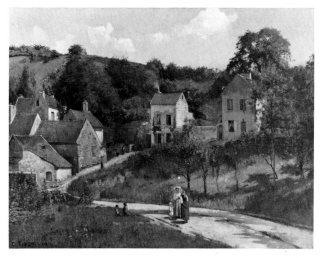

11

There is an echo of this composition, with its play on the diagonal, in P&V 262, of 1874 (Winterthur, Oskar Reinhart collection).

Reidemeister reproduces a modern photograph of the artist's viewpoint.

PROVENANCE: Paris, Jean-Baptiste Faure collection; Paris, Durand-Ruel (placed *en dépôt* by Faure, 14 June 1899 and purchased by Durand-Ruel, 6 June 1901); Berlin, Cassirer, by whom bought from Durand-Ruel, June 1901; Berlin, Thannhauser.
LITERATURE: Castagnary, 1868; Kirchbach, 1904, p. 124 repr.; Meier-Graefe, 1907; Holl, 1911, p. 41 repr.; Munich, Moderne Galerie (Heinrich Thannhauser), *Nachtragswerk III* (1918), pp. 19 and 119 repr.; Duret, 1918, repr. p. 36 and 1923, repr. p. 91; A. Fontainas and L. Vauxcelles, *Histoire générale de l'art française de la Révolution à nos jours*, Paris, 1922, repr. p. 162; B. E. Werner, 'Französische Malerei in Berlin', *Die Kunst für Alle* xlii (1927), p. 224; P&V, p. 20; A. Neumeyer, 'One step before Impressionism: Monet's *Jetty at Le Havre* and Pissarro's *View of Pontoise*', *Pacific Art Review* i (1941), pp. 17–24 repr.; T. Paulsson, 'From Rousseau to Pissarro', in *Idea and Form: Studies in the History of Art*, Stockholm, 1959, p. 214 repr.; Reidemeister, 1963, pp. 38–9 repr.; Coe, 1963, pp. 4–5, 11 and 16 repr.; Kunstler, 1967, repr. pl. 1 col.; A. Callen, *Jean-Baptiste Faure, 1830–1914*, Leicester University MA Thesis, 1971, p. 379 No. 504; Champa, 1973, p. 77 repr.; Rewald, 1973, repr. col. p. 159; J. Rewald, 'The impressionist brush', *Metropolitan Museum of Art Bulletin* xxxii (1973–4), [p. 13] repr. col. det.; Kunstler, 1974, p. 26; V. E. Barnett, *The Guggenheim Museum: Justin K. Thannhauser Collection*, New York, 1978, pp. 181–3 No. 67 repr. col.; Shikes and Harper, 1980, pp. 73–5, 84, and 130 repr.
EXHIBITED: Berlin, Künstlerhaus, *Erste Sonderausstellung in Berlin*, 9 Jan.–15 Feb. 1927 (189 repr.); Paris, Orangerie, 1930 (10 lent Galeries Thannhauser); Buenos Aires, Museo Nacional de Bellas Artes, *La pintura francesa de David a nuestros dias*, Jul.–Aug. 1939 (106) and subsequently at Montevideo, Apr.–May 1940 and Rio de Janiero, 29 Jun.–15 Aug. 1940; San Francisco, M. H. De Young Memorial Museum, *The painting of France since the French Revolution*, Dec.–Jan. 1940–1 (123 repr.); Worcester Art Museum, *The art of the Third Republic 1870–1940*, 22 Feb.–16 Mar. 1941 (1 repr.); Chicago Art Institute, *Masterpieces of French art*, 10 Apr.–20 May 1941, 123 repr.; Los Angeles County Museum, *The painting of France since the French Revolution*, Jun.–Jul. 1941 (104); The Portland Art Museum, *Masterpieces of French Painting*, 3 Sept.–5 Oct. 1941 (86); Pittsfield (Mass.), The Berkshire Museum, *French impressionist painting*, 2–31 Aug. 1946 (13).

12 EXHIBITED IN BOSTON ONLY

Landscape at Les Pâtis, Pontoise 1868

Paysage aux Pâtis, Pontoise

P&V 61

Canvas. 81 × 100 cm./32 × 39½ in. Signed and dated, lower right:
C. Pissarro '68.
Private collection, New York.

Although not a view of L'Hermitage in Pontoise, *Landscape at Les Pâtis* is very closely related in composition and technique to Cat. 9.

Landscape at Les Pâtis appears to have been a picture of particular importance for Cézanne, who executed a remarkably similar composition (V319) in 1879–82, strangely entitled by Venturi *La Côte de Galet, Pontoise*. The connections between these two pictures emphasize the influence of Pissarro's paintings of L'Hermitage on Cézanne during the 1870s. The pairing of works by these two artists, which is the approach so often favoured by scholars in this context, is perhaps less relevant than a consideration of the compositional principles underlying Cat. 9–12

included in this exhibition. The evidence of V 319, for example, suggests most strongly that Cézanne and Pissarro re-examined these motifs at L'Hermitage and Les Pâtis together during the second half of the 1870s. The depiction of the quarry seen in the centre of the present painting anticipates both Cézanne's method of working and his way of observing a landscape.

Les Pâtis, like L'Hermitage, is one of the older parts of Pontoise. It lies in the Viosne valley between the Château de Marcouville and Osny. Brettell has identified the site as 'a hillside near the village of Cernay'. It is an area famous for its mills, which Pissarro (P&V 62) and Cézanne (V 324) painted on different occasions.

PROVENANCE: Paris, Alexandre Bonin (husband of Jeanne, the artist's second daughter); Buenos-Aires, Emile Lernoud collection; Buenos-Aires, Dr. Carlos Zubizarretta collection; New York, Wildenstein, from whom acquired, 1955.
LITERATURE: *Catalogue of the Collection of Emile Lernoud*, Buenos-Aires, repr.; Rewald, 1973, repr. col. p. 145; Kunstler, 1974, repr. p. 75; Brettell, 1977, pp. 202–5 repr.
EXHIBITED: Buenos-Aires, *Amigos del arte, Exhibition No. 39*, 1932 (39); Hanover, New Hampshire, Hopkins Art Centre Galleries, Dartmouth College, *Impressionism 1865–1885*, Nov.–Dec. 1962 (no cat.).

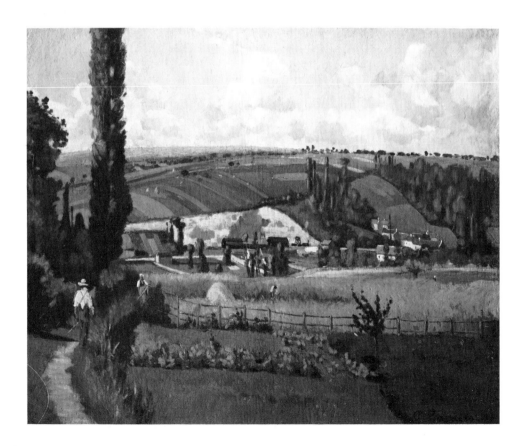

1869–1880

Along with several other artists, notably Daubigny, Bonvin, and Monet, Pissarro took refuge in England during the Franco-Prussian war and the Paris Commune of 1870–1. On returning to France the painter continued to live in Louveciennes where he had first gone to live in 1869, but he moved back to Pontoise in 1872 where he resided until 1882. Most of the motifs in the paintings of these years are of Louveciennes and Pontoise, or of the surrounding districts, but Pissarro's friendship with the painter Ludovic Piette also presented him with the opportunity of painting in Mayenne, at Montfoucault, which was one of the farms owned by Piette's family, near the small town of Melleraye. The autumn seasons of 1874–6 were spent at Montfoucault, but the visits were brought to a close by Piette's death in 1878. Prompted by the critic Theodore Duret the canvases painted at Montfoucault concentrate on rural themes. They represent Pissarro's first close examination of rural life and were conceived under the influence of J.-F. Millet, who died in 1875.

These are also the years associated with the formal grouping of those painters termed the Impressionists. The picture-dealer Durand-Ruel made a great effort after his return from England in 1871 to exhibit and sell the work of Pissarro, but his attempts met with little success. Like Monet, Renoir, and Degas, therefore, Pissarro sought places to show his paintings other than the Salon where his work was in any case frequently rejected. Pissarro, already aged forty-four, played a leading part in the organization of the first Impressionist exhibition held in the spring of 1874, when Monet exhibited the painting *Impression. Sunrise* from which the group derived its name, as the result of a jibe by a critic. Pissarro was, in fact, the only painter from the original group to exhibit in all eight of the Impressionist exhibitions, the other occasions being 1876, 1877, 1879, 1880, 1881, 1882, and 1886. The principal collectors of impressionist paintings at this time were Faure, Hoschedé, Choquet, Caillebotte, Murer, Gachet, and de Bellio, who all formed distinguished collections that included works by Pissarro.

Stylistically, the first half of the 1870s is perhaps Pissarro's best known creative period, and the canvases painted in England and shortly afterwards in France have been more readily appreciated than those painted at any other time in his whole career. The artist retains a firmly controlled geometric structure as the framework for his compositions, but he employs a lighter touch in his brushwork and a brighter palette, both of which show the influence of Monet, whose technique of freely applying broken, separate patches of pure pigment, Pissarro approached closely at this time. The paintings dating from the opening years of the 1870s therefore may, like those of Monet and Renoir, with good reason be described as the most purely impressionist in Pissarro's entire *oeuvre* (Figure 8, illustrated overleaf).

Another important feature of this decade is the continuation of Pissarro's working relationship with Cézanne, which was at its closest during the 1870s. The connections between Pissarro and Cézanne during these years have yet to be thoroughly studied, but their significance for the development of painting cannot be mistaken. There is a definite shift in Pissarro's approach to subject-matter that seems to begin in 1873, and, similarly, there is a greater variety in the technique of those canvases painted towards the middle of the decade. There is a tendency to model in blocks and to achieve a sense of regression by overlaying surfaces. The palette too becomes more unified. Both artists seem to have looked closely again at the work of Courbet and both often depicted the same landscape motifs. The evidence appears to suggest that Pissarro served as a catalyst for Cézanne, but the influence is perhaps best described as reciprocal. Both artists were preoccupied during the mid-1870s with the task of creating a new sense of space in their pictures by juxtaposing blocked-in areas of paint, which when seen in isolation are almost abstract, but when viewed in relation one to the other possess recognizable forms. This was admittedly a logical development from the style of painting adopted by Manet and Monet, but only Pissarro and Cézanne could see at this early date where it might lead. Indeed, Pissarro's paintings of L'Hermitage undertaken at the end of the 1860s (Cat. 9–11), served as an important directive for Cézanne while they were working together at Pontoise and Auvers-sur-Oise during the 1870s.

The effects of working in conjunction with Cézanne, however, may have caused the crisis in Pissarro's technique that came about during the second half of the 1870s. Where the combination of a firmly controlled composition with a richly worked surface was successfully fused, Pissarro produced canvases that exude an overriding feeling of spatial harmony, but often towards the end of the 1870s he felt that his paintings lacked clarity. Two styles are evident during the closing years of the 1870s. The first is an assembly of small comma-like strokes covering the canvas, and the second is the layering of brushstrokes so that the surface is raised in relief and textured. With such densely worked paintings there can be little wonder that Pissarro felt his canvases had become confused, and that his compositions did not possess the structural unity of those paintings executed at the beginning of the 1870s. He in fact painted far fewer works in 1878–9, and turned more to print-making as a means perhaps of solving his difficulties. Yet what Pissarro was essentially attempting to do, in these paintings dating from the end of the 1870s, was to seek for compositional unity by different means with greater

emphasis on facture and colour. Thus his compositions retain a rigidly controlled geometrical basis, in which figures and background are skilfully enmeshed. It is as though Pissarro embraces the spirit of Monet and Renoir in the context of Cézanne.

13
The Versailles road at Louveciennes (snow)
1869

La route de Versailles, à Louveciennes (effet de neige)
Canvas. 38.3 × 46.3 cm./15⅛ × 18¼ in.
Signed, lower left: *C. Pissarro.*
The Maryland Institute, Baltimore, on loan to the Walters Art Gallery

This is the same road as that depicted in Cat. 14. Pissarro has, in fact, painted it from exactly the same spot as P&V 77, also in

Williamstown.

The painting has a most interesting provenance having been bought, in January 1870, by George Lucas from Martin, who was one of Pissarro's first dealers. The picture was therefore in all probability completed towards the end of 1869, a year from which very few firmly datable works by Pissarro survive. The picture is directly comparable with Monet's two paintings of the *Versailles Road, Louveciennes*, which are also snow scenes (W 147–8). Snow, like water, was one of the motifs favoured by impressionist painters for the development of their ideas about light and colour.

For Martin see Rewald, 1973 *GBA*, p. 107. The picture does not occur in the *catalogue raisonné*.

PROVENANCE: Paris, Martin from whom bought by George A. Lucas 7 January 1870 for 20 frs.; Paris, George A. Lucas, by whom bequeathed to the Maryland Institute through his executor, Henry Walters, 1909/10.
LITERATURE: *The Diary of George A. Lucas: An American Agent in Paris, 1857–1909,* ed. L. M. Randall, Princeton University Press, 1979, i. p. 313 repr.
EXHIBITED: Baltimore Museum of Art, *The George A. Lucas Collection of the Maryland Institute,* 12 Oct.–21 Nov. 1965 (223).

Fig. 8. *The Versailles road at Louveciennes* P&V 96 Foundation E.G. Bührle Collection, Zurich

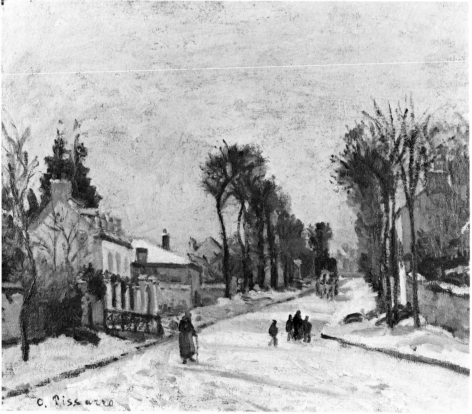

14
The Versailles road at Louveciennes (rain)
1870

La route de Versailles à Louveciennes (effet de pluie)

P&V 76

Canvas. 40.2 × 56.3 cm./15¾ × 22⅛ in. Signed and dated, lower left: *C. Pissarro 1870*.

Sterling and Francine Clark Art Institute, Williamstown, Massachusetts (inv. 825)

The Versailles road at Louveciennes (rain) is one of a number of fairly small paintings (P&V 71–86) undertaken by Pissarro in Louveciennes while living there in 1869–70. All these paintings explore the motif of a road seen under different temporal conditions placed on a diagonal or at right angles to the picture plane, as Monet had begun to do during the mid-1860s. Significantly, Pissarro and Monet often painted at the same sites in 1869–70, including Bougival (P&V 65: W 143, 149 and 150–2), and Marly (P&V 68: W 144), as well as Louveciennes. In fact, Monet painted this same road in Louveciennes twice in 1870 (W 147–148), the first of which closely resembles the present painting, whilst the second is comparable with P&V 77 also in Williamstown. Pissarro

remade some of these compositions in 1872 (for example P&V 138) after he had returned from England. Sisley also painted the Versailles road, but slightly later in 1875 (Daulte 161–2).

The view is taken looking northwards with the aqueduct at Marly visible in the background. Pissarro lived on the left-hand side of the Versailles road at No. 22. His house is visible in the distinguished painting of 1870 (P&V 96) now in the Bührle Foundation, Zürich (Figure 00), where the painter's wife and small daughter, Jeanne-Rachel, are depicted in the foreground. This last picture, too, underlines the affinity between Pissarro and Monet.

PROVENANCE: New York, Carstairs; R. S. Clark collection, acquired 5 May 1941 from Carstairs; Clark Art Institute, 1955.

LITERATURE: P&V, p. 29; *Williamstown, Clark Art Institute. French paintings of the 19th century*, 1963, No. 98 repr.; Coe, 1963, p. 6 repr. (incorrect caption); P. Courthion, *Impressionism*, New York, 1972, repr. p. 34; *List of paintings in the Sterling and Francine Clark Art Institute*, Williamstown, 1972, p. 80 repr.; Rewald, 1973, repr. p. 213; Champa, 1973, pp. 78–9 repr.; Shikes and Harper, 1980, p. 82 repr.

EXHIBITED: Paris, Georges Petit, *Cent ans de peinture française*, Jun. 1930 (21); London, Reid and Lefevre, *French painting of the 19th and 20th centuries*, 1930 (7); New York, Durand-Ruel, 1941 (19); Williamstown, Clark Art Institute, *French paintings of the nineteenth century*, 1956 (S- 32 repr.); New York, Wildenstein, *Treasures from the Clark Art Institute*, 1967 (27).

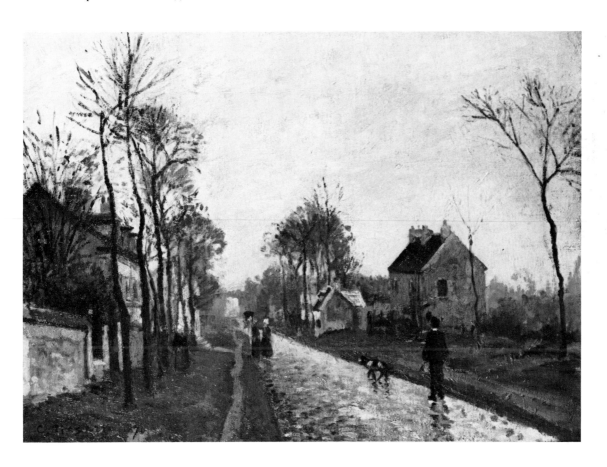

15
The Crystal Palace, London 1871

Le 'Crystal Palace', Londres
P&V 109
Canvas. 47 × 73.2 cm./$18\frac{1}{2}$ × $28\frac{3}{4}$ in. Signed and dated, lower left:
C. Pissarro 1871.
The Art Institute of Chicago, Chicago (inv. 1972. 1164)

The Crystal Palace, London is one of twelve paintings (P&V 105–116) inspired by Pissarro's visit to England in 1870–1, many of which are now in public collections. P&V 107 (Mellon Collection) includes another view of the Crystal Palace, which Daubigny had also depicted when he was in England in 1866 (M. Fidell-Beaufort and J. Bailly-Herzberg, *Daubigny, la vie et l'oeuvre*, Paris, 1975, Nos. 95–6 repr.). Compositionally and technically, the paintings executed by Pissarro in England are analogous to those done in Louveciennes in 1869–70 (Cat. 13–14), and the close stylistic connection with Monet can still be seen.

The subjects chosen for these paintings amply bear out Pissarro's claim to Wynford Dewhurst that 'Monet worked in the parks, whilst I, living at Lower Norwood, at that time a charming suburb, studied the effects of mist, snow and springtime' (W. Dewhurst, *Impressionist painting, its genesis and development*, London, 1904, pp. 31–2).

Rewald (1973, p. 257) states that *The Crystal Palace, London* was the first picture by Pissarro acquired by Durand-Ruel while in London in 1870–1, but this cannot be substantiated (House, 1978, pp. 636–40).

The Crystal Palace was built in Hyde Park in 1850–1 to house the Great Exhibition of 1851. It was then moved and reassembled at Sydenham in the south of London in 1852–4, but was destroyed by fire in 1936 (Henry Russell Hitchcock, *Early Victorian architecture in Britain*, New Haven, 1954, i. pp. 530–47). In contrast with the depictions by Manet (Rouart and Wildenstein 123) and Renoir (sold Sotheby's 1 December 1971, lot 17, repr. col.) of the Universal Exhibition of 1867 in Paris, Pissarro seems almost concerned to camouflage the Crystal Palace amongst its suburban surroundings.

PROVENANCE: Paris, Durand-Ruel; New York, Durand-Ruel; Henry J. Fisher collection; Chicago, Mr. and Mrs. B. E. Bensinger collection, by whom presented to the Art Institute, Chicago, 1972.
LITERATURE: Cardon, 1894; Alexandre, 1894; Tabarant, 1924, repr. pl. 10; P&V, pp. 30, 31; J. Rewald, 'Durand-Ruel: 140 years, one man's faith', *Art News* xlii (1943), p. 24 repr.; Bazin, 1947, pp. 124–5 repr.; Pool, 1967, p. 102 repr. col.; Rewald, 1973, repr. p. 257; J. House, 'The impressionists in London', *Burlington Magazine* cxv (1973), p. 194 repr.; House, 1978, p. 638; *The Art Institute of Chicago 100 masterpieces*, Chicago, 1978, p. 98 repr. col.; Shikes and Harper, 1980, p. 92.
EXHIBITED: Paris, Durand-Ruel, 1894 (6); New York, Durand-Ruel, *Exhibition of paintings by Degas, Renoir, Monet, Pissarro and Sisley prior to 1880*, 12 Oct.–2 Nov. 1931 (3 repr.); New York, Union League, *Exhibition of paintings by the master impressionists*, 8–20 Nov. 1932 (13); New York, Durand-Ruel, 1933 (2); New York, Durand-Ruel, *Exhibition of paintings by master impressionists*, 15 Oct.–10 Nov. 1934 (19); New York, Durand-Ruel, *Exhibition of French paintings from 1810 to 1880*, 3–22 Jan. 1938 (4); New York, Durand-Ruel, *Monet, Pissarro, Sisley before 1890*, 14 Nov.–3 Dec. 1938 (11); Los Angeles Museum, *The development of Impressionism*, 12 Jan.–28 Feb. 1940 (50 lent Durand-Ruel); Detroit, Institute of Arts, *The age of Impressionism and Realism*, 3 May–2 Jun. 1940 (32 lent Durand-Ruel); New York, Knoedler, *Paintings of London*, 29 Oct.–16 Nov. 1940 (21); New York, Durand-Ruel, 1941 (7); New York, Durand-Ruel, *Exhibition celebrating one hundred and fortieth birthday*, 15 Nov.–4 Dec. 1943 (15 repr. lent private collector); New Haven, Yale University, *Paintings, drawings and sculpture collected by Yale alumni*, 19 May–26 Jun. 1960 (57 repr. lent Fisher); New York, Acquavella, *Four masters of Impressionism*, 24 Oct.–30 Nov. 1968 (3 repr. col.); London, Hayward Gallery, *The Impressionists in London*, 3 Jan.–11 Mar. 1973 (33 repr.); New York, Hirschl and Adler, *Retrospective of a gallery, twenty years*, 8 Nov.–1 Dec. 1973 (74 repr.); Detroit, Institute of Arts, *The arts and crafts in Detroit: the movement, the society, the school*, 22 Nov.–17 Jan. 1977 (27 repr.).

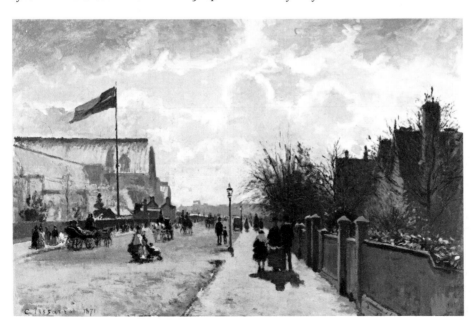

16 ILLUSTRATED IN COLOUR
Lordship Lane Station, Upper Norwood, London 1871
P&V III
Canvas. 45 × 74 cm./17¾ × 29⅛ in. Signed and dated, lower right: *C. Pissarro 1871*.
Courtauld Institute Galleries, London

Formerly entitled *Penge Station, Upper Norwood*, Mr. Martin Reid has demonstrated that the painting is really of the station at Lordship Lane (now demolished) in Upper Norwood on the old Crystal Palace (High Level) Railway. The view is from the footbridge across the cutting to the south of the station. The line was opened by the London-Chatham and Dover Railway in 1865 and was operated until 1954. As in the suburbs of Paris, so in London a network of railways was being created around the metropolis during the second half of the nineteenth century. To the south-east of London this development was given added impetus by the erection of the Crystal Palace at Sydenham (Cat. 15) in 1852–4 (Reid, pp. 254–7).

The association of railways with impressionist painting is well known. Monet's evocation of trains is particularly celebrated (W 438–49), but both Daubigny (*Le voyage au bateau*, for which see M. Fidell-Beaufort and J. Bailly-Herzberg, *Daubigny, la vie et l'oeuvre*, Paris, 1975, Nos. 199–200) and Pissarro explored the theme at an earlier date, if perhaps with less intensity.

Pissarro's painting of Lordship Lane station is in fact the first fully elaborated treatment of the train in impressionist painting. As many writers have observed, it may have been inspired by J. M. W. Turner's *Rain, steam and speed: the Great Western Railway* (M. Butlin and E. Joll, *The paintings of J. M. W. Turner*, New Haven – London, 1977, No. 409, pp. 232–3), which he could have seen in London, although, as Gage has argued, Pissarro's dispassionate treatment of the subject is closer to early prints of railways.

PROVENANCE: Paris, Alexandre Rosenberg; Chateau d'Osny, Lazare Weiller collection (Paris, 29 November 1901, lot 34 repr.); Paris, Tavernier; Paris, Pearson (Berlin, 18 October 1927, lot 53 repr.); sold anonymously, Paris, 23 June 1928, lot 82 repr.; Paris, Schoeller; Paris, Morot; Paris, Durand-Ruel; London, Tooth, from whom acquired by Samuel Courtauld June 1936; London, Samuel Courtauld collection, by whom bequeathed to the Courtauld Institute Galleries, 1947.
LITERATURE: Bazin, 1947, p. 150 repr.; Jedlicka, 1950, repr. pl. 6; Natanson, 1950, repr. pl. 6; D. Cooper, *The Courtauld Collection*, University of London, 1954, pp. 20, 106–7 repr.; Leymarie, 1955, i. p. 91 repr. col.; Rewald, 1963, p. 22 repr.; G. Chan, *Les peintres impressionnistes et le chemin de fer*, Paris, 1965, p. 15 repr. col.; J. Gage, *Turner, Rain, Steam and Speed*, Harmondsworth, 1972, pp. 67–8 repr.; Rewald, 1973, p. 256 repr.; Reid, 1977, pp. 254–7 repr.; House, 1978, p. 638; Lloyd, 1979, repr. col. pl. 8; Shikes and Harper, 1980, p. 92 repr.
EXHIBITED: London, Tooth, *La Flèche d'Or: important pictures from French collections*, 2–29 May 1936 (20); London, Tate Gallery, *Catalogue of the Samuel Courtauld memorial exhibition*, May–Jun. 1948 (51); Wakefield City Art Gallery, *French paintings from the Courtauld Collection*, July 1955 (no cat.); Paris, Orangerie, *Impressionnistes de la Collection Courtauld de Londres*, 1955 (37 repr.); London, Hayward Gallery, *The Impressionists in London*, 3 Jan.–11 Mar. 1973 (32 repr.); London, Courtauld Institute Galleries, *Samuel Courtauld's collection of French 19th century paintings and drawings*, 1976 (34 repr.).

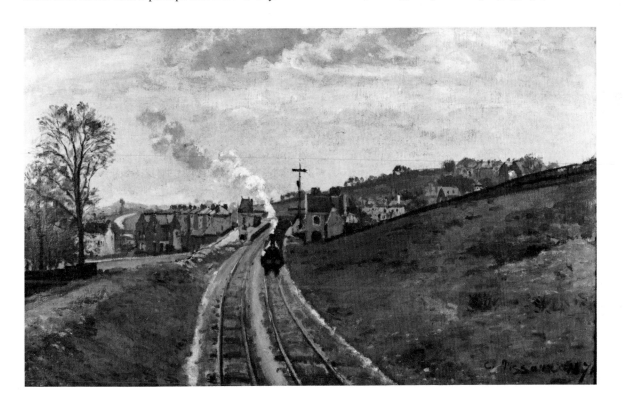

17
The 'Sente de Justice', Pontoise *c.* 1872

La Sente de Justice, Pontoise c. 1872
Canvas. 52.1 × 81.3 cm./20½ × 32 in. Signed, lower left:
C. Pissarro.
The Dixon Gallery and Gardens, Memphis, on loan from The
Brooks Memorial Art Gallery (inv. L.1976.2)

The painting does not occur in the *catalogue raisonné*. It is often
dated 1869–70, which is perhaps too early. The calligraphic
technique is more compatible with *The fence, autumn landscape*
(P&V 135), of 1872.

The subject is a pathway in Pontoise, now known as the Ruelle
des Poulies, which overlooks the town. The chimney of the gas-
works can be seen in the distance in the centre of the composition,
and the lantern of the church of Notre Dame is on the right.
Reidemeister reproduces a modern photograph of the pathway,
which Pissarro depicted again in a painting of 1872 now in the
Louvre (P&V 172).

The upper part of Pontoise is spread over a hillside and afforded
the artist the opportunity of creating compositions in which he
could juxtapose the various levels of the town. This device, which
can clearly be seen at work in the present painting, became an
important directive for the development of Pissarro's spatial sense
during the mid-1870s, as in Cat. 41.

An intimation of Goupil-Boussod and Valadon's interest in
buying this picture is recorded in a letter of 23 December 1891
(*Lettres*, pp. 272–3) from Camille to Lucien Pissarro, following a
visit from Joyant.

For the collector A. A. Pope see Rewald, 1973 *GBA*, p. 108.

PROVENANCE: Paris, Goupil-Boussod and Valadon, by whom bought from the artist
8 January 1892 for 800 frs. and subsequently sold to A. A. Pope 11 October 1893 for
900 frs.; Cleveland, A. A. Pope collection; New York, Wildenstein (1973);
Memphis, Mr. and Mrs. Hugo Dixon collection, by whom presented to The Brooks
Memorial Art Gallery.
LITERATURE: H. Wechsler, *French impressionists and their circle*, New York, 1953,
repr. col. pl. 12; Reidemeister, 1963, p. 50 repr.; Rewald, 1973 *GBA*, p. 79 and [103]
repr.; Rewald, 1973, repr. col. p. 266; Kunstler, 1974, repr. col. p. 15;
M. Milkovich, *The Dixon Gallery and Gardens. Paintings and sculpture*, Memphis,
1977, i. pp. 68–9, No. 30 repr. col.; Brettell, 1977, p. 90 repr.
EXHIBITED: New York, Wildenstein, 1965 (4 repr.); Memphis, The Dixon Gallery
and Gardens, *Impressionists in 1877*, 4 Dec.–8 Jan. 1977–8 (19 repr.).

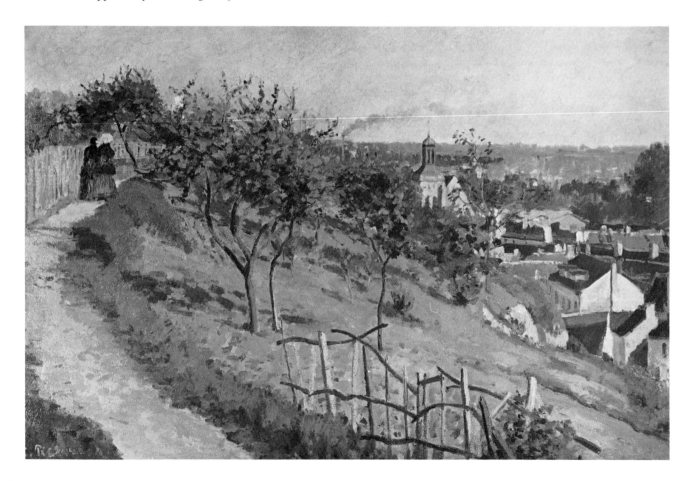

18 EXHIBITED IN BOSTON ONLY

Chestnut trees at Louveciennes 1872

Bois de chataigniers à Louveciennes

P&V 148

Canvas. 41 × 54 cm./16$\frac{1}{8}$ × 21$\frac{1}{4}$ in. Signed and dated, lower left:
C. Pissarro. 1872.

Mr. and Mrs. Alex Lewyt Collection, New York

The painting shows the park at Louveciennes with the aqueduct at Marly visible in the background, which occurs in four other pictures close in date (P&V 65, 85, 123 and Cat. 14). Pissarro painted the park at Louveciennes several times in 1870 (P&V 88 and 91) and in 1872 (P&V 144 and 146–7). Sisley, who lived and frequently worked in the same area, made the aqueduct itself the subject of a picture dating from 1874 (Daulte 133).

 Chestnut trees at Louveciennes can be related both to the *sous-bois*
tradition of the Barbizon school and to the later development of that theme by Cézanne in his paintings of the Jas de Bouffan (V 476). Here Pissarro has created a vivid surface pattern with the varied angles of the trees and the cast shadows in the foreground, but at the same time the inverted triangle in the centre opens out the composition to reveal the landscape beyond. Another notable feature is the intensity of the colours used for the shadows seen in the vibrant light of a spring day.

PROVENANCE: Paris, Durand-Ruel by whom probably bought from the artist 16 July 1872; Paris, Félix Gérard collection; (?) Paris, Paul Rosenberg; London, Tooth.
LITERATURE: Rewald, 1963, p. 82 repr. col.; Reidemeister, 1963, p. 49 repr.; Rewald, 1973, p. 295 repr. col.; Preutu, 1974, p. 27 repr. col.
EXHIBITED: London, Tooth, *La Flèche d'Or: important pictures from French collections*, 11 Nov.–4 Dec. 1937 (8); New York, Wildenstein, 1965 (9 repr. lent Lewyt); New York, Acquavella, *Four masters of Impressionism*, 24 Oct.–30 Nov. 1968 (6 repr. col. lent Lewyt).

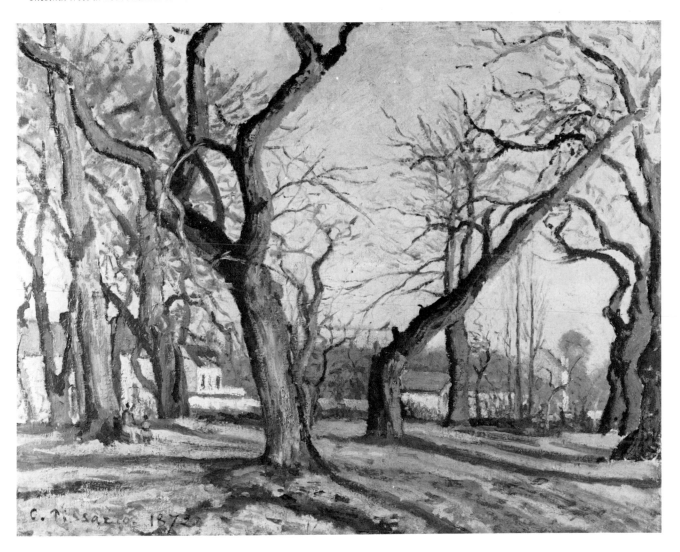

19
The lock at Pontoise 1872

L'écluse à Pontoise

P&V 156

Canvas. 58.3 × 83.6 cm./21 × 32¾ in. Signed and dated, lower left: *C. Pissarro 1872.*

Private collection

Even while Pissarro was painting in Louveciennes he was beginning to explore the possibilities of a detailed examination of motifs in and around Pontoise, not limiting himself as before to one particular area, L'Hermitage (Cat. 9–11). Pissarro depicted the lock at Pontoise frequently at this early stage. P&V 70, formerly in the collection of Jean-Baptiste Faure (A. Callen, *Jean-Baptiste Faure 1830–1914*, Leicester University MA Thesis, 1971, p. 380 No. 505), was possibly painted in 1867 and shows the lock from a similar angle. On the other hand, P&V 125 and 157 provide views of the

lock from the front. A later painting by Cézanne (V 316) of 1879–82 depicts a general view of the lock adjoining Pontoise and the Ile St. Martin.

The subject of a lock, or barrage is, in fact, one that can be closely associated with early Impressionism. Although not essayed by Monet, Sisley undertook such a painting in England (Daulte 118) in 1874. Pissarro did not return to the motif later, as he so often did where Pontoise was concerned.

PROVENANCE: Paris, Durand-Ruel; Paris, Charles Guasco collection (Paris, Georges Petit, 11 June 1900, lot 60 repr., *Les chalands au bord de la rivière*); Paris, Louis Schoengrun collection (Paris, Hôtel Drouot, 7 February 1901, lot 27 repr.); Paris, Max Behrendt collection; Paris (?), Gouin collection; New York, Wildenstein (1954–5).

EXHIBITED: Paris, Durand-Ruel, 1928 (7); Paris, Paul Rosenberg, *Exposition d'oeuvres importantes de grands maîtres du dix-neuvième siècle*, 18 May–27 Jul. 1931 (61 repr. lent Behrendt); Hartford, Wadsworth Atheneum, *Connecticut Collects*, 4 Oct.– 3 Nov. 1957 (37).

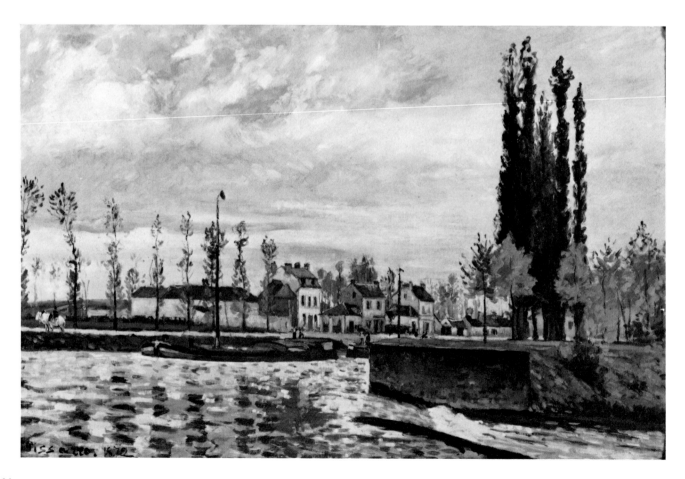

20 ILLUSTRATED IN COLOUR

The Crossroads, Pontoise (Place de Vieux Cimitière) 1872

Le Carrefour, Pontoise (Place de Vieux Cimitière)
P&V 180
Canvas. 55.8 × 91.4 cm./22 × 36 in. Signed and dated, lower
right: *C. Pissarro 1872.*
Museum of Art, Carnegie Institute, Pittsburgh (inv. 71.7)

The picture represents the crossroads near what had been a
mediaeval gateway to the old town of Pontoise above the Avenue
des Fossés. The area is now called the Place St. Louis and is still
used, as it was in Pissarro's own day, for markets. The same
crossroads seen from a different viewpoint occurs in P&V 211. As
in *La Sente de Justice* (Cat. 17), Pissarro exploits the hilly terrain on
which the town of Pontoise is positioned. The gently descending
foreground is balanced by the expanse of blue sky above. The
middle section of the composition is reduced to a thin strip, but it is
given greater variety by the houses, the foliage, and by the
procession of women on the right painted with a Boudinesque
dexterity. The palette is rich in pure colour (blue, green, yellow,
red, brown) reminiscent of Monet.

The painting was etched by Charles Courtry in 1873 for the
Galerie Durand-Ruel. Recueil d'estampes.

PROVENANCE: Paris, Durand-Ruel by whom bought from the artist, 23 August 1872,
La Place au Vieux Cimetière à Pontoise; New Jersey, Catholina Lambert collection
(New York, American Art Association, 12 February 1916, lot 67); Paris, Durand-
Ruel; Paris, Simon Bauer collection; sold anonymously New York, Parke-Bernet,
25 February 1970, lot 19 repr.; New York, Sam Salz, from whom acquired by the
Carnegie Institute through the generosity of the Sarah Mellon Scaife family, 1971.
LITERATURE: *Galerie Durand-Ruel. Recueil d'estampes*, 25me. livraison, Paris, 1875,
No. 245; Neugass, ('*Die Kunst für Alle*') 1930; S. Farrell, '*Le Carrefour, Pontoise*, by
Camille Pissarro', *Carnegie Magazine* xlv (1971), pp. 340–2 repr.; *Museum of Art,
Carnegie Institute. Catalogue of paintings*, Pittsburgh, 1973, p. 135 repr. col.; Lloyd,
1979, p. 5 repr. col.
EXHIBITED: Paris, Durand-Ruel, 1928 (5); Paris, Orangerie, 1930 (15); Paris,
Rosenberg, *Le grand siècle*, Jun.–Jul. 1936 (42); New York, Wildenstein, *12 years of
collecting*, 7 Nov.–15 Dec. 1973; Atlanta, High Museum of Art, *A French way of
seeing*, 4–27 Jan. 1974 (repr.).

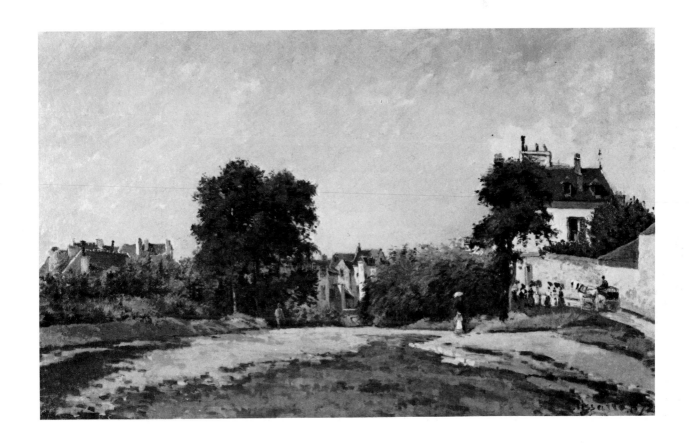

21 ILLUSTRATED IN COLOUR

Still-life: pears in a round basket 1872

Nature morte: poires dans un panier rond

P&V 194

Canvas. 46 × 55 cm./18 × 21⅝ in. Signed and dated, upper right: *C. Pissarro. 1872.*

Mrs. Marge Scheuer, New York

This picture is directly comparable with another still-life, *Apples with a jug on a table* (P&V 195), which was also bought from the artist by Durand-Ruel on the same day as the present picture. Both have the same patterned wallpaper in the background, similar, in fact, to that found in Cat. 24. Another still-life of pears in a bowl placed on a table covered with a cloth has been revealed by X-rays below the surface of *Landscape at Pontoise: trees in blossom* (P&V 388) of 1877 in the Musée du Louvre.

Pissarro has here limited himself to depicting a basket of fruit placed on a table covered with a sharply creased cloth. The basket is carefully positioned between two creases in the tablecloth, which continue the vertical lines of the wallpaper. As Cézanne began to do during this same decade, Pissarro has contrasted the rounded forms on the table with the vertical lines of the wallpaper and the horizontal emphasis of the table. It is a type of com-position that anticipates the still-lives painted by Gauguin during the mid-1880s (W Gauguin 208).

Compared with the earlier still-life of 1867 (Cat. 8), the palette and facture are totally different. The colours are now lighter and more softly gradated, whilst the brushwork possesses a suppleness that could never be achieved with a palette knife alone. As in the case of flower paintings, Pissarro only returned to still-life subjects much later in his life (P&V 1069–70 and 1116, of 1889 and 1900 respectively).

Interestingly, Durand-Ruel had bought two still-lives from Monet on 7 November 1872, namely W 244–5. Such pictures were perhaps easier to sell.

PROVENANCE: Paris, Durand-Ruel by whom bought from the artist 26 November 1872, *Panier de poires*; New York, A. Stone; New York, Mrs. Dorothy G. Noyes; sold anonymously New York, Parke-Bernet, 13 May 1970, lot 8 repr. col.; New York, Henry Pearlman collection.

LITERATURE: M. Roskill, *Van Gogh, Gauguin and the impressionist circle*, London-New York, 1970, p. 48 repr.

EXHIBITED: New York, Metropolitan Museum of Art, *Summer loan, 1971: paintings from New York collections: collection of Mr. and Mrs. Henry Pearlman*, 1971 (44); New York, Brooklyn Museum, *An exhibition of paintings, watercolours, sculpture and drawings from the collection of Henry Pearlman*, 22 May–29 Sept. 1974 (15 repr. col.); Princeton, The Art Museum Princeton University, *Selections from the collection of Mr. and Mrs. Henry Pearlman*, 8 Dec.–16 Mar. 1974–5 (no cat.).

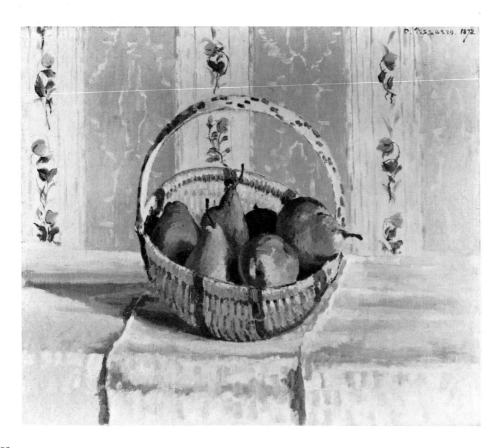

22

22 EXHIBITED IN BOSTON ONLY

Portrait of Minette (1865–1874) standing
c. 1872–3
Portrait de Minette, en pied
P&V 197
Canvas. 45 × 35 cm./18⅛ × 14 in. Signed with the artist's initials
lower left.
Wadsworth Atheneum, Hartford

Jeanne-Rachel, known as Minette, died at Pontoise on 6 April 1874,
aged nine. She was the second child and the first surviving
daughter of Camille and Julie Pissarro.

Pissarro often painted Minette before her early death. She
appears as a very small girl in P&V 96 (Zürich, Bührle Foundation,
Figure 00) and three other portraits of her are known besides Cat.
34 (P&V 192–3 and 289), as well as a gouache (P&V 1322 sold
Sotheby Parke-Bernet, 7 November 1979, lot 515, repr. col.). Of
these only P&V 193 is dated 1872. Pissarro also made a lithograph
of Minette on her death-bed (D 129).

The present portrait has a more interesting composition than the
other single portraits. It is notable for the positioning of the
diminutive figure within the room and for the still-life on the table
in the background. The preponderance of vertical lines, which
serves to emphasize the figure by stressing the frontality of the
pose, is mitigated by the curve of the table echoing the clasped
hands of the young girl. Pissarro evinced a rare interest in still-life
(Cat. 21) and flower painting (P&V 198–9) in 1872–3, all of which,
like the portraits of Minette, are possibly inspired by eighteenth-
century French painting, particularly the work of Fragonard. The
handling of the still-life in the portrait exhibited here is closer in
spirit to Chardin than Cat. 21.

A comparison with the *Portrait of Hortense Valpinçon* by Degas
(Lemoisne 206), of 1869, shows that where Degas offsets formality
of dress by informality of pose Pissarro does the reverse.

PROVENANCE: Camille Pissarro collection; Mme. Vve. Pissarro (Paris, Georges Petit,
3 December 1928, lot 48 repr.); Paris, Paul Rosenberg; Berlin, Bruno Stahl; New
York, Wildenstein; New York, Mrs. Anna Sorine collection.
LITERATURE: C. Cunningham, 'Portraits by Pissarro and Carrière', *Bulletin of the
Wadsworth Atheneum*, 4th series (1958), pp. 15–16 repr.; Rewald, 1963, p. 84 repr.
col.; Kunstler, 1974, repr. p. 75; Iwasaki, 1978, repr. col. pl. 6.
EXHIBITED: New York, Wildenstein, 1965 (17 repr.).

Illustrated on previous page

23

Landscape with flooded fields 1873
Paysage aux champs inondés
Canvas. 64.7 × 81.2 cm./25½ × 32 in. Signed and dated, lower
left: *C. Pissarro 1873*.
Wadsworth Atheneum, Hartford, Sumner Collection Purchase
Fund (inv. 1966. 315)

Like *The lock at Pontoise* (Cat. 19), this picture also displays the
painter's interest in the reflective qualities of water – a favourite
motif for impressionist painters, particularly Monet, but one to
which Pissarro was only occasionally attracted (P&V 557, of 1882,
and P&V 834–5, of 1893). Sisley, in fact, painted scenes of flooding
at Port-Marly four times in 1872 (Daulte 21–4) and again in 1876
(Daulte 236–40). The exact location of the flooded fields in
Pissarro's paintings and the identification of the factory are not
known. It is likely to be along the banks of the river Oise.
Comparison should be made with *The flood, St. Ouen L'Aumône*
(P&V 207), also painted in 1873.

Landscape with flooded fields does not occur in the *catalogue
raisonné* and the provenance cited below is only tentative, being
based upon the possible identification with the picture listed in a
letter of 4 June 1890 from Durand-Ruel to the artist (Venturi, 1939,
ii. p. 253).

PROVENANCE: possibly bought by Durand-Ruel from the artist in 1881, *Prairie
inondée*, and sold to May, 20 May 1882; Paris, Ernest May collection (Paris, Hôtel
Drouot, 4 June 1890, lot 58) bought Durand-Ruel and sold to Woolworth, 6 June
1890. Woolworth, from whom acquired by Harry K. Taylor; New York, Durand-
Ruel on deposit 18 Mar–21 April, 1927. Purchased from the estate of Harry K.
Taylor, by the Wadsworth Atheneum, 1966.
LITERATURE: *Wadsworth Atheneum Bulletin*, 6th series, iii (1967), pp. 10, 24 and 33
repr.; J. Rewald, 'The impressionist brush', *Metropolitan Museum of Art Bulletin*,
xxxii (1973–4), p. 56 repr. and col. det.

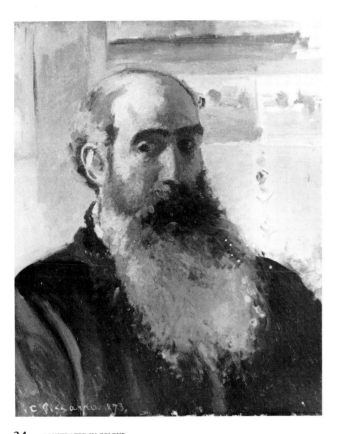

24 ILLUSTRATED IN COLOUR
Self-portrait 1873
Portrait de Camille Pissarro
P&V 200
Canvas. 56 × 46.7 cm./28⅝ × 18⅛ in. Signed and dated, lower left:
C. Pissarro. 1873.
Musée de Jeu de Paume, Paris (inv. RF 2837)

Although frequently reproduced, this self-portrait has hardly ever been seriously discussed. Yet the personal iconography of Camille Pissarro is of great interest, and is not unrelated to his role as an artist in France during the second half of the nineteenth century. He was often described by his contemporaries in biblical terms, being likened to Moses by Duranty (in *L'Artiste*, February, L (1880), p. 142), called the 'Good Lord' by Cézanne (*Conversations avec Cézanne*, ed. P.M. Doran, Paris, 1978, p. 21), 'an Eternal Father' by Thadée Natanson (*Peints à leur tour*, Paris, 1948, p. 59 in an essay entitled *The Apostle Pissarro*), and Abraham by George Moore (*Reminiscences of the impressionist painters*, Dublin, 1906, p. 39). These statements were partly induced by the artist's appearance, but also by what is best described as his professorial influence on painters of different generations, so that Emile Bernard could write mockingly of 'the dignity of his long beard and of his old talent' (Rewald, 1956, p. 312 n. 40).

This is the only self-portrait dating from the middle period of Pissarro's life. For the late self-portraits see Cat. 93. The evidence suggests that the artist began to grow a beard while in South America (Cat. 99) and two very early painted self-portraits now in Copenhagen, Royal Museum of Fine Arts, for which see E. Fischer, *Herbert Melbye's Samling*, Copenhagen, 1977, p. 22, repr. Shikes and Harper, 1980, p. 45). Certainly Pissarro had grown an extensive beard by the time he established himself in France, as can be seen in a drawing in Oxford (Brettell and Lloyd 40 verso) and in Cat. 215.

The paintings shown hanging behind the sitter in the present, traditionally posed, portrait cannot be identified, unlike those works appearing in Cat. 58.

PROVENANCE: Camille Pissarro collection; Paul-Emile Pissarro collection, fifth son of the artist, by whom presented to the Musée du Louvre, 1930 (entered the Musée du Louvre, 1947).
LITERATURE: P&V, p. 33; Jedlicka, 1950, pp. 10–11 repr.; Natanson, 1950, repr. pl. 14; Leymarie, 1955, ii, p. 49 repr. col.; *Musée National du Louvre, catalogue des peintures, pastels, sculptures impressionnistes*, Paris, 1959, p. 160 No. 307; Rewald, 1963, p. 92 repr. col.; T. Reff, 'Pissarro's *Portrait of Cézanne*', *Burlington Magazine* cix (1967), p. 628; M. Roskill, *Van Gogh, Gauguin and the impressionist circle*, New York–London, 1970, p. 48; Cogniat, 1974, repr. col. title-page; Kunstler, 1974, p. 38 repr. col.; Preutu, 1974, repr. col. p. 62; Iwasaki, 1978, repr. col. pl. 9; H. Adhémar and A. Distel, *Musée du Jeu de Paume*, Paris, 1979, p. 167 repr.; Shikes and Harper, 1980, repr. frontispiece.
EXHIBITED: London, Leicester Galleries, 1920 (56); Paris, Orangerie, 1930 (19 lent Paul-Emile Pissarro); Paris, Bernheim-Jeune, *Cent ans de portraits français 1800–1900*, Oct.–Nov. 1934 (unnumbered); Paris, Galerie de l'Elysée, Apr.–May 1936 (138); Paris, Seligman, *Portraits français de 1400–1900*, Jun.–Jul. 1936 (138); London, Agnew, 1937 (3); Dieppe, 1955 (no catalogue); Limoges, Musée Municipale, *De l'Impressionnisme à nos jours*, 1956 (21); Lisbon, Gulbenkian Foundation, *Un seculo de pintura francesa 1850–1950*, 1965 (112 repr.); Leningrad, Hermitage and Moscow, Pushkin Museum, *Peintures impressionnistes des musées francais*, 1970–1 (unnumbered); Madrid, Museo de Arte Contemporaneo, *Los impresionistas franceses*, 1971 (56 repr.); Paris, Palais de Tokyo, Musée d'Art et d'Essai, *Autoportraits de peintres*, 1978 (unnumbered).

25 ILLUSTRATED IN COLOUR
The Gisors road, Pontoise. Snow 1873
La route de Gisors à Pontoise. Effet de neige
P&V 202
Canvas. 60 × 73.3 cm./23½ × 29 in. Signed and dated, lower
right: *C. Pissarro 1873.*
Museum of Fine Arts, Boston (inv. 48.587)

Although there has been some disparity over the identification of
the street, the modern photograph reproduced by Reidemeister
proves conclusively that this is the road leading to the north-west
out of Pontoise to Gisors, which Pissarro had painted for the first
time in 1868 (P&V 63).

The composition is almost an exercise in geometry with
horizontal lines offset by short vertical strokes. The horizontal
lines create a series of 'steps' forming a broken diagonal that leads
the eye down the street towards the distant landscape. The
technique, characterized by short, crisp strokes accented with
touches of colour, still owes a great deal to Monet, who from the
late 1860s had frequently painted snow scenes. Such paintings,
together with those of Sisley, are important for an understanding of
the theory of Impressionism.

PROVENANCE: Paris, Durand-Ruel; New York, Durand-Ruel (by 14 September 1894);
Boston, John Taylor Spaulding collection, by whom bequeathed to the Museum of
Fine Arts, 1948.
LITERATURE: F. Watson, 'American collections: No. 2. The John T. Spaulding
collection', *The Arts* viii (1925), p. 336 repr.; A. Pope, 'French paintings in the
collection of John T. Spaulding', *Art News* xxvii (1930), p. 98 repr.;
W. G. Constable, *Boston Museum of Fine Arts. Summary catalogue*, Boston, 1955,
p. 52; Reidemeister, 1963, p. 55 repr.; Rewald, 1963, p. 88 repr. col.; Preutu, 1974,
repr. col. p. 39.
EXHIBITED: Boston, Museum of Fine Arts, *The collections of John Taylor Spaulding
1870–1948*, 26 May–7 Nov. 1948 (64); Manchester (New Hampshire), Currier
Gallery of Art, *Monet and the beginnings of Impressionism*, 8 Oct.–6 Nov. 1949 (18);
Berlin, Orangeries Schlosses Charlottenburg, *Die Ile de France und ihre Maler*,
29 Sept.–24 Nov. 1963 (15); Atlanta, High Museum of Art and Denver, Denver Art
Museum, *Corot to Braque. French paintings from the Museum of Fine Arts Boston*,
21 Apr.–17 Jun. and 13 Feb.–20 Apr., 1979–80 (32 repr. col.).

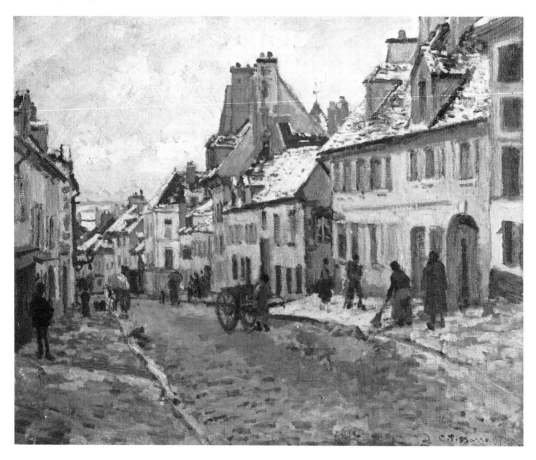

26
Hoar frost, the old road to Ennery, Pontoise
1873

Gelée blanche, ancienne route d'Ennery, Pontoise

P&V 203

Canvas. 65 × 93 cm./$25\frac{5}{8}$ × $36\frac{5}{8}$ in. Signed and dated, lower left:
C. Pissarro. 1873.

Musée de Jeu de Paume, Paris (inv. RF 1972. 27)

This is one of five paintings exhibited by Pissarro in 1874 at the first Impressionist exhibition (Venturi, 1939, ii. p. 256 Nos. 136–40).

The old road to Ennery leads from L'Hermitage over the hillside to the north-east of Pontoise. The hill itself forms a strong horizontal band, while the ploughed furrows and the pathway emphasize the diagonals. At the same time the artist has divided the picture surface vertically into four parts with the figure on the left, the trees in the centre on the horizon, and the tree on the right serving as markers. The bleak landscape and the means by which the composition has been divided reinforces the feeling of man's subjection to nature, a feeling which is often expressed in Pissarro's paintings of the 1870s. Indeed, Burty correctly likened this canvas to J.-F. Millet, the first published example of this much vaunted comparison. Castagnary, on the other hand, remarked upon the use of shadows cast by trees omitted in the composition itself, a technical device of striking originality that was used again during the neo-impressionist period and later (Cat. 63).

PROVENANCE: Paris, Jean-Baptiste Faure collection; Paris, Durand-Ruel (placed *en dépôt* by Faure 1900 and purchased jointly by Durand-Ruel, New York, and Georges Petit from Mme. Maurice Faure, 1 February 1919); Paris, Georges Petit; Paris, Eduardo Mollard collection (1939), by whom bequeathed to the Musée du Louvre, 1972.

LITERATURE: Burty, 1874; Leroy, 1874; Castagnary, 1874; Lora, 1874; J.-B. Faure, *Notice sur la collection J.-B. Faure suivie du catalogue des tableaux formant cette collection*, Paris, 1902, No. 82, p. 41 [A. Callen, *Jean-Baptiste Faure, 1830–1914*, Leicester University MA Thesis, 1971, p. 585 No. 82 and p. 386 No. 512]; H. Adhémar, 'Dernières acquisitions', *La Revue du Louvre* xxiii (1973), p. 289 repr.; M. Hours, 'Etudes radiographique. Manière et matière de l'Impressionnisme', *Annales laboratoire de recherche des Musées de France* 1974, p. 28 repr.; H. Adhémar and A. Distel, *Musée du Jeu de Paume*, Paris, 1979, p. 167 repr.; Lloyd, 1979, p. 5 repr. col.; Shikes and Harper, 1980, pp. 110–12 repr.

EXHIBITED: Paris, 1874 (137 *Gelée blanche*); Paris, Durand-Ruel, 1904 (24 lent Faure); Paris, Durand-Ruel, 1928 (13); Paris, Grand Palais and New York, Metropolitan Museum, *Impressionism. A centenary exhibition*, 21 Sept.–24 Nov. and 12 Dec.–10 Feb. 1974–5 (34 repr.).

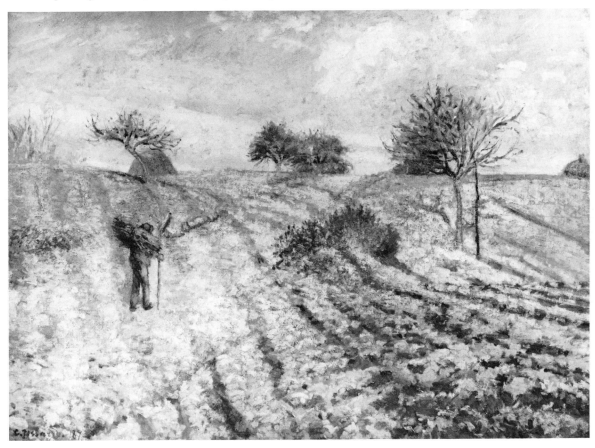

27
Hillside at L'Hermitage 1873

Coteau de L'Hermitage, Pontoise
P&V 209
Canvas. 61 × 73 cm./23⅞ × 28¾ in. Signed and dated, lower right:
C. Pissarro. 1873.
Durand-Ruel collection, Paris

Pissarro painted this composition twice, once as here in autumn and again in the following year in winter (P&V 238). The later painting was included in the second Impressionist exhibition (April 1876). There is also an early lithograph of the same subject (D 133, *c.* 1874).

The type of composition found in these works, with architectural elements offsetting the contours of the hillside, recalls the much larger canvases of L'Hermitage (Cat. 9–11) dating from the late 1860s. Now, however, the facture is very different, as the brushstrokes are broken and grouped in clusters.

Brettell has identified the houses as those on the rue Fond de L'Hermitage, a traditional street in L'Hermitage which Pissarro depicted less frequently than the more modernized rue L'Hermitage. For another rendering of the rue Fond de L'Hermitage slightly later in date see Cat. 42.

PROVENANCE: Paris, Durand-Ruel (recorded 25 August 1891).
LITERATURE: Bazin, 1947, p. 137; Coe, 1963, p. 9; D. Sutton, 'Revolutionary quartet', *Apollo* lxxvii (1963), p. 479 repr.; Brettell, 1977, pp. 181 and 189.
EXHIBITED: Paris, Durand-Ruel, 1921 (18); Paris, Durand-Ruel, 1928 (11); Albi, Musée d'Albi, *Toulouse-Lautrec: ses amis et ses maîtres*, 1951 (296); Paris, Orangerie, *Van Gogh et les peintres d'Auvers-sur-Oise*, 26 Nov.–28 Feb. 1954–5 (90); Paris, Durand-Ruel, 1956 (19); Paris, Durand-Ruel, 1962 (8); Hamburg, Kunstverein, *Wegbereiter der modernen Malerei: Cézanne, Gauguin, Van Gogh, Seurat*, 4 May– 14 Jul. 1963 (repr. pl. 3).

28
The factory on the Oise, Pontoise 1873

La crue de l'Oise, Pontoise
P&V 214
Canvas. 39 × 47 cm./15⅜ × 18½ in. Signed and dated, lower left:
C. Pissarro. 1873.
Earl of Jersey collection, Jersey, Channel Islands

The factory on the Oise, Pontoise forms part of a group of four pictures depicting the newly erected factory of Chalon et Cie, situated on the south side of the river Oise in St. Ouen l'Aumône on the opposite bank from Pontoise. Two other paintings from this group are included in the exhibition (Cat. 29–30), and a third (P&V 217) is in Montreal (Bronfman Foundation). There is also an etching of the factory (D 10 of 1874).

The factory owned by Chalon et Cie was built in the early 1860s and extended in 1872–3 (Brettell, 1977, pp. 137–8). It distilled alcohols from locally grown sugar beet. In all the paintings from this group Pissarro views the factory from across the river, altering the angle of vision on each occasion. Only in P&V 217 and Cat. 30 is the bank itself in evidence in the foreground, as it is in the etching D 10. As in P&V 217, Pissarro here depicts the factory from the right, and as in Cat. 30 a barge is included on the river.

PROVENANCE: Paris, Bignou; sold anonymously Paris (?), 7 June 1911, lot 34 repr.; sold anonymously Berlin, Paul Cassirer, 22 October 1932, lot 63 repr.; Berlin, Mme. Tilla Durieux collection, wife of Paul Cassirer; London, Reid and Lefevre.
LITERATURE: P&V p. 32; Brettell, 1977, pp. 139–45 repr.
EXHIBITED: London, Reid and Lefevre, *Pissarro and Sisley*, Jan. 1937 (6); Glasgow, McLellen Gallery (Reid and Lefevre), *French art of the 19th and 20th centuries*, Apr. 1937 (43); London, Reid and Lefevre, *The 19th century French masters*, Jul.–Aug. 1937 (29); Montreal, *Paintings by French masters of the 19th and 20th centuries*, Oct. 1937 (38); New York, Bignou, *Masterpieces by nineteenth-century French painters*, 11–30 Apr. 1938 (11); London, Reid and Lefevre, *Milestones in French painting*, Jun. 1939 (23).

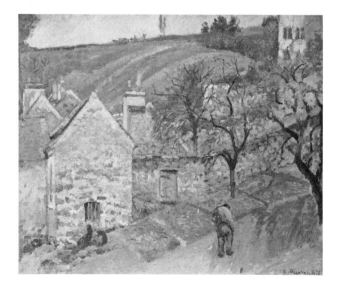

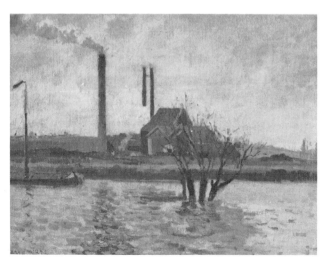

29 ILLUSTRATED IN COLOUR

Factory near Pontoise 1873

Usine près de Pontoise

P&V 215

Canvas. 47.7 × 55.9 cm./18⅜ × 22 in. Signed and dated, lower left: *C. Pissarro. 1873.*

Museum of Fine Arts, Springfield, the James Philip Gray collection

Of all the paintings forming the group of factory subjects dating from 1873 (see Cat. 28), this is the only picture in which the buildings are seen directly from the front. Although the factory is the dominant motif in each painting, here it is presented uncompromisingly. When Pissarro returned to the subject in 1876 (P&V 353–7) and 1879 (P&V 477) the factory was seen only as a motif in the background (Brettell, 1977, pp. 160–4).

In his discussion of the four paintings dating from 1873 Brettell has demonstrated, with the aid of contemporary maps and postcards, how Pissarro has altered the proportions of the factory and even rearranged the buildings and surrounding trees. Thus, in the present painting the chimneys and the roof over the central part are exaggerated, whilst there is no evidence to show that the tall sheds on the left ever existed at all. Similarly, in Cat. 30 the complex seems to be larger and to have an additional white-washed section on the right with an extra chimney, which was in fact the first part of the factory to have been erected in the early 1860s, but which cannot be made out in the other paintings.

PROVENANCE: Paris, Durand-Ruel (entered 23 July 1883, *Usine à St. Denis*); New York, Durand-Ruel (by 14 September 1894); E. Davis (?); New York, Durand-Ruel, from whom purchased by the Museum of Fine Arts, Springfield, 1937.

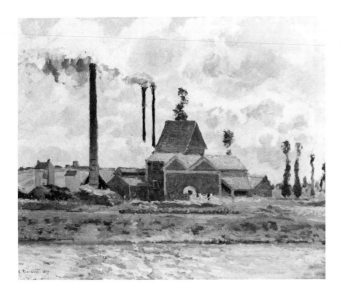

LITERATURE: *Springfield Museum of Fine Arts: Bulletin* iv (1938), unpaginated; Brown, 1950, p. 13 repr.; P&V, p. 32; Lanes, 1965, pp. 275–6; *Handbook of the Springfield Museum of Fine Arts*, Springfield, 1968, p. 33 repr.; Brettell, 1977, pp. 139–56; Lloyd, 1979, p. 12 repr. col.; Shikes and Harper, 1980, pp. 128–30 repr. col.

EXHIBITED: New York, Durand-Ruel, 1897 (18); New York, Durand-Ruel, 1936 (13); Baltimore, Museum of Art, 1936 (2 lent Durand-Ruel, New York); Springfield, Museum of Fine Arts, *Exhibition of master Impressionists*, 1937; Springfield, Museum of Fine Arts, *In freedom's search*, 15 Jan.–19 Feb. 1950 (5); Montreal, Museum of Fine Arts, *Six centuries of landscape*, 6 Mar.–13 Apr. 1952 (50); Amherst, College Museum of Art, 2–31 Jan. 1953; Mt. Holyoke College, *French and American Impressionism*, 5 Oct.–4 Nov. 1956 (20); New York, Wildenstein, 1965 (20 repr.); Providence, Rhode Island School of Design, *To look on nature: European and American landscape 1800–1874*, 3 Feb.–5 Mar. 1972 (pp. 143–4 repr.).

30 EXHIBITED IN BOSTON ONLY

The Oise on the outskirts of Pontoise 1873

L'Oise aux environs de Pontoise

P&V 218

Canvas. 45.3 × 55 cm./17⅞ × 21⅝ in. Signed and dated, lower right: *C. Pissarro. 1873.*

Sterling and Francine Clark Art Institute, Williamstown, Massachusetts (inv. 554).

The Oise on the outskirts of Pontoise is perhaps the climax of the series of four views of the factory owned by Chalon et Cie (see Cat. 28). In it the factory is seen from the left and, like P&V 217, Pissarro shows not only a part of the bank on which he was situated, but also more of the setting behind the factory. The painting therefore comprises buildings associated with modern urban life located in a traditional landscape, and not the stark image shown in Cat. 29. Thus, the present painting can be more easily associated with an earlier factory subject undertaken by Pissarro in the 1860s (P&V 66), or with those of 1876 (P&V 353–7).

Both Guillaumin (C. Gray, *Armand Guillaumin*, Chester, Conn., 1972, figs. 1, 10 and pl. 55) and Monet (W 206 and 213) painted industrial landscapes during the late 1860s and early 1870s that must have been known to Pissarro. Yet, given Pissarro's political philosophy, the image of the factory had a particular potency and it is one that recurs at intervals throughout his work (see Cat. 48, 66). Pissarro's attitude to industrialization in and around Pontoise has yet to be fully debated, although Brettell (1977, pp. 118–64) has reviewed the issue. Clearly it is an aspect of Pissarro's work that stands in close relation to Neo-Impressionism.

PROVENANCE: Paris, E. Garçin; New York, Durand-Ruel (1943); R. S. Clark collection; Clark Art Institute, 1955.

LITERATURE: P&V, p. 32; Jedlicka, 1950, repr. pl. 12; Natanson, 1950, repr. pl. 12; *Williamstown, Clark Art Institute. French paintings of the 19th century*, 1963, No. 97 repr.; Rewald, 1963, p. 94 repr. col.; London, Marlborough, 1968, Introduction to exhibition catalogue, p. 10 repr.; *List of paintings in the Sterling and Francine Clark Art Institute*, Williamstown, 1972, p. 78 repr.; Bellony-Rewald and Gordon, 1976, p. 136 repr.; Brettell, 1977, pp. 139–56; Shikes and Harper, 1980, pp. 128–30.

EXHIBITED: Paris, Marcel Bernheim, 1936 (14 lent Garçin); New York, Durand-Ruel, *Exhibition celebrating One Hundred Fortieth Anniversary*, 15 Nov.–4 Dec. 1943 (16 repr.).

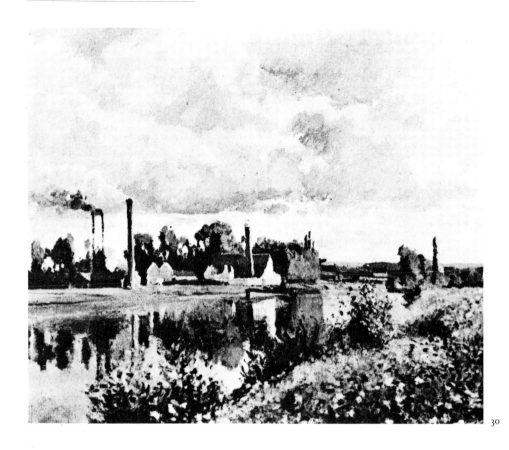

30

31
Ploughed fields near Osny 1873

Terrains labourés près d'Osny
P&V 220
Canvas. 46 × 55 cm./18 × 21⅝ in. Signed and dated, lower right:
C. Pissarro. 1873.
Durand-Ruel collection, Paris

The subject-matter of this painting resembles Cat. 26 and *Ploughed land* (P&V 258, Moscow, Pushkin Museum), of 1874. These three compositions prompt comparison with J.-F. Millet, particularly *Winter with crows* (Paris, 1975, No. 192). Yet, Pissarro's depiction of the fields, even allowing for seasonal differences, is neither so stark nor so bleak as Millet's rendering, and any symbolical meaning is negated by the narrative elements in each of the paintings by Pissarro. Compositionally, *Ploughed fields near Osny* is highly significant. As in Cat. 26, the ploughed furrows are used as sight lines to lead the eye up the hillside, and the horizon line, which is slightly curved, is placed high up the canvas. Such devices anticipate paintings dating from the second half of the 1880s (Cat. 68) and its radicalism may be appreciated by comparing a picture of the same subject by Sisley (Daulte 65) dating from 1873.

The painting was one of three by Camille Pissarro owned by Degas (*Collection Edgar Degas*, Paris, Georges Petit, 26–7 March 1918, lots 85 *Paysage* of 1872, 86 *Terrains labourés près Osny* of 1873, and 87 *Bords de rivière* of 1871). Lots 85 and 87 can be identified as P&V 163, now in the Ashmolean Museum, Oxford, and P&V 124.

It is clear from a letter, originally quoted under the entry for P&V 220, written by Pissarro to Duret on 8 December 1873 that, although the latter had bought the picture at auction, he had allowed it to pass to Degas. The letter discusses a replacement. For the circumstances of the sale see P&V, pp. 26–7.

PROVENANCE: Paris, Hôtel Drouot, 19 April 1873, bt. Duret by whom apparently ceded to Degas (see Commentary); Paris, Edgar Degas (Paris, Georges Petit, 26–27 March 1918 lot 86) bt. Durand-Ruel; Paris, Durand-Ruel; Paris, Paul Rosenberg; Paris, Durand-Ruel.
LITERATURE: Meier-Graefe, 1907, p. 161; A. Terrasse, *Degas*, Milan, 1972, repr. p. 90; Shikes and Harper, 1980, p. 121.
EXHIBITED: Paris, 1883 (2); Paris, Durand-Ruel, 1904 (22 lent Degas); Paris, Durand-Ruel, 1921 (40); Paris, Durand-Ruel, 1928 (14); Paris, Durand-Ruel, 1956 (20); Paris, Durand-Ruel, 1962 (9); Paris, Durand-Ruel, *Cent ans d'Impressionnisme 1874–1974*, 15 Jan.–15 Mar. 1974 (39 repr.); Bordeaux, Musée, *Naissance de l'Impressionnisme*, 3 May–1 Sept. 1974 (114 repr.).

31

32

32 ILLUSTRATED IN COLOUR
The haystack, Pontoise 1873

La meule, Pontoise

P&V 223

Canvas. 45 × 54 cm./$17\frac{3}{4}$ × $21\frac{1}{4}$ in. Signed and dated, lower right: *C. Pissarro. 1873.*

Durand-Ruel collection, Paris

This is one of Pissarro's best known landscapes of the 1870s. Like many other canvases of this decade, the suppleness of the brushwork, the delicacy of the palette, and the merits of the composition itself almost belie the boldness of the conception. The positioning of the haystack, for example, and its conical shape, are masterly. It marks the pivot of the composition, being silhouetted partly against the sky and partly against the distant landscape, whilst its sloping sides lead the eye diagonally downwards into the corners. The haystack is in fact just off centre. Furthermore, the foreground has been left empty and there is a total absence of any specific rural activity, thereby treating the haystack as though it is an object in a still-life.

The haystack is not a motif that occurs very frequently in Pissarro's *oeuvre*: P&V 185, which forms part of a series representing the Four Seasons, 233, 589 (Sotheby's, 2 April 1979, lot 26), 713, and 736 may be cited as compositions in which the form is instrumental in the division of the picture space.

PROVENANCE: Paris, Portier collection; Paris, Durand-Ruel (bought from Portier, 11 April 1899).
LITERATURE: Tabarant, 1924, repr. pl. 6; Venturi, 1935, p. 142 repr.; P&V p. 33; Venturi, 1950, p. 72 repr.; Jedlicka, 1950, repr. pl. 13; Natanson, 1950, repr. pl. 13; Leymarie, 1955, ii, repr. col. p. 17; Rewald, 1963, p. 96 repr. col.; Pool, 1967, p. 112 repr. col.; Blunden, 1970, p. 121 repr. col.; Kunstler, 1974, p. 23 repr. col.; Preutu, 1974, p. 48 repr.
EXHIBITED: Paris, Durand-Ruel, 1928 (12); Paris, Rosenberg, *Exposition d'oeuvres importantes de grands maîtres du dix neuvième siècle*, 1931 (62); Paris, Durand-Ruel, *De Corot à Van Gogh*, May–June 1934 (28); Paris, Durand-Ruel, 1956 (21); Berne, Kunstmuseum, 1957 (28); Paris, Musée Jacquemart-André, *Le Second Empire*, 1957, (uncatalogued); Paris, Durand-Ruel, 1962 (10 repr. col.); Stockholm, Nationalmuseum, *La douce France*, 7 Aug.–11 Oct. 1964 (27 repr.); Hamburg, Kunstverein, *Französischen Impressionnisten. Hommage à Durand-Ruel*, 28 Nov.–24 Jan. 1970–1 (34 repr. col.); Paris, Durand-Ruel, *Cent ans d'Impressionnisme 1874–1974*, 15 Jan.–15 Mar. 1974 (40 repr.).

33
Bourgeois house at L'Hermitage, Pontoise
1873

Maison bourgeoise à L'Hermitage, Pontoise

P&V 227

Canvas. 50.5 × 65.5 cm./$19\frac{3}{4}$ × $25\frac{5}{8}$ in. Signed and dated, lower right: *C. Pissarro. 1873.*

Kunstmuseum, Saint Gallen

Reidemeister (1963), who reproduces a modern photograph of the motif, established that the house is No. 46 of the rue de L'Hermitage at Pontoise. The picture was acquired by the Nationalgalerie Berlin during the artist's lifetime (*Lettres*, 7 November 1897, pp. 439–40), but was forcibly sold before the outbreak of the 1939–45 war.

While there is little surprising about the composition of *Bourgeois house at L'Hermitage*, the handling of the paint is best described as exploratory. The short, crisp brushstrokes of pure colour adopted by Pissarro during the early 1870s are now substituted by a looser, fussier manner of working that has its logical conclusion in the canvases dating from the late 1870s (Cat. 46–7). The same tendency can be found in P&V 230, of 1873, and in P&V 335, of 1875. In these pictures, as in the present one, compositional unity is no longer wholly dependent upon the drawing so much as on the overlaying of the paint surface and the tonal qualities derived from a more unified palette. These features are also characteristic of Pissarro's paintings executed in the manner of Cézanne during the mid-1870s (Cat. 39–42).

PROVENANCE: Paris, Durand-Ruel; Berlin, Nationalgalerie, by whom acquired in 1897, but forcibly sold in 1936; Eduard Sturzenegger, by whom bequeathed to the Kunstmuseum, Saint Gallen.

LITERATURE: Weisbach, 1911, p. 143 repr.; W. Uhde, *The Impressionists*, Vienna, 1937, repr. pl. 51; *Katalog de Sturzeneggerschen Gemälde sammlung des Stadt*

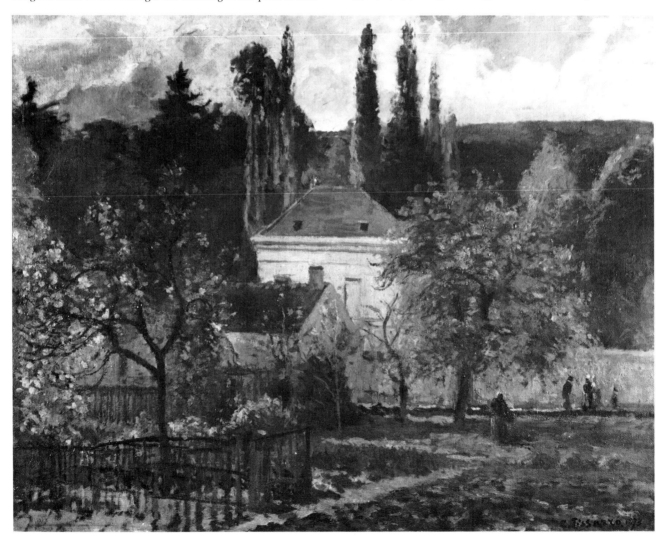

St. Gallen, St. Gallen, 1937, No. 61 repr.; *Lettres*, p. 440; Reidemeister, 1963, p. 57 repr.; L. Reidemeister, 'The National Galerie, Berlin', *Apollo* lxxx (1964), p. 91. EXHIBITED: Paris, Galerie de Gazette des Beaux-Arts, *La peinture française du XIXe siècle en Suisse*, Jun. 1938 (73 repr.); Amsterdam, Stedelijk Museum, Jul.–Sept. 1938 (191 repr.); Basle, Kunsthalle, *Impressionisten. Monet, Pissarro, Sisley*, 3 Sept.–20 Nov. 1949 (75); Paris, Durand-Ruel, 1956 (22); Berne, Kunstmuseum, 1957 (30); Paris, Petit-Palais, *De Géricault à Matisse: chefs d'oeuvre français des collections suisses*, Mar.–May 1959 (107); Wolfsburg, Stadthalle, *Französische Malerei von Delacroix bis Picasso*, 8 Apr.–31 May 1961 (117 repr. col.); Berlin, Orangeries Schlosses Charlottenburg, *Die Ile de France und ihre Maler*, 29 Sept.–24 Nov. 1963 (16).

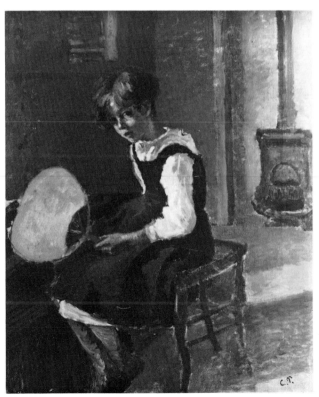

34

34 EXHIBITED IN LONDON AND PARIS ONLY
Portrait of Minette (1865–1874) seated holding a fan *c.* 1873

Portrait de Minette tenant un éventail

P&V 232

Canvas. 55 × 46 cm./21⅝ × 18 in. Signed with artist's initials, lower right.

The Ashmolean Museum, Oxford (inv. A 821), lent by the Visitors of the Ashmolean Museum

For biographical details and other portraits of the sitter see Cat. 22.

Like all the other portraits of Pissarro's first daughter, who died tragically young, this is a moving depiction of his sickly child. The figure sits on a stool in three-quarters profile, carefully positioned between a series of vertical lines established by a window, a doorway and a stove, all seen in the background. She is perhaps shown in her bedroom, since the item of furniture on the left appears to be a bed. It is interesting that Minette holds a Japanese fan, one of the rare instances where Pissarro demonstrates his interest in Japanese objects (for another see Cat. 58). It is significant that Pissarro exhibits this interest so early, although there is corroborative evidence in a letter written to the collector and critic Theodore Duret dating from 2 February 1873 (quoted in E. Scheyer, 'Far Eastern art and French Impressionists', *Art Quarterly*, vi (1963), pp. 127–8). Monet's *La Japonaise* (W 387), for example, dates from 1875–6, and Renoir's *Madame Georges Charpentier and her children* (Daulte/Renoir 266) dates from 1878

The colour in the portrait is subdued: the girl's dress is blue, but the background comprises muted browns, greys, greens, and reds. In this respect Cat. 22 and the present painting are closely related, both differing from the other portraits of Minette, which are notable for their light palette, particularly P&V 192–3.

The picture was cleaned in 1980.

PROVENANCE: London, Lucien Pissarro collection; Esther Pissarro collection, by whom presented to the Ashmolean Museum, Oxford, 1950.
LITERATURE: Cogniat, 1974, repr. col. p. 25; Shikes and Harper, 1980, repr. p. 126.
EXHIBITED: Paris, Manzi et Joyant, 1914 (69); London, Tate Gallery, 1931 (35), and subsequently at Birmingham, Oct.–Nov. 1931 (29), Nottingham, Nov.–Dec. 1931, Stockport, Jan. 1932 (4), Sheffield, Feb.–Mar. 1932 (4); London, O'Hana, 1954 (1).

35
The railway crossing at Les Pâtis near Pontoise 1873–4

La barrière du chemin de fer aux Pâtis, près Pontoise
P&V 266
Canvas. 65 × 81 cm./25 × 31⅞ in. Signed and dated twice, both times lower left: *C. Pissarro. 1873* and *C. Pissarro. 1874.*
The Phillips Family collection

The railway from Paris to St. Ouen l'Aumône had been opened in 1846 and a new bridge across the river Oise was built to carry the line on to Pontoise and beyond in 1863–4 (P&V 234). For Les Pâtis see Cat. 12.

The present painting is one of the finest dating from the 1870s and it is perfectly preserved. It is interesting to note that, unlike the painting of a railway undertaken in England (Cat. 16), Pissarro has here ignored the modernity of the subject by omitting any suggestion of a train, as he did in P&V 205 (Tokyo, National Museum of Western Art), which was also painted near Les Pâtis.

The composition is remarkably well ordered with the figures locked into a grid of vertical lines. Technically, the picture is important for its luminosity and the even paint surface.

It will be observed that the painting is dated twice implying that Pissarro made alterations, almost certainly to the architecture and to the figures. Indeed, a closely related lithograph (D 130), of 1874, might be evidence of Pissarro's later interest in the figures before he undertook the repainting. There is documentary evidence that these alterations had been completed by June 1874 (*Archives*, 1975, No. 5 and *Paul Cézanne. Letters,* ed. J. Rewald, Oxford, 1976, pp. 139–40, both quoted originally under the entry for P&V 266).

PROVENANCE: Paris, Bouvier (Paris, Hôtel Drouot, 14 April 1892, not in cat.); Paris, Durand-Ruel; Berlin, Cassirer (acquired from Durand-Ruel 12 Feb. 1891); Paris, L. Panis; Prague-Dejvice, B. Palkovsky; sold anonymously Stuttgart, Kunstkabinett, 37. Auktion (Moderne Kunst), 3–4 May 1962, lot 378 repr. col.; Mark Horowitz (Sotheby's, 29 April 1964, lot 41 repr.); Zurich, private collection; New York, Wildenstein.

LITERATURE: A. Fontainas and L. Vauxcelles, *Histoire générale de l'art français de la Révolution à nos jours*, Paris, 1922, repr. p. 161; A. Tabarant, 'Le cinquantaire de l'Impressionnisme', *La renaissance de l'art Français*, vii (1924), repr. p. 245; Holl, 1928, p. 148; Jedlicka, 1950, repr. pl. 15; Natanson, 1950 repr. pl. 15; G. Chan, *Les peintres impressionnistes et le chemin de fer*, Paris, 1955, p. 15 repr.; A. Brookner, 'Current and forthcoming exhibitions', *Burlington Magazine* civ (1962), p. 314; Kunstler, 1967, p. 27 repr. col.; Brettell, 1977, pp. 115–6 and 226 repr.

EXHIBITED: London, Marlborough, *French masters*, 1962 (16); New York, Wildenstein, *One hundred years of Impressionism, a tribute to Durand-Ruel*, 1970 (20 repr.).

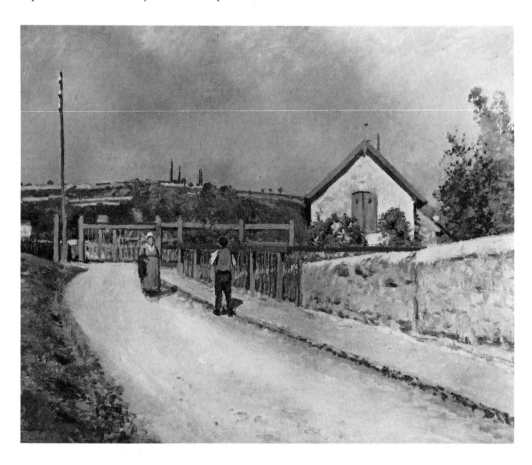

36
Female peasant pushing a wheelbarrow, Maison Rondest, Pontoise 1874

Paysanne poussant une brouette, Maison Rondest, Pontoise
P&V 244
Canvas. 65 × 51 cm./25⅝ × 20⅛ in. Signed and dated, lower left corner: *C. Pissarro 1874.*
Nationalmuseum, Stockholm (inv. 2086)

As in '*Gelée blanche*' (Cat. 26), the figure in the present painting plays an important part in the compositional structure of the picture. While the two walls dominate the left and right halves, the centre is marked by the figure pushing the wheelbarrow. The fact that the figure is seen directly from the front advancing towards the spectator links the foreground to the background, just as the vertical emphasis relates it to the walls on either side.

There is a drawing in Oxford (Brettell and Lloyd 85A recto) that may have been made in connection with *Female peasant pushing a wheelbarrow*. It shows a female figure wheeling a barrow, but she is dressed differently. The sheet forms part of a sketchbook used in Pontoise, and contains many such drawings in which Pissarro explores peasant activities in detail.

The house owned by Jean Baptiste Rondest (1832–1907) was in the L'Hermitage quarter of Pontoise. He was the local grocer. Pissarro includes the house again in an etching of 1882 (D 35). The owner was, in fact, an amateur collector, who possessed several works by Cézanne, Guillaumin and Pissarro (see P. Gachet, *Le Docteur Gachet et Murer*, Paris, 1956, p. 59, with additional information from Madame Edda Maillet, Musée de Pontoise), which were apparently given to him by the artists as a form of payment.

PROVENANCE: Paris, Henri Rouart (Paris, Galerie Manzi-Joyant, 3rd sale, 21–22 April 1913, lot 161 repr.); Berlin Hugo Perls collection. Presented to the Nationalmuseum, Stockholm by a consortium, 1918.
LITERATURE: P&V pp. 40–1; Leymarie, 1955, i, pp. 51, 54 repr. col.; W. Balzer, *Der französische impressionismus* Dresden, 1958, p. 69, No. 43 repr.; *Äldre Utländska Malningar och Skulpturer. Stockholm Nationalmuseum*, Stockholm, 1958, p. 155.

37
Piette's house at Montfoucault (snow) 1874

La maison de Piette à Montfoucault (effet de neige)
P&V 287
Canvas. 45.9 × 68.3/18⅛ × 26⅝ in. Signed and dated, lower left: *C. Pissarro. 1874.*
Sterling and Francine Clark Art Institute, Williamstown, Massachusetts (inv. 826)

Montfoucault was the name of one of the farms owned by the Piette family in Mayenne near the village of Melleray. The farm came to assume considerable importance in Pissarro's life primarily as a place of retreat, and the painting seasons spent there after the humiliation of the first Impressionist exhibition led to Pissarro's first close examination of rural life. Many of the motifs represented in pictures dating from the mid-1870s are of Montfoucault (Cat. 43, 45).

Pissarro painted Piette's house and the outbuildings of the farm several times during his first season at Montfoucault (P&V 269, 274, 278, 283–6, and 294). While the blue tones of the present painting are still redolent of Monet, the more fluid handling of the paint surface suggests a re-examination of Courbet, an artist who was of some significance for both Pissarro and Cézanne during the mid-1870s.

PROVENANCE: Paris, Ambroise Vollard; Paris, Bignou; New York, Sam Salz; New York, Durand-Ruel; R. S. Clark collection, acquired 1941 from Durand-Ruel (New York); Clark Art Institute, 1955.
LITERATURE: Jedlicka, 1950, repr. pl. 17; *Williamstown, Clark Art Institute. French paintings of the 19th century*, 1963, No. 96 repr.; *List of paintings in the Sterling and Francine Clark Art Institute*, Williamstown, 1972, p. 78 repr.; Shikes and Harper, 1980, repr. p. 122.
EXHIBITED: London, Reid and Lefevre, *Milestones in French painting*, Jun. 1939 (25 lent Vollard); New York, Durand-Ruel, 1941 (12); Williamstown, Clark Art Institute, *French paintings of the nineteenth century*, 1956 (S-2 repr.).

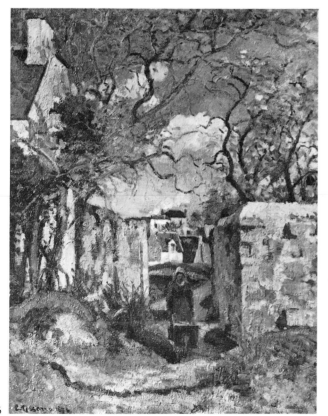

36

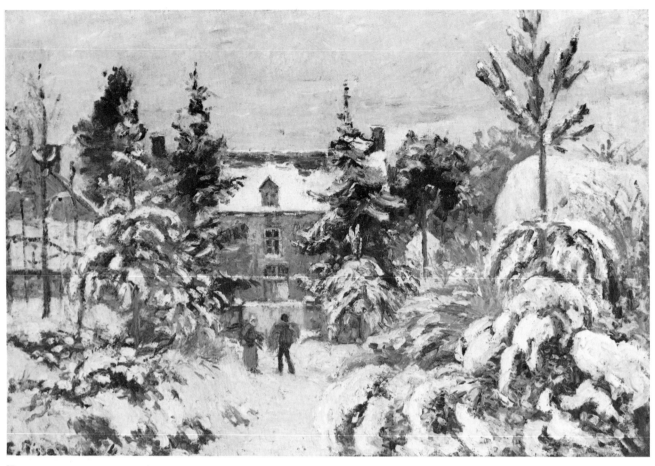

37

38
Portrait of Cézanne *c.* 1874
Portrait de Cézanne
P&V 293
Canvas. 73 × 59.7 cm./$28\frac{3}{4}$ × $23\frac{1}{4}$ in.
Private collection

Pissarro's *Portrait of Cézanne* stands as testimony to one of the most important relationships established in the development of French nineteenth-century painting. The portrait has been left unfinished at the lower edge, and it is undated. A date of 1874, however, is generally accepted and as such it is the earliest known portrait of Cézanne apart from two self-portraits (V 18 and 23). Both artists, in fact, painted or drew one another frequently while working together during the 1870s and early 1880s (Cat. 111, 216–7).

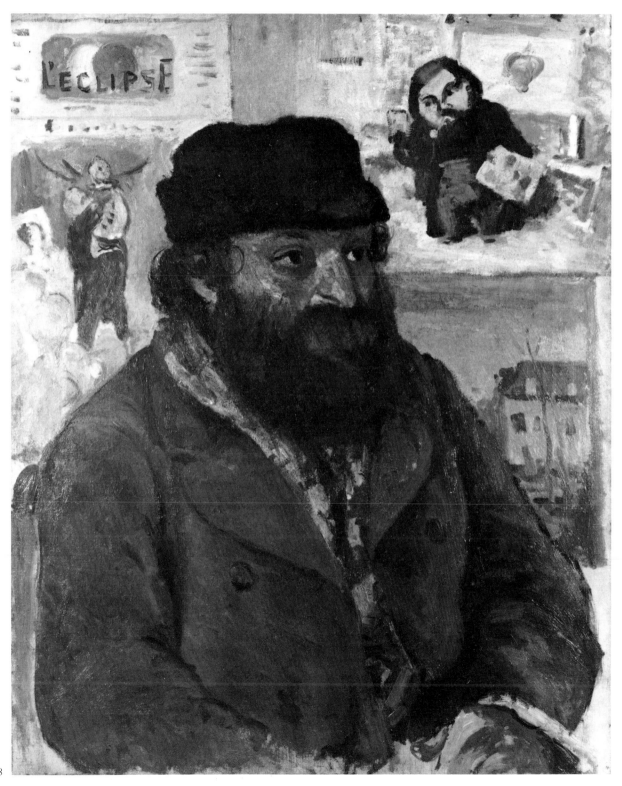

38

The most discerning analysis of Pissarro's *Portrait of Cézanne* is that by Reff, who points to the essential difference between this portrait and those executed by Manet of Zola (Rouart and Wildenstein 128) and by Degas of James Tissot (Lemoisne 175). In contrast with these portraits, Cézanne wears informal out-of-doors clothes as he does in the etching of 1874 (Cat. 155). Behind the sitter in the upper half are two political caricatures; on the left Adolphe Thiers by André Gill from *L'Eclipse* (4 August 1872) and on the right Gustave Courbet by Léonce Petit from *Le Hanneton* (13 June 1867).

Reff argues that this portrait had a political significance for Pissarro, but a specifically artistic significance for Cézanne in the use of anti-authoritarian images. In fact, it is probably intended to represent a shared outlook, as though both Pissarro and Cézanne are turning their backs on the gestures and posturing of Thiers and Courbet, choosing instead to stress their involvement with hard work and serious painting away from the centre of Paris. The manner of dress, both here and in contemporary photographs is perhaps an indication of the way Pissarro and Cézanne approached the task.

Mutual respect is acknowledged in other ways in the portrait. Behind Cézanne on the right is a landscape by Pissarro. Reff identified this as *The Gisors road, house of Père Galien* (P&V 206). The same picture appears in the background on the left of Cézanne's *Still-life with a soup tureen* (V 494), which implies, but does not necessarily prove, that the still-life was painted in Pissarro's studio at approximately the same time as the portrait (Reff, p. 628 n.15). Pissarro's own attitude to the portrait is suggested by the fact that it remained in his studio until the end of his life. For a contemporary photograph of Cézanne showing his face in close up see Rewald, 1939, fig. 40.

PROVENANCE: Camille Pissarro collection and almost certainly retained in the family (inventory of 1904 in Pissarro archives, Ashmolean Museum, Oxford, states the picture to be in Paris), but not recorded again until Basle, Robert von Hirsch collection (Sotheby's, 26 June 1978, lot 715 repr. col.).
LITERATURE: Vauxcelles, 1903; A. Rechberg, 'Die französische Ausstellung im Leipziger Kunstverein', *Zeitschrift für bildenden Kunst*, N.F. xxii (1911), p. 50 repr.; 'A French critic', 'Camille Pissarro and impressionist subject pictures', *Drawing and Design*, N.S. vi October (1920), pp. 166–8 repr.; Kunstler, 1930, repr. pl. 6; J. Rewald and R. Huyghe, 'Cézanne', *L'Amour de l'Art* xvii (1936), p. 161 repr.; J. Rewald, *Cézanne et Zola*, Paris, 1936, repr. fig. 30; F. Novotny, *Cézanne*, Vienna, 1937, p. 18 repr.; J. Rewald, *Cézanne, sa vie, son oeuvre, son amitié pour Zola*, Paris, 1939, repr. fig. 36; J. Rewald, *Paul Cézanne. A biography*, New York, 1948, repr. fig. 43; *Lettres*, Eng. eds. only, repr. pl. 51; Jedlicka, 1950, p. 9 repr. col.; Natanson, 1950, repr. col. pl. 9; Cooper, 1955, p. 104 repr.; J. Rewald, *Paul Cézanne*, London, [1956?], pp. 85–6, repr. pl. 31; P. Gachet, *Lettres impressionnistes au Dr. Gachet et à Murer*, Paris, 1957, p. 62 repr.; W. S. Meadmore, *Lucien Pissarro, un coeur simple*, London, 1962, pp. 25–6; Rewald, 1963, repr. p. 25; T. Reff, 'Pissarro's portrait of Cézanne', *Burlington Magazine* cix (1967), pp. 627–33 repr.; Rewald, 1973, repr. p. 298; M. Roskill, 'On the recognition and identification of objects in paintings', *Critical Inquiry* iii (1977), p. 686 repr.; Lloyd, 1979, p. 11 repr. col.; Shikes and Harper, 1980, p. 123 repr.
EXHIBITED: Bremen, Kunsthalle, *Grosse Kunstausstellung*, Feb.–Mar. 1910 (265); Leipzig, Kunstverein, *Die französische Ausstellung*, 1910 (265); Paris, Manzi and Joyant, 1914 (43); Basle, Kunsthalle, *Kunstwerke aus Basler Privatbesitz, 19. Jahrhundert Kunst*, 1943 (244); Paris, Orangerie, *Van Gogh et les peintres d'Auvers-sur-Oise*, 26 Nov.–28 Feb. 1954–5 (91 repr.); Basle, Kunsthalle, *Impressionisten: Monet, Pissarro, Sisley, Vorläufer und Zeitgenossen*, 3 Sept.–20 Nov. 1949 (68 repr.).

39
The quarry, Pontoise *c.* 1875

La carrière, Pontoise
P&V 251
Canvas. 58.2 × 72.5 cm./$22\frac{7}{8}$ × $28\frac{3}{8}$ in. Signed with the artist's initials, lower right.
Rodolphe Staechelin Foundation, Basle

The quarry, Pontoise is one of several works demonstrating the temporary mergence of the styles of Pissarro and Cézanne during the mid-1870s. Although often dated *c.* 1874, it is more reasonably placed in 1875 on comparison with a group of paintings executed with the palette knife in that year (P&V 300 and Cat. 40–2). The use of the palette knife, the limited range of the palette itself, the reduction of the composition to basic elements, and the renewed appreciation for the texture of paint are part of the exchange of ideas that took place between the two artists, at this time clearly working under the renewed inspiration of Courbet. A painting by Cézanne *The Etang des Soeurs at Osny near Pontoise* (V 174), of 1877, illustrates perfectly in its facture and treatment of subject-matter the degree of reciprocity between the two artists at this time. Significantly, the painting by Cézanne just cited was once owned by Pissarro.

It is notable that the quarry, which is the subject of the present painting, is depicted as a single element in the landscape and Pissarro avoids any of the connotations of physical labour associated with quarries that are found in the realist tradition.

PROVENANCE: acquired by Rodolphe Staechelin in 1920 from Munich, Mario Arbibi.
LITERATURE: P&V, p. 45; Bazin, 1947, repr. p. 194 det.; T. Reff, 'Cézanne's constructive stroke', *Art Quarterly* xxv (1962), p. 226 n. 29; Rewald, 1963, p. 100 repr. col.; Brettell, 1977, pp. 95 and 235–6 repr.
EXHIBITED: London, Stafford Gallery, 1911 (12); Berne, Kunsthalle, *Französische Meister des 19. Jahrhunderts und van Gogh*, 18 Feb.–2 Apr. 1934 (83); Basle, Kunstmuseum, 1936–7; Amsterdam, Stedelijk Museum, *Honderd Jaar fransche Kunst*, Jul.–Sept. 1938 (92); Basle, Kunstmuseum, 1956 (12 repr.); Paris, Musée Nationale d'art moderne, *Fondation Rodolphe Staechelin de Corot à Picasso*, 10 Apr.–28 Jun. 1964 (12 repr.); Basle, Galerie Beyeler, *Impressionistes: Monet, Renoir, Sisley, Degas, Pissarro, Cézanne*, Oct.–18 Nov. 1967 (22 repr. col.).

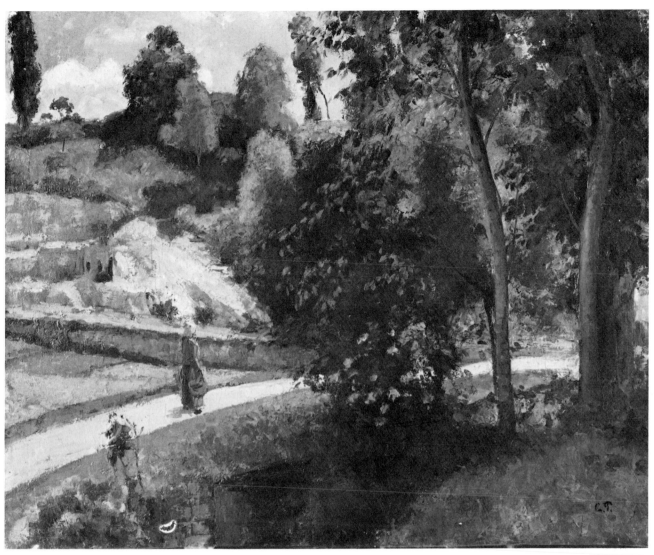

39

40
The Saint-Antoine Road at L'Hermitage, Pontoise 1875

Route de Saint-Antoine à L'Hermitage, Pontoise
P&V 304
Canvas. 52.5 × 81 cm./20½ × 31⅞ in. Signed and dated, lower right: *C. Pissarro. 1875.*
Private collection on deposit in the Kunstmuseum, Basle

There is a similar composition by Cézanne (V 172), *c.* 1875–7, but Reff, following Rewald (1939), has argued that the painting by Cézanne is in fact closer 'in viewpoint and scene' to an earlier version of the same subject painted by Pissarro in 1873 (P&V 212).

The main compositional differences between Pissarro's own two paintings of the subject are the changes in the terrain in the right foreground and the redistribution of the trees. Other differences derive from the fact that there is a seasonal change in the two paintings, P&V 212 being executed in winter. The composition of the present painting is somewhat more simplified and tighter, as the artist has concentrated upon the structural elements. The palette knife has been used in combination with large brushes.

The painting by Cézanne has two important similarities with Pissarro's version of 1875, namely the time of year and the placing of the road on a steeper diagonal. It is therefore more likely that V 172 is closer in date to the present painting as opposed to P&V 212. For other pairings in the work of Cézanne and Pissarro see Reff, pp. 220–1.

Brettell has identified the road as the Route d'Ennery (Route de Saint-Antoine), which is a continuation of the rue de L'Hermitage. The large house seen through the trees is the former convent, Les Mathurins, owned by Maria Desraimes, writer and politician (see Cat. 44).

PROVENANCE: Berlin, Cassirer; sold anonymously Paris, Hôtel Drouot, 24 February 1926, lot 78 repr. bt. Hessel; Paris, Joseph Hessel collection; Paris, Durand-Ruel (bought from Joseph Hessel 7 May 1926).
LITERATURE: *Gazette de l'Hôtel Drouot*, 2 Feb. and 25 Feb. 1926; *Le Figaro Artistique*, 25 March 1926, p. 378 repr.; *L'Art et les Artistes*, Feb. 1928, p. 151 repr.; *L'Amour de l'Art*, April 1928, p. 151; Holl, 1928, repr. p. 151; F. Neugass, 'Eine Pissarro-Ausstellung', *Kunst und Künstler* XXVI (1928), repr. p. 318; J. Rewald, *Cézanne, sa vie, son oeuvre, son amitié pour Zola*, Paris, 1939, repr. pl. 32; J. Rewald, *Paul Cézanne*, London, [1956?], p. 84 repr. pl. 35; Coe, 1963, pp. 9–10 and 21 n. 9; T. Reff, 'Cézanne's constructive stroke', *Art Quarterly* XXV (1962), pp. 220–1; Rewald, 1963, repr. p. 29; Brettell, 1977, pp. 187–8 repr.
EXHIBITED: Paris, Durand-Ruel, 1928 (23).

41 ILLUSTRATED IN COLOUR
The climbing path, L'Hermitage, Pontoise 1875

Le chemin montant, L'Hermitage, Pontoise
P&V 308
Canvas. 54 × 65 cm./21⅛ × 25¾ in. Signed and dated, lower right: *C. Pissarro/1875.*
The Brooklyn Museum, New York, gift of Dikran K. Kelekian (inv. 22.60)

In many respects this picture may be claimed as Pissarro's most far-reaching painting of the 1870s. Both its technique and composition can only be compared with Cézanne's landscapes of Auvers-sur-Oise dating from the late 1870s and early 1880s (V 315 and 318). The varying texture of the paint applied with the palette knife has enabled Pissarro to suggest the different levels of the terrain – the pathway on the right and the rooftops seen through the foliage on the left. The palette is noticeably lighter, creating a sense of dappled sunlight. The treatment of the path is perhaps the most daring feature of the composition. It extends upwards at the extreme right edge as though shaken out like a piece of silk, and the whole composition seems to be suspended in the air, although momentarily stabilized by Pissarro's convincing sense of form. The picture may be regarded as a reconsideration of the L'Hermitage landscapes of the late 1860s (Cat. 9–11) with the guidance of Cézanne. Interestingly, the rooftops seen through the trees anticipate the imagery chosen by Cézanne in likening the motif to playing-cards, as mentioned in a letter to Pissarro written in 1876 (*Paul Cézanne. Letters*, ed. J. Rewald, Oxford, 1976, pp. 145–6, 2 July 1876 written in L'Estaque).

For the collector Georges de Bellio and the inventory drawn up by Donop de Monchy see the articles by Niculescu. *The climbing path, L'Hermitage, Pontoise* is listed as No. 110 in accordance with the number which still appears on the back of the picture.

40

PROVENANCE: Paris, Georges de Bellio collection; Paris, Donop de Monchy collection (Mme. Donop de Monchy, daughter of de Bellio); Paris, Paul Rosenberg; Paris and New York, Dikran Khan Kelekian collection (New York, American Art Association, 31 January 1922, lot 137 repr.). Purchased by The Brooklyn Museum with funds donated by Dikran Khan Kelekian.
LITERATURE: Breuning, 'Full-length portrait of Pissarro, luminist', *Art Digest* xx (1945), p. 14; H. Wegener, 'French impressionist and post-impressionist paintings in the Brooklyn Museum', *Brooklyn Museum Bulletin* xvi (1954), pp. 6–7 repr.; Rewald, 1963, p. 102 repr. col.; R. Niculescu, 'Georges de Bellio, l'ami des impressionnistes (II)', *Paragone* No. 249 xxi (1970), p. 63 No. 110; M. Feldman, 'After Modernism', *Art in America* lix (1971), p. 68 repr.; Shikes and Harper, 1980, p. 174.
EXHIBITED: New York, Brooklyn Museum, *Paintings by contemporary English and French painters*, 29 Nov.–2 Jan. 1922–3 (181); Chicago, The Art Institute, *A century of progress*, 1 Jun.–1 Nov. 1934 (258); New York, Brooklyn Museum, *Leaders of American Impressionism*, Oct. 1937 (15); New York, Brooklyn Museum, *European paintings from the Museum collection*, 9 Nov.–1 Jan. 1944–5; New York, Wildenstein, 1945 (13 repr.); Hempstead, Long Island, *The arts come to Hempstead, First Annual Arts Festival*, 6 May–13 May 1945 (p. 39 repr.); Montreal, Museum of Fine Arts, *Manet to Matisse*, 27 May–26 Jun. 1949 (28); Manchester (New Hampshire), Currier Gallery of Art, *Monet and the beginnings of Impressionism*, 8 Oct.–6 Nov. 1949 (20); Richmond, Virginia, Museum of Fine Arts, *Paintings by the Impressionists and Post-Impressionists*, 20 Oct.–19 Nov. 1950; Palm Beach, Florida, Society of the Four Arts, Jan. 1960 (7 repr.); New York, Wildenstein, 1965 (30 repr.); New York, Wildenstein, *Paris–New York. A continuing romance*, 3 Nov.–17 Dec. 1977 (77 repr.).

42
The village pathway 1875

Le sentier du village
P&V 310
Canvas. 39 × 55.5 cm./$15\frac{3}{8}$ × $21\frac{7}{8}$ in. Signed and dated, lower right: *C. Pissarro. 1875.*
Rodolphe Staechelin Foundation, Basle

Brettell has established that this painting 'portrays the houses of the Fond de L'Hermitage from a viewpoint on the pathway which leads from the rue de L'Hermitage to the rue Victor Hugo on the Côte Saint-Denis'. Pissarro has apparently altered the terrain so that the foreground on the right appears to be steeper than it actually is, with the result that the newer buildings on the rue de L'Hermitage are obscured from view. Similarly, greater emphasis has been given to the foliage, which screens the two ends of the rue Fond de L'Hermitage. The artist has by these alterations emphasized the linearity of the street, as he does again in P&V 341, of 1876, and P&V 447, of 1878 (Basle, Kunstmuseum). In the present painting the firm horizontal band of the rooftops has been vigorously executed with the palette knife and accented with colour, whilst elsewhere the paint has been loosely handled, particularly on the foliage and the figures on the pathway.

PROVENANCE: acquired by Rodolphe Staechelin in 1917 in Geneva.
LITERATURE: P&V, p. 41; *Offentliche Kunstsammlung Kunstmuseum Basel. Katalog 19–20 Jahrhundert*, Basle, 1970, p. 75 repr.; Brettell, 1977, pp. 83 and 183 repr.; Iwasaki, 1978, repr. col. pl. 10.
EXHIBITED: London, New Burlington Galleries, *Exhibition of masters of French nineteenth century painting*, 1–31 Oct. 1936 (56 lent Staechelin); Paris, Musée Nationale d'art moderne, *Fondation Rodolphe Staechelin de Corot à Picasso*, 10 Apr.–28 Jun. 1964 (10 repr.); Basle, Galerie Beyeler, *Impressionnistes: Monet, Renoir, Sisley, Degas, Pissarro, Cézanne*, Oct.–18 Nov. 1967 (23 repr. col.).

41

42

43
The goose girl at Montfoucault (frost) 1875

La gardeuse d'oies à Montfoucault (gelée blanche)
P&V 324
Canvas. 57.8 × 73 cm./23¾ × 28¾ in. Signed and dated, lower left:
C. Pissarro. 75.
The John A. and Audrey Jones Beck collection

The goose girl at Montfoucault (frost) is one of fourteen paintings executed by Pissarro while staying on Piette's farm in 1875 (P&V 317–31). All are notable for the resplendent palette and the broad technique. Like *The pond at Montfoucault* (P&V 320) in the Barber Institute of Fine Arts, Birmingham, the present painting is conceived on a large scale, although neither equals *Winter at Montfoucault (snow)* and *Autumn (pond at Montfoucault)*, which were commissioned from the artist by Alfred Nunès and were clearly painted as a pair (P&V 328–9).

Brettell (1977, pp. 222–6) has observed that the surrounding countryside at Montfoucault was very different in character from the Parisian *campagne* in which Pontoise was located. Mayenne was characterized by small isolated farms each with their own fields, hedges, and ponds. It was essentially an enclosed agricultural community enabling Pissarro to study rural life in detail. All the Montfoucault paintings possess a Milletesque resonance, and it is possible that a symbolical element might have been intended with the dead tree dominating the centre of the composition, although there is a seasonal emphasis in each of these pictures. The motif of a figure passing through a gate is one to which Pissarro returned during the 1880s (Cat. 62) and in the 1890s (P&V 931).

PROVENANCE: Paris, Maurice Barret-Décap collection (Paris, 12 December 1929, lot 10 repr.) bt. Durand-Ruel; New York, Knoedler; Elliot City, Maryland, Mr. and Mrs. W. J. Dickey collection (New York, Parke-Bernet, 11 December 1963, lot 60 repr. col.).
EXHIBITED: Paris, Marcel Bernheim, 1936 (18).

44
The garden of the Mathurins, Pontoise, property of the Misses Desraimes 1876

Le jardin des Mathurins, Pontoise, propriété des Dames Desraimes
P&V 349
Canvas. 113 × 165 cm./44⅜ × 65⅛ in. Signed and dated, lower right: *C. Pissarro. 1876.*
The Nelson Gallery and Atkins Museum, Kansas City

The painting was exhibited in the third Impressionist exhibition, which was held in April 1877. It is executed on an unusually large scale for Pissarro and combines a well-ordered composition with a richly textured surface. Coe provides a careful analysis of the picture and suggests that it might have been inspired by Monet's painting *The artist's house at Argenteuil*, of 1873 (W 284). Indeed, the wide range of Pissarro's palette, the character of the brushstrokes, and the closer working of the surface suggest a detailed knowledge of Monet's canvases of this period (W 398–400), but the use of complementary colours anticipates Neo-Impressionism.

Les Mathurins was formerly a convent belonging to the Order of the Holy Trinity. It stands in the quarter of Pontoise known as L'Hermitage and was painted several times during the 1870s by Pissarro (P&V 212 and Cat. 40). P&V 394 and 396, were also identified by Coe as being depictions of the garden of Les Mathurins. Of these, P&V 394 is a large painting that was similarly included in the third Impressionist exhibition (167 *Coin du Jardin des Mathurins, à Pontoise*), and P&V 397 belonged to Eugène Murer, who lent it to the fourth Impressionist exhibition held in 1879 (175 *Château des Mathurins (Soleil couchant). Appartient à M. M . . .*).

When Pissarro was living in Pontoise one of the owners of Les Mathurins was Maria Desraimes (1828–1894), writer, politician, and the first elected deputy from Pontoise under the Third Republic. Pissarro shared many of her political views (Brettell, 1977, p. 80), which may account for his wanting to attempt this otherwise unfamiliar subject. The female figure in front of the house might be Maria Desraimes. She appears to be holding a globe, but the bestowal of this attribute remains unexplained.

The painting was No. 102 of the inventory drawn up by Donop de Monchy of the Georges de Bellio collection.

PROVENANCE: Paris, Georges de Bellio collection; Paris, Donop de Monchy collection (Mme. Donop de Monchy, daughter of de Bellio); Paris, Paul H. Ziegler collection.
LITERATURE: P&V, p. 42; Coe, 1963, pp. 1–22 repr.; Lanes, 1965, p. 276 repr.; R. Niculescu, 'Georges de Bellio, l'ami des impressionnistes (II)', *Paragone* No. 249 xxi (1970), pp. 67–8 repr.; Brettell, 1977, pp. 80–2 and 240–1.
EXHIBITED: Paris, 1877 (166 *Jardin des Mathurins à Pontoise*); Paris, Orangerie, 1930 (119 lent Ziegler); Paris, Durand-Ruel, 1956 (29); Berne, Kunstmuseum, 1957 (43); New York, Wildenstein, 1965 (33 repr.).

44

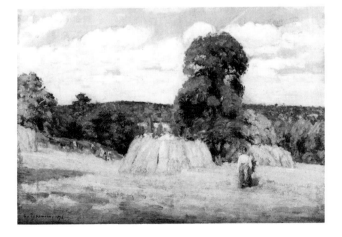

45

45
The harvest at Montfoucault 1876

La moisson à Montfoucault
P&V 364
Canvas. 65 × 92.5 cm./$25\frac{1}{2}$ × $36\frac{3}{8}$ in. Signed and dated, lower left:
C. Pissarro. 1876.
Musée de Jeu de Paume, Paris (inv. RF 3756)

The harvest at Montfoucault was exhibited in the third
Impressionist exhibition, which was held in April 1877. The
picture is painted in the broad manner associated with many of the
Montfoucault paintings, the brush and the palette knife combined.
It is far removed in style from Cat. 44 or even from P&V 363, a
harvesting scene also painted in 1876. Indeed, the contrast with
P&V 363 reflects an uncertainty in Pissarro's style which he can be
seen resolving in those paintings executed at the end of the 1870s

(Cat. 46–8). At the root of this stylistic dilemma is perhaps a growing interest in colour theory. It will be seen that there is a wider and more subtle range of colour in *The harvest at Montfoucault* than in the other Montfoucault canvases (Cat. 37, 43), particularly in the shadows.

PROVENANCE: Gustave Caillebotte collection, by whom bequeathed to the French state, 1894 (entered the collection in 1896 and transferred from the Musée de Luxembourg to the Musée du Louvre 1933).
LITERATURE: Anon., *Petite République Française*, 1877; P. Sebillot, 'Exposition des Impressionnistes', *Le Bien Public*, 7 April 1877; Kirchbach, 1904, pp. 124–5; P&V, p. 43; Rewald, 1939, No. 3 repr. col.; *Musée National du Louvre. Catalogue des peintures, pastels, sculptures impressionnistes*, Paris, 1959, p. 160 No. 308; Rewald, 1963, p. 104 repr. col.; Meier, 1965, p. 10 repr. col.; Pool, 1967, p. 168 repr.; Preutu, 1974, repr. col. pp. 40–1; Cogniat, 1974, repr. col. p. 33; Iwasaki, 1978, repr. col. pl. 12; H. Adémar and A. Distel, *Musée du Jeu de Paume*, Paris, 1979, p. 167 repr. col. det.; Shikes and Harper, 1980, p. 135 repr. col.
EXHIBITED: Paris, 1877, (180, *La Moisson appartient à M.C.* . . . i.e. lent Caillebotte); Dieppe, 1955 (no catalogue).

46
The Côte des Boeufs, Pontoise 1877

La Côte des Boeufs, Pontoise
P&V 380
Canvas. 115 × 87.5 cm./45¼ × 34½ in. Signed and dated, lower right: *C. Pissarro. 1877.*
National Gallery, London (inv. 4197)

The Côte des Boeufs is the hillside also called Côte de St. Denis off the rue Vieille de L'Hermitage. The same hill occurs in *The red roofs* (Cat. 47) and both paintings are closely related in style, although different in mood. It is perhaps relevant in the context of the present painting that in a letter of 13 October 1877 to Eugène Murer Pissarro refers to 'l'automne et ses tristesses'. The densely worked surface, the varied palette, the small broken brushstrokes, and the overlaying of the various parts of the composition are all characteristic of Pissarro's manner of working during the closing years of the 1870s. It is only slowly in this picture that the viewer detects the two figures walking along the pathway on the left, so well are they woven into the tapestry, and, again, it is only with a concentrated effort that the eye penetrates the twisting trunks and foliage of the trees in the foreground and middle distance to espy the buildings at the foot of the hill. The complicated internal rhythms are far removed from the clearly defined spatial intervals of earlier pictures.

An aquatint (D 16) of 1879 (Cat. 156–61), which is more closely related to *Sous-bois landscape at L'Hermitage* (P&V 444), shows Pissarro experimenting with this type of composition in another medium. Cézanne also painted the Côte des Boeufs from slightly higher up the hill and off to the left reducing the composition to its essential elements (V 173, *c.* 1875–7). Pissarro continued his examination of the *sous-bois* motif in P&V 441 and 538, both of which have a vertical format.

PROVENANCE: Madame Pissarro; Paris, Bernheim Jeune, to whom sold by the Pissarro family 17 December 1913 for 15000 frs., and by whom sold to Knoedler, 11 February 1920 (Oxford, Ashmolean Museum, Pissarro archives and Paris, Bernheim archives); London, C. S. Carstairs collection, by whom presented to the Tate Gallery through the National Art-Collections Fund 1926 (transferred to the National Gallery, 1950).
LITERATURE: Saunier, 1892, p. 34; Aurier, 1892, p. 283; Hamel, 1914, p. 27 repr.; Sickert, 1923, p. 40; Venturi, 1939, ii, pp. 34–5 No. 47; P&V, p. 43; Venturi, 1950, p. 74 repr.; Leymarie, 1955, ii, p. 58 repr. col.; M. Davies (revised C. Gould), *National Gallery catalogues. French school early 19th century. Impressionists, Post-Impressionists etc.*, London, 1970, pp. 113–14; Kunstler, 1974, repr. col. p. 29; Preutu, 1974, repr. col. p. 61; Brettell, 1977, pp. 243, 244–5, 249–50, and 308–9 repr.; Iwasaki, 1978, repr. col. pl. 16; Shikes and Harper, 1980, pp. 130 and 153 repr. col.
EXHIBITED: Paris, Durand-Ruel, 1892 (7 lent Mme. Pissarro); Paris, Durand-Ruel, 1904 (42 lent Mme. Pissarro); Bremen, Kunsthalle, *Grosse Kunstausstellung*, Feb.–Mar. 1910 (261 apparently lent by Kimbell and Co. Paris); London, Stafford Gallery, 1911 (18); Paris, Manzi et Joyant, 1914 (111); London, Grosvenor House, *Art Français, exposition d'art décoratif contemporain 1800–1885*, 1914 (59 lent private collector); London, Knoedler, *Exhibition of nineteenth century French painters*, Jun.–Jul. 1923 (39); Knoedler, *Exhibition of French nineteenth century painters*, 1924 (4); London, Tate Gallery, 1931 (21), and subsequently at Birmingham, Oct.–Nov. 1931 (17), Nottingham, Nov.–Dec. 1931, Stockport, Jan. 1932 (10), Sheffield, Feb.–Mar. 1932 (17), Bootle, Apr.–May 1932 (9); Manchester, *French art exhibition*, 22 Mar.– 1 May 1932 (41); London, Royal Academy, *Impressionism. Its masters, its precursors, and its influence in Britain*, 9 Feb.–28 Apr. 1974 (89 repr.).

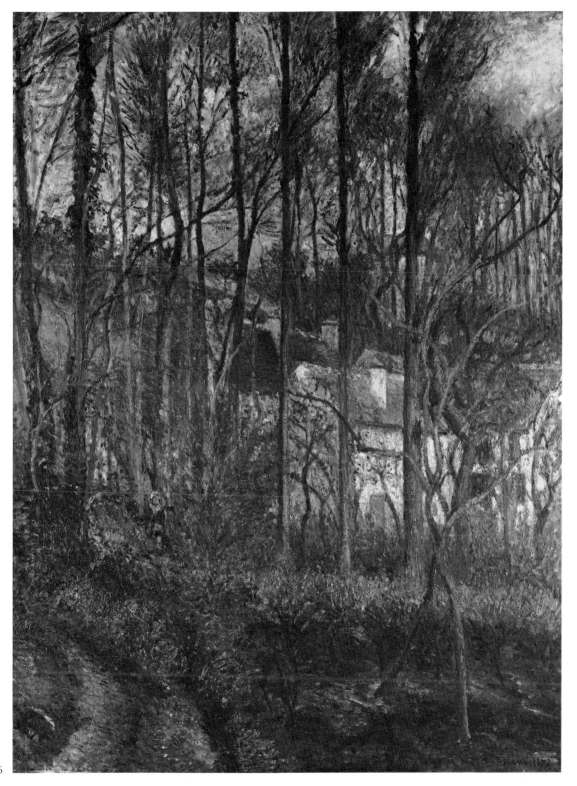

46

47
The red roofs, corner of the village, winter
1877
Les toits rouges, coin du village, effet d'hiver
P&V 384
Canvas. 54.5 × 65.6 cm./$21\frac{1}{2}$ × $25\frac{7}{8}$ in. Signed and dated, lower right: *C. Pissarro. 1877.*
Musée de Jeu de Paume, Paris (inv. RF 2735)

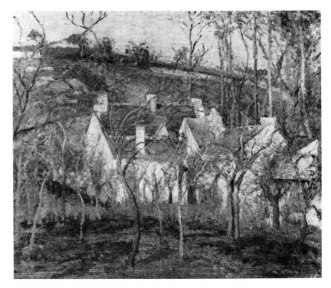

47

The red roofs, corner of the village, winter is stylistically analogous to the painting of *Côte des Boeufs* (Cat. 46) and indeed represents the same motif. The present painting, however, has a horizontal format and in this respect is comparable with *Sous-bois landscape at L'Hermitage* (P&V 444), of 1878. It is also more thickly painted than *Côte des Boeufs*, although just as varied in colour, thereby enhancing the over-all tapestry-like effect.

In *The red roofs* Pissarro has a powerful horizontal emphasis in the middle of the composition, which is created by the roofs of the houses and by the contour of the hillside, whereas on the right the roofs are placed at an oblique angle to the picture plane. In these respects the composition is reminiscent of the earlier landscapes of L'Hermitage dating from the late 1860s (Cat. 9–11), although here the trees screen the architectural features uniting foreground and background.

The buildings comprise an eighteenth-century farm off the rue Vieille de L'Hermitage on the Côte des Boeufs.

On the back of the canvas is a supplier's stamp, *Latouche*. The painting was X-rayed in 1972 revealing a portrait of a man beneath the present surface.

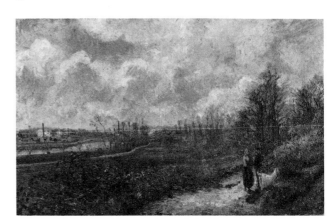

48

PROVENANCE: Gustave Caillebotte collection, by whom bequeathed to the French state, 1894 (entered the collection in 1896 and transferred from the Musée de Luxembourg to the Musée du Louvre, 1929).
LITERATURE: Kirchbach, 1904, p. 122; Focillon, 1928, p. 220 repr.; P&V p. 43; Rewald, 1939, No. 5 repr. col.; *Lettres*, p. 405, 16 April 1896; *Musée Nationale du Louvre. Catalogue des peintures, pastels, sculptures impressionnistes*, Paris, 1959, pp. 162–3 No. 312; G. Bazin, *Impressionist paintings in the Louvre*, London, 1961, p. 176 repr. col.; Rewald, 1963, p. 108 repr. col.; Meier, 1965, pp. 10 and 12 repr. col.; Blunden, 1970, p. 115; Preutu, 1974, repr. col. p. 47; Iwasaki, 1978, repr. col. pl. 15; H. Adhémar and A. Distel, *Musée du Jeu de Paume*, Paris, 1979, p. 167 repr. det.; Lloyd, 1979, p. 6 repr. col.
EXHIBITED: Amsterdam, Stedelijk Museum, *Tentoenstelling Vincent van Gogh en zijn tijdgenoeten*, Sept.–Nov. 1930 (246); Munich, Haus der Kunst, *Französische Malerei des 19 Jahrhunderts von David bis Cézanne*, 7 Oct.–6 Jan. 1964–5 (204 repr.); Lisbon, Gulbenkian Foundation, *Un século de pintura francesa 1850–1950*, 1965 (113).

48 EXHIBITED IN LONDON AND PARIS ONLY
The pathway at Le Chou 1878

La sente du Chou, Pontoise
P&V 452
Canvas. 57 × 92 cm./19¾ × 36¼ in. Signed and dated, lower right:
C. Pissarro. 1878.
Musée de la Chartreuse, Douai (inv. 2231)

The pathway at Le Chou was painted in 1878 and included in the sixth Impressionist exhibition, which was held in 1881. Pissarro in fact exhibited two paintings of Le Chou, one entitled *The pathway at Le Chou in March* and the other *The enclosure at Le Chou, morning* (64, *Le Clos du choux le matin. Appartient à M. J. P.*) possibly identifiable as P&V 446 or 497. Confusingly, Huysmans in a brilliant piece of criticism seems to refer to the present painting as *Sunset over the plain at Le Chou*, but his description makes it clear that he is discussing the work displayed here and not the other.

Le Chou is an area outside Pontoise on the banks of the river Oise where Pissarro frequently painted in the late 1870s (P&V 414, 446, 497). Earlier he had explored the motif from a vantage point looking in the opposite direction (P&V 213). For a modern photograph of the view as shown in the painting exhibited here see Reidemeister, 1963, p. 71. The pathway leads from Pontoise to Auvers-sur-Oise, and Pissarro has depicted the view looking across the river to St. Ouen l'Aumône, where the main industrial development in the area was taking place. In the centre of this panoramic view therefore is the factory that Pissarro had painted during the middle of the decade (Cat. 28–30).

PROVENANCE: Mme. Pissarro collection (Paris, Georges Petit, 3 December 1928, lot 35 repr.) bt. Pierre Malric. Acquired by the Musée de la Chartreuse, Douai, 1931.
LITERATURE: Geoffroy, 1881; Cardon, 1881; Gonzague-Privat, 1881; Silvestre, 1881; Huysmans, 1881 [1883]; Fénéon, 1886 [Halperin, p. 37]; Saunier, 1892, p. 34; Hamel, 1914, p. 28 repr.; Anon. 'Camille Pissarro Memorial Exhibition', *London Mercury*, July 1920, p. 352; Lecomte, 1922, repr. p. 68; P&V, pp. 44 and 49; Reidemeister, 1963, p. 71 repr.; Kunstler, 1974, p. 32 repr. col.; Brettell, 1977, p. 145 repr.
EXHIBITED: Paris, 1881 (63, *La Sente du choux en mars. Appartient à M.J.P.*, i.e. lent Mme. Pissarro); Paris, Durand-Ruel, 1892 (10 lent Mme. Pissarro); Paris, Durand-Ruel, 1904 (48 lent Mme. Pissarro); Bremen, Kunsthalle, *Grosse Kunstausstellung*, Feb.–Mar. 1910 (264); London, Stafford Gallery, 1911 (29); Paris, Manzi et Joyant, 1914 (22); London, Leicester Galleries, 1920 (72); Paris, Nunès et Fiquet, 1921 (1); Paris, Galerie André Weil, 1950 (18); Paris, Durand-Ruel, 1956 (33); Dieppe, 1955; Paris, Galerie Heim, *Chefs d'oeuvres du Musée de Douai*, 1956 (25 repr.); Douai, Musée de la Chartreuse, *Henri Duhem et ses amis impressionnistes*, Oct. 1963 (no cat.).

49 EXHIBITED IN BOSTON ONLY
Portrait of Mme. Pissarro sewing near a window 1878–9

Portrait de Mme. Pissarro cousant près d'une fenêtre
P&V 423
Canvas. 54 × 45 cm./21¼ × 17¾ in. Signed with the artist's initials lower left.
The Ashmolean Museum, Oxford, lent by the Visitors of the Ashmolean Museum (inv. A 823)

There are several painted portraits of the artist's wife, among them P&V 14 (Ashmolean Museum, Oxford) and P&V 290–1. Of these P&V 290 (Paris, Musée du Petit Palais) is executed in a style very close to that of Cézanne at a similar date, c. 1874. The present portrait dates from the late 1870s and its composition, if not its technique, somewhat resembles Renoir (Daulte 182). The composition also recalls certain drawings by Seurat that do, however, post-date the portrait (C. M. de Haucke, *Seurat et son oeuvre*, ii, Paris, 1961, Nos. 585 and 587). One of these (de Haucke, No. 587) was in fact eventually owned by Pissarro.

The portrait may have been made in Pissarro's studio in the rue des Trois-Frères in Paris, but this is uncertain (compare the pastel sold with the artist's collection, Paris, Georges Petit, 3 December 1928, lot 18 repr.). If this identification of the location is correct, the date of the portrait must then be 1878–9, slightly later than c. 1877 as suggested in the *catalogue raisonné*.

The picture was cleaned in 1979.

PROVENANCE: London, Lucien Pissarro collection; Esther Pissarro collection, by whom presented to the Ashmolean Museum, 1950.
LITERATURE: *Ashmolean Museum, Oxford. Catalogue of Paintings*, Oxford, 1961, p. 118; Shikes and Harper, 1980, repr. p. 156.
EXHIBITED: Tokyo, Sunshine Museum; Osaka, Municipal Museum; Fukuoka, Art Museum; *Ukiyo-e prints and the impressionist painters*, 15 Dec.–15 Jan., 22 Jan.–10 Feb., 15 Feb.–28 Feb. 1979–80 (II–28 repr. col. revised edn. II–30).

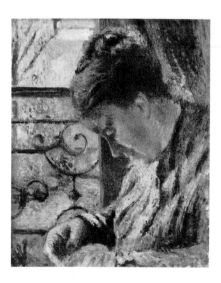

50 EXHIBITED IN LONDON AND PARIS ONLY

The outer boulevards: snow 1879

Les boulevards extérieurs, effet de neige

P&V 475

Canvas. 54 × 65 cm./21¼ × 25⅝ in. Signed and dated, lower left:
C. Pissarro. 1879.

Musée Marmottan, Paris (inv. 4021)

The subject is unusual for Pissarro at this date, as he only concentrated on painting the *boulevards* and *avenues* of Paris during the 1890s (Cat. 78–80). These later paintings, however, are observed from well above street level, whereas the viewpoint of *The outer boulevards: snow* is only just above the street. It is symptomatic of Pissarro at this point in his career that he paints an outlying *boulevard*, while during the 1890s he established himself in the centre of the city. Stylistically, the painting underlines the caricatural element in Pissarro's work, each figure being granted individuality by deft brushstrokes far removed from the blurred anonymity favoured by Monet in his two paintings of the *Boulevard des Capucines* (W 292–3), of 1873. Interestingly, Monet himself owned a painting by Pissarro (P&V 442) in which this same caricatural vein is evident.

Like Cat. 51, *The outer boulevards* was most probably painted at the end of 1879. It depicts the Boulevard Rochechouart with the Collège Rollin (now the Lycée J. Decour) on the left. A pastel of the adjoining Boulevard de Clichy (P&V 1545), which was shown in the sixth Impressionist exhibition (90 *Boulevard Rochechouart*), dates from 1880.

For other paintings owned by Georges de Bellio included in this exhibition see Cat. 41, 44.

PROVENANCE: Paris, Georges de Bellio collection; Paris, Donop de Monchy collection (Mme. Donop de Monchy, daughter of de Bellio). Bequeathed by Mme. Donop de Monchy to the Académie des Beaux-Arts de Paris, 1957, and exhibited at the Musée Marmottan.

LITERATURE: P&V, p. 44; R. Niculescu, 'Georges de Bellio, l'ami des impressionnistes' (I) and (II), *Paragone* No. 248 (1970), p. 54 and No. 249 (1970), p. 68, no. 103; *Musée Marmottan. Monet et ses amis*, Paris, 1971, p. 68 No. 95 repr.; Lloyd, 1979, pp. 7–8 repr. col.

EXHIBITED: Paris, Orangerie, 1930 (51 lent Donop de Monchy).

51

The warren at Pontoise, snow 1879

La garenne à Pontoise, effet de neige

P&V 478

Canvas. 60 × 73 cm./23¼ × 28⅜ in. Signed and dated, lower left:
C. Pissarro. 79.

The Art Institute of Chicago, Chicago, gift of Marshall Field (inv. 1964.200)

The exceptionally cold December of 1879, with a heavy snowfall at the beginning of the month, led to a renewal of interest in snow scenes amongst the Impressionists, particularly Monet (W 552–8), Sisley (Daulte 342–8), and Pissarro (P&V 475–9 and 481). The view over the rooftops seen beyond a prominent foreground recalls the composition of *The climbing path, L'Hermitage, Pontoise* (Cat. 41), although here the style is less obviously influenced by Cézanne.

PROVENANCE: Mme. Pissarro; Paris, Bernheim Jeune; Paris, Durand-Ruel (bought from Bernheim 9 August 1918).

LITERATURE: Venturi, 1939, ii. pp. 33–4 No. 46; R. Shiff, 'Seeing Cézanne', *Critical Inquiry* iv (1978), p. 803 n. 85.

EXHIBITED: Paris, Durand-Ruel, 1892 (11 lent Mme. Pissarro).

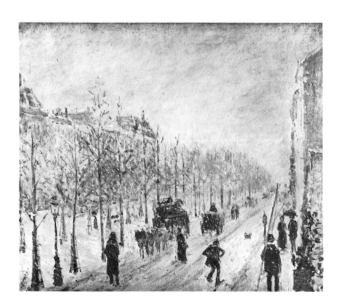

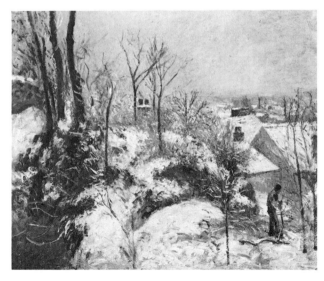

52 ILLUSTRATED IN COLOUR

The backwoods of L'Hermitage, Pontoise
1879

Le fond de L'Hermitage, Pontoise

P&V 489

Canvas. 126 × 162 cm./49⅝ × 63¾ in. Signed and dated, lower
left: *C. Pissarro. 1879.*

The Cleveland Museum of Art, Cleveland (inv. 51.356), gift of
Hanna Fund

Le fond de L'Hermitage, Pontoise is one of Pissarro's largest canvases
and it is painted throughout in the detailed style associated with
the work of the late 1870s (Cat. 46–48). It has been claimed that the
painting was included in the fourth Impressionist exhibition,
which was held in 1879, but a firm identification with any of the
pictures included on that occasion cannot be made (see Exhibited
section, below). On the other hand, the size of the painting suggests
that it was most probably intended for public exhibition and it is
possible that, like Renoir, Pissarro contemplated seeking a place at
the Salon of 1879.

The composition treated on this large scale may be regarded as a
summa of those pictures concerned with the *sous-bois* motif dating
from this and previous decades (see, for example, P&V 128 and
444). While the dappled effects of light piercing the foliage recall
Narcisse Diaz and an early work by Renoir (*Portrait of Jules le Coeur*

in the Forest of Fontainebleau, of 1866, Daulte 27), the screening
device of the trees was a motif that Cézanne continued to explore
later, particularly in his pictures of the grounds around the
Château Noir (V 779–80). Significantly, Monet was also interested
in employing foliage as a screen in two paintings (W 456–7) that
were included in the fourth Impressionist exhibition. Furthermore,
the presence of a goat in the centre, for which there are two slight
studies in Oxford (Brettell and Lloyd 132–3), brings to mind
Courbet's group of pictures of roe-deer (Fernier 552, 560 and 644,
of 1868).

PROVENANCE: Pissarro family; Paris, Bernheim Jeune, to whom sold by the Pissarro
family 17 December 1913 for 20,000 frs. and transferred to Bernheim Jeune,
Lucerne, 1917 (Oxford, Ashmolean Museum, Pissarro archives; Paris, Bernheim
archive); sold anonymously Paris, Hôtel Drouot, 20 June 1935, lot 59 repr. bt.
Schweller for 23,100 frs.; Paris, C. Comiot collection; Paris, Hector Brame and César
de Haucke, from whom purchased by the Cleveland Museum of Art, 1951.
LITERATURE: P&V, p. 44; H. S. Francis, '*Le Fond de L'Hermitage* by Camille Pissarro',
Bulletin of the Cleveland Museum of Art xxxix (1952), pp. 64–6 repr.; 'De David à
Toulouse-Lautrec dans les collections et musées américaines', *Art et Style* xxxiv
(1955), p. 22 repr.; W. M. Milliken, *In Memoriam Leonard C. Hanna Jr.*, Cleveland,
1958, No. 69 repr.; *Cleveland Museum of Art. Handbook*, Cleveland, 1978, p. 215
repr.
EXHIBITED: Paris, 1879 (168 *Lisière d'un bois* or 173 *Sous bois en été*); Paris, Durand-
Ruel, 1928 (30); Paris, Orangerie, 1930 (35 lent Bernheim Jeune); Paris, Marcel
Bernheim, 1936 (32 lent Comiot); Paris, Orangerie, *De David à Toulouse-Lautrec;
chefs d'oeuvre des collections américaines*, 1955 (45 repr.).

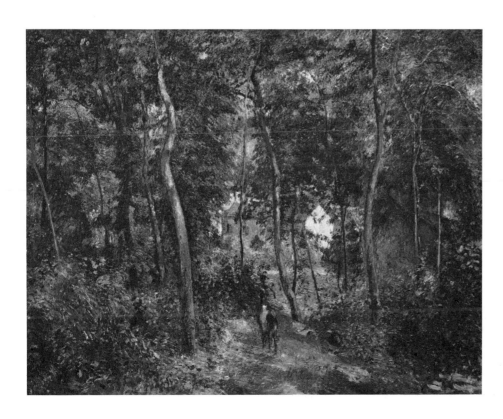

1880–1885

While the previous decade of Pissarro's working life has been readily appreciated, the first half of the 1880s has not attracted the degree of interest that it warrants. These were critical years for the Impressionists as a group and for individual members, nearly all of whom suffered financial hardship at this time. Cézanne had broken away after the third Impressionist exhibition (1877) and at the seventh (1880) totally new blood was introduced in the person of Paul Gauguin. The difficulties encountered by someone like Pissarro, who exhibited in all eight of the Impressionist exhibitions, to retain a group identity have often been recounted, and the self-doubts expressed about the direction of his own art are movingly recorded in his letters. To a certain extent most of the impressionist painters sought to change their style towards 1880 having established their principal criteria during the 1870s. Pissarro subjected his work to a rigorous analysis, while Monet and Renoir temporarily found new motifs and values of light in far-flung places. Typically Pissarro remained implacably installed just north of Paris, seeking a solution to his own self-doubts on the canvas itself, finally aligning himself with those younger painters who became associated with Neo-Impressionism. A visit to Rouen, in 1883, however, was of great significance for the artist, but this is at first more apparent in his prints and drawings than in the paintings.

Several changes are therefore perceptible in Pissarro's paintings dating from 1880–5. Firstly, regarding the compositions, there is less emphasis on recession and spatial depth. The basic elements – foreground, middle distance and background – tend to be flattened, so that the design is read upwards as a series of horizontal bands. Secondly, Pissarro's whole concept of the human figure changes, disproving totally the contention so widely and tradi-tionally held that he is solely a landscape painter. Both the drawings he made during these years (Cat. 118–120) and the prominence accorded the figure in his paintings attest a fresh assessment of the importance of the human figure in a composition. Where before, during the 1870s, the figures are carefully integrated with their surroundings, by the beginning of the 1880s it is the figures who dominate the compositions, often at the expense of the backgrounds. This was a slow process in the development of Pissarro's style and was probably nurtured by Degas. Thirdly, Pissarro's technique continues to evolve in favour of small, evenly distributed, and heavily loaded brushstrokes sometimes applied in parallel. These strokes are the equivalent of Cézanne's constructivist brushstrokes. The palette also becomes much more diverse as the artist applies smaller patches of pure colour. Increasingly, Pissarro overlays surfaces, so that figures are placed against their backgrounds, just as at the end of the 1870s he had screened

buildings with foliage. As in his prints of these years, it is as though Pissarro deliberately set himself the task of creating a visual clarity out of a confused and tangled web of natural forms. Yet this overlaying of the figures against the background is, like the screening of surfaces, a logical development from Pissarro's earlier work.

While developing these new facets of his style Pissarro did not always achieve successful results, and his failure to sell his work at this time led to a decline in output. None the less, where he achieved good results Pissarro shows that having matched Cézanne during the 1870s he can now equal Monet in dexterity of hand and acuity of eye. The younger critics, notably, J. K. Huysmans, readily appreciated this further evidence of the painter's skills.

53 ILLUSTRATED ON COVER (DETAIL)

The shepherdess (young peasant girl with a stick) 1881

Jeune fille à la baguette, paysanne assise
P&V 540
Canvas. 81 × 64.7 cm./$31\frac{7}{8}$ × $25\frac{1}{2}$ in. Signed and dated, lower right: *C. Pissarro. 1881.*
Musée de Jeu de Paume, Paris (inv. RF 2013)

The composition is one of the first in which Pissarro places greater emphasis on the figure. It is a painting that has certain affinities with Renoir, although the informality of the pose is perhaps inspired by Degas. Of the thirty or so paintings by Pissarro included in the seventh Impressionist exhibition, most involve the human figure and help to establish the artist as a major figure painter. In these paintings the figures dominate while the landscape serves as little more than a backdrop. The unity of the compositions stems from the facture and from the play of light on dappled surfaces. In his review of the seventh Impressionist exhibition Huysmans (*L'art moderne*, ed. Paris, 1975, p. 265) professed a keen admiration for Pissarro's figure paintings, and it is of course from Pissarro's paintings of these years that Gauguin evolved his style.

PROVENANCE: Paris, Durand-Ruel, probably *en dépôt* by 1883 and sent to New York Durand-Ruel by late 1886 from whence returned on 13 November 1899 and sold to Camondo 16 February 1910; Paris, Comte Isaac de Camondo collection, by whom presented to the Musée du Louvre, 1911.
LITERATURE: Burty, 1882; Chesneau, 1882; Morel, 1883; Kirchbach, 1904, p. 127 repr.; Stephens, 1904, repr. p. 415; P. Jamot, 'La collection Camondo au Musée du Louvre', *Gazette des Beaux-Arts* lvi (1914), p. 60 repr.; Neugass, *Die Kunst für Alle*, 1930, repr. p. 232; Manson, 1930, p. 414 repr.; P&V, p. 54; Rewald, 1939, No. 9 repr. col.; *Lettres*, p. 67; Jedlicka, 1950, repr. col. pl. 27; Natanson, 1950, p. 20 repr. col.; *Musée National du Louvre. Catalogue des peintures, pastels, sculptures impressionnistes*, Paris, 1959, p. 165 No. 318; Rewald, 1963, p. 120 repr. col.; Meier, 1965, p. 12 repr. col.; Kunstler, 1974, p. 42 repr. col.; J. Rewald, 'Jours sombres de l'Impressionnisme', *L'Oeil* No. 223 (1974), p. 18 repr.; Iwasaki, 1978, repr. col. pl. 19; H. Adhémar and A. Distel, *Musée du Jeu de Paume*, Paris, 1979, p. 167 repr. col. det.; Shikes and Harper, 1980, pp. 156 and 319 repr. col.

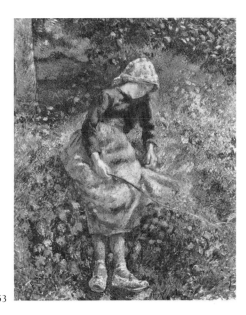

53

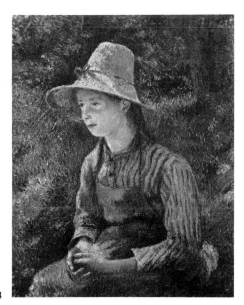

54

54
Young peasant girl wearing a hat 1881

Jeune paysanne au chapeau de paille

P&V 548

Canvas (relined). 73.4×59.6 cm./$28\frac{7}{8} \times 23\frac{1}{2}$ in. Signed and dated, lower right: *C. Pissarro 81*.

National Gallery of Art, Washington, Ailsa Mellon Bruce collection (inv. 2424)

Like the previous painting (Cat. 53), *Young peasant girl wearing a hat*, which was often referred to as *Young peasant girl resting* in the earlier literature, was also included in the seventh Impressionist exhibition held in 1882. The most remarkable quality of this picture is its sense of form. The figure is posed seated facing left in three-quarters profile. Her hands are clasped in her lap. The portrait is a three-quarters length. The image fills the canvas as it swells out in the lower half, balancing the conical shaped hat in the upper half.

The painting is both a traditional portrait and at the same time a work of immense significance for the younger generation of painters in France at the beginning of the 1880s, who oscillated towards Camille Pissarro. Symptomatic of this Janus-like character is the fact that its purity of form recalls on the one hand Italian Renaissance painting (Lionello Venturi referred to Piero della Francesca) and Corot, whilst on the other it anticipates Seurat and Gauguin. Pissarro's portrait possesses restraint, dignity, and calm in its characterization, whilst in its design it is solid and firm. It is at once the summation of the classical canon and yet an incitement to contravene that very prescription.

55 EXHIBITED IN LONDON ONLY
Portrait of Félix Pissarro (1874–1897) 1881

Portrait de Félix Pissarro
P&V 550
Canvas. 54 × 46 cm./$21\frac{3}{4}$ × $18\frac{1}{4}$ in. Signed and dated, upper left:
C. Pissarro. 1881.
The Tate Gallery, London (inv. 5574)

Félix-Camille Pissarro, known as Titi, was the third son of Camille and Julie Pissarro. He was a painter, engraver, and caricaturist working under the name of Jean Roch. He died in London of tuberculosis on 26 November 1897, aged twenty-four, at Kew while on a visit with his elder brother Georges.

There are several other painted portraits of Félix by his father (P&V 1553, 620 and 828), as well as some drawings (see Brettell and Lloyd 156).

As with the earlier portraits of Minette (Cat. 22, 34), the present portrait has a delightfully informal air, aided by the position of the head turned slightly towards the spectator in three-quarters profile.

PROVENANCE: London, Lucien Pissarro collection, by whom bequeathed to the National Gallery, London, 1949 (transferred to the Tate Gallery, 1950).
LITERATURE: Thornley, n.d. repr.; Kunstler, 1930, repr. pl. 9; R. Alley, *Tate Gallery Catalogues. The foreign paintings, drawings and sculpture*, London, 1959, pp. 191–2 repr.; Rewald, 1963, p. 128 repr. col.; Cogniat, 1974, repr. col. p. 45; Iwasaki, 1978, repr. col. pl. 21.
EXHIBITED: Paris, Georges Petit, 1887 (102); Paris, Durand-Ruel, 1904 (64); Paris, Blot, 1907 (6); Paris, Manzi et Joyant, 1914 (62); London, Leicester Galleries, 1920 (66); London, Tate Gallery, *List of loans at the opening exhibition of the Modern Foreign Gallery*, Jun.–Oct. 1926, p. 6; Paris, Orangerie, 1930 (53 lent Lucien Pissarro); London, Tate Gallery, 1931 (28), and subsequently at Birmingham, Oct.–Nov. 1931 (21), Nottingham, Nov.–Dec. 1931 (no cat.), Stockport, Jan. 1932 (24), Sheffield, Feb.–Mar. 1932 (24), Bootle, Apr.–May 1932 (21), Leeds, Jul. 1932 (9), Northampton, Aug.–Sept. 1932 (16), Blackpool, Sept. 1932 (16), Rochdale, Oct.–Nov. 1932 (no cat); London, Leicester Galleries, *Fifty years of portraits 1885–1935*, May–Jun. 1935 (58 repr.); London, Stafford Gallery, *Constable, Bonington, C. Pissarro*, 31 May–17 June, 1939 (14).

56
The rest, young female peasant lying on the grass, Pontoise 1882

Le repos, paysanne couchée dans l'herbe, Pontoise
P&V 565
Canvas. 63 × 78 cm./$24\frac{7}{8}$ × $30\frac{3}{4}$ in. Signed and dated, lower left:
C. Pissarro/82.
Kunsthalle, Bremen (inv. 960–1967/8)

While the subject recalls certain compositions by J.-F. Millet (for example, the pastel *The siesta*, repr. Paris, 1975, No. 176), the pose of the figure seen on a diagonal from slightly above is clear evidence of the influence of Degas. It is rare for Pissarro to create such spatial ambiguity as in this picture of a girl lying on the ground. A pastel that may have been drawn in connection with the present painting is P&V 1561 where, however, the girl is seen from a different angle.

Like Cat. 53–4, as well as in several other canvases dating from the first years of the 1880s, there is an evenness in the modelling. The differentiation between the figure and the background is not dependent upon outline, but on changes in colour.

PROVENANCE: Amsterdam, van Wisselinghe; Amsterdam, Dr. Hugo Oelze collection, by whom presented to the Kunsthalle, Bremen, 1967/8.
LITERATURE: Fagus, 1899, p. 546; G. Gerkens and U. Heiderich, *Katalog der Gemälde des 19. und 20. Jahrhunderts in der Kunsthalle Bremen*, Bremen, 1973, p. 268.
EXHIBITED: possibly Paris, Bernheim Jeune, 1899; Amsterdam, van Wisselinghe, *La peinture française du XIXe et XXe siècles*, 9 Apr.–9 May, 1931 (40 repr.); Bremen, Kunsthalle, *Ausstellung Paula Mondersohn-Becker*, 1976 (420); Bremen, Kunsthalle, *Zurück zur Natur: Die Kunstlerkolonie von Barbizon*, 6 Nov.–22 Jan. 1977–8 (426 repr. col.).

57
Female peasants tending cows, Pontoise 1882

Paysannes gardant des vaches, Pontoise

P&V 567

Canvas. 65 × 81 cm./$25\frac{3}{4}$ × $32\frac{1}{8}$ in. Signed and dated, lower right:
C. Pissarro. 1882.

Collection of Mrs. Paul Mellon, Upperville, Virginia

The composition of *Female peasants tending cows, Pontoise* is one of the least compromising of Pissarro's works dating from the first half of the 1880s. The background fills the whole canvas and the horizon line is only just visible below the upper edge of the painting. The figure on the left, placed boldly in the foreground with her back towards the spectator, marks the middle of the lower edge of the composition. From this figure the composition opens outwards and upwards in the direction of the upper corners, creating an inverted triangle. The alignment of the two figures establishes a diagonal running parallel to the line of trees in the left half. By such means Pissarro evolves those precisely formulated landscape backgrounds that characterize his neo-impressionist paintings (Cat. 68–9).

Again in *Female peasants tending cows* Pissarro provides evidence of his willingness to move his figures about freely, posing them in different attitudes and in different sections of the composition, but at the same time using the landscape almost as a backdrop to unify the design, tilting it up to avoid any appearance of recession. A drawing in Oxford (Brettell and Lloyd 137) is a study for the landscape in this painting and there is also a pastel of the figure with her back to the spectator (P&V 1560).

PROVENANCE: Paris, Durand-Ruel; Paris, private collection.
LITERATURE: J. Leclerq, 'Petites expositions: Galerie Durand-Ruel', *La chronique des arts et de la curiosité*, 15 April, 1899, p. 131; F. F. (= Fénéon), 'Les grands collectioneurs – M. Paul Durand-Ruel', *Bulletin de la vie artistique* x (1920), p. 267 repr.; Pica, 1908, p. 134 repr.; Kunstler, 1974, repr. col. p. 45.
EXHIBITED: Paris, Durand-Ruel, 1899 (45); Paris, Durand-Ruel, 1921 (28); Brussels, Palais des Beaux-Arts, *De David à Cézanne*, Nov.–Jan. 1947–8 (107 repr. lent Durand-Ruel); Venice, XXIV Biennale, 1948 (22 lent Durand-Ruel); Paris, Durand-Ruel, 1956 (47); Berne, Kunstmuseum, 1957 (62 lent Durand-Ruel); Paris, Durand-Ruel, 1962 (19); Washington, National Gallery of Art, *French paintings from the collection of Mr. and Mrs. Paul Mellon and Mrs. Mellon Bruce. Twenty-fifth anniversary 1941–1961*, Mar.–May 1966 (28 repr.); Richmond, Virginia Museum of Fine Arts, *French paintings from the Mellon collection*, 4 Apr.–5 Jun. 1967.

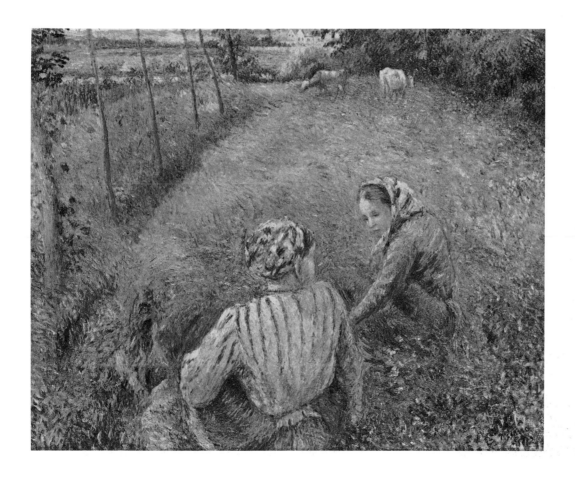

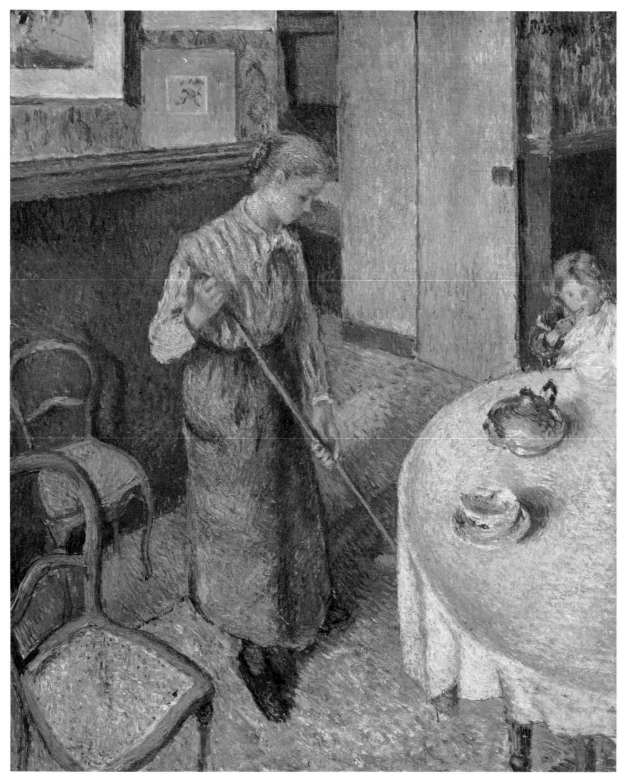

58

58 EXHIBITED IN LONDON ONLY
The little country maid 1882

La petite bonne de campagne

P&V 575

Canvas (relined). 63.5 × 53 cm./25 × $20\frac{7}{8}$ in. Signed and dated, upper right: *C. Pissarro. 82.*

The Tate Gallery, London (inv. 5575)

The picture was probably painted at Osny, where Pissarro moved in 1882 from Pontoise before finally settling in Eragny-sur-Epte a year later. P&V 574, also of 1882 (Chicago, The Art Institute), and in which the same figures appear, may also have been painted at Osny.

The little country maid is notable for the manner in which Pissarro has inserted the figures amidst a variety of shapes: vertical doorways and walls, horizontal cornice and picture frames, round-backed chairs and the round edge of a table. It is a type of composition that is strongly reminiscent of Degas, especially in the number of times objects and figures are cut off at the sides of the canvas. The technique, however, is closer to Monet and in both its range of colour and brushwork foreshadows Pissarro's neo-impressionist works (Cat. 62–71). This analogy is certainly true for the treatment of the tablecloth and the objects placed on it in the right half of the composition.

The pictures hanging on the wall behind the maid are identifiable. The still-life is a pastel of 1881 (P&V 1555) and the other is a Japanese painting on silk (Paris, Hôtel Drouot, 7–8 December 1928, lot 204).

The child represented in this painting is almost certainly Ludovic-Rodo, Pissarro's fourth son, for whom see Cat. 126.

PROVENANCE: London, Lucien Pissarro collection, by whom bequeathed to the National Gallery, London 1949 (transferred to the Tate Gallery, 1950).
LITERATURE: Thornley, (n.d.) repr.; Manson, 1920, repr. p. 87; Lecomte, 1922, repr. opp. p. 70; Tabarant, 1924, repr. pl. 22; Kunstler, 1930, repr. p. 229; Kahn, 1930, p. 698; R. Alley, *Tate Gallery catalogues, the foreign paintings, drawings and sculptures*, London, 1959, pp. 192–3 repr.; Rewald, 1963, p. 132 repr. col.; Preutu, 1974, repr. col. p. 53; Lloyd, 1979, p. 6 repr. col.
EXHIBITED: London, Doré Galleries, *Post-Impressionist and Futurist exhibition*, Oct. 1913 (5); Paris, Manzi et Joyant, 1914 (49); London, Leicester Galleries, 1920 (69); Paris, Nunès et Fiquet, 1921 (24); London, Leicester Galleries, *Modern French paintings*, Sept.–Oct. 1923 (39); Paris, Orangerie, 1930 (55 repr.); London, Tate Gallery, 1931 (24) and subsequently at Birmingham, Oct.–Nov. 1931 (19), Nottingham, Nov.–Dec. 1931, Stockport, Jan. 1932, Sheffield, Feb.–Mar. 1932 (29), Bootle, Apr.–May 1932, Leeds, Jul. 1932 (16), Northampton, Aug.–Sept. 1932, Blackpool, Sept. 1932, Rochdale, Oct.–Nov. 1932; Amsterdam, Stedelijk Museum, *Honderd Jaar fransche Kunst*, Jul.–Sept. 1938 (194 repr.); London, Royal Academy, *Impressionism, its masters, its precursors and its influence in Britain*, 9 Feb.–28 Apr. 1974 (90).

59 ILLUSTRATED IN COLOUR
Young woman washing dishes 1882

La laveuse de vaisselle

P&V 579

Canvas. 81.9 × 64.8 cm./$32\frac{1}{4}$ × $25\frac{5}{8}$ in. Signed and dated, lower right: *C. Pissarro/1882.*

Fitzwilliam Museum, Cambridge (inv. PD 53–1947)

Like his predecessor J.-F. Millet, Pissarro not only depicted the peasant at work in the fields, but also in a domestic environment, thereby providing a complete record of this particular social class in late nineteenth-century France. With his growing interest in the human figure during the late 1870s and early 1880s Pissarro could concentrate more on specific activities, as in P&V 471–2, of 1878, and P&V 473, of 1879, which are closely related in subject-matter to the present painting.

Stylistically *Young woman washing dishes*, like Cat. 58, anticipates Pissarro's interest in Neo-Impressionism, both in its iridescent palette and in the character of the brushstroke. For instance, the purple shadows cast by the foliage and set against the light-toned path in the left foreground may be compared with the shadows cast by the tree in Cat. 68.

The present painting was evidently made at 85 Quai de Pothuis, Pontoise, where Pissarro was living before moving to Osny. The sale of the picture is recorded in a notebook kept by the artist. The entry reads (*1er Juillet, 1882. Porte les toiles suivantes I T. 25 La Laveuse de vaisselle à l'huile 800 frs. . . .*), but the name of the buyer is not recorded and there is a discrepancy in the sum of money involved (see Provenance below). The present whereabouts of this notebook and others like it is unknown, regardless of the obvious importance of such information for Pissarro studies. So far only that for 1890 has been rediscovered.

PROVENANCE: Durand-Ruel, bought from the artist 28 June 1882 for 2500 frs.; London, Averkieff collection (1938); Paris, René Gimpel, by whom apparently bought from a Mrs. Tattersal (1939). Purchased by the Fitzwilliam Museum from Gimpel Fils, 1947. Spencer George Perceval Fund with the help of the National Art-Collections Fund.
LITERATURE: *National Art-Collections Fund. 48th Annual Report*, 1947, p. 13 repr.; J. W. Goodison with H. Gerson and D. Sutton, *Fitzwilliam Museum Cambridge. Catalogue of paintings. i. Dutch and Flemish, French, German, Spanish*, Cambridge, 1960, p. 188 repr.; F. Hoyland, '*La laveuse de vaisselle* by Camille Pissarro', *The Listener* lxxvii (1967), pp. 200–1 repr.
EXHIBITED: London, Gimpel Fils, *Five centuries of French painting*, Nov.–Dec. 1946 (14).

59

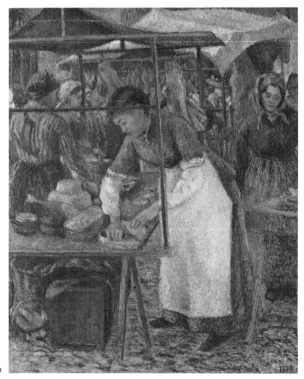

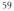

60

60 EXHIBITED IN LONDON ONLY
The pork butcher 1883
La charcutière
P&V 615
Canvas. 65 × 54.5 cm./25⅝ × 21⅜ in. Signed and dated, lower right: *C. Pissarro 1883*.
The Tate Gallery, London (inv. 5576)

The pork butcher is of the greatest interest, owing to the fact that Pissarro made several changes to the composition. Such changes are referred to in passing in a letter of 20 February 1883 to Lucien Pissarro (*Lettres*, p. 30), but they are fully revealed by X-rays. These show that the figure on the right was previously posed like that in the centre seen in profile bending inwards, whereas in the finished composition she is upright, balancing a further figure on the left and moving forwards as though out of the composition. The X-rays also show that the principal figure in the centre was originally given the features of an older woman, but that Pissarro finally decided on representing a younger person for whom his niece, Eugénie Estruc, known as Nini, served as the model, as stated in a letter of 22 July 1883 from Camille to Lucien Pissarro (quoted by Rewald, 1963, p. 134, but not in *Lettres*). For portraits of Eugénie Estruc, who also served as the model for P&V 1389, see P&V 653–4, 1391, and 1536.

Pissarro's main problem in devising this composition was the relationship of the figures to the market stalls. A preparatory drawing is included in the exhibition (Cat. 124). As in most of his market scenes (for example, P&V 576, of 1882) Pissarro places a triad of figures prominently in the foreground. These figures form a link between the spectator and the activities taking place in the background.

The market depicted here is almost certainly the weekly market held in Pontoise, with the church of St. Maclou seen in the background upper left.

PROVENANCE: London, Lucien Pissarro collection, by whom bequeathed to the National Gallery, 1949 (transferred to the Tate Gallery, 1950).
LITERATURE: Jacques, 1883; Manson, 1930, repr. p. 415; Kunstler, 1930, p. 236 and n. 1; P&V, p. 55; *Lettres*, p. 30; R. Alley, *Tate Gallery catalogues. The foreign paintings, drawings and sculpture*, London, 1959, p. 193 repr.; Rewald, 1963, p. 134 repr. col.; Preutu, 1974, repr. col. p. 59; Bellony-Rewald and Gordon, 1976, pp. 142–3 repr.; Lloyd, 1979, p. 7 repr. col.
EXHIBITED: London, Stafford Gallery, 1911 (20); London, Doré Galleries, *Post-Impressionist and Futurist exhibition*, Oct. 1913 (4); London, Leicester Galleries, 1920 (71); Paris, Orangerie, 1930 (63 lent Lucien Pissarro); London, Tate Gallery, 1931 (5), and subsequently at Birmingham, Oct.–Nov. 1931, Nottingham, Nov.–Dec. 1931, Stockport, Jan, 1932, Sheffield, Feb.–Mar. 1932, Bootle, Apr.–May 1932, Northampton, Aug.–Sept. 1932, Blackpool, Sept. 1932, Rochdale, Oct.–Nov. 1932; London, Stafford Gallery, *Constable, Bonington, C. Pissarro*, 31 May–17 Jun. 1939 (19).

61 EXHIBITED IN BOSTON ONLY
The poultry market, Gisors 1885

Le marché à la volaille. Gisors
P&V 1400
Tempera on canvas. 81 × 81 cm./$32\frac{1}{4}$ × $32\frac{1}{4}$ in. Signed and dated,
lower right: *C. Pissarro. 1885*.
Museum of Fine Arts, Boston (inv. 48.588)

Gisors is a large town approximately ten miles to the south of
Eragny-sur-Epte. It is in many ways comparable with Pontoise and
its mediaeval architecture, as well as its market, were frequently
depicted by Pissarro, who even contemplated undertaking a series
of lithographs of the town in the picturesque tradition (*Lettres*,
p. 81, 1 March 1884).

The poultry market, Gisors is unusual for its large square format,
and the available visual evidence suggests that the composition
may be a conflation of two separate market scenes. The left half,
notably the two female figures in the foreground, is derived from a
drawing included in the present exhibition (Cat. 129); the right
half, given the prominence of the female figure supporting her chin
with the left hand, depends upon a painting and a gouache, *Gisors
market (rue Cappeville)*, of 1885 (P&V 690 and 1401). These two
compositions are united in *The poultry market, Gisors* by such

features as the branches of the trees in the middle distance and by
the architecture in the background. The figure in the foreground
seen from the back also assists the fusion of the two halves. Pissarro
later adapted this composition in turn for another market scene
(P&V 1413), of 1887, with a vertical format.

It should be noted that the present tempera was once owned by
Monet. Regarding the exhibition of 1890 held at Goupil-Boussod &
Valadon, it should be observed that two temperas of the market at
Gisors were included. Although No. 16 of the exhibition is entitled
Marché à la volaille à Gisors, it is to be identified with P&V 1438 on
the basis of contemporary reviews, therefore implying that the
present work was exhibited as No. 17.

PROVENANCE: Giverny, Claude Monet collection; Michel Monet collection; New
York, Wildenstein; Boston, John T. Spaulding collection, by whom bequeathed to
the Museum of Fine Arts, Boston, 1948.
LITERATURE: *Impressionism in the collection of the Boston Museum of Fine Arts*,
Boston, 1973, No. 26 repr. col.; Kunstler, 1974, repr. p. 78; Shikes and Harper,
1980, repr. p. 203..
EXHIBITED: Paris, Goupil-Boussod & Valadon, 1890 (17); Paris, Durand-Ruel, 1904
(157 lent Claude Monet); Paris, Manzi et Joyant, 1914 (86); Paris, Orangerie, 1930
(Pastels 36 lent Michel Monet); Boston, Museum of Fine Arts, *The collections of John
Taylor Spaulding, 1870–1948*, 26 May–7 Nov. 1948 (65 repr.); New York,
Metropolitan Museum of Art, *100 paintings from the Boston Museum of Fine Arts*,
1970 (59 repr. col.).

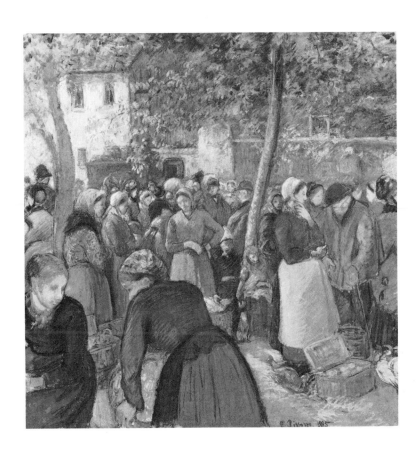

1885–1890

The five years 1885–1890 are associated with Camille Pissarro's direct involvement with Neo-Impressionism. The reasons for his adoption of this particular style of painting are fourfold. First, the actual technique of applying paint was in several respects a logical development of Pissarro's own style immediately prior to 1885. It has been seen that during the final years of the 1870s Pissarro used short, comma-like brushstrokes closely assembled on the canvas with a specific directional flow (Cat. 44, 46–8). This intricate manner of painting was perfected during the early 1880s (Cat. 53–4, 56–9), and the character of the brushstroke is not unrelated to that found in Pissarro's neo-impressionist paintings. Secondly, when adopting the smaller brushstrokes used in the paintings of the late 1870s, Pissarro felt that the surface of his paintings became overworked and murky in colour. In short, the compositions lost their clarity. To a certain extent this difficulty was partly overcome during the early 1880s when the artist chose to concentrate upon the figures in his pictures by varying their poses, while often reducing the landscape background to a formula (Cat. 57). This compositional procedure was maintained between 1885–1890 and is in accordance with the schematic method of working evolved by Seurat and Signac. Thirdly, the canvases of the late 1870s, although described by the artist himself as muddy, do in fact possess a colour range commensurate with that of Neo-Impressionism and on occasions he can also be found painting with complementary colours (Cat. 44). This introduced a luminosity to his pictures that anticipated his neo-impressionist works. Fourthly, the political standpoint of many of the Neo-Impressionists found favour with Pissarro. The negation of technical freedom, with the ensuing importance attached to the image, was regarded by the Neo-Impressionists as one way of establishing the autonomy of the artist and the primacy of the image. Pissarro's political views, which became more radical as the decades passed, broadly coincided with those expressed in the works of the Neo-Impressionists. Both artistically and politically therefore Camille Pissarro found himself in sympathy with Neo-Impressionism.

Pissarro's advocacy of neo-impressionist principles, however, was short-lived. Indeed, it could almost be argued that he himself was never a *pointilliste* in the strict, technical sense of the term. Most of the large canvases dating from these five years retain the short, comma-like brushstroke developed earlier in his career, and although this is more strictly controlled it is never reduced to a dot. Similarly, the small oil-sketches painted with wider, more even strokes are never as well ordered as those by Seurat. Furthermore, although Pissarro did fully understand the scientific principles of Neo-Impressionism, as evidenced in his correspondence with Durand-Ruel and Louis Hayet, he preferred to leave official theoretical explanations to his younger friends. The letters also show that Camille Pissarro was keen to develop certain aspects of the theory of Neo-Impressionism for himself, particularly *passage*. This term is first referred to as late as 1889 (*Lettres*, pp. 180–1) and may best be defined as the neo-impressionist equivalent to a half-tone, whereby complementary colours are separated by intermediary hues.

From a stylistic point of view it is in Pissarro's division of pure colour and in his search for compositional unity through the operation of colour that he shows himself to be in full accord with the Neo-Impressionists. The optical brilliance of many of his canvases dating from 1885–1890 is perhaps their most significant feature, and it is notable that Pissarro retained this luminosity at the beginning of the 1890s when he developed his own form of Neo-Impressionism. The frustration recorded in his letters at the slow method of facture was not allowed to interfere with the technical advantages gained from his espousal of new artistic theories. Yet, even if it would be an overstatement to say that Pissarro regarded Neo-Impressionism as a palliative with which to cure the faults inherent in his own style prior to 1885, since he quickly saw its disadvantages, he did, none the less, incorporate what he saw as its most redeeming features into his own manner of working. Regardless of Camille Pissarro's defection, however, many of the adherents remained on friendly terms, particularly Signac, Maximilien Luce, Théo van Rysselberghe, and Henri-Edmond Cross, as attested by their portraits of the painter (Cat. 218, 221, 227). Pissarro's admiration for Seurat was unrestricted and that painter's early death resulted in one of the most moving passages in Camille Pissarro's letters to Lucien (*Lettres*, pp. 221–2, 30 March 1891 and pp. 226–7, 1 April 1891).

62
In the garden, mother and child 1886

Au jardin, mère et enfant
P&V 691
Canvas. 39 × 32 cm./15⅜ × 12⅝ in. Signed and dated, lower left:
C. Pissarro. 1886.
Durand-Ruel collection, Paris

This is one of Pissarro's earliest paintings in the neo-impressionist style and it was included in the eighth Impressionist exhibition, which was held in 1886. It will be noted that the *pointilliste* technique is limited to small areas and that most of the work has been done with broader brushes, particularly the sky. Pissarro seems to have been engaged in painting a similar composition (P&V 692) at the same time, which, although of a different subject, is comparable in technique and size.

The subject of the present painting is distantly reminiscent of a composition by J.-F. Millet entitled *First steps* (Paris, 1975, No. 97).

PROVENANCE: sold anonymously Paris, Hôtel Drouot, 13 March 1894, bt. Durand-Ruel for 3500 frs.; Paris, Durand-Ruel.
LITERATURE: *Lettres*, p. 103.
EXHIBITED: Paris, 1886 (102 bis, *Mère et enfant*); Paris, Seligman, *Paysages de 1400 à 1900*, June, 1938.

63 EXHIBITED IN BOSTON ONLY
The Dieppe railway, Eragny-sur-Epte 1886

Le chemin de fer de Dieppe, Eragny
P&V 694
Canvas. 54 × 65 cm./21¼ × 25⅝ in. Signed and dated, lower left:
C. Pissarro. 1886.
Private collection, Gladwyne, Pennsylvania

Dieppe railway, Eragny-sur-Epte is, like *L'Ile Lacroix, Rouen* (Cat. 66), a 'modern' subject painted by Pissarro in a correspondingly 'advanced' style. The painting was included in the fourth group exhibition of '*Les XX*', which was held in Brussels in 1887.

The subject of the present painting was only painted directly on two other occasions, both times in England: firstly, in 1871 (Cat. 16), and, secondly, in 1897 (not in P&V, England, private collection, exhibited London, Matthiesen, 1950 (26)). In the second of these paintings the train is placed on a diagonal, as in *The Dieppe railway*, but because Pissarro was working in the suburbs of London, the picture includes signals, telegraph poles, and various buildings which serve to divide up the picture space vertically. Here, however, Pissarro depicts the train making its way through the countryside and the only sign of habitation is the shadow of a building in the lower right corner. The train is seen appearing out of the distance almost like a mirage on a clear summer's day. It is as though Pissarro has translated Monet's Gare Saint-Lazare paintings (W 438–49) into a rural context where the smoke disappears more quickly.

Of Pissarro's railway pictures both Cat. 16 and *The Dieppe railway* call to mind J. M. W. Turner's *Rain, steam and speed; the Great Western Railway* (M. Butlin and E. Joll, *The paintings of*

J. M. W. Turner, New Haven–London, 1977, No. 409 pp. 232–3), although both are to some extent removed from the spirit of Turner's work, since they negate any visual impression of speed or movement.

The railway line from Paris to Dieppe, which was opened during the first half of the 1880s, passed close to Eragny-sur-Epte.

PROVENANCE: Paris, Durand-Ruel on consignment 11 September 1886, sent to London (McLean, 7 Haymarket Street) 5 October 1886, returned to Durand-Ruel December 1886, sent to New York 6 April 1888, having finally been bought from the artist by Durand-Ruel and sold 20 February 1888 to J. J. Johnson; Philadelphia, J. J. Johnson collection; New York, Durand-Ruel (repurchased by 1894); Philadelphia, Carroll S. Tyson.
LITERATURE: Mirbeau, 1887; Verhaeren, 1887; P&V, p. 56; *Lettres*, p. 119, 30 December 1886 and pp. 135–6, 27 February 1887, repr. Eng. edn. only pl. 26; Venturi, 1939, ii, p. 232, No. 2; J. Rewald, 'The collection of Carroll S. Tyson Jr. Philadelphia', *Connoisseur* cxxxiv (1954), p. 64 repr.; F. Novotny, 'The reaction against Impressionism from the artistic point of view', in *Acts of the 20th international congress of the history of art IV*, Princeton, 1963, p. 102 repr.; Kunstler, 1974, repr. p. 78; Rewald, 1978, repr. col. p. 95.
EXHIBITED: Brussels, 1887 (3 lent Durand-Ruel); Paris, Georges Petit, 1887 (104 lent Durand-Ruel); New York, Durand-Ruel, 1936 (6); San Francisco, Museum of Art, *Impressionism*, Summer, 1938 (18 lent Durand-Ruel); University of Pittsburgh, Department of Fine Arts, *Exhibition of French painting of the nineteenth century*, 22 Apr.–17 May 1939 (11); New York, Durand-Ruel, 1941 (11); Toledo, Museum of Art, *Paintings of the French countryside*, Oct.–Nov. 1945 (25 lent Durand-Ruel); Pittsfield (Mass.), The Berkshire Museum, *French impressionist painting*, 2–31 Aug. 1946 (11 lent Durand-Ruel).

64 EXHIBITED IN PARIS AND BOSTON ONLY
Apple picking 1886
La cueillette des pommes
P&V 695
Canvas. 128 × 128 cm./$50\frac{3}{8}$ × $50\frac{3}{8}$ in. Signed and dated, lower left: *C. Pissarro 1886*.
Ohara Museum of Art, Kuranshiki, Japan

The subject is one which Pissarro portrayed often, over several decades (Cat. 106, 68, 213). This large painting, however, is particularly significant, as it is a composition that the artist began to evolve during the first half of the 1880s and was included in the eighth and final Impressionist exhibition. It is stated in the *catalogue raisonné* that the picture was also sent to Brussels for the group exhibition of 'Les XX', but this is a confusion with Cat. 68. References in the artist's letters show that the painting was worked on for a period of three years.

Pissarro first attempted the composition in a vertical format in 1881 (P&V 545), where two female figures pick up apples from beneath a centrally placed tree, while a third holds a stick with which to shake the branches.

In the present painting there have been some important adjustments, although the principal features have not been changed. Thus, the figure manipulating the stick is granted a more central position, whilst the tree is moved nearer to the right edge. Of the two female figures on the ground the one picking up fruit retains the same relation to the standing figure and the tree as in P&V 545. The other figure, who is shown eating an apple in the lower left corner, does not occur in the earlier painting, where, in fact, Pissarro chose instead to fill the lower right corner with a stooping figure. A tempera of 1882 (P&V 1363) is closely related compositionally to the present painting, but it has a horizontal format. It is described in the *catalogue raisonné* as a study for P&V 695. As in the market scenes (Cat. 61, 129, 146), so in the various compositions of *Apple picking* the artist appears to have wavered in his choice between a horizontal and a vertical format.

Pissarro prepared the composition of the present painting with great care. Drawings for at least two of the figures are known; for the standing figure see Cat. 130 and for the figure eating an apple there is a fine study in the Louvre (Cabinet des Dessins inv. RF 29536).

The style of the picture is of great interest and it is on an unusually large scale for a painting in the neo-impressionist manner. Care has been taken to include shadows that conveniently divide up the picture space and provide an internal rhythm that is matched by the closely worked surface. The painting won considerable praise from contemporary critics, one of whom, George Moore, wrote as follows: . . . sad greys and violets, beautifully harmonized. The figures seem to move as in a dream; we are on the thither side of life, in a world of quiet colour and happy aspiration. Those apples will never fall from the branches, those baskets that the stooping girls are filling will never be filled, that garden is the garden that life has not for giving, but which the painter has set in an eternal dream of violet and grey' (*Reminiscences of the impressionist painters*, Dublin, 1906, p. 40).

PROVENANCE: Paris, Durand-Ruel (en dépôt 5 July 1886 until 26 January 1887); Paris, Goupil-Boussod & Valadon (en dépôt for 3000 frs. 3 January 1891, but retrieved by the artist during 1891); Camille Pissarro collection (No. 312 on inventory list (1904) of the artist's estate and valued at 10,000 frs.); Paris, Bernheim Jeune (to whom sold probably by Mme. Vve. Pissarro, December 1913 for 20,000 frs., Oxford, Ashmolean Museum, Pissarro archives); Kyoto, Genzaemon Kamikawa bought from Bernheim Jeune, 1917; Osaka, Sankaku-do Gallery from whom purchased by the Ohara Museum 1 July 1941.
LITERATURE: Adam, 1886, p. 548; Ajalbert, 1886, p. 391; Darzens, 1886, p. 90; Fèvre, 1886, p. 150; Geffroy, 1886; E. Hennequin, 'Les Impressionnistes', *La vie moderne* 19 June 1886 p. 390; Mirbeau, 1886; Paulet, 1886; Geffroy, 1887; Kahn, 1887, p. 328; Meier-Graefe, 1907, p. 166; Moore, 1906, p. 40; G. Kahn, 'Les Impressionnistes et la composition picturale', *Mercure de France* xcix (16 September 1912), p. 412; Hamel, 1914, repr. p. 31; Kahn, *Mercure de France* (15 March 1930), p. 698; *Lettres*, pp. 55–6 (22 July 1883), 140 (18 March 1887), 147–9 (15 May 1887), and 266–7 (18 November 1891); Rewald, 1963, at p. 124; Shikes and Harper, 1980, p. 160.
EXHIBITED: Paris, 1886 (100 *La cueillette des pommes*); Paris, Georges Petit 1887 (101); Paris, Durand-Ruel, 1904 (78); Bremen, Kunsthalle, *Grosse Kunstausstellung*, Feb.–Mar. 1910 (259); Paris, Manzi et Joyant, 1914 (107).

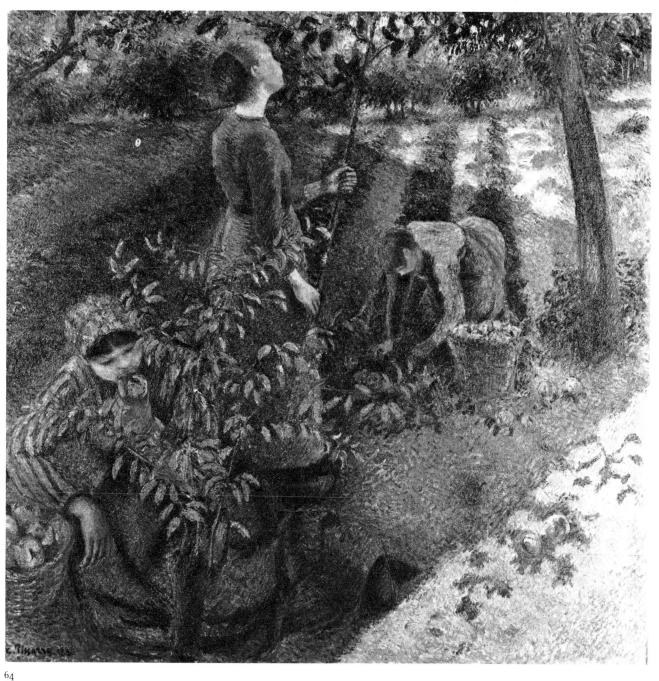

64

65
View from my window, Eragny-sur-Epte
1886–8

Vue de ma fenêtre, Eragny-sur-Epte

P&V 721

Canvas. 65 × 81 cm./25⅝ × 31⅞ in. Signed and dated, lower left:
C. Pissarro. 1888.

The Ashmolean Museum, Oxford, lent by the Visitors of the
Ashmolean Museum (inv. A 794)

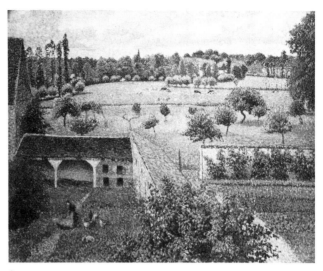

65

The canvas has been signed and dated twice. The first date, placed
just to the right of the signature fully visible now, has been
overpainted. It may once have read 1886, although this is by no
means absolutely certain. The claim, however, is a reasonable
deduction from a statement made by the artist in a letter to Lucien
Pissarro written on 30 July 1886, 'My *Grey weather* does not please
him [Durand-Ruel]; his son and Casburne also dislike it. What kills
art in France is that they only appreciate works that are easy to sell.
It appears that the subject is unpopular. They object to the red roof
and the backyard, just what gave character to the painting which
has the stamp of a modern primitive . . .' (*Lettres*, p. 109). Rewald
interpreted this as a description of the present painting, although
the words 'grey weather' were omitted from the title in the
catalogue raisonné. Pissarro presumably spent the next two years
slowly reworking parts of the canvas refining his *pointilliste*
technique. His use of the phrase 'modern primitive' surely applies
to the simple construction of the design, as much as to the subject-
matter.

The painting shows a view over the meadows towards
Bazincourt, a neighbouring village. The tall building at the left
edge was converted into the artist's studio when he finally bought
the house in 1892. The out-buildings seen in the rest of the picture
are partly visible in P&V 834, of 1893.

The painting was cleaned in 1979.

PROVENANCE: London, Lucien Pissarro collection; Esther Pissarro collection, by
whom presented to the Ashmolean Museum, 1950.

LITERATURE: Rewald, 1938, p. 289 repr.; P&V, p. 57; *Lettres*, p. 109 repr.; Anon.,
1952, p. 16 repr.; T. Mullaly, 'The Pointillists', *Apollo* lxiii (1956), p. 189 repr.;
Ashmolean Museum. Catalogue of paintings, Oxford, 1961, p. 118 repr.; Rewald,
1963, repr. p. 38; Dunstan, 1976, pp. 70 and 131 repr.; Lloyd, 1979, p. 7 repr. col.;
Shikes and Harper, 1980, p. 196 repr.

EXHIBITED: Paris, Durand-Ruel, 1889 (224); Paris, Manzi et Joyant, 1914 (17 bis);
Paris, Orangerie, 1930 (73 lent Lucien Pissarro); London, Tate Gallery, 1931 (6) and
subsequently at Birmingham, Oct.–Nov. 1931, Nottingham, Nov.–Dec. 1931,
Stockport, Jan. 1932, Sheffield, Feb.–Mar. 1932; London, Royal Academy,
Landscape in French art 1550–1900, 10 Dec.–5 Mar. 1950 (272 lent Esther Pissarro);
Amsterdam, Stedelijk Museum and Otterloo, Rijksmuseum Kroller-Muller, *Van
Gogh's grote tijdgenoten*, 1953 (45 repr.); London, O'Hana Gallery, 1954 (11); New
York, The Solomon R. Guggenheim Museum, *Neo-Impressionism*, 1968 (53 repr.);
London, Royal Academy, *Impressionism. Its masters, its precursors, and its influence
in Britain*, 9 Feb.–28 Apr. 1974 (91 repr.); London, Royal Academy, *Post-
Impressionism. Cross-currents in European painting*, 17 Nov.–16 Mar. 1979–80 (153
repr.).

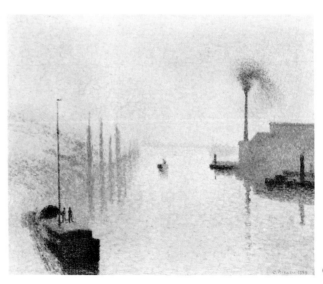

66

66
L'Ile Lacroix, Rouen, mist 1888

L'Ile Lacroix, Rouen, effet de brouillard
P&V 719
Canvas. 44 × 55 cm./18¼ × 21⅞ in. Signed and dated, lower right:
C. Pissarro. 1888
Pennsylvania Museum of Art, Philadelphia, John G. Johnson
collection (inv. 1060)

The painting was included in the sixth group exhibition of 'Les XX', which was held in Brussels in 1889. Cat. 68 was also shown on that occasion. *L'Ile Lacroix, Rouen, mist* has been signed twice identically. The signature and date lower left have been over-painted. Pissarro probably finally decided to place the signature on the right for reasons of compositional balance.

As Rewald (1963) pointed out, the composition was first essayed in a print made in Rouen in 1883 (D 69), to which can now be added Leymarie and Melot P 131 (see Cat. 180). The painting is notable for the subtlety of the palette comprising shades of white, pink, beige, and green for the sunlit areas seen through the mist, and shades of grey-blue and orange for the shadows. The over-all tone of mother-of-pearl forms a telling contrast with the other paintings of this period (Cat. 62–5, 68–71). There is evidence of some reworking, or changes of mind, around the smoke curling from the chimney on the right, but on the whole the canvas is thinly painted.

The Ile Lacroix of the title is on the right of the picture. It is, in fact, an island in the Seine at Rouen connected to the main parts of the city by the Pont Corneille. It was an industrialized area, and prominent in Pissarro's painting is the gas-works. For an earlier view of the island seen from the other direction see P&V 607.

PROVENANCE: Paris, Goupil-Boussod & Valadon by September 1888, and bought from the artist 22 November 1888 for 300 frs., sold to Dupuis on 29 June 1889 for 400 frs.; Paris, Dupuis; Paris, Durand-Ruel, by whom bought from Nottin (commiseur priseur) 13 May 1891 for 255 frs. and sold to J. J. Johnson 21 August 1891 for 800 frs.; Philadelphia, J. J. Johnson.
LITERATURE: Fénéon, 1888 [Halperin, p. 118]; Aurier, 1890 *Revue*, p. 513; Geffroy, 1890 (Boussod and Valadon), p. 11; W. R. Valentiner, *Catalogue of a collection of paintings and some art objects*, iii, Philadelphia, 1914, p. 141; P&V, p. 57; Venturi, 1939, ii, pp. 233–4 No. 4, 5; *John G. Johnson collection. Catalogue of paintings*, Philadelphia, 1941, p. 65; Leymarie, 1955, ii, repr. col. p. 92; Rewald, 1963, p. 138 repr. col.; Pool, 1967, pp. 244–5 repr.; London, Marlborough, 1968, Introduction to exhibition catalogue, p. 10 repr.; Rewald, 1973 *GBA*, pp. 34, 75 and [102]; J. Rewald, 'The impressionist brush', *Metropolitan Museum of Art Bulletin* xxx (1973–4), No. 29, repr. and col. det. [p. 39]; Kunstler, 1974, repr. col. p. 51; Bellony-Rewald and Gordon, 1976, repr. p. 245; L. Venturi, *Cézanne*, edn. Geneva, 1978, repr. p. 78; Rewald, 1978, repr. p. 99; Iwasaki, 1978, repr. col. pl. 24.
EXHIBITED: Paris, Goupil-Boussod & Valadon, 1888 (no cat.); Brussels, 1889 (6 lent Goupil-Boussod & Valadon); Paris, Goupil-Boussod & Valadon, 1890 (14 lent Dupuis); Philadelphia, Art Club, *Loan exhibition of paintings and other objects of art from private collections in Philadelphia*, 25 Jan.–7 Feb. 1892 (96 lent Johnson); New York, Wildenstein, 1945 (26 repr.); New York, Wildenstein and Philadelphia Museum of Art, *From Realism to Symbolism: Whistler and his world*, 4 Mar.–3 Apr. and 15 Apr.–23 May 1971 (114 repr.); London, Royal Academy, *Post-Impressionism. Cross-currents in European painting*, 17 Nov.–16 Mar. 1979–80 (154 repr.).

67
The flock of sheep, Eragny-sur-Epte 1888

Le troupeau de moutons, Eragny
P&V 723
Canvas. 46 × 55 cm./18 × 21⅝ in. Signed and dated, lower left:
C. Pissarro. 1888.
Private collection, Paris

The provenance of *The flock of sheep, Eragny-sur-Epte* testifies to its relevance for the Neo-Impressionists in as much as a traditional rural subject has been provided with a 'modern' setting and is treated in an 'advanced' style. Both J.-F. Millet (Paris, 1975, No. 154) and Pissarro (P&V 736, repr. Rewald, 1973 *GBA*, fig. 21 bis) frequently depicted this subject in the open fields, but here the sheep are being driven down a road in a village. Pissarro made an etching of a similar composition in 1889 (D 82).

A vigorous drawing of the shepherd seen from the back is in Oxford (Brettell and Lloyd 184), where there are also some slight studies for the dog (Brettell and Lloyd 185–6). Later, as part of a series of illustrations for *Travaux des champs* (Cat. 203–8), Pissarro twice included this particular composition, firstly (Brettell and Lloyd 370) with traditional *chaumières* at the side of the road, and, secondly (Brettell and Lloyd 369), as in the painting here, with bourgeois houses. Whatever the social significance of the houses may be they do allow Pissarro in the painting to show part of the road in shadow and part in sunlight. The sharp line dividing the shift from light to dark serves as a convenient aid in the application of neo-impressionist principles.

PROVENANCE: Paris, Paul Signac; Paris, Mme. Berthe Signac, first wife of Paul Signac, by whom given to the present owners.
LITERATURE: Signac, 25 December 1898 [J. Rewald, 'Extraits du Journal inédit de Paul Signac', *Gazette des Beaux-Arts* xlii (1953), pp. 37–8 repr.]; Kahn, 1930, pp. 699–700; P. Berthelot, 'Camille Pissarro: exposition du centenaire 1830–1903', *Beaux-Arts*, March 1930, p. 12; P&V, p. 57.
EXHIBITED: Paris, Durand-Ruel, 1889 (223 lent Signac); Paris, Orangerie, 1930 (74 lent Signac); Paris, Galerie de la Gazette des Beaux-Arts, *Seurat et ses amis*, Dec. 1933 (50); Venice, XXVI Biennale, 1952 (2, p. 387 repr.); Brussels, Musée Royaux, *Le Groupe des XX*, 1962 (92).

68 ILLUSTRATED IN COLOUR

Apple picking at Eragny-sur-Epte 1888

La cueillette des pommes, Eragny-sur-Epte

P&V 726

Canvas. 60 × 73 cm./23⅝ × 28¼ in. Signed and dated, lower right:
C. Pissarro. 1888.

Museum of Fine Arts, Dallas, Munger Fund Purchase

The subject is one that Pissarro attempted at various times during
the course of his career in different media (Cat. 106, 64, 213).
Significantly, it was not a subject depicted by J.-F. Millet and
Pissarro's preparatory work for this picture appears to have been
unusually detailed, including several drawings (Cat. 135), an oil-
sketch (repr. col. Cogniat, 1974, p. 48), and a gouache (P&V 1423).
The only major difference between the gouache and the finished
painting is in the inclusion of a fifth figure kneeling on the ground
at the right edge of the composition. Pissarro seems to have rubbed
out this figure on the gouache and substituted a horse and cart in
the painting, higher up the composition near the brow of the hill.

The palette is warm and the canvas positively throbs with the
heat of a late summer's afternoon. The splash of the shadows filling
the foreground has a powerful decorative effect. Such qualities
were fully exploited by Gauguin, whose rural imagery was initially
inspired by Pissarro's.

Interestingly, in a letter of 14 January 1889 from the artist to
Durand-Ruel, Pissarro quite explicitly gives the present painting a
date of 1887, even though today the canvas bears the date of 1888
(see Venturi, 1939, ii, p. 234 No. 5).

For the collector Desfossés see Rewald, 1973 *GBA*, p. 106.

68

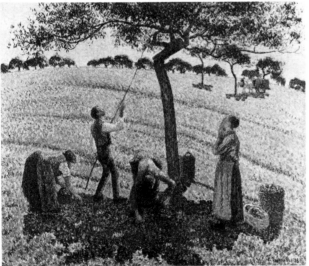

PROVENANCE: Paris, Goupil-Boussod & Valadon, by whom bought from the artist 18
March 1888 for 300 frs. and sold to Desfossés 26 July 1889 for 400 frs.; Paris, Victor
Desfossés (Paris, 26 April 1899, lot 50) bought Durand-Ruel for 1000 frs.; Paris,
Durand-Ruel; (?) Paris, Dureau; Berlin, Thannhauser; Hamburg, Dr. Max Emden
(Berlin, Hermann Ball and Paul Graupe, 9 June 1931, lot 41 repr.); Chicago, Max
Epstein.

LITERATURE: Fénéon, 1888, [Halperin, p. 102]; Fénéon, 1889 [Halperin, p. 138];
Maus, 1889; F.N., 1889; Le Roux, 1890; Antoine, 1890, p. 194; Aurier, 1890
Mercure, p. 143; Aurier, 1890 *Revue*, p. 512; Lecomte [1890]; Meier-Graefe, 1907,
p. 166; Venturi, 1939, ii, p. 234 No. 5; Rewald, 1973 *GBA*, pp. 21 and [103]; Lloyd,
1979, p. 9 repr. col.

EXHIBITED: Brussels, 1889 (5 lent Goupil-Boussod & Valadon); Paris, Goupil-Boussod
& Valadon, 1890 (6 lent Desfossés); (?) Paris, Durand-Ruel, 1904, (79 lent Dureau);
Chicago, Arts Club, 1946 (20 lent Epstein); Houston, Museum of Fine Arts, *From
Gauguin to Gorky in Cullinan Hall*, 20 Oct.–11 Dec. 1960 (55a); New York,
Wildenstein, 1965 (50 repr.); Tulsa, Oklahoma, Philbrook Art Centre, *French and
American Impressionism*, 2 Oct.–26 Nov. 1967 (12); New York, The Solomon
R. Guggenheim Museum, *Neo-Impressionism*, 1968 (52 repr.); Wichita, Kansas, Art
Museum, *Civilization revisited*, 4 Dec.–30 Jan. 1971–2; Dallas, Museum of Fine Arts,
Seventy-five years of art in Dallas, 25 Jan.–12 Mar. 1978.

69

The gleaners 1889

Les glaneuses

P&V 730

Canvas. 65 × 81 cm./25½ × 32 in. Signed and dated, lower left:
C. Pissarro. 1889.

Kunstmuseum, Basle, Dr. H. C. Emile Dreyfus Foundation (inv.
1970.14)

Although entitled *The harvesters* in the *catalogue raisonné*, Rewald
suggested tentatively that this painting could in fact be identified
with one called *The gleaners* exhibited at Goupil-Boussod &
Valadon in 1890, and as such listed in their ledgers. The dimensions
would seem to confirm this identification, although it has recently
been suggested that the title of the painting is really *The haymakers*.
This last is surely to be identified with P&V 729, which is entitled
The haymaking in the *catalogue raisonné* and was also exhibited at
Goupil-Boussod & Valadon in 1890 (2). Confusion between these
pictures perhaps stems from the fact that Lecomte, while
describing the present painting, refers to it as a haymaking scene.

The composition was first used for a fan in 1887 (P&V 1639), the
year in which J.-F. Millet's famous painting of *The gleaners* was
shown at the major retrospective exhibition of his work held at the
Ecole des Beaux-Arts (Paris, 1975, No. 65). There are several
references to Pissarro's painting of *The gleaners* in his
correspondence: 28 April 1888 (*Lettres*, pp. 168–9), 12 August 1888
(*Lettres*, p. 181) and 9 September 1888 (*Lettres*, p. 183).

The palette is very similar to that of *Apple picking* (Cat. 68).
Several changes in the poses of the figures are visible, notably to
the two central figures. The field is one at Eragny-sur-Epte and it is
the same as that seen in P&V 706, which, like the related
watercolour (Cat. 134), was made at a different time of year. A sheet
of studies of the baskets made in preparation for *The gleaners* is
reproduced by Rewald, 1963, p. 59.

PROVENANCE: Paris, Goupil-Boussod & Valadon, by whom bought from the artist 28 September 1889 for 620 frs. and sold to Buglé (or Bouglé) 27 October 1889 for 800 frs.; Paris, Eugène Blot (Paris, Hôtel Drouot, 2 June 1933, lot 90 repr.) bt. Emile Dreyfus; Basle, Dr. H. C. Emile Dreyfus.

LITERATURE: Lecomte [1890]; Rewald, 1973 GBA, [p. 103].

EXHIBITED: Paris, Goupil-Boussod & Valadon, 1890 (4 lent Bouglé); Paris, Orangerie, 1930 (77 lent Blot); Dusseldorf, Städtische Kunsthalle, *Vom Licht zum Farbe: nach impressionisten Malerei zwischen 1886 und 1912*, 27 May–10 Jul. 1977 (92 repr.); London, Royal Academy, *Post Impressionism. Cross-currents in European painting*, 17 Nov.–16 Mar. 1979–80 (155 repr.).

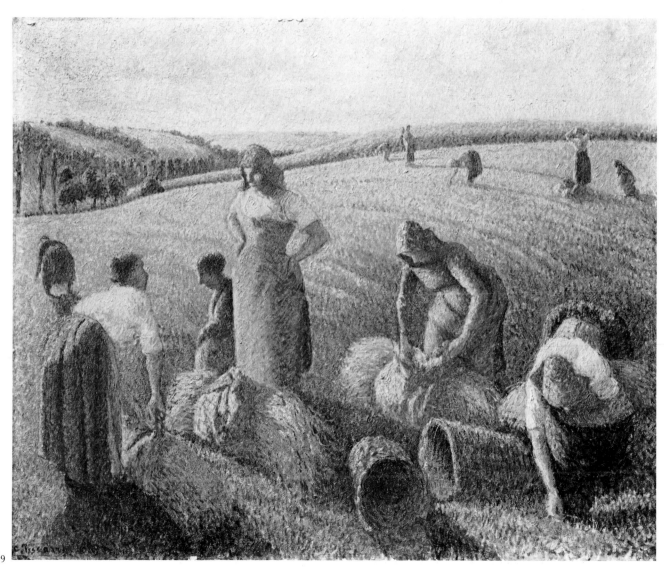

69

70
Charing Cross Bridge, London 1890
Le pont de Charing Cross, Londres
P&V 745
Canvas. 60 × 92 cm./23$\frac{1}{2}$ × 36$\frac{1}{4}$ in. Signed and dated, lower left:
C. Pissarro. 1890.
Collection of Mrs. Paul Mellon, Upperville, Virginia

The early provenance of this painting was established by Rewald. Pissarro repeated the composition in a picture executed after his return to France (P&V 805, sold Christie's 31 October 1978, lot 41A repr.). This second painting of Charing Cross Bridge was once thought to have been dated 1892, the year of a later visit to London by the painter, but the correct date is in fact 1891, as first observed in *The Impressionists in London*, Hayward Gallery, 3 Jan.–11 Mar. 1973, p. 77 n.8.

During his visit to England in the spring of 1890, in the company of Maximilien Luce, Pissarro painted in Hyde Park (P&V 744), Hampton Court (P&V 746), and Kensington Gardens (P&V 747), as well as executing views of Charing Cross Bridge and Old Chelsea Bridge (repr. Rewald, 1963, p. 39).

Charing Cross Bridge is here painted from Waterloo Bridge. In the centre of the composition are the Houses of Parliament and then, moving to the right, can be seen Westminster Hall, Westminster Abbey, Whitehall Court, and Cleopatra's Needle. Compositionally, the painting is somewhat firmer than Cat. 66 and technically the brushstrokes are also fuller. It is in short a picture in which Pissarro is moving away from Neo-Impressionism.

Monet made an extensive series of views of the Thames beginning in 1898, several of which include Charing Cross Bridge (*The Impressionists in London*, pp. 36–8 Nos. 4–12). Monet, however, worked from the balcony of his room in the Savoy Hotel.

PROVENANCE: Paris, Goupil-Boussod & Valadon, by whom bought from the artist 18 October 1890 for 650 frs. and sold to Elkins of New York 23 November 1891 for 3380 frs.; New York, Elkins collection; Paris, Durand-Ruel; Paris, Paul Harth collection; Paris, Rosenberg; Paris, Bignou; London, Lefevre; London, Carruth William Cargill collection (Sotheby's 11 June 1963, lot 34 repr. col.).
LITERATURE: P&V, p. 58; Francastel, 1939, repr. col.; Rewald, 1973 GBA, pp. 69–70 and [103] repr.; Blunden, 1970, p. 176 repr. col.; Iwasaki, 1978, repr. col. pl. 25.
EXHIBITED: Paris, Durand-Ruel, 1892 (45); Paris, Orangerie, 1930 (78 lent Harth); New York, Bignou, *Nineteenth century French paintings*, May 1940 (8); Washington, National Gallery of Art, *French paintings from the collection of Mr. and Mrs. Paul Mellon and Mrs. Mellon Bruce. Twenty-fifth anniversary exhibition 1941–1966*, Mar.–May 1966 (32).

71
Peasants in the fields, Eragny-sur-Epte 1890
Paysans dans les champs, Eragny-sur-Epte
P&V 755
Canvas. 65 × 81 cm./25$\frac{1}{2}$ × 32 in. Signed and dated, lower right:
C. Pissarro. 1890.
Albright-Knox Art Gallery, Buffalo (inv. 40.20)

The painting was entitled *The potato pickers* in the ledgers of Goupil-Boussod & Valadon. It is one of the last to have been painted by Pissarro in the neo-impressionist style.

The composition is distinctly reminiscent of J.-F. Millet, without actually being directly comparable with any one painting by that master, although he did in fact treat the subject (Paris, 1975, No. 64). The placing of the figures, the poses, the addition of incidental figures, such as the small child on the right, are certainly features that evoke comparison with Millet. The composition might be described as a conflation of *The gleaners* (Paris, 1975, No. 65) and *The two diggers* (Paris, 1975, No. 124), whereas in fact the relationship of the figures to the landscape is closer to *The Angelus* (Paris, 1975, No. 66). Yet, perhaps no other painting could more effectively demonstrate the differences of outlook between Millet and Pissarro. For Pissarro is here depicting a traditional peasant subject in an 'advanced' style, which implies a reinterpretation of the role of the peasant in society. Pissarro therefore infuses rural subjects with a radicalism that had by this date evaporated from Millet's own paintings.

Peasants in the fields is the same size as Cat. 69 and both show the same field viewed from different directions.

A drawing for the male figure is included in the exhibition (Cat. 140) and an elaborate pen and ink drawing of the whole composition is reproduced in T. Duret, *Histoire des peintres impressionnistes*, Paris, 1906, p. 6. It is not possible to say whether this last drawing is a highly finished compositional study or a record of the painting for use in another context. The style is closely related to that adopted for *Turpitudes sociales* (Cat. 142).

PROVENANCE: Paris, Goupil-Boussod & Valadon, by whom bought from the artist 18 October 1890 for 650 frs. and sold to Desmond Fitzgerald 21 November 1892 for 1820 frs.; New York, Desmond Fitzgerald collection (New York, American Art Association, 21–22 April 1927, lot 191 repr.); New York, A. Conger Goodyear collection, by whom presented to the Albright-Knox Art Gallery, 1940.
LITERATURE: A. C. Ritchie, *Catalogue of the paintings and sculpture in the permanent collection of the Buffalo Fine Arts Academy. Albright Art Gallery*, Buffalo, 1949, p. 96 repr.; Herbert, 1970, pp. 51–2 repr.; Rewald, 1973 GBA, pp. 66 and [103]; G. Pollock, *Millet*, London, 1979, pp. 5–6 repr.; S. A. Nash, *Albright-Knox Art Gallery. Painting and sculpture from antiquity to 1942*, New York, 1979, pp. 242–3 repr.
EXHIBITED: Buffalo, Fine Arts Academy and Albright Art Gallery, *Catalogue of a selection of paintings by Pierre-Auguste Renoir . . . supplemented by a selection of paintings . . . from the collection of A. C. Goodyear*, Jun.–Aug. 1928 (42); Chicago, Arts Club, 1946 (1); New York, Wildenstein, 1945 (29); Omaha, Joslyn Art Museum, *Twentieth century painting: the beginnings of modern painting. France 1800–1910*, 4 Oct.–4 Nov. 1951 (unnumbered); New York, Wildenstein, *Seurat and his friends*, 18 Nov.–26 Dec. 1953 (89); New Haven, Yale University Art Gallery, *Paintings and sculpture from the Albright-Knox Art Gallery*, 26 Apr.–4 Sept. 1961 (59); Buffalo, Albright-Knox Art Gallery, *Gifts to the Albright-Knox Art Gallery from A. C. Goodyear*, 1963 (9); Buffalo, Albright-Knox Art Gallery, *Paintings, sculpture, drawings and prints collected by A. Conger Goodyear*, 1966 (32); Washington, National Gallery of Art, *Paintings from the Albright-Knox Art Gallery*, 19 May–21 Jul. 1968 (p. 21 repr.).

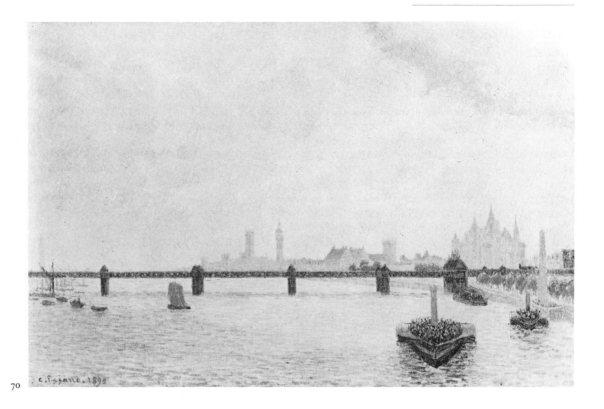

70

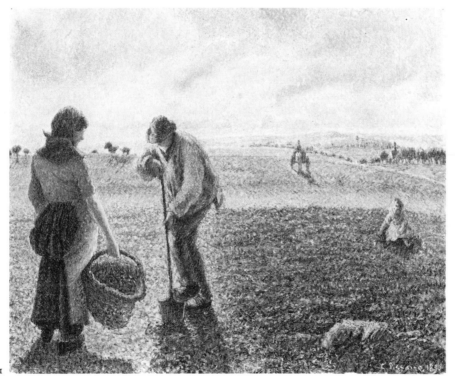

71

1890–1903

The paintings undertaken by Camille Pissarro during the last decade or so of his life fall conveniently into four groups, chiefly on the basis of their subject-matter: rural scenes, female bathers, urban views of Paris and Rouen, and the paintings of the busy ports of Dieppe and Le Havre. Beyond these categories may be mentioned small groups of domestic scenes, still-lives, and the views of Knokke-sur-Mer painted while Pissarro was in Belgium in 1894. On the whole though, as in Pontoise, Pissarro's world during his later years remains essentially static. Once he has found a suitable motif he makes only small shifts in his position, and frequently paints in series, as did Monet.

Stylistically, all these paintings mark a return to earlier compositional principles, particularly those that characterize the pictures executed during the first half of the 1870s. They are notable for the geometric framework underlying each canvas and Pissarro again concerns himself with recession. Yet, unlike the earlier canvases, the compositional principles are combined with a heavily-worked paint surface and a free technique. The late paintings of Pissarro are not very well known, perhaps unjustifiably so. He continued to be as productive during this part of his life as before, although it is possibly true that the incidence of weaker canvases increases. None the less, this last period is in many ways a summation, for the refinement of compositional procedures and an advance in technique seem to have allowed Pissarro to paint with greater freedom and confidence.

One of the more important aspects of this final period is the return to subject-matter traditionally associated with Impressionism. It is as if Pissarro was determined to reassess Impressionism. The rural paintings dating from the 1890s retain a luminosity of texture that is derived from the close working of the surfaces of his neo-impressionist paintings. There is an intensity about these paintings, now representing Eragny-sur-Epte as opposed to Pontoise, that enriches them with an almost visionary quality. This quality is even more apparent in the scenes of female bathers set in sylvan glades, reminiscent of the arcadian tradition in European art, which was also given renewed vigour by J.-F. Millet, Courbet and Cézanne. The arcadian feeling in Pissarro's later work was particularly admired by the younger critics such as Gustave Geffroy and Georges Lecomte. The palette in these pictures is warm, glowing, and varied. This is especially the case in those paintings of pure landscape, where the surface is encrusted with paint, attesting the superb eye that Pissarro had developed for the exact rendering of the effects of nature. Several of these pictures have been virtually ignored because their surfaces are now dirty, but when cleaned, as in the cases of Cat. 74, 85, 89, they can be as captivating as any picture executed by Monet during his final years.

The principal interest of the late rural paintings, beyond their colour, is Pissarro's treatment of the figure in the landscape. This again amounts to a resolution of problems that concerned him during the 1870s and 1880s, but neither the figures nor the landscape are allowed to dominate the composition one at the expense of the other. Now there is a perfect fusion, and it is apparent from the care with which Pissarro prepared these compositions, including those of the bathers, that the artist concentrated very hard upon balancing the monumentality of his figures within enclosed spaces.

Perhaps the most surprising category found amongst these late paintings is the urban scenes. Taken as a group these paintings mark Pissarro out as the most serious urban painter amongst the Impressionists, certainly in terms of concentrated topographical analysis. As far as Paris is concerned, Pissarro explored a theme that Manet, Monet, and Renoir had essayed during the 1860s and occasionally in the 1870s. Pissarro, however, did not paint urban views during the early part of his career, and it is characteristic of him that he should only turn to this theme and pursue it so relentlessly during the 1890s. It is well known that Pissarro painted the *avenues* and *boulevards*, bridges, and buildings of Paris from hotel bedrooms and similar vantage points situated well above street level. His recurrent eye trouble (dacryocystitis) may only have been partially responsible for this choice of position. There was possibly a reluctance on the part of the artist to descend into the street, implying an almost claustrophobic fear of the city from which many people dwelling beyond the boundaries of towns and cities profess to suffer. Although the pictures are often densely populated, the individuals in them are only characterized from a distance, so that Pissarro retains a feeling of anonymity as well as distance from his subject. The palette continues to be light and Pissarro uses high tones, although towards the end of the century there is a tendency to apply pastel shades and a great deal of white. These urban pictures are concerned primarily with spatial depth, but the vanishing point is normally placed high up on the canvas, so that once more those compositional principles initiated during the early 1870s are compounded with those practised during the 1880s.

Pissarro's treatment of urban themes is by no means limited to Paris. There are a number of views of Rouen dating from the 1890s, mainly of the two bridges across the Seine and of the *quais*, whilst several of the prints are devoted to the mediaeval streets of the city. Like Pontoise, Rouen, which Pissarro examined closely for the first time in 1883, held a special fascination for the painter because of its hybrid character, but it may have appeared even more attractive in that, unlike Pontoise, the inland port of Rouen was properly industrialized. Indeed, it is the workings of the

port, as opposed to the streets, that Pissarro tended to concentrate upon in his paintings during the 1890s. In these compositions (Cat. 75, 76, 83) bridges form diagonals that reach out across the canvas, while masts, funnels, hoists, and derricks afford an opportunity to enmesh the composition in a series of verticals and horizontals. As with the urban views of Paris, there is also a tendency to dwell upon a motif that is characteristic of earlier impressionist paintings, namely the depiction of smoke veiling a composition. Where Monet evokes the atmosphere of a railway station, Pissarro shows smoke issuing forth from chimneys and funnels, thereby also promoting a feeling of movement and activity. These fugitive effects and the problems created in their representation are the true measure of Pissarro's reiteration of impressionist principles.

During the last decade of his life Pissarro also began to investigate places associated with Impressionism – Berneval, Varengueville, Moret-sur-Loing. These movements nearer to the coast, perhaps encouraged by similar proclivities in Belgium in 1894, led Pissarro to explore Dieppe and Le Havre, the ports in which the painter's last major painting campaigns took place. Yet, even in these two places, he maintained an independent outlook, concentrating not upon the fashionable sites of these seaside resorts as Monet had done at Trouville and at Le Havre itself, but upon the harbours. As with the scenes of female bathers set in a rural context, which are so far removed in spirit and place from the detailing of port activities, so with the views of Rouen, Dieppe, and Le Havre, Pissarro is evolving a new iconography of marine painting. It is typical of Pissarro that the canvases of the inland harbour at Rouen, and the coastal ports of Dieppe and Le Havre, cannot be strictly described as marine subjects or as urban subjects. They are perhaps more accurately termed industrialized marine subjects. The loading and unloading of ships, the arrival and departure of vessels, the bustle of the quayside, all observed at different times of day in different kinds of weather and during various seasons, are the occurrences that Pissarro chose to paint. There is also a remarkable precision about the final works executed at Le Havre. Although there are a large number of canvases with only slight alterations in viewpoint the compositions are always confidently laid out and the details recorded with great assurance. There is no evidence of any failure in the artist's powers of observation or of execution.

Camille Pissarro's working life has therefore passed full circle. Not only has he returned to earlier modes of painting, but he has also once again become captivated by marine subjects; the harbour at St. Thomas and the activities of the dockside there kindled in the young artist the desire to paint and to draw, while the jetty and inner harbour at Le Havre were the principal sources of inspiration for his final works.

72
Bank holiday, Kew 1892
Fête à Kew
P&V 793
Canvas. 46 × 55 cm./18⅛ × 21⅝ in. Stamped with the artist's initials (Lugt 613 a) lower right.
Estate of the late Sir Charles Clore.

Bank holiday, Kew dates from the second of Pissarro's visits to England undertaken in the 1890s. He painted eleven canvases of motifs at Kew and this represents almost his total output during this visit to London in 1892 (P&V 793–803). As in the case of Charing Cross Bridge (Cat. 70), so Kew Gardens anticipates motifs executed by Pissarro in Paris later in the 1890s (Cat. 85–6).

Before his departure for London Pissarro had declared that he was going to paint 'some free and very vigorous things in London' (*Lettres*, pp. 284–5, 15 May 1892), but in fact the paintings of Kew Gardens are tightly handled in composition and technique, combining orderliness with optical splendour. They show the lingering influence of Neo-Impressionism. *Bank holiday, Kew*, however, is much looser and in some ways the composition foreshadows the pictures of the *Rue de l'Epicerie, Rouen* (Cats. 81–2), particularly in the relationship of the figures to the architecture. None the less, *Bank holiday, Kew* is an exceptional painting in Pissarro's *oeuvre*, like *The outer boulevards* (Cat. 50), especially in the emphasis placed on the figures.

PROVENANCE: Paris, Alexandre Bonin collection (Mme. Bonin was second daughter of Camille Pissarro); Amsterdam, W. Weinberg collection; London, Marlborough; London, Sir Charles Clore.
LITERATURE: J. House, 'The Impressionists in London', *Burlington Magazine* cxv (1973), p. 197.
EXHIBITED: London, Marlborough, *XIX and XX century European masters*, Summer, 1958 (48 repr.); London, Hayward Gallery, *The Impressionists in London*, 3 Jan.–11 Mar. 1973 (34 repr. and Introduction p. 16).

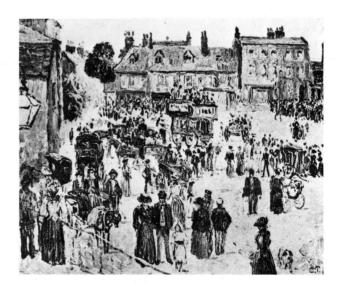

73
Place du Havre, Paris 1893

P&V 838

Canvas. 60.1 × 73.5 cm./23⅝ × 28⅞ in. Signed and dated, lower right: *C. Pissarro/93.*

The Art Institute of Chicago, Chicago, gift of Mrs. Potter Palmer (inv. 922.434)

Place du Havre, Paris belongs to the very first group of urban views of Paris painted by Pissarro (P&V 836–9). These paintings are mentioned in two letters written by the artist to his son Lucien in February and March 1893 (*Lettres*, p. 298, 27 February 1893, and p. 299, 3 March 1893 respectively). Each painting was executed from a viewpoint above the street from a room in the Hôtel Garnier near the Gare Saint-Lazare (Lecomte, 1922, p. 11), the station at which Pissarro would have arrived in Paris from Eragny-sur-Epte. The style of this first group of urban scenes is related to that of *Bank holiday, Kew* (Cat. 72), which can in turn be compared with *Place de la République, Rouen* (P&V 609), of 1883. In these pictures Pissarro adopts a looser style, as though activating the surface of the canvas to create an appearance of movement and of passing forms. This is true even of the architecture, which is used to anchor the composition, but is also governed by changing atmospheric conditions. Interestingly, Pissarro returned to this subject in 1897 (P&V 981–2 and 985) just before starting his series of the Boulevard Montmartre (Cat. 78). Indeed, he painted this same view of the Place du Havre again seen in the rain in 1897 (P&V 982).

Pissarro made lithographs of la rue Saint-Lazare (D 184) and of the Place du Havre (D 185), but both compositions differ from the paintings (Cat. 196–7).

PROVENANCE: Paris, Durand-Ruel; New York, Durand-Ruel; Chicago, Potter Palmer collection. Presented by Mrs. Potter Palmer to the Art Institute of Chicago, 1922.
LITERATURE: Coe, 1954, p. 95 repr.; *Paintings in The Art Institute of Chicago*, The Art Institute, Chicago, 1961, p. 359.
EXHIBITED: Paris, Durand-Ruel, 1893 (40).

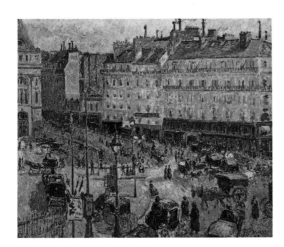

74
Morning, sunlight on the snow, Eragny-sur-Epte 1895

Matin, effet de soleil, hiver à Eragny-sur-Epte

P&V 911

Canvas. 82.3 × 61.5 cm./32⅜ × 24¼ in. Signed and dated, lower left: *C. Pissarro. 95.*

Museum of Fine Arts, Boston (inv. 19.1321)

The meadow at Eragny-sur-Epte, looking across to the neighbouring village of Bazincourt and seen at different times of the day and year, was one of Pissarro's main subjects during the 1890s. Directly comparable with the painting exhibited here, for example, is *Autumn, poplars, Eragny-sur-Epte* (P&V 894, Denver Art Museum), of 1894, resplendent in its warm greens and yellows, and *Autumn morning, poplars, Eragny-sur-Epte* (P&V 1096), of 1899.

The winter season of 1895 inspired seven paintings (P&V 905–11), of which P&V 906 most closely resembles the present picture in format and viewpoint. Here Pissarro has offset the white of the snow with pastel shades of yellow, orange, beige and pink. The shadows produced by the trees and the foliage are rendered with cool tones of violet, green, blue and grey. The crispness of light in the cold morning air is captured by subtle variations of these pigments mixed with white.

It is perhaps legitimate to compare these paintings of the meadow at Eragny-sur-Epte with late works by Corot, both as regards the screen of trees, which also recalls some of Pissarro's own prints of the early 1880s (D 32–3), and the treatment of light.

PROVENANCE: Paris, Durand-Ruel, bought from the artist 10 April 1894 and sent to New York 26 April 1897; New York, Durand-Ruel, from whom bought by Lyman; Boston, John Pickering Lyman. Presented to the Museum of Fine Arts by Theodora Lyman, 1919.
LITERATURE: P&V, p. 63; W. G. Constable, *Boston Museum of Fine Arts. Summary catalogue*, Boston, 1955, p. 51; *Impressionism in the collection of the Museum of Fine Arts, Boston*, Boston, 1973, No. 27 repr. col.
EXHIBITED: New York, Wildenstein, 1945 (32); Chicago, Arts Club, 1946 (2); Atlanta, High Museum of Art and Denver, Denver Art Museum, *Corot to Braque. French paintings from the Museum of Fine Arts, Boston*, 21 Apr.–17 Jun. and 13 Feb.– 20 Apr., 1979–80 (30 repr. col.).

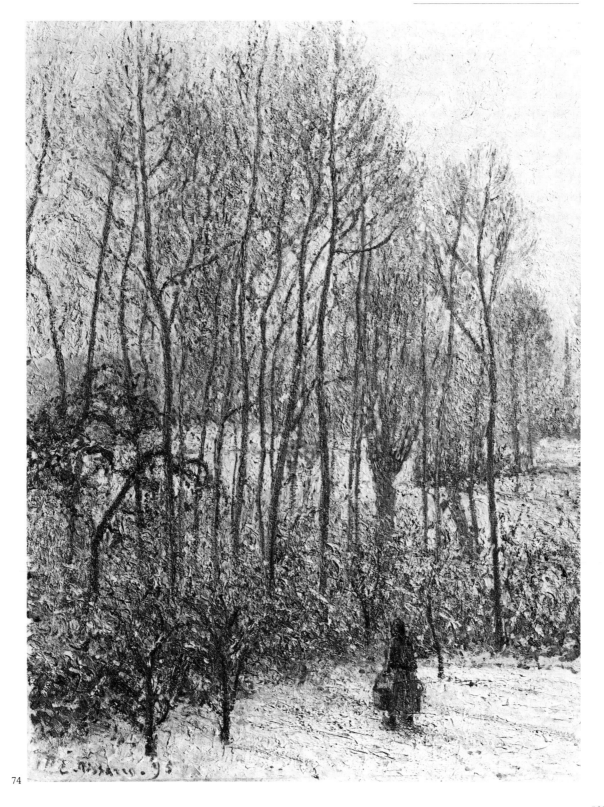

74

75 ILLUSTRATED IN COLOUR
The Boieldieu Bridge, Rouen, damp weather 1896

Le Pont Boieldieu à Rouen, temps mouillé

P&V 948

Canvas. 73.7 × 91.4 cm./29 × 36 in. Signed and dated, lower right: *C. Pissarro. 1896.*

Art Gallery of Ontario, Toronto (inv. 2415)

Pissarro made his first protracted visit to Rouen in the autumn of 1883. It was to be an important turning point in his life and the effect of the city, which he once described as being as beautiful as Venice (*Lettres*, p. 419, 2 October 1896), upon him is symbolized by the attention he paid to it in all media. Thirteen paintings survive from the first visit of 1883 (P&V 601–13), three of which are views of the cathedral as seen from the Cours-de-la-Reine similar to that painted by Monet in 1872 (W 217).

Pissarro returned to Rouen in 1896 when he worked there for two further sessions: the first from January–April 1896 when he stayed at the Hôtel de Paris (51 Quai de Paris), and the second from September–November 1896 when he stayed at the Hôtel d'Angleterre (Cours Boieldieu). Both these hotels commanded views of the port (*Lettres*, pp. 396–8, 20 January and 23 January 1896) and of the main bridges across the Seine – the Pont Boieldieu and the Pont Corneille. The Pont Boieldieu is the bridge depicted in the present painting, which is described in letters dating from 6 February and 7 March 1896 (*Lettres*, pp. 398–9 and 400–1

respectively), and almost certainly in a famous passage in a letter of 26 February 1896 (*Lettres*, pp. 399–400).

Pissarro began a dozen paintings during this opening campaign of 1896 in Rouen (*Lettres*, pp. 399–400, 26 February 1896), but he had completed twenty-eight canvases in all (P&V 946–73) by the end of his second campaign. It seems that the present painting was made from a window of the Hôtel de Paris. On the other side of the bridge is the Quai Saint-Sever and the Place Carnot with the front of the Gare d'Orléans visible in the upper left corner.

PROVENANCE: Paris, Durand-Ruel, bought from the artist 1896 and sent to New York late 1920s. Presented to the Art Gallery of Ontario by the Reuben Wells Leonard Estate, 1937.

LITERATURE: C. Mauclair, *The French Impressionists (1860–1900)*, London-New York, 1903, repr. p. 139; Meier-Graefe, 1907, p. 171; Pica, 1908, p. 137 repr.; Hamel, 1914, p. 31 repr.; A. Fontainas and L. Vauxcelles, *Histoire générale de l'art français de la Révolution à nos jours*, Paris, 1922, repr. p. 141; Jedlicka, 1950, repr. pl. 31; Natanson, 1950, repr. pl. 31; *The Art Gallery of Toronto. Painting and sculpture*, Toronto, 1959, p. 38 repr.; *Handbook*, Art Gallery of Ontario, 1974, p. 72 repr.; Shikes and Harper, 1980, repr. p. 292.

EXHIBITED: Paris, Durand-Ruel, 1896 (4); (?) New York, Durand-Ruel, 1897; Paris, Durand-Ruel, 1910 (11); Paris, Manzi et Joyant, 1914 (94); Paris, Durand-Ruel, *Oeuvres importantes de Monet, Pissarro, Renoir, Sisley*, 5–24 Jan. 1925 (38); New York, Durand-Ruel, *Master Impressionists*, 8 Apr.–20 Apr. 1929 (11); Buffalo, Fine Arts Academy, *Catalogue of exhibitions commemorating the 25th anniversary of the opening of the Albright Art Gallery*, Nov.–Dec. 1930 (55 repr.); (?) New York, Durand-Ruel, 1933 (12); Baltimore, 1936 (11); Cleveland, Museum of Art, *Twentieth Anniversary of Museum of Cleveland*, Jun.–Oct. 1936 (299); Toledo, Museum of Art, and Toronto, Art Gallery of Ontario, *The spirit of modern France*, Nov.–Dec. and Jan.–Feb. 1946–7 (50); New York, Wildenstein, 1965, (60 repr.).

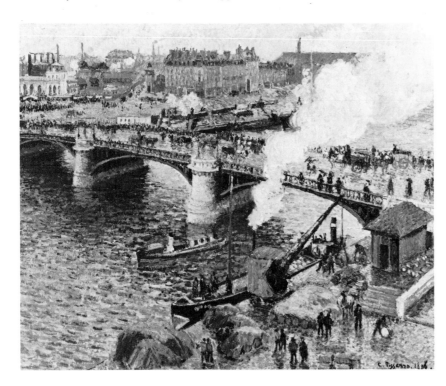

76
Le Grand Pont, Rouen 1896

P&V 956

Canvas. 73 × 92 cm./28¾ × 36¼ in. Signed and dated, lower left:
C. Pissarro. 96.
Museum of Art, Carnegie Institute, Pittsburgh (inv. 00.9)

Le Grand Pont, Rouen was one of the first paintings by Pissarro
acquired for a public collection in America. The bridge of the title
is the Pont Boieldieu, which is, however, seen from the opposite
side to the view shown in Cat. 75. Pissarro provides a detailed
description of the scene from his window in the Hôtel d'Angleterre
(*Lettres*, pp. 419–20, 2 October 1896), which would appear to be in
general accord with that shown in *Le Grand Pont, Rouen*. The
chimney towering over the buildings is part of the main gas-works
in Rouen in front of which is the Gare d'Orléans, whose curved
glass roof can be seen in this picture close to the chimney. P&V 964,
also of 1896, repeats this view of the Pont Boieldieu with some
changes in the foreground.

PROVENANCE: Paris, Durand-Ruel, bought from the artist 11 December 1896 and sent
to New York 15 March 1897; New York, Durand-Ruel, from whom purchased by
the Carnegie Institute, 1900.
LITERATURE: P&V, p. 64; Venturi, 1950, pp. 77–8 repr.; J. O'Connor, 'From our
Permanent Collection: The Great Bridge at Rouen', *Carnegie Magazine* XXV (1951),
pp. 236–7 repr.; Coe, 1954, p. 99 repr.; Rewald, 1963, p. 142 repr. col.; Pool, 1967,
p. 248 repr.; *Museum of Art, Carnegie Institute. Catalogue of paintings*, Pittsburgh,
1973, p. 125; Preutu, 1974, repr. p. 60; Bellony-Rewald and Gordon, 1976, p. 247
repr.; Lloyd, 1979, p. 7 repr.; Shikes and Harper, 1980, repr. col. p. 299.
EXHIBITED: New York, Durand-Ruel, 1897 (12); Pittsburgh, Carnegie Institute,
Fourth Annual International Exhibition, 1900 (189); New York, Wildenstein, 1945
(34); Chicago, 1946 (3); New York, Rosenberg, *The nineteenth-century heritage*,
7 Mar.–1 Apr. 1950 (19 repr.); Pittsburgh, Carnegie Institute, *French painting
1100–1900*, 18 Oct.–2 Dec. 1951 (112); Detroit, Institute of Arts, *The two sides of the
medal: French painting from Gérôme to Gauguin*, 28 Sept.–31 Oct. 1954 (54 repr.);
Palm Beach, Florida, 1960 (20 repr.); New York, Wildenstein, 1965 (61 repr. col.).

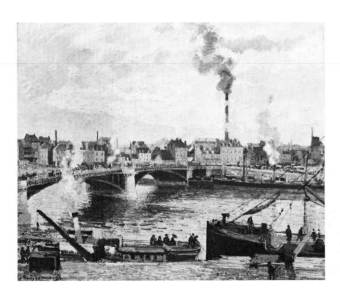

77
The rooftops of old Rouen, grey weather (the cathedral) 1896

Les toits du vieux Rouen, temps gris (la cathédrale)
P&V 973

Canvas. 72.3 × 91.4 cm./28½ × 36 in. Signed and dated, lower
right: *C. Pissarro. 1896.*
The Toledo Museum of Art, Toledo, gift of Edward Drummond
Libbey (inv. 51.361)

There are several references to this painting in the artist's
correspondence. He first announces the motif in a letter of 26
February 1896 (*Lettres*, p. 400), and it is apparent that the work was
finished by 7 March 1896 (*Lettres*, p. 401) when Pissarro was
negotiating with the famous collector François Depeaux for its sale.
The picture was not bought on this occasion, but was retained by
the artist for exhibition at Durand-Ruel's in Paris in the spring of
1896, when Pissarro displayed several of the paintings he had
recently finished in Rouen. The exhibition was a success and the
present picture was one of the most admired (*Lettres*, pp. 404–5, 16
and 25 April 1896), although Pissarro had been reluctant to include
a view of the cathedral because Monet had exhibited his series of
the façade of Rouen cathedral at the same gallery in the previous
year (*Lettres*, pp. 401–2 and 402–3, 17 and 24 March 1896
respectively).

The view is taken from the Hôtel de Paris looking over the city
away from the Seine. For a modern photograph of the same view
see Rewald, 1963, p. 43 or *Lettres*, fig. 50. The cathedral is seen
from the south side. An earlier attempt at this type of composition
(P&V 947) of the same year appears to have been less successful,
owing to the choice of a vertical format.

The subject epitomizes Pissarro's interest in Rouen, for here he
treats an old section of the city, comprising a traditional landmark,
in a totally modern way. The palette is remarkable for its range of
greys, balanced by warmer tones of red, orange, yellow, and
brown used for the slates of the roofs and the chimneys. Pissarro
clearly regarded this canvas as one of his finest and for him it
marked an advance in his technique (*Lettres*, p. 406, 25 April 1896).

PROVENANCE: Camille Pissarro collection; Mme. Vve. Pissarro (the estate number
125 occurs on the back of the canvas and on the stretcher); Paris, Durand-Ruel;
Berlin, Dr. Hans Ullstein collection; Berlin, Dr. and Mrs. Heinz Pinner (née
Ullstein); New York, Knoedler, from whom purchased by the Toledo Museum of
Art, 1951.
LITERATURE: Thornley, [n.d.], repr.; C. Mauclair, *Les peintres impressionnistes*,
Paris, 1904, repr. p. 161; Lecomte, 1922, repr. opp. p. 84; Mauclair, 1923, repr.
p. 192; Tabarant, 1924, repr. pl. 33; Koenig, 1927, repr.; Holl, 1928, repr. p. 167;
E. Waldmann, *Die Kunst des Realismus und des Impressionismus*, Berlin, 1927, p. 88
repr.; P&V, p. 64; Natanson, 1950, repr. pl. 38; Jedlicka, 1950, repr. pl. 38; *Lettres*,
pp. 400–6 repr.; Rewald, 1963, p. 144 repr. col.; Nochlin, 1965, p. 61 repr.; *The
Toledo Museum of Art. European paintings*, Toledo, 1976, pp. 128–9 repr.; Shikes
and Harper, 1980, pp. 293–4 repr.
EXHIBITED: Paris, Durand-Ruel, 1896 (21 lent Camille Pissarro); Paris, Manzi et
Joyant, 1914 (13); New York, Wildenstein, 1965 (64 repr.); Memphis, The Dixon
Gallery and Gardens, *Homage to Camille Pissarro. The last years 1890–1903*,
18 May–22 Jun. 1980 (8 repr. col.).

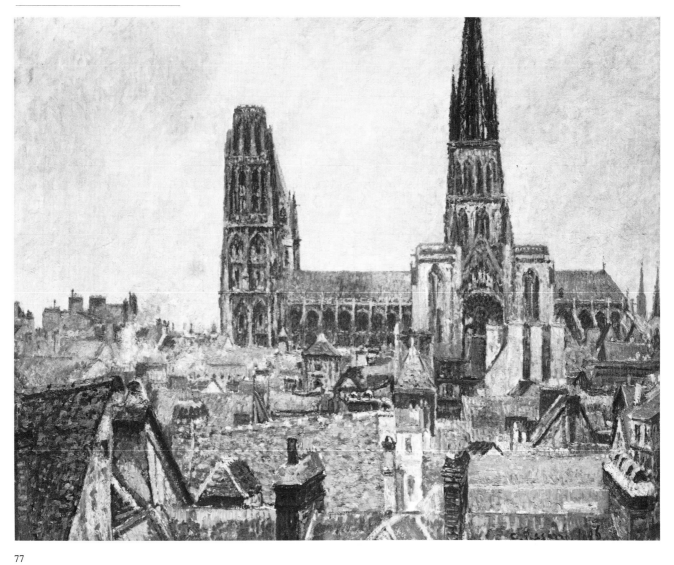

77

78

Boulevard Montmartre, mardi-gras 1897

P&V 995

Canvas. 65 × 81 cm./25 × 31½ in. Signed and dated, lower left:
C. Pissarro. 97.

The Armand Hammer Foundation, Los Angeles

Pissarro painted a series of thirteen views of the Boulevard Montmartre during the early months of 1897 (P&V 986–98) and there are several references to this group of paintings in the letters to Lucien (*Lettres*, pp. 431, 432–3, 8 February, 13 February and 5 March respectively).

The Boulevard Montmartre adjoins the Boulevard des Italiens on the one hand and the Boulevard Poissonnière on the other, forming part of a pattern of *boulevards* connecting the Place de la République to the Place de la Madeleine. The Boulevard Montmartre itself was first built in the eighteenth century. Pissarro painted each of his thirteen views of the Boulevard from the same window of the Grand Hôtel de Russie (1, rue Drouot) where he could look down on to the thoroughfare below. For photographs of the Grand Hôtel de Russie before its destruction in 1927 see Coe, 1954, p. 93 fig. 1 and of the Boulevard Montmartre see Kunstler, 1974, p. 57. The artist has depicted the Boulevard at different times of day, in various types of weather and once at night (P&V 994,

London, National Gallery) – this last being the only night painting in the whole of Pissarro's *oeuvre*. The present painting, together with P&V 996 (Cambridge, Mass. Fogg Art Museum) and P&V 997, show the celebrations for Mardi-Gras (14 February) held in 1897. Pissarro has omitted the lamp-post in the foreground, which appears in all the other pictures in the series. Monet had painted a similar scene in Paris in 1878, *Rue Montorgueil, holiday celebrations of 30 June 1878* (W 469–70).

Pissarro also made a lithograph of the Boulevard Montmartre (Cat. 199).

PROVENANCE: Paris, Maurice Barret-Décap collection; New York, Mr. and Mrs. Henry Luce collection; Zürich, Marlborough, Alte und Moderne Kunst; Los Angeles, Norton Simon collection (New York, Parke-Bernet, 5 May 1971, lot 24 repr. col.), bought by Armand Hammer.

LITERATURE: Neugass, 1928, repr. p. 319; P&V, p. 64; Coe, 1954, p. 107 repr.; Nochlin, 1965, p. 61; Lanes, 1965, p. 276; Kunstler, 1974, repr. p. 80; Shikes and Harper, 1980, p. 297 repr.

EXHIBITED: Paris, Durand-Ruel, 1898 (20); Paris, Durand-Ruel, 1921 (9); Paris, Durand-Ruel, 1928 (78); New Haven, Yale University Art Gallery, *Paintings, drawings, and sculpture collected by Yale alumni*, 19 May–26 Jun. 1960 (58 lent Luce); Utica, New York, Munson-Williams-Proctor Institute and Rochester, New York, The Rochester Memorial Art Gallery, *Masters of landscape East and West*, 15 Sept.–13 Oct. and 1 Nov.–1 Dec. 1963 (55 repr.); New York, Wildenstein, 1965 (65 repr. lent Luce); for a full list of exhibitions since the painting has been owned by Mr. Armand Hammer see *The Armand Hammer Collection*, Moultrie, Georgia, Moultrie-Colquitt County Library, 1–14 Feb. 1980 (22 repr. col.).

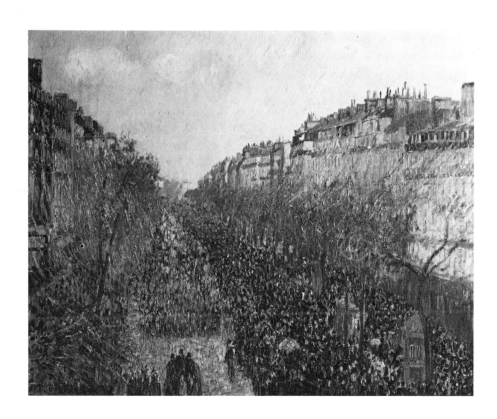

79
The Avenue de l'Opéra, sun on a winter morning 1898

Avenue de l'Opéra, soleil, matinée d'hiver

P&V 1024

Canvas. 73 × 91.8 cm./28¾ × 36⅛ in. Signed and dated, lower right: *C. Pissarro. 98.*

Musée de Saint Denis, Reims

Towards the end of 1897 Pissarro announced his intention to rent a room in the Hôtel du Louvre situated on the Place du Palais Royal. This allowed him views of the Rue Saint-Honoré, the Avenue de l'Opéra, and the Place du Théâtre Français (*Lettres*, pp. 441–2, 15 December 1897, 'I forgot to mention that I found a room in the Grand Hôtel du Louvre with a superb view of the Avenue de l'Opéra and the corner of the Place du Palais Royal. It is very beautiful to paint. Perhaps it is not aesthetic, but I am delighted to be able to paint these Paris streets that people have come to call ugly, but which are so silvery, so luminous and vital. They are so different from the *boulevards*. This is completely modern. I show in April'). Pissarro began his series of paintings from the Grand Hôtel du Louvre at the very end of 1897 and worked on them until the spring of 1898 (*Lettres*, p. 444, 6 January 1898, p. 447, 23 January 1898, and pp. 452–3, 11 April 1898).

The subjects presented from his room in the hotel posed quite different problems from those experienced while painting the Boulevard Montmartre (Cat. 78), or the Boulevard des Italiens (P&V 999–1000). While the latter were enclosed like a funnel, the Place du Théâtre Français and the Avenue de l'Opéra were open and spacious. The buildings, the roundabouts, and the Avenue itself allowed Pissarro to establish the framework of his composition, but he also had to contend with moving traffic and pedestrians entering and leaving the Place du Théâtre Français from a variety of directions.

The present painting has a blond tonality, and the sharp morning light is filtered across the composition from behind the spectator. The shadow of the hotel is in the foreground. Where the light is at its most intense (just to the left of centre) the brushwork is at its most free.

Pissarro regarded the whole of this series, nearly all of which were exhibited together at Durand-Ruel in 1898, as a great success (*Lettres*, pp. 453–4, 29 May 1898) and it was probably the precision with which he had rendered a scene characterized by perpetual movement that caused him to remark: 'My *Avenues* are so clear that they would not suffer alongside the paintings of Puvis de Chavannes' (*Lettres*, p. 454, 29 May 1898).

For a contemporary photograph of the view from the windows of the Grand Hôtel du Louvre see Kunstler, 1974 p. 65. The Avenue de l'Opéra in its present form was under construction from 1876–7 (A. Sutcliffe, *The autumn of central Paris. The defeat of town planning*, London, 1970, pp. 49–53).

PROVENANCE: Paris, Durand-Ruel bought from the artist 2 May 1898; Reims, Henry Vasnier (bought from Durand-Ruel 22 January 1902), by whom bequeathed to the Musée de Saint Denis, 1907.

LITERATURE: M. Sartor, *Musée de Reims. Catalogue sommaire de la Collection Henry Vasnier*, Reims, 1913, No. 209; Tabarant, 1924, repr. pl. 37; W. Uhde, *The Impressionists*, Vienna, 1937, repr. pl. 53; Duret, 1939, repr. p. 43; J. Vergnet and M. Laclotte, *Petits et grands musées de France. La peinture française des primitifs à nos jours*, Paris, 1962, pp. 182 and 284 repr.; Reidemeister, 1963, p. 169 repr.; H. Adhémar, 'L'époque impressionniste. Exposition des musées de France à Leningrad et à Moscou', *La Revue du Louvre* XX (1970), p. 394 repr.; Kunstler, 1974, repr. p. 65.

EXHIBITED: Paris, Durand-Ruel, 1898 (1); Paris, Orangerie, *Expositions des trésors de Reims*, Apr. 1938 (53); Reims, Musée des Beaux-Arts, *La peinture française au XIXème siècle de Delacroix à Gauguin*, 1948 (96); Japan, *Les sources du XXᵉ siècle*, 1961 (62); Berlin, Orangeries Schlosses Charlottenburg, *Die Ile de France und ihre Maler*, 29 Sept.–24 Nov. 1963 (55); Troyes, Musée des Beaux-Arts, *Renoir et ses amis*, 28 Jun.–14 Sept. 1969 (83 repr.); Leningrad, Hermitage and Moscow, Pushkin Museum, *Peintures impressionnistes des musées françaises*, Dec.–Feb. 1970–1 (unnumbered); Memphis, The Dixon Gallery and Gardens, *Homage to Camille Pissarro. The last years 1890–1903*, 18 May–22 Jun. 1980 (12a repr. col.).

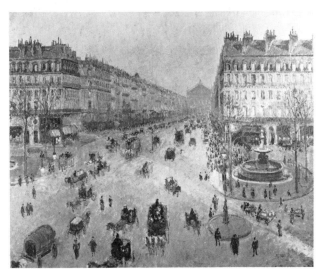

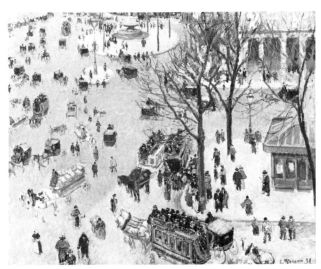

80

80 ILLUSTRATED IN COLOUR
La Place du Théâtre Français, Paris 1898

P&V 1031

Canvas. 73 × 92 cm./28½ × 36½ in. Signed and dated, lower right: *C. Pissarro. 98.*

County Museum of Art, Los Angeles, Mr. and Mrs. George Gard de Sylva collection (inv. M. 46.3.2)

La Place du Théâtre Français belongs to the series of paintings executed in 1898 from the window of a room of the Grand Hôtel du Louvre (see Cat. 79). As in P&V 1032 (Leningrad, Hermitage Museum), the artist looks straight down on to the Place du Théâtre Français in front of the hotel. The theatre itself is visible in the upper right corner of the canvas, but the Avenue de l'Opéra, which leads off the roundabout at the upper left is only suggested. The verticals and horizontals created by the trees and the façade of the theatre are almost overwhelmed by the movement of carriages and people. The general direction of all this activity is towards the upper left corner of the composition, which causes the spectator to 'read' the painting from the lower to the upper edge, as in a Japanese print.

PROVENANCE: Paris, Durand-Ruel bought from the artist 2 May 1898; Paris, Rosenberg; Paris, Durand-Ruel; New York, Durand-Ruel; Los Angeles, Mr. and Mrs. George Gard de Sylva, by whom presented to Los Angeles County Museum of Art, 1946.
LITERATURE: Stephens, 1904, repr. p. 434; Tabarant, 1924, repr. pl. 35; Jedlicka, 1950, repr. pl. 41; Natanson, 1950, repr. pl. 41; W. R. Valentiner, *The Mr. and Mrs. George Gard de Sylva Collection of French impressionist and modern paintings and sculpture*, Los Angeles County Museum of Art, 1950, p. 37 repr.; R. Bernier, 'Les nouvelles installations et les collections de Los Angeles County Museum', *L'Oeil* cxxiii (1965), p. 36 repr.; Nochlin, 1965, pp. 24–7; Pool, 1967, p. 249 repr.; W. Rubin, 'Jackson Pollock and the modern tradition, part II', *Artforum* v (1967), repr. p. 33; *Los Angeles County Museum of Art handbook*, Los Angeles, 1977, pp. 111–12 repr.; Shikes and Harper, 1980, p. 303 repr. col.
EXHIBITED: Paris, Durand-Ruel, 1898 (5); Paris, Durand-Ruel, 1921 (9); San Francisco Museum of Art, *Modern French paintings*, 18 Jan.–3 Mar. 1935 (32 repr. lent Durand-Ruel); San Francisco Golden Gate International Exposition, *Masterworks of five centuries*, 1939 (155); New York, Durand-Ruel, *Paintings of Paris*, 29 Oct.–16 Nov. 1940 (19); New York, Knoedler and Boston, Institute of Modern Art, *Views of Paris*, 1943; Los Angeles County Museum, *The Mr. and Mrs. George Gard de Sylva Collection of French impressionist and modern paintings and sculpture*, Oct. 1946 (13); Raleigh, North Carolina Museum of Art, *Masterpieces of art*, 6 Apr.–17 May 1959; Eugene, University of Origon, Museum of Art, *Treasure finds in Pacific Coast museums*, 2–25 Apr. 1962 (repr.); New York City, Public Education Association, *Seven decades 1895–1965*, 26 Apr.–21 May 1966 (37); Leningrad, Hermitage Museum, and subsequently at Moscow, Kiev, Minsk, Paris, *Paintings from American museums*, 1976; Memphis, The Dixon Gallery and Gardens, *Homage to Camille Pissarro. The last years 1890–1903*, 18 May–22 Jun. 1980 (13 repr. col.).

81 EXHIBITED IN BOSTON ONLY
La rue de l'Epicerie, Rouen 1898

P&V 1036

Canvas. 81.3 × 65.1 cm./32 × 25⅝ in. Signed and dated, lower left: *C. Pissarro/1898.*

The Metropolitan Museum of Art, New York, Mr. and Mrs. Richard J. Bernhard Fund (inv. 60.5)

Camille Pissarro returned to Rouen for another painting campaign in the late summer of 1898 (*Lettres*, pp. 457–60, 12 August–13 October 1898). During this period he painted nineteen canvases (P&V 1036–54). Three of these (P&V 1037 and Cat. 82) are of the rue de l'Epicerie, which he had first depicted in a watercolour in 1883 (London, Marlborough, *Masters of modern art from 1840–1960*, June–August 1960 (24 repr.)) and later used as the basis for an etching (D 64). Of the three paintings only the present picture shows the market stalls in position and the market in progress, thus prompting the expanded title *The Old Market at Rouen and the rue de l'Epicerie* favoured by the Metropolitan Museum of Art.

Pissarro first mentions his renewed interest in this motif in a letter dated 19 August 1898 (*Lettres*, p. 458). He probably observed the street from the Place de la Fierté where Samuel Prout (see Brettell and Lloyd, p. 35 repr.) and Monet (W 1316) had positioned

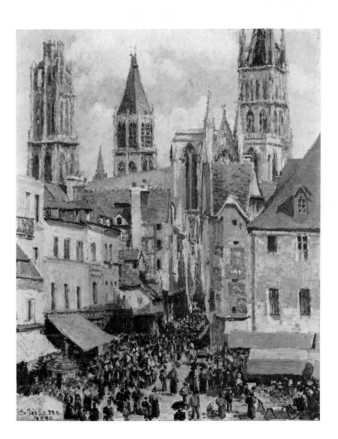

themselves. The square in which the weekly market took place on each Friday is the Place de la Haute-Vieille-Tour. The rue de l'Epicerie extends southwards towards the Seine from the cathedral. For a modern photograph taken before the damage inflicted in this part of the city in the 1939–45 war see *Lettres*, pl. 52. The distinguishing features of the cathedral are as follows: the Tour de la Beurre and the Tour de St. Romain on the west façade, the south portal known as the Portail de la Calende, and the main tower over the crossing.

The painting, which was cleaned in 1979, is notable for the compression of a variety of architectural forms, which link the upper and lower halves of the composition together.

PROVENANCE: Paris, Louis Bernard collection (Paris, Hôtel Drouot, 11 May 1901, lot 47) bt. Leclanché; Paris, Maurice Leclanché collection (Paris, Hôtel Drouot, 6 November 1924, lot 62); Paris, Auguste Savard collection (until 1939/40); Geneva, Roger Varenne collection (1939/40 until 1960). Purchased by the Metropolitan Museum of Art, 1960.

LITERATURE: Mauclair, 1903, repr. p. 135; Mauclair, 1904, repr. p. 161; Mauclair, 1923, repr. p. 192; F. Fels, 'Le retour à Lancelot. Impressionnistes', *ABC*, February, (1925), repr. p. 25; P&V, p. 65; A. Chamson and F. Daulte, 'Chefs d'oeuvres français des collections suisses', *Art et Style* l (1959) repr. col.; C. Sterling and M. Salinger, *The Metropolitan Museum of Art. A catalogue of the collection of French paintings* iii., New York, 1967, pp. 21–2 repr.; J. Rewald, 'The impressionist brush', *Metropolitan Museum of Art Bulletin* xxxii (1973–4), pp. 44–5 repr. col. det.; Iwasaki, 1978, repr. col. pl. 29; Lloyd, 1979, repr. col. pl. 40.

EXHIBITED: Berne, Kunstmuseum 1957 (98); Paris, Petit-Palais, *De Géricault à Matisse. Chefs d'oeuvres français des collections suisses*, 1959 (110); New York, Wildenstein, 1965 (68 repr.); New York, Knoedler, *Impressionist treasures*, 1966 (24); Boston, Museum of Fine Arts, *Masterpieces of painting in the Metropolitan Museum of Art*, 1970 (p. 85 repr. col.); Tokyo, National Museum of Western Art, and Kyoto, Municipal Museum, *Treasured masterpieces of the Metropolitan Museum of Art*, 10 Aug.–1 Oct. and 8 Oct.–26 Nov. 1972 (101); Leningrad, Hermitage Museum, and Moscow, Pushkin Museum, *100 Paintings from the Metropolitan Museum*, 1975 (69).

82 EXHIBITED IN LONDON AND PARIS ONLY
La rue de l'Epicerie, Rouen 1898

P&V 1038

Canvas. 81 × 65 cm./$31\frac{7}{8}$ × $25\frac{7}{8}$ in. Signed and dated, lower left: *C. Pissarro. 98.*

Private collection

Compared with the other two paintings of the rue de l'Epicerie dating from 1898 (see Cat. 81), the present work differs in that the artist has slightly altered his position by moving just to the left of the Place de la Fierté. This provides the spectator with a view right up to the steps of the south portal of the cathedral and gives the composition, aided by the empty foreground, a perspectival focus that neither of the other two canvases has. As a result, the emphasis on the architectural rhythms is less marked. Unlike the more vigorous style of Cat. 81, the surface here is closely worked with a mesh of small even brushstrokes reminiscent, as is the shadow in the foreground, of Pissarro's neo-impressionist canvases such as the *Dieppe railway* (Cat. 63). The palette, however, in its light tones of pink, red, yellow, beige, ochre, and green retains the buoyancy of the picture in the Metropolitan Museum of Art (Cat. 81).

PROVENANCE: Paris, F. Moch collection, sold anonymously Sotheby's, 1 July 1975, lot 6 repr. col.

LITERATURE: Thornley, [n.d.] repr.; Duret, 1906, repr. p. 54; A. Fontainas and L. Vauxcelles, *Histoire générale de l'art français de la Révolution à nos jours*, Paris, 1922, repr. p. 167.

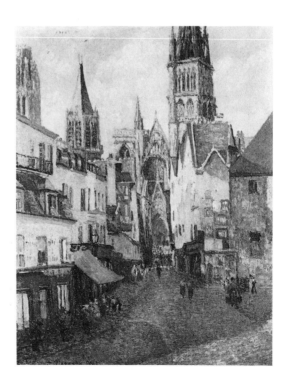

83
Sunset, the port at Rouen (smoke) 1898

Soleil couchant, port de Rouen (fumées)
P&V 1039
Canvas. 65 × 81 cm./25½ × 32 in. Signed and dated, lower right:
C. Pissarro. 98.
National Museum of Wales, Cardiff (inv. 1066)

The painting was probably made from the window of a room in the Hôtel de l'Angleterre, where Pissarro first stayed in 1896 (see Cat. 75), and to where he must have returned in 1898, although there is no documentary evidence to prove this. The view is looking upstream away to the artist's right and in the opposite direction from the Pont Boieldieu. The warehouses, in so far as they can be made out through the smoke, appear in numerous other paintings done while Pissarro was in Rouen in 1896 and 1898 (P&V 946, 957–60, 965, 967–9 and 1042, 1047, 1051–4). Indeed, this was the principal motif of these years, together with the Pont Boieldieu. The later group of pictures includes a chimney to the left of the buildings, which is omitted from the earlier group. In the present picture the smoke at the left edge blowing towards the spectator

probably issues from this chimney, thereby concealing it.

The scene is painted looking directly into the setting sun. The activity in the foreground is therefore silhouetted against the sky, casting long shadows. Ingamells suggested correctly that the subject and its treatment may have been inspired by Claude Lorrain and J. M. W. Turner, whose harbour scenes in the National Gallery, London, were juxtaposed as Pissarro knew (*Lettres*, pp. 499–501, 8 May 1902). For the juxtaposition itself see M. Wilson, *Second sight. Claude: The Embarkation of the Queen of Sheba. Turner: Dido building Carthage*, National Gallery, London, 14 Feb.–13 Apr. 1980.

PROVENANCE: London, Leicester Galleries, where bought by Miss Margaret Davies (June, 1920); Montgomeryshire, Gregynog Hall, Margaret Davies collection, by whom bequeathed to the National Museum of Wales, 1963.
LITERATURE: Hamel, 1914, p. 31; Anon., *London Mercury* 1920, p. 352; *National Museum of Wales. Catalogue of the Margaret S. Davies Bequest*, 1963, No. 101; J. Ingamells, *The Davies Collection of French Art*, Cardiff, 1967, pp. 62–3 repr.
EXHIBITED: Paris, Manzi et Joyant, 1914 (32); London, Leicester Galleries, 1920 (90); London, Wildenstein, *Paintings from the Davies Collection*, 1–30 Mar. 1979 (19 repr.); Paris, Musée Marmottan, *Chefs d'oeuvres impressionnistes du Musée National du Pays de Galle*, May–Jun. 1979 (16).

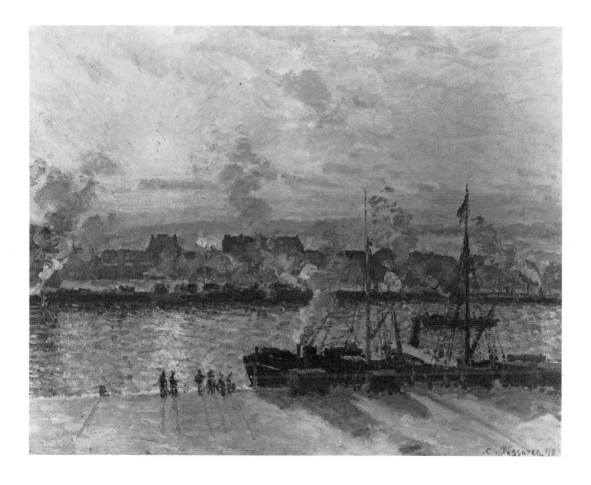

84
The siesta, Eragny-sur-Epte 1899

La sieste, Eragny-sur-Epte
P&V 1078
Canvas. 65 × 81 cm./25⅝ × 31⅞ in. Signed and dated, lower left:
C. Pissarro. 99.
Durand-Ruel collection, Paris

The siesta, Eragny-sur-Epte belongs to a small group of paintings
that appear to have been executed during the summer of 1899 (P&V
1071–81). Of these P&V 1079 is now in Stuttgart (Staatsgalerie) and
P&V 1080 is in the Mellon collection. These two paintings, together
with the present picture, are notable for the masterly way in which
Pissarro has fitted the figure into the landscape. Here the supine
figure of the young female peasant is at first reminiscent of those
paintings of peasants resting in the fields dating from the early
1880s (Cat. 56–7), but in the present painting the figure is related to
the wall enclosing the orchard. Pissarro has therefore established a
feeling of recession by a series of 'steps' backwards into the
picture: the branches at the left, the pile of hay, the tree behind it,
and finally the buildings in the far distance. The subject is one that
J.-F. Millet depicted (Paris, 1975, No. 176), but the mood of
Pissarro's late rural paintings is very different. Where Millet shows
the peasants in open fields Pissarro places them in the
comparatively private sphere of an orchard or meadow. The
exploration of this private world is a major theme of paintings
dating from the last decade of Pissarro's life.

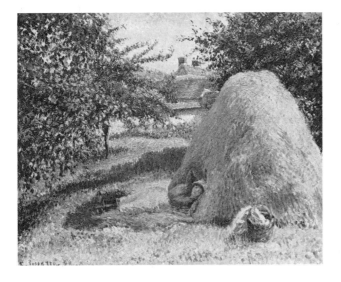

PROVENANCE: Paris, Durand-Ruel, bought from the artist 27 November 1899.
LITERATURE: Thornley, (n.d.) repr.; Holl, 1904; Kunstler, 1930, repr. pl. 28; J.B., 'La
Sieste', *L'Illustration*, 1 March, lxxxviii (1930), repr. col.; Neugass *Deutscher Kunst
und Dekoration*, 1930, p. 153 repr.
EXHIBITED: Paris, Durand-Ruel, 1901 (20); Paris, Durand-Ruel, 1904 (113); Paris,
Durand-Ruel, 1928 (85); Paris, Orangerie, 1930 (98 lent Durand-Ruel); Paris,
Durand-Ruel, *Paysages par Claude Monet, C. Pissarro, Renoir et Sisley*, 14–31 Jan.
1933 (22); Paris, Durand-Ruel, 1956 (95); Berne, Kunstmuseum, 1957 (102); Paris,
Durand-Ruel, 1962 (44 repr.); Memphis, The Dixon Gallery and Gardens, *Homage to
Camille Pissarro. The last years 1890–1903*, 18 May–22 Jun. 1980 (15 repr. col.).

85
Tuileries Gardens, Paris 1900

Jardin des Tuileries
P&V 1133
Canvas. 73.6 × 92.3 cm./29 × 36⅜ in. Signed and dated, lower
right: *C. Pissarro. 1900.*
Glasgow Art Gallery and Museum, Glasgow (inv. 2811)

The intention of painting a series of pictures of the Jardin des
Tuileries was announced by Camille Pissarro in a letter to Lucien
dated 4 December 1898 (*Lettres*, p. 464: 'We have engaged an
apartment at 204 rue de Rivoli, facing the Tuileries, with a superb
view of the Garden, the Louvre to the left, in the background the
houses on the *quais* behind the trees, to the right the Dôme des
Invalides, the steeples of Ste. Clothilde behind the solid mass of
chestnut trees. It is very beautiful. I shall paint a fine series').
Progress, however, was slow, mainly because of adverse weather
(*Lettres*, p. 465, 22 January 1899, and p. 467, 16 March 1899), but
on 12 April 1899 he reports 'I have done much work on my
Tuileries series' (*Lettres*, p. 467), and on 23 May 1899 he writes 'I
sent Durand-Ruel eleven of my *Tuileries* canvases, I am keeping
three of them' (*Lettres*, p. 468). These can be identified as P&V
1097–1110.

Pissarro spent a second season painting in this same apartment in
the rue de Rivoli and completed a further fourteen canvases of the
Jardin des Tuileries (P&V 1123–36) during the course of the first
half of 1900. Both the present painting and the following (Cat. 86)
are from this second series, which, apart from small shifts of
viewpoint, repeats the same views found in the earlier one.

Where in the paintings of the *boulevards* and *avenues* the
symmetry of the buildings and the streets provided a com-
positional basis, so here the patterns of the Jardin des Tuileries, as
originally designed by André Le Nôtre between 1664 and 1679,
allowed the artist to redeploy his verticals, horizontals, and circles
in a new context – one that may have reminded him of Kew
Gardens (for example P&V 795).

In the present painting the Pavillon de Flore of the Palais du
Louvre can be seen on the left. Just discernible in the far distance is
possibly the dome of the church of St. Thomas d'Aquin. The blond
tonality of the series of the *avenues* (Cat. 79) is now superseded by a

predominantly green tone. The circular pattern of the paths in the centre of the composition has been rhythmically repeated several times, whereas the foliage in the foreground has been laid in lightly and in some places while the paint layers beneath were still wet. The variety of brushstrokes complements the wide range of the palette.

The picture was cleaned in 1974.

PROVENANCE: Glasgow, Alexander Reid; Glasgow, Sir J. Richmond, bought from Alexander Reid (1911) and by whom presented to the Glasgow Art Gallery and Museum, 1948.
LITERATURE: A. Storrock, 'Impressionist paintings in Glasgow', *Apollo* lvii (1953), p. 42; T. J. Honeyman, *Catalogue of French paintings, Glasgow Art Gallery and Museum*, Glasgow, 1953, p. 43 repr.; W. J. Macaulay, 'Some additions to the Glasgow Art Collection', *Scottish Art Review*, iv No. 3 (1953), p. 13 repr.
EXHIBITED: Glasgow, Art Gallery and Museum, *The spirit of France*, 1943 (26 lent Richmond); Edinburgh, *A century of French art*, 1944 (187 lent Richmond); Edinburgh, Royal Scottish Academy, *123rd annual exhibition* 1949 (276); London, Royal Academy, *Landscape in French art*, 10 Dec.–5 Mar. 1950 (279); Paisley, Art Institute, *Annual exhibition*, 1952; Glasgow, Scottish Arts Council, *A man of influence: Alexander Reid*, 1967 (36 repr.); Edinburgh, Royal Scottish Academy, *Boudin to Picasso*, 1968 (15 repr.).

85

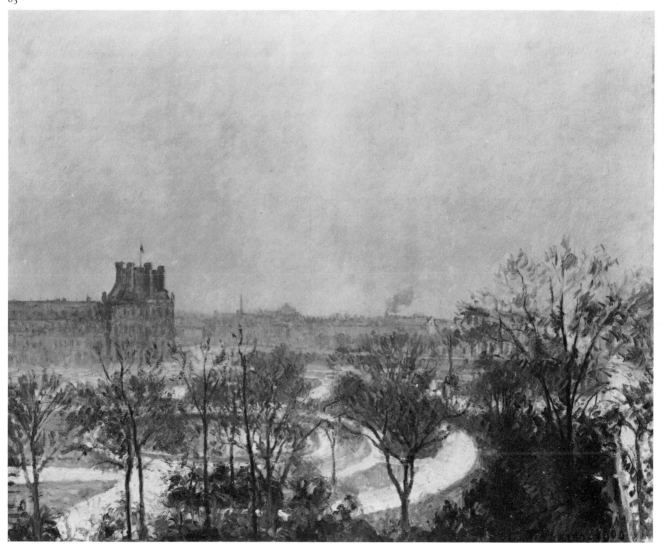

86 ILLUSTRATED IN COLOUR
La Place du Carrousel, Tuileries 1900

P&V 1136

Canvas (Contet). 54.9 × 65.4 cm./21 × 25¾ in. Signed and dated, lower left: *C. Pissarro. 1900.*

National Gallery of Art, Washington, gift of Ailsa Mellon Bruce (inv. 2427)

La Place du Carrousel, Tuileries is one of the series of paintings of the Jardin des Tuileries undertaken by Pissarro from a room in the rue de Rivoli during the first half of 1900 (P&V 1123–36). See Cat. 85. The present painting appears to have been made in the late spring or early summer and it is possibly the last of the series. Pissarro remained in Paris until the end of June. Unlike the earlier series of the Jardin des Tuileries painted in 1899 this is the only view of the Place du Carrousel undertaken in 1900. The composition is in fact almost identical to three canvases dating from the previous year (P&V 1108–10), although the Place du Carrousel is shown at a different time of year. Here the sunlight enlivens the façades of the buildings and the burgeoning trees cast long shadows. Clever use has been made of the jutting section of the Palais du Louvre in the middle distance on the left, which offsets the rest of the Palais when seen from this oblique angle.

Monet had painted four similar views of the Jardin des Tuileries in 1876 from an apartment at 198 rue de Rivoli owned by Victor Choquet (W 401–4).

La Place du Carrousel was originally the area between the Palais du Louvre and the Palais des Tuileries. The Arc de Triomphe du Carrousel, visible in the middle distance, was built between 1806–8 by Vivant Denon on the designs of Percier and Fontaine, to commemorate the Napoleonic victories of 1805. It is based on the Arch of Septimius Severus in Rome.

The present painting must have been placed *en dépôt* with Bernheim Jeune, although finally it appears to have been retained by the family. This is undoubtedly the picture exhibited as No. 33 in the Durand-Ruel exhibition of 1901, since the three others of this subject (P&V 1108–10) were also included on that occasion (No. 16–18).

PROVENANCE: Camille Pissarro collection; Mme. Vve. Pissarro collection (Paris, 3 December 1928, lot 44 repr.); Berlin, Bruno Stahl collection (confiscated by Hermann Goering for his private collection); Paris, Bruno Stahl collection; New York, Wildenstein; New York, Ailsa Mellon Bruce collection, acquired 1949, and by whom presented to the National Gallery of Art, 1970.

LITERATURE: Stephens, 1904, repr. p. 419; Kunstler, 1928, p. 506 repr.; Coe, 1954, p. 113 repr.; *National Gallery of Art. European paintings: an illustrated summary catalogue*, Washington, 1975, p. 272 repr.; J. Walker, *National Gallery of Art, Washington*, New York, 1975, p. 514 No. 774 repr. col.

EXHIBITED: Paris, Durand-Ruel, 1901 (33 lent Bernheim Jeune); Paris, Manzi et Joyant, 1914 (50); Paris, Orangerie, *Les chefs d'oeuvre des collections privées françaises retrouvés en Allemagne*, 1946 (33); San Francisco, California Palace of the Legion of Honor, *French paintings of the nineteenth century from the collection of Mrs. Mellon Bruce*, 1961 (35 repr.); Washington, National Gallery of Art, *French paintings from the collection of Mr. and Mrs. Paul Mellon and Mrs. Mellon Bruce. Twenty-fifth anniversary exhibition 1941–1966*, 17 Mar.–1 May 1966 (37 repr.).

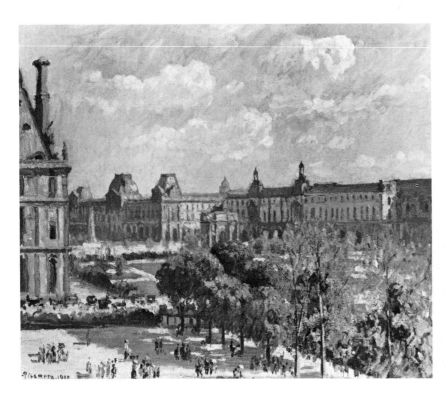

87
The Louvre, winter sunshine, morning 1900

Le Louvre, soleil d'hiver, le matin
P&V 1158
Canvas. 73 × 92 cm./28¾ × 36¾ in. Signed and dated, lower left:
C. Pissarro. 1900.
Durand-Ruel collection, Paris

Pissarro found an apartment (28 Place Dauphine on the Ile de la Cité) nearer to the Seine in March 1900, and began an extensive series of views that included the two aisles of the Pont Neuf, the equestrian statue of Henri IV set on the Place du Vert-Galant abutting the Pont-Neuf and forming the tip of the Ile de la Cité, and the Palais du Louvre on the right bank of the Seine (*Lettres*, p. 474, 16 March 1900, 'I found an apartment on the Pont-Neuf. It has a very fine view. I am going to move in July . . . I am simply afraid of failing once again to avail myself of a picturesque part of Paris'). Pissarro, however, does not seem to have actually begun the series until the autumn, completing it during the following year (*Lettres*, p. 482, 1 January 1901 and p. 483, 21 February 1901). As stated in this second letter, these paintings are of motifs observed in winter

(P&V 1155–81). The present painting belongs to this first group of canvases, but the artist returned to the same apartment for two other painting campaigns (*Lettres*, p. 484, 13 November 1901, and p. 496, 26 November 1902 respectively), undertaking almost identical views seen in similar wintry conditions (P&V 1210–28, all of 1902, and P&V 1278–85, all of 1903).

Of all the series of paintings of Paris executed by Pissarro, these three painted in his apartment at the Place Dauphine are perhaps the least appreciated. *The Louvre, winter sunshine, morning*, however, is one of the very finest of the three series. The soft wintry morning light is diffused into a range of pale colours evenly applied with small brushstrokes, while the composition itself remains firm and assured.

The bridge seen in the middle distance is the Pont des Arts, now in the process of being reconstructed.

PROVENANCE: Paris (?), Bayer collection; Paris, Durand-Ruel.
LITERATURE: C. L. Borgmeyer, *The master Impressionists*, Chicago, 1913, p. 191.
EXHIBITED: London, Grafton Galleries, *Pictures by Boudin, Cézanne, Degas, Manet, Monet, Morisot, Pissarro, Renoir, Sisley*, Jan.–Feb. 1905 (198); Paris, Durand-Ruel, 1910 (19); Paris, Durand-Ruel, 1956 (104); Berne, Kunstmuseum, 1957 (104); Paris, Durand-Ruel, 1962 (47).

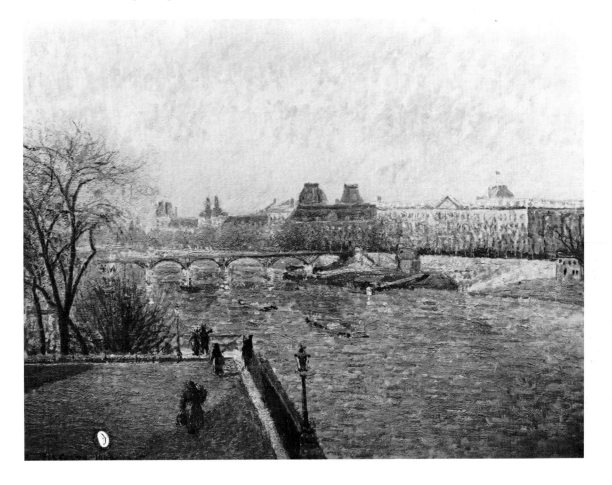

88

The Fair at Dieppe, sunshine, afternoon 1901

La foire à Dieppe, soleil, après-midi

P&V 1200

Canvas. 73 × 91.8 cm./29 × 36½ in. Signed and dated, lower right: *C. Pissarro. 1901.*

Philadelphia Museum of Art, Philadelphia (inv. 1950.92.12)

Pissarro searched relentlessly for new motifs during his last years (*Lettres*, pp. 483–4, 19 June 1901) and spent two summers painting in Dieppe. On both occasions Pissarro took a room in the Hôtel du Commerce on the Place Duquesne overlooking the church of Saint Jacques (*Lettres*, p. 484, 19 July 1901), but only during this first campaign did he concentrate on those subjects seen from his window. In 1902 he painted the inner harbour and the port from a room rented in the Poissonnerie (*Lettres*, p. 491, 11 July 1902 and p. 492, 11 August 1902).

A dominating image in the paintings dating from 1901 (P&V 1194–1200) is the church of Saint Jacques, sometimes surrounded by market stalls and at other times, as here, by the annual fair held in August (*Lettres*, pp. 493–4, 15 August 1902). The present painting has only a section of the west face of the church and only a part of the carrousel, which is prominent in the two other related pictures (P&V 1197–8). Compared with P&V 1197–8 Pissarro has shifted his viewpoint further to the right and included more of the stalls erected in the Place Saint Jacques. Each painting, however, shows the rue Saint Jacques leading away from the church and thronging with people. Both the style of the paintings executed in Dieppe and the subject-matter parallel those done in Rouen (Cat. 75–7, 81–3).

PROVENANCE: Paris, Durand-Ruel, bought from the artist 6 November 1901 and sold to Bernheim Jeune 16 January 1902; Paris, Bernheim Jeune; Le Havre, Van de Velde collection; Washington, Duncan Phillips Memorial Gallery; Paris, Gaston Lévy collection; Paris, Paul Rosenberg; Paris, J. Hessel collection; Ottawa, H. S. Southam collection; Philadelphia, Mr. and Mrs. W. William M. Elkins.

LITERATURE: Fontainas, 1902, p. 246; Stephens, 1904, repr. p. 429; Tabarant, 1924, repr. pl. 38; D. Phillips, *A collection in the making*, Washington–New York, 1926, p. 33 repr.; Venturi, 1939, ii pp. 48–9, No. 74–6; Jedlicka, 1950, repr. pl. 49; Natanson, repr. pl. 49.

EXHIBITED: Paris, Bernheim Jeune, 1902 (4); Paris, Orangerie, 1930 (11 lent Hessel); London, Agnew 1937 (26); Zurich, Galerie Aktuargus, 1938 (1); Philadelphia, Museum of Art, *Masterpieces from Philadelphia private collections*, May 1947, catalogue published in *The Philadelphia Museum Bulletin* xlii (1947), p. 84 repr.

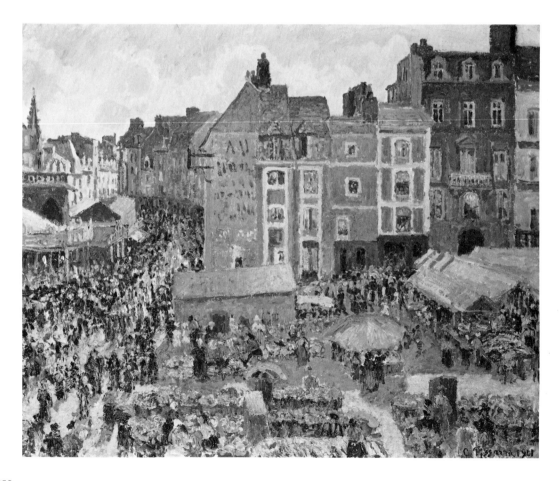

89
Sunset at Eragny-sur-Epte, autumn 1902

Soleil couchant à Eragny, automne
P&V 1268
Canvas (Contet). 73 × 92 cm./28¾ × 36¼ in. Signed and dated,
lower left: *C. Pissarro. 1902.*
The Ashmolean Museum, Oxford, lent by the Visitors of the
Ashmolean Museum (inv. A 795)

The painting has often been confusingly entitled *Autumn morning*
in the literature. It was cleaned in 1979–80.

Pissarro painted several canvases of the meadow at Eragny-sur-
Epte seen from his studio window during the autumn of 1902 (P&V
1265–7), all of which are heavily worked over a long period and
demonstrate the acuity of Pissarro's eye at this late stage in his life.
The full range of Pissarro's palette for his late pictures is here
apparent, dominated by green, yellow, brown, purple, black with
touches of red and blue. There is also a considerable variety in the
brushstrokes with the branches of some of the trees in the
foreground, for example, lightly brushed over the denser layers of
paint beneath that have evidently been extensively reworked.

It is no exaggeration to claim for this late rendering of the
orchard at Eragny-sur-Epte, caressed by the evening sun, an
intensity of execution that is only comparable with Monet's work
at Giverny.

PROVENANCE: London, Lucien Pissarro collection: Esther Pissarro collection, by
whom presented to the Ashmolean Museum, 1950.
LITERATURE: Hamel, 1914, p. 31; *Ashmolean Museum Oxford. Catalogue of paintings,*
Oxford, 1961, p. 118; Lloyd, 1979, p. 10 repr. col.
EXHIBITED: London, Stafford Gallery, 1911 (9); London, Doré Galleries, *Post-
Impressionism and Futurist exhibition,* Oct. 1913 (2); Paris, Manzi et Joyant, 1914
(18); London, Tate Gallery, 1931 (25) and subsequently at Birmingham, Oct.–Nov.
1931, Nottingham, Nov.–Dec. 1931, Stockport, Jan. 1932, and Sheffield, Feb.–Mar.
1932; London, Matthiesen Gallery, 1950 (36 lent Esther Pissarro); London, O'Hana
Gallery, 1954 (21).

90
The Pont Royal and the Pavillon de Flore
1903

Pont Royal et Pavillon de Flore
P&V 1286
Canvas. 54.5 × 65 cm./21¼ × 25⅝ in. Signed and dated, lower
right: *C. Pissarro. 1903.*
Musée du Petit Palais, Paris (inv. 134)

Pissarro suddenly moved to the Hôtel du Quai Voltaire on the left
bank of the Seine in the spring of 1903, thus interrupting the
previous series of paintings undertaken at his apartment at 28 Place
Dauphine (Cat. 87). 'I am doing at present a series of canvases from
the Hôtel du Quai Voltaire: the Pont Royal and the Pont du
Carrousel, and also the sweep of the Quais Malaquais with the
Institut de France in the background and, to the left, the banks of
the Seine; superb motifs of light' (*Lettres*, p. 499, 30 March 1903).
Pissarro made two other paintings of the Pont Royal and the
Pavillon de Flore, which forms part of the Palais du Louvre (P&V
1287–8). He continued to work on the full series of canvases (P&V
1286–97) until the months of May and June (*Lettres*, p. 499, 8 May
1903, and p. 502, 9 June 1903).

Pont Royal and the Pavillon de Flore is imbued with the sharp
crystalline light of spring. Comparison may be made with *The
Louvre, winter sunshine, morning* (Cat. 87) to appreciate the subtlety
in the treatment of light. Here, though, the texture of the paint is
thicker and the colours more varied in tone (green, blue, red, pink,
white). The Pont Royal was enlarged and restored in 1839–44.

PROVENANCE: acquired 1905.
LITERATURE: H. Lapanze, *Catalogue sommaire des collections municipales*, Paris, 1906,
No. 100; C. Gronkowski, *Catalogue sommaire des collections municipales*, Paris, 1927,
No. 352; Rewald, 1963, p. 158 repr. col.; Reidemeister, 1963, p. 174 repr.; Kunstler,
1974, p. 71 repr. col.; Preutu, 1974, repr. col. p. 67; Lloyd, 1979, p. 10 repr. col.
EXHIBITED: Paris, Musée municipale d'art moderne, Pavillon de la ville de Paris,
Exposition universelle. La vie parisienne, 1937; Reims, Musée des Beaux-Arts, *Les
étapes de l'art contemporain*, 1951 (34); Paris, Grand Palais, Salon d'Automne, *Bi-
millenaire de ville de Paris*, 1951 (35); Rotterdam, Boymans van Beuningen Museum,
Frans meesters uit het Petit-Palais, 1952–3 (103); Paris, Musée du Petit-Palais, *Un
siècle d'art français 1850–1950*, 1953 (415 repr.); Dieppe, 1955 (no cat.); Annecy,
Palais de l'Isle, *Impressionnistes peintres de l'eau*, 1958 (42); Paris, Musée Carnavalet,
Paris vu par les maîtres de Corot à Utrillo, Mar.–May 1961 (90); Berlin, Orangeries
Schlosses Charlottenburg, *Die Ile de France und ihre Maler*, 29 Sept.–24 Nov. 1963
(57); Atlanta, High Museum of Art, *The taste of Paris*, 1968; Bucarest/Cracow/Iassi,
Pictura celebre din muzeele parisului remekmuvei, 1971 (41); New Delhi, National
Gallery of Art, *Modern French paintings*, 1977–8 (45); Tokyo/Tochigi/Sapporo/
Kyoto, *Chefs d'oeuvre des Musées de la Ville de Paris*, 1979 (62).

91
The Port of Le Havre 1903

Port du Havre

P&V 1305

Canvas. 59 × 81 cm./23½ × 32 in. Signed and dated, lower left:
C. Pissarro. 1903.

Sir Isaac and Lady Wolfson collection, London

Pissarro spent his last summer painting at Le Havre. He stayed at
the Hôtel Continental overlooking the *quai* from the beginning of
July until the end of September (*Lettres*, pp. 504–7, 6 July–
22 September 1903). During these summer months Pissarro painted
eighteen canvases (P&V 1298–1315), all of the jetty, dockside, and
the inner harbour at Le Havre (*Lettres*, pp. 504–5, 11 July 1903,
'Unfortunately everything works at cross-purposes this year. Since
things were so bad I was compelled to do a series which I thought
would please my collectors: the Jetty at Le Havre, of which the
people of the town are proud; and really it has character').

The two paintings of Le Havre exhibited here (see Cat. 92) pro-
vide a panoramic view of the inner harbour. The present painting
looks to the left and includes the Grand Quai, while Cat. 92 shows a
part of the old jetty leading off to the right with the pilot station in
the foreground and the signalling station beyond. All of Pissarro's
paintings of Le Havre incorporate these two basic views of the
harbour, although there are small shifts in position.

Monet had painted the harbour at Le Havre several times during
the 1860s and 1870s (W 88–9, 109, 259, 261–4 and 294–7), and once
in 1883 (W 815), when he referred in a letter to the 'incessant
movement of boats'. Such was also the attraction for Pissarro.

The technique of the Le Havre paintings has altered since those
painted in Rouen (Cat. 81–3) and Dieppe (Cat. 88). It is now closer to
that used for the late views of Paris (Cat. 90), particularly in the
opacity of the paint and the abundant use of white, so that each
canvas has a slightly chalky appearance.

PROVENANCE: New York, Wildenstein.

EXHIBITED: Winston-Salem, North Carolina, Gallery of the Public Library, *Collector's
opportunity*, 22 Apr.–3 May 1963, pp. 76–8 repr.; New York, Wildenstein, 1965
(87 repr.); London, Marlborough, 1968 (30 repr.).

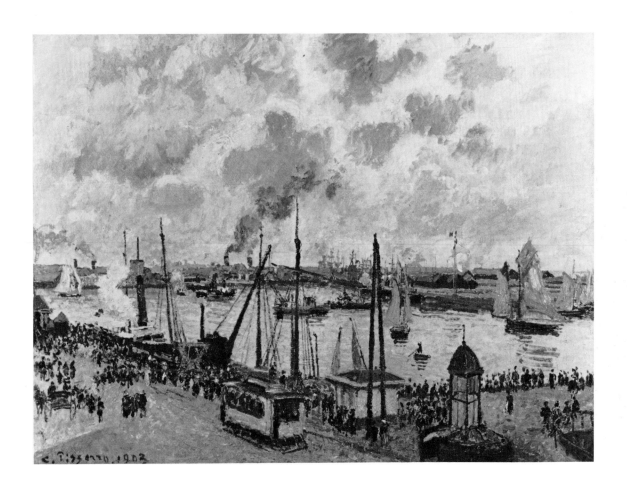

92 EXHIBITED IN PARIS ONLY
The pilots' jetty at Le Havre, high tide, afternoon sun 1903

L'anse des pilotes au Havre, haute mer, après-midi, soleil
P&V 1310
Canvas. 54 × 65 cm./21¼ × 25⅞ in. Signed and dated, lower left:
C. Pissarro. 1903.
Musée des Beaux-Arts, Le Havre

The view is taken from the Hôtel Continental near the jetty at Le Havre looking towards the harbour mouth. It complements the view shown in the previous picture (Cat. 91) and both form part of Pissarro's final series of paintings. Two canvases from this series were sold to the Musée des Beaux-Arts in Le Havre just prior to Pissarro's departure (*Lettres*, p. 507, 22 September 1903). One of those pictures is that exhibited here: the other is P&V 1315.

The Musée des Beaux-Arts was formerly situated on the old inner harbour. It was the subject of a picture by Monet (W 261), of 1873, but was destroyed in the 1939–45 war.

A particularly striking feature of the present painting is the precision with which Pissarro has laid in the metal lamp-post just to left of centre, a vertical to which every other line in the composition can be related. Pissarro's sense of spatial division remained unerring to the last.

Two sheets from a sketchbook used by the artist in Le Havre are included in the exhibition (Cat. 149–50).

PROVENANCE: acquired from the artist by the Musée des Beaux-Arts, Le Havre, 1903.
LITERATURE: de la Villehervé, 1904; R. Lecuyère, 'Regards sur les musées de Province XXVIII – Le Havre', *L'Illustration* 13 April, 1935, p. 430 repr.; P&V, p. 66; Shikes and Harper, 1980, repr. p. 313.
EXHIBITED: Paris, Orangerie, 1930 (135); Paris, Musée National d'art moderne, *De Corot à nos jours au Musée du Havre*, Dec.–Jan. 1953–4 (86); Le Havre, Chambre du Commerce du Havre, Palais de la Bourse, *Le Havre et les Havrais au XIXe siècle*, 19 Jul.–15 Sept. 1958 (no cat.); Paris, *Trois millenaires d'art et de marine*, Feb.–Jun. 1965 (no cat.); Leningrad, Hermitage, *Les peintres du Havre fin XIXe, début XXe*, 25 Jun.–31 Jul. 1973 (no cat.).

93 EXHIBITED IN LONDON ONLY
Self-portrait 1903

Portrait de Camille Pissarro par lui-même
P&V 1316
Canvas. 41 × 33 cm./16½ × 13⅛ in. Signed and dated, lower left:
C. Pissarro. 1903.
The Tate Gallery, London, lent by the Trustees of the Tate Gallery (inv. 4592)

This is the last of the four painted self-portraits recorded in the *catalogue raisonné*. There are two dating from the previous year (P&V 1114–15), both of which are in a freer and somewhat more ebullient style. The present self-portrait, like that of 1873 (Cat. 24), is carefully composed, the head precisely positioned between the corner of the room on the left and the view through the open window on the right, with the brim of the artist's hat counteracting the verticals. The figure is seen in half-length against the glass of the closed part of a window. Through the open part of the window is the view from Pissarro's apartment (28 Place Dauphine) overlooking the Pont-Neuf, which balances the corner of the room on the left. The buildings seen through the open window have been identified as those formerly on the site of the present Samaritaine. They also appear in pictures belonging to the Pont-Neuf series (P&V 1210–13), but here they are seen in reverse, since the artist has painted this self-portrait while looking at himself in the mirror.

The painting dates from the first months of 1903 when Pissarro was still working at 28 Place Dauphine, which he finally left for the Hôtel du Quai Voltaire by the end of March (*Lettres*, p. 499, 30 March 1903). The brushwork is still very light and the paint surface comparatively thin, relating more to the paintings undertaken in Dieppe (Cat. 88) than to the final views of Paris (Cat. 90), or to the series of Le Havre (Cat. 91–2).

PROVENANCE: Camille Pissarro collection; Mme. Vve. Pissarro collection; London, Lucien Pissarro collection, by whom presented to the Tate Gallery, 1931.
LITERATURE: Hamel, 1914, pp. 31–2; Duret, 1923, repr. p. 38; Tabarant, 1924, repr. pl. 1; Kahn, 1930, p. 699; P&V, p.66; *Lettres*, repr. pl. 66 and Eng. edn. pl. 88; Jedlicka, 1950, repr. pl. 53; Natanson, 1950, p. 26 repr.; R. Alley, *Tate Gallery catalogues. The foreign paintings, drawings and sculpture*, London, 1959, pp. 189–90 repr.; Bellony-Rewald and Gordon, 1976, p. 249 repr.; Lloyd, 1979, p. 3 repr.
EXHIBITED: Paris, Durand-Ruel, 1904 (130 lent Mme. Vve. Pissarro); London, Leicester Galleries, 1920 (84); London, Tate Gallery, *List of loans at the opening exhibition of the Modern Foreign Gallery*, Jun.–Oct. 1926, p. 6; Paris, Orangerie, 1930 (117 lent Lucien Pissarro); London, Tate Gallery, 1931 (23); Paris, Durand-Ruel, 1956 (111 repr.); London, Marlborough, 1968 (32 repr. and Introduction, p. 13).

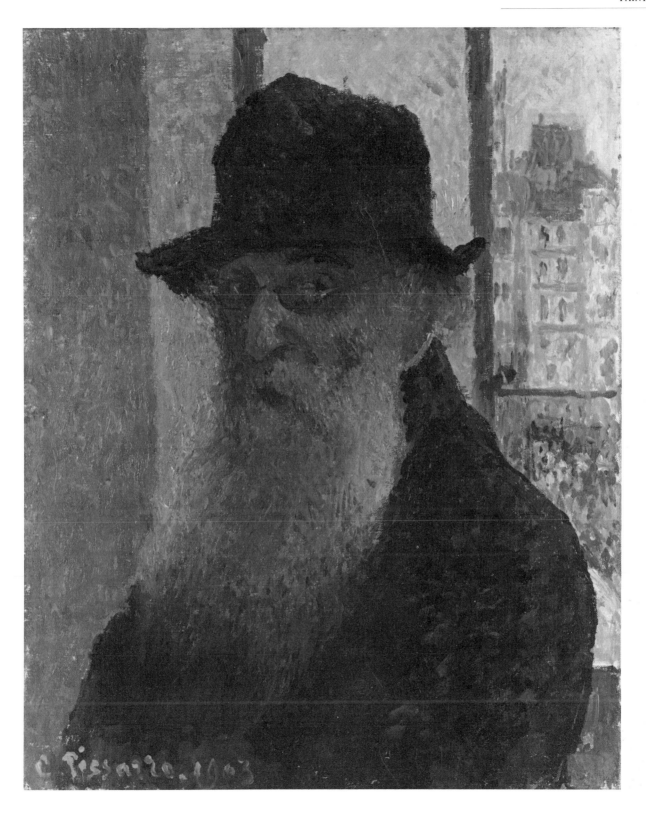

C. Pissarro. 1903

Catalogue of Drawings

The Drawings

The most striking feature of Camille Pissarro's drawings is their superabundance. He was a most prolific draughtsman. Numerically, his corpus of drawings is far greater than that of Monet, Renoir or Sisley, and considerably greater than that of Manet and Cézanne. Only Degas is comparable with Pissarro in his insistence upon drawing.

It is necessary to emphasize the significance of the size of Pissarro's corpus of drawings, because so much stress has been laid on the spontaneity of impressionist painting, both as regards inspiration and technique, with the result that little attention has been paid to preparatory procedures. A close study of Pissarro's drawings shows that, like Degas, he prepared his compositions with the utmost precision and care before beginning work on the canvas. The method of preparation was not always a question of plotting the design ready for transference on to the canvas itself, but of building up an impressive range of visual information that could be introduced or omitted as the painter refined his thoughts about a particular composition. Pissarro was an empirical artist. Nothing he recorded in the form of a drawing was ever wasted and it was on his sketching tablets and in his sketchbooks (over twenty-five of which can be partially reconstituted) that he built up a repertoire of landscape motifs and figures. At first these were almost casually observed, but then, later, they would be slowly elaborated before being inserted into a composition, and sometimes used again in different contexts. In a few instances we can follow the preparatory process from the original sketch, and in the case of figure painting we can watch Pissarro making further studies from life before withdrawing into his studio and resorting to posed models (Cat. 116, 120, 130, 145, 148). What emerges from all this is that Pissarro is an impressionist painter who uses drawings in a strictly traditional manner, but, as in his paintings, what makes this connection particularly interesting is the contrast between the orthodoxy of his approach and the radicalism of the results.

The drawings therefore complement his paintings not just because individual sheets may be related to a particular composition, but because, in a more general sense, the drawings pertain to problems that Pissarro had to face as a painter, to the extent that one's understanding of him as an artist is incomplete without a knowledge of them. Two examples of this importance may be cited: first, in Pissarro's growing interest in the human figure at the end of the 1870s and the beginning of the 1880s, and, secondly, in his attitude towards Neo-Impressionism. Other features, however, not all of which are exhaustively treated in the paintings, are more sharply defined in the drawings. These are the treatment of the nude, the love of caricature, and the espousal of anarchist causes.

The earliest drawings, done before leaving St. Thomas for France in 1855, are of interest not only for the range and character of observation, but also for the breadth of style and confidence in execution. The pencil is used pithily with heavy accenting. The pen produces fine lines grouped in areas of dense hatching (Cat. 94–5). While both these styles may have partly been derived from drawing manuals and other such published sources that might well have been available to him, the wash drawings, some of them without pencil underdrawing, are remarkable for their strength and vigour (Cat. 97).

On reaching France Pissarro began to draw in the manner of those painters associated with the Barbizon school, particularly Corot and Rousseau. Although he still retained the pencil, Pissarro began to use the softer media, such as chalk and charcoal, often on coloured paper (Cat. 102–4). The more finished drawings dating from the late 1850s and 1860s assume the form of compositional studies, but by the 1870s the artist begins to use sketchbooks for recording motifs seen in Pontoise and the surrounding districts. The most important stylistic feature of many of these drawings is their tonal quality whereby distance and recession are defined by areas of shading. Outlines, too, tend to be blurred or suffused and figures are often conceived in geometrical terms with short, broken strokes (Cat. 109–10). The fact that Pissarro resorted to sketchbooks implies a reduction in scale, but, at the same time, he began to explore the human form on larger sheets of paper. Gradually, by the beginning of the 1880s, the human figure assumes greater importance in Pissarro's work and the artist explores the curvilinear contours in numerous studies of different sizes (Cat. 118–19). Outlines are now free-flowing, loose and constantly redrawn, the sense of form created by bursts of hatching almost nonchalantly applied to the figure.

A fresh concern in the drawings dating from the second half of the artist's life is colour. Chalks of different hues are skilfully blended in landscape studies of melting beauty (Cat. 113, 133), just as pastel is often introduced for figure studies frequently made on coloured papers (Cat. 116, 145, 148). By contrast, where the landscape studies are executed in a multiplicity of short cross-hatched strokes delicately spread across the sheet, the figure studies are often strong and powerfully conceived. Watercolour, which had played such an important role in the early drawings but seems to have been less frequently used during the 1860s and 1870s, was reintroduced during the second half of the 1880s in the context of Neo-Impressionism and was particularly favoured in 1890 and afterwards (Cat. 134, 138–9).

Three new developments, however, emerged during the 1880s and 1890s. Two of these have their ultimate origins in the Venezuelan period, but were reactivated by an all-important visit to Rouen in 1883. Sheets from a sketchbook used on that occasion include caricature studies as well as topographical drawings. Both these interests were pursued in the later decades and were to a certain extent amalgamated in Pissarro's treatment of anarchist subject-matter, which reaches a climax in the album of drawings entitled *Turpitudes sociales* (Cat. 142). Where before the pithy pencil line hastily defined the salient characteristics of a person or scene, now, towards 1890, Pissarro, influenced by such artists as Charles Keene and Gustave Doré, picked up his pen again and immediately responded to the facility, sharpness, and stark lighting effects afforded by the instrument. Pissarro's pen lines in the 1890s have a variety that is comparable with his chalk strokes of the 1870s and 1880s.

Camille Pissarro's corpus of drawings concludes in the way it began, that is with marine subjects (Cat. 149–50). The somewhat exotic scenes of life in the maritime harbour of St. Thomas, or of La Guaira in Venezuela, are replaced by studies made in northern France at Dieppe and Le Havre. It is symptomatic of Pissarro that he drew such scenes in almost exactly the same manner as before 1855, with short telegraphic dots and flicks, and limited areas of hatching, but, now, understandably, this style is far less intricate and is on occasion almost reflective. The significance of this return to marine subjects at the end of his life would surely not have been lost on an artist like Pissarro, who had a deeply philosophical approach to life and art.

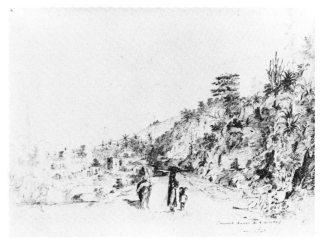

94
'Chemin Neuf de Caracas' (Venezuela) 1852

Pen and ink over pencil. 24.6 × 34.8 cm./9⅝ × 13¾ in. Signed in pencil, lower right, with the artist's initials.
Inscribed and dated in ink, lower right, *Chemin Neuf de Caracas / 17 Dec. 52*, and in pencil, lower left, *Route de Caracas 17 Dec. 52*. Several further annotations in pencil and ink on right.
Banco Central de Venezuela, Caracas (No. 26)

Fritz Melbye and Camille Pissarro arrived in Venezuela by ship from the island of St. Thomas in November 1852. The present drawing was therefore made just over one month after their arrival at the port of La Guaira, where they delayed before proceeding to Caracas. Pissarro has positioned himself on the road leading out of La Guaira looking back towards the harbour.

The design was first made in pencil and then reworked with the pen. Two features indicated in pencil are still visible in the drawing, although they were not redrawn in pen. These are the tree on the left and the figure on horseback in the centre. The drawing exhibits a remarkable confidence in the handling of the composition and in the variety of line achieved by accenting many of the pen strokes. There is a study in pencil of the same view on the verso of the drawing. A similar view of the harbour at La Guaira is in the Museo de Bellas Artes, Caracas (inv. 59.79).

Fritz Melbye painted an identical view of La Guaira, for which a carefully drawn study exists (Boulton, 1966, repr. pp. 60 and 61). It is interesting that the tree that Pissarro indicates on the left of his composition, but did not redraw in ink, occurs in Melbye's landscape.

PROVENANCE: Fritz Melbye; Ramon Paez collection; New York, Cyrus McCormick collection; New York, Hammer Galleries, from whom bought by the Banco Central de Venezuela, Caracas, 1964.
LITERATURE: Boulton, 1966, p. 14 repr.
EXHIBITED: New York, Hammer Galleries, 1964 (20 repr.); Paris, 1978 (31 repr. incorrectly as No. 3).

95
'Camino Nuevo de Caracas' (Venezuela) 1852

Pen and ink over pencil. 26.8 × 35.7 cm./10½ × 14 in. Signed in pencil, lower right, with the artist's initials strengthened with pen and ink, superimposed over a monogram.
Inscribed in ink, lower right: *Camino Nuevo de Caracas*. Several annotations in pencil throughout, of which only . . . *chaud foncé pour les* . . . is legible upper right.
Watermark: HUDELIST
Museo de Bellas Artes, Caracas (inv. 59.64)

Like the previous drawing (Cat. 94), this sheet shows the coast road leading from La Guaira to Caracas. A ship is briefly indicated out to sea on the left and the building in the centre on the promontory is a coastal fortification. The coastal defences at La Guaira form the subject of a drawing in pencil now at Yale University Art Gallery (Gift of Mr. and Mrs. Arthur Rosenbloom, 1925). The technique and the composition are also comparable with the previous drawing. Here, however, the hatching is even tighter and has been controlled in such a way as to suggest the play of light on surfaces. Pissarro was to use this method of hatching to good effect in his early etchings (D 1–6, see Cat. 151–2), and it is possible that many aspects of the artist's style of drawing before 1855 were, in fact, derived from drawing manuals which exhibited similar qualities.

The subject of a road along which figures pass was, of course, to become one of great importance for Pissarro.

PROVENANCE: Paris, Hélène Pillement collection; Paris, Galerie Jacques Dubourg (1948), from whom acquired by the Museo de Bellas Artes, Caracas, 1959.
LITERATURE: Boulton, 1966, p. 15 repr.; Boulton, 1975, p. 39 repr.
EXHIBITED: Caracas, 1959 (14); New York, 1968 (43); Paris, 1978 (3 repr. incorrectly as No. 31); Caracas, Ministerio de Relaciones Exteriores, *El pintor Camille Pissarro en Venezuela*, Jun. 1978 (p. 22 repr.); Caracas, Galeria de Arte Nacional, *Juan Lovera y su tiempo*, Nov. 1978.

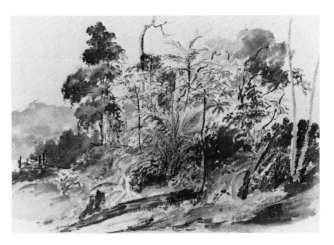

96
Dance at an inn *c.* 1854

Danse à l'auberge
Brown wash over indications in pencil. 37.6 × 55 cm./14¾ ×
21⅝ in. Signed with the point of the brush, in brown wash lower
left: *C. Pissarro fecit* (rubbed).
Banco Central de Venezuela, Caracas (No. 32)

Boulton entitles the drawing *Carnival dance*. The medium of brown
monochrome wash is one that Pissarro used fairly frequently in
Venezuela (see Cat. 99, as well as Boulton, 1966, pp. 19, 31, and 40).
In all these drawings Pissarro has used the blank paper to create
different effects of light, varying the texture of the wash
accordingly.

The present drawing is evidence of Pissarro's early interest in
genre, although this particular subject is not one the artist repeated
after 1855. Even allowing for the broad execution with the brush,
there is a great deal of characterization in the individual figures,
and it is not difficult to see in such drawings Pissarro's fascination
for caricature that became so pronounced later in his life.

PROVENANCE: Fritz Melbye; Ramon Paez collection; New York, Cyrus McCormick
collection; New York, Hammer Galleries, from whom bought by the Banco Central
de Venezuela, 1964.
LITERATURE: Boulton, 1966 repr. col. between pp. 26–7; Boulton, 1975, p. 38 repr.;
Shikes and Harper, 1980, p. 29 repr.
EXHIBITED: New York, Hammer Galleries, 1964 (5 repr.); Paris, 1978 (35 repr.).

97
Entrance to a wood *c.* 1854

Orée d'un bois
Watercolour over indications in pencil. 37.6 × 54.9 cm./
14¾ × 21⅝ in.
Banco Central de Venezuela, Caracas (No. 1)

This is one of several watercolour studies of vegetation undertaken
by Pissarro when in Venezuela. Others are reproduced by Boulton,
1966, between pp. 28–9, 24, and 34–5. Most of the sheets in this
style are in the collection of the Banco Central de Venezuela (see
Paris, 1978, Nos. 18–22). Such drawings are amongst the finest
executed by Pissarro while working with Fritz Melbye. In each
case the underdrawing in pencil has been overlaid by watercolour
often very freely applied. There is a remarkable combination of
close observation, recorded in the pencil underdrawing, and
technical exuberance, seen in the application of the washes. It is
likely that Pissarro made many of these vivid studies of tropical
vegetation while on a visit to the Avila mountains to the south of
Caracas.

Although Pissarro concerned himself throughout his life with
rural landscape, at no other time did he subject natural forms to
such detailed and concentrated analysis, not only in these
powerful watercolours, but also in a large number of pencil studies.
No doubt in the context of South America this preference was
related to the Romantic conception of nature seen in its original,
unbridled state. Several painters, notably Thomas Cole and
Frederick Edwin Church, who later owned a group of drawings by
Melbye and Pissarro, depicted such scenes of the northern and
southern American continents.

PROVENANCE: Fritz Melbye; Ramon Paez collection; New York, Cyrus McCormick
collection; New York, Hammer Galleries, from whom bought by the Banco Central
de Venezuela, Caracas, 1964.
LITERATURE: Boulton, 1966, repr. col. between pp. 32–3.
EXHIBITED: New York, Hammer Galleries, 1964 (9 repr.); Paris, 1978 (17).

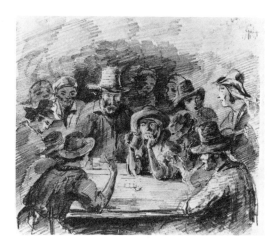

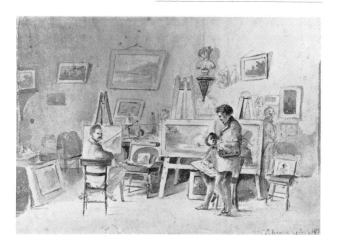

98
The card players 1854

Les Joueurs de cartes
Pencil. 25.4 × 29 cm./10 × 11⅜ in. Signed in pencil, lower right, with the artist's monogram and again, upper right corner *C. Pissarro* (rubbed).
Inscribed in pencil, upper right: *Galipan/1854*.
Banco Central de Venezuela, Caracas (No. 28)

Pissarro made numerous figure studies while in Venezuela, often crowding the sheet with several at a time (for example, Rewald, 1963 repr. p. 50), and, indeed, filling whole sketchbooks such as that owned today by Dr. Gamboa, Caracas. Certain drawings, however, like that exhibited here, have been brought to a high degree of finish and were perhaps intended to form the basis for paintings. The style is characterized by the wide range of hatching with pencil. Another drawing of this subject, with only minor differences in the placing and poses of the figures, is also now in the collection of the Banco Central de Venezuela. It is in pen and ink and was probably drawn before the present sheet.

The subject is one that had been essayed by realist painters as early as the seventeenth century, but Pissarro has clearly taken this scene from life.

Cézanne, who was to develop the theme of the card players further, also drew the subject for the first time during the 1850s (A. Chappuis, *The drawings of Paul Cézanne, a catalogue raisonné* i. London, 1973, No. 36 repr.) using an engraving as his source of inspiration. Pissarro, however, unlike Cézanne, did not attempt the subject again.

Galipan is at the foot of the Avila mountains to the south of Caracas, an area which Pissarro explored extensively.

PROVENANCE: Fritz Melbye; Ramon Paez collection; New York, Cyrus McCormick collection; New York, Hammer Galleries, from whom bought by the Banco Central de Venezuela, Caracas, 1964.
LITERATURE: Boulton, 1966, p. 38 repr.; Boulton, 1975, p. 38 repr.
EXHIBITED: New York, Hammer Galleries, 1964 (6 repr.); Paris, 1978 (32 repr.).

99
The artists' studio, Caracas 1854

L'atelier des artistes, Caracas
Brown wash over indications in pencil. 38 × 54.8 cm./14⅞ × 21⅝ in. Signed and dated, in brown wash with the brush, lower right: *C. Pissarro fecit 185–* (see entry below).
Banco Central de Venezuela, Caracas (No. 43)

There has been some confusion over the date and identification of the figures in this drawing. When exhibited by the Hammer Galleries of New York in 1964, and later when published by Benisovich and Dallett, the date was read as 1851. As a result, the drawing was thought to have been made on St. Thomas. Boulton (1966) corrected this by comparing the drawing with another by Pissarro now in Denmark, which also shows the artists' studio (Boulton, 1966, p. 23 repr. and Rewald, 1963, p. 50 repr. top left) and is clearly inscribed *Caracas 25 de Abril 1854*. None the less, the present drawing when exhibited in Paris in 1978 was still dated 1851. Close examination of the original, however, shows that the lower right corner of the paper, where the date is placed, has been cut and repaired, so that the final digit is incomplete. There can be little reasonable doubt that this last digit was originally a 4 and not a 1.

As regards the identification of the figures, that on the left turning round to face the spectator is Fritz Melbye. Boulton (1966) first suggested that the other seated figure was the young Pissarro, but in 1975 he demonstrated conclusively that Pissarro is, in fact, the standing figure holding a palette. This self-portrait is therefore one of the earliest known likenesses of the artist. He has a moustache and a short beard, as in the self-portrait drawing in Copenhagen (repr. Benisovich and Dallett, 1966, p. 44 fig. 1).

The sheet is of biographical interest, showing the artists' studio in Caracas. None of the works hanging on the wall or placed on the easels can be firmly identified. The framed picture on the back wall is similar to *View of La Guaira* by Melbye (repr. Boulton, 1966, p. 59 top), whilst that on the middle of the three easels somewhat

100

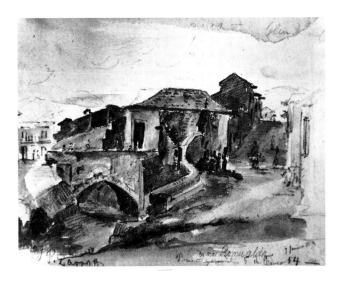

resembles Cat. 1 of the present exhibition in composition, although it appears to be somewhat larger in size. The portrait behind Pissarro is signed with his name, in the same way as he identifies his house by an inscription on another drawing of this period (repr. Boulton, 1966, p. 19, exhibited Paris, 1978 (38)).

PROVENANCE: Fritz Melbye; Ramon Paez collection; New York, Cyrus McCormick collection; New York, Hammer Galleries, from whom bought by the Banco Central de Venezuela, Caracas, 1964.
LITERATURE: Benisovich and Dallett, 1966, pp. 45–46; Boulton, 1966, p. 91 repr. col.; Boulton, 1975, p. 41 repr.; Shikes and Harper, 1980, p. 32 repr.
EXHIBITED: New York, Hammer Galleries, 1964 (repr. frontispiece); Paris, 1978 (37) repr.

100
Bridge at Caracas, Venezuela 1854
Pont à Caracas, Venezuela
Watercolour over pencil. 24 × 30.5 cm./$9\frac{1}{2}$ × 12 in. Signed and dated in pencil, lower centre: *C. Pissarro.5 Janv.54.*
Collection of Mrs. Paul Mellon, Upperville, Virginia

The bridge may be compared with that in the following drawing (Cat. 101), but the disposition of the buildings, and the palm tree prominently placed on the left, confirm that it is not identical. The close dating on both sheets, however, suggests that the drawings were probably made at close intervals, if not on the same day, in the outskirts of Caracas.

PROVENANCE: sold anonymously Sotheby's, 1 May 1969, lot 272 repr.

101
The Bridge of Dona Romualda 1854
Le Pont de Doña Romualda
Watercolour over pencil. 24.2 × 31.3 cm./$9\frac{1}{2}$ × $12\frac{1}{4}$ in. Signed in pencil, lower left, with the artist's initials followed by *Pizarro.* Dated in pencil 5 *de Enero 54* and again 7 *Janvier 1854* lower right.
Inscribed in pencil *Puenta de ña Romualda* at lower edge right of centre. Annotated in pencil . . . *gris-bleu froid* (upper right) and *ve* . . . (left of centre).
Museo de Bellas Artes, Caracas (inv. 59.54)

The bridge is very similar to that shown in Cat. 100. Indeed, the drawings might have been made on the same day, since both are dated 5 January 1854, although the present sheet also bears the slightly later date of 7 January 1854. Such inconsistencies are probably the result of Pissarro inscribing the dates on a later occasion, unless he returned to the site.

The compactness of the composition reveals Pissarro's ability, even at this early stage of his life, to combine the unusual lie of natural terrain with the geometrical shapes of buildings. These aspects were to be properly explored in the canvases undertaken in the late 1860s (Cat. 9–12).

PROVENANCE: Paris, Hélène Pillement collection; Paris, Galerie Jacques Dubourg (1948), from whom acquired by the Museo de Bellas Artes, Caracas, 1959.
LITERATURE: Joets, 1947, repr. p. 96; Boulton, 1966, p. 25 repr. col.
EXHIBITED: Caracas, 1959 (4); New York, 1968 (39); Caracas, Ministerio de Relaciones Exteriores, *El pintor Camille Pissarro en Venezuela*, Jun. 1978 (p. 22 repr.); New York, Centre for Inter-American Relations, *A century of Venezuelan landscape painting*, Mar. 1979.

102
Chailly *c.* 1857–60

Charcoal on beige coloured paper. 31.5 × 48.8 cm./12⅜ × 19¼ in.
Signed, lower left: *C. Pissarro.*
Inscribed in charcoal, lower left, with the title. Pin marks in
corners. Framing indicated in charcoal horizontally 45mm. above
lower edge.
The Ashmolean Museum, Oxford, lent by the Visitors of the
Ashmolean Museum

The drawing shows Pissarro's increasing skill in the handling of
the softer media in conjunction with coloured paper, a method of
drawing that he adopted soon after his arrival in France. Three
other studies of a similar group of crab apple trees are known, two
of which are in the Mellon collection, and the third was sold at
Sotheby Parke-Bernet, 12 May 1977, lot 211 repr. All these
drawings may have been made in connection with *Landscape on the
outskirts of Paris* (P&V 11), of 1857. The present drawing and that
sold in 1977 are inscribed *Chailly*, the plain extending to the south
of Paris where members of the Barbizon school had painted during
the 1840s, and where Monet was to paint in 1864–5 (W 19 and
55-7).

PROVENANCE: London, Lucien Pissarro collection; Esther Pissarro collection, by
whom presented to the Ashmolean Museum, 1950.
LITERATURE: Brettell and Lloyd 60 recto.

103
Nanterre *c.* 1860–5

Lugt 613e
Charcoal heightened with white chalk on grey paper. 24.3 ×
30.9 cm./9½ × 12⅛ in.
Inscribed in charcoal, lower right, with the title.
The Ashmolean Museum, Oxford, lent by the Visitors of the
Ashmolean Museum

The vigorous hatching recalls the technique developed for both
landscape drawings and genre studies before 1855 (Cat. 98), but
here it is executed with a softer medium and on a coloured paper.
The chiaroscural effect is intensified by the addition of white
chalk.

Nanterre is a small town west of Paris. It is now a suburb of the
city. The composition has affinities with landscapes painted by
Chintreuil, a follower of Corot with whom Pissarro worked briefly
at this time (see *Antoine Chintreuil 1814–1873*, Catalogue de
l'exposition organisée par les villes de Bourg-en-Bresse et Pont-
de-Vaux, 1973, No. 18 repr.). Pissarro's composition, however, is
much tighter than anything found in Chintreuil's *oeuvre* and the
forms are more compressed. The slight turn in the pathway recalls
the early etching of La Roche-Guyon (Cat. 152), for which Pissarro
made a preparatory drawing (Sotheby's, 6 May 1959, lot 2). The
drawing for the etching is in reverse and was apparently executed
in red chalk – the only instance so far discovered of Pissarro using
this medium. The style of the drawing of La Roche-Guyon is very
close to the present sheet. It is interesting that Cézanne later based a
painting, *The turn in the road at La Roche-Guyon* (V 441), of 1885, on
this type of composition.

PROVENANCE: London, Lucien Pissarro collection; Esther Pissarro collection, by
whom presented to the Ashmolean Museum, 1950.
LITERATURE: Brettell and Lloyd 61.

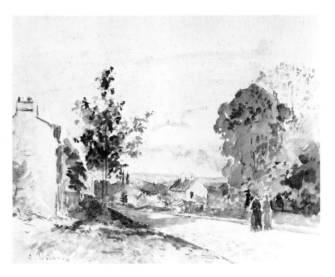

104
Study of a wooded landscape *c.* 1860–5

Etude de paysage boisé

Lugt 613a

Charcoal with grey and blue washes thickened with chinese white. 24.3 × 41 cm./$9\frac{1}{2}$ × $16\frac{1}{8}$ in.

Pin marks in three corners. Framing indicated in charcoal with ruled lines.

The Ashmolean Museum, Oxford, lent by the Visitors of the Ashmolean Museum.

The ruled lines framing the composition imply that Pissarro had intended to use the study as the basis for a painting, but no such finished work is known. The drawing was probably made in one of the surrounding areas of Paris associated with the Barbizon school. The sylvan setting is reminiscent of Corot. The broad technique recalls the studies of tropical landscape executed in Venezuela (Cat. 97), but here Pissarro has mixed the media, using thick washes in combination with charcoal.

PROVENANCE: London, Lucien Pissarro collection; Esther Pissarro collection, by whom presented to the Ashmolean Museum, 1950.
LITERATURE: Brettell and Lloyd 62.

105
The Versailles road at Louveciennes *c.* 1870

La route de Versailles à Louveciennes

Watercolour over pencil. 19 × 25.2 cm./$7\frac{1}{2}$ × 10 in. Signed with the point of the brush in wash, lower left: *C. Pissarro*.

Collection of Mrs. Paul Mellon, Upperville, Virginia

The drawing is comparable with those paintings undertaken by Pissarro in Louveciennes in 1869–70 and again in 1872. Indeed, the road is the same as that in Cat. 13, 14, or in P&V 96 (Zürich, Bührle Foundation, Figure 8). Although this last has a vertical format and Pissarro has positioned himself closer to the house, the viewpoint is very similar, and the use of figures walking down the road is also common to both, as is the time of year. It is therefore possible that Pissarro first designed P&V 96 with a horizontal format. A pastel of *The Versailles road at Louveciennes* (P&V 1514), *c.* 1872, is also comparable with the present watercolour. Another watercolour of Louveciennes showing the St. Germain road was sold at Sotheby's, 11 December 1969, lot 17 repr.

PROVENANCE: Cape Province, South Africa, Captain J. Pattinson-Knight (Sotheby's, 24 November 1964, lot 7 repr.).
EXHIBITED: London, Leicester Galleries, 1943 (1); Washington, National Gallery of Art, *French paintings from the collection of Mr. and Mrs. Paul Mellon and Mrs. Mellon Bruce. Twenty-fifth anniversary exhibition, 1941–1966*, Mar.–May 1966 (219 repr.).

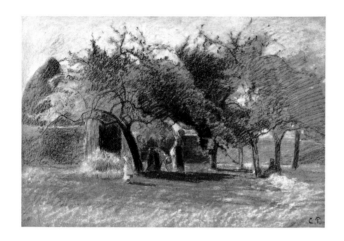

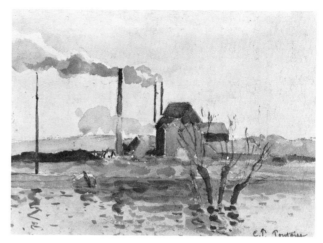

106 EXHIBITED IN LONDON ONLY
Apple picking 1870–5
La cueillette des pommes
Lugt 613a
Pastel on buff coloured paper. 34.2 × 49.4 cm./$13\frac{1}{2}$ × $19\frac{1}{2}$ in.
City Art Gallery, York (inv. 464)

This is an early pastel dating from the first half of the 1870s, a period from which very few of Pissarro's pastels have survived. The medium has in fact been used very sparingly, almost as a system of highlighting. Both the precise, controlled technique, which is most apparent in the branches of the tree on the left, and the composition itself suggest a date in the early 1870s. The precise positioning of the trees in the middle distance is reminiscent of two paintings of 1872, *Apple trees in blossom* (P&V 152) and *Orchard in bloom, Louveciennes* (P&V 153).

Pissarro made other compositions of this subject during the 1880s (see Cat. 64, 68) and intended to include it in *Travaux des champs* (Brettell and Lloyd, 330 and 332).

PROVENANCE: Paris, Ludovic-Rodolphe Pissarro, the artist's fourth son; London, Wildenstein; London, Desmond Coke collection; London, Redfern Gallery, from whom purchased by York City Art Gallery, 1950.
LITERATURE: *York City Art Gallery preview*, iii. No. 11, July (1950), p. 123 repr.
EXHIBITED: London, Wildenstein, 1936 (24).

107
The factory on the Oise, Pontoise 1873
L'usine sur les bords de l'Oise, Pontoise
Watercolour over pencil. 17.3 × 25 cm./$6\frac{3}{4}$ × $9\frac{7}{8}$ in. Signed in pencil, lower right, with the artist's initials.
Inscribed in pencil, lower right *Pontoise*.
Collection of Mrs. Paul Mellon, Upperville, Virginia

This watercolour was made in preparation for the painting of the same title included in the exhibition (Cat. 28). The composition has for the most part been faithfully retained in the finished work, thus showing that Pissarro still relied upon his watercolours as part of the preparatory process for a painting. Another example of a watercolour dating from the first half of the 1870s being used in preparation for a painting is *The Gisors road (snow)*, in the collection of Mr. and Mrs. Alex Lewyt, New York, which relates to P&V 191 *c*. 1872.

PROVENANCE: sold anonymously Sotheby's, 3 July 1969, lot 214.

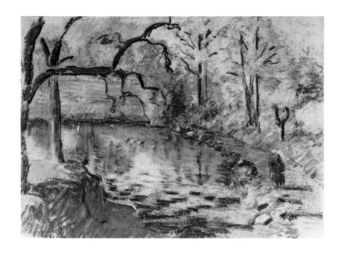

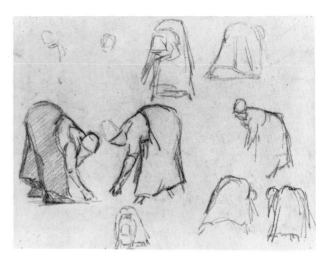

108
The pond at Montfoucault 1874–5

L'abreuvoir à Montfoucault
P&V 1525
Pastel. 24.9 × 35.4 cm./$9\frac{3}{4}$ × 14 in. Signed in pastel, lower left:
C. Pissarro.
Inscribed, lower right: *No. 13.*
The Ashmolean Museum, Oxford, lent by the Visitors of the
Ashmolean Museum

Another pastel (P&V 1527) shows the same pond at Montfoucault
in summer. Seasonal pairings of this type are often hinted at in
Pissarro's paintings of the mid-1870s, particularly those of
Montfoucault (P&V 328–9). The artist depicted the pond several
times. This pastel is of especial interest because it marks a technical
advance on *Apple picking* (Cat. 106), drawn at the beginning of the
1870s. Here the medium has been applied in different ways,
reserving the smoother surface for the water and a rougher texture
for the trees and foreground.

PROVENANCE: London, Lucien Pissarro collection; Esther Pissarro collection, by
whom presented to the Ashmolean Museum, 1950.
LITERATURE: Brettell and Lloyd 86.
EXHIBITED: London, Leicester Galleries, 1931 (20); London, Matthiesen, 1950 (42);
London/Nottingham/Eastbourne, 1977–8 (12); London, JPL Fine Arts, 1978 (7).

109
Sheet of studies of female peasants working in a field *c.* 1874–6

Feuille d'études: paysannes aux champs
Black chalk. 23.8 × 31.6 cm./$9\frac{3}{8}$ × $12\frac{3}{8}$ in.
Pin marks in corners.
The Ashmolean Museum, Oxford, lent by the Visitors of the
Ashmolean Museum

These figures occur on the verso of a sheet which has a drawing of a
tree in fine pencil on the recto. The style of the recto is distinctly
Corotesque and probably dates from the 1860s, while the verso is
surely later, perhaps dating from the mid-1870s. A drawing with
similar figures, and almost certainly from the same sketching
tablet, is in the collection of Professor Charles de Tolnay, Florence.

The studies are notable for the modular treatment of the human
form. An early interest in this way of drawing can be seen on
certain sheets done in South America (Caracas, Museo de Bellas
Artes, inv. 59.88 (A)), but it became more persistent during the
mid-1870s (Brettell and Lloyd 73A recto, 81 recto, and 98A recto).

PROVENANCE: London, Lucien Pissarro collection; Esther Pissarro collection, by
whom presented to the Ashmolean Museum, 1950.
LITERATURE: Brettell and Lloyd 58 verso.

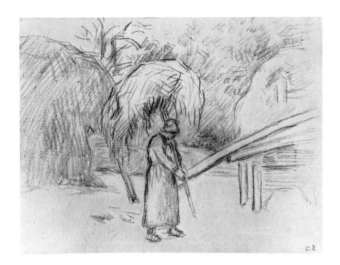

110
Study of a female peasant carrying a load of hay *c*. 1875

Etude pour une paysanne portant une gerbe du foin
Lugt 613e
Charcoal. 23.9 × 30.5 cm./$9\frac{3}{8}$ × 12 in.
Evidence of a watermark along the lower edge in a cursive script, possibly *Lalanne*.
The Ashmolean Museum, Oxford, lent by the Visitors of the Ashmolean Museum

Like the preceding drawing (Cat. 109), this sheet was almost certainly drawn in Montfoucault. It is a fine example of Pissarro's handling of the softer media and of his treatment of the human figure in the mid-1870s. The figure has been perfectly fused with the background and there is little differentiation in the texture of the charcoal over the whole surface. The study is not directly related to a specific painting, but a female peasant carrying a load of hay is included in P&V 321, of 1875, and a similar background may be found in a pastel, P&V 1529, *c*. 1875, both scenes of Montfoucault.

PROVENANCE: London, Lucien Pissarro collection; Esther Pissarro collection, by whom presented to the Ashmolean Museum, 1950.
LITERATURE: Brettell and Lloyd 80.

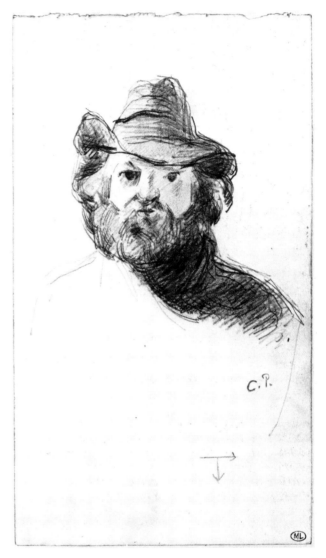

111
Portrait of Cézanne 1874–9

Portrait de Cézanne
Lugt 613e
Pencil. 19.6 × 11.3 cm./$7\frac{3}{4}$ × $4\frac{1}{2}$ in.
Musée du Louvre, Paris (Cabinet des Dessins, inv. RF 11996)

The sheet once clearly formed part of a sketchbook, as indicated by the frayed upper edge. The dimensions are the same as those of eight drawings now in Oxford (Brettell and Lloyd 85), and it is almost certain that the present sheet forms part of the same sketchbook, which appears to have been used between 1874–9.

Pissarro has here successfully captured the mercurial qualities of Cézanne's character. Rewald dated the drawing *c*. 1874, but that is possibly too early. Indeed, stylistically there is a kinship with

Cézanne's self-portrait drawing formerly in the collection of Maurice Gobin, Paris (V1238 and Andersen, No. 5 repr.), particularly in the hatching and the play of light. As in Cézanne's own drawing, Pissarro has concentrated upon the relationship between the eyes, nose, and mouth, which are given added intensity by being depicted so close together with the result that they are almost invested with an element of caricature. Andersen dates Cézanne's self-portrait drawing *c.* 1877–8.

Pissarro and Cézanne often painted or drew one another during the 1870s (see Cat. 38, 216–7).

PROVENANCE: Camille Pissarro collection; Mme. Vve. Pissarro collection (Paris, Georges Petit, 3 December 1928, lot 22 repr.), bought by the Société des Amis du Louvre, by whom presented to the Musée du Louvre,
LITERATURE: R. Huyghe, 'Acquisitions à la vente Pissarro', *Bulletin des musées de France* i (1929), p. 19 repr.; J. Rewald and R. Huyghe, 'Cézanne', *L'Amour de l'Art* xvii (1936), p. 161 repr.; J. Rewald, *Cézanne et Zola*, Paris, 1936, repr. pl. 29; J. Rewald, *Cézanne, sa vie, son oeuvre, son amitié pour Zola*, Paris, 1939, repr. pl. 35; *Lettres*, Eng. edn. only, repr. pl. 50; C. G. Heisse, *Grosse Zeichner des XIX. Jahrhunderts*, Berlin, 1959, p. 150 repr.; Rewald, 1963, repr. p. 26; W. Andersen, *Cézanne's portrait drawings*, Cambridge (Mass.) – London, 1970, p. 15 repr.; I. Dunlop and S. Orienti, *The complete paintings of Cézanne*, London, 1972, repr. p. 83; Rewald, 1973, repr. p. 313; Shikes and Harper, 1980, p. 123 repr.
EXHIBITED: Paris, Orangerie, 1930 (50); Paris, Orangerie, *Nouvelles acquisitions 1922–1932*, 1933 (213); Bucarest, *Wortraits français*, 1938 (72).

112
Double-portrait of Camille Pissarro and Paul Gauguin *c.* 1880

Double portrait de Camille Pissarro et de Paul Gauguin
Charcoal (portrait of Paul Gauguin by Camille Pissarro), and coloured chalks (portrait of Camille Pissarro by Paul Gauguin), both on blue paper. 35.8 × 49.5 cm./14 × 19½ in. (uneven)
Musée du Louvre, Paris, (Cabinet des Dessins inv. RF 29538)

Gauguin appears to have first met Pissarro sometime in 1874. Rewald (*Lettres*, p. 35 n.2) postulates that they were introduced by Gustave Arosa, who in 1872 had commissioned Pissarro to paint a series of canvases of the four seasons (P&V 183–6). Pissarro served as Gauguin's mentor during the late 1870s and early 1880s, although he later disapproved of his pupil's style and advocacy of Symbolism. As in the case of Cézanne, Gauguin's relationship with Pissarro has never been studied in detail. Mainly as a result of Pissarro's intervention, Gauguin began to exhibit with the Impressionists in 1879, and the two artists often painted together in and around Pontoise and Auvers-sur-Oise before Gauguin left for Copenhagen in 1884.

The double-portrait is usually dated 1883, but there is no external evidence to support this and it may be slightly earlier, particularly as regards the drawing by Pissarro. Another drawing of Gauguin by Pissarro, which is stylistically compatible with this sheet, is in one of Gauguin's sketchbooks now in the National-museum, Stockholm (inv. 22/1936, measuring 29.5 × 23.3 cm. repr. C. Gray, *Sculpture and ceramics of Paul Gauguin*, Baltimore, 1963,

112

p. 2 fig. 1). This shows Gauguin in the act of carving an early sculpture, perhaps to be identified with *La petite parisienne* (Gray, *op. cit.*, pp. 112–3 No. 4 repr.) dating from 1881. Pissarro himself owned an early relief carving by Gauguin, *La toilette* (Gray, *op. cit.*, pp. 118–9 No. 7) inscribed *à mon ami Pissarro* and dated 1882.

Not the least interesting aspect of the present sheet is the contrast in styles. Compared with the rather abrasive way in which Pissarro has drawn Gauguin's features in the double-portrait, the younger man has adopted a suffused and gentle style.

PROVENANCE: Paul-Emile Pissarro collection, the artist's fifth son, from whom acquired by the Musée du Louvre, 1947.
LITERATURE: *Lettres*, repr. pl. 15; G. M. Sugana *L'opera completa di Paul Gauguin*, Milan, 1972, repr. p. 84 (left half of sheet only); Rewald, 1973, repr. p. 488; Kunstler, 1974, p. 7 repr.; Adler, 1978, repr. pl. 28; Shikes and Harper, 1980, pp. 181–2 repr.
EXHIBITED: Paris, Musée du Louvre, *Donations et acquisitions du Cabinet des Dessins*, 1955 (34); Chicago, Art Institute/Minneapolis, Institute of Arts/Detroit, Institute of Arts/San Francisco, California Palace of the Legion of Honour, *French drawings. Masterpieces from seven centuries*, 1955–6 (142); Hamburg, Kunsthalle/Cologne, Wallraf-Richartz-Museum/Stuttgart, Würtembergischen Kunstverein, *Französische Zeichnungen von den anfänge bis zum ende des Neunzehnjahrhundert*, 1 Feb.–16 Mar., 22 Mar.–5 May, 10 May–7 Jun. 1958 (190 repr.); Paris, Orangerie, *Vingt ans d'acquisitions au Musée du Louvre 1947–1967*, 16 Dec.–Mar. 1967–8 (499).

113 · EXHIBITED IN PARIS ONLY
Study of a landscape at Pontoise 1880–3

Etude de paysage à Pontoise
Coloured chalks on buff coloured paper. 25 × 32.3 cm./$9\frac{7}{8}$ × $12\frac{3}{4}$ in.
Signed and inscribed in black chalk, lower left:
C. Pissarro. Pontoise. Colour annotations in black chalk *rose vert . . .*
Musée du Louvre, Paris (Cabinet des Dessins inv. RF 28793)

A very similar landscape drawing, probably from the same sketching tablet, is also in the Cabinet des Dessins (inv. RF 28801). The style is notable for the gentle application of the chalks, some being cross-hatched and grouped together, others being long and flowing. Particularly fine is the way the light flickers across the surface. Compositionally, although neither drawing in the Louvre can be related to a finished painting, the type of landscape depicted on both sheets is characteristic of Pissarro's procedure at the beginning of the 1880s. Compare, for example, *Landscape at Chaponval* (P&V 509, now in the Musée du Louvre) and *Female peasants in the fields, Pontoise* (P&V 515), both of 1880.

PROVENANCE: Bayonne, Antonin Personnaz, by whom bequeathed to the Musée du Louvre, 1937.
LITERATURE: Brettell and Lloyd, p. 23 repr.

114
Study of a female peasant seated at a spinning wheel 1880–5

Etude pour une paysanne assise devant une rouet
Charcoal heightened with a dark wash. 30 × 23.1 cm./12 × $9\frac{1}{4}$ in.
Signed in charcoal, lower right: *C. Pissarro.*
The Phillips Family Collection

The study relates to a gouache entitled *The spinner* (P&V 1353), which is dated *c.* 1881 in the *catalogue raisonné.* Rewald dated the drawing on stylistic grounds to 1885–90, but the earlier date is preferable, since Pissarro did sometimes draw in the tenebrist style before his neo-impressionist phase. Both the subject and the technique are reminiscent of J.-F. Millet (Paris, 1975, No. 75). In the gouache the head is bent further forward and the distaff is held at a slightly steeper angle.

PROVENANCE: Richard Pissarro collection, the artist's grandson; New York, The New Gallery.
LITERATURE: Rewald, 1963 repr. p. 61.

115
The artist's mother and her maid 1880–5

La mère de l'artiste et sa bonne
Lugt 613e
Charcoal. 28.4 × 21.9 cm./$11\frac{1}{4}$ × $8\frac{5}{8}$ in.
Inscribed in pencil by a later hand, lower left: *Grand Mère et sa bonne.*
Numbered in blue chalk, upper left corner on verso: *275*
Ashmolean Museum, Oxford, lent by the Visitors of the Ashmolean Museum

The features of the seated figure are clearly recognizable as those of the artist's ageing mother, Rachel Pissarro (1795–1889), of whom Pissarro made several drawings towards the end of her long life. These drawings culminate in two etchings D 73 and 80 (Cat. 183), of 1888 and 1889 respectively. For the relevant drawings see Brettell and Lloyd 145, 194–5, the last of which is a brief study of Rachel Pissarro in her coffin – one of the few instances of an impressionist painter essaying the theme of death. The present study is notable for the delicate use of charcoal, which creates a softly modulated flow of light across the surface. The retention of free-flowing lines for the treatment of the maid's skirt and the tendency to repeat outlines suggest a date between 1880–5 comparable with Cat. 114. It is interesting that Pissarro does adopt a fully tenebrist style in the manner of Seurat for the preparatory drawing (Brettell and Lloyd 194) relating to D 80.

PROVENANCE: London, Lucien Pissarro collection; Esther Pissarro collection, by whom presented to the Ashmolean Museum, 1950.
LITERATURE: Brettell and Lloyd 152.

116
Study of a young female peasant seen from the back in three-quarters profile facing right 1881

Etude de paysanne vue de dos et tournée de trois quarts vers la droite
Charcoal heightened with blue and white chalks on blue-grey paper. 44.7 × 31.2 cm./$17\frac{1}{2}$ × $12\frac{1}{4}$ in.
The British Museum, London, lent by the Trustees of the British Museum (inv. 1920.7.12.3)

The figure occurs at the extreme left edge of a gouache entitled *At the riverside* (P&V 1357), of 1881. The pose and the dress of the figure are almost exactly retained for the gouache, although the head does appear to be inclined downwards at a slightly sharper angle. Furthermore, in the gouache the figure is cut in half at the left by the edge of the composition. The drawing thus provides a good example of the artist working from a posed model. The subject of the gouache seems essentially to be a conversation piece between two female figures on the banks of the river Oise. No studies for the other figure, who wears a hat and holds a flower, are known.

PROVENANCE: acquired by the British Museum from Messrs Ernest, Brown and Phillips, 1920.

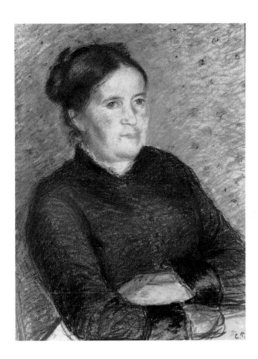

118

PROVENANCE: Mme. Vve. Pissarro collection; Georges Pissarro collection, the artist's second son; London, Rosenberg and Helft; Alberta, Countess of Sandwich collection.
LITERATURE: *Lettres*, repr. pl. 3; Rewald, 1963, repr. p. 56; Adler, 1978, repr. pl. 3; Shikes and Harper, 1980, repr. p. 179.
EXHIBITED: London, Rosenberg and Helft, *From Ingres to Van Gogh*, Feb.–Mar. 1937 (24); London, Matthiesen, 1950 (39); London, Marlborough, 1968 (35 repr.).

117
Portrait of Madame Pissarro (1838–1926)
c. 1881

Portrait de Madame Pissarro
P&V 1565
Pastel. 61 × 47 cm./24 × 18½ in.
Signed, lower right, with the artist's initials.
Private collection

Although undated, the portrait may have been made shortly before the comparable *Portrait of Lucien Pissarro* (Cat. 123). The sitters are similarly posed with their arms folded and both are seen in three-quarters profile facing right. The *Portrait of Lucien Pissarro* is slightly more loosely handled and is not so finished. It also possesses a wider range of colour in the background. By contrast, in the *Portrait of Madame Pissarro* the outline of the figure is more sharply offset against the background. The wallpaper appears to be the same as that in the *Portrait of Félix Pissarro* (Cat. 55), which is dated 1881 and must therefore have been executed at Pontoise before the family moved to Osny at the end of 1882.

The sitter's maiden name was Julie Vellay. She was born in Grancey-sur-Ource in Burgundy, of peasant stock, and was employed in the household of Pissarro's mother in Paris as a maid shortly before 1862. Camille and Julie Pissarro were eventually married in London in 1871 (14 June). The couple had seven children in all, five sons and two daughters. The role of Julie Pissarro in the painter's life has often been misrepresented, but the image of a nagging wife and harassed mother has been corrected in recent biographies, notably that by Shikes and Harper.

118
Study of a female peasant reclining on the ground seen from the back 1882

Etude pour une paysanne couchée vue de dos
Black chalk with charcoal and some pastel heightened in places with gouache. 34.8 × 53.7 cm./13¾ × 21⅛ in. Signed, lower right, with the artist's initials in dark ink.
Ashmolean Museum, Oxford, lent by the Visitors of the Ashmolean Museum

The drawing is a powerful study that relates to the figure centrally placed in the lower foreground of *The weeders* (P&V 563), of 1882, a painting that was possibly included in the seventh Impressionist exhibition (No. 112 *Les sarcleuses*). A similar figure occurs in a fan (not in P&V) dated 1882 entitled *Spring: female peasants in a field* (Christie's, 25 March 1980, lot 65 repr. col.). The pastel and gouache on the drawing are limited to the kerchief, whilst the charcoal has been used to strengthen the underdrawing in black chalk. In the finished painting the figure has been placed on a steeper diagonal, but the lower part of the legs is omitted, as in the drawing. Pissarro seems to have made numerous studies for this picture, which denotes how carefully he prepared his paintings at the beginning of the 1880s (see also Cat. 119).

PROVENANCE: London, Lucien Pissarro collection; Esther Pissarro collection, by whom presented to the Ashmolean Museum, 1950.
LITERATURE: Brettell and Lloyd 125.
EXHIBITED: London/Nottingham/Eastbourne, 1977–8 (17).

119
Study of a female peasant weeding *c.* 1882

Etude pour une paysanne sarclant
Black chalk with watercolour. 17.3 × 21.2 cm./6¾ × 8¼ in. Signed in black chalk, lower left, with the artist's initials.
Musée du Louvre, Paris (Cabinet des Dessins, inv. RF 30103)

The sheet forms part of a sketchbook in which Pissarro made a series of studies using black chalk in combination with water-colour. Another eight sheets from the sketchbook are in the Cabinet des Dessins (inv. RF, 30099, 30096, 30105, 30106, 30102, 30100, 30098, 30101), nearly all of which can be related to compositions dating from the first half of the 1880s, when Pissarro was re-evaluating the significance of the human figure in his work. Some of the studies, notably inv. RF 30098 (exhibited Vienna, *Von Ingres bis Cézanne. Aquarelle und Zeichnungen aus dem Louvre,* 19 November–25 January 1976–7, No. 43 repr.) and RF 30099, were used again in compositions dating from the late 1880s and early 1890s.

It seems highly likely that the present study was drawn in connection with *The weeders* (P&V 563), of 1882. The drawing may have been a first idea for the figure lying on her left side seen from the front in the middle distance. A drawing for this same figure in which the pose matches the final painting more closely is in Oxford (Brettell and Lloyd 126), and a study for the figure on the left of the group was exhibited in London in 1978 (JPL Fine Arts, 1978 (22 repr.)).

PROVENANCE: Paris, Zacharie Astruc collection; Paris, Carle Dreyfus collection (acquired 1938), by whom bequeathed to the Musée du Louvre, 1953.
LITERATURE: Brettell and Lloyd p. 21 repr.
EXHIBITED: Paris, Musée du Louvre (Cabinet des Dessins), *Collection Carle Dreyfus,* Apr.–May 1953 (188).

120
Study of two female harvesters 1882

Etude pour deux moissonneuses
Lugt 613e
Black chalk on pink paper prepared with a thin layer of chinese white. 42.8 × 63.8 cm./16¾ × 25⅛ in. (uneven). Signed in blue chalk, lower left, with the artist's initials.
Numbered in blue chalk, lower right, *48A.*
The Ashmolean Museum, Oxford, lent by the Visitors of the Ashmolean Museum

This magnificent sheet relates to the painting in tempera, *The harvest* (P&V 1358, Tokyo, Bridgestone Museum of Art), of 1882, which was included in the seventh Impressionist exhibition (No. 113 *La moisson*). Pissarro made a number of studies for this painting, many of which are in Oxford (Brettell and Lloyd 118–23). Amongst these are an early compositional study (Brettell and Lloyd 122), a pastel (P&V 1558), and several figure studies. The full preparatory process for *The harvest* is discussed in detail by Brettell and Lloyd (pp. 43–6). The painting itself is one of the most radical undertaken by Pissarro during the 1880s, and this helps to explain the complexity of the preparatory stages. It seems that Pissarro began the composition during the summer of 1881, and that some of the drawings were probably made from life at that time. Yet the present sheet surely marks the closing part of the preparatory process, and was possibly made from a posed model based on earlier studies. In the finished painting Pissarro has retained both the figures on this sheet, but he has altered their positions, by placing the woman bending in the left half to the right of the one carrying the sheaf of wheat. Essentially, Pissarro is here refining his ideas on the disposition of the figures having, it seems, decided upon their poses.

PROVENANCE: London, Lucien Pissarro collection; Esther Pissarro collection, by whom presented to the Ashmolean Museum, Oxford, 1950.
LITERATURE: Brettell and Lloyd 123.
EXHIBITED: London, Leicester Galleries, 1931 (29); London, Calmann Gallery, 1938 (9); London/Nottingham/Eastbourne, 1977–8 (16 repr.); Tokyo, Sunshine Museum/Osaka, Municipal Museum of Fine Arts/Fukuoka, Art Museum, *Ukiyo-e prints and the impressionist painters,* 15 Dec.–15 Jan., 22 Jan.–10 Feb., 15 Feb.–28 Feb. 1979–80 (II–29 repr. revised edn. II–33).

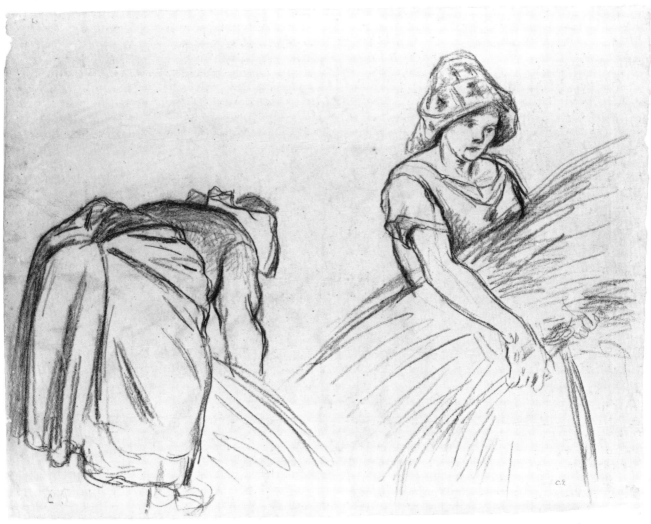

120

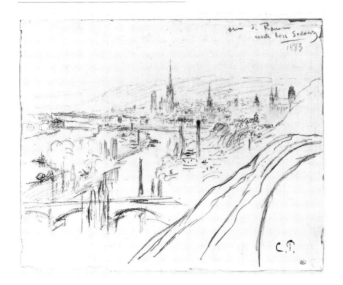

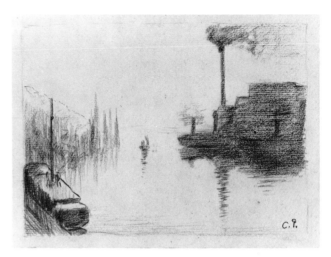

122

121
View of Rouen 1883

Vue de Rouen

Charcoal. 22.7 × 28.7 cm./9 × $11\frac{1}{4}$ in. (uneven).
Inscribed and dated in charcoal, upper right, *vue de Rouen/route de bon secours/1883*.
Musée du Louvre, Paris (Cabinet des Dessins, inv. RF 29531)

The drawing is dated in the year in which Pissarro made his first extended visit to Rouen. The artist's initial reactions to the city are recorded in a sketchbook used in the autumn of 1883 (Brettell and Lloyd 158). By the time Pissarro came to explore Rouen there was a firmly established topographical tradition for the city enshrined in Baron Taylor's *Voyage pittoresque et romantique dans l'ancienne France* (Paris, 1820–78). Distant views had also attracted artists. The favourite viewpoint was Canteleu, a village five or so miles to the west overlooking the city on the road to Le Havre, from where Corot (Robaut 2032–3 and Supplement iii 45), amongst others, had painted the city. Pissarro in fact describes this view in a letter to Lucien of 22 October 1883, but he himself never painted it. Neither was the view shown in the present sheet developed any further. This is Rouen seen from the heights of Bon Secours to the north-east of the city. A modern photograph of the view is reproduced in Kunstler, 1974, p. 50. The hill in the right foreground is part of the Côte Sainte-Catherine, which appears in several of Pissarro's paintings, drawings and prints of Rouen (Cat. 122, 179–181). In the left foreground can be seen the industrialized islands of the Seine – the Ile Brouilly and the Ile Lacroix (Cat. 66). The bridge in the immediate foreground is the railway bridge, which crosses the Ile Brouilly, and in the distance can be made out the Pont Corneille and the Pont Boieldieu. Centrally placed is the Cathedral and on the right the most prominent spires are those of the churches of St. Maclou and St. Ouen respectively. Monet was to paint two views of Rouen from near this spot in 1892 (W 1314–5).

PROVENANCE: Paris, Paul-Emile Pissarro collection, the artist's fifth son, from whom acquired by the Musée du Louvre, 1947.
LITERATURE: Kunstler, 1974, repr. p. 50; Cogniat, 1974, repr. p. 32.
EXHIBITED: Berne, *Dessins français du Musée du Louvre*, 11 Mar.–30 Apr. 1948 (108); Paris, Musée du Louvre, *Maîtres du blanc et noir au XIXe siècle de Proud'hon à Redon*, 1968 (59).

122
L'Ile Lacroix, Rouen 1883

Lugt 613e

Charcoal. 14.2 × 19.4 cm./$5\frac{1}{2}$ × $7\frac{5}{8}$ in.
Framing indicated in charcoal 12.8 × 17.7 cm.
The Ashmolean Museum, Oxford, lent by the Visitors of the Ashmolean Museum

There are two possibilities regarding the purpose of this drawing. It relates compositionally both to an etching D 69 and to the painting of 1888 included in this exhibition (Cat. 66). At first sight it is tempting to connect the drawing with the painting, since both are in styles associated with Neo-Impressionism, but Pissarro was in fact developing the tenebrist style of drawing over a number of years (Cat. 114–5), so that the drawing could be earlier than the painting. Furthermore, it now seems likely that D 69 dates from 1883 on the basis of an impression annotated and dated 1883 by the artist (New York Public Library, Avery Collection, repr. Rewald, 1963, p. 58). Admittedly, the tenebrist drawings made by Seurat of industrial subjects are later in date, but then Pissarro did make an aquatint of the Ile Lacroix in 1883 (Leymarie and Melot P 131, and Brettell and Lloyd 287). The present drawing also relates far more closely to the two prints of 1883 than to the painting of 1888, where there are minor changes in the left half involving the height and number of trees.

PROVENANCE: London, Lucien Pissarro collection; Esther Pissarro collection, by whom presented to the Ashmolean Museum, 1950.
LITERATURE: Brettell and Lloyd 159.
EXHIBITED: London/Nottingham/Eastbourne, 1977–8 (28).

123
Portrait of Lucien Pissarro (1863–1944) 1883

Portrait de Lucien Pissarro
P&V 1563
Pastel. 55.2 × 37.6 cm./21¾ × 14¾ in. Signed and dated in red
pastel, lower left: *C. Pissarro. 83.*
The Ashmolean Museum, Oxford, lent by the Visitors of the
Ashmolean Museum

Lucien Pissarro, the artist's eldest son and a distinguished artist in
his own right, spent a year in England in 1883–4. He remained in
France for the next six years until 1890 when he finally decided to
live in England, marrying an English girl, Esther Bensusan, in 1892.
Comparison should be made with the *Portrait of Madame Pissarro*
(Cat. 117), which is close in date. There are two other drawings of
mother and son on the back of a letter to Camille Pissarro from
Gauguin dated 8 December 1882 (Brettell and Lloyd 155).

PROVENANCE: London, Lucien Pissarro collection; Esther Pissarro collection, by
whom presented to the Ashmolean Museum, 1950.
LITERATURE: *Lettres*, repr. pl. 2; London, Marlborough, 1968, Introduction to the
catalogue, repr. p. 13; Rewald, 1978, repr. det. p. 127; Adler, 1978, repr. pl. 9;
Brettell and Lloyd 157 repr. col.; Shikes and Harper, 1980, repr. p. 187.
EXHIBITED: London, Matthiesen, 1950 (40 repr.); London/Nottingham/Eastbourne,
1977–8 (6).

124
Study of a market 1883

Etude, un marché
Lugt 613e
Blue watercolour over black chalk. 21.5 × 16.4 cm./8⅜ × 6½ in.
The Ashmolean Museum, Oxford, lent by the Visitors of the
Ashmolean Museum

The study relates very closely to *The pork butcher* (Cat. 60). Of
especial interest is the fact that the drawing accords with the final
composition adopted by the artist, as opposed to the original
design, which is known through X-rays. Pissarro, it seems, was
using this study to redefine the position of the figures in relation
both to one another and to the market stalls.

Both the present drawing and the following sheet (Cat. 125)
originally formed part of a sketchbook containing some of
Pissarro's finest drawings. There are twelve sheets from this
sketchbook in Oxford and another eight sheets are known to be in
other collections (Brettell and Lloyd 168). Most of the drawings are
studies of market scenes dating from the early 1880s when Pissarro
first became interested in the subject.

PROVENANCE: London, Lucien Pissarro collection; Esther Pissarro collection, by
whom presented to the Ashmolean Museum, 1950.
LITERATURE: Brettell and Lloyd 168E.

125
Study of two women conversing 1883

Etude, deux femmes en conversation
Lugt 613e
Grey and brown washes over black chalk heightened in places
with gouache. 21.8 × 16.7 cm./8½ × 6½ in.
The Ashmolean Museum, Oxford, lent by the Visitors of the
Ashmolean Museum

Like the previous drawing (Cat. 124), this sheet forms part of a
sketchbook used by Pissarro at the beginning of the 1880s and
mainly devoted to market subjects. The drawings are notable also
for the use of mixed media. Here, for instance, the draperies have
been rendered with two tones of wash heightened with gouache.
The compactness of the figures, the element of caricature in their
clothes and general attitudes, as well as the modelling are all
masterly. No doubt these two women were observed at a market,
but Pissarro does not seem to have incorporated them into a
finished painting.

PROVENANCE: London, Lucien Pissarro collection; Esther Pissarro collection, by
whom presented to the Ashmolean Museum, 1950.
LITERATURE: Brettell and Lloyd 168G.

126
Portrait of Ludovic-Rodolphe Pissarro
(1878–1952) *c.* 1883–4

Portrait de Ludovic-Rodolphe Pissarro
Lugt 613e
Black chalk. 21.1 × 16.7 cm./8¼ × 6½ in.
The Ashmolean Museum, Oxford, lent by the Visitors of the
Ashmolean Museum

This is one of Pissarro's finest portrait drawings. It also provides a
good summary of the evolution of the artist's style of drawing at
the beginning of the 1880s. The straight, broken outlines are
reminiscent of studies made in the mid-1870s; the regular, even
hatching is another feature characteristic of drawings dating from
the 1870s; and the delicately drawn curls of the hair are
comparable with the more curvilinear outlines that are found in the
figure studies of the early 1880s. All these features display a
profound skill in the handling of black chalk.

Pissarro often depicted Ludovic-Rodolphe at the beginning of
the 1880s (see Cat. 58). There are two further studies in Oxford
(Brettell and Lloyd 148–9) and a third was formerly in the von
Hirsch collection (Sotheby's, 27 June 1978, lot 280 repr.).

Ludovic-Rodolphe was the artist's fourth son and the compiler,
together with Lionello Venturi, of the official *catalogue raisonné* of
his father's work.

PROVENANCE: London, Lucien Pissarro collection; Esther Pissarro collection, by
whom presented to the Ashmolean Museum, 1950.
LITERATURE: Brettell and Lloyd 153; Shikes and Harper, 1980, repr. p. 200.
EXHIBITED: London/Nottingham/Eastbourne, 1977–8 (7 repr.).

127
The Côte-Sainte-Catherine, Rouen 1884

La Côte-Sainte-Catherine, Rouen
Lugt 613e
Pencil. 15 × 19.7 cm./6 × 7¾ in.
The Ashmolean Museum, Oxford, lent by the Visitors of the
Ashmolean Museum

The drawing is a preparatory study in reverse for the print executed in etching and drypoint with aquatint, *The Côte Sainte-Catherine, Rouen* (D 48, Cat. 180) of 1884. The study is approximately the same size as the print and the changes between the two are minimal: an extra figure was added to the barge in the foreground, the quayside with the bollards was strengthened, and the smoke from the chimney was allowed to block out more of the hillside.

The bridge joins the Ile Brouilly to the banks of the Seine and the hill in the background (Côte-Sainte Catherine) is near where Pissarro drew his panoramic view of Rouen in 1883 (Cat. 121).

The fact that the drawing is in reverse to the print suggests that it formed part of the transference process, which also accounts for its neat, precise style.

PROVENANCE: London, Lucien Pissarro collection; Esther Pissarro collection, by whom presented to the Ashmolean Museum, 1950.
LITERATURE: Brettell and Lloyd 284.
EXHIBITED: London/Nottingham/Eastbourne, 1977-8 (25).

128
Study of a young female peasant leaning against a tree 1884

Etude, jeune paysanne appuyée à un arbre
Lugt 613a
Black chalk heightened with watercolour. 53.2 × 41.8 cm./
21 × 16½ in. (sight).
Watermark evident in two places, once at the feet of the figure
and again along the right edge.
Whitworth Art Gallery, University of Manchester, Manchester
(inv. D. 11. 1946)

The study was made for the tempera *The turkey-girl* (P&V 1414) now in the Museum of Fine Arts, Boston, of 1884 and not *c.* 1887, as stated in the *catalogue raisonné*. In the finished composition Pissarro has transferred the stick to the right hand, but otherwise the pose and the setting have been almost exactly retained. The pose has also been used for P&V 1417, *Shepherdess with her flock of sheep*, a gouache dated 1887, although a number of changes have been made in the dress of the figure, who, in addition, holds the stick differently.

Large-scale figure studies of this type, drawn first in a soft medium and then heightened in a limited way with watercolour or gouache, appear to have been made mainly during the second half of the 1880s. Another example, and one possibly from the same sketching tablet as the present sheet, was sold at Christie's, 27 June 1978, lot 146 repr. col.

PROVENANCE: London, Lucien Pissarro collection; Esther Pissarro collection, by whom presented to the Whitworth Art Gallery, 1946.
EXHIBITED: London, The Arts Council, *Drawings and water-colours from the Whitworth Art Gallery, University of Manchester*, 1960 (97).

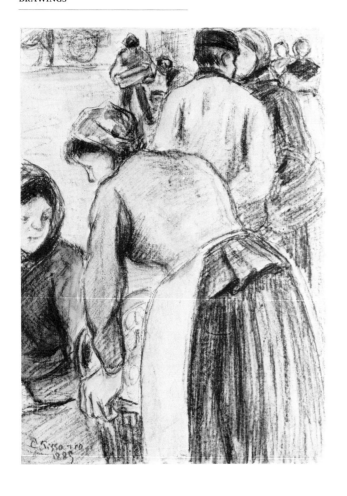

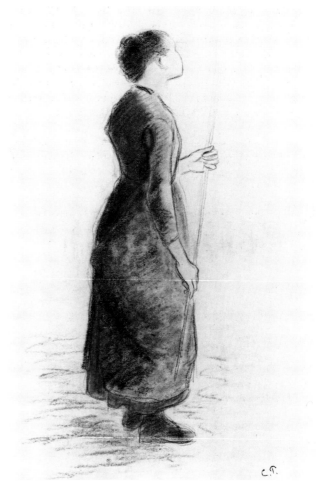

129
Study of a market 1885

Etude, un marché
Black chalk heightened with watercolour. 28 × 20.2 cm./11 × 8 in.
Signed and dated in black chalk, lower left: *C. Pissarro/1885.*
Private collection

The study relates most closely to the left half of the tempera *The poultry market, Gisors* (Cat. 61), of 1885. The two figures in the foreground, both of whom are stock figures in Pissarro's market scenes, are very similar to those placed in the left foreground of the gouache. This last has a horizontal format, whereas the present study is vertical. Indeed, it is possible that the gouache is an amalgam of two separate market compositions (see Cat. 61). Pissarro does not appear to have evolved the composition of this drawing any further, except in the context of the gouache.

PROVENANCE: London, Lucien Pissarro collection; Esther Pissarro collection.

130 EXHIBITED IN PARIS ONLY
Study of a young female peasant holding a stick 1885–6

Etude pour une jeune paysanne tenant une baguette
Lugt 613e
Pastel on pink paper. 61.2 × 47 cm./24⅛ × 18½ in.
Evidence of a watermark in centre and at lower edge in each case the name of the paper manufacturer.
Musée du Louvre, Paris (Cabinet des Dessins, inv. RF 29537)

The figure occurs in a painting entitled *Apple picking*, which exists in at least two versions painted at the beginning of the 1880s. The first (P&V 545) is dated 1881 and the second (P&V 695) is dated 1886 (Cat. 64).

The drawing has been made from a posed model, whose features, pose, and dress are identical in both the finished paintings and in a tempera of 1882 (P&V 1363). In P&V 545 of 1881, however, the thumb of the left hand is placed along the pole, which also seems to

be the case in the tempera, as far as can be judged from the reproduction. Yet, in the painting of 1886 (Cat. 64) the thumb of the left hand is held across the pole. It will also be observed that in P&V 545 and 1363 the right hand of this same figure is partly concealed by foliage, whereas in the version of 1886 the hand is clearly visible. Correspondingly, it has been carefully drawn in the present study, which suggests that it was made for the final version of this particular composition. Such a date can also be supported on stylistic grounds.

An interesting sheet of studies for this painting was included in the sale of the collection of Alexandre Bonin (Paris, Hôtel Drouot, 26 June 1931, lot 91), but the present whereabouts of the drawing is not known.

PROVENANCE: Paris, Paul-Emile Pissarro collection, the artist's fifth son, from whom acquired by the Musée du Louvre, 1947.
LITERATURE: Cogniat, 1974 repr. col. p. 84.
EXHIBITED: Paris, Orangerie, *Pastels*, 1949 (93); Paris, Orangerie, *Vingt ans d'acquisitions au Musée du Louvre 1947–1967*, 16 Dec.–Mar. 1967–8 (500).

131
The pig market, the fair of St. Martin, Pontoise 1886

Le marché aux cochons, foire de la St. Martin, Pontoise
Pen and ink over indications in pencil. 17.5×12.5 cm./$6\frac{7}{8} \times 4\frac{7}{8}$ in.
Signed in ink, lower left, with the artist's initials.
Musée du Louvre, Paris, (Cabinet des Dessins, inv. RF 36502)

Three drawings in the *pointilliste* style, including the present sheet, are mentioned in the artist's correspondence with Lucien Pissarro at the end of December 1886. A letter of 27 September 1886 (*Lettres*, p. 117) refers to 'a *Little market* and a *St. Martin* (pig dealers)' drawn 'with pen and in little dots'. A second letter of 30 December 1886 (*Lettres*, pp. 119–20) states 'I told you that I made two drawings in dots. I have done another in the same manner: *The wheat market at Gisors* . . .'. Of these the *Little market* is in the Metropolitan Museum (Robert Lehman collection), New York, and *The wheat market at Gisors* was apparently given by Lucien Pissarro to J. B. Manson, as stated in the sale catalogue Sotheby's, 7 July 1960, lot 91, but cannot now be traced. Pissarro also made some watercolour drawings of landscapes in the *pointilliste* style. One such was sold at Sotheby Parke-Bernet, South Africa, 4 March 1975, lot 3 repr. col. It is evident from Pissarro's letters that he made these drawings for immediate sale and not in preparation for paintings.

131

PROVENANCE: London, Lucien Pissarro collection; New York, John Rewald collection (Sotheby's, 7 July, 1960, lot 90 repr.); Paris, Max Kaganovitch, by whom presented to the Musée du Louvre, 1970.
LITERATURE: *Lettres*, p. 118 repr.; C. Roger-Marx, *Le paysage français. De Corot à nos jours*, Paris, 1952, repr. p. 60; H. Wechsler, *French Impressionism*, 1953, repr. frontispiece; C. G. Heise, *Grosse Zeichner des XIX. Jahrhunderts*, Berlin 1959, pp. 150–1 repr.; Rewald, 1963, repr. p. 59; Kunstler, 1974, repr. p. 53; Rewald, 1978, repr. p. 100.
EXHIBITED: San Francisco, California Palace of the Legion of Honour, *19th century French drawings*, Mar.–Apr. 1947 (81); New York, Wildenstein, *Seurat and his friends*, 18 Nov.–26 Dec. 1953 (92); Los Angeles, Municipal Art Gallery, *The collection of Mr. and Mrs. John Rewald*, Mar.–Apr. 1959 (99); New York, The Solomon R. Guggenheim Museum, *Neo-Impressionism*, 1968 (49 repr.); Paris, Galerie Max Kaganovitch, *Les 30 ans de la Galerie Max Kaganovitch*, 1966; Leningrad, Hermitage and Moscow, Pushkin Museum, *Donation Kaganovitch*, 1978 (25).

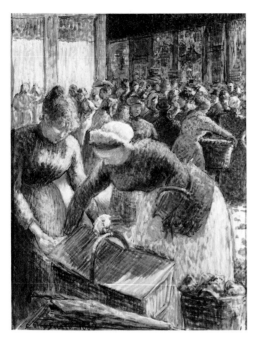

132
The market at Gisors 1887

Le marché de Gisors
Gouache with watercolour. 315 × 24 cm./12⅜ × 9½ in. Signed and
dated with the point of the brush in gouache, lower left:
C. Pissarro 1887.
Museum of Fine Arts, Boston (inv. 1973. 144)

This gouache is of interest for two reasons. Firstly, its technique,
which although not strikingly *pointilliste*, is in the neo-
impressionist manner. Similarly, the blue tones offset by orange
depends upon the neo-impressionist theory of complementary
colours. Secondly, it is rare for Pissarro to depict markets as
interiors. There is, for example, no finished painting of such a
market scene and so far only one known drawing portrays a
market interior. This is in the Fogg Art Museum, Cambridge
(Mass.) inscribed *Un coin des Halles* (inv. 1943. 394, measuring
29.5 × 22.8 cm.) and dated 1889. It is executed in gouache over
black chalk.

The market at Gisors as a composition involves two figures
placed prominently in the foreground. The table with the umbrella
in front of them, the baskets placed at various angles, and the
stooping figures all help to create internal rhythms that are made
even more convincing by the oblique viewpoint. In the figures
placed in the middle distance Pissarro's caricatural style is evident
– a style that he was to perfect in the pen and ink drawings related
to *Turpitudes sociales* (Cat. 142).

PROVENANCE: Carmel, California, Alden Brooks collection; Beverly Hills, Frank Perls
collection; Beverly Hills, Paul Kantor collection; Pasadena, Norton Simon collection.

133
Study of a house at Eragny-sur-Epte 1885–90

Etude, une maison à Eragny-sur-Epte
Lugt 613e
Coloured chalks. 22 × 30 cm./8⅝ × 11¾ in.
Cut vertically in the centre and subsequently rejoined.
Watermark (cut) visible at upper edge, almost certainly *E.D & Cie*
in a lyre shaped cartouche.
The Ashmolean Museum, Oxford, lent by the Visitors of the
Ashmolean Museum

The style of this sheet is clearly related to that of two drawings in
the Musée du Louvre (see Cat. 113), although the handling of the
chalks is here slightly more rigid. The house behind the fence is
depicted in three paintings, two of which are entitled *The Delafolie
house at Eragny-sur-Epte* (P&V 669, Paris, Musée du Louvre, and
678, Boston, Museum of Fine Arts), of 1885, whilst the third is
entitled *Meadow at Eragny-sur-Epte* (P&V 733), of 1889. In each of
these compositions the house is only partially represented, but
always with the fence in the foreground. In the present drawing
the house holds a central position in the composition.

PROVENANCE: London, Lucien Pissarro collection; Esther Pissarro collection, by
whom presented to the Ashmolean Museum, 1950.
LITERATURE: Brettell and Lloyd 192.

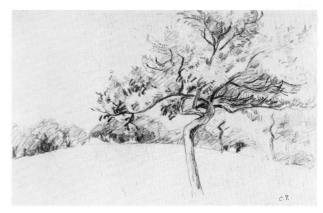

134
Study of a landscape with a ploughed field, Eragny-sur-Epte 1885–90

Etude, paysage au champ labouré, Eragny-sur-Epte
Watercolour over pencil. 20.9 × 47.6 cm./$8\frac{1}{4}$ × $18\frac{3}{4}$ in.
Numbered and signed in black chalk, lower right:
No. 14 C. Pissarro.
The Ashmolean Museum, Oxford, lent by the Visitors of the
Ashmolean Museum

Although there is a basic difference in the seasons, the field is most
probably the same as that shown in *The gleaners* (Cat. 69). Another
watercolour of the same ploughed field was exhibited in London in
1968 (London, Marlborough, 1968 (37 repr.)). This last is dated
Avril '88. The broad, broken stabs of colour common to both
watercolours are related in style to the oil-sketches done in
Pissarro's neo-impressionist manner (P&V 703–8), and there is a
close resemblance both compositionally and technically with
Ploughing at Eragny-sur-Epte (P&V 706), *c.* 1886.

PROVENANCE: purchased by the Ashmolean Museum, 1945.
LITERATURE: Brettell and Lloyd 191.
EXHIBITED: London/Nottingham/Eastbourne, 1977–8 (42).

135
Study of the orchard at Eragny-sur-Epte with a tree in the foreground 1885–90

Etude, le verger à Eragny-sur-Epte avec un arbre au premier plan
Lugt 613e
Black chalk. 19.1 × 30.5 cm./$7\frac{1}{2}$ × 12 in.
The Ashmolean Museum, Oxford, lent by the Visitors of the
Ashmolean Museum

The drawing formed part of the preparatory process for *Apple
picking at Eragny-sur-Epte* (Cat. 68), of 1888, for which an oil sketch
in the Musée Faure, Aix-les-Bains (repr. col. Cogniat, 1974, p. 48)
and a gouache (P&V 1423) also exist. There are several other related
drawings in Oxford (Brettell and Lloyd 180F, 180G recto, and 181).
All of these drawings and the oil-sketch, although not the gouache,
concentrate upon the landscape, which comprises a high curving
horizon and an isolated tree placed prominently in the foreground.
These are the basic elements of a type of composition investigated
by Pissarro during his neo-impressionist years.

PROVENANCE: London, Lucien Pissarro collection; Esther Pissarro collection, by
whom presented to the Ashmolean Museum, 1950.
LITERATURE: Brettell and Lloyd 182.
EXHIBITED: London/Nottingham/Eastbourne, 1977–8 (27 repr.); Tokyo, Sunshine
Museum/Osaka, Municipal Museum/Fukuoka, Art Museum, *Ukiyo-e prints and the
impressionist painters,* 15 Dec.–15 Jan., 22 Jan.–10 Feb., 15 Feb.–28 Feb. 1979–80
(II-31 repr. revised edn. II-35).

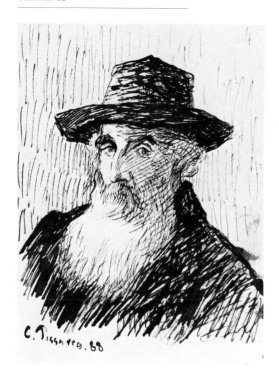

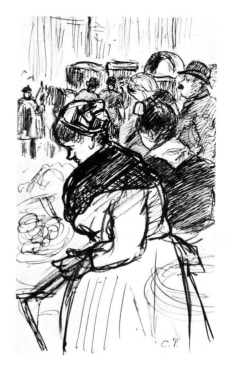

136
Self-portrait 1888

Autoportrait

Pen and ink. 17.4 × 13 cm./$6\frac{3}{4}$ × $5\frac{1}{8}$ in. Signed and dated in ink, lower left: *C. Pissarro. 88.*

S. P. Avery Collection, New York, Prints Division, New York Public Library, Astor, Lenox and Tilden Foundations

The self-portrait is a rare dated example of a drawing by Pissarro in pen and ink. Pissarro made the portrait especially for Samuel Avery, the American collector and dealer, who in April 1888 had purchased several prints from the artist's own dealer, Portier (*Lettres*, pp. 167–8 quoted on p. 191 of this Catalogue).

PROVENANCE: New York, Samuel P. Avery.
LITERATURE: *Lettres*, pp. 167–8 repr. pl. 12; Rewald, 1963, repr. p. 57; Kunstler, 1974, repr. p. 49; Adler, 1978, repr. frontispiece; Shikes and Harper, 1980, repr. p. 262.
EXHIBITED: Boston, Museum of Fine Arts, 1973 (56).

137
Study of a market *c.* 1890

Etude, un marché

Lugt 613e

Pen and ink over pencil. 19.2 × 11.5 cm./$7\frac{1}{2}$ × $4\frac{1}{2}$ in.

Fogg Art Museum, Cambridge, Massachusetts (inv. 1965. 324)

The lower edge of the drawing is frayed, which suggests that it once formed part of a sketchbook. The type of glazed paper is characteristic of those sheets used in connection with *Turpitudes sociales* (Cat. 142). The pen work, too, varying from a light zig-zag line to the heavy outlines and accented passages on the two female figures in the foreground is axiomatic of Pissarro's pen style of the early 1890s. A comparable drawing, both in style and in its study of the social mores of a local market, is in Oxford (Brettell and Lloyd 214). The brief suggestion of architectural details in the background and the horse-drawn carts imply that the present drawing may have been made in Gisors (see Cat. 186–9), which he depicted several times in 1889–90 (P&V 1432–3 and 1436–8).

PROVENANCE: New York, Kraushear (1928); Cambridge (Mass.), Meta and Paul J. Sachs, by whom bequeathed to the Fogg Art Museum, 1965.
EXHIBITED: Cambridge, Fogg Art Museum, *Exhibition of French painting of the nineteenth and twentieth centuries*, 6 Mar.–6 Apr. 1929 (106); Boston, 1973 (60).
LITERATURE: *Beaux-Arts*, 1936, p. 6 repr.; Cambridge (Mass.), Fogg Art Museum, and New York, Museum of Modern Art, *Memorial exhibition. Works of art from the collection of Paul J. Sachs (1878–1965)*, 1966–7, listed p. 210.

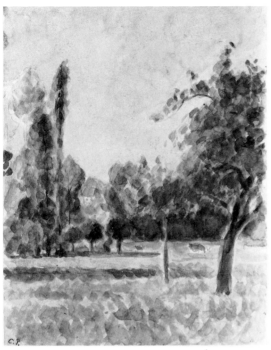

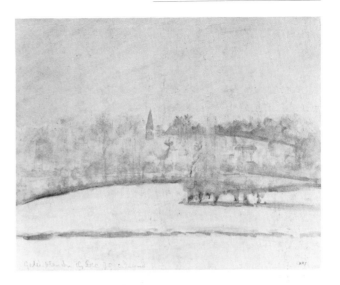

138
Study of the orchard of the artist's house at Eragny-sur-Epte *c.* 1890

Etude, le verger de la maison de l'artiste, à Eragny-sur-Epte
Lugt 613e
Watercolour over pencil. 28.3 × 22.5 cm./$11\frac{1}{8}$ × $8\frac{7}{8}$ in.
The Ashmolean Museum, Oxford, lent by the Visitors of the
Ashmolean Museum

A pastel of this same view, but without the grazing cattle, is dated
c. 1902 in the *catalogue raisonné* (P&V 1607). Such a date is almost
certainly too late for this full-bodied watercolour, which forms
such a contrast with '*Hoar frost*' (Cat. 139). The comparison serves
to demonstrate the wide range of Pissarro's interest in the medium
of watercolour at the beginning of the 1890s. Another watercolour
of the meadow at Eragny-sur-Epte dated 1890 is in the British
Museum (inv. 1920. 10. 18.1).

PROVENANCE: London, Lucien Pissarro collection; Esther Pissarro collection, by
whom presented to the Ashmolean Museum, 1950.
LITERATURE: Brettell and Lloyd 238.
EXHIBITED: London/Nottingham/Eastbourne, 1977–8 (44); London, JPL Fine Arts,
1978 (35).

139
Hoar frost 1890

'Gelée blanche'
Watercolour over pencil. 20.8 × 26.2 cm./$8\frac{1}{8}$ × $10\frac{1}{4}$ in. Signed,
inscribed and dated in pencil, lower left: *Gelée blanche 19 Dec. 90
C. Pissarro*.
Numbered in black chalk, lower right, *No. 1*.
The Ashmolean Museum, Oxford, lent by the Visitors of the
Ashmolean Museum

A fine example of Pissarro's numerous watercolours made in 1890,
all of which display an interest in observing familiar motifs at
various seasons of the year. The precise dating of the sheet is
characteristic of the others executed in this year. The view is taken
from the artist's house at Eragny-sur-Epte, looking across the
meadows to the neighbouring village of Bazincourt. The same
composition occurs in three paintings: P&V 631–2, of 1884, P&V
707, *c.* 1884, the last of which is in Pissarro's neo-impressionist
style. The composition was frequently repeated during the 1890s
(P&V 775, 779, 782, 785–6). The present drawing, like the pastel
(P&V 1586 *c.* 1890), P&V 631–2 and 779, omits the trees that are
shown in the foreground of the other compositions.

PROVENANCE: F. Hindley Smith collection, by whom bequeathed to the Ashmolean
Museum, 1939.
LITERATURE: Brettell and Lloyd 234.
EXHIBITED: London, Royal Academy, *Impressionism. Its masters, its precursors, and
its influence in Britain*, 9 Feb.–28 Apr. 1974 (93); London/Nottingham/Eastbourne,
1977–8 (41); London, JPL Fine Arts, 1978 (34).

140
Study of a male peasant digging 1890

Etude pour un paysan en train de bêcher
Lugt 613a
Charcoal. 44.3 × 29.4 cm./17⅞ × 11½ in.
Art Gallery of Ontario, Toronto (inv. 71/302)

A study for the male figure in *Peasants in the fields* (Cat. 71). Just as the subject of the picture is clearly reminiscent of J.-F. Millet, so is the handling of this preparatory drawing, which is also closely related to Seurat. The sheet is one of Pissarro's comparatively rare studies of the male peasant. The pose is repeated in the finished picture, but certain aspects of the dress are given greater emphasis in order to increase the feeling of *controposto*, namely the man's right sleeve and the bag slung over his back. A direct comparison may be made with Millet's drawings of male peasants digging, as for example those made in connection with the composition entitled *The two diggers* (Paris, 1975, Nos. 115–24 and 128).

Pissarro may have adapted the figure in this drawing for a late lithograph D 168, of 1896.

PROVENANCE: London, Lucien Pissarro collection; New York, John Rewald collection; Toronto, Samuel J. and Agala Zacks, by whom acquired in New York 1953 and presented to the Art Gallery of Ontario, 1970.
LITERATURE: *Handbook*, Art Gallery of Ontario 1974, p. 100 repr.
EXHIBITED: Toronto, Art Gallery of Ontario, *A tribute to Samuel J. Zacks from the Sam and Agala Zacks Collection*, 1971 (99 repr.).

141
Study of church and farm, Eragny-sur-Epte 1890

Etude, église et ferme, Eragny-sur-Epte
Lugt 613a
Charcoal. 24 × 31 cm./9⅜ × 12⅛ in.
Pin marks in corners. Numbered in blue chalk on verso *258*.
The Metropolitan Museum of Art, New York, Dick Fund (inv. 48.10.10)

It seems that Pissarro first attempted this view of Eragny-sur-Epte in 1884 (P&V 630 and 642) from a position nearer to the buildings. There can be little doubt, however, that the present study was made in connection with the etching in colour *Church and farm at Eragny-sur-Epte* (D 96), of 1894–5 (Cat. 185), which was based on a painting (P&V 766) of 1891 now in the Musée du Louvre. For both the painting and the etching in colour Pissarro has selected a higher viewpoint than in the two paintings of 1884.

PROVENANCE: Ludovic-Rodolphe Pissarro, the artist's fourth son; New York, John Rewald. Purchased by the Metropolitan Museum 1948.

TITLE PAGE

F. 13

142
'Turpitudes sociales'
An album of twenty-eight drawings 1890

Each, pen and brown ink over brief indications in pencil on glazed paper. Each, 31.5 × 24.5 cm./$12\frac{3}{16}$ × $9\frac{7}{16}$ in. Each, signed in pen with the artist's initials.

Mr Daniel Skira, Switzerland

This album of twenty-eight drawings is one of the most important documents for a proper understanding of Camille Pissarro. It amounts to a profession of his political beliefs and forms a counterpart to such projects as *Travaux des champs* (Cat. 203–8) where the emphasis is on rural life. The album remained within the family during the artist's lifetime, having been sent on 29 December 1889 to the sisters Esther and Alice Isaacson, the children of his cousin, with two accompanying letters, one of which, undated, provides an explanation and brief description of the drawings up to f. 22, but omitting f. 1. 'And now once again the famous book carefully bound and ornamented in gold by Lucien. I have felt obliged, as befits your education and your sex, to choose the most shameful ignominies of the bourgeoisie. I do not believe

that I have exceeded the bounds of truth. You will see that the models are based on life rather than being contrived'. Both these letters are included in the facsimile edition published in Geneva (Albert Skira) with an introduction by André Fermigier in 1972, as they were inserted into the original album.

The album comprises the following drawings:

Title-page; signed in ink with the artist's initials and dated 1890, followed by, f. 1 *Capital*; f. 2 *The arranged marriage*; f. 3. *The Temple of the Golden Calf*; f. 4. *The exchange brokers*; f. 5. *The suicide of an exchange broker*; f. 6. *The Cardinal's funeral*; f. 7. *Hardwork*; f. 8. *The slaves at rest*; f. 9. *The St. Honoré Prison*; f. 10 *The hanged man*; f. 11 *Jean Misère*; f. 12 *Suffocation*; f. 13 *The suicide of the forsaken*; f. 14 *No more bread*; f. 15 *Piece of bread*; f. 16 *Poverty in a black hat*; f. 17 *Art in a slump*; f. 18 *Sophie Grande*; f. 19 *The beggar*; f. 20 *'Strugleforlifeurs'*; f. 21 *Virtue rewarded*; f. 22 *Little scene from married life*; f. 23 *The drunkards* (*the poor take to drink to forget their suffering*); f. 24 *Before the accident*; f. 25 *After the accident*; f. 26 *Hospital*; f. 27 *The funeral procession of the poor*; f. 28 *Uprising*.

Opposite each drawing, on the verso of the preceding folio, Pissarro has written the title and in the cases of ff. 1, 7, 10–12,

14–15, and 28 an apposite quotation has been taken from various issues of Jean Grave's *La révolte*. Folio 19 is inspired by Baudelaire.

A number of drawings relating to those appearing in the album are known. These are: Oxford, Ashmolean Museum (Brettell and Lloyd 210A) for f. 3; Oxford, Ashmolean Museum (Brettell and Lloyd 210B) for f. 12; formerly in the possession of Lucien Pissarro (CI neg. 51/37 (2), pen and ink, inscribed in pencil *Au Café*, 220 × 175 (sight)) for f. 21; formerly in the possession of Lucien Pissarro (CI neg. 52/51 (41), no details known) for ff.24–5. These drawings are all executed in pen and ink on glazed paper and are all of approximately the same dimensions as those in the album. As such, they constitute part of a sketchbook in which Pissarro undertook preliminary studies for *Turpitudes sociales*. Other sheets, some of which may be rejected ideas for the album, are in the Ashmolean Museum, Oxford (Brettell and Lloyd 210 where yet other drawings, in addition to those already mentioned, are listed). See also Cat. 143.

Turpitudes sociales provides abundant evidence of Pissarro's style of drawing with the pen. In fact, it is the climax of his use of this medium, since there are hardly any drawings made with the pen dating from the 1890s. The style is clearly connected with etching, comprising a mesh of jigging lines, indistinct outlines, and a variety of cross hatching. Pissarro has also made ample use of the white paper for the treatment of light. The vigour of the pen work perfectly matches the subjects of the drawings, which exhibit not only a wide variety of incidents, but also a deep yearning for social justice. Stylistically, and also with regard to its subject-matter, the album may have been inspired by Gustave Doré's illustrations to *London; a pilgrimage* (1872). A careful examination of Doré's illustrations reveals no direct connections, but *Turpitudes sociales* certainly forms part of that tradition, and, furthermore, it is no exaggeration to say that Pissarro's album is hardly artistically inferior to Doré's famous publication. Shikes and Harper have asserted that f. 13 is derived from George Cruickshank (*The drunkard's children. A sequel to 'The bottle' in eight plates*, London, 1881 edn., Pl. VIII, kindly identified by Dr. Celina Fox), but it is to be presumed that Pissarro based many of his drawings in *Turpitudes sociales* on his own observations. This can be proved in the case of f. 6, which is based upon a scene witnessed in Rouen in 1883. The original funeral is recorded in a large watercolour now in the Musée du Louvre (inv. RF 11997, repr. *Von Ingres bis Cézanne. Aquarelle und Zeichnungen aus dem Louvre*, Vienna, Albertina, Nov. 1976–Jan. 1977 (44 repr.)). This watercolour (Cogniat, 1974, repr. col. p. 44) depicts the state funeral for Cardinal de Bonnechose (1800–83), who was Archbishop of Rouen from 1858, as well as a Cardinal and Senator. The other scenes in the album appear to have been less formally conceived.

PROVENANCE: Geneva, Albert Skira.

LITERATURE: *Labyrinthe*, Geneva, 15 November 1944, repr.; R. L. and E. W. Herbert, 'Artists and anarchism; unpublished letters of Pissarro, Signac and others – I', *Burlington Magazine* cii (1960), p. 479; Cogniat, 1974, repr. pp. 62–3, 79, 82–3; Shikes and Harper, 1980, pp. 231–5, ff. 1, 3, 9, 14, and 28 repr.

143
An illustration for 'Turpitudes sociales' 1890

Illustration pour Turpitudes sociales

Lugt 613e
Pen and brown ink over brief indications in pencil on glazed paper. 32.6 × 25.1 cm./12¾ × 10 in.
The Denver Art Museum, Denver, the Edward and Tullah Hanley Memorial Gift to the People of Denver and the Area (inv. 1974. 395 (E-615))

Although slightly larger in size, there can be little doubt that this drawing was intended for inclusion in the album of drawings entitled *Turpitudes sociales* (Cat. 142). For some unknown reason the sheet was omitted. Perhaps either f. 1. *Capital*, or f. 3. *The Temple of the Golden Calf*, were substituted. Compositionally, the sheet relates to f. 1, but thematically it is closer to f. 3. There are some other known drawings which include preliminary ideas for *Turpitudes sociales* (Brettell and Lloyd 210E and 210F), but none is so highly finished as the present one.

PROVENANCE: England, Dr. Harold Widdup collection; London, Redfern Gallery; Verona, New Jersey, Dr. Milton Lauria (1964); New York, Parke Bernet, 26 May 1966, lot 11 bt. Hanley; Bradford, Pennsylvania, Dr. T. Edward and Tullah Hanley, by whom presented to the Denver Art Museum, 1974.

144
Self-portrait 1890–1900
Autoportrait
Lugt 613e
Black chalk. 18.4 × 13.6 cm./$7\frac{1}{4}$ × $5\frac{3}{8}$ in.
The Detroit Institute of Arts, Detroit, John S. Newberry Bequest
(inv. 65. 165)

The uneven lower edge is evidence that the sheet once formed part
of a sketchbook. The inscription along the lower edge is not by the
artist and is presumably an instruction for the mounter. The
drawing cannot be dated narrowly, but both the appearance of the
artist and the handling of the chalk suggest that it is late. Rewald
places the drawing *c.* 1898. The image is framed by ruled lines.
These may have been drawn by the artist for compositional
reasons, but the drawing does not relate to the two painted self-
portraits (P&V 1114–5) dated *c.* 1900 in the *catalogue raisonné*. It is
possible that Pissarro intended to use it as the basis for a print.

PROVENANCE: Paris, Alexandre Bonin collection (Mme. Bonin was second daughter
of Camille Pissarro); André Bonin, the artist's grandson; New York, John S.
Newberry, by whom bequeathed to the Detroit Institute of Arts, 1965.
LITERATURE: *Great drawings of all time* ed. I. Moskowitz, iii. *French. Thirteenth
century to 1919*, text by Agnes Mongan, New York, 1962, No. 773 repr.; Rewald,
1963, repr. p. 40.
EXHIBITED: New York, Charles E. Slatkin Gallery, *French Master drawings*, 1959 (90);
Cambridge (Mass.), Fogg Art Museum, *Thirty-three French drawings from the
collection of John S. Newberry*, Jun.–Oct. 1960 (28); Boston, Museum of Fine Arts,
Fifty-one watercolours and drawings – the John S. Newberry Collection, 1962 (24);
Detroit, The Detroit Institute of Fine Arts, *The John S. Newberry Collection*,
13 Oct.–14 Nov. 1965 (p. 73 repr.); Michigan, The Kalamazoo Institute of Arts,
French Impressionists, 11 May–18 Jun. 1967 (no cat.).

145
Study of a young woman washing her feet 1895
Etude pour une jeune femme se lavant ses pieds
Coloured chalks with touches of pastel.
53.1 × 38.9 cm./$20\frac{7}{8}$ × $15\frac{1}{4}$ in.
The Ashmolean Museum, Oxford, lent by the Visitors of the
Ashmolean Museum

The study relates to the figure in *Young female bather washing her
feet* (P&V 903), of 1895, which is in turn derived from *Woman
washing her feet in the river* (P&V 901), of 1894. A similar figure
occurs naked in *Female bather in the woods* (P&V 904, New York,
Metropolitan Museum of Art), of which there is a monotype
(Shapiro and Melot, p. 19 No. 4 repr.). Another drawing connected
with the present study was formerly in the collection of Lucien
Pissarro (CI neg. 52/49 (31), black chalk, measuring 21.4 × 23.8
cm). It is limited to the bather's legs and hands.

 The theme of the bather in an arcadian setting is redolent of
French eighteenth-century painting (Lloyd, 1975, p. 275).

PROVENANCE: London, Lucien Pissarro collection; Esther Pissarro collection, by
whom presented to the Ashmolean Museum, 1950.
LITERATURE: Brettell and Lloyd 259.
EXHIBITED: London/Nottingham/Eastbourne, 1977–8 (56 repr.); Memphis, The
Dixon Gallery and Gardens, *Homage to Camille Pissarro. The last years 1890–1903*,
18 May–20 Jun. 1980 (31 repr. col.).

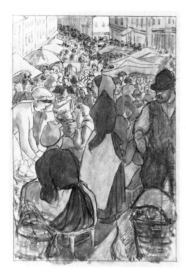

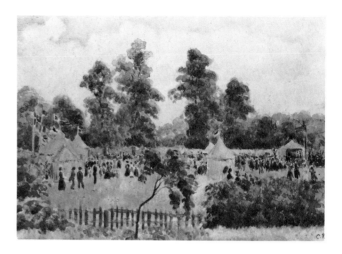

146
Study of a market at Gisors *c.* 1895

Etude, marché de Gisors
Black chalk with pen and ink, grey and brown washes,
heightened with chinese white on tracing paper.
27.5 × 20.9 cm./10¾ × 8¼ in. (size of paper); 25 × 17.4 cm./
9⅞ × 6¾ in. (size of composition).
Framing indicated in black chalk.
Private collection

The drawing was made in preparation for the etching in colour,
Gisors Market (Rue Cappeville) (D 112), which Delteil dates *c.* 1894
(Cat. 186–9). The etching is, in fact, described in a letter from
Camille Pissarro to Lucien, written on 18 January 1895, as being in
progress (*Lettres*, pp. 363–4). The same market is depicted in a
painting of 1885 (P&V 690), for which there is a related gouache
(P&V 1401). A number of drawings were made in connection with
the etching, most of them now in Oxford (Brettell and Lloyd 256
and 295–9). Three of these, like the present drawing, are on tracing
paper and formed part of the transference process. It is clear from
the drawings that Pissarro had some difficulty in deciding upon the
final composition and, indeed, there is evidence that he changed
the format from a horizontal to the vertical that he usually used for
his market scenes. The design for the horizontal composition is
recorded in a tracing in Oxford (Brettell and Lloyd 295), which was
taken from a drawing formerly in the collection of Lucien Pissarro,
now only known from a photograph that was discovered too late to
be included in the catalogue prepared by Brettell and Lloyd. Some
of the figures, notably the seated woman seen from the back, the
woman standing in the centre, and the male figures on the far right,
are found in both the horizontal and the vertical compositions.

PROVENANCE: London, Lucien Pissarro collection; Esther Pissarro collection.
LITERATURE: Brettell and Lloyd, pp. 50–1 repr. discussed at No. 295.

147
Jubilee fête, Bedford Park, London 1897

Fête du Jubilée, Bedford Park, Londres
Lugt 613e
Watercolour. 24 × 34 cm./9½ × 13⅜ in.
Private collection

This watercolour probably preceded the painting of the same
subject (P&V 1007), of 1897. In the finished painting the artist has
moved further back from the fence, before which he has placed two
trees screening the view of the park. He has also extended the
composition on the right by introducing part of a large marquee to
balance the tents on the left. It is instructive to compare the
painting *Jubilee fête, Bedford Park, London* with two paintings of
the same year, both depicting cricket matches being played in the
same setting (P&V 1005 and 1008), where Pissarro again shifts his
viewpoint and alters the distribution of the trees for compositional
reasons.

The Jubilee referred to in the title is that celebrating the sixtieth
anniversary of Queen Victoria's ascent to the throne – the Diamond
Jubilee.

PROVENANCE: London, Lucien Pissarro collection; London, Dr. Ruth Bensusan-Butt
collection, Lucien Pissarro's sister-in-law.
EXHIBITED: Colchester, Castle Museum, *Festival of Britain exhibition*, 1951 (76).

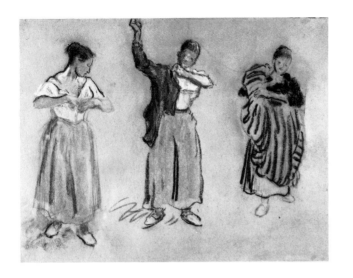

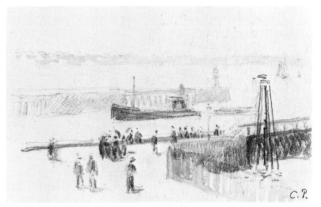

148
Study of three female figures dressing *c.* 1900

Etude, trois femmes s'habillant
Pastel on pink paper. 45.7 × 60.4 cm./18 × 23¾ in.
The British Museum, London, Department of Prints and
Drawings (inv. 1920. 7. 12.2). Lent by the Trustees of the British
Museum.

The sheet is a fine example of Pissarro's late figure studies. Drawn
from posed models inspired by attitudes that the artist must have
observed in life, the technique, and to a limited extent the subject
also, are influenced by Degas. Again it is symptomatic of Pissarro's
composite methods of preparation towards the end of his life, that
he used these studies in a number of diverse works. The figures on
the left and right of the drawing recur almost exactly in the
gouache *After the bathe in the woods* (P&V 1487), while the central
figure was used for another gouache entitled *Workers in the fields*
(P&V 1486). Neither of these gouaches is dated. However, the
central figure was also incorporated into an important painting,
that is of particular significance for Pissarro's treatment of figures
in a landscape setting during the last phase of his life. This is
Harvest at Eragny-sur-Epte (P&V 1207, Ottawa, National Gallery of
Canada), of 1901. A tempera of the same subject and virtually
identical in composition (P&V 1495) differs in one significant
respect, namely in the arrangement of the figures in the middle
distance where two female peasants are shown harvesting. In the
finished painting these have been omitted and replaced by the
figure appearing in the centre of the present drawing.

PROVENANCE: acquired by the British Museum from Messrs. Ernest, Brown and
Phillips, 1920.

149
Study of the entrance to the harbour, Le Havre 1903

Etude, entrée du port du Havre
Lugt 613e
Pencil heightened with brown wash. 10.6 × 17 cm./4⅛ × 6⅝ in.
The Ashmolean Museum, Oxford, lent by the Visitors of the
Ashmolean Museum

Both the present drawing and Cat. 150 form part of a sketchbook
used by Pissarro in Le Havre during the final months of his life.
Several other sheets are in Oxford (Brettell and Lloyd 278 A–D,
G–K). As in a similar sketchbook used in Dieppe in 1901–2 (Brettell
and Lloyd 277), the sheets comprise numerous drawings of motifs
that were incorporated into the final paintings, but no
compositional sketches made directly for specific paintings. As
befits the practice of recording visual data, the style is notational –
flicks, dots, dashes all hurriedly assembled on the page. Only in the
present drawing has a wash been added.

The crane appearing in Cat. 150 occurs in P&V 1301, 1303–8, and
1315. Only in P&V 1301 and 1308 is the hoist at approximately the
same angle, but in both these paintings the shipping is arranged
differently.

PROVENANCE: London, Lucien Pissarro collection; Esther Pissarro collection, by
whom presented to the Ashmolean Museum, 1950.
LITERATURE: Brettell and Lloyd 278E.
EXHIBITED: London/Nottingham/Eastbourne, 1977–8 (60).

150
Study of the quayside, Le Havre 1903

Etude, quai au Havre
Lugt 613e
Pencil. 10.5 × 16.9 cm./$4\frac{1}{8}$ × $6\frac{5}{8}$ in.
Annotated in pencil, upper right: *jettée Havre*.
The Ashmolean Museum, Oxford, lent by the Visitors of the
Ashmolean Museum

See Catalogue number 149.

PROVENANCE: London, Lucien Pissarro collection; Esther Pissarro collection, by
whom presented to the Ashmolean Museum, 1950.
LITERATURE: Brettell and Lloyd 278F.
EXHIBITED: London/Nottingham/Eastbourne, 1977–8 (61).

Pissarro as print-maker

Barbara Stern Shapiro

*'What a pity there is no demand for my prints,
I find this work as interesting as painting,
which everybody does, and there are so few who
achieve something in engraving. They can be
counted.'*

<div align="right">*Lettres*, p. 375</div>

It is generally accepted that professional print-makers have furthered and perfected the technical means of executing prints, while it is primarily great painters who have creatively expanded the boundaries. Of all the Impressionists, Pissarro was the truest *peintre-graveur* and most diligently pursued the art of print-making. Etching and lithography became a necessary and integral part of his artistic activity, and once he began to work on prints in 1863 he never abandoned the medium. Over two hundred plates with multiple impressions are evidence of his profound interest.

Until recent times Pissarro's prints were virtually unknown, despite the proliferation in the 1920s of an enormous number of posthumous impressions, commissioned by members of the artist's family who owned the plates. It was only through a few dealers' small exhibitions, and through family auction sales, that the variety and extent of Pissarro's printed work were brought to the public's attention. Within the last half dozen years or so, however, two exhibitions have successfully demonstrated Pissarro's involvement in print-making, the importance of his efforts, and his significance as an impressionist painter who freely translated his pictorial ideas into prints.[1]

Although Pissarro had difficulty in finding a market for his prints, there were individuals who nevertheless gradually acquired them, so that a substantial number exist today in various places. Samuel Putnam Avery, a New York dealer, obtained a group of etchings and a self-portrait drawing (Cat. 136) in 1888; these purchases were eventually donated to the New York Public Library's print department, of which Avery was a major benefactor. Pissarro mentioned to Lucien:

'Portier [a French dealer] wrote that to complete the sale [of etchings] I would have to do a self-portrait in pen and ink and send it along with the proofs to the said museum. I am supposed to get fifty francs for the self-portrait. I made the portrait and dispatched it, but I have heard nothing since.' (*Lettres*, pp. 167–8)

Frederick Keppel and E. G. Kennedy were also early buyers. In 1891, Pissarro claimed: 'So then there are three American dealers who have my engravings, the three biggest dealers: Avery, Keppel and Kennedy'. (*Lettres*, p. 254). Later in the 1920s other dealers came to admire Pissarro's prints, and many of their acquisitions have found their way into public and private collections. America is the repository of a surprising number of beautiful impressions printed during the artist's lifetime. Before his death, Pissarro presented a group of more than eighty-five etchings in superb impressions to the Musée du Luxembourg, housed in the Bibliothèque Nationale, Paris. Over a period of years, Lucien and Esther Pissarro, as well as their daughter, Orovida, gave an extensive collection of the family's work to the Ashmolean Museum, Oxford, including a selection of Camille's etchings and lithographs.[2] These various deposits of fine early impressions serve as the true measure of the artist's highest achievement in print-making.

Stylistically, Pissarro's printed work falls into three categories, each determined primarily by his interest in technical processes and by the compositional explorations he made in his paintings. He was much too independent and skilful, however, to consider print-making as purely a reflection of his paintings; for example, one would be hard pressed to put together a group of neo-impressionist prints. The first of the three categories comprises those prints executed before 1879. All the early etchings (see for example Cat. 151–5), were direct, simple statements in which Pissarro employed the most academic of methods – straightforward use of etched lines – and avoided the facile manipulation of ink. His compositions were uncomplicated in subject-matter and in their rendering of light, and they reflect a kinship with the painter-printmakers of the Barbizon school. It is significant that Pissarro did not participate in the French etching club, '*La Société des Aquafortistes*,' founded in 1862 by Alfred Cadart, print-dealer and publisher, and by Auguste Delâtre, a professional *imprimeur-artiste*. The two men are recognized today for their efforts to revive original etching as practised by Rembrandt, but their emphasis on the importance of inking and plate tone as an expressive formula did not appeal to Pissarro.

A group of twelve lithographs, made by Pissarro in 1874, the same year as the first Impressionist exhibition, were very direct in style, and all were executed on paper which was then transferred to stone. They were either economical crayon drawings or sensitive, airy sketches in pen and ink. Despite his devotion to Daumier, however, Pissarro aban-

doned lithography for twenty years after his first efforts.

The second category of work was embarked upon in 1879, when Pissarro, who was approaching fifty, began to collaborate with Edgar Degas, initiating a middle phase in his career. Degas conceived the idea of publishing a journal of original prints, *Le Jour et la Nuit*,[3] and, using his studio as a workshop, he introduced Pissarro to inventive and unorthodox print-making techniques.[4] Their joint efforts, which have been amply documented, led to some exciting changes in Pissarro's prints, as well as in those works produced by Degas. Stimulated by the interchange of new approaches to etching, Degas responded with his own notable images, as for example, *At the Louvre: Mary Cassatt in the Etruscan Gallery* (J. Adhémar and F. Cachin, *Edgar Degas gravures et monotypes*, Paris, 1973, No. A53 repr.), which Degas intended to be his contribution to the journal. For both artists and for Mary Cassatt, who also contributed to *Le Jour et la Nuit*, the prints of this period constituted a major departure from any printed work being produced by other artists. Of all their colleagues who participated in the various Impressionist exhibitions, only these painters fully understood the extensive possibilities of the etching medium and creatively seized upon its tools and materials. Admittedly, Manet produced nearly one hundred etchings and lithographs, but he was less committed to making prints and many of his images represent, for the most part, a transference of painted motifs.

The prints of Degas and Pissarro were a veritable *cuisine* of intaglio processes. Along with the little known softground, the novel use of aquatint, the dusting of resin grains, the salt grain method, as well as the drypoint and etched line work, they also incorporated printing imperfections and accidents with acid into the design of the print. An example of this casual manner can be seen in the way the two artists printed from at least six plates of the same size (approx. 11.8×16 cm.), each one bearing the manufacturer's name and address, 'Schneider, 9 Berlin' – fragments of the plate manufacturer's name, printed in reverse, appear on the platemark edge of many of their impressions. (See lower right edge, Fig. 1)[5]. Not only did the reproducing of the 'named' plates constitute a cavalier attitude, it also confirmed the close working relationship between the two artists; Degas, who preferred copper plates and complained about Pissarro's use of 'greasy' zinc pieces, must have obtained the more expensive plates and shared them with his colleague. Furthermore one should consult the records of the Degas *atelier* sales of 1918, when over three hundred prints, mostly by contemporaries of Degas, were sold at auction after the artist's death. More than thirty impressions by Pissarro dating from 1879–1882, were in the sale, indicating thereby that their collaboration extended until at least 1882 (see Cat. 156–177).[6] In 1891 Degas found some of

Fig. 1. *Setting sun*, 1879, drypoint and aquatint, The Ashmolean Museum, Oxford.

Pissarro's lost plates, including *The Hovel* (D 20) and *Le Père Melon* (D 25) – 'a whole parcel was discovered by Degas . . . while cleaning up his studio', wrote Pissarro, 'and he has put them aside for me; I still don't know how many of them there are in the lot'. (*Lettres*, p. 230).

The prints of these brief years were triumphs of print-making, characterized by unusual textural and light effects and a broad range of tonal values, all achieved by unconventional means. The methods used were so inventive, individual and closely blended that they are not susceptible to analysis. For the first time in the nineteenth century, the etching medium, with all its most creative ramifications, was explored artistically for its own sake. Its role as a means of reproducing paintings was completely rejected; instead, the intention to fashion impressionistic, painterly images without obvious contours or noticeable etched lines was brilliantly achieved.

The most significant feature of Pissarro's prints was his innovative commitment to making a series of impressions; by annotating and signing his name to the prints as they were developed through progressive stages, or sequence of states, he not only accepted the changing description of time and light, but he also gave equal credence and emphasis to all the elements that make up the image itself. Pissarro forces the viewer to examine the entire package, so to speak, to appreciate the integral parts rather than merely focus on the so-called final state. With each change recorded by the printing of an impression, he could alter a visual experience (see, for example, *Beggar's footpath*, D 33), portray extraordinary seasonal transformations (D 31, Cat. 173–4), change his mind about the intention of the composition (D 39, Cat. 177), or experiment with the many possible technical solutions to the various artistic questions that the subject may have presented (D 23, Cat. 164–8). All these

considerations, unlike those in paintings, could be accomplished on a single plate without the loss of the original concept. Even Pissarro's vocabulary of annotations – *épreuve d'état, épreuve d'artiste, épreuve définitif, épreuve de choix* – is essentially unhierarchical and gives equal weight to the differing proof impressions.

The third category of Pissarro's print-making style evolved from the mid-1880s to the last years of his life, when he used prints constantly as a means of recording his observations. As he moved away from the influence of Degas, he devised processes which were less variable and painstaking and many of the subsequent etchings relied on *manière grise* (grey manner) for a fixed tone (D 65, Cat. 181). In a review of the seventh exhibition organised by *La Revue Indépendante* in January 1888, the critic Félix Fénéon described in detail this method of print-making in which abrasives, such as sandpaper rolled into a stump, emery cloth, or metal brushes, were used to establish tonal areas more commonly achieved by aquatint. Pissarro could alter the sharp lines, reduce the effect of light, or give a misty, grey value to the impressionistic image.[7]

For these last two decades Pissarro's etchings and lithographs were a series of transcriptions, small sketches, topographical records (his trips to Rouen, Paris and London, were all described in prints), or technical experiments. Just as his paintings and drawings are a guide to his geographical and stylistic wanderings, his prints similarly indicate his social, political and pictorial pursuits. In the 1880s, when the human figure assumed a greater importance in his work, Pissarro depicted energetic peasants set in rural environments (D 63, Cat. 178), or bourgeois travellers in urban scenes (D 46, Cat. 179). His etchings range from small, picturesque vignettes (D 48, Cat. 180), to plates that recall the chiaroscuro of Rembrandt (D 90, Cat. 184), to colour renderings achieved through complicated intaglio procedures (D 112, Cat. 186–9). These last works were produced after Pissarro had acquired his own press in 1894. He had until that time tried to avoid professional printers, (although on occasion he used Salmon and, with reservations, Delâtre), because it went too much against his nature. Not only was he reluctant to incur the expense of outside printers, but he also truly believed that he alone could obtain the proper inking, wiping with the cloth, and appropriate coloration with the right paper. When admiring Whistler's prints he wrote, 'no professional printer could substitute for him, for inking is an art in itself and completes the etched line. Now we would like to achieve suppleness *before* the printing.' (*Lettres*, p. 33).

Although Pissarro's lithographs do not reveal the dramatic changes or multiple development of states characteristic of his etchings, they reflect as a group his command of the medium and its importance as another vehicle for his pictorial ideas. The fact that he returned to lithography twenty years after his initial attempt was undoubtedly due to the vigorous efforts of print publishers, who became, in the 1890s, the generative force in popularizing original lithographs. André Marty, the director of the journal *L'Estampe Originale*, which first appeared in March 1893, persuaded Pissarro to contribute two prints (see D 142, Cat. 190). Ambroise Vollard, the enterprising gallery owner and publisher, was a major promotor of colour lithography. Although Pissarro was alternately amused by and critical of Vollard's grandiose ambitions, he was quite definitely stimulated by the dealer. Pissarro negotiated with Vollard, but never made a print for him, and defiantly continued to work in black and white (with one exception, D 194), even though colour was at that time in fashion.

In addition to his etchings and lithographs, Pissarro executed monotypes, probably learning the technique from Degas. Once the two artists began painting on an etching plate with acid and liquid aquatint, or brushing the smooth surface with varnishes, or even photographic collodions, and gelatins, it was just a question of time before they would eliminate the etched basis. Degas relentlessly pursued the medium for more than fifteen years. Pissarro also regarded it seriously, although his *oeuvre* was very much smaller. About thirty monotypes are evidence of his interest and demonstrate his individual method of procedure: as in his paintings of the 1880s and 1890s Pissarro drew on the plate with brush-strokes of thickish paint and, on occasion, touched up the surface of the sheet with heavier pigments. The freedom and directness of painting on the plate, together with the precision required in the act of printing appealed to Pissarro; understandably, this combination of disciplines did not attract professional print-makers.[8] Of historical interest are a group of small monotypes that are pleasing, but lack the aesthetic importance of the large monotypes. Their authenticity was questioned when they first became known, but their provenance proves that Pissarro had merely prepared uncomplicated and unique illustrations for his children.[9] Pissarro and his sons called themselves the 'Artists of Eragny' and collaborated on a monthly 'house journal', entitled *Le Guignol*, filled with artistic and often satirical creations. At the end of each year, Lucien would collate the issues and Georges would design a decorative binding.[10] The descendants of Pissarro have retained some of these journals of which *The stooping peasant* (Fig. 2) is one of the monotype illustrations.[11] The technique is baffling, for Pissarro has duplicated softground and etched line work, as well as aquatint grains with a tacky greasy ink; the subject, however, bears comparison with a pen drawing on tracing paper in the Ashmolean Museum, Oxford (Fig. 3), and a woodcut of *The sower* (Fig. 4) drawn by Camille and engraved by Lucien Pissarro in 1888. In all three graphic works, there is a similarity in the direct, crisp lines,

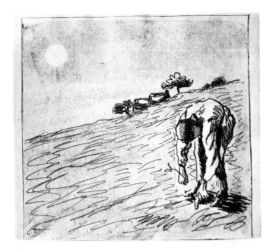

Fig. 2. *The stooping peasant*, c. 1889–90, monotype,
Private collection.

Fig. 3. *The sower*, pen and ink on tracing paper,
The Ashmolean Museum, Oxford (Brettell and Lloyd 307).

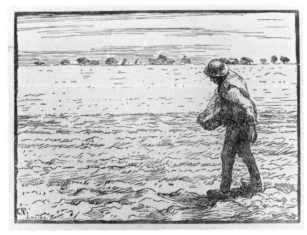

Fig. 4. *The sower*, for *Travaux des champs*, 1888, woodcut,
The Ashmolean Museum, Oxford.

the quality of sunlight, and the summarily indicated trees on the horizon line.

Camille Pissarro, the most prolific impressionist print-maker, responded to every new mode of expression, and forthrightly embraced any innovative method that would appropriately describe his pictorial observations. Many of his prints were major works in which content and technique perfectly complemented each other, some were more simplified studies, others reflected the trends of his paintings, and a few of the prints were quick records of visual data. Ultimately, his large output must be acknowledged as an important corpus in itself, which documents the development of his style and his adventurous technical investigations. In full command of broad and varied print-making skills, Pissarro freely examined his favourite subjects and motifs, and effectively rendered, in a small format, all that was most compelling and interesting within the impressionist aesthetic.

Facsimiles of stamps found on posthumous editions:

Dark grey; posthumous impressions[12]

Blue; 1907 edition

Brown; 1920 edition

Dark grey; 1922, 1923, 1930 editions

Appendix

The printed works on paper illustrated in this catalogue are impressions taken during Pissarro's lifetime and contrast greatly with the numerous posthumous editions made over a period of almost thirty years after the artist's death. The early impressions were printed by the artist, or directly under his active supervision; he chose his inks carefully and preferred the warmth and texture of hand-made papers. The inscriptions in Pissarro's hand are unique personal records of his working methods and reflect his profound interest in a sequence of states, or multiple expressions of the same motif. The late editions of over one thousand prints unfortunately disregard the artist's intentions, and are neither representative of his concern with technique, nor of his artistic achievement. Both can only be fully comprehended in the range of fine impressions printed during his lifetime.

Selected annotations in Pissarro's hand:

From Cat. 168

From Cat. 177

From Cat. 178

From Cat. 180

From Cat. 189

From Cat. 197

Footnotes

1. Boston, Museum of Fine Arts, *Camille Pissaro: the impressionist print-maker*, 1973 (catalogue by Barbara Stern Shapiro), and Paris, Bibliothèque Nationale, *L'Estampe impressionniste*, 1974 (catalogue by Michel Melot).

2. Of the 282 prints donated to the Ashmolean Museum, there are many distinctive lifetime impressions, but the majority are from cancelled plates. See Anne Thorold, 'The Pissarro Collection in the Ashmolean Museum, Oxford', *Burlington Magazine*, cxx (1978), pp. 642–5, for an account of the Pissarro Gift to Oxford.

3. The well-meaning efforts of Degas to start up a new journal failed. See Ronald Pickvance, *Degas 1879*, Edinburgh, National Gallery of Scotland, 1979, p. 76, for a discussion of *Le Jour et la Nuit*.

4. The important letter from Degas to Pissarro discussing techniques is published in *Lettres de Degas*, ed. Marcel Guérin, Paris 1931, No. xvi, pp. 33–6. For a translation see *Degas, Letters*, Oxford, 1948, No. 34, pp. 56–9.

5. Certain Degas proofs with this plate name were first noted by Paul Moses, *Etchings by Degas*, University of Chicago, 1964, p. 19 and I am indebted to Antonia Lant, whose paper for the University of Leeds provided further information. Degas plates (Adhémar and Cachin, *op. cit.*, Nos. A 29, 37 and 32 respectively) are: *Behind the curtain*, *The two dancers*, *The laundresses*, and the Pissarro plates are: *St. Martin's Day Fair at Pontoise*, D 21; *Setting sun*, D 22; and *Tree and ploughed field*, D 26. According to Janet Buerger, International Museum of Photography, Rochester, New York, the 'scored' corners of these prints suggest that they were made on Daguerreotype plates. Schneider of Berlin may have been a manufacturer of photographic plates.

6. Pissarro prints owned by Degas were D 15, 16, 17, 18, 21, 23, 24, 25, 31, 39, and probably 19 and 20. Two of these impressions are in the present exhibition (Cat. 156, 163).

7. The quotation by Félix Fénéon is given in Michel Melot, *L'Estampe impressionniste*, Paris, 1974, pp. 109–110. See also Joan V. Halperin, *Félix Fénéon, oeuvres plus complètes*, Geneva, 1970, i. p. 92.

8. For a discussion of monotypes, including those by Pissarro, see *The painterly print: monotypes from the 17th to the 20th century*, New York, The Metropolitan Museum of Art, 1980.

9. A group of these monotypes was first noted in the Pollag sale, Zürich, 1973, lots 2310–2314. Eight were cited in Barbara S. Shapiro and M. Melot, 'Catalogue sommaire des monotypes de Camille Pissarro' *Nouvelles de l'estampe*, xix (1975), p. 22, two of which were exhibited in Paris, *L'Estampe impressionniste*, nos. 265–6.

10. See C. Kunstler, *Landscapes and cities*, New York, n.d. pp. 42–4, and Kathleen Adler, *Camille Pissarro*, London, 1978, p. 132.

11. I am grateful to M. and Mme. Félix Pissarro for bringing this unpublished monotype to my attention.

12. Jean Cailac (*Print Collector's Quarterly*, xix (1932), p.76) states that the Pissarro *atelier* stamp was placed on certain impressions produced during the artist's lifetime and found in his studio after his death. The lifetime impressions of D 93, 94 and 187 with Pissarro's annotations differ greatly in quality of printing from the large editions of 50 to 100 impressions of these prints that bear this studio stamp. I am persuaded that it was placed on posthumous impressions probably intended for use in a publication.

151
By the water's edge *c.* 1863

Au bord de l'eau

D 2

Etching on copper, only state, on laid paper.

31.4 × 23.7 cm./21⅜ × 9⅜ in.

Museum of Fine Arts, Boston, George Peabody Gardner Fund (inv. 63.323)

According to Delteil, who catalogued Pissarro's prints in 1923, this etching and a variant in reverse of the same subject were the artist's first attempts at print-making. Delteil based his judgments on the family collections of Pissarro's prints as well as on those owned by the family's business adviser, Teissier, the printer of his late lithographs, Tailliardat, and the American dealers Samuel P. Avery, Kennedy, and Frederick Keppel. Above all, Pissarro himself had given to the Musée du Luxembourg about eighty-five impressions of his etched work, with inscriptions and dedications in his own hand.

In the light of Pissarro's printed *oeuvre*, this etching would take precedence stylistically and technically. The arcadian rural setting, a motif favoured by the artists of the Barbizon school, and the silver tonality of the idealized landscape are reminiscent of Corot's lyrical etchings and *cliché verres*. The loose network of fine cross-hatched lines, made with one biting of the acid bath, is the most direct and traditional method of executing an etching and gives no inkling of the remarkable and highly innovative techniques that Pissarro would attempt later.

Only three impressions of D2 are at present known. One impression in the Bibliothèque Nationale (where the prints from the Luxembourg Museum are now housed) is inscribed '*à mon ami Gachet*'. Dr. Paul Gachet, who signed his paintings, Van Ryssel, was the Pissarro family's homoeopathic physician and is known today for his role as friend and collector of the Impressionists. He made his etching press available to Pissarro, Cézanne, and Guillaumin during the summer of 1873.

LITERATURE: Leymarie and Melot P 2; Melot, 1974, No. 43.
EXHIBITED: Boston, Museum of Fine Arts, 1973 (1).

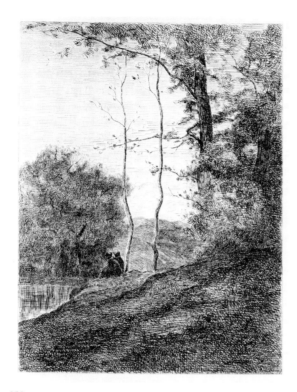

151

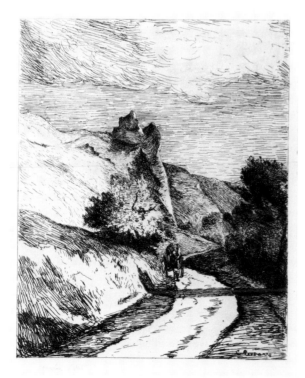

152

152
La Roche-Guyon *c.* 1866

D 5

Etching, first state, on wove paper. 31.8×24 cm./$12\frac{9}{16} \times 9\frac{7}{16}$ in.
Signed on the plate: *C. Pissarro.*
Inscribed, not in Pissarro's hand: *Epreuve d'état.*
The Cleveland Museum of Art, Cleveland, Delia E. and
L.E. Holden Funds (inv. 76.20)

Pissarro has subtly directed the viewer's eye to the remains of the mediaeval castle at La Roche Guyon, a small town on the banks of the Seine. According to contemporary guidebooks, it was a favourite tourist site, and during the 1860s Pissarro frequently painted there (Cat. 5, 7). The artist has centralized the idiosyncratic rock formation, and by clustering the deeply etched lines, he has contrasted light and dark segments in order to feature the geological outcrop. This print marks a firm departure from the more tentative and traditional etching technique noted in D 2 (Cat. 151). Pissarro executed another etching of La Roche Guyon in 1880 (D 27), which may have been included in the fifth Impressionist exhibition (Paris, 1880, No. 141).

The theme of the winding country road frequented by peasants who stood, conversed, walked, or travelled between villages and markets was a subject favoured by Pissarro. *La Roche Guyon,* among a few other early etchings, initiated this motif into his printed work.

An impression of the first state in the Bibliothèque Nationale is dedicated '*à mon ami Gachet*' and, like the preceding etching (Cat. 151), must have been offered to Dr. Gachet years after its execution.

PROVENANCE: Zürich, Dr. S. Pollag (Zürich, Galerie Wolfgang Ketterer, 27 November 1973, No. 10, lot 2161); California, Light.
LITERATURE: Leymarie and Melot P 5; 'The year in review for 1976', *The Bulletin of The Cleveland Museum of Art,* February, lxiv (1977), No. 89, p. 76.
EXHIBITED: Cleveland, The Cleveland Museum of Art, *The year in review for 1976,* Feb. 1977 (89).

153/154
Peasant woman feeding her child 1874
Paysanne donnant à manger à un enfant
D 12
Etching and aquatint on zinc. 12.5 × 12 cm./$4\frac{7}{8}$ × $4\frac{3}{4}$ in.

LITERATURE: Leymarie and Melot P12; Melot, 1974, No. 46, 47.

153
Etching, first state, printed in brown on wove paper.
Inscribed in pencil: *n° 5-I^er état/Paysanne donnant à manger/à un enfant (zinc).*
The Ashmolean Museum, Oxford, lent by the Visitors of the Ashmolean Museum

PROVENANCE: London, Lucien Pissarro collection; Esther Pissarro collection, by whom presented to the Ashmolean Museum, 1950.

154
Etching and aquatint, fourth state, printed in black on laid paper, 1880s rework of 1874 plate.
Inscribed in pencil: *4^e état n°1/Paysanne donnant à manger à un enfant zinc.*
Museum of Fine Arts, Boston, gift of Mr. and Mrs. Adolph Weil, Jr. in memory of Adolph and Rossie Schoenhof Weil (inv. 1977.741)

PROVENANCE: Camille Pissarro collection; Mme. Vve. Pissarro (Paris, Hôtel Drouot, 7 December 1928 lot 11).

The relationship of Pissarro's art with that of his predecessor, Jean-François Millet, is often commented upon, but a direct comparison between this print and an etching by Millet serves to point up the essential differences between the two artists (Fig. 5). This comparison was noted by Melot (1977). Millet's etching, *The porridge*, was made after a painting exhibited by the artist in the Salon of 1861. In both works, he has infused the subject with a spiritual quality that is reminiscent of the early images of the Virgin and Child. Pissarro, on the other hand, made a direct observation of a simple, everyday act and gave a sense of informality to the domestic genre scene. A small child stands before its mother, who casually turns aside; the two figures set in a spacious, comfortable interior are unified by humble gestures rather than by formal compositional arrangement. Pissarro's oft-quoted statement that 'it is I who am Jewish, but he [Millet] who is Biblical' (letter to Theodore Duret of 12 March 1882) is strikingly apt in this context.

Millet relied upon the traditional method of cross-hatching for modelling, whereas Pissarro preferred clusters of short lines, which give a more decorative, patterned effect. The first state of Pissarro's plate was rendered in the same linear manner as his other early etchings and lithographs. Much later in the 1880s, he re-worked the plate with aquatint to create three further states. This dark, inky effect recalls the manipulations of Degas, who altered an etched portrait of the engraver Baron Joseph Tourny with unusual monotype inking, nearly twenty years after its execution in 1857. (J. Adhémar and F. Cachin, *Edgar Degas gravures et monotypes*, Paris, 1972, repr. A8b.) Pissarro's efforts were less valid in the second and third states, but in the fourth state, illustrated here, he judiciously scraped and burnished in highlights and lighter tones, that reveal the earlier etched lines and successfully change the mood and atmosphere. Delteil gives the date of reworking as 1889 placing all of the 'dark' prints around the etching of *Grand' mère* (Cat. 183).

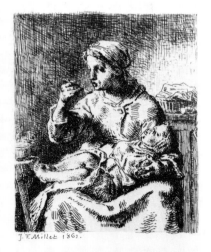

Fig. 5 Jean-François Millet (1814–75), *Peasant Feeding Her Child*, 1861, etching, Museum of Fine Arts, Boston, Harvey D. Parker Collection

153

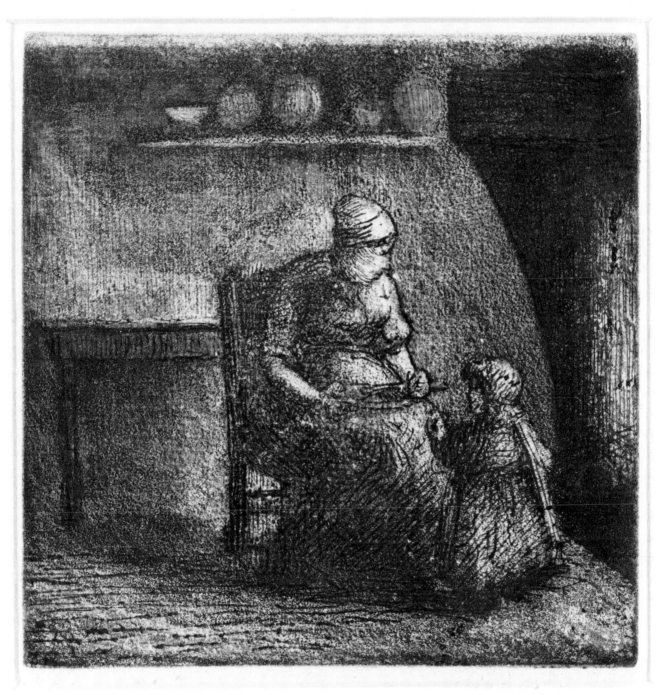

154

155
Portrait of Paul Cézanne 1874

Portrait de Paul Cézanne

D 13

Etching on copper, only state, on laid paper.

27 × 21.8 cm./$10\frac{5}{8}$ × $8\frac{5}{8}$ in.

Inscribed in pencil: *1^{er} Etat n^o 13/Cézanne.*

Private collection

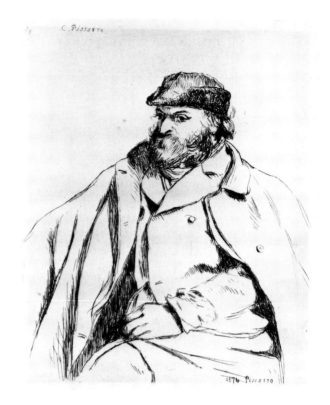

In the summer of 1873 Pissarro and Cézanne visited Dr. Paul Gachet at Auvers-sur-Oise, where, in his studio, they experimented with the etching medium. This impressive portrait, dated 1874, is a direct, simplified study in reverse (by nature of the printing process) of the painted portrait of Cézanne (Cat. 38). In both images, Cézanne wears the same rugged outdoor clothing – a distinctive cap and heavy, buttoned coat – although in the etching a voluminous cloak thrown over his shoulders fills more than half of the plate. Unlike the painting with its literary and political illustrations tacked up on the wall, the print has a blank background which sets off the imposing figure.

The economic use of bold, etched lines conveys Cézanne's character; there was no attempt to model the face or figure, nor were descriptive aids required to express his forceful personality. This impression is one of about twenty that Pissarro had printed; many of the early impressions bear the artist's dedications to his friends, among them: *'à M. Meyer van Deham'* (Fogg Museum), *'à M. van Gogh'* (Stedelijk Museum), *'à mon ami Gausson'* (repr. Lecomte, 1922). The etched portrait was later published in a short study of Cézanne by Emile Bernard in 1892, and reproduced as an illustration for a catalogue of Cézanne's paintings held at the gallery of Ambroise Vollard in November 1895.

In some of the impressions printed during Pissarro's lifetime, the image appears smaller due to a masking out of the signatures at the top and bottom; what often appears as an unusual proof is, in reality, the same version, for the inkless signature can be detected. At least 75 impressions were printed posthumously in 1911 and 1920.

LITERATURE: Leymarie and Melot P 13.

EXHIBITED: Boston, Museum of Fine Arts, 1973, (3).

156–161
Wooded landscape at L'Hermitage, Pontoise
1879
Paysage sous bois à L'Hermitage, Pontoise
D 16
Softground etching, aquatint, and drypoint on copper.
21.8 × 26.8 cm./8¾ × 10⅝ in.

LITERATURE: Leymarie and Melot P16; Melot, 1974, No. 235.
EXHIBITED: Boston, Museum of Fine Arts, 1973 (6–11).

156

156
Softground etching and aquatint, first state, on white wove paper.
Stamped in red on verso: *Atelier Ed. Degas* (Lugt 657).
Museum of Fine Arts, Boston, Lee M. Friedman Fund (inv. 1971.267).
PROVENANCE: Paris, Degas collection; Paris, Comiot collection; Paris, Marcel Guérin collection; D. David-Weill collection.

157
Softground etching and aquatint, second state, on buff laid paper.
Inscribed in black chalk: *n⁰ 2-1ᵉʳ état/Paysage sous bois à l'Hermitage/(Pontoise)* and *C. Pissarro*.
Stamped on verso: *Pennell Collection* (Lugt 2017).
Library of Congress, Washington

157

158
Softground etching and aquatint, third state, on laid paper.
Inscribed in pencil: *n⁰ 1-2ᵉ Etat/Paysage sous bois à l'Hermitage/Pontoise* and *C. Pissarro*.
The Minneapolis Institute of Arts, Minneapolis, gift of Philip W. Pillsbury, 1959
PROVENANCE: Camille Pissarro collection; Mme. Vve. Pissarro collection (Paris, Hôtel Drouot, 7 December 1928, lot 15).

159
Softground etching and aquatint, fourth state, on laid paper.
Inscribed in black chalk: *n⁰ 2-3ᵉ état/Paysage sous bois à l'Hermitage Pontoise* and *C. Pissarro*.
Philadelphia Museum of Art, Philadelphia, McIlhenny Fund

158

160
Softground etching, aquatint, and drypoint, fifth state, on laid paper.
Inscribed in black chalk: *n⁰ 1-4ᵉ état/Paysage sous bois à l'Hermitage/Pontoise* and *C. Pissarro*.
Museum of Fine Arts, Boston, Lee M. Friedman Fund (inv. 1971.268)
PROVENANCE: Camille Pissarro collection; Mme. Vve. Pissarro collection (Paris, Hôtel Drouot, 7 December 1928, lot 17); D. David-Weill collection.

159

160

161

161
Softground etching, aquatint, and drypoint, sixth state, on oriental paper.
Inscribed in pencil: *C. Pissarro*.
Museum of Fine Arts, Boston, Katherine Eliot Bullard Fund, Prints and Drawings Discretionary Fund, Anonymous Gifts, and Gift of Cornelius C. Vermeule III (inv. 1973.176)

In 1879 Edgar Degas conceived the idea of publishing a journal of prints, *Le Jour et la Nuit*, which was to include his own prints and those of Pissarro, Mary Cassatt, Félix Braquemond and others. Although no single issue ever materialized, three distinguished prints by Degas, Cassatt, and Pissarro attest to the care and serious concern which went into the project. In their desire for successful images, the artists based their prints on existing paintings. *Wooded landscape at L'Hermitage*, one of Pissarro's most renowned prints, is based on his painting of the same title dated 1879 (P&V 444, incorrectly dated 1878 and now in the collection of Dr. and Mrs. Nicholas S. Pickard). Pissarro retained the essential design of figural elements, reversed in the print, and used a remarkable combination of softground etching and layers of aquatint grains to duplicate on paper the dense, painted brushstrokes on the canvas.

In the first state (uncatalogued by Delteil) the key structural forms were vaguely established by softground lines. Fine aquatint grains created the over-all grey tones that supported the dark tree trunks, which, in turn, were brushed on the plate with lift-ground.

A small amount of scraping introduced the light, cubic-shaped houses. Just as Pissarro's 'screen' paintings of this period (Cat. 46–7) demonstrate his interest in the fusion of figures with surroundings, so this initial state indicates his preoccupation with rendering a kaleidoscopic impression of the Pontoisian landscape, rather than focusing on separate visual items.

In the second state Pissarro painted wisps of acid directly on the plate in the same positive manner that he used to manipulate paint and turpentine. The sky, hilly terrain, and underbrush merge into a grey monochromatic tonality relieved only by the coarsely aquatinted tree trunks. In the third and fourth states, the acid tints blended mightily with the aquatint layers. Further scraping, however, now prevented the tapestry of tightly-knit foliage from overwhelming the subtly penetrating light. At this point, the barely perceptible torso of the male figure is no longer intersected by a tree trunk.

As Pissarro became more involved with the inherent possibilities of technique, he scraped and polished the grey matrix and dark areas to increase the volume of light. In the fifth state, a balance of light and dark and a closer harmony of values was achieved; and, finally, in the sixth state, only a few additional drypoint accents were added. A light aquatint application compensates for the previous extensive scraping, which models, in a more satisfying way, the undergrowth in the foreground. With the exception of the first state, which was found in Degas's studio after his death and was probably forgotten by Pissarro, each impression was annotated as it represented a new state. This acceptance by the artist of a sequence of printed changes was an unconventional practice and exemplified the impressionist aesthetic, whereby a series of equivalent views of the same motif were relevant and justified (see Melot, 1977, pp. 14 ff.).

The finished plate was given to Salmon, a professional printer, who made an edition of fifty on oriental paper. The artist, pleased with the results, exhibited four states in a frame at the fifth Impressionist exhibition in 1880 (No. 139). Other sequences were also included on that occasion: three states of D20 (No. 142), three states of D21 (No. 140), and two states probably of D17 (No. 142). This may well have been the first occasion that an artist exhibited intermediate working proofs of a print, and it is proof of the confidence that Pissarro had in his own skills to display, for critical approval, the progressive steps and changes that he attempted. Impressions were later shown at Durand-Ruel in 1889 and 1890.

162
Horizontal landscape 1879

Paysage en long

D17

Etching and aquatint, third state, on white wove paper.

11.7 × 39.5 cm./4½ × 15½ in.

Inscribed in black chalk: *nº 2/Epreuve d'artiste/cuivre paysage en/long* and *C. Pissarro.*

Museum of Fine Arts, Boston, Ellen Frances Mason Fund (inv. 34.580)

This horizontal panorama displays a spaciousness that is unique in Pissarro's printed work and unknown in that of other impressionist print-makers. The format is related to the series of four horizontal panels commissioned by Achille Arosa, and painted by Pissarro in 1872–73 (P&V 183–6). They may have been originally inspired by the landscape designs of the Japanese woodblock artist, Hiroshige. Admiring Rembrandt as he did, Pissarro must also have been aware of the Dutch landscape etchings in wide format, so obviously appropriate for this genre.

Pissarro 'stretched' the landscape depicted in the more complex plate he completed for *Le Jour et la Nuit* (Cat. 156–61). As in that print, he has rendered these three states primarily in a variety of aquatint tones, clarified in each successive state by additional etched lines that gently delineate the trees, and houses.

Impressions of this print taken during Pissarro's lifetime are rare. Those known to me are: a first state, private collection, Paris; second state, British Museum; third state, Museum of Fine Arts, Boston, and the Art Institute of Chicago. The one known

impression of the second state is inscribed '*zinc*,' and the few extant impressions of the third state carry the notation '*cuivre*'. The zinc plate had a sharp edge, whereas the copper plate was bevelled. To confirm this curious fact, there are two impressions in the Ashmolean Museum taken from different plates that were rudely cancelled after a posthumous edition was printed (Fig. 6a & b). Two notebook pages in the Pissarro Archive in Oxford further substantiate the existence, at one time, of two plates. On a '*Liste des Plaques sur la table*' of Paul-Emile Pissarro (fifth son of the artist) at his home in Paris and dated 2 July 1919, there is indicated (No. 69) '*paysage en long 1 cuivre 1 zinc*'. On a page '*Liste des Plaques chez M. Porcaboeuf*', from a booklet dated 24 October 1923, is written '*Paysage en long/(electro)*'. Evidently the intaglio plate was duplicated by means of electrotyping (*galvanoplastie*). A wax mould of the original zinc plate was placed in an electro-plating bath, until an adequate film of copper was deposited in order to reproduce every indentation with great fidelity. (See Félix Brunner, *A handbook of graphic processes*, New York, 1962, p. 287, for further details.)

Knowing that Pissarro and Degas were working together at this time, one can only presume that the two artists, interested in this relatively new process, experimented with one of Pissarro's plates to obtain astonishing results. In the 1918 sale of the collection of Edgar Degas (Paris, Georges Petit, 26–27 March, 1918, lot 309), there is listed *Le Vallon pièce en forme de frise*, which undoubtedly refers to this *Horizontal landscape*.

LITERATURE: Leymarie and Melot P17.

EXHIBITED: Boston, Museum of Fine Arts, 1973 (12).

a

b

Fig. 6 *Paysage en long*, 1879, two impressions from cancelled plates, The Ashmolean Museum

163
The woman on the road 1879

La femme sur la route
DI8
Aquatint with etching and drypoint on copper, fourth state.
Platemark (irregular): 15.6×21 cm./$6\frac{1}{8} \times 8\frac{1}{4}$ in.
Sheet: 17×24.7 cm./$6\frac{5}{8} \times 9\frac{3}{4}$ in.
Stamped in red on verso: *Atelier Ed. Degas* (Lugt 657)
Library of Congress, Washington, Pennell Fund

On a thinly hammered, irregularly shaped piece of copper, Pissarro created one of his most painterly and technically unusual prints. It is one that could never have been executed by traditional print-makers and probably would not have been made without the encouragement of Degas, who owned two proofs, including this impression.

Although it is difficult to unravel Pissarro's methods with precision, it is evident that he first delineated the composition with lightly etched lines. At least three different aquatint layers, ranging from a very fine texture to a more open, granular network, were applied in varying strengths to indicate the pictorial elements. Most unusual are the billowy clouds, which were essentially painted on the plate. Pissarro worked in a 'positive' and 'negative' fashion; he washed the fine aquatint onto the area of sky, then painted with 'stop-out' to shape and protect the forms when the plate was dipped into an acid bath.

Each compositional element enjoys the same degree of representation. The clouds are as strong as the surrounding hills; even the slight, remote peasant figure is clearly established against the lightly printed road.

After making a boundary to contain the image, Pissarro indiscriminately extended beyond the lines, using the margins as a testing area for crosshatching and softground work, while ink coagulated around the plate edges. It is possible that the plate was not entirely finished; one can still, however, appreciate the forcefulness and skill with which the artist expressed his vision.

Lifetime impressions of the print are extremely rare; under the supervision of Lucien, much of the marginal work was removed in the posthumous edition.

LITERATURE: Leymarie and Melot PI8; Melot, 1974, No. 243.

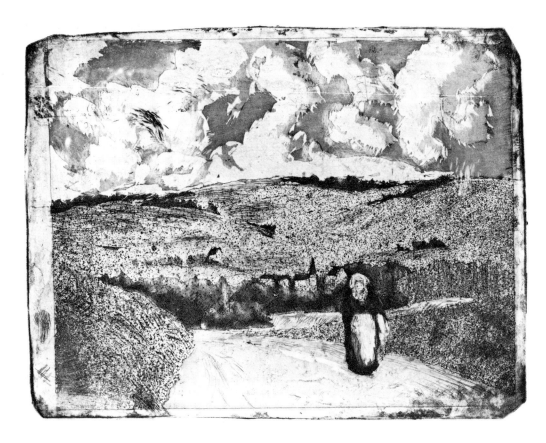

164–168 ILLUSTRATED IN COLOUR
Twilight with haystacks 1879
Crépuscule avec meules
D 23
Aquatint with etching and drypoint on copper.
10.5 × 18 cm./$4\frac{1}{8}$ × $7\frac{1}{8}$ in.

LITERATURE: Leymarie and Melot P 22; Melot, 1974, No. 237–238.

164
Second state, printed in blue on wove paper.
Inscribed in pencil, not by Pissarro: *outremer*.
The Ashmolean Museum, Oxford, lent by the Visitors of the Ashmolean Museum

PROVENANCE: London, Lucien Pissarro collection; Esther Pissarro collection, by whom presented to the Ashmolean Museum, 1950.

165
Third state, printed in red on laid paper.
Inscribed in pencil: *no 7 Epreuve d'artiste/Crépuscule (cuivre)* and *C. Pissarro/imp par E. Degas*; in another hand: *vermillon*
The Art Institute of Chicago, Chicago, The Clarence Buckingham Collection (inv. 1979. 650)

PROVENANCE: Berne, Kornfeld and Klipstein, 20–22 June 1979, No. 169 lot 1092; Düsseldorf, C. G. Boerner.

166
Third state, printed in brown on verso of wedding invitation.
Inscribed in pencil: *n⁰ 8 épreuve d'artiste/cuivre crépuscule* and *C. Pissarro/imp. par Degas*; in another hand: *brun Vandyke*.
Bibliothèque Nationale, Paris, Cabinet des Estampes.

EXHIBITED: Paris, Bibliothèque Nationale, *L'estampe impressionniste* 1974 (238).

167
Third state, printed in red-brown on laid paper.
Inscribed in pencil: *n⁰ 9/épreuve d'artiste/cuivre – crépuscule* and *C. Pissarro/imp. par E. Degas*; in another hand: *brun rouge*.
National Gallery of Canada, Ottawa

PROVENANCE: Vente Hôtel Drouot, 13 April 1973, lot 10.
LITERATURE: *Canadian Art Review*, iv, no. 2 (1977) p. 136, no. 70 repr.

168
Third state, printed in black on wove paper.
Inscribed in black chalk and pencil: *no 3 Epreuve d'artiste/crépuscule (cuivre)* and *C. Pissarro/imp. par Salmon*.
Museum of Fine Arts, Boston, Lee M. Friedman Fund (inv. 1974.533)

PROVENANCE: Zürich, Dr. S. Pollag (Zürich, Galerie Wolfgang Ketterer, 27 November, 1973, No. 10 lot 2175); California, Light.

If one could characterize a typical impressionist print, then *Twilight with haystacks* would be an outstanding example. The artist has created a *tour de force* of luminosity and even when printed in black and white, this etching conveys an extraordinary implication of colour and light.

The composition was realized in three states. Initially, a rhythm of forms including two small figures, a curved road, double haystacks, and a row of trees on the horizon were all established by means of liquid aquatint (grains of rosin mixed in ether or alcohol), that literally puddled into abstract shapes. Additional coarser aquatint grains then created different textures and deeper tones. In the third state fine etched and drypoint lines clarified forms, especially the imperfectly silhouetted trees. Touches of acid brushed directly onto the sky heighten the effect of scudding clouds. Although all the components enjoy the same pictorial weight, the uneven aquatint and acid effects set up a delicate and shimmering balance between the recognizable and the illusionistic.

Of great appeal are the colour proofs of the second and third states, printed for the most part by Degas. Currently known are impressions in Van Dyke brown (Bibliothèque Nationale), in ultramarine and in crimson lake (Ashmolean Museum), in vermilion (Chicago Art Institute), in red-brown and in green (National Gallery, Ottawa). Their existence raises many tantalizing questions about the involvement of Pissarro and Degas in making colour prints. For instance, Degas may have been influenced by his neighbour, Louis Mante, a bassoonist in the Paris *Opéra*, who was an avid and inventive photographer (see Jacqueline Millet, 'La Famille Mante, Une Trichromie, Degas, L'Opéra,' *Gazette des Beaux-Arts*, xciv (1979), pp. 105–112). In his aim to keep 'the colours of Nature,' M. Mante produced a *chromophotolithographie* as early as 1856. He is better known as the father of the young Mante sisters, ballerinas in the *corps de ballet* and frequent models for Degas. Since Degas was fond of experimentation in photography and print-making, he must have tempted Pissarro to try for the unusual colour sensations in *Twilight with haystacks*. Although distinctly different, it is also worth noting the curious experiment in colour etching by Félix Braquemond. The print, *At the Zoological Gardens*, was begun in 1873 and shown at the fourth Impressionist exhibition in 1879. (See Joel Isaacson, *The crisis of Impressionism 1878–1882*, University of Michigan, 1979, pp. 52–4).

The impressions in blue and red were printed in a straightforward manner, without selective wiping. The colours are surprisingly clear and have an intensity of hue found in many of Pissarro's paintings. In contrast, the Ottawa impression, delicately wiped and printed in reddish-brown ink, suggests an early morning light rather than twilight. The fine etched lines are barely visible, the aquatint tones are softened, and the two figures who walk down the turning path seem dissolved in sunlight.

The Bibliothèque Nationale impression, darkly inked in brown, is casually printed on the verso of the wedding invitation of Louis Gonse, director of the *Gazette des Beaux-Arts*. It is dated 'Paris, 17 juin 1879', and verifies the period when Degas and Pissarro were working most closely together.

As a group, these prints in colour are the equivalent of Monet's series of painted haystacks, and by special inking reflect the same modification of light and atmosphere as their painted counterparts. Only from the unchanging configurations and their fixed shadows can one ascertain that the 'changing' light in the prints is based on an etched and constant armature. Melot (1977, p. 16) astutely makes the comparison between Pissarro's prints and Monet's paintings, although Monet did not attempt his haystack sequence until nearly a decade after Pissarro and Degas had completed these distinctive and creative prints.

164

165

166

167

168

169–170
Rain effect 1879

Effet de pluie
D 24
Etching and aquatint on zinc. 16 × 21.4 cm./6¼ × 8½ in.

LITERATURE: Leymarie and Melot P 23; Melot, 1974, No. 239.
EXHIBITED: Boston Museum of Fine Arts, 1973 (17).

169
Second state, aquatint only, on laid paper.
The Ashmolean Museum, Oxford, lent by the Visitors of the
Ashmolean Museum

PROVENANCE: London, Lucien Pissarro collection; Esther Pissarro collection, by
whom presented to the Ashmolean Museum, 1950.

169

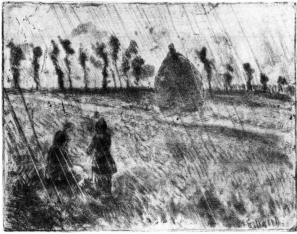

Effet de pluie *C. Pissarro*

170

170
Sixth state, printed in brown on buff laid paper.
Inscribed in ink: *Effet de pluie* and *C. Pissarro*: signature etched
in plate.
The New York Public Library, New York, Prints Division

PROVENANCE: New York, Samuel P. Avery collection.

It is evident that Pissarro studied Japanese woodcut prints by
Ukiyo-e ('floating world') artists and was especially aware of those
that depicted rain and snow effects. Inspired, perhaps, by
Hiroshige, Pissarro embarked on *Rain effect*, a remarkable
adventure in the development of different states.

In the second state, a light aquatint grain barely indicates the
eventual compositional elements, although the misty quality of
light is already apparent. Even though unfinished by nineteenth-
century standards, the abstract detached quality of this early state
appeals to our twentieth-century sensibility. With etched and
drypoint lines, Pissarro shaped the islands of aquatint into a row of
trees that parade across the horizon, a large hayrick near an
indistinct path, and into two peasant figures resting from their
labours. In the fourth state (the four known impressions were
incorrectly annotated *2e état*), he used a multi-pronged tool to
produce grass-like strokes in the foreground terrain. One
impression bears an annotation, not in Pissarro's hand (possibly by
his son, Ludovic-Rodolphe) that gives a surprising description of
the technique: '*Imprimé par E. Degas*' and '*aquatinte coulée par
Pizarro, 2e état reprise au pinceau métallique sur vernis mou.*' Rather
than scratch directly onto the plate with a sharp tool, Pissarro used
the more sophisticated and unusual method of softground in order
to draw freely but with better control. A letter from Degas
appropriately describes what may have taken place. 'To obtain
equal hues [aquatint] this is necessary; to get more or less regular
effects you can obtain them with a stump or with your finger or
any other pressure on the paper which covers the softground.'
(*Lettres de Degas*, ed. M. Guérin, Paris, 1931, No. XVI, pp. 33–6).

In the sixth and last state, the atmospheric light was sharply
reduced with the addition of pronounced oblique strokes. Again,
using a unique and probably adapted tool (just as Degas has baffled
today's print-makers with his use of the *crayon électrique* or Voltaic
pencil), Pissarro created a convincing sensation of falling rain.
With added finesse, he burnished or 'erased' subtle slashes into the
darker areas of the figures and field, increasing the effect of driving
rain. The traditional canon of print-making processes was
disregarded; calling upon his affection for Japanese prints and
mindful of the technical expertise of Degas, Pissarro developed his
own inventive manner.

The final state was printed in about ten impressions during
Pissarro's lifetime, before a posthumous edition of fourteen; this
impression printed in brown provides a softer effect than those in
black ink. Degas owned at least one impression of *Rain effect*,
although he may have printed more.

171–172
Woman in a kitchen garden *c.* 1880

Femme dans un potager

D 30

Etching on zinc. 24.8 × 16.9 cm./$9\frac{3}{4}$ × $6\frac{5}{8}$ in.

LITERATURE: Leymarie and Melot P 30; Melot, 1974, No. 246.
EXHIBITED: Boston, Museum of Fine Arts, 1973, (26,27).

171
First state, etching, on laid paper.
Inscribed in pencil: *1er état no 2.*
The Art Institute of Chicago, Chicago, William McCallin McKee
Memorial Collection (inv. 46.441)

172
Third state, etching, softground etching, and aquatint, on laid
paper.
The Art Institute of Chicago, Chicago, William McCallin McKee
Memorial Collection (inv. 46. 441/2).

This image is typical of Pissarro's concern with the small vegetable garden usually shown, as here, attended by a single peasant woman. In this instance, the manageable plot of ground, the bare sinewy trees, the distant house and wall, and the exaggerated cabbage leaves all enframe the strongly rendered, bent figure whose face anonymously merges with the natural forms. The intimate and informal character is in contradistinction to Millet's figures, who toil on the land heroically. Here the woman performs her daily chores effortlessly without the moral sense of earthly renewal depicted by Millet.

Pissarro used two plates prepared with softground and three state changes to determine this final representation. *The cabbage field* (D 29, Fig. 7) is a similar but less finished version; the compositional elements were not formally conceived as modules nor was the woman included. Both prints were preceded by preparatory drawings: a small drawing on thin tissue and at least two pencil studies on grainy paper that were used to transfer the design to the plates (Fig. 8, 9). All these studies have softground deposits on their versos; the Washington drawing has blind stylus marks as well, which caused additional particles of the waxy ground to lift when the sheet was removed, and signifies its role in the transfer process. Two other preliminary studies for D 29 are known (Sotheby's, 4 July 1968, lot 263 repr. and London, JPL Fine Arts, 1978 (14 repr.)).

It is obvious that Pissarro explored this motif with care, reaching his final results through a series of disciplined steps. His working procedures belie the modern notion that impressionist art was merely a spontaneous reaction to a perception of nature.

The combination of intaglio techniques on a single plate was barely considered until Degas and Pissarro abandoned conventional printing procedures and set about making their images in an unorthodox fashion. In *Woman in a kitchen garden* bold lines were deeply etched into hard and soft grounds, aquatint was added, there was scraping and burnishing, and even accidental scratches were incorporated into the image. Degas referred to this print when he wrote: 'No need to compliment you on the quality of the art of your vegetable gardens.' (*Lettres de Degas*, ed. M. Guérin, Paris, 1931, No. XVI, pp. 33–6).

171

172

Fig. 7 *Le Champs de choux* (The Cabbage Field), about 1880, softground etching, National Gallery of Art, Rosenwald Collection

Fig. 8 Drawing for *The Cabbage Field*, about 1880, pencil with softground on verso, The Ashmolean Museum

Fig. 9 Drawing for *The Cabbage Field*, about 1880, pencil with softground on verso, National Gallery of Art, Rosenwald Collection

Fig. 7

Fig. 8

Fig. 9

173–174
Woman emptying a wheelbarrow 1880
Femme vidant une brouette
D 31
Drypoint and aquatint on copper. 32 × 23.2 cm./$12\frac{1}{2}$ × $9\frac{1}{8}$ in.

LITERATURE: Leymarie and Melot P 31.

173
Drypoint, second state, on wove paper.
Inscribed (incorrectly) in black chalk: *4ᵉ état nᵒ 1/femme vidant une brouette*
The Ashmolean Museum, Oxford, lent by the Visitors of the Ashmolean Museum
PROVENANCE: London, Lucien Pissarro collection; Esther Pissarro collection, by whom presented to the Ashmolean Museum, 1950.

174
Drypoint and aquatint, twelfth state on cream laid paper.
Inscribed (incorrectly) in black chalk: *11ᵉ état nᵒ 1/femme vidant une brouette/aquateinte (belle épreuve).*
Sterling and Francine Clark Institute, Williamstown
PROVENANCE: Camille Pissarro collection; Mme. Vve. Pissarro (Paris, Hôtel Drouot, 7 December 1928, lot 43); New York, Deitsch, 1957, cat. 5 No. 28.
EXHIBITED: Boston, Museum of Fine Arts, 1973 (24 – see also illustrations of four other states).

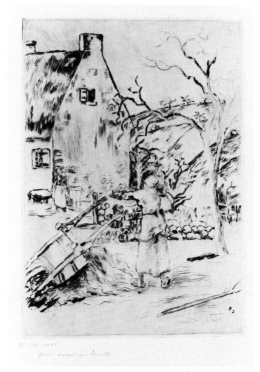

173

These two impressions are merely the first and the final statements of one of Pissarro's most unusual and technically complex prints. Delteil cited eleven states, and Cailac (1932), who made later additions to Delteil's catalogue, mentions another change, which brings the total to twelve. Pissarro himself casually and often inaccurately annotated the development of states; more important is the fact that he inscribed the successive impressions, proving that he conceived the various proofs as part of a sequence of related views expertly manipulated on a plate. In a small printed format he provided a unique progression of seasonal effects.

Of great interest are the impressions possessed by Degas, which confirm his involvement with the production of the print. According to Delteil, Degas owned two states and, in the 1918 sales held after his death, there were also eight proofs including a maculature of the tenth state. After taking an impression from the plate, Degas ran a second sheet through the press withdrawing the remaining ink; Degas, who was known for his extreme tendency to hoard possessions, could not even dispose of this unusual but obviously experimental impression (see Berne, Kornfeld and Klipstein, 1971, No. 142, lot 1066, repr., incorrectly listed as a first state). In general, the Degas impressions were printed with an additional tone of ink, reflecting the artist's concentration on monotypes at this time. (*Atelier Ed. Degas* impressions are found at The Art Institute of Chicago (IV and X/XI states); Library of Congress (V); Museum of Art, Rhode Island School of Design (VIII)).

In the first three states, Pissarro firmly established the

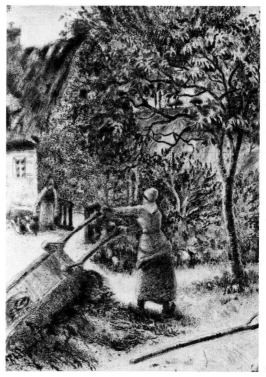

174

composition with drypoint lines. In the Ashmolean Museum impression, the rich drypoint burr reinforces the bleak wintry scene accentuated by the barren tree at right. Pissarro's initials appear in reverse in the lower right corner.

The artist continued to investigate the pictorial forms and, as the drypoint lines weakened, he added further tone to the plate by employing his inventive *manière grise* (grey manner) technique (one impression is even sub-titled *manière grise*). This unique method consisted of using abrasive materials such as sand-paper, emery stone, or metal brushes to scratch the surface of the plate, which could then be printed 'dry' or even bitten with acid. Whatever his means, Pissarro created a fixed tonal matrix without requiring the special manipulation of ink each time the plate was printed. The earlier reversed initials were now converted into his name with the date, 1880.

After the sixth state, Pissarro completely altered the plate with additional scraping and, notably, by piling on a coarse-grained aquatint. The original drypoint contours receded into the layers of aquatint, and the simplified winter landscape became a painterly, lush summer setting. The signature and date were now removed.

In the twelfth and last state, Pissarro applied new aquatint touches, simulating foliage. Some fresh drypoint accents further delineated the once barren tree and its spiky-leafed branches, giving a greater structural clarity. The rich textures and formal images merged into a 'vivid sensation', a sense of changing time rather than a change of forms was effectively and uniquely rendered.

Throughout the development of this 'printed painting,' Pissarro repeatedly altered the definition of space and the relationship of the working figures to their landscape. One enduring motif was the steep embankment which acted as a backdrop for the scene. Although pictorially unusual, it is topographically correct, for the town of Pontoise is indeed surrounded by hills, which dictated the high horizon line noted in so many of Pissarro's works.

A gouache (P&V 1342), simpler in composition and in reverse, may have served as the source for the drypoint. In the *catalogue raisonné*, however, the date of the gouache is probably based on the print.

175
Chestnut vendor 1881
Marchande de marrons
D 15
Drypoint, first state before steelfacing, on laid paper.
20.8 × 16.9 cm./$8\frac{1}{8}$ × $6\frac{3}{8}$ in.
Inscribed in pencil: *Epreuve tirée chez Degas/ Al. R.* and stamped in violet: *Alexis Rouart collection* (Lugt 2187a)
Museum of Fine Arts, Boston, Horatio Greenough Curtis Fund (60.1459)

This drypoint is generally accepted as the first print that Pissarro made in collaboration with Degas, although its obvious relationship to a gouache dated 1881 (P&V 1348) suggests that a date later than Delteil's 1878 must now be accepted. In the gouache there is one less figure in the foreground, and the architecture is more detailed and expanded, yet the many similarities and the fact that the drypoint was printed in reverse (therefore copied from its painted source) are of great significance. A watercolour of the same subject as the print, unfortunately not dated, is reproduced in Rewald, 1962, (French edn. only), p. 45.

This impression was printed at Degas's studio on his press; another impression (National Gallery of Art, Washington, Rosenwald Collection) bears the red Degas *atelier* stamp on the verso, confirming once more that Degas frequently printed the plates that Pissarro brought to Paris.

Pissarro inscribed the watercolour and an impression in the Bibliothèque Nationale, '*Foire de la Saint-Martin*', thereby localizing this market scene. The fair, one of the major events of the year in Pontoise, took place in the late autumn. Although this subject is depicted in other media, the print is unusual in technique and compositional arrangement.

The staccato flecks of drypoint, rich in burr, create sharp accents in contrast to the soft grey tonality of the delicate lines. This sensitive balance of tones can only be attained in a well-printed impression such as the one illustrated here. Aware of the fragility of drypoint, Pissarro had the plate steel-faced after taking only a few impressions; unfortunately, the results were not as rich or as satisfying as they had been before. In the late nineteenth century, the mechanical process of steel-facing copper plates for further editions was much in favour. Although it was most successful with line etchings, delicate drypoint and aquatint work could not be well preserved. (Compare the drypoints before and after the steel-facing of *The Saltimbanques* series completed by Pablo Picasso in 1905, for which see B. Geiser, *Pissarro, peintre-graveur*, I, Berne, 1955, No. 6, 11, 12 and others).

About twenty years later, in 1896, Pissarro returned to this plate, most likely removing the steel facing in order to re-work the image.

PROVENANCE: Ludovic-Rodolphe Pissarro collection, the artist's fourth son; New York, Peter H. Deitsch, October 1957, cat. 5, no. 22.
LITERATURE: Leymarie and Melot P 15; Melot, 1974, No. 234.
EXHIBITED: Boston, Museum of Fine Arts, 1973 (5).

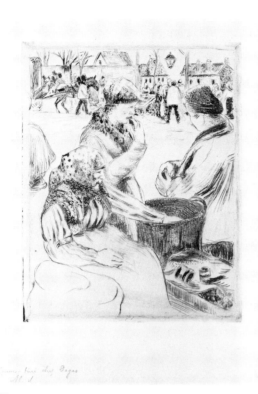

175

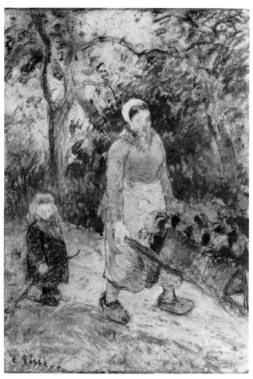

176

176 EXHIBITED IN BOSTON ONLY
Woman with a wheelbarrow 1882
Femme à la brouette
D 36
Gouache, pastel and black crayon over drypoint.
25.1 × 17.2 cm./$9\frac{7}{8}$ × $6\frac{3}{4}$ in.
Museum of Art, Rhode Island School of Design, Providence, gift
of Mrs. Gustav Radeke

For those impressionist painters who made prints, it was inevitable
that they would occasionally overpaint an impression with chalks,
gouache, pastel, or watercolour. Degas, the most proficient and
prolific practitioner of this art, had been covering monotypes with
resplendent pastel since about 1875, and his work may have served
as a model for Pissarro.

In 1882 Pissarro made a drypoint of which he printed only a few
impressions. A long accidental scratch can be noted along the
length of the right side of the image (reproduced in Delteil), and the
artist's efforts to burnish and remove the unwanted line were
apparently unsuccessful. With pastel, gouache, and black crayon,
Pissarro transformed one impression of the unsatisfactory print
into a small, stunning painting. Using short strokes and thick dabs
of vivid colours – blues, two shades of green, yellow, orange, and
violet – he extended the range of tonal and textural possibilities.
Fragments of worn drypoint lines can still be detected beneath the
overpainting and continue to function as contour outlines. Pissarro
framed the drawing with a distinctive rose/mauve border, in
keeping with his interest in white or coloured frames: 'As for
urging Durand-Ruel to hold an exhibition in a hall decorated by us,
it would, I think, be wasted breath. You saw how I fought with him
for white frames, and finally I had to abandon the idea.' (*Lettres*,
p. 33).

Although this composition is nearly the same as a gouache of
1892 (P&V 1469), the latter is less tightly conceived than the
gouache over drypoint study. As early as 1879 Pissarro began to
heighten prints with pastel and continued this practice into the
1890s (see D 25, 63, 101, 116, 161 and catalogued as P&V 1542,
1572, 1573, 1591, 1600 respectively).

PROVENANCE: New York, Frederick Keppel collection; Providence, Mrs. Gustav
Radeke.
LITERATURE: 'The Radeke Collection of Drawings', *Rhode Island School of Design
Bulletin*, xix, No. 4 (1931), p. 68; Leymarie and Melot P 36 (listed as a drypoint).
EXHIBITED: Buffalo, Albright Art Gallery, *Exhibition of master drawings selected from
the Museum and private collections of American art*, 1937, (118 as a drawing); Boston,
Museum of Fine Art, 1973 (38); Museum of Art, Rhode Island School of Design,
*Selection V: French watercolours and drawings from the Museum's collection
c. 1800–1910*, 1–25 May, 1975 (58).

177
Mother nursing her child 1882

Enfant tétant sa mère

D 39

Aquatint with drypoint on copper, second state, on cream laid paper. 12.4 × 11.3 cm./4¾ × 4⅜ in.

Inscribed in black chalk: *2e état – no 2/Enfant tétant sa mère cuivre aquat.* and in pencil, lightly; *2e état*

Private collection

177

The renowned print curator Arthur Hind (1880–1957) wrote that the delicate grey tones employed by Pissarro in his prints were derived from the transparent hues of the Japanese woodcuts. Also influenced by the Japanese aesthetic was the artist's placement of the mother and child near the surface of the picture plane, so abruptly cut by the edge of the plate.

The composition was first rendered in soft curving shapes of aquatint, barely controlled by lightly drawn drypoint lines. Here, in the second state, Pissarro dramatically altered the plate. Additional drypoint crisply clarified and modified the pictorial contours and suggested an ornamental wallpaper that replaced, in part, the original voluminous bed.

In the third state (Fig. 10), the initial silver tonality has disappeared, and reworking with needle and aquatint layers has produced a forceful contrast of light and dark. The profile and coiffure of the mother are more sharply described and the baby, now bareheaded, turns to his mother and is nursing. The abstract background shapes have become geometric quadrants that contain an open window, two chairs, and various patterned textures. This intimate scene prefigured the multiple decorative surfaces, and interior settings, that Edouard Vuillard later preferred in his paintings and prints of contemporary domestic life.

During the 1880s, Pissarro worked in two manners: curvilinear and geometric. The paintings of this decade were often experimentations in differing treatments of composition and space; it is significant that the three states of this print permitted Pissarro to move from one formula to another all within the confines of a single copper plate. Making a print enabled the artist to record with relative speed a change of intentions, without having to initiate a new composition.

Lifetime impressions of *Mother nursing her child* are very rare; one impression was owned by Degas and appeared in the 1918 studio sale entitled, *Le sein* (Paris, Georges Petit, 26–27 March 1918, lot 308).

PROVENANCE: Camille Pissarro collection; Mme. Vve. Pissarro (Paris, Hôtel Drouot, 7 December 1928 lot 54); Zürich, Dr. S. Pollag (Zürich, Galerie Wolfgang Kettner, 27 November 1973, No. 10, lot 2189); California, Light.

LITERATURE: Boston, 1973 (27 first state); Leymarie and Melot P 39 (third state).

Fig. 10 *Enfant tétant sa mère*, 1882, aquatint with drypoint, third state, Bibliothèque nationale, Cabinet des estampes

178
Potato harvest 1882

Récolte de pommes de terre
D 63
Etching and aquatint on copper, seventh state, on buff laid
paper. 28 × 22 cm./11 × 8⅝ in.
Inscribed in ink: *La récolte de pommes de terre/à Pontoise 1882*
and *C. Pissarro*
The New York Library, New York, Prints Division

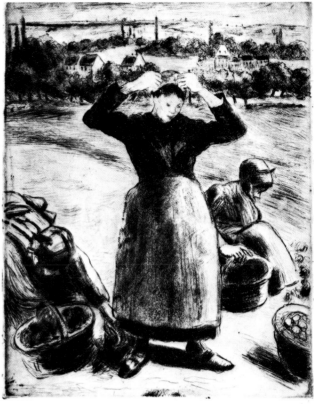

During the 1880s Pissarro changed the emphasis in his treatment of
human figures. His desire to give the peasant models a more
prominent role is admirably revealed in this study of harvesters.
The sturdy figure, who stands and adjusts her bonnet, towers
above her crouched companions and dominates the Pontoisian
landscape that rises up like a crown behind her. A band of open
fields, sketchily indicated, spatially separates the two parts of the
composition.

At first, Pissarro used etched lines that resembled those of a pen
and ink drawing. As he moved from the initial stage, he scratched
the plate (*manière grise*), added linework, and applied a dusting of
aquatint grains that darkly modelled the peasant figures, especially
the standing woman. Of equal importance is the work that Pissarro
courageously removed; by 'erasing' with a burnisher,
modifications of the figures and costumes were achieved and the
sharp tonal effects were reduced. Finally, small touches of aquatint
and drypoint lines added reinforcement. This impression, acquired
by Avery, was annotated '*1882*' by Pissarro confirming that Delteil
was incorrect in his date of 1880. This etching was one of the prints
that Pissarro favoured, for he showed it in the eighth Impressionist
exhibition of 1886 (No. 109). There is a proof heightened with
pastel (P&V 1573) made in the same year as *Woman with a
wheelbarrow* (Cat. 176), one more instance of Pissarro's working in
another medium over a printed image.

PROVENANCE: New York, Samuel P. Avery collection.
LITERATURE: Leymarie and Melot P 62; Rewald, 1963, repr. p. 55.

179
Promenade in Rouen: Cours Boieldieu 1883

Cours Boieldieu, à Rouen

D 46

Drypoint, first state, on cream laid paper. 15 × 19.5 cm./ $5\frac{7}{8} \times 7\frac{5}{8}$ in.

Inscribed in pencil: *1er état n° 1*/(crossed out: *Port de Rouen (St Sever)*)/*cuivre (avec femme à gauche)* and *Cours Boëldieu à Rouen*.

Museum of Fine Arts, Boston, Lee M. Friedman Fund (inv. 58.129)

LITERATURE: Leymarie and Melot P 47.

EXHIBITED: Boston, Museum of Fine Arts, 1973 (29).

180
Côte Sainte-Catherine, Rouen 1883

Côte Sainte-Catherine, à Rouen

D 48

Etching, drypoint and aquatint, fourth state, on laid paper. 15 × 19.4 cm./$5\frac{7}{8} \times 7\frac{3}{4}$ in.

Inscribed in pencil: *4e état n° 1*/*Côte Ste. Catherine à Rouen* and *C. Pissarro*/*imp. par C.P.*; title scratched into plate.

Museum of Fine Arts, Boston, Ellen Frances Mason Fund (inv. 34.582)

LITERATURE: Leymarie and Melot P 48.

EXHIBITED: Boston, Museum of Fine Arts, 1973 (30).

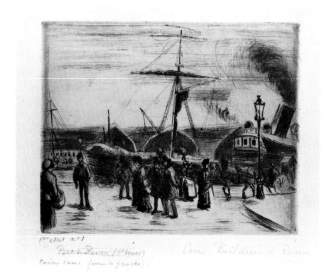

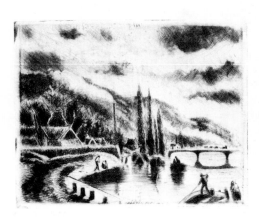

In the late summer of 1883, Pissarro travelled to Rouen searching for fresh views and motifs. He was so delighted with the readily accessible and diverse subjects that he stayed until the end of November, working steadily on at least a dozen paintings, numerous sketches and finished drawings, and preparing about six etchings. Although dated 1887 by Delteil, impressions of the Rouen scenes purchased by Samuel P. Avery (now in the New York Public Library collection) were inscribed by Pissarro and dated 1883 (see D 42, 44, 53, 54). These Rouen etchings were indeed conceived in 1883 and probably completed in early 1884, when Pissarro visited Paris and made use of the printing facilities there.

The commonality of papers, and the similar pen and ink inscriptions with dates, suggest that the Avery impressions were printed together at a time closer to their acquisition. Pissarro may have followed a long tradition of great artists, such as Dürer, Rembrandt, and Goya, who printed their plates when the interest or need arose. In 1888 Pissarro wrote: 'A letter has come from Portier with the news that the etchings I gave him in payment for the one hundred francs I owed him, have been sold to a museum in New York . . . [Avery was the purchaser]. Portier wrote to complete the sale I would have to do a self-portrait in pen and ink . . .' (*Lettres*, pp. 167–8). The portrait mentioned in this letter is Cat. 136, of the present exhibition.

Cours Boieldieu (D 46) was a busy waterfront promenade along the river Seine in Rouen. Pissarro heightened the sense of bustling activity by using various pictorial elements, such as vertical ships' masts, oblique lines of rigging, and spirals of smoke that issue from the tilted funnels. The frieze of engaged figures includes fashionably dressed men and women, as well as maids and labourers who attend to their various errands and tasks.

Another print noted by Delteil under the title *Port de Saint-Sever* (D 45) is most likely an earlier state of the etching illustrated here; the fact that Pissarro scratched out the pencil notation *Saint-Sever* on the Boston impression confirms this theory. The crisp, deeply etched lines of this unique first state of *Cours Boieldieu* were effectively supplemented by the dark grey shading tones of the

manière grise technique.

Côte Sainte-Catherine (D 48) is a hill to the north-east of Rouen overlooking the city (see Cat. 121). In contrast to the preceding view, this image is essentially a painterly landscape conceived in terms of small dark geometric patches superimposed on a curved vaporous background. Although the small figures of the labourers are indeed noticeable, the landscape fairly engulfs them, as well as the factory buildings and the train that crosses the bridge. Even the outpouring industrial smoke merges with the hills and abundant clouds. Pissarro used *manière grise* to form a variety of grey shapes, and with touches of aquatint he created a delicate balance of printed tonalities. The over-all slow pace and the hazy light that pervades the scene are in marked contrast to the preceding view.

This impression of the fourth state was printed by Pissarro. Curiously, his inscription in the lower margin is framed by another platemark that extends beyond the bevelled platemark of the printed image.

In the Ashmolean Museum, Oxford, there is a precise, fine pencil drawing, in reverse, for this image (Cat. 127) with no signs of softground on its verso.

Another drawing in Oxford (Brettell and Lloyd 287), with softground fragments was definitely used for transfer to a roughly aquatinted plate, later abandoned by the artist (uncatalogued by Delteil, but reproduced by Leymarie and Melot P 131). An inscription on the recto of the sheet, carefully written in reverse, 'Rouen Cote S' Catherine 83', pulls together all the relevant Rouen etchings and firmly establishes their correct date of execution.

181

Square in Rouen: Place de la République
1883

Place de la République à Rouen
D65
Etching on copper, second state, printed in black on buff laid paper. 15 × 17.2 cm./6 × 6¾ in.
Inscribed in ink: *La place de la République/à Rouen (effet de pluie) 1883* and *C. Pissarro* (pencil signature is erased).
The New York Public Library, New York, Prints Division

Pissarro was especially fascinated by the old narrow streets of Rouen (Cat. 81, 194), but occasionally he depicted its quays (Cat. 83), harbours (Cat. 75–6), and open squares. In this print the artist selected a high viewing point from which he could observe the various activities of pedestrians, horse-drawn carriages, and the tramway. There are at least two pen and ink drawings in the same direction as the print (Brettell and Lloyd 291 for both), that reveal Pissarro's preoccupation with the placement of the figures and forms. The motifs in the etching were united by a proficient use of *manière grise*. Pissarro carefully scratched the plate in parallel lines, then painted out some of the shaded work, providing a sculpturesque modelling in tone as well as a remarkable puddling effect of rain; usually the appearance of wet streets was accomplished by means of aquatint.

Lucien Pissarro refers to this print, which he proudly showed to his artist friends Charles Ricketts and Charles Shannon, in a letter to his father of March 1891 (quoted in *Lettres*, p. 223), '. . . and here is word for word what Ricketts said to me of the *Place de la République* (D 65): " You know I certainly prefer certain of your father's etchings to those of Whistler, and to find another such etcher you have to go back as far as Rembrandt . . ." Isn't that a delightful compliment? I believe he is right because it is Rembrandt who invented that free etching on beaten metal. By not bothering yourself too much with the technical finish, you have found something similar to what Rembrandt did; a way of using the metal sympathetic to the medium. That is precious . . .'

There are about five impressions of the last state. The posthumous edition of forty impressions loses much of the rich inky effect noted in the lifetime printings.

The etching of the *Place de la République* was shown at the eighth Impressionist exhibition in 1886 (No. 112) along with other Rouen scenes (No. 110 and 113). There are two paintings of the same square, one of which includes a tram being pulled by horses, that could have been developed from the etchings (P&V 608, of 1883, and 609).

PROVENANCE: New York, Samuel P. Avery collection.
LITERATURE: Leymarie and Melot P 64.
EXHIBITED: Boston, Museum of Fine Arts, 1973 (53).

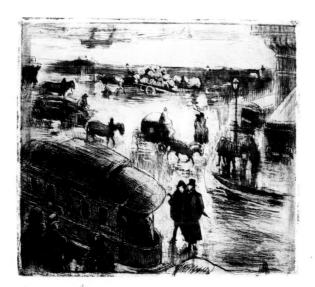

La place de la République à Rouen, effet de pluie, 1883. *C. Pissarro.*

182
Field and mill at Osny 1885

Prairie et moulin, à Osny

D 59

Etching, drypoint and aquatint, sixth state, on laid paper.
16 × 24 cm./$6\frac{1}{4}$ × $9\frac{1}{2}$ in.
Inscribed in pencil: *No. 5/Epreuve d'artiste/prairie et moulin à Osney (Pontoise) acqua cuivre* and *C. Pissarro*.
The Ashmolean Museum, Oxford, lent by the Visitors of the Ashmolean Museum

For a brief period Pissarro lived in Osny before finally settling in Eragny in the spring of 1884. However, judging from Pissarro's annotation on the New York Public Library impression, this view was not made until 1885.

The clearly defined foreground fence, the spacious sunlit meadow in the middle ground, and the background of distant farmhouses screened by a row of trees are representative of a formula that Pissarro assiduously applied to his lyrical paintings of the 1880s. The etching corresponds to a painting, dated 1884, of the same motif seemingly in reverse and without the prominent fence (P&V 626).

Pissarro conceived the composition geometrically with cubed shapes vying with rectangular modules; yet the potential mathematical sharpness is negated by the delicate handling of the printed technique. Fine etched and drypoint lines were delicately stroked on to the plate, while aquatint grains, used sparingly, darken the shadows and accentuate the effect of sunlight.

Pissarro reported to Lucien with pleasure that Degas had praised this etching when he saw it at an exhibition of *peintres-graveurs* in 1891 (*Lettres*, p. 210). Pissarro himself was not pleased with many impressions of the last state because he believed, rightly, that it had lost much of its suppleness when the plate was steelfaced.

PROVENANCE: London, Lucien Pissarro collection; Esther Pissarro collection, by whom presented to the Ashmolean Museum, 1950.
LITERATURE: Leymarie and Melot P 58.

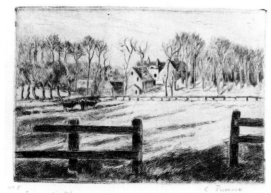

183
Grandmother (light effect) 1889/91

Grand'mère (effet de lumière)

D 80

Etching and aquatint on copper, seventh state on laid paper.
17.5 × 26 cm./$6\frac{7}{8}$ × $10\frac{1}{4}$ in.
Inscribed in pencil: *5^e état n^o 2 / La grand mère (effet de lumière)* and *C. Pissarro*.
Museum of Fine Arts, Boston, Horatio Greenough Curtis Fund (inv. 62.482)

This etching was probably the last representation Pissarro made of his mother, Rachel, called 'grand'mère', who died on 30 May 1889. Her fixed stare at the strong candlelight, the large empty armchair, and the horizontal coffin-like format of the image, convey a momentary intensity as the elderly woman clung to light and life. It is interesting that Pissarro returned to a traditional drawing style and etching technique when confronted with such a personal subject. The dramatic chiaroscuro, the ominous enframing curtains, and the use of a tight network of parallel and crosshatched lines are all reminiscent of Rembrandt. Only the touches in the last state of enriching aquatint (first employed in the eighteenth century) indicate a more modern period. Even though Pissarro preferred to find his own method, in this unique instance, he has thoroughly responded to the past.

A large charcoal drawing in Oxford (Brettell and Lloyd 194, measuring 22.5 × 29.1 cm.), rendered in the same tenebrous style, must have served as the basis for the print.

This impression, reproduced in Delteil, was incorrectly annotated by the artist as '5^e état – n^o 2.' There is a curious reference in an unpublished part of a letter from Camille to Lucien dated April 8, 1891 (Ashmolean Museum, Oxford) that mentions: 'I also have [the print of] grandmother lying on her bed, I have reworked it with grains and lines . . . it has turned out well, I still have to . . . scrape certain parts of the background to give that smoky blackness so characteristic of evening by candlelight.'

It is possible that Pissarro did indeed execute this etching almost two years after his mother's death. More evidence is required to determine if Delteil, and members of the Pissarro family who gave him information for the catalogue, had assumed the earlier date just before her death. On the other hand Pissarro may have decided later to add new work to an old plate.

PROVENANCE: Camille Pissarro collection; Mme. Vve. Pissarro (Paris, Hôtel Drouot, 7 December 1920, lot 113); Ludovic-Rodolphe Pissarro collection the artist's fourth son; New York, Peter H. Deitsch, October 1957, cat. 5, no. 34.
LITERATURE: Leymarie and Melot P 80.
EXHIBITED: Boston, Museum of Fine Arts, 1973 (33).

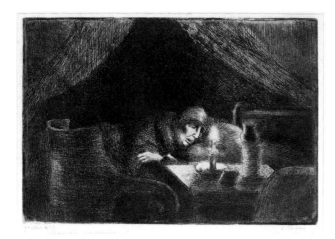

183

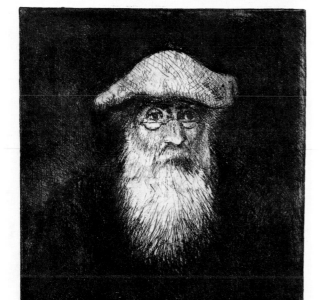

184

184
Self-portrait 1890–1

Camille Pissarro par lui-même
D 90
Etching on zinc, second state, on heavy wove paper.
18.7 × 17.8 cm./$7\frac{1}{4}$ × $7\frac{3}{8}$ in.
Inscribed in pencil: *1er Etat no 12/Portrait* and *C. Pissarro.*
Boston Public Library, Boston, Print Department

Pissarro made few self-portraits (Cat. 24, 93, 136) and only one etched portrait, which dates from when he was over sixty. Unlike Rembrandt, who favoured widely varying expressions, Pissarro, gentle and patriarchal of countenance, imparted his distinctive personality in one printed example. His full white beard, half-rimmed glasses, and soft artist's cap are all well-known personal attributes, and emerge from a shadowy, Rembrandtesque background. Pissarro gazes directly and thoughtfully at the viewer with a pensive quality and psychological insight that earned him religious sobriquets (see Cat. 24).

The zinc plate of poor quality did not yield many rich impressions; however, this example with an extra tone of ink that gently models the artist's features was especially well printed. All the impressions appear to be numbered by Pissarro, and many were dedicated and given to members of his family and friends, including his son Lucien, his niece Esther Isaacson, and his friend Dr. Parenteau. In unpublished portions of letters to Lucien of 1891 (Ashmolean Museum, Oxford) Pissarro discussed this portrait: 'I plan to give proof of my portrait to Alice and Esther' (8 April), 'I have my portrait that I will send you when I am in Paris' (2 May), and further, (13 May) 'I will send you the proofs you ask for as soon as possible together with my proof of the self-portrait; Jacques has printed it for me of course. . . . I have made it for friends. I was not very pleased with it. I had a poor plate and no means of pulling state proofs. (Perhaps a reference to the fine prints Pissarro gave to the Luxembourg Museum. He did not offer an impression of *Self-portrait.*

The illustration for Leymarie and Melot P 89 led me to believe that there was an intervening state between the first and third. Unfortunately, the figural contours of the photogravure reproduction had been retouched in the negative. Recent examination of the original print at the Bibliothèque d'art et d'archéologie, Paris, confirms that there are, in fact, only two states of the self-portrait as listed by Delteil. Furthermore, Pissarro, confusingly, disregarded the rare but documented first state (see Paris, Hôtel Drouot, 7 December 1928, lot 121) and casually annotated all the subsequent impressions of the second as: ''1er état.'

PROVENANCE: New York, Harlow, from whom purchased by Albert H. Wiggin 1930.
LITERATURE: Leymarie and Melot P 89.

185
Church and farm at Eragny-sur-Epte 1894–5
Eglise et ferme d'Eragny
D 96
Etching in colour on laid paper. 15.8 × 24.8 cm./$6\frac{3}{16}$ × $9\frac{3}{4}$ in.
Inscribed in pencil: *nᵒ 2–3ᵉ état | Eglise et ferme d'Eragny*
National Gallery of Art, Washington, Rosenwald collection

With the exception of the remarkable colour impressions of *Twilight with haystacks* (Cat. 164–8), printed by Degas, it was not until 1894, after he had obtained a press, that Pissarro devised his own method of making colour etchings. In a number of letters to Lucien, Pissarro discussed his efforts and thereby established the time span when he was most actively engaged in executing these prints; Delteil's date of 1890 has proved to be too early (although Ludovic-Rodolphe Pissarro (1922) claims that the black and white etched work was done in 1890). More important, a painting of the exact motif, dated 1895 (P&V 929, Musée du Louvre) and composed in the same direction as the print, offers additional evidence for the later date. It is possible that Pissarro enjoyed the printed image of the church and farm in Eragny-sur-Epte and, with slight alterations, fashioned an oil on canvas. A drawing made in

connection with this print is included in the present exhibition (Cat. 141) and another in pen and ink was exhibited in London in 1955 (Leicester Galleries, 1955, (10 repr.))

The etching was developed through six states in which portions of the black and white line work were variously emphasized or muted. A series of colour 'editions' was then attempted; three plates of red, yellow, and blue were printed over a key plate that had established the initial composition in black, grey, or grey-brown. An impression of the sixth state in the Art Institute of Chicago, heightened with pastel, must have served as the colour model.

The subtle ink variations and alterations in the printing of the plates created different effects of colour and atmosphere, and give the sensation of viewing a distant landscape in the tremulous sunlight. The colours in this impression are strong and especially well balanced, the over-all rose tonality suggesting a warm, glowing sunset. In the posthumous printing the congenial colours that Pissarro subtly juxtaposed to give a special luminosity are completely denied.

PROVENANCE: New York, Frederick Keppel collection.
LITERATURE: Leymarie and Melot P 91.

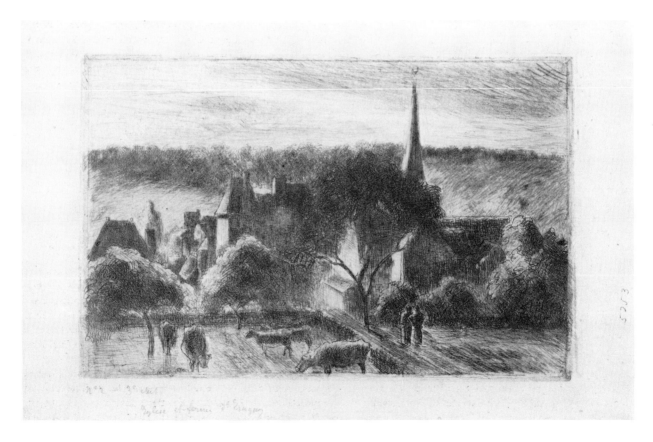

186–89
The market at Gisors: Rue Cappeville 1894–5

Marché de Gisors (Rue Cappeville)

D 112

Etching in colour. Platemark: 20.2 × 14.2 cm./$7\frac{7}{8}$ × $5\frac{5}{8}$ in.

LITERATURE: Leymarie and Melot P 112.

186

Etching, first state, with coloured washes on laid paper.
Inscribed in pencil: *no 2.*
Private collection, Boston

187

Etching, second state, with blue wash on laid paper.
Inscribed in black chalk: *N⁰ 4ᵉ*
Musée du Louvre, Paris, Cabinet des Dessins

PROVENANCE: Camille Pissarro collection: Mme. Vve. Pissarro (Paris, Hôtel Drouot, 7 December 1928, lot 156).

188

Etching, seventh state, coloured with crayons on laid paper.
Sheet: 27.9 × 20.5 cm./11 × $8\frac{1}{16}$ in.
Inscribed in pencil: *n⁰ 8 état n⁰ 1 / coloriée au crayon de couleur / accompagner les traits en général*; title in another hand, various notations by the artist in side margins.
The Ashmolean Museum, Oxford, lent by the Visitors of the Ashmolean Museum

PROVENANCE: London, Lucien Pissarro collection; Esther Pissarro collection, by whom presented to the Ashmolean Museum, 1950.

189

Etching, seventh state, printed in colour on laid paper, Sheet: 26.5 × 21 cm./$10\frac{3}{8}$ × $8\frac{1}{4}$ in.
Inscribed in pencil: *n⁰ 7 ep d'art / Marché de Gisors (rue Cappeville)* and *C. Pissarro*; lower margin: *B* in reverse, printed in blue, *R* in reverse printed in red, *jaune* in reverse printed in yellow.
Museum of Fine Arts, Boston, Katherine Eliot Bullard Fund (inv. 59.538)

PROVENANCE: London, Orovida Pissarro (Sotheby's, 8 April 1959, lot 264).
EXHIBITED: Boston, Museum of Fine Arts, 1973 (37).

Although Pissarro was primarily interested in landscape views, he also liked to depict market scenes and local fairs. The crowds of figures set in an open-air, animated environment, compelled him to explore these subjects in every artistic medium. With the same concentration that Degas brought to his investigations of theatrical and urban life, Pissarro examined the various market populations.

The Market at Gisors: rue Cappeville was one of five colour etchings produced by the artist. It is especially noteworthy because of the existence of an elaborate sequence of preparatory drawings and printed impressions, that demonstrate Pissarro's studious attempts with technique and motif. In the Ashmolean Museum, Oxford, alone, there are two small studies on tracing paper, one of the background houses (Brettell and Lloyd 297) and another of the male figure at right (Brettell and Lloyd 296), a pencil study on tracing paper drawn to scale and in the same direction as the printed image (Cat. 188, Brettell and Lloyd 298), a large horizontal pen and ink and chalk tracing (Fig. 11, Brettell and Lloyd 295), an annotated etched proof coloured with crayons (Brettell and Lloyd 299), and one finished impression in colour inscribed by the artist.

Fig. 11 *Marché de Gisors*, 1894–5, pen and ink with chalk on tracing paper, The Ashmolean Museum

Another horizontal drawing in pen heightened with gouache (Fig. 12, known only from a photograph) was the source for the tracing in Oxford; both sheets show Pissarro's original intention to devise a horizontal composition with a panoramic format and scattered foci. The figures were sketchily indicated, and the buildings compressed and abruptly cropped.

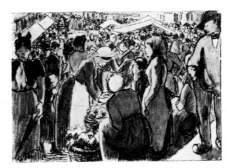

Fig. 12 *Marché de Gisors*, 1894–5, gouache, present whereabouts unknown

A drawing with a vertical format (Cat. 146) reveals that Pissarro eventually decided to telescope the view and feature a selection from his repertoire of market figures: the observing male peasant and the females in profile standing or seated with backs turned to the viewer. Pissarro extracted the seated figure, for which there is a separate study in Oxford (Brettell and Lloyd 256), from an etching by Léon Lhermitte.

The etching was first executed in black and white through seven states. According to Delteil there are three hand-coloured impressions of the first state: the example shown here (Cat. 186), is tinted with watercolour washes of pale blue, purple, red ochre, and

186

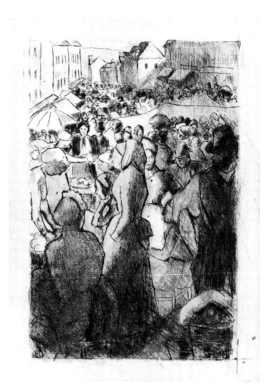

187

188

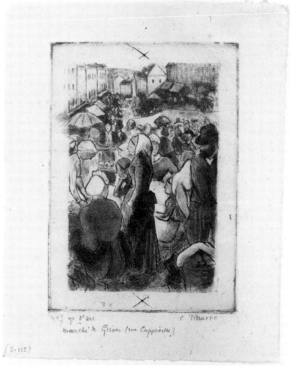

189

apple green that differ in hue and value from the finished print; a second state (Cat. 187) was painted selectively with a blue wash only. In both impressions the silhouetted figures delicately coloured in flat areas of watercolour recall the stylization found in Japanese woodcuts.

In the seventh and last state much of the line work was removed, leaving, primarily, the pronounced curvilinear outlines. A proof was hand-coloured with crayons (Cat. 188) before Pissarro made the final colour plates. In addition to the line or key plate, printed in grey or black, three new plates were etched for each colour area using an orange-red, bright blue, and lemon yellow. The pure colours were either printed in full strength or overlaid, giving additional tones of orange, purple, green, and brown. It was a complicated procedure because the sheet had to be properly aligned with each plate and put through the rollers of the press four times. Pin holes in the top and bottom margins indicate the registration marks. Since the colours blended differently with every printing, each impression is, in a sense, unique. Just as Pissarro strived for an acceptable impression, so he made constant adjustments to the composition from the initial watercolours to the finished print – this method provided him with a sequential progression that kept his work in motion and open for experimentation; even after he applied the fixed colour plates and completed the process, he captured a different sensation in every proof.

In January 1895 Pissarro wrote to Lucien: 'I received my coloured plates, I had them steeled. I will send you soon a fine print of . . . a *Market* in black, retouched with tints . . . I have already got some fine proofs; it is very difficult to find just the right colours.' (*Lettres*, p. 363.)

This impression of the seventh state is one of the nine printed in colour by Pissarro. In the posthumous editions of 1923 and 1930 by Alfred Porcaboeuf, the pleasing tones and proper colour relationships that Pissarro preferred are totally lacking.

Compared to the *Chestnut vendor* (Cat. 175), this vertical image is far more complex and vigorous. The earlier drypoint, conceived in simple, horizontal planes, contains unworked areas and only a few distinct points of interest, whereas *The market at Gisors* presents a different geometric arrangement of competing forms. The animated surface is almost entirely filled with lines and colour.

190
Bathers in the shade of wooded banks 1894
Baigneuses à l'ombre des berges boisées
D 142
Lithograph, second state, on *chine collé* mounted on white paper with *L'Estampe originale* blind stamp on lower right margin.
15.9 × 21.7 cm./$6\frac{1}{4}$ × $8\frac{1}{2}$ in.
Inscribed in pencil: *C. Pissarro*.
The Metropolitan Museum of Art, New York, Rogers Fund (inv. 21.60.4)

LITERATURE: Leymarie and Melot P 144.

191
Bathers wrestling 1894
Baigneuses luttant
D 160
Lithograph on zinc, only state, on *chine fixé*.
18 × 26 cm./$7\frac{1}{8}$ × $10\frac{1}{4}$ in.
Inscribed in pencil: *Ep d'état n° 2* and *C. Pissarro*.
National Gallery of Art, Washington, Rosenwald collection

PROVENANCE: Camille Pissarro collection; Mme. Vve. Pissarro (Paris, Hôtel Drouot, 7 December 1928, lot 207).
LITERATURE: Leymarie and Melot P 148.
EXHIBITED: Boston, Museum of Fine Arts, 1973 (39).

Between 1894 and 1896 Pissarro painted a series of nudes bathing outdoors and it is fair to say that he realized this subject more successfully in a group of lithographs than in any other medium. With consummate skill, he raised the technique of lithography to expressive heights and in these prints achieved a superb harmony of motif and mode. Using lithographic ink (tusche), the artist painted the images with broad dark strokes, then diluted the ink to model the figures with translucent grey washes. None of the nudes was clearly described; instead, Pissarro brushed and wiped the seemingly abstract forms into recognizable compositions.

In January 1894 he wrote, 'And at Tailliardat's I had pulled several lithographs on zinc of *Bathers wrestling*, playing in the water, as in the first proofs' (*Lettres*, pp. 332–3) and later in April: 'I have done a whole series of printed [lithographic] drawings in romantic style which seemed to me to have a rather amusing side: *Bathers*, plenty of them, in all sorts of poses, in all sorts of paradises.' (*Lettres*, pp. 339–40.) Given his rural environment, it would have been difficult for the artist to engage nude female models and after a relatively few studio pieces, the subject was abandoned. Later in 1896, when he made several more attempts, he commented: 'What annoys me is being unable to work outdoors; I am making gouaches and bathers here, and for lack of a model I am posing myself!' (*Lettres*, p. 412.)

Pissarro was obviously aware of Cézanne's extensive oil and watercolour studies of nude bathers when he executed his series of

190

191

lithographs of the same subject. His efforts, in fact, were far more exciting and accomplished than the bather lithographs begun two years later by Cézanne in the autumn of 1896. (Douglas Druick, 'Cézanne's lithographs', *Cézanne, the late work*, New York, 1977, pp. 119–37.) Commissioned by Ambroise Vollard, who pestered both artists for prints, especially ones in colour, Cézanne's lithographs show a singular lack of feeling for the medium. Pissarro, on the other hand, exploited its artistic possibilities. Although he used a professional printer, Pissarro was extremely confident with the materials and inspired by them, unlike Cézanne, who was woefully dependent on Auguste Clot, a remarkable printer who simulated in colour lithography Cézanne's water-colour washes. Above all, Pissarro's prints were intended for private purposes, rather than as a commercial venture.

It is interesting to note the curious title that Pissarro gave to D 160 and to a variant in reverse, D 159. Although the pair of bathers at the left of the image appear to be grappling with each other, *Bathers wrestling* hardly describes the voluptuous figures in a sylvan setting who boisterously jostle and splash in the water. Pissarro probably recalled Cézanne's bacchanalian depictions of the late 1870s; a watercolour (V 897) and painting (V 379–80) entitled *La lutte d'amour* comprise several pairs of energetic, wrestling figures in a seemingly erotic environment. Although Pissarro expressed dislike for Renoir's painting of playful *Bathers* exhibited at Galerie Georges Petit in 1887 (Philadelphia Museum of Art, Tyson collection), he must have been affected by the large composition. The initial source for Renoir's painting was a *bas-relief* of *Bathing nymphs* executed by Girardon in 1668–70 at Versailles (see Barbara Ehrlich White, 'The *Bathers* of 1887 and Renoir's Anti-Impressionism', *The Art Bulletin*, lv (1973), p. 120, repr. p. 116, fig. 22.) This decorative frieze may have also served as a starting point for Pissarro, whose horizontal lithographs of spirited bathers show a striking resemblance to it in subject, format, and postures. One can only postulate whether Pissarro's sudden and unique undertaking of such intimate scenes in 1894

masked his own sensual inclinations at this time.

On the basis of the artist's letters, Delteil's date of 1896 is no longer acceptable for the prints of bathers. Furthermore, the second state of *Bathers in the shade of wooded banks* appeared in the March 1895 portfolio of *L'Estampe Originale*, in an edition of 100. Only six or seven impressions of *Bathers wrestling* were taken during the artist's lifetime. A projected posthumous printing was never realized because the zinc plate had corroded.

192–193
Market at Pontoise 1895

Marché à Pontoise

D 147

Lithograph on stone. Image: 30.6 × 22.8 cm./12⅛ × 9 in.

192

Lithograph, first state, printed in black on *chine appliqué*.
Inscribed in pencil: *1ᵉʳ état n° 1* and *Marché*.
Trustees of the British Museum, London, Campbell Dodgson
Bequest, 1949

PROVENANCE: Camille Pissarro collection; Mme. Vve. Pissarro (Paris, Hôtel Drouot,
7 December 1928, lot 190) bt. Campbell Dodgson.
EXHIBITED: London, British Museum, *From Manet to Toulouse-Lautrec. French
Lithographs 1860–1900*, 1978 (64).

193

Third state, printed in brown on *chine appliqué*.
Inscribed in pencil: *Ep. def n° 5 / Marché à Pontoise* and
C. Pissarro.
Trustees of the British Museum, London, Campbell Dodgson
Bequest, 1949.

LITERATURE: Leymarie and Melot P 157 (as *Marché à Gisors*).
EXHIBITED: London, British Museum, *From Manet to Toulouse-Lautrec. French
Lithographs 1860–1900*, 1978 (65).

On 8 April 1895 Camille Pissarro wrote 'I have a large lithograph on
stone in process, a *Market*. I am working on it here in Paris. I
messed it up with wash, scratched it, rubbed it with sandpaper; I
do not know what will come of it, but it was foolish of me to make a
Market, I should have done some *Bathers*.' (*Lettres*, p. 375.)

Despite Pissarro's misgivings, this lithograph is one of his most
forceful market images. To be sure, he made many representations
of market places in all media, but in this example he has captured
the essence of a favourite subject. Pissarro isolated a fragment of
activity, yet, perversely, he forces the viewer to look around the
back of the stolid central figure. The strong peasant woman towers
above a mass of cluttered baskets and acts as a vertical pivot and
source, from which the noise and activity emanate. The several
figures who dominate the foreground plane are set against a sea of
anonymous faces. Only a few touches, such as the crosshatching on
the kerchief of a woman in the middle distance, distinguish the
various figures.

Pissarro did not declare an architectural environment, and in
fact by lowering the upper edge of the composition he heightened,
even in this large vertical format, the sense of crowdedness and
commotion.

As his letter describes, he scratched and rubbed the stone with
crayon and wash to obtain a broad range of values. In the first state,
the image was established in a traditional linear fashion. For the
subsequent states, much of the line work was erased and redrawn
in lithographic wash; the effect is softer and more tonal with

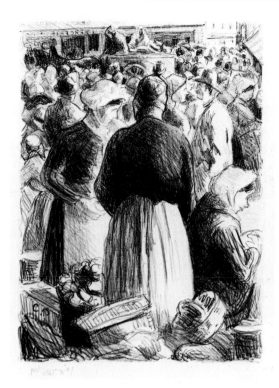

192

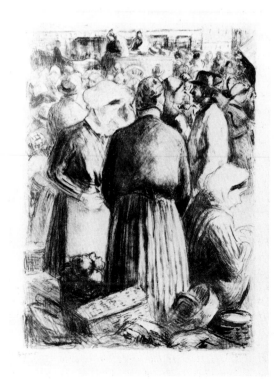

193

greater emphasis placed on fewer figures.

The third state, exhibited here, is uniquely printed in brown. Pissarro and his printer, Tailliardat, apparently tried an impression in coloured ink rather than print it on a sheet of coloured laid paper, as was done in many of his other lithographs. Unlike the posthumous impressions of this image, which were printed in black on sheets of coloured paper, this impression in brown on white is far more direct and effective.

The lithograph is based on a related painting dated 1895 catalogued as *Gisors Market* (P&V 932, Nelson Gallery – Atkins Museum, Kansas City, Missouri). Since the painting was not exhibited during Pissarro's lifetime, it is possible that Pissarro and Venturi incorrectly identified the particular site. The title of the painting was accepted for this lithograph by Leymarie and Melot (P 157) and by Shapiro (1973 Checklist No. 78). However, all the impressions I have since examined are inscribed *Marché à Pontoise* and it would therefore be more accurate to accept the artist's own title. To add to the confusion, it is known that Pissarro frequented both the Gisors and Pontoise market places as well as many other small fairs, even after he had moved to Eragny-sur-Epte in 1884.

194
Rouen: rue Saint-Romain 1896

Rue Saint-Romain, à Rouen
D 176
Lithograph on zinc, first state, on white wove paper.
18.9 × 14.1 cm./$7\frac{3}{8}$ × $5\frac{1}{2}$ in.
Museum of Fine Arts, Boston, Lee M. Friedman Fund (inv. 1973.4)

On at least two occasions during the 1890s, Pissarro travelled to Rouen and was again attracted to the old streets, churches, and sculpture. He was especially fond of the rue Saint-Romain which he depicted in four different lithographic plates (D 176–9). In a letter to Lucien dated 6 February 1896 he wrote: 'I ordered some [prepared] zinc plates to make lithographs of Rouen. I have begun some sketches of old streets which are being destroyed . . . I wish you could see the rue St. Romain, it is splendid. I hope it will have a certain interest.' (*Lettres*, p. 399.) Just as Baron Taylor had earlier compiled a lithographic record of French topography in his renowned *Voyages pittoresques et romantiques dans l'ancienne France* (1820–1878), so Pissarro felt compelled to preserve a visual memory of this mediaeval view.

Unlike his prints of Parisian scenes, Pissarro's views of Rouen are usually observed at street level. All four lithographs show the same view, each more or less occupied by undefined figures who stroll down the narrow street. There are subtle stylistic differences characterized by use of the lithographic crayon in a dense fashion to pick up the texture of the coated plate (D 176), or the drawing of a more linear design with greater freedom (D 179).

Most of the few impressions of the second state were printed on various sheets of coloured laid paper (Ingres) mounted on white, a method used by Pissarro and his printer to introduce colour into his lithographs. After a posthumous edition of six to twelve proofs, the plates were destroyed.

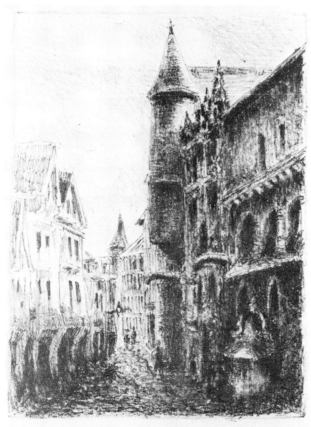

194

195
Beggar with a crutch 1897

Mendiant à la béquille

D 187

Lithograph, first state, on grey laid paper with red and blue
fibres mounted on white. 25 × 30.5 cm./$9\frac{7}{8}$ × 12 in.
Inscribed in pencil: *Epreuve d'Essai Ie Etat*; stamped: *Tailliardat*
(Lugt 2387 a suppl.)
National Gallery of Art, Washington D.C.

Unlike most of his impressionist colleagues, Pissarro was *avant-garde* in his political thinking and subscribed to the theories of
Pierre Kropotkin (1842–1921), the anarchist philosopher, and his
collaborator, Jean Grave (1854–1939). Pissarro contributed money
and art to their publications, and much of his work reflects his
concern for contemporary social issues.

It has been demonstrated that the motif of a road was a favourite
and frequent theme for Pissarro: he used it as a pictorial device to
organize his compositions and, more significantly, as a symbolic
route that connected the rural villages and ultimately brought
closer the cities and their industrial expansion.

With this symbolism in mind, Pissarro made two lithographs
(D 153 and 154) for the 1896–1900 series of *Les Temps Nouveaux* (a
weekly anarchist journal published by Grave) that are similar in
subject-matter and sensibility to *Beggar with a crutch*. Robert
Herbert ('Artists and anarchism: unpublished letters of Pissarro,
Signac and others, I,' *Burlington Magazine*, cii (1960), p. 478)
considers these figural types as homeless vagabonds who wander
along country roads, symbols of oppression (see also D 140 and
183). Although Pissarro readily sympathized with the abused rural
beings, his underlying sense of pictorial form and technique
frequently cancelled the anarchist implications. As a group, these
prints were drawn with a considerable understanding of the
multiple effects that could be obtained from lithographic crayons
and inks. Pissarro even went so far as to have many impressions
mounted on sheets of coloured Ingres paper, which served to
heighten their lyrical quality.

In this lithograph, the artist cleverly manipulated the print
techniques. He delineated the composition with pen and tusche,
then, with forceful and varied crayon strokes, modelled the
prominent figure of the one-legged beggar, and shaded darkly the
rough foliage and horizontal hedge. The stand of trees at right and
the small children are summarily sketched with both lithographic
methods. In marked contrast to the elderly man are the young girls
who resemble the silhouetted, decorative figures found in the
series of lithographs executed by Paul Gauguin in 1889; it is this
kind of picturesqueness that veiled Pissarro's political beliefs.

PROVENANCE: Zürich, Dr. S. Pollag (Zürich, Galerie Wolfgang Ketterer, 27 November
1973, No. 10, lot 2300).
LITERATURE: Leymarie and Melot P 187.

196
Street in Paris: Rue Saint-Lazare 1897

Rue Saint-Lazare, à Paris

D 184

Lithograph on zinc, only state, on beige laid paper mounted on
white paper. 21.1 × 14.3 cm./$8\frac{1}{4}$ × $5\frac{5}{8}$ in.
Inscribed in purple pencil: *Ep defi no 19 / Rue Saint Lazare à
Paris / sur Z* and *C. Pissaro*.
The Ashmolean Museum, Oxford, lent by the Visitors of the
Ashmolean Museum

PROVENANCE: London, Lucien Pissarro collection; Esther Pissarro collection, by
whom presented to the Ashmolean Museum, 1950.
LITERATURE: Leymarie and Melot P 188.
EXHIBITED: Tokyo, Sunshine Museum / Osaka, Municipal Museum / Fukuoka, Art
Museum, *Ukiyo-e prints and the impressionist painters*, 15 Dec.–15 Jan., 22 Jan.–
10 Feb., 15 Feb.–28 Feb., 1979–80 (II–41 repr.revised edn. II–46 repr.).

196

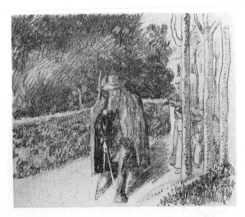

195

225

197
Square in Paris: Place du Havre 1897

Place du Havre, à Paris

D 185

Lithograph on zinc, second state, on green laid paper mounted on white paper. 14.4 × 21.3 cm./$5\frac{5}{8}$ × $8\frac{3}{8}$ in.

Inscribed in pencil: *Ep defi no 2 / Place du Havre à Paris* and *C. Pissarro*

The Ashmolean Museum, Oxford, lent by the Visitors of the Ashmolean Museum

PROVENANCE: London, Lucien Pissarro collection; Esther Pissarro collection, by whom presented to the Ashmolean Museum, 1950.
LITERATURE: Leymarie and Melot P 189.

The compositions of *Place du Havre* and *Rue Saint-Lazare* in Paris correspond to the 1883 etchings of old streets and squares in Rouen (Cat. 179–81). The present images were conceived from a vantage point high above street level, where Pissarro could observe the moving pedestrians and bustling traffic patterns. Pissarro first painted Parisian views in 1893 (Cat. 73), describing them as 'very beautiful'. Then he returned in 1897 to produce his famous series of paintings, as well as two lithographs of the same sites; *Rue Saint-Lazare*, however, is seen in reverse from the painted version (P&V 981).

Like his paintings, which became looser and more calligraphic in the last decades, the lithographs were executed far more freely than the earlier etched views of Rouen. With broad crayon strokes, Pissarro depicted in *Place du Havre* a frieze of figures, carriages and a crowded tram drawn by a pair of horses. There is a tension between the horizontal bands and oblique lines of active forms that parade across the square. A series of sketchy crayon marks and areas of modulating lithographic wash heighten the sense of hurried movement. Pierre Bonnard must have been aware of Pissarro's 1897 lithographs of Parisian scenes. Bonnard's series, *Quelques aspects de la vie de Paris*, published and first exhibited in 1899 by Ambroise Vollard, shows an affinity in subject-matter, field of vision, and technique with Pissarro's urban prints.

Most of the late lithographs were printed on coloured sheets of Ingres paper, mounted on a firm white paper; this example of *Place du Havre* on green displays a painterly effect. Some of the prints, including *Rue Saint-Lazare*, were inscribed with a soft purple pencil. One can easily conceive that Pissarro annotated these impressions at Tailliardat's workshop with an available copying crayon.

198
Peasant group *c.* 1899

Groupe de paysans

D 189

Lithograph, only state, on grey-green laid paper, mounted on white paper. 13.2 × 11.1 cm./$5\frac{1}{4}$ × $4\frac{3}{16}$ in.

Inscribed in pencil: *n° 3 / Groupe de paysans (variante)* and *C. Pissarro.*

Museum of Fine Arts, Boston, Lee M. Friedman Fund (inv. 1973.5)

LITERATURE: Leymarie and Melot P 195.
EXHIBITED: Boston, Museum of Fine Arts, 1973 (42).

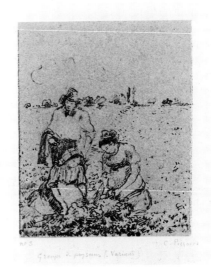

198

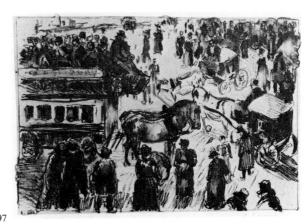

197

199
Boulevard Montmartre *c.* 1899

D 191

Lithograph, only state, on beige laid paper, mounted on white paper. 14.5 × 11.3 cm./$5\frac{3}{4}$ × $4\frac{1}{2}$ in.
Inscribed in pencil: *n⁰ 2 / Bd Montmartre* and *C. Pissarro.*
Museum of Fine Arts, Boston, Lee M. Friedman Fund (inv. 1973.150)

LITERATURE: Leymarie and Melot P 197.
EXHIBITED: Boston, Museum of Fine Arts, 1973 (Checklist No. 85).

These two modest-sized lithographs succinctly reveal Pissarro's attentiveness to both the country and city milieu. With delicate, calligraphic lines, flecks of ink (like Monet's much maligned 'black tongue-lickings'), and short crayon strokes, Pissarro captured the essential qualities of a serene peasant group and a busy Parisian boulevard; the viewer's eye must assemble the various activated lithographic marks in order to form the composition.

This impression of *Peasant group* is printed on a grey-green sheet that enhances its pastoral quality; in fact, it is difficult to ascertain whether the peasant figures are working or picnicking in the fields. The *Boulevard Montmartre* is on a creamy beige paper that corresponds in atmosphere to Pissarro's misty painted renderings of the street series. Unlike the lithograph, *Market at Pontoise* (Cat. 192–3), whose punchy strength was diminished in the posthumous editions by the use of coloured sheets, the temporal effects of coloured light were made more acute in these two vignettes.

Pissarro abandoned working out of doors in the last decades of his life, owing to frequent eye infections. Although it seems that the artist was standing nearby in a meadow when he recorded this peasant group, he probably executed the lithograph on a prepared zinc plate in his studio. On his city visits Pissarro protected himself by making his observations from behind hotel windows where, like Monet, he could continually examine the same view under a variety of weather conditions. Since *Boulevard Montmartre* was dated by Delteil two years after his series of boulevard paintings of 1897, it was evidently done from memory.

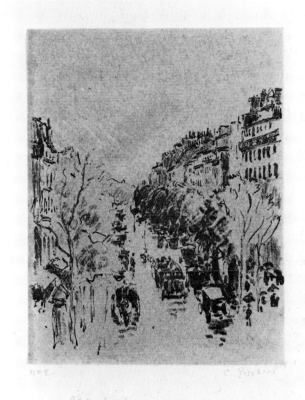

199

200
The fireside 1880–5
Le foyer
Monotype in black ink. 12.7 × 17.7 cm./5 × 7 in. Stamped lower
left corner: C.P. (Lugt 613e)
Princess Fevsi

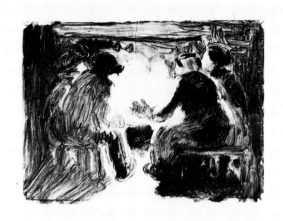

200

Pissarro became acquainted with Degas's monotypes as early as
1877, when several of the latter's 'drawings made with greasy ink
and printed' were shown in the third Impressionist exhibition; but
his first direct involvement with the technique probably occurred
when the two artists collaborated on their journal of prints (*Le Jour
et la Nuit*) about 1879–80. Although Pissarro executed a few
monotypes in the 1880s, the main body of his work (about thirty
monotypes) was produced around 1894–5.

In this image, a blazing fire casts a reflected glow on the faces and
outstretched hands of two pairs of peasant figures, seated on either
side of a massive fireplace; a central space is apparently reserved
for the viewer who comes upon the intimate, domestic scene. The
firelight, soft and powerful at the same time, unites the occupants
in their dark and light, black and white environment.

Pissarro wiped and brushed a mass of warm-toned black ink in
various directions to create the composition. He diluted the ink to
draw with short strokes the male figures and their shadows, and
with a heavier pigment he indicated the female peasants seated
more nearly in darkness. A horizontal smear represents the heavy
mantel and continues along the sides of the plate, partially
enframing the image. Although the subject is clearly understood,
the forms and facial features were not precisely drawn. Often
Pissarro would use a pointed brush to define figural contours, but
in this instance he has painted the composition with broad,
decisive strokes.

The technical style of this work relates to the monotypes that
Pissarro created when he was closest to the orbit of Degas;
however, a later date, based on his total production, may also be
considered. The colouration and application of ink correspond to a
pair of landscapes recently given a date in the 1880s (see *The
painterly print*, New York, The Metropolitan Museum of Art, 1980,
No. 35,36).

The fireside is related to a gouache entitled *La veillée* (P&V 1328,
sold Sotheby Parke Bernet, 20 October 1977, lot 108 repr.), which is
unclearly signed and dated, but is given a convincing date of 1879
in the *catalogue raisonné*. An etching by A. M. Lauzet copied after
the gouache (see Georges Lecomte, *L'Art impressionniste, d'après la
collection privée de M. Durand-Ruel*, Paris, 1892, facing p. 80),
shows the same inky, tonal effects practised by Degas and Pissarro
in their printed work of this period.

EXHIBITED: London, Leicester Galleries, 1955 (17).

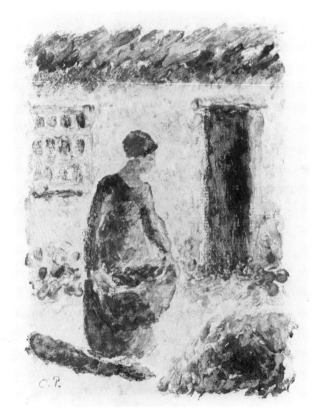

201

201
Woman carrying a basket *c.* 1889

Paysanne portant une manne
Monotype in oil colours. Image: 16 × 11.5 cm./$6\frac{1}{4}$ × $4\frac{1}{2}$ in.;
platemark: 23 × 16 cm./$9\frac{1}{16}$ × $6\frac{1}{4}$ in.; sheet: 24.6 × 16.3 cm./
$9\frac{3}{4}$ × $6\frac{3}{8}$ in.
Stamped lower left corner: *C.P.* (Lugt 613e)
Paris, Archives Paul Prouté S.A.

This monotype is especially interesting, for it is, in one sense, an offset or counterproof of a painting whose support is, uniquely, a zinc plate (P&V 735, Aix-Les-Bains, Musée Faure repr. col. by Cogniat, 1974, p. 57.) Pissarro must have intended the work to be a monotype, but was tempted by the thick impasto and unity of the small composition to keep the plate intact, instead of cleaning and wiping it for the next etched or painted print. After taking this impression, he filled in the areas where pigment had been lost in the printing process, overpainted the diminished image, added touches of bright accents, and enjoyed the plate as a miniature painting.

The method of transferral is obscure. There are registration marks at the top and bottom of the sheet, and a platemark curiously extends beyond the crossed lines. The over-all monotype image is smaller than its painted counterpart, which suggests that it was not subjected to the full pressure of the printing press. The colours were thinly printed, but in certain areas, such as the door and foreground pile of hay, the pigment has drawn more heavily from the densely worked painting. The bright colours – blues, oranges, reds, and greens – were kept subdued, and applied to the plate in clusters of short, curved brushstrokes. Even though the hues are less intense on the monotype sheet, the juxtaposition of the colour *taches* in the 'pointilliste' manner produces a lively pictorial surface. The painting on zinc and the monotype on paper reflect Pissarro's neo-impressionist phase and can safely be dated about 1889.

PROVENANCE: Camille Pissarro collection; Mme. Vve. Pissarro collection (Paris, Hôtel Drouot, 7 December 1928, lot 234).
LITERATURE: Shapiro and Melot, 1975, p. 20 No. 12.
EXHIBITED: Paris, Bibliothèque Nationale, 1974 (264).

202
Woman fixing her hair 1894

Femme se coiffant
Monotype with colour on wove paper. 17.8 × 12.8 cm./7 × 5 in.
Signed with pigment in lower left corner: *C.P.*
The Metropolitan Museum of Art, New York, Harris Brisbane Dick Fund, 1947

Of all Pissarro's monotypes only one is dated, and its execution in 1894 corresponds to the etched and lithographed work undertaken by the artist in the same year. A letter from Pissarro to Lucien, written in April 1894, mentions that the weather was uncertain for 'poor painting' and that he was content to work indoors on 'romantic printed drawings' of bathers and 'some interiors as well, *Paysannes à leur toilette*, etc.' 'They are very amusing', he writes, 'because of their black and white values – which gives the tone for the pictures. I have heightened some of them with colours.' (*Lettres*, pp. 339–40.)

The majority of Pissarro's monotypes were conceived in black and white with occasional additions of colour patches. Here, he has wiped the ink with a rag in many different directions to indicate the young girl fixing her hair, the large bed with its voluminous covering, and the straight-backed chair piled with clothes. The essential configurations were reinforced with a pointed brush, and the patterned texture of the bed curtains and wall covering was achieved by dabbing at the ink.

Touches of reddish pink colour the woman's upraised arms and breast, she wears a skirt of burnt sienna and a deep black bodice. Pissarro also darkened the shadows cast by the bed, establishing a firm spatial placement and repeated small touches of heavier pigment throughout the composition to add further modelling. Areas of oily residue on the verso of the sheet confirm the different viscosities of ink. Although these flecks of colour and inky tones were apparently printed, it is often difficult to determine whether Pissarro added the accented portions to the plate, or touched up the surface of the sheet after the image was taken.

This monotype relates directly to a painting (P&V 864, formerly in the collection of the American artist, Arthur B. Davies) and to a pastel (P&V 1599, Ottawa, National Gallery of Canada). All the images face in the same direction; the monotype, which is more broadly rendered, may have served as the prototype for the more finished versions. A similar monotype (Shapiro and Melot, 1975, p. 20, No. 9, Museum of Fine Arts, Boston) includes the same distinctive bed, small decorative pictures, and straight-backed chair, as well as the same young model. These works are proof of Pissarro's profound interest in experimenting with a multiplicity of media to depict the same motif.

PROVENANCE: New York, John Rewald collection.
LITERATURE: Shapiro and Melot, 1975, p. 20, No. 10; Boston, Museum of Fine Arts, 1973 (43).

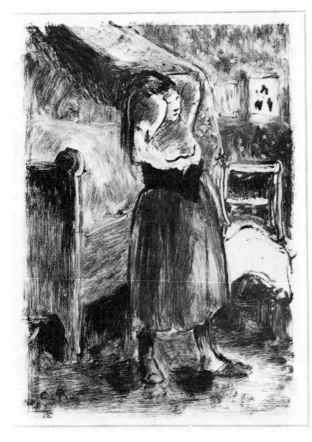

202

203–208
Travaux des champs 1893
Travaux des champs (1er série)
A portfolio of six woodcuts from drawings by Camille Pissarro and engraved and printed by Lucien Pissarro. Each sheet signed in the block: *C.P.* and stamped in various colours: *LP sc.* Printed in an edition of less than twenty-five on various oriental papers.
Private collection

203
Ploughing
Le labour
Printed in blue-green ink. Image: 12×16 cm./$4\frac{3}{4} \times 6\frac{5}{16}$ in.

204
Women tending cows
Les gardeuses de vaches
Printed in blue-green ink. Image: 11.6×16 cm./$4\frac{9}{16} \times 6\frac{5}{16}$ in.

205
Work in the fields
Etudes (travaux des champs)
Printed in olive-green ink. Image: 20.2×16 cm./$7\frac{7}{8} \times 6\frac{5}{16}$ in.

206
Woman feeding hens
Femme aux poules
Printed in ochre and blue ink. Image: 12.8×18.8 cm./$5 \times 7\frac{3}{8}$ in.

207
Weeders
Les sarcleuses
Printed in colour from five blocks. Image: 17.4×11.3 cm./ $6\frac{7}{8} \times 4\frac{3}{8}$ in.

208
Women hay-making
Les faneuses
Printed in colour from six blocks. Image: 17.1×11.4 cm./ $6\frac{3}{4} \times 4\frac{1}{2}$ in.

LITERATURE: Leymarie and Melot P 199–204; Melot, 1974, No. 267–8 (repr. Pl. V, VI); Brettell and Lloyd, pp. 66–85.

The execution of the *Travaux des champs* series is extensively supported in the Ashmolean Museum by watercolours and drawings (Fig. 13), tracings, pieces of celluloid with the design indented (Fig. 14), annotated proofs (Fig. 15), and numerous letters between Camille and Lucien, as well as a two-volume *Studio Book* compiled and annotated by Lucien with additions by his wife, Esther. The father and son had planned a large series of illustrations dealing with aspects of country life in accordance with the changing seasons. As early as 1886, they were discussing this

collaboration, which continued through several phases up until the death of Camille Pissarro. Perhaps recalling the failure of *Le Jour et la Nuit* undertaken by Degas in 1879, Pissarro constantly approached dealers in the hope that this joint work could be published and sold. Lucien, in turn, seemed painfully dependent on his father's advice and expertise, and in 1895, nearly ten years after their initial conversations, Camille could not persuade his son to do the drawings himself.

The date of issue for the first portfolio is usually given as 1895, but there is sufficient evidence to suggest that the prints were available for sale two years earlier. Although Lucien's pencil notations were sometimes inaccurate, he repeatedly wrote the date

Fig. 13 *Les Sarcleuses*, 1893, pen and ink with pale red, blue, and green washes, The Ashmolean Museum

Fig. 14 *Les Sarcleuses*, 1893, celluloid with red indentations, The Ashmolean Museum

Fig. 15 *Les Sarcleuses*, 1893, pen and ink and watercolour with pencil annotations, The Ashmolean Museum

Fig. 16 *Les Sarcleuses*, 1893, colour woodcut mounted on page with pencil annotations, The Ashmolean Museum

Fig. 13 Fig. 14

Fig. 15 Fig. 16

of 1893 on the relevant page of his *Studio Book* (Fig. 16, for example). There are many prospectus sheets advertising the portfolio under the imprint of the Vale Press in 1893, and later with dates of 1894, 1895 (Hacon and Ricketts), 1898, and even 1904 (Vale Publications), that attest the efforts to sell even a few copies. The work was not a commercial success, and the fifty or so drawings made by Camille for the various stages of the projected series were eventually abandoned, until after his death when Lucien attempted another printing. A full account of the various unpublished parts of *Travaux des champs* may be found in Brettell and Lloyd, pp. 75–85. Judging from the amount of preparation, the artists must have intended *Travaux des champs* to be far more comprehensive than was realized in the first published portfolio. Indeed, on an iconographical basis, the project forms an interesting contrast with *Turpitudes sociales* (Cat. 142).

Camille Pissarro made the initial drawing, often duplicated on tracing paper, and Lucien transferred it to the block in reverse, so that when printed it would conform to Camille's original intention. Careful measurements of the block were made to eliminate the need for reduction – only many years later would Lucien use photographic means to make corrections or reduce his father's drawings for the successive folios. The initial zinc plate for *Femme aux poules*, Plate IV, cracked in printing; Camille re-did the drawing exactly, but it was not successful, and finally, Lucien was obliged to recut a wood block from the original drawing.

Plate I, *Ploughing*, probably served as the model for the colour lithograph, *The plough*, which Pissarro offered in 1898 to Jean Grave as an illustration for the anarchist paper, *Les Temps Nouveaux*. In view of Pissarro's admiration for the old masters, one is not surprised to find that a woodcut by Hans Holbein the Younger entitled *The ploughman* (Scene XXXVIII from the *The Dance of Death*, 1545) provided the pictorial source for both of these prints. Although the images are reversed, the quality of the crisp, spare lines in the two woodcuts is remarkably similar, as are the distant landscapes where a church spire breaks the horizon (Lloyd, 1975, pp. 722–6).

The sheet of studies, *Work in the fields*, Plate III, most successfully represents Camille Pissarro's social and pictorial aims. Each vignette is a spirited sketch of an aspect of farm work rendered with understanding, grace, and a sense of whimsy. There is no question that Pissarro admired the woodcut sketches in Hokusai's *Manga*; not only was there a similar schematic recording of common, everyday events, but, Pissarro also artfully arranged the individual images on the page in a manner that reflected his interest in *Japonisme*. In fact, Camille and Lucien Pissarro sometimes referred to *Travaux des champs* as 'our *Manga*' (Brettell and Lloyd, pp. 68–9).

The two multi-coloured prints, *The weeders* (Plate V) and *Women haymaking* (Plate VI), achieved in a small format the same shimmering effects sought by Camille in his paintings. Five or six blocks, one for each primary colour, were applied directly or overlaid to create additional hues, all contained and offset by the pronounced black outlines. The consistent use of colours of equal

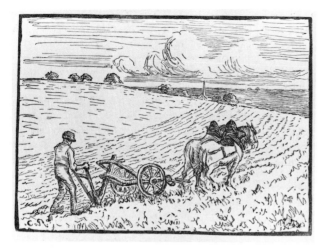

203

204

205

206

intensity for the entire image negated the traditional concept of distance and perspective. A fine linear pattern, incorporating the grain of the block, added a further textural grid and increased the sense of an 'optical mixture'. The intention of the project, to depict field labourers, dissolved, as it were, into colourful printed images with a high degree of sunlight and decoration. Camille's pencil annotations on a watercolour proof in Oxford (Brettell and Lloyd 328), include *'Lumière de soleil couchant orangé, rouge / effet intense de soleil couchant avec ombres profondes et lumière vive et orangée'*, and are especially significant in this context.

An impression of *Women tending cows*, (Plate II), printed in blue and fully watercoloured, lacks Lucien's cutting stamp in the lower left corner (formerly, London, William Weston Gallery, *Fine prints by 19th and 20th century British and European Masters*, catalogue no. 10 (1975), No. 40 repr. col.) The existence of other examples hand-coloured by Lucien suggests that he may have printed extra proofs not intended for the published portfolios, and that in this instance, he was tempted to paint the monochromatic woodcut. With green, blue, yellow, and red 'pointilliste' touches of watercolour, he created a unique dappled effect.

207

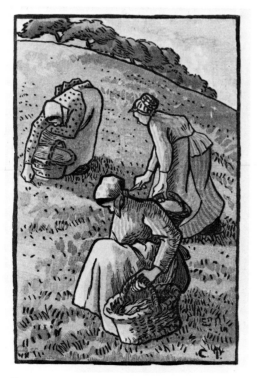

208

208a
Seven printing plates

The woman on the road
Thin, hammered copper plate.

Self-portrait
Thin zinc plate.

Church and farm at Eragny-sur-Epte
Four heavy copper plates – a key plate for outline and three plates for red, yellow and blue.

Square in Paris : Place du Havre
Prepared lithographic zinc plate.

Bibliothèque Nationale, Paris, Cabinet des estampes, Gift of the Pissarro family, 1930

In 1930 members of the Pissarro family presented a large collection of the artist's printing plates to the Bibliothèque Nationale. There are small sheets of copper, some beaten thin and a selection of zinc pieces, some now corroded as well as many plates that had been steel-faced for posthumous editions. Of special interest are the mechanically grained zinc plates used for lithographs. As a group these various metal surfaces are indispensable in furthering our knowledge of Pissarro's working methods. Impressions taken from the plates on exhibition appear as cat. nos. 163, 184, 185, 197 respectively.

Catalogue of Fans

Pissarro first exhibited fans at the fourth Impressionist exhibition held in April–May, 1879. The artist included twelve fans out of a total of thirty-seven works. In no other Impressionist exhibition did Pissarro include so many fans, there being only single examples in the fifth and eighth exhibitions. There are thirty-five fans listed in the *catalogue raisonné* and several others are known. These seem to have been executed regularly from 1879 onwards, but there is a notable decline in the rate of production after 1890. It seems that Pissarro's interest in the painting of fans was first aroused by Degas, who, as with print-making, was keen to attempt new art forms. In fact, Degas and Pissarro were the main painters of fans amongst the Impressionists.

For Pissarro the adoption of the fan as an art form came at a critical time, namely at the close of the 1870s. To a certain extent the fan may have assisted Pissarro in his search for compositional unity. The emphasis that had to be placed on the two corners of the fan meant that figures were given prominence against the background. Landscapes and horizon lines in the upper half of the fan either have a horizontal emphasis or else echo the curvature of the fan itself. Whilst many of the compositions are reworkings of earlier works, Pissarro also showed considerable originality in this format. He sought different atmospheric effects in compositions of seasonal import, but at the same time did not spurn more 'modern' themes, such as the railway bridge at Pontoise (P&V 1619) and the port at Rouen (P&V 1633). There are also some fans in the neo-impressionist style.

It is often stated that Pissarro painted fans for what are best termed socialist reasons, as a cheaper art form that would achieve a wider circulation. There is, however, little direct evidence to support this claim. There are not all that many fans when compared with the complete *oeuvre*, and not many of these appear to have been used in a purely conventional way (P&V 1635 is perhaps an exception). As far as one can tell, the prices paid for fans do not suggest that they were regarded as cheaper art forms. Indeed, the whole history of the fan, as adumbrated by Charles Blanc, for example, implied exclusivity and it seems that Degas and Pissarro failed to counteract this tradition, whatever their intention may have been. The main difference that can be detected between the eighteenth-century fan and the impressionist fan lies in the subject-matter, in that decorative subjects yielded to narrative. The radicalism of the fans by Degas and Pissarro is in the choice of subject-matter, but, paradoxically, this reduced the effect of the fan as a utilitarian object.

209
Winter, the outskirts of Lower Norwood (London) 1879

L'Hiver, environs de Lower Norwood
Gouache and watercolour on silk. 25 × 54 cm./$9\frac{3}{4}$ × $21\frac{1}{4}$ in.
Signed, lower right: *C. Pissarro.*
Museum of Fine Arts, Springfield, the Robert J. Freedman
Memorial Collection (inv. 73. D 22)

Gerstein has identified this fan, which does not occur in the *catalogue raisonné*, as one of the twelve exhibited by Pissarro in the fourth Impressionist exhibition (Nos. 189–200, for convenience see Venturi, 1939, ii. pp. 263–4). The landscape background is based upon two drawings made in London in 1870–1. One is now in Oxford (Brettell and Lloyd 68E verso) and the other is a watercolour that was retained in the artist's collection (Paris, Georges Petit, 3 December 1928, lot 4 repr.). Both drawings are related to a painting of 1871 (P&V 112). In using these drawings again for the present fan, Pissarro has fused the motifs of Lower Norwood and added the figure in the right foreground. There is further evidence of Pissarro using for fans, at a later date, compositions that had first been evolved in England (Brettell and Lloyd 101).

Gerstein correctly remarks on the juxtaposition in this fan of agricultural labour and modern industry, the former symbolized by the figure in the foreground and the latter by the factory in the background. Only rarely in his work (P&V 245, 353–4, and 434) is Pissarro so explicit in this matter.

Three of the fans in the 1879 Impressionist exhibition are listed as belonging to Mlle. L, whose identity is still uncertain (see further Gerstein, *op. cit.* p. 109).

PROVENANCE: Paris, Mlle. L (see commentary above); Paris, Galerie Charpentier, 18 March 1959, lot 25 repr.; Paris, Moritz Gutmann; Springfield, Robert J. Freedman collection, by whom bequeathed to the Museum of Fine Arts, Springfield, 1973.
LITERATURE: *Catalogue of the Robert J. Freedman Collection*, Springfield Museum of Fine Arts, n.d., pp. 42 and 43 repr.; M. Gerstein, *Impressionist and post-impressionist fans*, Harvard University Ph.D thesis, 1978, pp. 110–3 No. 3 repr.
EXHIBITED: Paris, 1879 (190 lent Mlle. L.); University of Maryland Art Gallery/Louisville, J. B. Speed Museum/Ann Arbor, University of Michigan Museum of Art, *From Delacroix to Cézanne: French watercolour landscapes of the nineteenth century*, 26 Oct.–4 Dec., 9 Jan.–19 Feb., 1 Apr.–14 May 1977–8 (134 repr.).

210
View of Rouen, Cours-la-Reine 1885

Vue de Rouen, Cours-la-Reine
Gouache and watercolour over pencil and black chalk on silk.
34 × 67 cm./$13\frac{3}{8}$ × $26\frac{3}{8}$ in. Signed and dated, lower right:
C. Pissarro. 1885.
Yale University Art Gallery, New Haven, The Stephen Clark
Fund (inv. 1975.53)

The fan is ultimately derived from a painting of 1883 (P&V 603), which shows the cathedral of Rouen as seen from the Cours-la-Reine (*Lettres*, pp. 59–60, 11 October 1883), a motif, as Pissarro well knew (*Lettres*, p. 67, 20 November 1883), of which J. M. W. Turner had made a watercolour. There is, however, a closer connection with an etching *The port at Rouen near the customs house* of 1884 (D 50). Compositionally, the scene is extended somewhat on the right of the etching and includes a figure on the left, but the reflections on the water are similar in the fan, as well as the general background.

Two other fans of Rouen, besides the present example, are known; P&V 1633, of 1885, which is based on an etching of 1883 (D 43) and for which a study in watercolour is in the Bronfman Foundation, Montreal, and *Place de la République, Rouen*, which is only known in a drawing (repr. Cogniat, 1974, p. 17) probably made in 1885 and based on two paintings of 1883 (P&V 608–9). For both of these fans see Gerstein, *op. cit.*, Nos. 30 and 33 respectively.

The present fan does not occur in the *catalogue raisonné*.

PROVENANCE: Paris, Durand-Ruel, bought directly from the artist 21 January 1886 for 200 frs.; New York, American Art Association, 19 February 1886; Paris, Durand-Ruel, 8 November 1886; New York, Durand-Ruel, 19 October 1887; sold Geneva, Galerie Motte, 29 June 1973; New York, Lucien Goldschmidt, from whom acquired by Yale University Art Gallery.
LITERATURE: *Art Journal* xxxv No. 2 (1975–6), p. 158 repr.; *Yale University Art Gallery Bulletin* xxxvi (1976), p. 33 repr.; M. Gerstein, *Impressionist and post-impressionist fans*, Harvard University Ph.D Thesis, 1978, pp. 160–1 No. 32 repr.
EXHIBITED: New York, National Academy of Design, *The Impressionists of Paris*, 1886 (37).

211
The turkey girl 1885

La gardeuse des dindons
Gouache on silk. 32 × 64 cm./12½ × 25⅛ in. Signed and dated, lower left: *C. Pissarro 1885*.
The Brooklyn Museum, New York, gift of Mr. Edwin C. Vogel (inv. 59.28)

The composition is not derived from a painting and the only other time Pissarro essayed the subject was in a tempera *c.* 1887 (P&V 1414) now in the Museum of Fine Arts, Boston (see Cat. 128). The fan is therefore an original composition designed specifically for this format and not adapted from another work. Gerstein has observed that the lower edges of the fan were originally angled, but that later the artist levelled off the edges and filled in the space. These additions can easily be seen on the fan today. The composition is highly characteristic of Pissarro's methods during the first half of the 1880s, with the figure set against a high horizon line. The fan does not occur in the *catalogue raisonné*.

PROVENANCE: Paris, Mme. Bonoy collection (1948); Paris, Galerie Roux Hentschel (1948); Paris, Weil (1950); Paris, Gas (1950); Paris, Matthey (1951); Paris, Galerie de l'Elysée; New York, E. and A. Silbermann Galleries; New York, Knoedler, from whom bought by Edwin C. Vogel. Presented to the Brooklyn Museum by Edwin C. Vogel, 1959.
LITERATURE: G. Needham in *Japonisme. Japanese influence on French art 1854–1910*, Cleveland Museum of Art, p. 119 repr. (reprinted in B. E. White, *Impressionism in perspective*, Englewood Cliffs, New Jersey, 1978, p. 130 repr.); M. Gerstein, *Impressionist and post-impressionist fans*, Harvard University Ph.D Thesis, 1978, pp. 169–70 No. 39 repr.
EXHIBITED: New York, The Brooklyn Museum, *Paintings by contemporary English and French painters*, 29 Nov.–2 Jan. 1922–3 (184).

211

212

212
Female peasants placing pea sticks in the ground 1890

Rameuses de pois
P&V 1652
Gouache with traces of black chalk on grey-brown paper.
40.7 × 64.1 cm./16 × 25¼ in. (size of paper); 39 × 60.2 cm./15¼ × 23⅝ in. (size of fan-shaped composition). Signed and dated in red gouache, lower left: *C. Pissarro 1890*.
The Ashmolean Museum, Oxford, lent by the Visitors of the Ashmolean Museum

This is one of Pissarro's finest fans and its shape is unique, owing to the flat lower edge in conjunction with the steep angled corners. The fan was sent by Camille Pissarro as a gift to his son in January 1891 (*Lettres*, pp. 201–3).

The composition should be compared with P&V 772, of 1891 (New York, Parke-Bernet, 10 March 1971, lot 10 repr. col.), a painting of the same subject once owned by Monet, which has a vertical format. Gerstein argues that, regardless of the difference in date, the painting precedes the fan, mainly because on the fan the composition is tighter and has been expanded to suit the different shape. It is difficult to prove the validity of this. The main differences between the painting and the fan are that in the latter the two figures in the background have been transposed, an extra figure on the right has been included, and that there is a greater emphasis on the landscape background, surely meant to be a representation of Eragny-sur-Epte or Osny. Common to both the painting and the fan, however, is the dance-like rhythm of the figures. The treatment of the light and the pale tones of the fan evoke a rural arcadia far removed from the world of J.-F. Millet, or, indeed, from Pissarro's own renderings of peasant life during the 1870s.

PROVENANCE: London, Lucien Pissarro collection; Esther Pissarro collection, by whom presented to the Ashmolean Museum, 1950.
LITERATURE: M. Gerstein, *Impressionist and post-impressionist fans*, Harvard University Ph.D Thesis, 1978, pp. 217–19 No. 66 repr.; Brettell and Lloyd 219.
EXHIBITED: Tate Gallery, 1931, but only shown subsequently at Birmingham, Oct.–Nov. 1931 (33), Nottingham, Nov.–Dec. 1931; Stockport, Jan. 1932 (2); Sheffield, Feb.–Mar. 1932 (3); Gloucester, *Modern French painters*, May–Jun. 1936 (22); London, O'Hana, 1956 (73); London, Royal Academy, *Impressionism. Its masters, its precursors, and its influence in Britain*, 9 Feb.–28 Apr. 1974 (92); London/Nottingham/Eastbourne, 1977–8 (38); Tokyo, Sunshine Museum/Osaka, Municipal Museum/Fukouka, Art Museum, *Ukiyo-e prints and the impressionist painters*, 15 Dec.–15 Jan., 22 Jan.–10 Feb., 15 Feb.–28 Feb. 1979–80 (II-32 repr. col. revised edn. II-36).

Catalogue of Ceramics

213
Apple picking c. 1884–5

La cueillette des pommes
P&V 1665
Oil on faience. 19 × 39 cm./7½ × 15⅜ in.
J.P.L. Fine Arts Ltd, London and Mme. Katia Pissarro

Together with three other ceramic tiles (P&V 1666–8), which were sold in Paris on the same occasion (Paris, Georges Petit, 3 December 1928, lots 56 and 58–9), this rare example of Pissarro's painting on ceramic was apparently used to decorate a *jardinière*. The composition is not directly related to any of the paintings of this subject (P&V 545 or Cat. 64, 68), although it could be said to incorporate motifs from the different types of composition exemplified in these pictures. There is, however, a closer connection with a gouache (P&V 1422), which also depicts two women using a ladder and a man carrying baskets set within a rectangular format. In the tile, the cart on the right of the gouache is omitted, while an additional female figure is inserted in the left half, where she is shown picking up apples off the ground. There is

also an affinity with the design made for inclusion in *Travaux des champs* (Brettell and Lloyd 338–9).

Pissarro here relishes the light background provided by the faience and the whole effect is one of luminosity. The application of the paint suggests a date towards the middle of the 1880s. Of the other tiles to which this is related, P&V 1668, *St. Martin's Fair at Pontoise*, is rectangular in shape and the same size, whereas the other two, *Potato harvest* and *Female peasant in a cabbage field* (P&V 1666–7 respectively) are almost square.

Although it is known that Camille Pissarro did become interested in the decoration of ceramic tiles between 1877–80 (Shikes and Harper, p. 138), the full extent of this practice has yet to be ascertained (see Cat. 214). The tiles discussed in this entry may not even come into the same category.

PROVENANCE: Camille Pissarro collection; Mme. Vve. Pissarro (Paris, Georges Petit, 3 December 1928, lot 57 repr.); Paris, Hugues (grandson of the artist) and Katia Pissarro.
EXHIBITED: Tokyo, Sunshine Museum/Osaka, Municipal Museum/Fukuoka, Art Museum, *Ukiyo-e prints and the impressionist painters*, 15 Dec.–15 Jan., 22 Jan.–10 Feb., 15 Feb.–28 Feb. 1979–80 (II–31 repr. col. revised edn. only).

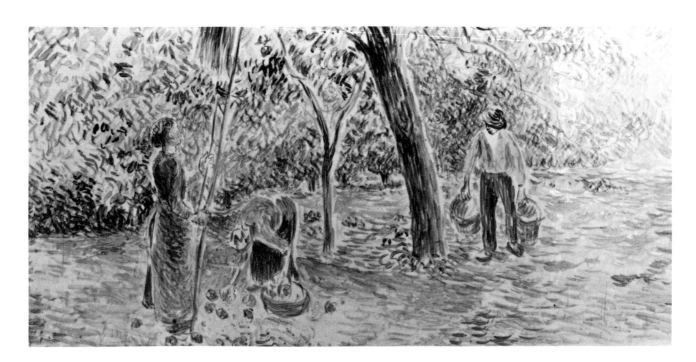

214 EXHIBITED IN BOSTON ONLY
The outskirts of Pontoise. Peasants resting, Montfoucault

Environs de Pontoise. Le repos des moissonneurs, Montfoucault
Each, tile: 11.4 × 11.4 cm./$4\frac{1}{2}$ × $4\frac{1}{2}$ in.
Each, frame: 21 × 20.7 cm./$8\frac{1}{4}$ × $8\frac{1}{8}$ in.
Each, verso of frame: *Dupré, Faubg St. Honoré, 141*
Private collection

These two tiles differ considerably from the ceramic pieces known to be by Pissarro (Cat. 213), yet their subject-matter, painterly style, jewel-like colours and, above all, their provenance, suggests that Pissarro furthered his artistic experimentations in yet another manner.

Mary Cassatt, who first exhibited with the impressionist group in 1879, admired and respected Pissarro. She was committed to his art and made many efforts to find purchasers for his work; she and her family were among those who acquired his paintings, gouaches, and fans. Mary Cassatt joined Degas and Pissarro in their 1879 publishing venture (*Le Jour et la Nuit*), and it may have been at this time that she acquired these small tiles. The unmarked clay pieces suggest that they were the efforts of an amateur ceramicist rather than part of a commercial endeavour.

Both tiles (as well as a third not exhibited) show a remarkable resemblance to certain paintings. *The outskirts of Pontoise* relates to P&V 400, which was in the collection of Eugène Murer, and to P&V 502, *The towpath* of 1879, while *Peasants resting, Montfoucault* relates to P&V 319 of 1875, which was sold in Paris in 1879. Pissarro may have made small replicas or mementoes of a few paintings before they left his ownership, which would preclude the likelihood that they were copies of his oils by another and later hand. In the nineteenth century a tile factory specializing in *tuiles décoratifs* existed in nearby Osny and Pissarro might have made use of these facilities (Shikes and Harper, 1980, p. 138).

Like their counterparts in oil, the landscape views on the tiles were painted with thick curved brushstrokes readily apparent under the high glaze, and each composition was packed with foliage, billowy clouds, and small picturesque details. The brilliant blue sky shares the same colour intensity as the white clouds, the vegetation in various greens, and the touches of red accents.

Mary Cassatt owned paintings by Pissarro that are not found in the *catalogue raisonné*, as well as a fan that also went undetected (exhibited *Mary Cassatt at home*, Boston, Museum of Fine Arts, 5 Aug.–24 Sept. 1978, No. 66 – this fan is probably the same one that was shown in the fourth Impressionist exhibition of 1879, No. 200, 'Cueillette de petits pois, Eventail: app. à Mlle. C'). It is therefore possible that these tiles by Pissarro have also escaped general notice.

PROVENANCE: Mary Cassatt.

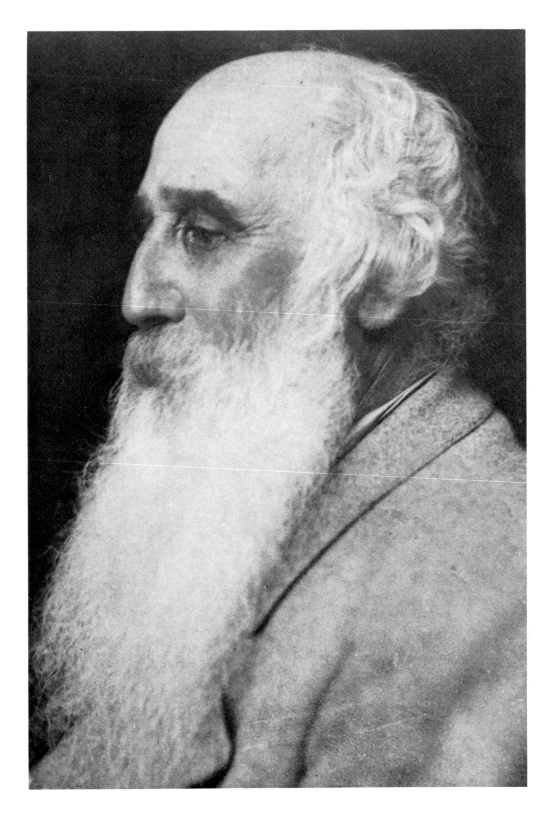

Images of Camille Pissarro

215

JULES CARDOZE (recorded 1861–1898)

Portrait of Camille Pissarro seated at an easel seen in three-quarters profile facing left from the back 1861

Camille Pissarro assis devant son chevalet

Pencil. 19 × 13 cm./$7\frac{1}{2}$ × $5\frac{1}{8}$ in. Signed and dated in pencil, lower left: *Jules Cardoze/1861.*

Collection of M. and Mme. Félix Pissarro, Menton

This is possibly the earliest portrait of Camille Pissarro after the painter's arrival in France in 1855. Another of the same date was also sold on 8 December 1928 (Paris, Hôtel Drouot, 8 December 1928, lot 278, 22 × 12 cm., for 180 frs.). A portrait of Cardoze by Camille Pissarro dating from this same period is in the Ashmolean Museum, Oxford (Brettell and Lloyd 40), on the verso of which there is a self-portrait by Pissarro.

The clear pencil outlines, the almost fussy accents used for the creases in the trousers, and the neat hatching in the present sheet are close to Pissarro's own style of drawing during the late 1850s and early 1860s. The treatment of the sitter's hair at the back anticipates a drawing of Pissarro by Cézanne (A. Chappuis, *The drawings of Paul Cézanne. A catalogue raisonné*, London, 1973, i. No. 301 p. 112 repr.).

Jules Cardoze, novelist and artist, was apparently distantly related to Camille Pissarro (Kunstler, 1930, p. 224) and, indeed, maintained close contact with the family up until the 1890s. In 1861 Cardoze was living at 17, rue Notre Dame de Lorette in Paris.

PROVENANCE: Camille Pissarro collection; Mme. Vve Pissarro collection (Paris, Hôtel Drouot, 8 December 1928, lot 277, for 90 frs.); Félix Pissarro, the son of Georges (Manzana) Pissarro.

216
PAUL CÉZANNE (1839–1906)
Portrait of Camille Pissarro c. 1873

Portrait de Camille Pissarro
Pencil. 10 × 8 cm./4 × 3⅛ in.
Inscribed in pencil by a later hand *Portrait de C. Pissarro/par Cézanne.*
Collection of Mr. J. Rewald, New York

All authorities are agreed that the drawing dates from the mid-1870s when the two artists exerted considerable influence upon one another. Rewald and Chappuis suggest *c.* 1873, whilst Andersen favours 'the early winter months of 1874'.

Besides Cat. 217 below, Andersen catalogues three further sheets by Cézanne with portraits of Camille Pissarro (Andersen, Nos. 231, 233 and 245).

PROVENANCE: London, Lucien Pissarro collection; London, Leicester Galleries; London, Sir Hugh Walpole collection, (sold London, Leicester Galleries, 1945 (128)); Keswick, Portinscale, Dr. F. Springell collection.
LITERATURE: Kunstler (Letters), 1930, repr. p. 223; J. Rewald, *Cézanne et Zola*, Paris, 1936, repr. pl. 34; J. Rewald and R. Huyghe, 'Cézanne', *L'Amour de l'Art* XVII (1936), p. 192 repr.; J. Rewald, *Cézanne, sa vie, son oeuvre, son amitié pour Zola*, Paris, 1939, repr. fig. 34; *Lettres*, Eng. edn. only, repr. pl. 49; J Rewald, *Cézanne*, New York; 1948, repr. fig. 48; J. Rewald, *The ordeal of Paul Cézanne*, London, 1950, repr. fig. 33; A. Neumeyer, *Cézanne drawings*, New York–London, 1958, No. 28 repr.; J. Rewald, *Cézanne*, London, 1959 and 1965, repr. fig. 33; J. Rewald, *Paul Cézanne. Briefe*, Zurich, 1962, repr. p. 161; J. Rewald, *Paul Cézanne*, New York, 1968, fig. 41; *The world of Cézanne*, repr. p. 68; W. Andersen, *Cézanne's portrait drawings*, Cambridge (Mass.) – London, 1970, No. 230 repr. pp. 9, 13, 14, 17, and 208; Rewald, 1973, repr. p. 312; A. Chappuis, *The drawings of Paul Cézanne. A catalogue raisonné*, London, 1973, i, No. 298 p. 112 repr.; Adler, 1978, repr. fig. 17; Shikes and Harper, 1980, pp. 123–4 repr.
EXHIBITED: New York, Wildenstein, *Cézanne*, 1947 (87 repr.); Toledo, Museum of Art, 1949 (no cat.); Vienna, Belvedere, *Paul Cézanne 1839–1906*, 14 Apr.–18 Jun. 1961 (86); Aix-en-Provence, Pavillon Vendôme, *Paul Cézanne 1839–1906*, 1 Jul.–15 Aug. 1961 (40); Washington, Phillips Collection/Chicago, Art Institute/Boston, Museum of Fine Arts, *Cézanne*, 27 Feb.–28 Mar., 17 Apr.–16 May, 1 Jun.–3 Jul. 1971 (66 repr.); Newcastle upon Tyne, Laing Art Gallery and London, Hayward Gallery, *Watercolour and pencil drawings by Cézanne*, 19 Sept.–4 Nov. and 13 Nov.–30 Dec. 1973 (13 and p. 153 repr.); Paris, Orangerie, *Cézanne dans les musées nationaux*, 19 Jul.–14 Oct. 1974 (53 repr.).

216

217

217
PAUL CÉZANNE (1839–1906)
Full-length portrait of Camille Pissarro out of doors with a walking stick and knapsack (recto) c. 1877
Camille Pissarro
Landscape study with trees (verso) c. 1877
Etude de paysage avec arbres
V 1235
Pencil. 21.2 × 12.9 cm./$8\frac{3}{8}$ × 5 in.
Musée du Louvre, Paris (Cabinet des Dessins inv. RF 11995)

The recto has been variously dated: Venturi (1872–6), Novotny (c. 1877), Neumeyer (1872–6), Rewald (c. 1873 or 1874), Reff (c. 1877), Andersen (1875–7), and Chappuis (1874–7). On the verso is a brief landscape study dated 1876–9 by Chappuis (No. 758). As Rewald first observed, the portrait of Pissarro is, in fact, based on a photograph in which Pissarro and Cézanne are shown with two other painters standing by a wall in Pontoise (repr. J. Rewald, *Cézanne et Zola*, Paris, 1936, pl. 32). In support of his dating c. 1877 Reff writes: 'The full tonal scale of the photograph is reduced to a few strong contrasts freely indicated by swift hatchings, giving the work an air of a spontaneous sketch. A tendency typical of Cézanne's draughtsmanship in the 1880s – to stress the shapes of objects by reducing them or eliminating their textures and tones – appears already here: the dark leather boots and light cotton breaches are rendered as uniformly white, distinctly outlined shapes.'

PROVENANCE: Camille Pissarro collection; Mme. Vve. Pissarro (Paris, Galerie Georges Petit, 3 December 1928, lot 62 repr.). Purchased by the Société des Amis du Louvre and presented to the Musée du Louvre, 1928.
LITERATURE: *La Renaissance*, 1928, repr. p. 13; *La Revue de l'Art ancien et moderne*, 1928, repr. p. 410; R. Huyghe, 'Acquisitions à la vente Pissarro', *Bulletin des musées de France* i (1929), p. 19 repr.; *Parnassus*, i. April (1929), repr. p. 13; J. Rewald and R. Huyghe, 'Les sources d'inspiration de Cézanne', *L'Amour de l'Art* xvii (1936), p. 192 repr.; J. Rewald, *Cézanne et Zola*, Paris, 1936, repr. fig. 34; F. Novotny, *Cézanne*, Vienna, 1937, No. 119; J. Rewald, *Cézanne*, New York, 1948, repr. fig. 42; A. Neumeyer, *Cézanne drawings*, New York–London, 1958, No. 29 repr.; T. Reff, 'Cézanne's drawings, 1875–1885', *Burlington Magazine* ci (1959), p. 172 repr.; S. Longstreet, *Paul Cézanne. Drawings*, Los Angeles-Borden, 1964, repr.; *Cézanne*, Paris (Hachette), 1966, repr. 107 (incorrect caption); J. Rewald, *Paul Cézanne*, New York, 1968, repr. fig. 39; W. Andersen, *Cézanne's portrait drawings*, Cambridge (Mass.)–London, 1970, p. 209 No. 232 repr.; Rewald, 1973, p. 296 repr.; A. Chappuis, *The drawings of Paul Cézanne. A catalogue raisonné*, London, 1973, i. No. 300 p. 112 repr.; L. Venturi, *Cézanne*, edn. Geneva, 1978, repr. p. 5; Adler, London, 1978, repr. pl. 18; Shikes and Harper, 1980, repr. p.116.
EXHIBITED: Paris, Orangerie, 1930 (57); Bucarest, *Le dessin français au XIX e et XXe siècles*, 1931 (63 repr.); Bucarest, *Le portrait français*, 1938 (16 repr.); Paris, Orangerie, *Les achats du Musée du Louvre et les dons de la Société des Amis du Louvre, de 1922 à 1932*, 1933 (132); Paris, Orangerie, *Cézanne*, 1936 (144); Lyons, Musée des Beaux-Arts, *Centenaire de Paul Cézanne*, 1939 (58); London, Wildenstein, *Homage to Paul Cézanne*, 1939 (77); Vienna, Belvedere, *Paul Cézanne 1839–1906*, 14 Apr.– 18 Jun. 1961 (88); Aix-en-Provence, Palais du Vendôme, *Paul Cézanne 1839–1906*, 1961 (41); Newcastle-upon-Tyne, Laing Art Gallery and London, Hayward Gallery, *Watercolour and pencil drawings by Cézanne*, 19 Sept.–4 Nov. and 13 Nov.–30 Dec. 1973 (15 and p. 153 repr.); Paris, Orangerie, *Cézanne dans les musées nationaux*, 19 Jul.–14 Oct. 1974 (54 repr.)

218
HENRI-EDMOND CROSS (1856–1910)
Portrait of Camille Pissarro reading c. 1890
Camille Pissarro Lisant
Black chalk. 43 × 55 cm./17 × $21\frac{5}{8}$ in. Signed in monogram in black chalk on right just above centre.
M. Henri M. Cachin Collection

The style of this magnificent sheet is clearly inspired by Seurat, but it is difficult to date without a more detailed study of drawings by Henri-Edmond Cross (J. Sutter, *Les Néo-Impressionnistes*, Neuchâtel, 1970, pp. 63–76 reproduces some examples). The artist was from Douai. He moved to Paris in 1881 and exhibited frequently with 'Les Indépendants' and 'Les XX'.

A former owner of this drawing, Charles Hall Thorndyke (1875–1935), was born in Paris of American parents. He became friendly with the older impressionist artists and the Neo-Impressionists.

PROVENANCE: Charles Hall Thorndyke collection.
EXHIBITED: Saint-Tropez, Musée de l'Annonciade, *Paul Signac et ses amis*, 1975.

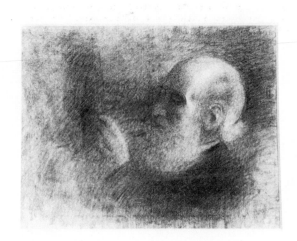

219
JEAN-LOUIS FORAIN (1852–1931)
Portrait of Camille Pissarro 1890–1900
Camille Pissarro

Watercolour. 21 × 14 cm./$8\frac{1}{4}$ × $5\frac{1}{2}$ in.

Inscribed in chalk, lower right: *à Pissarro / L. Forain.*

Collection of M. Claude Bonin, Paris

Rewald dates this watercolour *c.* 1897. Pissarro greatly admired Forain's skill as a draughtsman and social commentator, even though Forain was fiercely anti-Semitic. There are several references to the artist in Camille Pissarro's correspondence with Lucien. Three drawings by Forain were sold with Camille Pissarro's collection in 1928 (Paris, Hôtel Drouot, 8 December 1928, lots 287–9).

PROVENANCE: Alexandre Bonin collection (Mme. Bonin was second daughter of Camille Pissarro).
LITERATURE: Rewald, 1963, repr. p. 40.

220
ARMAND GUILLAUMIN (1841–1927)
Portrait of Camille Pissarro painting a blind
c. 1868
Camille Pissarro peignant un store

Canvas. 45.5 × 37.8 cm./$17\frac{7}{8}$ × $14\frac{7}{8}$ in. Signed, lower right: *Guillaumin.*

Musée Municipal de Limoges, Limoges (inv. P. 156 on deposit from the Musée du Louvre)

Pissarro first met Guillaumin through Cézanne at the Académie Suisse in the early 1860s. Guillaumin exhibited with the Impressionists frequently. This portrait is comparable in style and colour to the paintings executed with the palette knife by Cézanne and Pissarro during the final years of the 1860s (Cat. 7–8). It might be said that the portrait symbolizes the financial struggle faced by impressionist painters when they were forced to accept menial jobs in order to support themselves as painters. Pissarro himself in a letter of 1872 to Antoine Guillemet records that Guillaumin, who had little financial support, took on manual labour to earn extra money (see C. Gray, *Armand Guillaumin*, Chester, 1972, pp. 5, 6–7, and 10–11). Pissarro himself owned five works by Guillaumin, including a still-life of 1869 (Paris, Galerie Georges Petit, 3 December 1928, lots 77–81 repr.).

PROVENANCE: acquired by the Musée du Louvre, 1950, (RF 1950–35); placed *en dépôt* at Musée Municipal de Limoges, 1951.
LITERATURE: Lecomte, 1926 repr. pl. 1; G. Serret and D. Fabiani, *Armand Guillaumin. Catalogue raisonné de l'oeuvre peint*, 1971, No. 1; C. Gray, *Armand Guillaumin*, Chester, 1972, pp. 5–6 repr. fig 6; Rewald, 1973, repr. p.192; Shikes and Harper, 1980, p.84 repr.

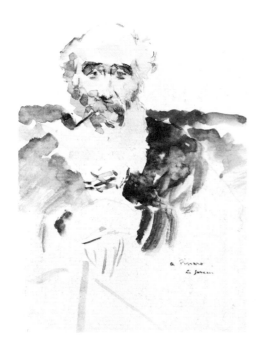

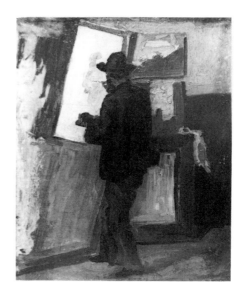

221

MAXIMILIEN LUCE (1858–1941)
Portrait of Camille Pissarro smoking a pipe 1890
Camille Pissarro fumant la pipe
Black chalk. 13 × 10 cm./$5\frac{1}{8}$ × 4 in. Signed and dated in black chalk, lower right: *Luce/90.*
Collection of Mr. John Rewald, New York.

Luce made many such portraits of his friends and contemporaries usually in this free-flowing, spontaneous style. Compare, for example, the *Portrait of Lucien Pissarro* (repr. *Lettres*, pl. 13) dated 1891. Luce was an ardent political anarchist, who first came to know Camille and Lucien Pissarro during the mid-1880s. Another portrait of Camille Pissarro by Luce is reproduced by J. Sutter, *Les Néo-Impressionnistes*, Neuchâtel, 1970, p. 160. It is in a tenebrist style and is apparently dated 1895.

Camille Pissarro owned four paintings by Luce, including the important *Vue prise à Montmartre* of 1887 (Paris, Galerie Georges Petit, 3 December 1928, lot 84–87 repr.). They travelled to England together in 1890 (Cat. 70).

PROVENANCE: Félix Fénéon, Paris, gift to the present owner (1938).
LITERATURE: J. Rewald, *Georges Seurat*, New York, 1943, p. 64 repr.; *Lettres*, Eng. edn. only, repr. pl. 20; Rewald, 1978, p. 88, repr.
EXHIBITED: New York, Wildenstein, *Seurat and his friends*, 18 Nov.–26 Dec. 1953 (uncatalogued).

222

LUDOVIC PIETTE (1826–1878)
Portrait of Camille Pissarro painting out of doors *c.* 1870
Camille Pissarro peignant en plein air
Gouache on canvas. 27 × 33 cm./$10\frac{3}{4}$ × $13\frac{1}{4}$ in. Signed, lower right: *L. Piette.*
Private collection

Rewald tentatively dates the portrait *c.* 1870, but there can be no certainty on this point. Neither is it possible to say where the portrait was made.

Piette exhibited at the third and fourth Impressionist exhibitions. His work is now best represented in the Musée de Pontoise (see *Pontoise du XVIIIe siècle au début du XXe*, 1978, Nos. 72–4 and 84). Pissarro himself owned several works by Piette, which were sold with his collection in 1928 (Paris, Hôtel Drouot, 8 December 1928, lots 302–307). For Piette see further p. 79 above.

PROVENANCE: Camille Pissarro collection; Mme. Vve. Pissarro (Paris, Galerie Georges Petit, 3 December 1928, lot 71 repr.); Alexandre Bonin collection (Mme. Bonin was second daughter of Camille Pissarro).
LITERATURE: Rewald, 1963, repr. p. 16; Rewald, 1973, repr. p. 207, Shikes and Harper, 1980, repr. p. 84.

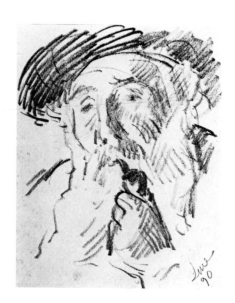

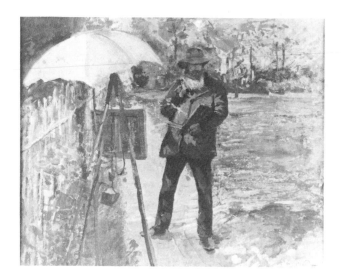

223
GEORGES (MANZANA) PISSARRO (1871–1961)
Portrait of Camille Pissarro smoking, seen by candlelight *c.* 1897
Camille Pissarro fumant à la lumière d'une bougie
Conté crayon. 41.5 × 31.5 cm./16$\frac{3}{8}$ × 12$\frac{3}{8}$ in. Signed and inscribed in conté, lower right: *Manzana Pissarro / portrait de C. Pissarro.*
Collection of M. and Mme. Félix Pissarro, Menton

Georges (Manzana) Pissarro was Camille Pissarro's second son. As an artist he was clearly influenced by Art Nouveau. His *oeuvre* also includes several broadly drawn caricatural studies of many of his father's friends and contemporaries. Some of these drawings, as in the present case, are based on photographs. Janine Bailly-Herzberg, who compiled the catalogue of the exhibition held in 1973, considers this portrait to be very close to a photograph of Camille Pissarro taken by Georges in London in June 1897.

PROVENANCE: Félix Pissarro, son of Georges (Manzana) Pissarro.
EXHIBITED: Les Andelys, Musée des Andelys, *Exposition rétrospective Manzana-Pissarro 1871–1961*, 1 Apr.–12 Jun. 1972 (52 repr. on cover): Paris, Galerie Dario Boccara, *Manzana Pissarro*, 16 May–15 Jun. 1973 (58 repr.).

224
GEORGES (MANZANA) PISSARRO (1871–1961)
The Impressionists' picnic *c.* 1900
Le pique-nique des Impressionnistes
Pen and ink. 21 × 26.5 cm./8$\frac{1}{4}$ × 10$\frac{1}{2}$ in. Signed in pen and ink, lower right: *Manzana. Pissarro.*
Further inscriptions along the lower edge identifying the characters from left to right: *Guillaumin, Pissarro, Gauguin, Cézanne* (at the easel), *Madame Cézanne, le petit Manzana.*
Collection of M. and Mme. Félix Pissarro, Menton

The drawing is no more than a *jeu d'esprit*. It is a scene from childhood, apparently witnessed in 1881, recalled by the artist at a later date. This type of humorous, anecdotal drawing was cultivated by younger members of the Pissarro family, who often produced whole albums of caricatures of family life at Pontoise and Eragny-sur-Epte.

PROVENANCE: Félix Pissarro, son of Georges (Manzana) Pissarro.
LITERATURE: *Jardin des Arts*, March 1972; *Etudes d'art français offertes à Charles Sterling*, 1975, repr. fig. 218; Shikes and Harper, 1980, pp. 153–4 repr.
EXHIBITED: Les Andelys, Musée des Andelys, *Exposition rétrospective Manzana-Pissarro 1871–1961*, 1 Apr.–12 Jun. 1972 (89 repr.): Paris, Galerie Dario Boccara, *Manzana Pissarro* 16 May–15 Jun. 1973 (73 repr.).

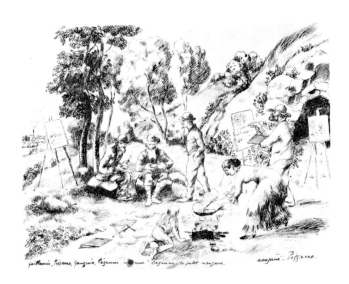

225

LUCIEN PISSARRO (1863–1944)
Study of Camille Pissarro etching seen from the back *c.* 1884

Camille Pissarro, de dos, en train de graver
Pen and ink. 22 × 17.6 cm./$8\frac{5}{8}$ × $6\frac{7}{8}$ in. Signed in pen and ink, lower right: *L.Vellay*, over which the artist has placed his monogram *L.P.* in a darker ink.
The Ashmolean Museum, Oxford, lent by the Visitors of the Ashmolean Museum

The drawing is in Lucien Pissarro's early pen style. The artist has signed the sheet using his mother's maiden name. The date *c.* 1884 accorded the drawing in *Lettres* is probably correct. Although not a drawing of high quality, it is of some interest as a document of Pissarro's print-making habits and techniques, at a time when his use of the medium was increasing. In this context, comparison might be made with the drawing by Cézanne of Dr. Gachet etching (A. Chappuis, *The drawings of Paul Cézanne. A catalogue raisonné*, London, 1973, i. No. 292 p. 111 repr. and W. Andersen, *Cézanne's portrait drawings*, Cambridge (Mass.)–London, 1970, No. 28 p. 70 repr.).

Another drawing by Lucien Pissarro of his father etching is reproduced in *Lettres* (pl. 32) where it is dated *c.* 1895. This is in pastel and has been brought to a higher finish than the present drawing.

PROVENANCE: London, Lucien Pissarro collection; Esther Pissarro collection, by whom presented to the Ashmolean Museum, 1950.
LITERATURE: *Lettres*, repr. pl. 11; Adler, 1978, repr. pl. 21.

226

LUCIEN PISSARRO (1863–1944)
Portrait of Camille Pissarro seated in a chair, seen in profile facing left, holding his palette 1890

Camille Pissarro, de profil vers la gauche, tenant une palette
Black chalk. Framed in black chalk by ruled lines.
25 × 19.8 cm./$9\frac{7}{8}$ × $7\frac{3}{4}$ in.
The Ashmolean Museum, Oxford, lent by the Visitors of the Ashmolean Museum

The drawing was made by Lucien Pissarro for the frontispiece of *Les hommes d'aujourd'hui* (No. 366), which was issued after February 1890, as can be deduced from the accompanying text written by Georges Lecomte. The drawing is seen in reverse direction from the final lithograph, which was executed by Charles Decaux. The size of the print is 19.2 × 15 cm.

PROVENANCE: London, Lucien Pissarro collection; Esther Pissarro collection, by whom presented to the Ashmolean Museum, 1950.
EXHIBITED: London/Nottingham/Eastbourne, 1977–8 (65).

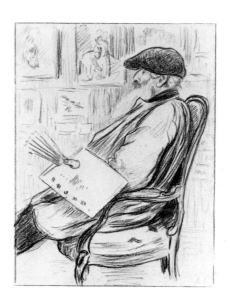

227
LUCIEN PISSARRO (1863–1944)
Portrait of Camille Pissarro asleep *c.* 1885–90
Camille Pissarro endormi
Black chalk. 20.2 × 13 cm./8 × 5⅛ in.
The Ashmolean Museum, Oxford, lent by the Visitors of the
Ashmolean Museum

The style of the drawing suggests a date shortly before 1890.

PROVENANCE: London, Lucien Pissarro collection; Esther Pissarro collection, by
whom presented to the Ashmolean Museum, 1950.
EXHIBITED: London/Nottingham/Eastbourne, 1977–8 (63).

228
LUCIEN PISSARRO (1863–1944)
Family group 1890–1900
Groupe de famille
Coloured chalks. 16.3 × 21.4 cm./6⅜ × 8⅜ in.
The Ashmolean Museum, Oxford, lent by the Visitors of the
Ashmolean Museum

When published in *Lettres* the drawing was entitled *The fireside at
Eragny-sur-Epte*. The composition, with the artist filling the left
foreground, the treatment of the light, and the intimacy of the
scene prompt comparison with Vuillard. Mme. Pissarro is seated on
the right, sewing. The other two figures are presumably members
of the family or household, but cannot be identified.

PROVENANCE: London, Lucien Pissarro collection; Esther Pissarro collection, by
whom presented to the Ashmolean Museum, 1950.
LITERATURE: *Lettres*, repr. pl.33.

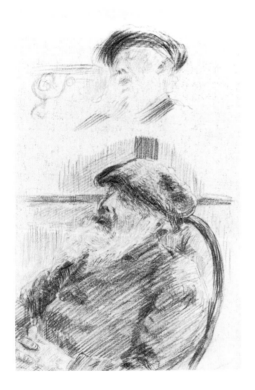

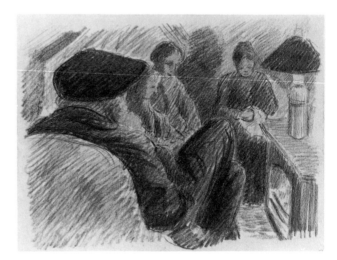

229

THÉO VAN RYSSELBERGHE (1862–1926)

Portrait of Camille Pissarro 1890–1900

Camille Pissarro
Conté crayon. 28 × 21.5 cm./11 × 8½ in.
Inscribed in conté crayon, upper right: *pour mon amie Berthie*
and signed in monogram.
Collection of the late Ginette Signac

Théo van Rysselberghe was a founding member of '*Les XX*', to
whose exhibitions in Brussels both Camille and Lucien Pissarro
were invited to contribute (Cat. 63, 66, 68 above). Camille Pissarro
saw a great deal of Théo van Rysselberghe when he left France for
Belgium during the summer of 1894, fearing arrest from the police
during the anarchist violence (*Lettres*, pp. 346–351), and the
younger artist became a family friend.

A portrait of Camille Pissarro's second daughter, Jeanne (repr.
Lettres, pl. 31) by van Rysselberghe, was sold with Camille
Pissarro's collection in 1928 (Paris, Galerie Georges Petit, 3
December 1928, lot 89 repr.).

Little is known about van Rysselberghe's drawings and it is
therefore difficult to date the sheet accurately. The sitter's age is
perhaps the best guide. The drawing is dedicated to the first wife of
Paul Signac. The maiden name of Mme. Signac was Berthe Roblès.
She was a distant relative of Camille Pissarro.

PROVENANCE: Paris, Mme. Berthe Signac collection, first wife of Paul Signac.

230

THÉODORE MULLER (1819–1879)

Design for an urban project in Pontoise 1864

Projet d'urbanisme, Pontoise
Lithograph. Imprimerie Lemercier, Paris.
30.3 × 46 cm./12 × 18⅛ in.
Musée de Pontoise, Pontoise

The project was submitted in 1864 and was underway by 1869. The
purpose was to connect the centre of the town to the newly built
station. This was done by creating the rue Imperiale (now rue
Thiers) leading from the Place de la Gare in the foreground to the
church of St. Maclou (upper centre). Other places that should be
noted are: the church of Notre Dame (centre left edge); the Jardin
Publique (upper left corner), near where the Parc-aux-Charettes is
situated; the river Oise (upper right) with the Ile du Pothuis and
the factory of Chalon et Cie; and in the distance (upper right) the
more rural area of L'Hermitage.

EXHIBITED: Pontoise, Musée, *Pontoise du XVIIe siècle au début du XXe*, 27 May–
30 Sept. 1978 (89 repr.)

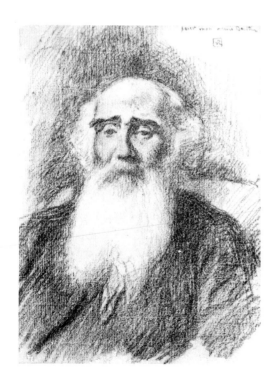

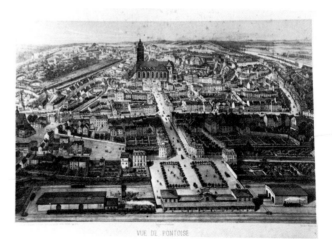

VUE DE PONTOISE

Selected Bibliography

Martha Ward

The most comprehensive bibliography of Pissarro is in the *catalogue raisonné* of 1939 by L.-R. Pissarro and L. Venturi. Although often inaccurate, it contains many references, particularly from the early twentieth century, not included here.

No attempt has been made to provide a literature on the impressionist movement as a whole, despite its obvious value for an understanding of Pissarro. For this, the reader may consult the excellent annotated bibliographies in J. Rewald's *History of Impressionism* (latest rev. ed. New York, 1973) and *Post-Impressionism, from Van Gogh to Gauguin* (latest rev. ed. New York, 1978).

Emphasis has been placed on criticism of Pissarro during the nineteenth century; this material has been arranged chronologically to allow the user to follow easily the course of critical thinking on Pissarro. For a more general bibliography of impressionist criticism, the reader is referred to O. Reutersvärd's *Impressionisterna: Inför publik och kritik*, Stockholm, 1952.

Only catalogues for the nineteenth-century exhibitions in which Pissarro's works appeared are listed in Part IV.

Where it has been possible to single out a passage on Pissarro in a general article or book, page numbers have been cited. An asterisk designates those works which are, in the opinion of the compiler, particularly valuable for the new documentation included or for the presentation of a significant interpretation of Pissarro.

The reader will find further references in the literature sections under the catalogue entries. These sections cite texts with passages on the individual paintings or drawings and record the first publication of a reproduction. Subsequent places of reproduction are included where it is felt that the context of publication is important, even though the text may not specifically refer to the painting or drawing.

Under the individual entries will also be found citations for twentieth-century group exhibitions.

In addition to the books by Pissarro and Venturi, Rewald and Reutersvärd cited above, I have benefited greatly in this task from theses by J. House (*Claude Monet: his aims and methods c. 1877–1895*, University of London, 1976) and S. Levine (*Monet and his critics*, New York and London, 1976), and references given me by C. Parsons and J. Bailly-Herzberg.

I. Contemporary Literature

1859 ASTRUC, Z. *Les 14 stations du Salon*, Paris, 1859, pp. 286–7.
LEPINOIS, E. de B. de. *L'art dans la rue et l'art au Salon*, Paris, 1859, p. 225.

1863 CASTAGNARY, J.-A. 'Salon des refusés, XIV' *L'Artiste*, 1 Dec. 1863. Repr.: Castagnary, *Salons*, Paris, 1892, I, pp. 175–6.

1865 RAVENEL, J. [A. Sensier] 'Salon de 1865' *L'Epoque*, I, 15 June 1865.

1866 CASTAGNARY, J.-A. 'Salon de 1866' *La Liberté*, 5–13 May 1866. Repr.: Castagnary, 1892, I, p. 235.
ROUSSEAU, J. 'Le Salon de 1866, IV' *L'Univers Illustré*, IX, 14 July 1866, p. 447.
ZOLA, E. 'Adieux d'un critique d'art' *L'Evénement*, 20 May 1866. Repr.: Zola, *Mon salon*, Paris, 1866; Zola, *Mes haines*, Paris, 1867; F.W.J. Hemmings and R.J. Niess, *Emile Zola: Salons*, Geneva and Paris, 1959, p. 78.

1868 CASTAGNARY, J.-A. 'Salon de 1868, V' *Le Siècle*, 7 May–12 June 1868. Repr.: Castagnary, 1892, I, p. 278.
REDON, O. 'Le Salon de 1868' *La Gironde*, 1 July 1868.
*ZOLA, E. 'Mon Salon, III. Les naturalistes' and 'Les paysagistes' *L'Evénement Illustré*, 19 May and 1 June 1868. Repr.: Hemmings and Niess, 1959, pp. 126–9, 135.

1870 ASTRUC, Z. 'Le Salon, sixième journée' *L'Echo des Beaux-Arts*, I, 12 June 1870.
CASTAGNARY, J.-A. 'Salon de 1870' *Le Siècle*, May 1870. Repr.: Castagnary, 1892, I, p. 426.
*DURET, T. 'Le Salon: les naturalistes, Pissaro [sic]' *L'Electeur Libre*, 12 May 1870. Repr.: Duret, *Critique d'avant-garde*, Paris, 1885, pp. 7–8.
RAVENEL, J. [A. Sensier] 'Préface au Salon de 1870' *La Revue Internationale de l'Art et de la Curiosité*, III, 15 April 1870, p. 323.

1873 CHESNEAU, E. 'Notes au jour le jour sur le Salon de 1873' *Paris-Journal*, 11 May 1873.
GALERIE DURAND-RUEL, Recueil d'Estampes, Paris [1873–5]. 'Préface' by P.A. Silvestre, 1873, pp. 22–3.

1874 [BURTY, P.] 'Exposition de la société anonyme des artistes' *La République Française*, 25 April 1874. Repr.: *Centenaire de l'Impressionnisme*, Paris, Grand Palais, 1974, pp. 261–2.
*CASTAGNARY, J.-A. 'L'Exposition du boulevard des Capucines; Les Impressionnistes' *Le Siècle*, 29 April 1874. Repr.: *Centenaire de l'Impressionnisme*, 1974, p. 265.
CHESNEAU, E. 'Avertissement préalable' *Paris-Journal*, 9 May 1874.
*LEROY, L. 'L'Exposition des impressionnistes' *Le Charivari*, 25 April 1874. Repr.: *Centenaire de*

l'Impressionnisme, 1974, pp. 259–60.

LORA, L. de. 'Petites nouvelles artistiques: exposition libre des peintres impressionnistes' *Le Gaulois*, 18 April 1874. Repr.: *Centenaire de l'Impressionnisme*, 1974, p. 257.

MONTIFAUD, M. de. 'L'Exposition du boulevard des Capucines' *L'Artiste*, 1 May 1874. Repr.: *Centenaire de l'Impressionnisme*, 1974, p. 267.

SILVESTRE, P.A. 'Chronique des beaux-arts: l'exposition des révoltés' *L'Opinion Nationale*, 22 April 1874.

1876　''BARON SCHOP'' [T. de Banville] 'La semaine parisienne, l'exposition des intransigeants, l'école des Batignolles, impressionnistes et plein air' *Le National*, 7 April 1876.

BIGOT, C. 'L'Exposition des ''intransigeants''' *La Revue Politique et Littéraire*, 2nd series, X, 8 April 1876, p. 351.

BLEMONT, E. 'Les Impressionnistes' *Le Rappel*, 9 April 1876.

DURANTY, E. *La nouvelle peinture*, Paris, 1876. Repr.: Paris, 1946.

ENAULT, L. 'L'Exposition des intransigeants' *Le Constitutionnel*, 10 April 1876.

PORCHERON, E. 'Promenades d'un flaneur: les impressionnistes' *Le Soleil*, 4 April 1876.

POTHEY, A. 'Chronique: exposition des ''impressionalistes'' chez Nadar, boulevard des Capucines' *La Presse*, 31 March 1876.

SILVESTRE, A. 'Exposition de la rue Le Peletier' *L'Opinion Nationale*, 2 April 1876.

VASSY, G. 'L'Exposition des impressionnistes' *L'Evénement*, 2 April 1876.

WOLFF, A. 'Le calendrier parisien' *Le Figaro*, 3 April 1876.

1877　ANONYMOUS. 'Exposition des impressionnistes' *La Petite République Française*, 10 April 1877.

BERTALL. 'Exposition des impressionnistes' *Paris-Journal*, 9 April 1877.

BIGOT, C. 'L'Exposition des ''impressionnistes''' *La Revue Politique et Littéraire*, 2nd series, XII, 28 April 1877, p. 1047.

*JACQUES. 'Menus propos: salon impressionniste' *L'Homme Libre*, 12 April 1877.

LORA, L. de. 'L'Exposition des impressionnistes' *Le Gaulois*, 10 April 1877.

MANTZ, P. 'L'Exposition des peintres impressionnistes' *Le Temps*, 22 April 1877.

*RIVIERE, G. 'L'Exposition des impressionnistes' *L'Impressionniste: Journal d'Art*, 6 April 1877, p. 2 and 14 April 1877, pp. 3–4. Repr.: Venturi, *Les archives de l'Impressionnisme*, II, Paris, 1939, pp. 308, 317–8.

1878　*DURET, T. *Les peintres impressionnistes*, Paris, 1878. Repr.: Duret, *Critique d'avant-garde*, Paris, 1885, pp. 75–80; Duret, *Les peintres impressionnistes*, Paris, 1923.

1879　BURTY, P. 'L'Exposition des artistes indépendants' *La République Française*, 16 April 1879.

DURANTY, E. 'La Quatrième exposition faite par un groupe d'artistes indépendants' *La Chronique des Arts et de la Curiosité*, 19 April 1879, pp. 126–7.

HAVARD, H. 'L'Exposition des artistes indépendants' *Le Siècle*, 27 April 1879.

HERVILLY, E. d'. 'Exposition des impressionnistes' *Le Rappel*, 11 April 1879.

P.L. [P. Laurent] 'Eau-forte de M. Pissarro' *Les Beaux-Arts Illustrés*, III, 1879, p. 96.

*MARTELLI, D. 'Gli Impressionisti, mostra del 1879' *Roma Artistica*, 27 June and 5 July 1879. Tr.: F. Errico, *Diego Martelli: Les Impressionnistes et l'art moderne*, Paris, 1979, p. 30.

WOLFF, A. 'Les Indépendants' *Le Figaro*, 11 April 1879.

1880　ANONYMOUS. 'La journée parisienne: impression d'un impressionniste' *Le Gaulois*, 24 Jan. 1880. Repr.: *L'Artiste*, 1880, p. 142.

BURTY, P. 'Exposition des oeuvres des artistes indépendants' *La République Française*, 10 April 1880.

CHARRY, P. de 'Le Salon de 1880; préface, les impressionnistes' *Le Pays*, 10 April 1880.

EPHRUSSI, C. 'Exposition des artistes indépendants' *La Gazette des Beaux-Arts*, 2nd series, XXI, 1880, p. 487.

SILVESTRE, A. 'Le Monde des arts: exposition de la rue des Pyramides' *La Vie Moderne*, 24 April 1880, p. 262.

ZOLA, E. 'Le naturalisme au Salon' *Le Voltaire*, 18–22 June 1880. Repr.: Hemmings and Niess, 1959, pp. 233–54.

1881　CARDON, E. 'Choses d'art: l'exposition des artistes indépendants' *Le Soleil*, 7 April 1881.

DALLIGNY, A. 'Les Indépendants, sixième exposition' *Le Journal des Arts*, 8 April 1881.

*C.E. [C. Ephrussi] 'Exposition des artistes indépendants' *La Chronique des Arts et de la Curiosité*, 16 April 1881, p. 127.

*G.G. [G. Geffroy] 'L'Exposition des artistes indépendants' *La Justice*, 17 April 1881.

GOETSCHY, G. 'Exposition des artistes indépendants' *Le Voltaire*, 5 April 1881.

GONZAGUE-PRIVAT. 'L'Exposition des artistes indépendants' *L'Evénement*, 5 April 1881.

MANTZ, P. 'Exposition des oeuvres des artistes indépendants' *Le Temps*, 23 April 1881.

SILVESTRE, A. 'Le Monde des arts' *La Vie Moderne*, 16 April 1881, p. 251.

VALABREGUE, A. 'Beaux-Arts: l'exposition des impressionnistes' *La Revue Littéraire et Artistique*, IV, 15 April 1881, p. 181.

1882　*BURTY, P. 'Les Aquarellistes, les Indépendants et le Cercle des Arts Libéraux' *La République Française*, 8 March 1882.

CHAMPIER, V. 'La Société des artistes indépendants' *L'Année Artistique*, IV, 1881–82, Paris, 1882, p. 168.

CHARRY, P. de. 'Beaux-Arts' *Le Pays*, 14 March 1882.

CHESNEAU, E. 'Groupes sympathiques: les peintres impressionnistes' *Paris-Journal*, 7 March 1882.

HAVARD, H. 'Exposition des artistes indépendants' *Le Siècle*, 2 March 1882.

HENNEQUIN, E. 'Les expositions des arts libéraux et des artistes indépendants' *La Revue Littéraire et Artistique*, V, 11 March 1882, p. 155.

*HEPP, A. 'Impressionisme [sic]' *Le Voltaire*, 3 March 1882.

NIVELLE, J. de. 'Les Peintres indépendants' *Le Soleil*, 4 March 1882.

SALLANCHES, A. 'L'Exposition des artistes indépendants' *Le Journal des Arts*, 3 March 1882.

*SILVESTRE, A. 'Le Monde des arts' *La Vie Moderne*, 11 March 1882, p. 151.

1883 DARGENTY, G. 'Exposition des oeuvres de M. Pissarro' *Le Courrier de l'Art*, 31 May 1883, p. 255.

HENRIET, F. 'L'exposition des oeuvres de C. Pissaro [sic]' *Le Journal des Arts*, 25 May 1883.

*HUSTIN, A. 'Exposition de Pissarro' *Le Moniteur des Arts*, 11 May 1883, p. 166.

*HUYSMANS, J.-K. 'L'Exposition des indépendants en 1880,' 'L'Exposition des indépendants en 1881' and 'Appendice I' [1882] in *L'Art Moderne*, Paris, 1883. Repr.: Huysmans, *L'Art Moderne/Certains*, Paris, 1975, pp. 105, 235–8, 251–2, 265.

JACQUES, E. 'Exposition de M. Pissarro' *L'Intransigeant*, 14 May 1883.

LABARRIERE, P. 'Exposition Pissaro [sic], boulevard de la Madeleine, 9' *Le Journal des Artistes*, 1 June 1883.

*MOREL, H. 'Camille Pissarro' *Le Réveil*, 24 June 1883.

WEDMORE, F. 'The Impressionists' *Fortnightly Review*, n.s. XXXIII, Jan. 1883, p. 81.

1885 DURET, T. *Critique d'avant-garde*, Paris, 1885, pp. 7–8, 75–80. Repr. of Duret 1870 and 1878.

VERHAEREN, E. 'L'Impressionnisme' *Journal de Bruxelles*, 15 June 1885. Repr.: Verhaeren, *Sensations*, Paris, 1928, p. 180.

1886 ANONYMOUS [H. Le Roux?] 'L'exposition des impressionnistes' *La République Française*, 17 May 1886.

ADAM, P. 'Peintres impressionnistes' *La Revue Contemporaine*, IV, April–May 1886, pp. 548–9.

_____ . et al. 'Camille Pissarro' in *Petit Bottin des Lettres et des Arts*, Paris, 1886, p. 98.

AJALBERT, J. 'Le Salon des impressionnistes' *La Revue Moderne*, 20 June 1886, pp. 390–1.

DARZENS, R. 'Exposition des indépendants' *La Pléiade*, May 1886, p. 90.

*FENEON, F. 'VIIIe exposition impressionniste' *La Vogue*, 13–20 June 1886. Repr.: with revisions: Fénéon, *Les Impressionnistes en 1886*, Paris, 1886. Repr.: J.U. Halperin, *Félix Fénéon: oeuvres plus que complètes*, I, Geneva and Paris, 1970, pp. 29–38.

_____ . 'L'Impressionnisme aux Tuileries' *L'Art Moderne*, 19 Sept. 1886. Repr.: Halperin, I. pp. 29–38.

FEVRE, H. 'L'Exposition des indépendants' *Revue de Demain*, May 1886, pp. 150–1. Repr.: Fèvre, *Etude sur le Salon de 1886 et sur l'Exposition des Impressionnistes*, Paris, 1886.

FOUQUIER, M. 'Les Impressionnistes' *Le XIXe Siècle*, 16 May 1886.

GEFFROY, G. 'Salon de 1886: VII. Hors du Salon, les impressionnistes' *La Justice*, 21 May 1886.

*MIRBEAU, O. 'Exposition de peinture: 1 rue Laffitte' *La France*, 21 May 1886.

PAULET, A. 'Les Impressionnistes' *Paris*, 5 June 1886.

1887 CHAMPSAUR, F. 'A travers les ateliers' in *Le Défilé*, Paris, 1887, pp. 131–40.

DESCLOZEAUX, J. 'L'Exposition internationale de peinture' *L'Estafette*, 15 May 1887.

FENEON, F. 'Le Néo-Impressionnisme' *L'Art Moderne*, 1 May 1887. Repr.: Halperin, I, pp. 71–6.

*GEFFROY, G. 'Chronique: Salon de 1887: X. Hors du Salon, rue de Sèze et rue Laffitte' *La Justice*, 13 June 1887.

GEORGET, A. 'Exposition internationale de peinture' *L'Echo de Paris*, 17 May 1887.

HUYSMANS, J.-K. 'L'exposition internationale de la rue de Sèze' *La Revue Indépendante*, June 1887, p. 353.

KAHN, G. 'La vie artistique' *La Vie Moderne*, 21 May 1887, p. 328.

*MIRBEAU, O. 'L'Exposition internationale de la rue de Sèze' *Gil Blas*, 14 May 1887.

''TRUBLOT'' [P. Alexis] 'A minuit: la collection Murer' *Le Cri du Peuple*, 21 Oct. 1887. Repr.: P. Gachet, *Deux amis impressionnistes*, Paris, 1957, p. 159.

VERHAEREN, E. 'Le Salon des Vingt à Bruxelles' *La Vie Moderne*, 26 Feb. 1887, p. 138.

1888 CHRISTOPHE, J. 'Chronique: chez Durand-Ruel' *Le Journal des Artistes*, 10 June 1888, p. 185.

FENEON, F. 'Calendrier de décembre, 1887 . . . V. Vitrines des marchands de tableaux . . . VII. Exposition de la Revue Indépendante' *La Revue Indépendante*, Jan. 1888. Repr.: Halperin, I, pp. 90, 92.

_____ . 'Calendrier de mars . . . II. Aux vitrines des marchands de tableaux, chez Van Gogh . . .' *La Revue Indépendante*, April 1888. Repr.: Halperin, I, pp. 102–3.

_____ . 'Quelques impressionnistes' *La Cravache*, 2 June 1888. Repr.: Halperin, I, p. 127.

_____ . 'Calendrier de septembre . . . III. Chez M. Van Gogh' *La Revue Indépendante*, Oct. 1888. Repr.: Halperin, I, p. 118.

LEGENDRE, M. 'L'Exposition de la Galerie Durand-Ruel' *Le Journal des Arts*, 12 June 1888.

''POINTE-SECHE'' [F. Buhot] 'Le Whistlerisme et le Pissarisme à l'exposition des XXXIII' *Le Journal des Arts*, 13 Jan. 1888.

1889 [FENEON, F.] 'Exposition Pissarro' *L'Art Moderne*, 20 Jan. 1889. Repr.: Halperin, I, pp. 137–8.

*FENEON, F. 'Les peintres-graveurs' *La Cravache*, 2 Feb. 1889. Repr.: Halperin, I, p. 140.

KAHN, G. 'Chronique: l'art français à l'exposition' *La Vogue*, n.s., I, 1889, pp. 132–3.

MAUS, O. 'Le Salon des XX à Bruxelles' *La Cravache*, 16 Feb. 1889.

F.N. [F. Nautet?] 'Arts, sciences et lettres: l'exposition Pissarro' *Le Journal de Bruxelles*, 19 Jan. 1889.

1890 ALEXANDRE, A. 'Camille Pissaro [sic]' *Paris*, 28 Feb. 1890.

ANTOINE, J. 'Exposition Camille Pissarro' *Art et Critique*, II, 1 March 1890, pp. 141–2.

*AURIER, G.-A. 'Camille Pissarro' *La Revue Indépendante*, March 1890, pp. 503–15. Repr.: Aurier, *Oeuvres posthumes*, Paris, 1893, pp. 235–44.

_____ . 'Beaux-Arts: expositions de février-mars' *Le Mercure de France*, I, April 1890, pp. 143–4.

DARGENTY, G. 'Chronique des expositions: . . . II. M. Pissaro [sic]' *Le Courrier de l'Art*, 7 March 1890, p. 75.

*LECOMTE, G. 'Camille Pissarro' *Les Hommes d'Aujourd'hui*, VIII [1890].
────────── . 'Toiles récentes de M. Camille Pissarro' *Art et Critique*, II, 6 Sept. 1890, pp. 573–4.
"LE PASSANT." 'Les on-dits' *Le Rappel*, 10 March 1890.
LE ROUX, H. 'Exposition C. Pissarro' *Le Temps*, 7 March 1890.
SERTAT, R. 'Exposition C. Pissarro' *Le Journal des Artistes*, 2 March 1890, p. 58.

1891 BERALDI, H. 'Camille Pissarro' in *Les Graveurs du XIXe siècle*, XI, Paris, 1891, pp. 12–4.
*FENEON, F. 'Cassatt, Pissarro' *Le Chat Noir*, 11 April 1891. Repr.: Halperin, I, pp. 185–6.
HAMERTON, P.G. 'The present state of the fine arts in France: IV. Impressionism' *Portfolio*, XXII, Feb. 1891, pp. 72–3.
G.L. [G. Lecomte] 'Expositions à Paris: . . . Camille Pissarro, Mary Cassatt' *L'Art Moderne*, March 1891, pp. 136–7.
LECOMTE, G. 'M. Camille Pissarro' *La Plume*, 1 Sept. 1891, pp. 301–2.
A.M. [A. Mellerio] 'Les artistes à l'atelier: C. Pissarro' *L'Art dans les Deux Mondes*, 6 June 1891, p. 31.
*MIRBEAU, O. 'Camille Pissarro' *L'Art dans les Deux Mondes*, 10 Jan. 1891, pp. 83–4.
*VAN DE VELDE, H. *Du paysan en peinture*, Brussels [n.d., lecture delivered in 1891], pp. 17–9. Remarks on Pissarro repr.: *L'Art Moderne*, 22 Feb. 1891, pp. 60–2, and *L'Art Moderne*, 28 Aug. 1892, pp. 276–7.

1892 *ALEXANDRE, A. 'Chroniques d'aujourd'hui: Camille Pissarro' *Paris*, 2 Feb. 1892.
ANDREI, A. 'Les Petits Salons: Camille Pissaro [sic]' *La France Nouvelle*, 23 Feb. 1892.
ANONYMOUS. 'Camille Pissarro' *L'Art Moderne*, 7 Feb. 1892, p. 47.
*ANTOINE, J. 'Critique d'art: exposition de M. Camille Pissarro' *La Plume*, 15 Feb. 1892, pp. 101–2.
AURIER, G.-A. 'Choses d'art: chez Durand-Ruel' *Le Mercure de France*, III, March 1892, p. 283.
COOLUS, R. 'A Pissarro' (poem) *La Revue Blanche*, n.s., II, Feb. 1892, p. 125.
DALLIGNY, A. 'Expositions particulières . . . Pissaro [sic]' *Le Journal des Arts*, 12 Feb. 1892.
FENEON, F. 'Exposition Camille Pissarro' *L'Art Moderne*, 14 Feb. 1892. Repr.: Halperin, I, p. 209.
────────── . Untitled note in *L'En Dehors*, 21 Feb. 1892. Repr.: Halperin, II, p. 895.
CH. F. [C. Frémine] 'Les on-dits' *Le Rappel*, 3 Feb. 1892.
GSELL, P. 'La Tradition artistique française; I. L'Impressionnisme' *La Revue Politique et Littéraire*, XLIX, 26 March 1892, p. 404.
"KALOPHILE L'ERMITE." 'Chroniques: . . . III. Les Arts, Camille Pissarro, exposition Durand-Ruel' *L'Ermitage*, IV, 1892, pp. 117–8.
LECOMTE, G. 'Exposition Camille Pissarro' *Art et Critique*, IV, 6 Feb. 1892, pp. 49–52.
────────── . *L'Art Impressionniste d'apres la Collection Privée de M. Durand-Ruel*, Paris, 1892.
A. de L. [A. de Lostalot] 'L'Exposition des peintures de M. Camille Pissarro' *La Chronique des Arts et de la Curiosité*, 6 Feb. 1892, pp. 41–2.

MIRBEAU, O. 'Camille Pissarro' *Le Figaro*, 1 Feb. 1892. Repr.: Mirbeau, *Des Artistes, première série*, Paris, 1922, pp. 145–53.
*SAUNIER, C. 'L'Art Nouveau: I. Camille Pissarro' *La Revue Indépendante*, April 1892, pp. 30–40.
VALLOTON, F. Article on Pissarro in *La Gazette de Lausanne*, 24 Feb. 1892.

1893 ANONYMOUS. 'M. Camille Pissarro' *L'Art Français*, 25 March 1893.
────────── . 'Au jour le jour: encore des peintres . . . Camille Pissarro' *Le Temps*, 17 March 1893.
MICHEL, A. 'Exposition d'art' *Le Journal des Débats*, 16 March 1893.
MOORE, G. 'Monet, Sisley, Pissarro and the decadence' in *Modern Painting*, London and New York, 1893, pp. 84–90. Repr.: London, 1897 and numerous subsequent editions.
MUTHER, R. 'Camille Pissarro' in *Geschichte der Malerei im XIX. Jahrhundert*, II, Munich, 1893, pp. 638–43.

1894 *ALEXANDRE, A. 'L'Art à Paris: Camille Pissarro' *Paris*, 8 March 1894.
C.J. 'Notes d'art' *L'Estafette*, 21 March 1894.
*CARDON, L. 'Camille Pissarro' *L'Evénement*, 6 March 1894.
G.G. [G. Geffroy] 'Camille Pissarro, chez Durand-Ruel, exposition d'oeuvres de l'artiste' *Le Matin*, 6 March 1894.
*GEFFROY, G. 'Histoire de l'impressionnisme' and 'Camille Pissarro' in *La vie artistique, histoire de l'Impressionnisme*, 3rd series, Paris, 1894, pp. 1–53, 96–110.
"MERCURE." 'Choses d'art: exposition Camille Pissarro' *Le Mercure de France*, X, April 1894, p. 377.
[SILVESTRE, A.] 'Oeuvres de M. Camille Pissarro' *L'Art Français*, 10 March 1894.

1895 JOURDAIN, F. 'Camille Pissarro' in *Les Décorés, ceux qui ne le sont pas*, Paris, 1895, pp. 193–7.

1896 ALEXANDRE, A. 'La Vie artistique: les oeuvres de Camille Pissarro' *Le Figaro*, 17 April 1896.
FENEON, F. 'L'Exposition Camille Pissarro' *La Revue Blanche*, n.s., X, 15 May 1896. Repr.: Halperin, I, p. 238.
GEFFROY, G. 'L'Art d'aujourd'hui: Camille Pissarro' *Le Journal*, 18 April 1896. Repr.: Geffroy, *La Vie artistique*, 6th series, Paris, 1900, pp. 174–80.
HOFFMANN, E. 'Camille Pissarro' *Le Journal des Artistes*, 6 April 1896.
T.S. [Thiebault-Sisson] 'Notes d'art' *Le Temps*, 18 April 1896.
ZOLA, E. 'Peinture' *Le Figaro*, 2 May 1896. Repr.: Hemmings and Niess, 1959, pp. 265–70.

1897 DUHEM, H. *Renaissance*, Paris, 1897, pp. 24–5.
MIRBEAU, O. 'Famille d'artistes' *Le Journal*, 6 Dec. 1897. Repr.: Mirbeau, *Des artistes, deuxième série*, Paris, 1924, pp. 39–45.
ROGER-MILES, L. 'Camille Pissarro' in *Art et Nature*, Paris, 1897, p. 67.

1898 ALEXANDRE, A. 'La Vie artistique . . . II. Vues de Paris de M. Pissarro' *Le Figaro*, 3 June 1898.
AUBRY, P. 'La Vie artistique: Claude Monet- Camille Pissarro, Galerie Durand-Ruel' *Le Siècle*, 5 June 1898.

FONTAINAS, A. 'Art moderne . . . Galerie Durand-Ruel: exposition d'oeuvres de MM. Claude Monet, Renoir, Degas, Pissarro, Puvis de Chavannes' *Le Mercure de France*, XXVII, July 1898, p. 280.

GEFFROY, G. 'Camille Pissarro' *Le Journal*, 25 June 1898. Rev. version: Geffroy, *La Vie artistique*, 6th series, Paris, 1900, pp. 180–5.

HOFFMANN, E. 'Les Petits salons, Camille Pissarro' *Le Journal des Artistes*, 5 June 1898, p. 2311.

JOURDAIN, F. 'Les Hommes du jour, Camille Pissarro' *L'Eclair*, 18 June 1898.

LECOMTE, G. 'Quelques syndiqués, Camille Pissarro' *Les Droits de l'Homme*, 4 June 1898. Repr.: *Revue Populaire des Beaux-Arts*, II, 18 June 1898, pp. 42–4.

1899 FAGUS, F. 'Petite gazette d'art: Camille Pissarro' *La Revue Blanche*, n.s., XVIII, 1 April 1899, pp. 546–7.

FONTAINAS, A. 'Art moderne: exposition de tableaux de Monet, Pissarro, Renoir et Sisley . . .' *Le Mercure de France*, XXX, May 1899, p. 530.

LECLERCQ, J. 'Petites expositions: Galerie Durand-Ruel' *La Chronique des Arts et de la Curiosité*, 15 April 1899, pp. 130–1.

*SIGNAC, P. *D'Eugène Delacroix au Néo-Impressionnisme*, Paris, 1899. Repr.: F. Cachin, *P. Signac: D'Eugène Delacroix au Néo-Impressionnisme*, Paris, 1964, 1978.

THIEBAULT-SISSON. 'Une Histoire de l'Impressionnisme' *Le Temps*, 17 April 1899.

1900 FORTUNY, P. 'Camille Pissarro' in *Collection Eugène Blot* (sales catalogue) Hôtel Drouot, 9 and 10 May 1900.

*GEFFROY, G. 'Camille Pissarro' in *La Vie artistique*, 6th series, Paris, 1900, pp. 174–85. Reprint of Geffroy 1896 and 1898.

KAHN, G. 'L'Art à l'exposition: la centennale' *La Plume*, XI, 15 Aug. 1900, pp. 507–8.

MELLERIO, A. 'Camille Pissarro' in *L'Exposition de 1900 et l'art impressionniste*, Paris, 1900, pp. 7, 36–8.

1901 MORET, R. 'Camille Pissarro' *Art et Littérature*, 5 Feb. 1901.

*THIEBAULT-SISSON. 'Au jour le jour: choses d'art, Camille Pissarro' *Le Temps*, 20 Jan. 1901.

VERHAEREN, E. 'L'Art moderne' *Le Mercure de France*, XXXVII, Feb. 1901, p. 547.

1902 FONTAINAS, A. 'Art moderne: expositions . . . Monet et Pissarro . . .' *Le Mercure de France*, XLVIII, April 1902, pp. 246–7.

RIAT, G. 'Expositions de Sisley et de MM. Monet et Camille Pissarro' *La Chronique des Arts et de la Curiosité*, 22 Feb. 1902, p. 59.

SAUNIER, C. 'Gazette d'art: Monet, Pissarro, Sisley' *La Revue Blanche*, n.s., XXVII, 1 March 1902, pp. 385–6.

1903 *BERNARD, E. 'Deux morts: Paul Gauguin, Camille Pissarro' *La Nouvelle Revue d'Egypte Littéraire, Artistique et Sociale* (Alexandria), IV, Dec. 1903, pp. 469–70.

CRUCY, F. 'Notes prises auprès d'Octave Mirbeau' *L'Aurore*, 15 Nov. 1903.

DEWHURST, W. 'Impressionist painting, its genesis and development' *The Studio*, XXIX, 15 July 1903, pp. 94–112.

DUHEM, H. 'Camille Pissarro, souvenirs' *Le Beffroi* (Lille), Dec. 1903. Repr.: Duhem, *Impressions d'Art Contemporain*, Paris, 1913.

GEFFROY, G. 'Causeries: Camille Pissarro' *La Dépêche de Toulouse*, 20 Nov. 1903.

JOURDAIN, F. 'Camille Pissarro' *Les Temps Nouveaux*, IX, 19–25 Dec. 1903.

LE BLOND, M. 'Camille Pissaro [sic]' *L'Aurore*, 15 Nov. 1903.

LECOMTE, G. 'Camille Pissarro' *L'Oeuvre Nouvelle*, Dec. 1903, pp. 408–11.

MAUCLAIR, C. 'Pissarro et le paysage moderne' *La Nouvelle Revue*, XXV, 15 Dec. 1903, pp. 537–43.

——————. 'The secondary painters of Impressionism – Camille Pissarro, Alfred Sisley, Paul Cézanne . . .' in *The French Impressionists*, London and New York, 1903, pp. 132–6. Tr.: *L'Impressionnisme, son histoire, son esthétique, ses maîtres*, Paris, 1904.

*MAUD, P.L. [M. Denis] 'Camille Pissarro' *L'Occident*, Dec. 1903, pp. 294–6. Repr.: Denis, *Théories*, Paris, 1913, and O.R. d'Allonnes, *Denis: Du Symbolisme au Classicisme*, Paris, 1964, pp. 149–51.

MOURNEY, G. 'Camille Pissarro' *Les Arts*, Dec. 1903, pp. 38–42.

PAULET, A. 'Camille Pissarro' *L'Oeuvre Nouvelle*, Dec. 1903, pp. 411–4.

ROGER-MILES, L. 'Opinions: Camille Pissarro' *L'Eclair*, 17 Nov. 1903.

SOISSONS, Comte de. 'The etchings of Camille Pissarro' *The Studio*, XXX, 15 Oct. 1903, pp. 59–63.

VAUXCELLES, L. 'Camille Pissarro' *Gil-Blas*, 14 Nov. 1903.

II. Literature since Pissarro's death

ADLER, K. *Camille Pissarro: a biography*, London, 1978.

ALEXANDRE, A. 'Un mot sur Pissarro' *Comoedia*, 22 Jan. 1910.

ANONYMOUS. 'Camille Pissarro, memorial exhibition, Leicester Galleries' *The London Mercury*, II, July 1920, pp. 351–3.

——————. 'Pissarro, o il dramma del divisionismo' *Sele Arte* (Florence), I, July–Aug. 1952, pp. 15–8.

BAILLY-HERZBERG, J. 'Essai de reconstitution grâce à une correspondance inédite du peintre Pissarro du magasin que le fameux marchand Samuel Bing ouvrit en 1895 à Paris pour lancer l'Art Nouveau' *Connaissance des Arts*, Sept. 1975, pp. 72–81.

BAZIN, G. *L'Amour de l'Art* (special issue on Impressionism), n.s., XXVII, nos. 3 and 4, 1947.

BELL, C. *The French Impressionists*, London and New York, 1952.

BELLONY-REWALD, A. and R. GORDON. *The lost world of the Impressionists*, London and Boston, 1976. Tr.: *Le Monde retrouvé des Impressionnistes*, Paris, 1977.

BENISOVICH, M. and J. DALLETT. 'Camille Pissarro and Fritz Melbye in Venezuela' *Apollo*, LXXXIV, July 1966, pp. 44–7.

BLUNDEN, M. and G. *Journal de l'Impressionnisme*, Geneva, 1970. Tr.: *Impressionists and Impressionism*, Geneva, 1970.

BODELSEN, M. 'Early impressionist sales, 1874–94, in the light of some unpublished procès-verbaux' *Burlington Magazine*, CX, June 1968, pp. 330–49.

——————. 'Gauguin, the collector' *Burlington Magazine*, CXII, Sept. 1970, pp. 590–615.

BOULTON, A. *Camille Pissarro en Venezuela*, Caracas, 1966.

_____ . 'Camille Pissarro in Venezuela' *Connoisseur*, CLXXXIX, May 1975, pp. 36–42.

_____ . 'Un error sobre Camille Pissarro' *Boletin Historico* (Caracas), May 1975, pp. 239–43.

*BRETTELL, R. *Pissarro and Pontoise: the painter in a landscape*, unpublished Ph.D. thesis, New Haven, Yale University, 1977.

*BRETTELL, R. and C. LLOYD. *Catalogue of the drawings by Camille Pissarro in the Ashmolean Museum*, Oxford, 1980.

BROOKNER, A. 'Pissarro at Durand-Ruel's' *Burlington Magazine*, CIV, Aug. 1962, p. 363.

BROUDE, N. 'Macchialioli as "proto-impressionists"; realism, popular science and the re-shaping of Macchia romanticism 1862–1886' *Art Bulletin*, LII, Dec. 1970, p. 409.

*BROWN, R. 'Impressionist technique; Pissarro's optical mixture' *Magazine of Art*, XLIII, Jan. 1950, pp. 12–5. Repr.: B. White, *Impressionism in perspective*, Englewood Cliffs, 1978, pp. 114–21.

_____ . *The color technique of Camille Pissarro*, unpublished Ph.D. thesis, Cambridge, Harvard University, 1952.

CAILAC, J. 'The prints of Camille Pissarro; a supplement to the catalogue by Loys Delteil' *The Print Collector's Quarterly*, XIX, Jan. 1932, pp. 74–86.

*CHAMPA, K. 'Pissarro – the progress of Realism' in *Studies in early Impressionism*, New Haven, 1973, pp. 67–79.

COE, R.T. 'Camille Pissarro in Paris; a study of his later development' *Gazette des Beaux-Arts*, 6th series, XLIII, Feb. 1954, pp. 93–118. Tr.: pp. 128–34.

*_____ . 'Camille Pissarro's *Jardin des Mathurins*; an inquiry into impressionist composition' *Nelson Gallery Atkins Museum Bulletin* (Kansas City), IV, 1963, pp. 1–22.

COGNIAT, R. *Pissarro*, Paris, 1974 and 1978. Tr.: *Pissarro*, New York, 1975.

COOPER, D. 'The literature of art' (review of *Camille Pissarro: Letters to his son Lucien*) *Burlington Magazine*, LXXXIII, Jan. 1946, p. 24.

_____ . 'The painters of Auvers-sur-Oise' *Burlington Magazine*, XCVII, April 1955, pp. 100–5.

DE LA VILLEHERVE, R. 'Choses du Havre; les dernières semaines du peintre Camille Pissarro' *Havre-Eclair*, I, 25 Sept. 1904.

DEWHURST, W. 'Camille Pissarro, Renoir, Sisley' in *Impressionist painting*, London and New York, 1904, pp. 49–56.

DUNSTAN, B. 'Camille Pissarro' in *Painting methods of the Impressionists*, London and New York, 1976, pp. 68–75.

DURET, T. 'Camille Pissarro' *Gazette des Beaux-Arts*, 3rd series, XXXI, 1 May 1904, pp. 395–405. Expanded version in: Duret, *Histoire des peintres impressionnistes*, Paris, 1906. Repr.: Paris, 1919, 1923, 1939. Tr.: *Manet and the French Impressionists*, Philadelphia and London, 1910, London, 1912, Philadelphia, 1922. Tr.: *Die Impressionisten*, Berlin, 1909, 1918, 1923.

ELIAS, J. *Camille Pissarro*, Berlin, 1914.

FERMIGIER, A. 'Pissarro et l'anarchisme' in *Turpitudes sociales*, Geneva, 1972, pp. 3–8.

FIERENS, P. 'Beaux-Arts: Pissaro [sic]' *Le Journal des Débats*, XXXVII, 7 March 1930, pp. 401–3.

FOCILLON, H. 'L'Impressionnisme' in *La Peinture aux XIXe et XXe siècles: du réalisme à nos jours*, Paris, 1928, p. 217.

FONTAINAS, A. and L. VAUXCELLES. 'Camille Pissarro, Sisley, Guillaumin . . .' in *Histoire générale de l'art Français de la Révolution à nos jours*, Paris, 1922, pp. 159–68.

FRANCASTEL, P. *Monet, Sisley, Pissarro*, Paris, 1939.

GEORGE, W. 'Pissarro' *L'Art Vivant*, II, 15 March 1926, pp. 201–4.

GERHARDT, E. *Camille Pissarro, peintre et anarchiste*, unpublished Diplôme de l'Ecole des Hautes Etudes en Sciences Sociales, Université de Paris, 1980.

GRABER, H. 'Camille Pissarro' in *Camille Pissarro, Alfred Sisley, Claude Monet nach eigenen und fremden Zeugnissen*, Basel, 1943, pp. 19–107.

GREENBERG, C. 'Grand Old Man of Impressionism' (review of *Camille Pissarro: letters to his son Lucien*) *The Nation*, CLVIII, 24 June 1944, pp. 740–2.

GÜNTHER, H. *Camille Pissarro*, Munich, Vienna and Basel, 1954.

GUERMAN, M. *Pissarro*, Leningrad, 1973.

HAMEL, M. 'Camille Pissarro: exposition rétrospective de ses oeuvres' *Les Arts*, March 1914, pp. 25–32.

HERBERT, R. 'City vs. country: the rural image in French painting from Millet to Gauguin' *Artforum*, VIII, Feb. 1970, pp. 51–2.

HIND, A.M. 'Camille Pissarros Graphische Arbeiten. Seine Radierungen, Lithographien und Monotypien und Lucien Pissarros Holzschnitte nach seines Vaters Zeichnungen' *Die Graphischen Künste*, XXXI, 1908, pp. 34–48.

HOLL, J.C. 'Camille Pissarro et son oeuvre' *L'Oeuvre d'Art International*, VII, Oct.–Nov. 1904, pp. 129–56. Repr.: Holl, *Camille Pissarro et son oeuvre*, Paris, 1904; Expanded version: *Portraits d'Hier*, III, July 1911, pp. 35–64.

_____ . 'Pissarro' *L'Art et les Artistes*, XXII, Feb. 1928, pp. 144–70.

*HOUSE, J. 'New material on Monet and Pissarro in London in 1870–71' *Burlington Magazine*, CXX, Oct. 1978, pp. 636–42.

IOUDENITCH, I.V. *Paysages de Pissarro à l'Hermitage*, Leningrad, 1963.

IWASAKI, Y. *Pissarro*, Tokyo, 1978.

JARVIS, J.A. *Camille Pissarro*, Virgin Islands, 1947.

JEDLICKA, G. *Pissarro*, Berne, 1950.

JOETS, J. 'Camille Pissarro et la période inconnue de St-Thomas et de Caracas' *L'Amour de l'Art*, XXVII, 1947, pp. 91–7.

KAHN, G. 'Art: une rétrospective Camille Pissarro' *Mercure de France*, CL, 1 Feb. 1913, pp. 636–7.

_____ . 'Art: Loys Delteil, *Le Peintre-Graveur Illustré*, tome XVII' *Mercure de France*, CLXIX, 1 Feb. 1924, pp. 779–82.

_____ . 'Camille Pissarro' *Mercure de France*, CCXVIII, 1 March 1930, pp. 257–66.

_____ . 'Le Rétrospective de Pissarro' *Mercure de France*, CCXVIII, 15 March 1930, pp. 697–700.

KIRCHBACH, W. 'Pissarro und Raffaëlli, zwei Impressionisten' *Die Kunst unserer Zeit*, XV, 1904, pp. 117–36.

KOENIG, L. *Camille Pissarro*, Paris, 1927.

KUNSTLER, C. 'Camille Pissarro' *La Renaissance*, XI, Dec. 1928, pp. 497–508.

_____ . 'La Maison d'Eragny' *ABC, Magazine Artistique et Littéraire*, V, March 1929, pp. 79–83.

_____ . *Paulémile Pissarro*, Paris, 1928.

_____ . 'A propos de l'exposition du Musée de l'Orangerie aux Tuileries; le centenaire de Camille Pissarro' *L'Art Vivant*, VI, 1 March 1930, pp. 185–90.

_____ . *Camille Pissarro*, Paris, 1930.

_____ . *Pissarro: villes et campagnes*, Lausanne and Paris, 1967. Tr.: *Pissarro: landscapes and cities*, New York [n.d.].

_____ . *Camille Pissarro*, Milan, 1972. Tr.: *Camille Pissarro*, Paris, 1974.

LANES, J. 'Loan exhibition at Wildenstein' *Burlington Magazine*, CVII, May 1965, pp. 274–6.

*LECOMTE, G. *Camille Pissarro*, Paris, 1922.

———————— . 'Un Centenaire: un fondateur de l'Impressionnisme, Camille Pissarro' *Revue de l'Art Ancien et Moderne*, LVII, March 1930, pp. 157–72.

LETHEVE, J. 'J.-K. Huysmans et les peintres impressionnistes: une lettré inédite à Camille Pissarro' *Bulletin de la Bibliothèque Nationale*, IV, June 1979, pp. 92–4.

LEYMARIE, J. *L'Impressionnisme*, 2 vols., Lausanne [1955]. Tr.: *Impressionism*, 2 vols., Lausanne [1955].

LEYMARIE, J. and M. MELOT, *Les gravures des Impressionnistes: Manet, Pissarro, Renoir, Cézanne, Sisley, oeuvre complet*, Paris, 1971. Tr.: *The graphic works of the Impressionists*, London and New York, 1972.

LLOYD, C. 'Camille Pissarro and Hans Holbein the Younger' *Burlington Magazine*, CXVII, Nov. 1975, pp. 722–6.

———————— . *Pissarro*, Oxford and New York, 1979.

———————— . 'The literature of art . . . Camille Pissarro, a biography' (review of Adler) *Burlington Magazine*, CXX, Oct. 1978, pp. 683–4.

MALVANO, L. *Pissarro*, Milan [1965]. Tr.: *Pissarro*, Paris, 1967.

MANSON, J.B. 'Camille Pissarro' *The Studio*, LXXIX, May 1920, pp. 82–8.

———————— . 'Camille Pissarro' *The Studio*, XCIX, June 1930, pp. 409–15.

———————— . *Camille Pissarro, a lecture delivered by the late J.B. Manson to the Ben Uri Art Society on January 23rd 1944*, London, 1946.

MATISSE, H. Conversation with Pissarro, in A. Barr, *Matisse: his art and his public*, New York, 1951, 1974, p. 38. Repr.: B. White, *Impressionism in perspective*, Englewood Cliffs, 1978, p. 26.

MAUCLAIR, C. 'Les Artistes secondaires de l'Impressionnisme' in *L'Impressionnisme, son histoire, son esthétique, ses maîtres*, Paris, 1904. Rev. ed. 1923. Tr. of Mauclair, 1903.

MEADMORE, W.S. *Lucien Pissarro: un coeur simple*, London, 1962.

MEIER, G. *Camille Pissarro*, Leipzig, 1965.

*MEIER-GRAEFE, J. 'Camille Pissarro' *Kunst und Künstler*, II, Sept. 1904, pp. 475–88. Repr.: Meier-Graefe, *Impressionisten: Guys, Manet, van Gogh, Pissarro, Cézanne*, Munich, 1907, pp. 153–72.

MELOT, M. *L'Estampe Impressionniste*, Bibliothèque Nationale, Paris, 1974 (exhibition catalogue).

*———————— . 'La Pratique d'un artiste: Pissarro graveur en 1880' *Histoire et Critique des Arts*, II, June 1977, pp. 14–38. Tr.: 'Camille Pissarro in 1880: an anarchistic artist in bourgeois society' *Marxist Perspectives*, II, Winter 1979–80, pp. 22–54.

MOORE, G. *Reminiscences of the impressionist painters*, Dublin, 1906, pp. 39–41.

MORICE, C. 'Deux morts: Whistler, Pissarro' *Mercure de France*, L, April 1904, pp. 72–97. Expanded version: Morice, *Quelques maîtres modernes*, Paris, 1914, pp. 28–45.

NATANSON, T. 'L'apôtre Pissarro' in *Peints à leur tour*, Paris, 1948, pp. 59–63.

———————— . *Pissarro*, Lausanne [1950].

NEUGASS, F. 'Camille Pissarro 1830–1903 zur Zentenarausstellung in der Orangerie der Tuilerien' *Die Kunst für Alle*, VL, May 1930, pp. 232–9. Tr.: 'Camille Pissarro 1830–1903, 100th anniversary, July 10, 1930' *Apollo*, XII, pp. 65–7.

———————— . 'Camille Pissarro' *Deutsche Kunst und Dekoration*, XXXIV, Dec. 1930, p. 159.

*NICOLSON, B. 'The anarchism of Camille Pissarro' *The Arts*, no. 11, 1946, pp. 43–51.

NOCHLIN, L. 'Camille Pissarro: the unassuming eye' *Art News*, LXIV, April 1965, pp. 24–7, 59–62.

PATAKY, D. *Pissarro*, Budapest, 1972.

PERRUCCHI-PETRI, U. 'War Cézanne Impressionist? Die Begegnung zwischen Cézanne und Pissarro' *Du*, XXXV, Sept. 1975, pp. 50–65.

PERRUCHOT, H. 'Pissarro et le Néo-Impressionnisme' *Jardin des Arts*, Nov. 1965, pp. 48–57.

PICA, V. 'Camille Pissarro, Alfred Sisley . . .' in *Gl'Impressionisti Francesi*, Bergamo, 1908, pp. 125–38.

PISSARRO, L.-R. 'The etched and lithographic work of Camille Pissarro' *The Print Collector's Quarterly*, IX, Oct. 1922, pp. 274–301.

———————— . 'Au sujet de Pissarro' *Beaux-Arts*, LXXIV, 26 June 1936, p. 2.

POOL, P. *Impressionism*, London and New York, 1967.

PREUTU, M. *Pissarro: monografie*, Bucarest, 1974.

REFF, T. 'Copyists in the Louvre' *Art Bulletin*, XLVI, Dec. 1964, p. 556.

*———————— . 'Pissarro's Portrait of Cézanne' *Burlington Magazine*, CIX, Nov. 1967, pp. 626–33.

REID, M. 'Camille Pissarro: three paintings of London. What do they represent?' *Burlington Magazine*, CXIX, April 1977, pp. 251–61.

*REIDEMEISTER, L. *Auf den Spuren der Maler der Ile de France*, Berlin, Staatliche Museen, 1963.

REWALD, J. 'L'Oeuvre de jeunesse de Camille Pissarro' *L'Amour de l'Art*, XVII, April 1936, pp. 141–5.

———————— . 'Camille Pissarro: his work and influence' *Burlington Magazine*, LXXII, June 1938, pp. 280–91.

———————— . *Camille Pissarro au Musée du Louvre*, Paris and Brussels, 1939.

———————— . *Pissarro*, Paris [1939].

———————— . 'Camille Pissarro in the West Indies' *Gazette des Beaux-Arts*, 6th series, XXII, Oct. 1942, pp. 57–60.

———————— . 'Pissarro's Paris and his France; the camera compares' *Art News*, XLII, 1 March 1943, pp. 14–7, and 15 March 1943, p.7.

———————— . *Pissarro*, Paris, 1953.

———————— . *Camille Pissarro*, Paris, 1954. Tr.: *Camille Pissarro*, New York, 1954.

———————— . *Pissarro*, Paris, 1962. Reduced text, tr.: *Pissarro*, London and New York, 1963.

*———————— . *The History of Impressionism*, New York, 4th rev. ed., 1973. Earlier eds.: 1946, 1955, 1961. Tr.: *L'Histoire de l'Impressionnisme*, Paris, 1955, 1965, 1971, 1976.

*———————— . GBA. 'Theo van Gogh, Goupil and the Impressionists' *Gazette des Beaux-Arts*, 6th series, LXXXI, Jan. 1973, pp. 1–64, Feb. 1973, pp. 65–108.

*———————— . *Post-Impressionism, from van Gogh to Gauguin*, New York, 3rd rev. ed., 1978. Earlier eds.: 1956, 1962. Tr.: *Le Post-Impressionnisme*, Paris, 1961.

REY, R. 'Pissarro aux Iles Vierges' *Beaux-Arts*, LXXIV, 1 May 1936, p. 6.

ROGER-MARX, C. 'Les Eaux-fortes de Pissarro, Galerie Bine' *La Renaissance*, X, April 1927, pp. 203–5.

———————— . 'Camille Pissarro' *Les Annales Politiques et Littéraires*, 15 Dec. 1928, pp. 578–9.

———————— . *Camille Pissarro*, Graveurs français nouveaux, no. 1, Paris, 1929.

ROSENSAFT, J.B. 'Le Néo-Impressionnisme de Camille Pissarro' *L'Oeil*, Feb. 1974, pp. 52–7, 75.

SERULLAZ, M. *Camille Pissarro*, Arcueil, 1955.

SHAPIRO, B. 'Four intaglio prints by Camille Pissarro' *Boston Museum Bulletin*, LXIX, 1971, pp. 131–41.

SHAPIRO, B. and M. MELOT, 'Catalogue sommaire des monotypes de Camille Pissarro' *Nouvelles de l'Estampe*, Jan.–Feb. xix (1975), pp. 16–23.

*SHIKES, R. and P. HARPER, *Pissarro: his life and work*, New York and London, 1980.

SICKERT, W. 'French pictures at Knoedler's Gallery' *Burlington Magazine*, XLIII, July 1923, pp. 39–40. Repr.: O. Sitwell, *A free house*, London, 1947, pp. 155–8.

STEIN, M. *Camille Pissarro*, Copenhagen, 1955.

STEPHENS, H. 'Camille Pissarro, impressionist' *Brush and Pencil*, XIII, March 1904, pp. 411–27.

*TABARANT, A. *Pissarro*, Paris, 1924. Tr.: *Pissarro*, New York and London, 1925.

THIEBAULT-SISSON. 'Camille Pissarro et son oeuvre' *Le Temps*, 30 Jan. 1921.

THORNLEY. *Vingt-cinq illustrations d'après Pissarro*, Paris, n.d.

THOROLD, A. 'The Pissarro collection in the Ashmolean Museum, Oxford' *Burlington Magazine*, CXX, Oct. 1978, pp. 642–5.

VENTURI, L. 'L'Impressionismo' *L'Arte*, XXXVIII, March 1935, pp. 118–49. Tr.: 'Impressionism' *Art in America*, XXIV, July 1936, pp. 94–110. Repr.: B. White, *Impressionism in perspective*, Englewood Cliffs, 1978, pp. 105–13.

————————. *Les Archives de l'Impressionnisme*, II, Paris, 1939.

————————. 'Camille Pissarro' in *Impressionists and Symbolists*, New York and London, 1950, pp. 67–79.

WEISBACH, W. *Impressionismus: ein Problem der Malerei in der Antike und Neuzeit*, II, Berlin, 1911, pp. 142–4.

WHITE, H. and C. *Canvases and careers: Institutional change in the French painting world*, New York, 1965.

Rouen, 1900, p. 4.

HERBERT, R. and E. 'Artists and anarchism: unpublished letters of Pissarro, Signac and others' *Burlington Magazine*, CII, Nov. 1960, pp. 472–82, and Dec. 1960, pp. 517–9. Letters to Grave. Tr.: 'Les Artistes et l'anarchisme' *Le Mouvement Social*, July–Sept. 1961.

JOETS, J. 'Lettres inédites de Pissarro à Claude Monet' *L'Amour de l'Art*, XXVI, 1946, pp. 58–65.

KUNSTLER, C. 'Des Lettres inédites de Camille Pissarro à Octave Mirbeau (1891–1892) et à Lucien Pissarro (1898–1899)' *La Revue de l'Art Ancien et Moderne*, LVII, March 1930, pp. 173–90, and April 1930, pp. 223–6.

LAPRADE, J. de. 'Camille Pissarro d'après des documents inédits' *Beaux-Arts, Chronique des Arts . . .*, 17 April 1936, p. 1, and 24 April 1936, pp. 1, 7. Letters to Duret and Murer.

LECOMTE, 1922, *op. cit.* Letters to Mirbeau.

LETTRES (abbrev.) *Camille Pissarro: lettres à son fils Lucien*, ed. J. Rewald, Paris, 1950. Tr.: *Camille Pissarro: letters to his son Lucien*, London and New York, 1943. 3rd ed., rev. and enl., Mamaroneck, 1972. 4th ed. rev. London, 1980.

NICULESCU, R. 'Georges de Bellio, l'ami des impressionnistes' *Revue Romaine d'Histoire de l'Art*, I, 1964, pp. 209–78. Repr.: *Paragone*, XXI, Sept. 1970, pp. 25–66, and Nov. 1970, pp. 41–55.

REWALD, J. *Paul Cézanne*, New York, 1947. Letters to Zola and Huysmans.

————————. *Georges Seurat*, Paris, 1948. Letters to Signac, Van de Velde and Fénéon. Repr. in Rewald, 1978, *op. cit.*

TABARANT, 1924, *op. cit.* Letters to Duret and Murer.

VENTURI, L. 'Lettres de Camille Pissarro' (to Durand-Ruel) and 'Lettres à Octave Maus' in *Les Archives de l'Impressionnisme*, II, Paris, 1939, pp. 9–52, 232–40.

III. Pissarro's letters

N.B. J. Bailly-Herzberg is preparing a complete edition of Pissarro's correspondence; the first volume, containing letters up to 1885, is to be published in Paris in 1980.

ARCHIVES de Camille Pissarro, Paris, Hôtel Drouot, 21 Nov. 1975. (Sales catalogue.) Preface by M. Melot.

AUTOGRAPHES et documents divers, Paris, Hôtel Drouot, 15 June 1977. (Sales catalogue.) Letters to Monet.

BAILLY-HERZBERG, J. *Correspondance de Camille Pissarro à son fils Georges dit Manzana et à sa nièce Esther Isaacson, commentaires et étude critique*, unpublished Diplôme de Troisième Cycle, Paris IV Sorbonne.

[BESSON, G.] 'L'Impressionnisme et quelques précurseurs' *Bulletin des Expositions*, III, Paris, Galerie d'Art Braun et Cie, 22 Jan.–13 Feb. 1932. Letters to Duret.

CACHIN-SIGNAC, G. 'Autour de la correspondance de Signac' *Arts*, 7 Sept. 1951, p. 8. Letter to Signac.

[CACHIN-SIGNAC, G.] 'Lettres de Pissarro à Paul Signac et Félix Fénéon' *Les Lettres Françaises*, 8–15 Oct. 1953, p. 9.

DEWHURST, 1904, *op. cit.* Letters to Dewhurst.

FERMIGIER, 1972, *op. cit.* Letters to Esther Isaacson.

GACHET, P. (ed.). *Lettres impressionnistes au Dr. Gachet et à Murer*, Paris, 1957.

GEFFROY, G. 'Lettres de Pissarro à Claude Monet' in *Claude Monet, sa vie, son oeuvre*, II, Paris, 1922, pp. 9–17. Repr.: Paris, 1980, pp. 269–77.

GIRIEUD, J. (ed.). *Les amis des monuments Rouennais; pour la maison du XVe siècle de la rue Saint-Romain; protestations,*

IV. Catalogues of exhibitions during Pissarro's lifetime

1859 PARIS, Palais des Champs-Elysées, *Salon de 1859, explication des ouvrages . . .*, beginning 15 April 1859.

1862 ROUEN, Musée des Beaux-Arts, *Exposition de la Société des Amis des Arts de Rouen*, 1 Oct.–15 Nov. 1862.

1863 PARIS, Palais des Champs-Elysées, Annexe, *Catalogue des ouvrages . . ., refusés par le Jury de 1863 et exposés, par décision de S.M. l'Empereur au Salon Annexe*, beginning 15 May 1865.

1864 PARIS, Palais des Champs-Elysées, *Salon de 1864, explication des ouvrages . . .*, beginning 1 May 1864.

1865 PARIS, Palais des Champs-Elysées, *Salon de 1865, explication des ouvrages . . .*, beginning 1 May 1865.

1866 PARIS, Palais des Champs-Elysées, *Salon de 1866, explication des ouvrages . . .*, beginning 1 May 1866.
 BORDEAUX, *Exposition de la Societé des Amis des Arts de Bordeaux.*
 LILLE, *Exposition de la Société des Amis des Arts de Lille.*

1868 PARIS, Palais des Champs-Elysées, *Salon de 1868, explication des ouvrages . . .*, beginning 1 May 1868.

1869 PARIS, Palais des Champs-Elysées, *Salon de 1869, explication des ouvrages . . .*, beginning 1 May 1869.

1870 PARIS, Palais des Champs-Elysées, *Salon de 1870, explication des ouvrages . . .*, beginning 1 May 1870.

1871 LONDON, German Gallery, *First annual exhibition of the Society of French Artists*, March 1871. (Typescript in the Durand-Ruel Archives.)
LONDON, South Kensington, *International exhibition*, May 1871.

1872 LONDON, German Gallery, *Second annual exhibition of the Society of French Artists*.
ROUEN, Musée des Beaux-Arts, *Exposition de la Société des Amis des Arts de Rouen*, 31 March–15 May 1872.
LONDON, German Gallery, *Third exhibition of the Society of French Artists*.
LONDON, German Gallery, *Summer exhibition*, 1872.

1874 PARIS, 35, boulevard des Capucines [Nadar's studio] *Société Anonyme des Artistes Peintres, Sculpteurs, Graveurs . . . première exposition*, 15 April–15 May 1874. Repr.: L. Venturi, *Les Archives de l'Impressionnisme*, Paris, 1939, II, pp. 255–6.
LONDON, German Gallery, *Eighth exhibition of the Society of French Artists*.
LONDON, German Gallery, *Ninth exhibition of the Society of French Artists*.

1875 LONDON, German Gallery, *Tenth exhibition of the Society of French Artists*.

1876 PARIS, 11 rue Le Peletier, *Catalogue de la 2e exposition de peinture . . .*, [Durand-Ruel] April 1876. Repr.: Venturi, II, pp. 257–9.
PAU, *Société des Amis des Arts de Pau: livret du Salon*.

1877 PAU, *Société des Amis des Arts de Pau: livret du Salon*, beginning 8 Jan. 1877.
PARIS, 6, rue Le Peletier, *Catalogue de la 3e exposition de peinture . . .*, April 1877. Repr.: Venturi, II, pp. 259–61.

1879 FLORENCE, *Catalogo delle Opere Ammesse alla Esposizione Solenne della Società d'Incoraggiamento delle Belle Arti in Firenze*.
PARIS, 28, avenue de l'Opéra, *Catalogue de la 4e exposition de peinture . . .*, 10 April–11 May 1879. Repr.: Venturi, II, pp. 262–4.

1880 PARIS, 10, rue des Pyramides, *Catalogue de la 5e exposition de peinture . . .*, 1–30 April 1880. Repr.: Venturi, II, pp. 264–5.

1881 PARIS, 35, boulevard des Capucines, *Catalogue de la 6e exposition de peinture . . .*, 2 April–1 May 1881. Repr.: Venturi, II, pp. 265–7.

1882 PARIS, 251, rue Saint-Honoré (Salons du Panorama de Reichshoffen), *Catalogue de la 7e exposition des artistes indépendants* [March 1882]. Repr.: Venturi, II, pp. 267–9.
TOURS, Salons de l'Hôtel de Ville, *Exposition des Amis des Arts de la Touraine*.

1883 LONDON, Dowdeswell and Dowdeswell, *Société des Impressionnistes*, April–July 1883.
PARIS, 9, boulevard de la Madeleine [Galerie Durand-Ruel] *Exposition des oeuvres de C. Pissarro*, May 1883.
BOSTON, International exhibition for art and industry, *Catalogue of the art department, foreign exhibition*.

1885 BRUSSELS, Hôtel du Grand Miroir. Group exhibition organized by Durand Ruel.

1886 NEW YORK, American Art Galleries, *Special exhibition: works in oil and pastel by the Impressionists of Paris*, March 1886. Subsequently shown: The National Academy of Design.
PARIS, 1, rue Laffitte, *Catalogue de la 8e exposition de peinture . . .*, 15 May–15 June 1886. Repr.: Venturi, II, pp. 269–71.
NANTES, *Ville de Nantes: exposition des beaux-arts*, 10 Oct.–30 Nov. 1886.
NEW YORK [American Art Galleries?] *Collection [of] modern paintings selected during the past summer by M. Durand-Ruel, Paris* [Dec. 1886–Jan. 1887?].

1887 BRUSSELS, Musée Moderne, *Catalogue de la IVe exposition annuelle des XX*, Feb. 1887.
PARIS, Galerie Georges Petit, *Exposition internationale de peinture et de sculpture, 6ème année*, 8 May–8 June 1887.
NEW YORK, National Academy of Design, *Catalogue of celebrated paintings by great French masters . . .* 25 May–30 June 1887.

1888 PARIS, Galerie Durand-Ruel, *Divers artistes*, 25 May–25 June 1888.

1889 PARIS, Galerie Durand-Ruel, *Peintres-graveurs*, 23 Jan.–14 Feb. 1889.
BRUSSELS, Musée Moderne, *Catalogue de la VIe exposition des XX*, Feb. 1889.
PARIS, Exposition Universelle, *Beaux-Arts: centennale de l'art Français, 1789–1889*.

1890 PARIS, Galerie Boussod et Valadon, *Exposition d'oeuvres récentes de Camille Pissarro*, 25 Feb.–15 March 1890. Preface, 'Camille Pissarro,' by G. Geffroy. Repr.: Geffroy, *La Vie artistique*, Paris, 1892, pp. 38–46.
PARIS, Galerie Durand-Ruel, *Deuxième exposition de peintres-graveurs*, 6–26 March 1890.

1891 BRUSSELS, Musée Moderne, *Catalogue de la VIIIe exposition annuelle [des XX]*, Feb. 1891.
BOSTON, Chase's Gallery, *Catalogue of paintings by the Impressionists of Paris: Claude Monet, Camille Pissarro, Alfred Sisley, from the Galleries of Durand-Ruel, Paris and New York*, 17–28 March 1891. Anonymous preface, 'Camille Pissarro,' pp. 9–10.
PARIS, Galeries Durand-Ruel, *Exposition de pastels, aquarelles et eaux-fortes par Camille Pissarro*, April 1891.
NANTES, Société des Amis des Arts de Nantes, *Catalogue des ouvrages exposés dans les salons de l'exposition, Galerie Préaubert*, 4 April–4 May 1891.

1892 PHILADELPHIA, The Art Club of Philadelphia, *Loan exhibition of paintings and other objects of art from private collections in Philadelphia*, 25 Jan.–7 Feb. 1892.
PARIS, Galeries Durand-Ruel, *L'Exposition Camille Pissarro*, Feb. 1892. Preface by G. Lecomte.
ANTWERP, *Association pour l'Art: catalogue de la première exposition annuelle*, May–June 1892.

1893 PARIS, Galeries Durand-Ruel, *Exposition d'oeuvres récentes de Camille Pissarro*, 15–30 March 1893.

CHICAGO, Columbian Exposition, *Loan collection of foreign masters owned in the United States.*

1894 BRUSSELS, *Catalogue de la première exposition de la Libre Esthétique*, 17 Feb.–15 March 1894.
PARIS, Galeries Durand-Ruel, *Exposition Camille Pissarro: tableaux, aquarelles, pastels, gouaches*, March 1894.

1895 BRUSSELS, *La Libre Esthétique: catalogue de la 2e exposition*, 23 Feb.–1 April 1895.

1896 PARIS, Galeries Durand-Ruel, *L'Exposition d'oeuvres récentes de Camille Pissarro*, 15 April–9 May 1896. Preface, 'L'Oeuvre de Camille Pissarro,' by A. Alexandre, pp. 5–14.
PARIS, Galerie Vollard, *Exposition des peintres-graveurs*, 15 June–20 July 1896.

1897 NEW YORK, Durand-Ruel Galleries, *Paintings by Camille Pissarro: views of Rouen*, March–April 1897.
PITTSBURGH, Carnegie Institute, *The second annual exhibition held at the Carnegie Institute*, 4 Nov. 1897–1 Jan. 1898.

1898 PARIS, Galeries Durand-Ruel, *Exposition d'oeuvres récentes de Camille Pissarro*, 1–18 June 1898.
PITTSBURGH, Carnegie Institute, *The third annual exhibition held at the Carnegie Institute*, 3 Nov. 1898–1 Jan. 1899.

1899 PARIS, Galerie Bernheim-Jeune et fils, *Exposition de tableaux par C. Pissarro*, 22 March–15 April 1899.
PARIS, Galeries Durand-Ruel, *Exposition de tableaux de Monet, Pissarro, Renoir et Sisley*, April 1899.
PITTSBURGH, Carnegie Institute, *The fourth annual exhibition held at the Carnegie Institute*, 2 Nov. 1899–1 Jan. 1900.

1900 NANTES, Société des Amis des Arts de Nantes, *Catalogue des ouvrages exposés . . .*, April 1900.
PARIS, Exposition Universelle de 1900, *Centennale de l'art Français, de 1880 à nos jours.*
PITTSBURGH, Carnegie Institute, *The fifth annual exhibition held at the Carnegie Institute*, 1 Nov. 1900–1 Jan. 1901.

1901 PARIS, Galeries Durand-Ruel, *C. Pissarro*, 14 Jan.– 2 Feb. 1901.
BRUSSELS, La Libre Esthétique, Feb. 1901.

1902 PARIS, Galerie Bernheim-Jeune et fils, *Tableaux impressionnistes*, beginning 2 April 1902.

1903 VIENNA, *Entwicklung des Impressionismus in Malerei u. Plastik: XVI. Ausstellung der Vereinigung Bildender Künstler österreichs Secession*, Jan.–Feb. 1903.
NEW YORK, Durand-Ruel Galleries, *Exhibition of Paintings by Camille Pissarro*, 28 Nov.–12 Dec. 1903.

V. One-man exhibitions since Pissarro's death

1904 PARIS, Galeries Durand-Ruel, *Catalogue de l'exposition de l'oeuvre de Camille Pissarro*, 7–30 April 1904. Preface, 'Camille Pissarro,' by O. Mirbeau. Repr.:

Mirbeau, *Des Artistes, deuxième série*, Paris, 1924, pp. 224–34.

1907 PARIS, Galerie Eugène Blot, *L'Exposition Camille Pissarro*, 27 May–15 June 1907. Preface by G. Lecomte, pp. 1–6.
PARIS, Galeries Durand-Ruel, *L'Exposition de l'oeuvre gravé de Camille Pissarro*, 18 Nov.–5 Dec. 1907.

1908 PARIS, Galeries Durand-Ruel, *Exposition Pissarro*, March 1908. (Typescript in the Durand-Ruel Archives.)
PARIS, Galerie Bernheim-Jeune, Pissarro exhibition, 1908.

1910 PARIS, Galeries Durand-Ruel, *Tableaux et gouaches par Camille Pissarro*, 10–26 Jan. 1910.

1911 LONDON, Stafford Gallery, *Exhibition of pictures by Camille Pissarro*, beginning 13 Oct. 1911. Preface, 'Camille Pissarro,' by W. Sickert. Repr.: O. Sitwell, *A Free House*, London, 1947, pp. 139–42.
PARIS, Salon d'Automne, *Les eaux-fortes et les lithographies de Camille Pissarro*, Oct. 1911. Preface by T. Duret.

1914 PARIS, Galerie Manzi et Joyant, *Rétrospective C. Pissarro*, Jan.–Feb. 1914.

1916 NEW YORK, Durand-Ruel Galleries, *Exhibition: paintings by Camille Pissarro, 1830–1903*, 27 Jan.– 12 Feb. 1916.

1917 NEW YORK, Durand-Ruel Galleries, *Exhibition: paintings by Pissarro*, 3–17 Feb. 1917.

1919 NEW YORK, Durand-Ruel Galleries, *Exhibition of recently imported works by Pissarro*, 6–20 Dec. 1919.

1920 LONDON, Leicester Galleries, *Catalogue of a memorial exhibition of the works of Camille Pissarro*, May 1920, Preface, 'A note on Pissarro,' by J.B. Manson, pp. 5–7, and 'On the etchings and lithographs of Camille Pissarro,' by C. Dodgson, pp. 10–13.

1921 PARIS, Galeries Durand-Ruel, *Tableaux, pastels et gouaches par Camille Pissarro*, 27 Jan.–19 Feb. 1921.
PARIS, Galeries Nunès et Fiquet, *Catalogue de la collection de Madame Veuve C. Pissarro*, 20 May– 20 June 1921. Preface, 'Camille Pissarro,' by G. Geffroy, pp. 1–5. Rev. ed.: 'Souvenirs de Pissarro' in *Claude Monet, sa vie, son oeuvre*, II, Paris, 1922, pp. 3–7. (Repr. Paris, 1980, pp. 263–7.)

1923 NEW YORK, Durand-Ruel Galleries, *Exhibition of paintings by Camille Pissarro 1830–1903*, beginning 1 Dec. 1923.

1927 PARIS, Galerie Max Bine, *Exposition des eaux-fortes de Camille Pissarro*, 18 March–15 April 1927. Preface by C. Roger-Marx.
LONDON, Leicester Galleries, *Catalogue of an exhibition of etchings and lithographs by Camille Pissarro, 1830–1903*, Dec. 1927. Preface, 'The etchings of Pissarro,' by C. Roger-Marx. (Tr. of preface for Paris, Bine, 1927.)

1928 PARIS, Galerie Marcel Bernheim, *Dessins et pastels par Camille Pissarro*, 24 Feb.–8 March 1928.
PARIS, Galeries Durand-Ruel, *Tableaux de Camille*

Pissarro, 27 Feb.–10 March 1928.

1929 LYONS, Galerie A. Poyet, Pissarro exhibition, May 1929.

1930 PARIS, Musée de l'Orangerie, *Exposition Camille Pissarro, organisée à l'occasion du centenaire de la naissance de l'artiste*, Feb.–March 1930. Introductions by A. Tabarant and R. Rey.

1931 LONDON, Leicester Galleries, *Catalogue of an exhibition of gouaches, pastels and drawings by Camille Pissarro (1830–1903)*, June 1931. Preface, 'Camille Pissarro,' by W. Sickert.
LONDON, National Gallery, Millbank (Tate Gallery) *Exhibition of oil paintings by Camille Pissarro*, 27 June–10 Oct. 1931. Foreword by J.B.M. [J.B. Manson].

subsequently shown: BIRMINGHAM, Museum, Oct.–Nov. 1931. NOTTINGHAM, Castle Museum, Nov.–Dec. 1931. STOCKPORT, War Memorial Buildings, Jan. 1932. SHEFFIELD, Mappin Art Gallery, Feb.–March 1932. BOOTLE, Public Museum, Apr.–May 1932. LEEDS, City Art Gallery, July 1932. NORTHAMPTON, Art Gallery, Aug.–Sep. 1932. BLACKPOOL, Grundy Art Gallery, Sept. 1932. ROCHDALE, Art Gallery, Oct.–Nov. 1932.

1933 NEW YORK, Durand-Ruel Galleries, *Exhibition of paintings by Camille Pissarro in retrospect*, 3–24 Jan. 1933.

1934 PARIS, Galerie Marcel Bernheim, *Pissarro et ses fils*, 30 Nov.–13 Dec. 1934. Preface, 'Pissarro et ses fils,' by G. Kahn.

1936 LONDON, Wildenstein and Co., *Exhibition of works by Camille Pissarro*, 16 Jan.–7 Feb. 1936.
NEW YORK, Durand-Ruel Galleries, *Exhibition of paintings by Camille Pissarro*, 2–28 March 1936.
PARIS, Galerie Marcel Bernheim, *Les premières époques de Camille Pissarro, de 1858 à 1884*, 22 May–11 June 1936.
BALTIMORE, The Baltimore Museum of Art, *C. Pissarro*, 1–30 Nov. 1936.

1937 LONDON, Thomas Agnew and Sons, *Paintings and drawings by Camille Pissarro*, Dec. 1937.

1938 LONDON, The Calmann Gallery, *Gouaches, pastels and watercolours by Camille Pissarro*, 16 May–2 June 1938.

1941 NEW YORK, Durand-Ruel Galleries, *The art of Camille Pissarro in retrospect*, 24 March–15 April 1941. Preface, 'Camille Pissarro,' by L. Venturi.

1943 LONDON, Leicester Galleries, *Three generations of Pissarros: Camille, Lucien, Orovida*, June 1943. Foreword by R. Mortimer.

1944 NEW YORK, The Carstairs Gallery, *Paris by Pissarro*, 12–26 April 1944. Preface, 'Paintings of Paris by Camille Pissarro,' by G. Wescott.

1945 NEW YORK, Wildenstein and Co., *Camille Pissarro: his place in art*, 24 Oct.–24 Nov. 1945. 'Chronological survey,' pp. 13–30.

1946 CHICAGO, The Arts Club of Chicago, *Catalogue of an exhibition of paintings by Camille Pissarro*, 8–30 Jan. 1946.

1948 PARIS, Galerie Jacques Dubourg, *C. Pissarro (1830–1903): dessins, aquarelles, gouaches*, 25 May–9 June 1948.

1949 TOLEDO, The Toledo Museum of Art, *Pissarro*, May–June, 1949.

1950 PARIS, Galerie André Weil, *Exposition Pissarro*, 1–27 June 1950. Preface by G. Huisman.
LONDON, Matthiesen Gallery, *A Camille Pissarro exhibition*, 28 June–25 July 1950.

1954 LONDON, O'Hana Gallery, *Three generations of Pissarros, 1830–1954*, 22 April–15 May 1954. Preface by J. Rewald.

1955 LONDON, Leicester Galleries, *Camille Pissarro (1830–1903): a collection of pastels and studies*, June–July 1955. Preface and notes by L. Abul-Huda.
DIEPPE, Musée des Beaux-Arts, Pissarro exhibition [6 July–12 September 1955].

1956 PARIS, Galerie Durand-Ruel, *Exposition Camille Pissarro*, 26 June–14 Sept. 1956. Preface by R. Domergue.
LONDON, O'Hana Gallery, *Drawings, watercolours and the complete etched work of Camille Pissarro*, 25 Oct.–10 Nov. 1956.

1957 BERNE, Berner Kunstmuseum, *Camille Pissarro*, 19 Jan.–10 March 1957. Preface, 'Camille Pissarro,' by F. Daulte, pp. 6–9.
NEW YORK, Peter H. Deitsch, *Camille Pissarro: drawings, watercolors and rare prints*, Oct. 1957.

1958 LONDON, Leicester Galleries, *Camille Pissarro (1830–1903): a collection of drawings*, June 1958.

1959 CARACAS, Museo de Bellas Artes, *Pissarro en Venezuela; Dibujos de Camille Pissarro, Donación de la Fundación Creole*, May 1959. Preface, 'Camille Pissarro en Venezuela,' by A. Boulton.

1960 PALM BEACH, FLORIDA, The Society of the Four Arts, *Loan exhibition of paintings and drawings by Camille Pissarro, 1830–1903*, 9–31 Jan. 1960. 'Chronology,' repr. from 1945 New York, Wildenstein.

1962 NEW YORK, Hammer Galleries, *Camille Pissarro, drawings from the collection of Mrs. Lucien Pissarro and Mme. Rodo Pissarro*, 23 April–5 May 1962.
PARIS, Galerie Durand-Ruel, *Camille Pissarro, 1830–1903*, 29 May–28 Sept. 1962. Preface by J. Dupont.

1964 NEW YORK, Hammer Galleries, *Camille Pissarro in Venezuela*. Text by J. Rewald, pp. 5–29.

1965 NEW YORK, Beilin Gallery, *Exhibition of Pissarro drawings*, 23 March–5 April 1965. Preface is taken from Rewald, 1963.
NEW YORK, Wildenstein and Co., *Loan exhibition C. Pissarro*, 25 March–1 May 1965. Preface by J. Rewald.

1966 WINTERTHUR, Kunstmuseum Winterthur, *Camille*

Pissarro 1830–1903; Radierungen und Zinkographien aus der Sammlung Carl Heinz Jucker, 23 Jan.–27 Feb. 1966. Preface by C.H.J.

1967 LONDON, Leicester Galleries, *Catalogue of an exhibition of early and other drawings by Camille Pissarro, 1830–1903*, 1–24 Feb. 1967.

1968 NEW YORK, Center for Inter-American Relations, Art Gallery, *Pissarro in Venezuela*, 1 Feb.–6 March 1968. Preface pp. 5–18, is repr. of Boulton, 1966.
LONDON, Marlborough Gallery, *Pissarro in England*, June–July 1968. Preface, 'Pissarro: the White Knight of Impressionism,' by J. Russell, pp. 7–13.

1973 LONDON, Leicester Galleries, *Three generations of the Pissarro family*, 1 March–14 April 1973.
*BOSTON, Boston Museum of Fine Arts, *Camille Pissarro: the impressionist printmaker*. Catalogue by B. Stern Shapiro.

1976 WEST PALM BEACH, FLORIDA, Norton Gallery and School of Art, *Pissarro drawings from the collection of Mr. and Mrs. F.L. Schoneman*, 5 Dec. 1976–5 Jan. 1977. Catalogue by R. Brettell.
PONTOISE, Musée de Pontoise, *Camille Pissarro, sa famille, ses amis*, 10 Dec. 1976–28 Feb. 1977.

1977 LONDON, Morley Gallery, *Camille Pissarro: drawings from the Ashmolean Museum, Oxford*, 3 Nov.–9 Dec. 1977. Catalogue by L. Abul-Huda.

 subsequently shown: NOTTINGHAM, Nottingham University Art Gallery, 11 Jan.–11 Feb. 1978. EASTBOURNE, Towner Art Gallery, 25 Feb.–26 March 1978.

1978 PARIS, Ambassade du Venezuela en France, *Camille Pissarro en Venezuela 1852–1854; 40 aquarelles et dessins*, 24 Feb.–21 April 1978. Introduction, 'Un Voyage au siècle dernier,' by R. Soler.
LONDON, JPL Fine Arts, *A selection of drawings, watercolours, and pastels by Camille Pissarro, c. 1853–1903*, June–July 1978.
NEW YORK, The New York Public Library, *Camille Pissarro and impressionist print-makers*, 15 April–15 July 1980.

1980 MEMPHIS, TENNESSEE, The Dixon Gallery and Gardens, *Hommage to Camille Pissarro; the last years, 1890–1903*, 18 May–22 June 1980.
CARACAS, Museo de Bellas Artes, *Camille Pissarro*, Jul.–Aug. 1980. Preface by Alfredo Boulton.

VI. Sales catalogues of Pissarro's work

1906 PARIS, Hôtel Drouot, *Catalogue des tableaux, aquarelles, pastels, dessins et gravures par Camille Pissarro, provenant de son atelier*, 25 June 1906.

1928 PARIS, Galerie Georges Petit, *Catalogue des oeuvres importantes de Camille Pissarro et de tableaux, pastels, aquarelles, dessins, gouaches par Mary Cassatt, Cézanne [. . .] composant la Collection Camille Pissarro*, 3 Dec. 1928.
PARIS, Hôtel Drouot, *Catalogue de l'oeuvre gravé et lithographié de Camille Pissarro; eaux-fortes, aquatintes, lithographies, monotypes et des tableaux, aquarelles, pastels, dessins par Camille Pissarro, Bonvin, Cardoze [. . .] composant la Collection Camille Pissarro*, 7–8 Dec. 1928. Introduction, 'L'Oeuvre gravé et lithographié de Camille Pissarro,' by J. Caillac, pp. 5–8.

1929 PARIS, Hôtel Drouot, *Catalogue de l'oeuvre gravé et lithographié (deuxième partie) — eaux-fortes, aquatintes, lithographies, monotypes et des estampes modernes par P.A. Besnard, E. Carrière [. . .] composant la Collection Camille Pissarro*, 12–13 April 1929.

1931 PARIS, Hôtel Drouot, *Catalogue des tableaux, aquarelles, pastels, dessins par Camille Pissarro (1830–1903) composant la Collection de Monsieur A. Bonin*, 26 June 1931.

1951 PARIS, Hôtel Drouot, *Catalogue des dessins, aquarelles, eaux-fortes et lithographies par Camille Pissarro; dessins aquarelles, estampes par Camille Pissarro appartenant à Madame X*, 15 Feb. 1951.

Maps and town plans

MANCHE (Channel)

Varengeville
Dieppe
Etretat
SEINE
Le Havre
EPTE
Rouen
Trouville
OISE
Villiers
Gisors Eragny
Caen
Pont-de-l'Arche
Lisieux
Fourjes
La Roche-Guyon
Auvers-sur-Oise
Pontoise
Osny
Montmorency
Argenteuil
Mantes
MARNE
Nanterre
Louveciennes
PARIS
Lagny
Bougival
Champigny
Versailles
La Varenne
Chennevières
SEINE
Melun
Chailly
SEINE
Barbizon
Fontainebleau
Moret-sur-Loing
Mayenne
LOING
YONNE
Le Mans

Map of northern France showing places where Pissarro worked

Map of the centre of Paris showing the streets painted by Pissarro and vantage points of the hotels used – Gare Saint Lazare, Boulevard Montmartre, Place du Théâtre Francais, Rue de Rivoli, Place Dauphine on Ile de la Cité, and Quai Voltaire

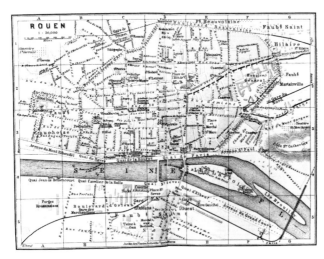

Map of Rouen (*Baedeker*)

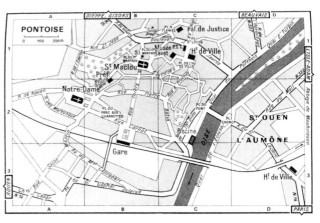

Map of Pontoise (*Michelin*)

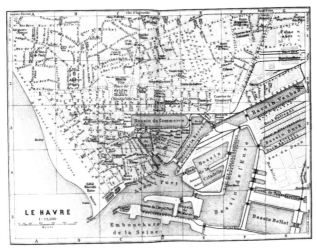

Map of Le Havre (*Baedeker*)

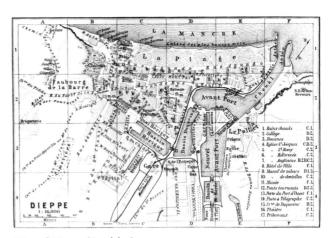

Map of Dieppe (*Baedeker*)